S0-BFC-892

DATE DUE

DEC 27 '93			
RT'D DEC 06 '93			
OCT 0 4 2005 RECEIVED			
OCT 0 4 2005			

HIGHSMITH #LO-45220

PASSION
AND REBELLION

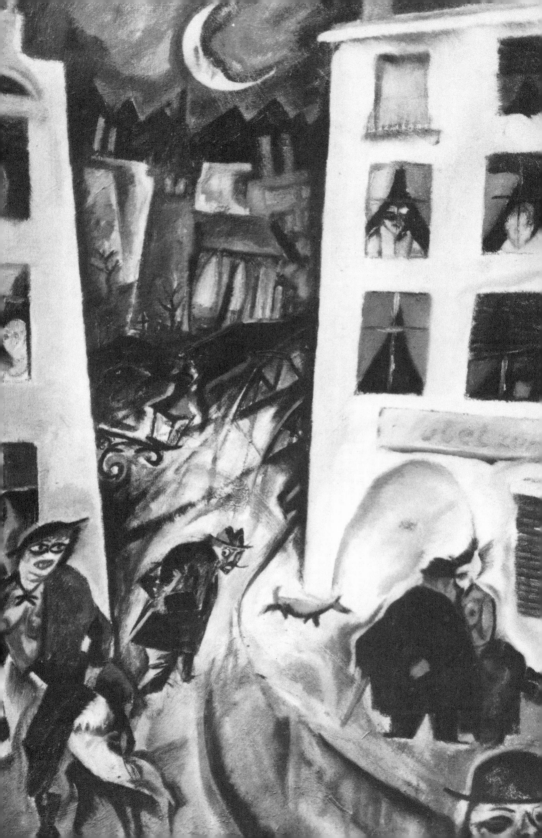

PASSION AND REBELLION

The Expressionist Heritage

Edited by
Stephen Eric Bronner
& Douglas Kellner

COLUMBIA UNIVERSITY PRESS
NEW YORK

NX
550
A1 P374
1988

c.1

#17439133
DLC

6-29-89

Library of Congress Cataloging in Publication Data
Columbia University Press
Morningside Edition 1988

LIBRARY OF CONGRESS
Library of Congress Cataloging-in-Publication Data

Passion and rebellion : the expressionist heritage / edited by Stephen
Eric Bronner & Douglas Kellner. — Morningside ed.
 p. cm.
 Reprint. Originally published: South Hadley, Mass. : J.F. Bergin,
1983.
 Includes bibliographies and index.
 ISBN 0-231-06762-3. ISBN 0-231-06763-1 (pbk.)
 1. Expressionism (Art)—Germany. 2. Arts, German. 3. Arts,
Modern—20th century—Germany. I. Bronner, Stephen Eric, 1949–
II. Kellner, Douglas, 1943– 88-2623
NX550.A1P374 1988 CIP
700'.943—dc19

First Published in 1983 by
J. F. Bergin Publishers, Inc.

Copyright © 1983 by Stephen Eric Bronner and Douglas Kellner
All rights reserved. No part of this publication may be reproduced or transmitted in
any form or by any means, electronic or mechanical, including photocopy, recording
or any information storage or retrieval system, without permission in writing from
the publisher.

 The editors wish to thank **New German Critique,** Jean-Michel Palmier, Wilhelm
Fink Verlag, and Suhrkamp Verlag for permission to reprint or translate the contri-
butions by Mitzman, Palmier, Vietta, and Kneif published in this book.

Frontispiece: *The Street* (*Die Strasse*), Georg Grosz.
(Courtesy The Solomon R. Guggenheim Museum)

Printed in the United States of America

Contents

FILM 361

Illustrations

Preface

The time has come for a new encounter with Expressionism. Despite the influence which certain individual artists have exerted on the American cultural milieu, it is fair to say that Expressionism has remained shrouded in relative obscurity. This is all the more remarkable since Expressionism was clearly one of the most powerful artistic movements of the twentieth century. Painting, literature, theater, music, and film were never the same after the expressionist explosion. And there were socio-political effects as well, which influenced both the Left and the Right during one of the most turbulent periods in German history. Indeed, even today, the expressionist drive toward social change and the creation of new forms of life continue to provide images and ideas which can animate the desire for a transformation of reality through critical insights, and frequently utopian visions, that attempt to liberate creativity and life from repressive social and cultural constraints. In this sense, the legacy of Expressionism retains emancipatory elements which provide what Ernst Bloch has called an "unclaimed heritage."

Earlier studies have generally stressed only particular thematic or aesthetic aspects of the expressionist phenomenon. The present collection of essays, however, will seek to offer a new beginning for understanding Expressionism as a socio-cultural movement. Thus, *Passion and Rebellion* will attempt to examine Expressionism in terms of its origins, artistic tendencies, and theoretical-aesthetic presuppositions, along with its socio-political impact. By the same token, the particular contributions of major artists will be discussed. Consequently, this anthology will contain: (1) a general historical overview and interpretation of Expressionism as an avant-garde movement; (2) an analysis of the expressionist tendencies within the major fields of art; (3) some new interpretations of artists and topics within particular artistic media; and (4) evaluations of the social and aesthetic effects and contributions of the expressionist rebellion.

The following studies are interdisciplinary, uniting scholars from a variety of academic fields. Although there are real philosophical and aesthetic differences amongst the collaborators, the separate chapters are integrated into a systematic framework. Each chapter was chosen in view of the contribution it would make to the project as a whole, and the editors have worked closely with the contributors to assure a certain coherence for the anthology. Hence, the great majority of these essays are being published for the first time and were specially commissioned for this volume. Moreover, within a critical socio-political perspective, we have attempted to select essays which will portray a diversity of views and interpretations that will do justice to the complexity of Expressionism, its contradictions, and the ambivalent character of its legacy.

A collaborative effort permeated this entire enterprise which has proved beneficial to the project and — we hope — to the contributors themselves. The potential benefits of interdisciplinary cooperation have too often been ignored, and perhaps this anthology will inspire other ventures of a similar sort. Consequently, the editors would like to thank our contributors for their cooperation in proposing articles and in creatively responding to criticisms of earlier versions of their essays. We would also like to extend our special thanks to Nancy Anderson, Carolyn Appleton, Rosalyn Baxandall, Rhonda Breen, Jim Fleming, Deidre O'Shea, Joel Rogers, Peggy Seeger, and Debbie Steinberg for their support and encouragement during the period in which this work was conceived and developed. We have experienced diverse pleasures in the critical collaborative interactions that were undertaken in the preparation of this volume. We also experienced, however, the tragic loss, first of Betty Weber, who was to have written on expressionist theater; next of Herbert Marcuse, who was to have elaborated his reflections on Expressionism and aesthetics; and then of our contributor and dear friend, Henry Pachter. It is to these three socialist scholars that we would like to dedicate this volume.

TOWARD A REINTERPRETATION OF EXPRESSIONISM

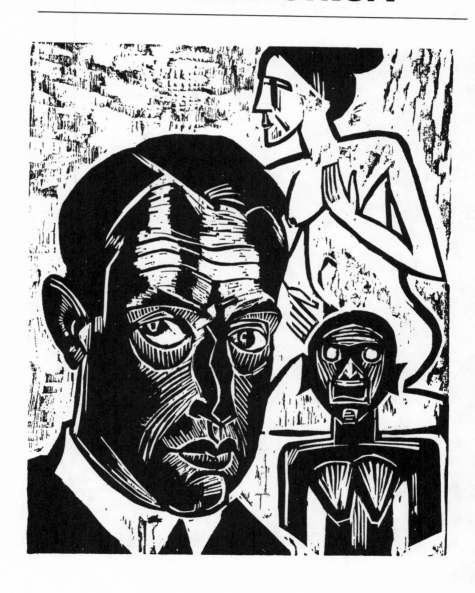

1
Expressionism and Rebellion

Douglas Kellner

The expressionist rebellions affirmed the primacy of a passionate subjectivity against traditional social norms and artistic forms. While maintaining a posture of artistic and social revolt, the Expressionists attacked the values and institutions of German bourgeois society and culture through provocative artistic attitudes and productions. Yet although the Expressionists championed subjectivity, passion, and rebellion, throughout this book it will be argued that Expressionism is a much more complex movement than is usually recognized. Against standard academic interpretations which reduce Expressionism to a species of irrational pathos, mystical vision, or merely a formal set of innovations in the arts, this introductory chapter — supported by many of the following studies — will attempt to show that Expressionism provides insights into the constitution of the modern epoch and social criticism of the effects on human life brought about by capitalist industrialization. Expressionism will therefore be re-interpreted as an avant-garde artistic movement which responded rebelliously to the development of bourgeois society in the era of industrial capitalism. From this perspective, Expressionism is not only important as an artistic phenomenon, but also as a social movement and integral part of the emergence of twentieth-century culture and consciousness which provides critical insights into an epoch that is not yet over.

Defining Expressionism

Over the past decades, there have been many, often contradictory, attempts to define Expressionism.[1] Sometimes Expressionism is characterized as a form of philosophical idealism or subjectivism, while both Marxists like Georg Lukacs and standard academic interpretations present it as a species of irrationalism.[2] For instance, Bernard S. Myers characterizes Expressionism in a way that stresses solely its subjective elements: "Fundamentally, the Expressionist artist stands for mysticism, self-examination, contemplation of the other-worldly, and speculation on the infinite — expressed in terms of great feeling or emotive tension."[3] Although there exist within Expressionism elements of speculative metaphysics and emphasis on vision, intuition, and what is labelled as the "irrational," this emphasis cannot adequately define the movement as a whole. Indeed, many Expressionists sought to overcome traditional academic distinctions between rationalism-irrationalism, objectivism-subjectivism, and materialism-idealism. In others, these polarities waged fierce battles which sometimes swayed toward one pole and sometimes the other. While some Expressionists were clearly irrationalists and extreme subjectivists, others articulated a subjective experience of objective historical crisis. Their fantasies were often grounded in real potentialities; their concern for the individual was sometimes accompanied by a drive toward social transformation; their idealism was frequently tempered by materialism; and their subjective revolts often contained rational critiques of ideology and society.

Artistically, Expressionism is often presented within the history of art as a rejection of Impressionism, Realism, and Naturalism. It has been claimed, for instance, that Expressionism is characterized by "(i) the use of various anti-naturalist or 'abstracting' devices, such as syntactical compression or symbolic picture-sequences, (ii) the assault on the sacred cows of the Wilhelmine-bourgeoisie from a left-wing internationalist position, (iii) the choice of the theme of spiritual regeneration or renewal, and (iv) the adoption of a fervent declamatory tone."[4] This description is misleading because expressionist "abstraction" often provided socio-historical insight and combined symbolist with realist elements. As a response to the prevailing norms and values of bourgeois society, the Expressionists espoused a variety of political positions from left-internationalist to right-nationalist. Some Expressionists criticized the sort of spiritual renewal, mystical apocalypse, and messianic revolution promoted by others, satirizing and attacking declamatory rhetoric in the arts, as well as artistic conventions and cliched journalistic and everyday language.

A problem with many standard characterizations of Expressionism is that they often take the ideological pronouncements of expressionist artists, or literati, at face value as accurate descriptions of expressionist art. In fact, the avant-garde movements which flourished in Europe during the first two decades of the century gave rise to a welter of artistic ideologies

which sometimes had little to do with the best art in the movement.[5] Intense market competition forced each new movement, or artistic tendency, to justify its novelty and importance by trumpeting its claims as a radical break with tradition which achieved a momentous artistic revolution. As part of the international avant-garde revolts, there appeared many ideological manifestoes which proclaimed the superiority of expressionist art. The expressionist avant-gardes attracted followers who produced interpretive works to publicize the movement. Wishing to more fully participate in the expressionist sub-cultures, these literati and publicists championed expressionist painting, poetry, music, theater, and film. They wrote manifestoes, reviews, and books praising and selling Expressionism to an initially inhospitable German public. Expressionist artists, too, energetically promoted both their works and the movement as a whole, producing artistic ideologies which explained and legitimized their artistic endeavors.

Indeed, Expressionism was one of the most self-conscious movements in the history of art and literature, accompanied by reams of theoretical writing and legitimating ideologies. As Geoffrey Perkins puts it, "common to both the art and literature of Expressionism, and most important for its relatively rapid success as well as for its equally abrupt end, were the 'pure' theoreticians, a band of knight-errant Doctors of Philosophy or Law, who neither painted nor wrote, but explained."[6] Since these artistic ideologies tended toward bombastic pathos, they often mystified the achievements of particular expressionist artists and works. The many later interpretations of Expressionism which followed the pronouncements of its ideologues tended to reproduce ideologies originally conceived to promote and legitimate the movement.

Another questionable, yet standard, way of interpreting Expressionism involves dividing the movement into two stages or tendencies: an earlier critical, negative and immensely creative artistic stage contrasted with a later, allegedly naive, rhetorical, and political "activist" stage where Expressionism degenerates into cliche and bombast. This theory of "two Expressionisms" was formulated by Wolfgang Paulsen in his 1935 book *Aktivismus und Expressionismus*[7] and by Walter Sokel in his influential 1959 book, *The Writer in Extremis,* who distinguishes between an early "sophisticated and modernist version of Expressionism" which developed a "new form" and a later "naive or rhetorical Expressionism" that haplessly preached a New Man.[8] Although there are many conflicting tendencies in Expressionism, it is doubtful whether one can neatly separate the "naive" from the "sophisticated," the "rhetorical" from the "formal," or the "artistic" from the "political." Some of the most modernist and aesthetically creative Expressionists were among the most rhetorical and were also, in their way, "political." "Activist" Expressionists were often "modernist" and experimental in their techniques, while those accused of being "messianic" and "rhetorical" (e.g., Kaiser) were often critical of excessive rhetoric and naive hopes for the New Man.

Since both artistic and political, formal and rhetorical tendencies are often found in the same artists or works, it is really impossible to separate neatly Expressionists into two essential categories.[9]

Expressionism therefore contains an anomalous heritage. Many interpretations of Expressionism suppress its contradictions and offer one-sided and inaccurate characterizations. In view of the heterogeneity of the expressionist rebellions, there is really no "essence" of Expressionism that allows itself to be captured in a simple definition. The difficulties in defining it, however, should not lead to agnosticism over the possibility of characterizing and interpreting Expressionism as an artistic movement. In part as a reaction to earlier simplified and problematical definitions of Expressionism, a tendency appeared in the late 1950's which in one form claimed that Expressionism could not be defined,[10] and in a more extreme form urged the abandonment of all literary "isms" and totalizing concepts in literary analysis.[11] While these positions raised serious questions about the adequacy of previous characterizations of Expressionism, they surrender, in effect, historical-philosophical analysis which might describe and interpret Expressionism as a movement with specific artistic-ideological tendencies and politico-cultural effects. Hence, while admitting that there is no simple definition, or "essence," of Expressionism, nonetheless there is still the problem of defining it as an artistic movement. This task should not be performed, however, by interpreting Expressionism as an emanation of the Teutonic soul, seeing the movement as an epiphenomenon of a peculiarly German worldview or spirit. John Willett, for instance, claims that Expressionism contains "a number of components which are seen as characteristically 'Teutonic,' not only by the outside world but also by many German critics: darkness, introspection, a concern with the mysterious and uncanny, massive metaphysical speculation, a certain gratuitous cruelty and a brilliant linear hardness, expressed by the most extravagant convolutions."[12] Others stress the primitivism inherent in Expressionism and its celebration of the natural and primordial.[13] These interpretations fail to see, however, that Expressionism responds to experiences of an emerging "modern" mechanized, industrialized world and that "primitivism" and "modernism" are peculiarly mixed in Expressionism. The expressionist reaction to modernity often invokes shock and passionate revolt, utilizing grotesque and sometimes primitive forms to express an experience and vision. Consequently, expressionist distortion, grotesqueness and ugliness — central formal features of expressionist art — are ways of visualizing and interpreting experiences of the emerging industrial society and are not simply expressions of a "Teutonic soul."

Moreover, Expressionism should be seen as an international artistic tendency.[14] The predecessors of German Expressionism came from a variety of countries, and Expressionism itself had impact throughout Europe and the United States. It was not the Germans alone who turned to the "irrational" and the "primitive" in art. The French philosopher

Rousseau is often perceived as the dominant European advocate of the "natural," and the French painters Gaugin, Henri Rousseau, and the Fauvists — as well as Europeans like Van Gogh and Munch — utilized "primitive" forms in their art. Further, expressionist painters like Kandinsky, Jawlensky, and Chagall were Russians, as were a group of "primitivist" poets. Strindberg vitally influenced expressionist drama, and Baudelaire, Rimbaud, Whitman, Dostoyevsky, and others influenced expressionist writing. Expressionism should therefore be seen as part of a series of avant-garde revolts and not as an epiphenomenon of the German "soul."

Nonetheless, an adequate interpretation must explain why the tendencies which we now call "Expressionism" took their most characteristic forms and had their greatest impact in Germany. In order to explain the origins and rise to cultural dominance of Expressionism in Germany from around 1910 to the early 1920's, one must focus on the social conditions and cultural infrastructure which shaped the expressionist movement in Germany. To begin, Expressionism had its roots in a specific German cultural tradition. Germany had a long history of artistic revolt and extreme individualism exhibited in its baroque drama and painting, *Sturm und Drang,* and Romanticism.[15] The crucial philosophical influence on Expressionism was Nietzsche, whose impact in Germany at the turn of the century was extremely powerful. In music, Beethoven, Wagner, and Mahler were part of the German heritage. The plays of Strindberg, Büchner, and the proto-Expressionist Frank Wedekind were part of the German repertoire by 1910. Both Romanticism and the Gothic and Baroque traditions of painting influenced expressionist creations in the pictoral arts. Moreover, Germany possessed a cultural infrastructure which could promote avant-garde developments in the arts — a cafe culture, theaters, music halls, cabarets, art galleries, literary and political journals, and publishing houses, some of which promoted expressionist art.[16] Groups of painters, *Die Brücke* and *Der Blaue Reiter,* produced, exhibited, and propagated expressionist painting, and new poets and writers had access to expressionist journals like *Der Sturm* and *Die Aktion.* Expressionist sub-cultures arose in Munich, Dresden, Berlin, and other German cities which provided a supportive environment for the growth and propagation of the movement. Consequently, it was the cultural tradition and infrastructure in Germany and — as I shall argue in this chapter — the peculiar development of German industrial capitalism which helped produce Expressionism as a dominant artistic movement in Germany, and not any nebulous Teutonic soul.

Romanticism, Nietzsche, and the Rise of the Subjective Orientation

To understand the origin and genesis of Expressionism, we must see it as a late development in the series of romantic anti-capitalist revolts that

emerged in the nineteenth century. The Romantics helped produce what Stephen Bronner has termed a "subjective orientation" which characterizes much of the later developments in German art and philosophy.[17] Against the prosaic realism, possessive individualism, and calculating objectivism of the emerging capitalist market society, the Romantics emphasized the creative individual, artistic genius, and the powers of imagination. Consequently, in the manifold romantic rebellions, there was a growing concern for the "inner life" and the creative powers of the individual.

Earlier in the industrial revolution, the English poet William Blake had attacked the "Satanic mills" and called for spiritual rebirth in the face of the material and spiritual decay which industrialization produced.[18] The English romantic poets idealized nature, withdrawing to the Lake Country and other regions unspoiled by industrialization and urbanization.[19] German Romantics — like Novalis, Hölderlin, and the Schlegels — looked back to a Golden Age and fought for a revitalization of culture and spiritualizing of the personality in the face of industrialization and mechanization.[20] Along with the young Hegel who shared their general orientation, the Romantics were among the first to perceive the alienation of the individual in the modern world and to call for a new society and revitalized subjectivity. They believed that by completely unfettering the creative powers of the individual imagination, a new spiritualized world could be created, and they affirmed the organic wholeness of man and nature, art and life, in a period when new forces challenged and assaulted the human subject.

During the nineteenth century, the rise of the subjective orientation was thus a response to what were perceived as threats to freedom and creativity. New social powers and structures overwhelmed a sensitive, cultural intelligentsia, producing a crisis of confidence which brought about an inward turn and increased focus on subjectivity and the "inner life." The triumph of industrial capitalism, coupled with the rise of mass society, urbanization, mechanized war, and the rapid tempo of technological and social change, led many to turn from the social and political realms to a cultivation and concern with individual subjectivity. The new subjectivist philosophies attempted to set the subject free from Objective or Absolute Idealism, as well as from the Creative Imagination of the Romantics. The individual subject was proclaimed the center of the universe and the primary locus of value, resulting in the disintegration of the Absolute and the absolutizing of the Subject. Such a philosophical rebellion began with the Romantics and was continued by the young Hegelians, Kierkegaard, and Max Stirner, and assumed an even more radical form with Nietzsche.[21]

Friedrich Nietzsche anticipated the expressionist rebellions in his polemical attacks on bourgeois society and culture, coupled with his demand for an emancipatory art and philosophy. His impact was deeply felt by many Expressionists, such as the playwright Reinhard Sorge, whose

poem "Christ and Nietzsche" put them on the same level as redeemers of mankind, and the poet Gottfried Benn, who described Nietzsche as the "world scale giant of the post-Goethean era."[22] Nietzsche attracted the Expressionists because they perceived in him a powerful critique of modern society and call for self-transformation.

Nietzsche's analysis of the modern era is crucial for understanding the expressionist project and its (often unarticulated) epistemological-metaphysical assumptions. For Nietzsche, the death of God was the decisive fact of the epoch, and deeply affected the totality of life. In his view, religion had declined as a viable philosophical system; consequently, many traditional values were rendered obsolete or threatened by the demise of a Deity who guaranteed value, meaning, and transcendence. In characteristically dramatic fashion, Nietzsche proclaimed the death of God in a passage that is proto-expressionist in its vigor and rhetoric:

> The *Madman.* Have you not heard of the madman who lit a lantern in the bright morning hours, ran to the market place, and cried incessantly, "I seek God! I seek God!" As many of those who do not believe in God were standing around just then, he provoked much laughter. Why, did he get lost? said one. Did he lose his way like a child? said another. Or is he hiding? Is he afraid of us? Has he gone on a voyage? or emigrated? Thus they yelled and laughed. The madman jumped into their midst and pierced them with his glances. . . . God is dead. God remains dead. And we have killed him. How shall we, the murderers of all murderers, comfort ourselves? What was holiest and most powerful of all that the world has yet owned has bled to death under our knives. Who will wipe this blood off us? What water is there to clean ourselves? What festivals of atonement, what sacred games shall we have to invent? Is not the greatness of this deed too great for us? Must not we ourselves become gods simply to seem worthy of it?[23]

The death of God, Nietzsche believed, had ushered in a new era of nihilism in which the traditionally highest values were devaluated, resulting in a loss of confidence and security, leading to a weakening of the will and decline of human power.[24] He argued that the death of God also undermined the foundation of modern philosophy which, in his view, rested on religious assumptions. The absolute certainty of the substantial subject, which Descartes posited as the necessary foundation for modern philosophy, rested on belief in a Deity who guaranteed the subject's knowledge and even immortality. Kant's critique of reason left room for religious beliefs and assumed a transcendental subject as the foundation of universal knowledge.[25] Some interpreters have seen Hegel as providing a sort of philosophical theodicy which conceptualized the totality of being as the manifestation of an absolute subject, interpreted by the religious Hegelians as God. Although Feuerbach and the young Hegelians claimed that idealist philosophy was theology in disguise, Nietzsche drew more extreme metaphysical and epistemological consequences.[26]

The death of God, Nietzsche suggested, brought about metaphysical homelessness and epistemological relativism. With no absolute ground- ing for knowledge and no certainty for one's perceptions, knowledge becomes a product of the individual subject. Here Nietzsche radicalized Kant, whose "Copernican revolution" maintained that knowledge is the product of a universal subject. While for Kant, *a priori* forms of cognition and knowledge guaranteed the universality and truth of claims to knowledge, Nietzsche subjectivized Kant's critique of pure reason and argued that each individual creates his/her own view of the world. Conse- quently, ideas and philosophies should be judged to the extent to which they promote or negate the individual's life, and not according to epistemological criteria. Nietzsche's "perspectivism" stands as one of the most radically subjectivist epistemologies in the history of philosophy, and it helped undermine the foundation of objectivistic theories of knowledge. For Nietzsche, truth is a subjective construct and knowledge is a ruse of the will to power, used to dominate and control nature and other people.[27]

Nietzsche's epistemology had radical consequences for the concept of art and the nature of artistic activity. If there was no objective reality for the artist to "imitate," then the role of art was individual expression or creation. Classical realist art assumed the existence of a fixed and stable external "reality" which art was to picture or mirror. But if this "reality" dissolved in a flux of individual perceptions, then the artist was freed from the constraints of any fixed notions of art or reality. Nietzsche's "relativism" thus profoundly influenced the expressionist worldview and aesthetic perspectives.

Moreover, Nietzsche proclaimed that the very notion of a subject of knowledge or action is a fiction: "My hypothesis: subject as multiplicity."[28] In this interpretation, the "subject" becomes a bundle of drives and impulses, some of which are not even conscious. The autonomous subject is dethroned; the individual seen as a field of con- flicting forces and drives. In this view, one cannot necessarily know one's own nature and cannot be sure that perceptions, ideas, or words corres- pond to any external or objective reality. This sundering of language and reality, thought and being, provided the foundation for many Expres- sionists' views of the world. For some, it created a situation of despair and extreme subjectivism, while others found Nietzsche's ideas very liberating. Freed from traditional constraints, the individual could create a novel world of thoughts and actions, as well as unique worlds of art. The poet Georg Trakl, for instance, rejected the poetic ego of lyric poetry and opened up a new field of literary expression in which dreams, fantasies, and the unconscious could function on an equal level of importance to consciousness and rationality.[29] Nietzsche had a powerful impact on Strindberg, Munch, and other artists who were in turn important in- fluences on Expressionism.

For the expressionist generation, Nietzsche was one of the most

powerful critics of the modern age by virtue of his attacks against German philistinism, religion, and mass society. Practically all Expressionists followed Nietzsche in opposing the society of the *"Bildungsphilister"* ("complacent bourgeois") and, like Nietzsche, they perceived threats to individual subjectivity through new social forces and institutions. Above all, the Expressionists were entralled by Nietzsche's summons to create a superior individual, the *Übermensch*. They became fascinated with his radical transvaluation of values combined with his call for an overthrow of the highest existing values, and were impressed by his daring attempt to develop a new art and language which would combine philosophy, literature, and individual expression. Nietzsche's visionary, rhapsodic prose in works like *Thus Spoke Zarathrustra* provided a liberating sense that the artist could create and express anything. His championing of the body, passions, and ecstasy inspired the Expressionists, who themselves opposed bourgeois morality and advocated a freer sexuality. Furthermore, his emphasis on spiritual renewal and advocacy of creativity as the highest value were important for the Expressionists' sense of the artistic calling. And many Expressionists were taken with Nietzsche's apocalyptic vision of a new world, of a *Götterdämmerung* (Twilight of the Idols) and *Morgenröte* (A New Day).

Almost all expressionist artists of the period absorbed Nietzschean ideas through osmosis, if not by direct study. Nietzsche's ideas were "in the air" and helped create the intellectual atmosphere in which Expressionism emerged. Moreover, his radical critiques of epistemology, science, and rationalism were carried further by Freud, Bergson, and irrationalists like Klages. Their analyses continued the trend to "de-center" the subject and to picture human reality as a chaotic, fragmentary forcefield of conflicting drives, ideas, and emotions. Bergson described the "flow" of "lived experience" and argued that immediate intuition provided a more direct access to reality than analytical reason. The philosophy of life (*Lebensphilosophie*), too, made lived experience and empathetic intuition (*Einfühlung*) of others' thoughts and feelings the key to cultural interpretation.[30]

Tendencies in the philosophy of science also nourished the subjective orientation. Richard Avenarius, Ernst Mach, and later positivists denied that perceptions mirror external reality, claiming that all we could know are our own sense-perceptions and not any "objective" external world.[31] Mach attacked all forms of metaphysics as untenable dogmatism, arguing that science itself is no more than a symbolic construct to help us with practical activities and therefore without any absolute status. Mach rejected all absolute concepts, believing that atoms, space, time, causality, and all our knowledge are simply instruments we use within various theories and practical behavior. The impact of Mach's relativism was intensified by Einstein's relativity theory which, to many, caused a crisis in the foundation of the sciences. Centuries of scientific certainty rooted in Newtonian physics were thus overthrown and "relativi-

ty" was one of the most discussed and disturbing concepts of the day.

In this universe, there were no absolutes or certainties; even the basic elements of experience, which were the basis of knowledge and action, themselves were perceived by the Machians as subjective sensations which did not necessarily correspond to any external reality. Nietzsche, Freud, Mach, and others put in question the concept of a substantial self as the foundation of sense-perceptions. This form of "subjectivism without a subject" (Kolakowski) helped at once to produce philosophical skepticism and relativism, as well as attempts to ground knowledge and re-establish a transcendental subject or bedrock of epistemic certainty.[32] The neo-Kantians and phenomenologists, for example — who were among the dominant philosophical currents during the rise of Expressionism — followed the critical epistemologies, yet attempted to escape the dilemmas of relativism. Various neo-Kantians attempted to resurrect subjectivity and to re-establish absolute ethical values,[33] while Husserl sought to establish essential truths which would be ascertained in a phenomenological "intuition of essence" (*Wesensschau*) and grounded in a transcendental subject.[34]

The expressionist generation grew up in the ferment of this philosophical situation, reproducing its contradictions in their thought and works. They were influenced in various ways by the relativism and perspectivism of Nietzsche, Mach, and others, as well as by the attempts to vindicate subjectivity and establish a realm of essential being and truth advocated by the neo-Kantians and Husserl. Thus Expressionism is marked by tendencies of nihilism and relativism, as well as by attempts to overcome these tendencies. Many were influenced by the ethical idealism of the neo-Kantians, while others engaged in the quest for essence that derived from Husserl and the phenomenologists. Although they may not have explicitly studied these theories, most Expressionists had some knowledge of philosophy and engaged in heated intellectual disputes in their cafes and artistic circles.

It would be a mistake of academic idealism, however, to see Expressionism simply as a reaction to trends in European philosophy and art. These trends themselves were part of a complex socio-historical development and the Expressionists — like other avant-garde movements of the period — were sensitive to the transformations taking place in their socio-historical situation. Expressionists sensed far-reaching change occurring and saw themselves moving into a new era. This "epochal consciousness" made them acutely aware of the novel features in their socio-historical environment; it also made them open to the need for radical change, and ready to create a "new art" as a harbinger of "new life." The sense of an old era passing and the resultant confusion and disorientation that such a situation created is articulated in Jacob van Hoddis's poem "End of the World":

> The bourgeois' hat flies off his pointed head,
> the air re-echoes with a screaming sound.

Tilers plunge from roofs and hit the ground,
and seas are rising round the coasts (you read).

The storm is here, crushed dams no longer hold,
the savage seas come inland with a hop.
The greater part of people have a cold.
Off bridges everywhere the railroads drop.[35]

"End of the World" suggests the end of a stable, well-ordered cosmos, where one could gain epistemological and metaphysical certainty from knowing that the world and social life were governed by stable laws and conventions. In van Hoddis's poem, this certainty is exploded as chaos and confusion, while a lack of causal order reigns in both the poem and the world depicted: hats fly off, the air is full of screams, houses collapse, and a storm is about to break, as the complacent bourgeoisie sniffle about, unaware of the changes coming, getting their news and experience "second-hand" from newspapers. The structure of van Hoddis's poem reflects the disconnected, disordered world which the poet envisages: the images are pungent but are not ordered in a coherent poetic structure; rather, there is a rush of simultaneous word-pictures which are assembled pell-mell, literarily without apparent rhyme or reason. A sense of coming catastrophe pervades the poem, however, and a sense of threats to the imagining subject is evoked. The poem at once suggests the end of lyric poetry — with its harmonious forms and universe of beautiful illusion — as well as the end of a society which could produce lyric poetry. Such changes in experience and poetic form and content can be read as a reaction to the alienation of the individual and "crisis of subjectivity" in the transition to industrial capitalism.

Expressionism, Industrial Capitalism, and the Crisis of Subjectivity

Expressionism arose in a period in which analyses of the alienation, reification, and dehumanization of the individual, and the fragmentation of the human personality, had become widespread. As a reaction to the crisis of subjectivity, Expressionism contained passionate reaffirmations of individuality. The expressionist rebellions contained impulses toward the fulfillment and spiritual realization of the individual combined with revolts against repressive socio-cultural conditions. Herein is contained the ambivalent heritage of Expressionism that at once attacks bourgeois society, yet is excessively individualistic, and thereby retools traditional bourgeois ideologies of subjectivity. For although most expressionist rebellions possess elements of social critique, many of their categories and solutions borrow from traditional metaphysical and religious doctrines (i.e., Soul, Heart, Humanity, Love, Transcendence, and the like).

 The expressionist defense of subjectivity sought an inward realm of

retreat, whereby individuality and humanity could be preserved, protected against assaults from a repressive society and a destructive socio-economic order. As Marcuse puts it, "The 'flight into inwardness' and the insistence on a private sphere may well serve as bulwarks against a society which administers all dimensions of human existence."[36] The Expressionists experienced successively the triumph of industrial capitalism, the rise of the administered society, and the ravages of imperialist war. Their emphasis on subjectivity was a defensive maneuver against the oppression of the subject in the emerging organized capitalist society, although expressionist subjectivity would also take aggressive forms, advocating "activism" and artistic and social revolt.

After the Franco-Prussian war of 1870-71 industrial development in Germany proceeded at a rapid pace, producing giant monopolies, trusts, cartels, and a powerful "finance capital" establishment by the 1880's.[37] Germany's political unification and its victory in the war with France generated intense nationalism. Moreover, the French reparation payments enabled Germany to accelerate its industrialization process and to surpass other European countries in many industries. The belated industrial revolution transformed a previously provincial, agrarian society into one of the industrial-economic powers of the world. Electrical, chemical, and textile industries grew, as did mining, iron, steel, machine-tool, and arms industries. The transportation and communications systems swiftly expanded; railroads were built throughout Germany; canals were constructed; harbors were built and enlarged; and the German merchant fleet traversed the entire globe as Germany entered the race for the colonialization of the world, soon becoming a major imperialist power.

The mechanization of labor, social transformation, and war, combined with the rise of big cities and industrial regions, provided psychic shocks to those who were not sympathetic to the new industrialized world. Others were put off by the spread of the capitalist market economy, which reduced everything — even people and artworks — to the commodity-form, and which measured value by "exchange-value" as it forced market competition on every region of socio-economic or cultural life. Most of the expressionist generation was born and lived through this "great transformation," which was the subject of many popular and widely read sociological treatises. The German sociologist Tönnies described the transition as movement from organic, natural communities founded on close personal ties and kinship (Gemeinschaft) to a fragmented, industrialized, and egotistical exchange-society (Gesellschaft). Max Weber analyzed the "disenchantment of the world," the "iron cage" of bureaucracy and technological rationality, and the decline of spirituality brought about by capitalist development. Georg Simmel and Werner Sombart analyzed the impact of the rise of big cities, a market-economy, and the role of money.[38]

Industrialization in Germany was not only relatively late and rapid,

but was also exceptionally uneven and full of tensions. In the struggle for monopolization of the major industries, the dominant economic powers were split among themselves. They faced a relatively militant and well-organized working class, as well as agricultural and upper-class quasi-feudal sectors who were hostile to industrialization. Consequently, monopoly capitalism was not able to impose its hegemony on Germany without tension and resistance. The working class remained staunchly Social Democratic, and certain German traditions of community, religion, and culture also resisted capitalist domination.[39]

Although enough wealth and stability existed to support a leisure class of artists and intellectuals, the intelligentsia was split between those who willingly served the existing order and those who were alienated from Wilhelmine society. The critical intelligentsia, including the Expressionists, regarded the typical German bourgeois as a *Bildungsphilister* or *Spiesser*: stodgy, conservative, greedy, nationalistic, and militaristic.[40] Yet although they were alienated from the bourgeoisie, most Expressionists could neither identify with the working class nor its political movement. The German Social Democrats saw themselves as the inheritors of bourgeois enlightenment and democracy. They believed that the German bourgeoisie had renounced the revolutionary heritage of the 1848 Revolution, and they saw themselves as the preservors of the progressive aspects of bourgeois culture. Thus, the Social Democrats supported realism and sometimes "revolutionary romanticism" in the arts, and called for the self-formation (*Bildung*) of the working class through assimilation of the progressive elements of bourgeois culture. The Expressionists, however, opposed what they saw as the shallow materialism and enlightenment rationalism of the Social Democrats, whom they perceived as a mere extension of the bourgeoisie. Consequently, they saw all party politics as part of the corrupt society which they opposed, and consequently renounced traditional political activity.

Expressionism is thus a complex socio-class phenomenon: many Expressionists were dependent on their rich fathers, or bourgeois art patrons, for financial support, whereas many others glorified "lumpen" elements, such as prostitutes, the destitute and unemployed, or the criminal. On the whole, the Expressionists stood between the two dominant classes. Expressionists tended to see themselves as outsiders and Expressionism was, in part, the revolt of alienated youth and frustrated artists against a society which had in effect "marginalized" them. Many Expressionists were Jews, while others were foreigners living in Germany; almost all were bohemians or non-conformists of one sort or another. As rebels and outsiders, the Expressionists rebelled at once against both tradition and conventional social practices. Their status as outsiders led them to seek refuge in artistic circles which provided the nuclei for what became the expressionist movement.

The Expressionists tended to glorify youth and its freedom against the family, school, church, workplace, and bourgeois morality. Such a

posture defined expressionist theater as a theater of revolt and made generational conflicts a central theme.[41] As Jost Hermand writes, "a hunger for life" and "hatred of the bourgeois philistine" permeates expressionist literature.[42] Against philistine values, the Expressionists advocated sexual freedom, love, artistic creativity, and the development of personality. Above all, the Expressionists championed passion and intensity. As Jost Hermand points out,

> It was all the same whether one opposed the bourgeoisie, occupational oppression, positivistic sciences, or relativistic historicism: intensity was always invoked. Life, Love, Freedom: everything must lead to "fulfillment." While *Jugendstil* wrote the "beautiful life" on its banner, for the Expressionists the "delirious life" in every thread of one's being was envisioned. "I know that there is only one ethical ideal of life: intensity," Rubiner wrote. Similarly, Kurt Pinthus said that "one should not ask about the quality of this art but about its intensity." Hence, one heard from everywhere of human indetermination, revolutionary ecstasy, or the boundless unchaining of the individual. Everyone wanted to live in "red-hot passion," in intoxication and in dionysian orgy, dedicating oneself to the unleashing of one's desires and feelings.[43]

The Expressionists felt that they could not express their experiences and visions in traditional artistic forms and were driven to create new ones. While art had previously provided a realm of beautiful illusion, this aesthetic sphere no longer seemed relevant to many Expressionists, who were daily faced with the ugliness of industrial society and found the aesthetic illusionism of "beautiful" art to be at once a fraud that excluded significant contemporary realities and an ineffectual escape from modern society. While some Expressionists reacted against the heartlessness and inhumanity of the emerging capitalist-industrial order with calls to increase love and humanity, others documented the ugliness and corrosive effects on human and social life of the industrial process. Although many Expressionists saw themselves as the bearers of new values, which would "renew humanity" while creating a New Man and new society,[44] they also articulated the unease, anxiety, and pent-up hostility felt by many in the expanding industrial society. The experience of war and revolution confirmed the more extreme expressionist visions, and Expressionism became a dominant artistic tendency and movement in post-war Germany, as it spread as well to the rest of the world.

In the following pages an interpretation will be offered which will present the Expressionists as an avant-garde movement anticipating, charting and criticizing momentous changes taking place in industrial society and everyday life. In this reading, Expressionism is valuable for, among other things, providing insights into — and rebellions against — the transformations which industrial capitalism helped to produce. The following interpretation presupposes that experience is integrally social and historical, and that art and artistic movements articulate

social-historical experience in a given era in ways that illuminate their socio-historical world.[45] The notion that human senses and consciousness are shaped by the social world and in turn produce artifacts expressive of this development was theorized by Walter Benjamin: "Within extensive historical periods, the type and ways of sense-perception transform themselves along with the whole mode of human existence in a social collectivity. . . . The human faculties of sense-perception. . . are not only naturally but are also historically conditioned."[46] An historical-materialist approach thus regards Expressionism as the articulation of historically shaped perceptions and visions during an important period of capitalist development, rather than the product of universal or individual subjectivity or a solely artistic revolt.

Whereas Nietzsche had anticipated the crisis of subjectivity, the Expressionists articulated a series of new experiences concerning the fragmentation and alienation of the individual, combined with attempts at reintegration. In this sense, Expressionism discloses changes in the individual subject and its experiences in the modern era. Expressionist poetry, painting, music, and film often show changes in the speed and tempo of everyday life, brought about by technological developments. The experience of oneness with nature and a closed, organic community was no longer the context for artistic production; the life of the city, factory, industrialized transportation, mass media, and modern warfare supplied a new context. Experience became quicker, more fragmented, and often chaotic and disconnected. The Expressionists either clinically dissected these experiences or tried to "re-enchant" the world through art. Some Expressionists projected new worlds more amenable to human values and activities in calling for a "renewal of humanity" and thus countered the alienation and disintegration of the individual in bourgeois society by various projects of disalienation and rebirth.

Industrialization and the Rationalization of Everyday Life

The Expressionists portrayed and attacked various features of industrialization and the market economy as part of a series of adversary avant-garde revolts which produced tensions between the socio-economic system and culture of the bourgeoisie.[47] The triumphant capitalist system required calculability in the market for survival and success; therefore, one had to be able to quantify and rationally determine exchange-value in order to conform with the rules of the market society. The Expressionists saw that the domination of quantitative-objective exchange-value led to a diminution of individuality, as the market, bureaucracy, and instrumental rationality imposed their structures on everyday life. Against this trend, the Expressionists sought to reaffirm individuality and to criticize bourgeois rationality. Expressionist painters like Kandinsky strove for the spiritual, the unique, and the transcendent,

while Klee found elements of joy in childlike spontaneity and playfulness in art, as well as in a realm of spiritual expression. Nolde, Marc, Macke, and Barlach returned to pre-capitalist primitivism inspired by the shapes of animals and natural objects. Writers like Kafka provided a devastating vision of stifling routine and bureaucracy by articulating oppressive irrationality behind the facade of bourgeois rationality.

In a series of satirical plays called "the heroic life of the bourgeoisie," the playwright Carl Sternheim attacked bourgeois egotism and the primacy of exchange-value, making fun of the greed of a class which valued the medium of exchange — money — above all else. His sardonic play *The Strongbox* shows how monetary greed becomes a force that overpowers eroticism, human and social values, and artistic creativity.[48] The male protagonists become maniacally obsessed with a rich aunt's inheritance, which she keeps locked in a strongbox. In their preoccupation, they completely forget the charms and passions of the women protagonists. Sternheim insisted that in any conflict between money and sex, or money and art, the bourgeois greed for money would inevitably triumph.[49]

The very form and style of expressionist art responds to the rhythms of a new social reality. Whereas earlier romantic poetry expresses the rhythms and harmonies of nature, expressionist poetry frequently reflects the tempo and disharmonies of an industrialized society through condensed declamation, discontinuous syntax, and breathless diction. Expressionist music as well articulates the turmoil, discordant passions, and confusions unleashed by modern society. Unlike such pieces as Beethoven's *Eroica,* which captures the revolutionary passions of the Napoleonic era, or his *Pastoral* symphony, which contains a deep yearning for harmonious reconciliation with nature, the expressionist music of the early Schoenberg shrieks with the cries of a troubled and threatened subject in an unsettling world, and Berg's opera *Lulu* portrays the chaos, decay, and disharmonies of urban life. The "telegraphic style" of some expressionist drama reproduces the tempo and diction of a mechanized society. Consider the fragment describing an automobile accident by Carl Sternheim in his play *Citizen Schippel*:

Hicketier:	What a wreck . . . Your grace, highness.
The Prince:	Get water, linen . . . And best of all, a woman.
Hicketier:	My wife was scared.
Wolke:	(*with a deep bow*) Wolke!
The Prince:	Heard you the first time. What of it? Well, Mr. Hicketier?
Hicketier:	At your service.
The Prince:	Butchers. Bloody scratches. The day started badly. Old woman ran across the road, slow rain dropping, grey cloud.[50]

This reduction of events, objects, machines, weather, and people into equivalent tokens of linguistic exchange forces them into a continuum of neutral objects in which all objects are equivalent in value. Expres-

sionist drama and poetry reacted to this collapse of values either by satirically reproducing the flat, cliched language of industrial society, or by replacing it with more evocative and poetic language. Expressionist language often abstracted from the oppressive concreteness of industrial society and attempted to express the essentially human in the face of massive dehumanization. In his play *Gas,* for instance, Georg Kaiser gives the Engineer extremely formal technical language and terse diction, while the visionary social revolutionary speaks a lofty, philosophical language and the workers speak a simple, yet poetical, one.[51] In these ways, expressionist language either articulates, or opposes, the inmost tendencies of industrial society and its effects on human life. Expressionist writers therefore use different types and forms of language as much to present character types, to debate issues, or to project visions, as to develop character or to advance plot.

In their quest for human and social essence, Expressionists often used character types (the Son, the Father, the Workers, etc.), or class masks, to present their fictional protagonists. This resulted, ironically, in a lack of individuality in their characters and little concrete detail with regard to their personalities and social conditions. Consequently Naturalists, like Zola, tend to surpass most Expressionists both in portraying the social conditions of capitalism, and in depicting its suffering victims as individual, human beings. The Expressionists tended, for the most part, to concern themselves with general suffering and oppression rather than particular instances. Nonetheless, their works are full of concern for the poor, oppressed, and other victims of the industrialization process. As Walter Sokel points out:

> Johannes Becher sees armies of joyless workers trudging to the factory day in and day out; Albert Ehrenstein sees scrofulous children of the slums playing "telephone" by shouting down into a sewer hole; piece-time workers who dare not take time out on Sundays impress Rubiner; abandoned young women with illegitimate babies play vital roles in Sorge's *Beggar* and Johst's *Young Man;* a diseased prostitute brings happiness to Wolfenstein's Poet in *Visit of the Times;* old housemaids who have spent their lives in unceasing drudgery are by their very existence a flaming accusation of the middle-class poet Werfel, who is allowed to live a life of comfort and leisure.[52]

The poet Paul Zech pictured the inhuman working and social conditions of the German working class, while regretting their wasted lives:

> Sweat holds fast the crumbling frames;
> Sweat brewed of many men's blood
> And a pious life flows like pus from old sores.
> Many have wasted and lost their hearts here,
> Sired children with weak wives...
> Yet the churches and merchants stand solid as though hewn from ore.[53]

Georg Kaiser developed this theme in his *Gas* trilogy where he pictures a working class forced to toil in dangerous and oppressive conditions, unable to collectively bring about its own liberation.[54] Another vivid, critical vision of the capitalist labor process is found in Fritz Lang's film *Metropolis,* which depicts masses of workers enslaved in an underground city by a machine apparatus, greedy capitalists, and mad scientists, while the upper classes live in luxury in a city above ground. The conclusion is extremely naive, as a series of conflicts are resolved through a sentimental reconciliation of father and son, capital and labor, and heart and mind; but Lang's powerful images of oppressed workers and their susceptibility to political manipulation are striking. Neither Lang, nor most Expressionists, however, effectively portray workers as individuals with any real sympathy or understanding. They were, nonetheless, able to portray the far-reaching changes brought about by industrialization and the urbanization process.

The City and Urbanization

Much expressionist art is the art of the city, nurtured in cafes, cabarets, and bohemian subcultures. Some of its best artists transcribe the cynicism and worldly decadence of the urbanite, or the sensitive cry of a humanity crushed by urban-industrial civilization. Here expressionist writing was influenced by Baudelaire, who, as Walter Benjamin has argued, stands as the great poet of Paris, the capital of the nineteenth century.[55] Baudelaire — the bohemian poet par excellence — ironically attacked the bourgeoisie and their culture and, like the Expressionists, he sympathized with outsiders like prostitutes, ragpickers, or criminals. He too lived the bohemian life to the full, partaking of drugs, sex, alcohol and other stimulants. Paris was a central theme and backdrop to Baudelaire's poetry, which presented a variety of hallucinatory images of city life. Likewise, the Expressionists prowled through the ever-changing cityscape, portraying its alienating and dehumanizing effects. Kirchner and his comrades in *Die Brücke* painted the frenzy and decadence of city life in street scenes, cafe portraits, and pictures of harried urbanites, registering the shocks and transformations of the urbanization process, while the poets Lichtenstein, Heym, and Benn described the altered modes of experience and perception in urban life.[56] The rapid growth, electrification, and excitement of the metropoles fascinated a literary generation and produced such (different) city novels as Rilke's *The Notebooks of Malte Laurids Brigge,* Joyce's *Ulysses,* Kafka's *The Trial,* and Döblin's *Berlin Alexanderplatz.*[57] The various forms of alienation in city life are also portrayed in Kaiser's plays, Brecht's *Jungle of the Cities,* Heym's novel *Der Irre,* Schoenberg's and Berg's music, and Lang's *Mabuse* films and his *M.*

Cities were sometimes mythically demonized as the source of dangers and destructive powers, as in Heym's poem, "The God of the City";

> On a block of houses he spreads his weight.
> The winds rest blackly round his brow.
> He looks with rage into the distant solitude,
> Where the last houses are lost in the land.
>
>
>
> He stretches out his butcher's fist into the gloom.
> He shakes it. A sea of fire surges
> Through a street. And the smoke and fire roars
> and devours it, till day breaks late.[58]

The Expressionists often personified the city and the world of objects, giving them powers robbed from human beings. In Heym's poem "The City," he writes: "A thousand windows steal through the night/and blink with eyelids, red and small"; in his poem "Night," "the strange houses march forth" and "many a person was swept away."[59] Within the noisy, hectic, and often unfriendly cities, the Expressionists found refuge in artistic cafes, such as the one celebrated in a poem, "Cafe," by Ivan Goll.[60] Whereas many expressionist artistic circles were centered in a cafe culture,[61] Gottfried Benn found the cafes of the bourgeoisie repugnant. His poem "Night Cafe" portrays a bizarre description of the night-life in a Berlin cafe.[62] Benn clinically dissects the repulsive bourgeois figures, and then fixates on a beautiful woman, but since "a paunched obsesity waddles after her," his sexual fantasy will probably remain just that: the woman in question appears to be in the company of the hated bourgeois, whose fat pocketbook no doubt compensates in her eyes for his unattractive appearance.

Benn himself glorified withdrawal from urban-industrial life in favor of an immersion in nature, as did many pre-eminent expressionist painters like Nolde and Marc.[63] For Franz Marc, human life was more ugly and less innocent than animal life and nature, while Emil Nolde glorified a primitivistic and atavistic regression into nature. Nolde, Barlach, and others invested nature with spiritual qualities, finding a sort of religious transcendence in a spiritualization of nature. Expressionist nature mysticism and religious tendencies should thus be perceived, in part at least, as a reaction to the emerging industrial society and not simply as an autonomous religious-spiritual quest. Moreover, most Expressionists were not nostalgic. They did not seek a return to some Golden Age, but instead confronted the novelties and, to many, obscenities of modernity.

The Mechanization of Transportation and War

The mechanization of transportation produced changes in the modalities of experience. Space and time contracted, the tempo of life was speeded

up, and new shocks were imposed on the human sensibility by trains and automobiles.[64] A series of expressionist poems record the impact of the new means of transportation: Ernst Stadler composed a poem "Train Station," Heym depicted a "Suburban Station," Ernst Blass poeticized the effects of an "Auto Trip" on the human sensibility, and Gottfried Benn wrote poems about trains.[65] The films of Fritz Lang also feature the new modes of transportation and show corrupted individuals committing murder and evil deeds in trains, cars, street trams, airplanes, and even a flight to the moon (*Frau am Mond*). Stadler's poem "Journey over the Rhein-bridge at Night" articulates the expressionist experience of the changed patterns of experience and shows their poetic response to the new industrialized rhythms:

> The whole world is but a narrow gallery railed round by night,
> into which conveyor positions of blue light now and then tear
> sudden skylines: fiery circle of globs of light, roofs, chimneys,
> smoking, rushing...only momentarily...and all black again.
>
> Now lights come tumbling towards us...lost, inconsolably
> isolated...more...and accumulate...and grow dense.
> Skeletons of grey house-fronts lie exposed, turning pale in the
> half-light, dead — something must happen....
>
> O the curving of millions of lights, silent sentinel, before
> whose glittering parade the waters roll heavily downwards.
> Endless cordon, posted by the side of night in greeting!...
>
> And then the long lonely stretches. Bare banks. Silence.
> Night. Reflection. Meditation. Communion. And the glow and
> urge towards the last, consecrating things. To the festival
> of procreation. To ecstasy. To prayer. To sea. To extinction.[66]

The images of the train speeding through the night to an unknown destination, and the evocative visions the experience produced, provide a symbolic picture of the expressionist worldview. A similar response is found in Benn's poem "Express Train," which reveals as well an urge to regress to primitive sexuality and nature in the face of a mechanical world:

> Brown as brandy. Brown as leaves. Red brown. Maylay yellow.
> Berlin-Trelleborg Express and the east coast strands.
> Flesh that went naked.
>
> Tanned even to the mouth by the sea.
> Plunged ripe, for grecian joy.
> In sickle-seeking: how far off summer is!
> Second last day already of the ninth month.
> Stubble and last tonsil thirst within us.
> Unfoldings, the blood, the tiredness,
> The dahlia's proximity bemuses us.
> Male brown hurls itself on female brown:

A woman's only for a one night stand.
and if all went well, perhaps for one more!
Ah! and then the being-by-yourself again!
These mutenesses! This being driven on!

A woman is something with a smell.
Ineffable! Die away! Mignonette.
There lies the South, shepherd and seas.
Joy leans on every declivity.

Female light brown falls frenzied on male dark brown:
Hold me! Darling, I'm falling!
My neck has grown so weary.
Oh, this sweet feverseething
last smell from the gardens.[67]

The poem begins with a rapid succession of images, much as would appear to the passenger of an express train looking out of the window. The poet fixates, however, on images of nature ("Flesh that went naked") and wished to regress to a more primitive condition ("grecian joy"). He sees a winter of discontent rapidly approaching and wishes to return to the warm days of summer. Lust arises and he fantasizes about sexual ecstasy ("Male brown hurls itself on female brown"). In such a rootless mechanized world, however, even sexuality — that powerful but fleeting merger with nature — is depersonalized: "A woman's only for a one night stand." The poet is haunted by this transience, his loneliness, his need, his alienation from nature. He wishes to return to another world in "the South, shepherd, and seas." He imagines orgasm as partial escape, as the last immersion in the "garden" of "sweet feverseething" nature allowed to the mechanized world. Benn's poem contains an irony and biting sarcasm that distinguishes it from neo-romantic and symbolist poets like Rilke and Stefan George. His regression to nature — to an *Ursein* — was an almost desperate reaction to a fiercely hated modernity. The world of eroticism in his works is thus an elsewhere, a world with different bodies, rhythms, and experience to which one could travel in order to escape industrial life, but which only provided temporary refuge.

In the view of many artistic avant gardes throughout the world, the new rhythms of industrialized-urbanized life rendered obsolete older forms of poetry which corresponded to a simpler, more leisurely, experience of life. Poets from Whitman to T.S. Eliot to Hart Crane recognized that the older forms of lyric poetry were dead, and expressionist poetry helped provide the transition to new poetic forms, content, and functions. The increasingly rapid tempo of mechanized life is expressed in their strings of adjectives, accumulated sets of strewn-together nouns, and the destruction of syntax. Whereas Marinetti and the Futurists celebrated mechanization and speed,[68] the Expressionists responded more critically and ironically to the new experiences, providing a critique of mechanized technology and its impact on human life. Likewise, although the Futurists celebrated mechanized war, the Expressionists, after some initial en-

thusiasm for World War I, provided critical visions of mechanized slaughter and the horrors of mass war.

Indeed, World War I was a crucial experience for the expressionist generation. Some Expressionists anticipated its horror and destruction in their apocalyptic poems. Georg Heym imagined war as a sleeping monster about to awaken in a prophetic 1913 poem "War," of which I cite the first strophe:

> He is risen who was long asleep,
> He is risen from beneath the vaulted keep.
> In the dark, unrecognized, huge, he stands
> And crushes the moon between his swarthy hands.[69]

Expressionist war poems ranged from Heym's visions of war as a cathartic destruction of a hated society to critical attacks on the actual effects of war like August Stramm's "Battlefield":

> Yielding clod lulls iron off to sleep
> bloods clot the patches where they oozed
> rusts crumble
> fleshes slime
> sucking lusts around decay.
> Murder on murder
> blinks
> in childish eyes.[70]

Stramm's collage of "word-pictures" depicts the rape of the earth by mechanized warfare and the destruction of human beings. The war destroyed many of the greatest expressionist creators, driving the survivors to write anti-war poetry, literature, and drama.[71] Kafka, in stories like "The Penal Colony," prophesized the evils of the concentration camps, depicting instruments of torture which could destroy enemies and control the population. Outrage over the war drove many Expressionists to the left; they concluded that revolutionary political action and the destruction of bourgeois society were necessary to end the obscenities of imperialist wars. Some Expressionists participated in the 1918 German Revolution, but most quickly recoiled from what they perceived as the violence advocated by the communists and vacillated politically. Some, however, actively joined or supported the communists (Becher, Brecht, Eisler), while others came to embrace fascism (Nolde, Benn, Johst). Hence, whereas the war politicized many Expressionists — and prepared Germany and Europe for the expressionist vision — the political tendencies chosen varied and fragmented the Expressionists into collections of groups or individuals who took quite different positions on art and politics in Weimar Germany.

The Massification of Culture and Commodification of Art

The development of mass media of communication and the transformation of organs of discursive communication into tools of commerce were begun by the transformation of newspapers from instruments of bourgeois enlightenment (Habermas)[72] to fragmentary, disjointed collages of sensationalistic news, pictures, advertisements, and ideological slogans. In the nineteenth century, newspapers had provided a more orderly, rational, and comprehensive articulation of news and ideas, whereas the modern newspaper became increasingly a commercial instrument of bourgeois hegemony. The Expressionists shared with Karl Kraus a concern for the degeneration of language in the new journalese and satirized it in their poetry. Van Hoddis, in his poem "End of the World," ironically announced a castrophe in newspaper style: "On the coasts — it was announced — the floods are ascending."[73] Reinhard Sorge's play *The Beggar* describes the lust for sensation of a newspaper public:

> Second Listener: Listen: earthquake in Central America!
> Voices: Ha, ha! Well, well! How many killed?
> Second Reader: Five thousand.
> Third Listener: What a filthy mess!
>> *Commotion.*
> Second Reader: Skirmish near Tripolis.
> Voices: How many killed?
> Second Reader: About two hundred dead. Three hundred and fifty wounded.
>> *Murmur.*
> Second Reader, *skimming the paper:* Crash of a French pilot.
> Ninth Listener: Always those French . . .
> Fourth Listener: How many dead?
>> *Laughter.*
> Third Reader: Mass revolt in Spain . . .
> First Reader: Mine disaster . . .
> Second reader, *continuing to skim:* factory fire . . . Hurricane flood.
> First reader: Train accident . . .
> Tenth Reader: Stop! I'm freezing! Brr . . .
> Voices: Stop!![74]

Whereas symbolist and neo-romantic poets withdrew from this mass-mediated world, expressionist artists critically confronted it and analytically dissected it in their works. The Expressionists' fascination with the film, and use of film as a vehicle for their art, showed their ability to come to terms with modernity and to use the new media for their purposes. Expressionists not only made important contributions to the art of the cinema, but also used cinematic techniques in their writing.[75] The development of German expressionist film was an important means of

communicating their vision throughout the world, and some Expressionists saw film as *the* modern art form and their age as the age of film.[76] More effectively than any other art media, film reflected the pace and affairs of city life and a mechanized environment, with its nervous succession of images which provided an appropriate analogue to the quickened tempo of modern life. Consequently, the expressionist intervention in the cinema was a natural consequence of their urge to articulate and utilize the technical transformations during their era.[77]

The commodification of art and the new possibilities for public communication in the mass media provided the Expressionists with challenges and possibilities. The commercialization of art led to two opposing responses by the European avant-garde: on one hand, contempt for the art market and withdrawal from it, leading to production of "art for art's sake." This was the response of French and German Symbolists, Neo-Romantics, and others who produced increasingly esoteric art for a self-defined elite. The other response was a quasi-public intervention, in which art was to edify and aid in the transformation of individuals and society. This sense of mission, shared by many Expressionists, helps to explain why certain among them felt that provocation and shock were needed to arouse a complacent bourgeoisie, and why others adopted a consciously moralizing and declamatory tone and style. But here Expressionism fell prey to a contradiction which it never resolved: the Expressionists wanted a mass following and social change, yet they made few concessions to public taste in their abstract paintings and music, complex lyrics and novels, esoteric style, and frequent attacks on the bourgeois art public. Moreover, when their style and forms were widely accepted by the 1920's, their message was discounted and their hopes for a new society and spiritual rebirth were dashed after the failures of the German revolution and the stabilization of capitalism. Consequently, no one was more disgusted than the Expressionists themselves with their eventual popularity and acceptance as part of the official culture.[78]

Scientism and Instrumental Rationality

The mechanization and industrialization of society helped produce changes in the concepts of knowledge and reason. The triumph of science as the measure and method of knowledge restricted reason to calculation of means, such that reason became an instrument of science and practical everyday affairs. The expressionist response was a critique of science and what is today called "instrumental reason."[79] This hostility toward science led to rejection of "scientific" types of art like Naturalism and Pointilism. The Expressionists opposed all forms of positivism — which was becoming the dominant ideology — in an era in which earlier liberal and humanist ideals were sacrificed by those strata interested in industrial and technical progress, streamlined class-domination, or im-

perialist conquest. The Expressionists violently opposed the bourgeois ideologies of science and progress, championing instead subjective expression and individual vision against objectivistic knowledge.

The Expressionists championed poetic-subjective forms of experience as a reaction against the triumph of scientific-technical reason and the construction of a technological society. Their works thus represent the underside of what Adorno and Horkheimer call the "dialectic of Enlightenment." Against the hegemony of repressive reason, they took up repressed elements of experience, moving from the highs to the lows of experience, from visions of Heaven to Hell. Their "extremism" should thus be seen as disgust with the "moderation" of bourgeois rationality and common sense. The "return of the repressed" in expressionist works, however, often exploded into excessive, even outrageous, celebration of the "irrational." Many Expressionists fell prey to sexual atavism, while others came to glorify war, or to embrace fascism, that strange mixture of cultural irrationalism and a threatened capitalist rationality. Others were attracted to mysticism and religious transcendence as escape from the limits of bourgeois rationality.[80]

One cannot, however, simply dismiss the Expressionists as religious mystics, or gross irrationalists, as Lukacs and others have done,[81] without specifying what forms the alleged "irrationalism" takes and what is wrong with such forms. "Irrationalism" is a broad and generally vague concept that covers a variety of phenomena, some admirable, some blameworthy. When using the term "irrational" one should specify whether one means: (1) concern with passion, eroticism, and subjective experience; (2) rejection of scientific causality or discursive, logical connections; (3) advocacy of violent and destructive forms of social behavior (such as rape, criminality, war, etc.); (4) a political ideology like fascism or imperialism; or (5) an ethical ideal that posits supreme value beyond reason. Since various of these elements are found in different expressionist artists and works, to use the term "irrational" in a useful fashion one must specify what sort of irrational features are present and what is objectionable about them.

Although some Expressionists fell prey to excessively violent and politically reactionary forms of irrationalism, others carried out a useful critique of the sort of bourgeois rationality which affirms a cold, calculating reason as the guiding principle of life.[82] The plays, for instance, of Wedekind, Sternheim, and Kaiser mock those characters who embody bourgeois reason and who are insensitive to passion, love, artistic concerns, and individual freedom — ideals which they and other Expressionists affirm. Kafka as well exposes the irrationality behind the facade of bourgeois rationality in his novels and stories, providing a disturbing vision of a world in which reason is an instrument of oppression. Fritz Lang's films put in question the codes of bourgeois rationality and many of his films mourn misunderstood lovers crushed by the forces of a repressive rationality and society.[83]

Although some expressionist art contains an immanent critique both of irrationalism and a restrictive rationality, few, if any, Expressionists achieved an adequate synthesis of reason and emotion, social description and personal vision, or social critique and utopian fantasy. While their attacks on repressive reason were progressive — as were their concerns for individuality, passion, love, and community in an inhuman capitalist market society — they do not really develop convincing alternatives to the society and forms of life criticized. Consequently, while their works often subvert bourgeois codes of art, reason, and ideology, and contain what Bloch calls "traces of liberation," the expressionist heritage is a contradictory one. Expressionism, along with the avant-garde modernist movements related to it, produced some of the last attempts to preserve individual subjectivity against assaults by increasingly powerful and repressive societies. The famous cries and shrieks of expressionist art thus represent the cries of the individual subject facing repression and threats to its autanomy, inner life, and values. In conclusion, we must therefore ask: Do the Expressionists provide new forms of subjectivity and human life which contain emancipatory alternatives to the detested bourgeois society? This leads us to evaluate the expressionist heritage, to analyze its contradictions, and to suggest reasons for its failures which will also validate its achievements.

Expressionism's Contradictory Tendencies and Heritage

Walter Benjamin's description of Baudelaire provides an apt characterization of the Expressionists: "Baudelaire was a secret agent — an agent of the secret discontent of his class with its own rule."[84] Expressionist discontent and passion — intense, personal, and explosive — demanded new forms for its expression, leading to many artistic innovations. The expressionist rebellions often led to undisciplined excess, but, where successful, produced works that revolutionized artistic expression and influenced later aesthetic creation. Expressionist passion and rebellion, however, took many, often contradictory, forms. The Expressionists tended to support rebellion per se, without, in many cases, specifying what forms a liberated humanity would take. They tended to stress a "cult of the self" and an unleashing of passions, but their often undifferentiated stress on "self" and "passions" led to contradictory emphases. On the one hand, there was a call for the "unchaining of Eros," for the total liberation of sexuality, among many Expressionists.[85] For Expressionists like Benn and Nolde the goal of instinctual liberation often took the form of a glorification of primitivism and an unleashing of all instincts and desire, no matter what its forms or effects.[86] Against these atavistic tendencies, other Expressionists tended toward an extreme idealism of spirit, wishing to enhance and cultivate *Geist* in order to make it the guiding force of life.[87]

The expressionist cult of the self consequently took many forms, ranging from a passionate call for the full unfolding of individual talents and powers to a search for common humanity and expression of the "primal self."[88] Some Expressionists championed individual freedom and revolt, while others urged ecstatic surrender to collective forms or nature. Further, there were conflicting emphases on brotherhood, peace, and love, contrasted with glorification of unleashed violence and even war.[89] The Expressionists neither overcame nor reconciled these contradictions; consequently, their ideals of liberation were disparate and often in conflict. Consequently, beyond its undeniable transformative effects on the arts, it is doubtful whether the expressionist revolts had any lasting political or social effects.

Against criticism that art should not be evaluated in socio-political terms, one could answer that the Expressionists demanded to be taken seriously politically and socially, as well as artistically. Few movements were as "politicized" and made such extravagant socio-political claims for their art. Consequently, it is fair to stress that while the Expressionists revolutionized art, they failed in their aspirations to revolutionize society. One problem is that they simply expected too much from art. It is not clear that even the most "political" or "revolutionary" art can effect social change, unless certain socio-economic and political conditions are present. Moreover, Lukacs is correct to claim that Expressionism never really transcended bourgeois society and ideology, and never produced an adequate new ideology, politics or social alternatives.[90] For, despite their manifold revolts against bourgeois society, the Expressionists never comprehended, or adequately criticized, capitalism as a system of production and never specified any tendencies or contradictions within capitalism which might lead to a new and better society.

In short, most Expressionists did not really understand economics or politics. Their attacks on bourgeois society included violent diatribes against liberalism, trade unionism, the working class movements, and the "masses," but they failed to see any even relatively progressive forces in bourgeois society and tended to reject the liberal tradition of democracy, human rights, and equality as part of the facade of the hated bourgeois society. Hence, the total revolt of many Expressionists tended toward nihilism. Not all Expressionists were nihilists, or anti-liberal, but the contradictions in the movement made impossible any unitary activity that would provide genuine political alternatives, thus leading to the ultimate failure of expressionist politics and the eventual collapse of the movement as a whole.

The Expressionists were tolerated as the court jesters of the bourgeoisie, for they did not pose a threat to the hegemonic interests of capital. In the era of the re-stabilization of capitalism in Weimar Germany, the bourgeoisie supported and even acclaimed expressionist art, thus making Expressionism part of the official culture in Weimar (see the satire on this situation in the first scene of Brecht's *Baal.*).[91] Hence,

although the Expressionists remained anti-bourgeois, they were not clearly or consistently anti-capitalist, except perhaps as a species of "romantic anti-capitalism."[92] Indeed, in retrospect, it can be argued that the Expressionists even helped in the transition to advanced capitalism, for they attacked some obsolete and reactionary features of bourgeois society which hindered the next stage of capitalist development. In this context, expressionist calls for sexual liberation and revolts against repressive authority and obsolete values, as well as their stress on feeling and the unfolding of individuality, helped create a climate congenial to the development of consumer capitalism, which required instant gratification, craving for the new, eroticized youth-consumer culture, and the "rootless freedom" of movement and choice. Consequently, the Expressionists were really attacking a bourgeois society on the wane and helped prepare for the advent of a more advanced form of capitalism.

In relation to bourgeois individualism and egotism, the Expressionist heritage is also ambiguous. On one hand, the Expressionists found possessive individualism, consumerism, exploitation, and money-worship repugnant, yet they too reproduced forms of bourgeois individualism in their excessive concern for individual selfhood, vision, and expression. Nonetheless, it is also evident that tendencies within Expressionism criticized the excessive subjectivism and Nietzschean pathos of the *Übermensch*. Plays like Kaiser's *From Morning to Midnight,* Brecht's *Baal,* Lang's *Mabuse* films, and expressionist tyrant and monster films warned against the dangers of an unrestrained egotism and the concomitant destruction unleashed by an unfettered Ego wreaking its will to power in a destructive and chaotic manner. But German Expressionism on the whole — so obsessed with subjectivity, *Innerlichkeit,* and an often demonic conception of the superior individual beyond good and evil — tended to fuel an excessive bourgeois individualism, putting the individual above other people and society. Hence, Expressionism did not provide viable alternatives to bourgeois individuality, but instead intensified it. Lacking clear concepts of intersubjectivity, an alternative society, and social transformation, Expressionism could not overcome the social forces against which it rebelled and which it often brilliantly depicted and harshly criticized.

Despite its deficiencies and failures, the expressionist heritage contains some emancipatory features beyond its liberating effects on artistic production. The Expressionists' drive toward social change and the creation of new forms of life still provide us with images and ideas to animate radical individual and social change. Their utopian images of transcendence contain social and individual alternatives and project examples of struggles to liberate life and creativity from repressive social and cultural forms.

The expressionist heritage contains traces of liberation still to be achieved, and, as I have argued, expressionist art provides insights into capitalist development and the resulting alienation and dehumanization.

To the heartlessness and spiritlessness of bourgeois society, the Expressionists reacted with passionate emphasis on heart and spirit. Against the disintegration of community brought on by mechanization and industrialization, the Expressionists created new artistic circles and communities. Responding to the suppression of music, poetry, and color by the often drab process of industrialzation and urbanization, the Expressionists created colorful paintings, lyrical poetry, and expressive music. To the lack of social concern in an individualistic exchange-society, some Expressionists responded with a sense of social mission and, in the face of the alienation of the individual in industrial capitalism, Expressionists produced various schemes of disalienation. Confronting a crisis of subjectivity, the Expressionists called for a "renewal of humanity."

From this standpoint, expressionist art can be interpreted as a critical source of knowledge, depicting the odysseys of modern subjectivities disintegrating yet trying to reintegrate, dying yet attempting to be reborn. The expressionist rebellions pose in an especially dramatic and acute fashion the central problems of the modern age: What sort of persons do we want to be? What sort of culture should we produce? What sort of society do we want? What sort of politics should we engage in? What kind of world do we want to live in? Although the Expressionists' answers were contradictory and inconclusive, they posed the questions with a passionate urgency, and they disclosed the social conditions and crises of life in the modern era with brilliance, insight, and prescience.

Notes

*For helpful comments and criticisms of earlier drafts, I would like to thank Nancy Anderson, Carolyn Appleton, Wes Blomster, Stephen Bronner, Hugh Grady, Henry Pachter, Mark Ritter, Marc Silberman, Susan Wells, and Barbara Wright. I am also indebted to the contributors to this anthology, as some of the positions argued here, as well as the general thrust of the interpretation, rely on the detailed studies which follow this introductory essay.

[1] For a succinct discussion of the various attempts to define Expressionism over the last three decades, see Roy Allen, *Literary Life in German Expressionism* (Göppingen: Alfred Kummerle, 1974). For a useful German anthology, which contains representative attempts to characterize and interpret Expressionism, see Hans Gerd Rötzer, editor, *Begriffsbestimmung des literarischen Expressionismus* (Darmstadt: Wissenschaftliche Buchgesellschaft, 1976). For useful bibliographies on the primary and secondary literature, see Silvio Vietta and Hans-Georg

Kemper, *Expressionismus* (München: Wilhelm Fink, 1975) and Roy Allen *German Expressionist Poetry* (Boston: Twayne Publishers, 1979). See the annotated bibliography at the end of *Passion and Rebellion* for sources and information on the literature on Expressionism.

[2]Georg Lukacs, "'Grosse und Verfall' des Expressionismus," in Rötzer, *op. cit.,* and *Realism in Our Time* (New York: Harper and Row, 1971). Examples follow in the text and notes of standard academic interpretations which tend to see Expressionism as a species of irrationalism and subjective mysticism, which is sometimes praised and sometimes damned.

[3]Bernard S. Myers, *The German Expressionists: A Generation in Revolt* (New York: Praeger, 1957), p. 43.

[4]In his book on Expressionism, R.S. Furness cites the above passage by Malcolm Pasley as "an admirable summing up of the Movement." See *Expressionism* (New York: Harper and Row, 1973), p. 1. The following discussion shall show that such a characterization is completely misleading.

[5]Many critics of Expresssionism, such as Lukacs, *op. cit.,* and many academic interpretors, or defenders, of Expressionism take the ideological legitimations of the movement by its propagators, like Edschmid, Bahr, Pinthus, etc. as providing accurate descriptions of Expressionism. Almost every standard interpretation, for example, cites Edschmid's manifestoes as crucial in defining the movement, failing to see that Edschmid himself provides a specific ideology of Expressionism that is excessively subjective and mystical. Consequently, many interpretations mistake the ideology for the art — which are often at odds with each other. Against this practice, I would argue that the ideologies of Expressionism — like all ideology — mystify and distort much expresssionist art, while they legitimate a certain tendency as "genuine Expressionism." Renato Pöggioli has an interesting discussion of how avant-garde movements produce ideologies to rationalize and celebrate their own artistic productions. See his *The Theory of the Avant-Garde* (New York: Harper and Row, 1971), pp. 4ff., passim. On the concept of "ideology" that I am using here, see my article, "Ideology, Marxism, and Advanced Capitalism," *Socialist Review* 42 (Nov. - Dec. 1978), pp. 37-65. The ideology of Expressionism is an example of what I call an "ideological region," in this case, the region of avant-garde artistic ideologies. On the concepts of artistic tendencies, movements, and formation, see Raymond Williams, *Marxism and Literature* (New York: Oxford, 1977) and Pöggioli, *op. cit.*. For collections of expressionist ideological pronouncements, see *Voices of German Expressionism,* editor, Victor Miesel (New York: Prentice-Hall, 1970) and, in German, *Literaturrevolution 1910 - 1925,* editor, Paul Portner, (Neuwied: Luchterhand, 1960) and *Theorie des Expressionismus,* editor, Otto F. Best (Stuttgart: Reclam, 1976). Crucial ideological

manifestoes and interpretations include: On expressionist paint-
ing, Wilhelm Worringer, *Abstraktion und Einfühlung* (München:
1907); Paul Fechter, *Der Expressionismus* (München: Piper,
1914); Hermann Bahr, *Expressionismus* (München: Delphin,
1916); and Wassily Kandinsky, *Concerning the Spiritual in Art*
(New York: Wittenborn, Schultz, 1947). On literature and Ex-
pressionism as a movement, see Kasimir Edschmid, *Frühe
Schriften* (Neuwied: Luchterhand, 1970) and Kurt Pinthus's in-
troduction to *Menschheitsdämmerung* (Berlin: Rowohlt, 1920;
new, revised edition 1959). Some expresssionist ideologies of
the theater are translated in *An Anthology of German Expres-
sionist Drama,* editor, Walter Sokel (Garden City: Anchor
Doubleday, 1963).

[6]Geoffrey Perkins, in his book *Contemporary Theory of Ex-
pressionism* (Bern and Frankfurt: Herbert Lang & Cie, 1974),
argues that a radical disjunction exists between the ideologies
of expressionist painting and the actual art works themselves,
but nowhere demonstrates this by a discussion of artistic pro-
duction. Studies in *Passion and Rebellion* will show how the
ideologies of Expressionism, which have coalesced into stan-
dard academic interpretations, are often subverted, or con-
tradicted by many examples of expressionist art.

[7]Wolfgang Paulsen, *Expressionismus und Aktivismus* (Bern
and Leipzig: Gotthelf, 1935).

[8]Walter Sokel, *The Writer in Extremis* (Stanford: Stanford
University Press, 1959).

[9]On the expressionist concept of the New Man, see my
chapter "Expressionist Literature and the Dream of the New
Man" in the present book. Barbara Wright in her chapter
"Sublime Ambition" in this book argues that expressionist art
and politics must be taken together and seen as an unitary
phenomenon — albeit contradictory. She attempts to show the
similar political and aesthetic preoccupations shared by so-
called "artistic" and "activist" Expressionists and argues that
their positions contain similar flaws. See also her Ph.D. disserta-
tion, *Expressionist Utopia: The Pursuit of Objectless Politics*
(University of California at Berkeley, 1977), as well as the book
by Eva Kolinsky, *Engagierter Expressionismus* (Stuttgart:
Metzler, 1970).

[10]See the analysis by Richard Brinkmann, *Expressionismus:
Forschungsprobleme 1952-1960* (Stuttgart: Metzler, 1961).

[11]See Allen's discussion and critique of this trend in Ger-
man scholarship in *Literary Life, op. cit.,* pp. 4ff..

[12]John Willett, *Expressionism* (New York: McGraw-Hill,
1970), p. 21.

[13]Christopher Middleton, "The Rise of Primitivism and its
Relevance to the Poetry of Expressionism and Dada," in
Bolshevism in Art (Manchester: Carcanet, 1978).

[14]See the anthology, *Expressionism as an International Literary Phenomenon,* edited by Ulrich Weisstein (Paris and Budapest: Didier and Akademiai Kiado, 1973) which details the "foreign influences" on German expressionist drama, poetry, and prose, as well as the impact of Expressionism in turn on avant-garde movements and art in England, America, and Western and Eastern Europe. These studies do not, however, really explain why Expressionism took its most characteristic forms and had its greatest impact in Germany; the essays also, for the most part, reproduce the standard academic interpretations of Expressionism, producing few fresh interpretations of the movement or of expressionist art-works.

[15]On baroque drama, see Walter Benjamin, *The Origin of German Tragic Drama* (London: New Left Books, 1977). On the tendencies toward rebellion and emancipation in German literary tradition, see Herbert Marcuse's brilliant doctoral dissertation, *Der deutsche Kunstlerroman,* 1922, published for the first time in *Schriften* 1 (Frankfurt: Suhrkamp, 1978), and discussed in my forthcoming book *Herbert Marcuse and the Crisis of Marxism.*

[16]On the expressionist infrastructure, see Allen, *Literary Life, op. cit.*; Paul Raabe, editor, *The Era of German Expressionism* (Woodstock, N.Y.: Overlook Press, 1974); and the studies in Part I of *Passion and Rebellion.*

[17]On the nature and function of the concept of subjectivity in the modern world, see Colin Morris, *The Discovery of the Individual* (New York: Harper and Row, 1972); John Lukas, *The Passing of the Modern Age* (New York: Harper and Row, 1971); Thomas Seung, *Cultural Thematics: The Formation of the Faustian Ethos* (New Haven: Yale, 1976); and the forthcoming study by Stephen Eric Bronner, *The Transformation of Subjectivity.*

[18]William Blake, *The Portable Blake* (New York: Vintage, 1961).

[19]On Romanticism see Alvin W. Gouldner, "Romanticism and Classicism" in *For Sociology* (New York: Basic Books, 1973); Raymond Williams, *Culture and Society* (New York: Harper and Row, 1966); and Edward Thompson, *William Morris, Romantic Revolutionary* (New York: Pantheon, 1977). For a criticism of the Williams-Thompson interpretation of Romanticism, see Terry Eagleton, *Criticism and Ideology* (London: New Left Books, 1976).

[20]On German Romanticism, see Walter Benjamin, *Der Begriff der Kunstkritik in deutschen Romantik* (Frankfurt: Suhrkamp, 1973) and Marshall Brown, *The Shape of German Romanticism* (Ithaca: Cornell University Press, 1979).

[21]On the Young Hegelians, see Karl Löwith, *From Hegel to Nietzsche* (Garden City: Anchor Doubleday, 1967) and the blistering polemics in Frederick Engels and Karl Marx, *The German Ideology, Collected Works,* Volume 5 (New York: International Publishers, 1976). On Nietzsche and his impact on

Expressionism, see Gunter Martens, *Vitalismus und Expressionismus* (Stuttgart: Kohlhammer, 1971); Walter Sokel, *The Writer in Extremis, op. cit.*; and Silvio Vietta and Hans-Georg Kemper, *Expressionismus, op. cit..*

[22]Willett, *op. cit.*, p. 21, and Sokel, *op. cit..*

[23]Friedrich Nietzsche, in *The Portable Nietzsche* (New York: Viking, 1968), pp. 95-6.

[24]Friedrich Nietzsche, *The Will to Power* (New York: Random House, 1968).

[25]Immanuel Kant, *Critique of Pure Reason* (New York: Saint Martin, 1965). On the impact of Kant's "Copernican revolution" on Expressionism, see Sokel, *op. cit..* I would like to contest here Sokel's claim that Expressionism derives from the philosophy and aesthetics of Kant. Despite the critical thrust of his "Copernican revolution" in philosophy, Kant tried to defend an objectivistic concept of knowledge and truth against Hume's skeptical attacks, carrying out as well a defense of the claims of reason to attain a priori truth. Moreover, Kant's aesthetics were not as "modernist" as Sokel claims. Richard Clark in a "Review Article: Sokel, Kafka, and Kant" shows in detail how Sokel misrepresents Kant's aesthetics (in *German Expressionism, Review of National Literatures,* Vol. 9, 1978, pp. 151ff.). Against Sokel, I would argue that Nietzsche was much more important than Kant for the Expressionist's views on art and reality — although, as I argue below, a variety of intellectual sources influenced their views and artistic practices.

[26]Ludwig Feuerbach, *The Essence of Christianity* (New York: Harper and Row, 1957).

[27]Nietzsche, *The Will to Power, op. cit.,* and Arthur Danto, *Nietzsche as Philosopher* (New York: Macmillan, 1965).

[28]Nietzsche, *Werke in Drei Banden,* Editor Karl Schlechta (München: Piper, 1966) Volume 3, p. 473.

[29]See the study of Trakl by Hans-Georg Kemper, in Vietta and Kemper, *op. cit.,* pp. 214ff.

[30]Paulsen, *op. cit.,* and Vietta-Kemper, *op. cit.,* discuss the intellectual context of the time and the Expressionist's appropriation of Nietzsche and other ideas "in the air."

[31]On Avenarius, Mach, and other positivists of the period, see Leszek Kolakowski, *The Alienation of Reason* (New York: Doubleday, Anchor, 1969) and the fiery polemics by V.I. Lenin in his 1909 book *Materialism and Empiriocriticism* (New York: International Publishers, 1932). The following discussion of the similarity between the epistemological positions of Mach and the Expressionists suggests that it was no accident that Lenin chose Mach for a detailed epistemological critique. For suggestions of the importance of Mach in the cultural situation of the time, I am indebted to conversations and correspondence with Henry Pachter.

[32]Kolakowski, *op. cit.*, p. 101.

[33]On the neo-Kantian response to relativism, positivism, and the crisis of subjectivity, see Andrew Arato, "The Neo-Idealist Defense of Subjectivity," *Telos* 21 (Fall 1974), pp. 108-161 and Wright, *op. cit.*.

[34]See Edmund Husserl, *Ideas* (New York: Collier, 1962). Victor Lange points to the similarities between the phenomenological and expressionist quest for essence, both grounded in a theory of absolute subjectivity and intuition, but he does not adequately stress the differences. See "Expressionism: A Topological Essay," in *German Expressionism, op. cit.*, especially pp. 27-30.

[35]Jacob van Hoddis, "End of the World," translated in *Modern German Poetry*, edited and translated by Michael Hamburger and Christopher Middleton (London: Macgibbon & Kee), p. 49. Van Hoddis's poem was the opening selection in Pinthus's anthology *Menschheitsdämmerung, op. cit.*, and is often cited as the first prototypical "expressionist poem." See Ritter's discussion of "Early Expressionist Poetry" in *Passion and Rebellion*.

[36]Herbert Marcuse, *The Aesthetic Dimension* (Boston: Beacon Press, 1978), p. 38. Marcuse sees Expressionism and Surrealism as anticipating "the destructiveness of monopoly capitalism, and the emergence of new goals of radical change," p. xi.

[37]On Germany's political economy and industrial development during the period, see Henry Pachter, *Modern Germany* (Boulder: Westview, 1979); Martin Kitchen, *The Political Economy of Germany 1815-1914 (London: Croom Helm, 1978); Hans Ulrich Wehler, Das zweite Kaiserreich, 1871-1914* (Gottingen: 1973); Kenneth D. Barkin, *The Controversy over German Industrialization* (Chicago: The University of Chicago Press, 1970); and W.O. Henderson, *The Rise of German Industrial Power* (Berkeley: University of California Press, 1975). On the cultural and social context of the period, see Roy Pascal, *From Naturalism to Expressionism* (New York: Basic Books, 1973).

[38]Ferdinand Tönnies, *Community and Society* (New York: Harper and Row, 1963); Max Weber, *From Max Weber* (New York: Oxford, 1946); Georg Simmel, *Essays on Sociology, Philosophy, and Aesthetics* (New York: Harper and Row, 1965) and *The Philosophy of Money* (London: Routledge & Kegan Paul, 1978); Werner Sombart, *Der Bourgeois* (Munich: Duncken und Humboldt, 1913) and *Der moderne Kapitalismus* (Munich: Duncken und Humboldt, 1921) and Georg Lukacs, *History and Class Consciousness* (Cambridge: MIT Press, 1971).

[39]See the sources in note 47 and Ernst Bloch's analysis of the cultural and ideological contradictions of the era in *Erbschaft dieser Zeit* (Frankfurt: Suhrkamp, 1962), part of which is translated with an introduction in *New German Critique*, 11 (Spring 1977).

[40]Pascal, *op. cit.*

[41]On generational conflict in expressionist theater, see Peter Uwe Hohendahl, *Das Bild der bürgerlichen Welt im expressionistischen Drama* (Heidelberg: Rothe, 1967) and Horst Denkler, *Drama des Expressionismus* (München: Fink, 1967).

[42]Jost Hermand, "Expressionismus als Revolution," in *Von Mainz nach Weimar* (Stuttgart: Metzler, 1969).

[43]Hermand, *op. cit.*, p. 323.

[44]See Wright, "Sublime Ambition," *op. cit.*, and Kellner, "New Man," *op. cit.*.

[45]In his Paris Manuscripts of 1844, Marx wrote that "the development of the five senses is the labor of the entire previous world history," suggesting further that science, industry, and culture are the "open book" of human powers, the objectifications of a historically formed human nature. See Karl Marx, *Economic and Philosophical Manuscripts of 1844* in Marx-Engels, *Collected Works,* Volume 3 (New York: International Publishers, 1975).

[46]Walter Benjamin, "The Work of Art in the Age of Mechanical Reproduction," in *Illuminations* (New York Shocken, 1969).

[47]Contradictions between the culture and political economy of the bourgeoisie are discussed in Ernst Bloch, *Erbschaft, op. cit.*; Raymond Williams, *Culture and Society* (New York: Harper and Row, 1966); and Daniel Bell, *The Cultural Contradictions of Capitalism* (New York: Basic Books, 1976). On the rise of industrialism and the early responses by artists, see Karl Polanyi, *The Great Transformation* (Boston: Beacon Press, 1957).

[48]Carl Sternheim, *The Strongbox,* in Sokel, *An Anthology, op. cit.*, pp. 90ff.

[49]For more of Sternheim's delightful plays, see Carl Sternheim, *Five Plays* (London: Calder and Boyars, 1970).

[50]Carl Sternheim, *Citizen Schippel,* in Willet, *op. cit.*, pp. 98-9.

[51]Georg Kaiser, *Gas I* and *II,* in *Five Plays* (London: Calder and Boyars, 1970). Discussed in Kellner, "New Man," *op. cit.*.

[52]Sokel, *op. cit.*, p. 143.

[53]Paul Zech, "Factory Cities on the Wupper: The Other City," translated in Allen, *Expressionist Poetry, op. cit.*, p. 107.

[54]Kaiser, *Gas, op. cit.*.If one substitutes "nuclear energy" for "gas," Kaiser's *Gas* plays provide a brilliant allegory of the dangers of nuclear energy and warfare.

[55]Walter Benjamin, *Charles Baudelaire: A Lyric Poet in the Era of High Capitalism* (London: New Left Books, 1973).

[56]Vietta-Kemper, *op. cit.*, and Ritter, *op. cit.*.

[57]See Zimmerman's study of Döblin's *Berlin Alexanderplatz* in *Passion and Rebellion.*

[58]Heym, "The God of the City," translated in Allen, *op. cit.,* p. 82.

[59]Heym, cited from Vietta-Kemper, *op. cit.,* pp. 44f.

[60]Ivan Goll, "Cafe," in Allen, *op. cit.,* pp. 73-4.

[61]On expressionist cafe-culture, see the chapter by Henry Pachter in this book.

[62]Gottfried Benn, "Nightcafe," translated in *Primal Vision* (New York: New Directions, 1971), p. 220. Cited and discussed in Ritter, *op. cit.*

[63]See the studies by Ritter, Kellner, and Bronner in this book.

[64]On the impact of new modes of transportation on the human sensibility and culture, see Siegfried Giedeon, *Mechanization Takes Command* (New York: Norton, 1969); Vietta-Kemper, *op. cit.*; and Wolfgang Schievelbusch, "Industrialized Travel," *Telos* 21, Fall 1974, and "Railroad Space and Railroad Time," *New German Critique,* 14.

[65]For Pinthus, *Menschheitsdämmerung, op. cit.* and the Appendix "The Train-Motif in Impressionism and Expressionism," in Richard Samuel and R. Hinton Thomas, *Expressionism in German Life, Literature and the Theatre* (Cambridge: W. Heffer, 1939).

[66]Ernst Stadler, "Journey over the Rhein-bridge at Night," translated in Lange, *op. cit.,* pp. 37-8.

[67]Gottfried Benn, "Express Train," in *Gottfried Benn,* edited by J.M. Richie (London: Oswald Wolff, 1972), p. 107.

[68]F.T. Marinetti *Selected Writings* (New York: Farrar, Straus and Giroux, 1971.) On Marinetti and Futurism, see Stephen Eric Bronner, "F.T. Marinetti: The Theory and Practice of Futurism," *Boston University Journal,* Vol. XXV, No. 2, 1977.

[69]Georg Heym, "Der Krieg," *Dichtungen und Schriften,* I, editor Karl Ludwig Schneider (Hamburg: Heinrich Ellermann, 1960ff.), translated by Mark Ritter.

[70]August Stramm, "Battlefield," in Hamburger-Middleton, editors, *Modern German Poetry, op. cit.,* p. 23.

[71]See the list in Willet, *op. cit.,* p. 104.

[72]Jürgen Habermas, *Strukturwandel der Öffentlichkeit* (Neuwied und Berlin: Luchterhand, 1962).

[73]Jakob van Hoddis, "End of the World," *op. cit.* Armin Arnold in a clever article, "Halley's Comet and Jakob van Hoddis' Poem 'Weltende'" (in *German Expressionism, op. cit.*) deflates the myths that surround van Hoddis's poem and suggests that the work is an ironic analysis of the fear propagated in the German press that Halley's comet was going to cause wide-spread destruction. This interpretation supports the reading of Expression-

ism proposed here by underlining the close relationship between expressionist texts and the contemporary social environment.

[74]Reinhard Sorge, *The Beggar, An Anthology, op. cit.,* pp. 22ff.

[75]On cinema and Expressionism, see Rudolf Kurtz, *Expressionismus und Film* (Berlin: 1926; reprinted, Zürich: Hans Rohr, 1965); Siegfried Kracauer, *From Caligari to Hitler* (Princeton: Princeton University Press, 1947); Lotte Eisner, *The Haunted Screen* (Berkeley: University of California Press, 1973); and the chapters by Silberman, Rubinstein, Wolitz, and Kaplan in this book.

[76]Kurtz, *op. cit.*

[77]Vietta-Kemper, *op. cit.,* pp. 110ff.

[78]On the expressionist disgust with their popularity and faddish acceptance by the bourgeois public, see Hans-Jörg Knobloch, *Das Ende des Expressionismus* (Frankfurt: Peter Lang, 1975), pp. 7ff.

[79]On the "critique of instrumental reason," see T.W. Adorno and Max Horkheimer, *Dialectic of Enlightenment* (New York: Seabury, 1972) and Max Horkheimer, *Eclipse of Reason* (New York: Seabury, 1974).

[80]See Benn's works translated in *Primal Vision, op. cit.* and *Gottfried Benn, op. cit.* and the study of Nolde by Bronner, *op. cit.*

[81]Lukacs, "'Grosse und Verfall'," *op. cit.* and the articles in *Die Expressionismusdebatte,* editor Hans-Jurgen Schmitt (Frankfurt: Suhrkamp, 1976), from which articles by Bloch and Lukacs are translated in *Aesthetics and Politics* (London: New Left Books, 1977). See also Bronner's article on the Expressionism debate in *Passion and Rebellion.*

[82]See Vietta-Kemper, *op. cit.,* pp. 153ff. for many examples.

[83]On expressionist attacks on bourgeois codes of rationality in the films of Lang, see Kaplan, *op. cit.*

[84]Benjamin, *Charles Baudelaire, op. cit.,* p. 104.

[85]Hermand, *op. cit.*

[86]Middleton, *op. cit.* See the studies of expressionist poetry by Ritter and of Nolde by Bronner in *Passion and Rebellion.*

[87]See Wright, "Sublime Ambition," *op. cit.*

[88]Hermand, *op. cit.* and Kellner, "New Man," *op. cit.*

[89]*Op. cit.*

[90]Lukacs, *op. cit.*

[91]See Bertolt Brecht, *Baal,* in Sokel, editor, *An Anthology of German Expressionist Drama* (Garden City: Anchor Books, 1963); and my study of the play in "New Man," *op cit.*

[92]On "romantic anti-capitalism," see Ferenc Feher, "The Last Phase of Romantic Anti-Capitalism," *New German Critique* 10 (Winter 1976-7).

SOCIETY
AND POLITICS

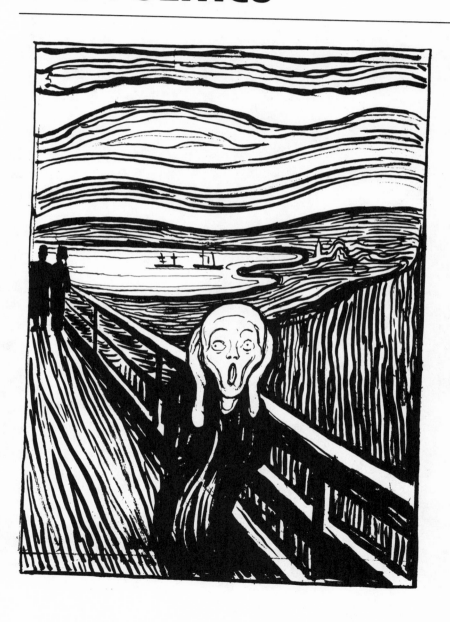

2
Expressionism and Cafe Culture

Henry Pachter

Each generation has its own way of voicing protest and acting it out. At the end of the nineteenth century, the naturalist rebels — Gerhart Hauptmann, Bruno Wille, Wilhelm Bölsche, and other friends — had established their exile ten miles outside Berlin, near Müggelsee, a lake that was the end point for the Sunday excursions of city dwellers.[1] Some of that generation had studied abroad and had known the coffeehouses in Paris or Rome, but they did not transfer the coffeehouse cult to Germany. Although, of course, some writers, like other people, had their *Stammtisch* ("regular table")[2] this was not the "life of bohemia."

The next generation was that of *art nouveau*, called *Jugendstil* by the Germans. It was an urban rebellion, and its center was the artists' quarter of Munich; Schwabing, around the turn of the century, was Germany's answer to the *rive gauche*. Here were the artists' cafes, the studios, the editorial offices of the satirical weekly *Simplicissimus* and of the exuberant magazine *Jugend* (Youth), which gave its name to the flowing, decorative style. The literary youth movement of that generation was led by Arno Holz, Frank Wedekind, Richard Dehmel, Johannes Schlaf and others who looked up to Nietzsche, Oscar Wilde, and Walt Whitman. In his monograph on *Die Boheme* (Stuttgart, 1968), Helmut Kreuzer

describes it as "informal groups living or gathering in artist or student quarters of large cities, meeting in public places like cafes, bookstores, and galleries or studios and editorial offices." Their life style more or less deliberately displayed their contempt of conventionality, authority, and middle-class values; their expressions, in art and writing, defied traditional wisdom and academic respectability.

As their enemies saw them, they were especially antagonistic to philistine notions of family, property, and career. Averse to materialism and to profit, this particular generation also practiced and preached sexual liberation and "life reform." Among its friends was the Viennese architect Adolf Loos, who had started the "Truth in Living" movement. However, not all bohemians were "life reformers." Some dressed like dandies (Sternheim, Benn), or even wore a monocle (Rudolf Leonhard) or a red vest (Roda Roda); others were extravagant (Else Lasker-Schüler), deliberately sloppy (John Höxter), or hirsute (Erich Mühsam).

"Nature" and "Truth" were the slogans which these artists contrasted with the pushy, materialistic bourgeoisie of the new empire, with its stuffy, hypocritical *Kultur* and its academic art. Yet, Schwabing was really an epicenter of the new *Reich*. Its hand-me-down materialism appeared slightly dated, its opposition to the *nouveau-riche* imperialism of Wilhelm II a mere offshoot of the local resistance against Prussian predominance, or of the good old days' resentment against the twentieth century. Munich was rapidly falling behind. When Gottfried Benn's *Morgue* appeared, *Zwiebelfisch*, once *the* avant-garde paper, wrote: "A person who goes mad used to see white mice dancing. Modern Berlin has gone him one better; it sees rats."

The Munich natives were condescendingly referred to as *Hiasl* (boors); they cordially retaliated by calling the Schwabing crowd *Schlawiner*, which may have been telescoped from *schlappe Wiener*, "sloppy Viennese," since many bohemians had come from the Austrian monarchy and its Slav (bohemian!) provinces — maybe also because they needed haircuts and did not do much except debate all day long.[3] In the early days of the century, the Munich crowd still included, apart from the painters, many names that were to become significant — Heinrich Mann, Leonhard Frank, Gustav Meyrink, Klabund (Alfred Henschke), and also the *Simplicissimus* cartoonists Olaf Gulbransson and Henri Bing, the future Dadaist Hugo Ball, and Erich Mühsam.

Nevertheless, the writers who were to become identified with Expressionism soon left for Berlin: the true contemporary opposition had to locate itself where the new bourgeoisie met with the new licentiousness. Geography here becomes significant, and we have to pinpoint the location. At the eastern end of Unter den Linden was the Royal Palace; to its north, east, and south extended "working Berlin," the throbbing city with its middle classes whom the artists despised, and its laboring masses whom they ignored — good, old, conservative, and progressive Berlin with its traditional virtues and vices. At the western end of Unter den

Linden, beyond the Brandenburg Gate and Potsdamer Platz, where the Wall runs today, began *das feine Berlin* with its civil-servant and banker families — the distinguished "Old West."

But the city expanded further west. New, modern houses with electric lighting, elevators, and central heating were built for the new bourgeoisie between the suburbs of Charlottenburg and Wilmersdorf (still outside the city limits). This was the "New West," fashionable and luxurious, stretching along the new artery, Tauentzienstrasse and Kurfürstendamm. Three literary reminders: it was here that Effi Briest took residence in a new building; here that Christopher Isherwood strolled in search of adventure; and here, of course, that Josephin Peladan and Pitigrilli (the immoralists idolized in the 1920s) learned about cocaine. A strong contingent of Jewish bourgeoisie and the beginnings of an entertainment industry added spice to the area. At the far end of Kurfürstendamm was Lunapark, an amusement center where bohemians used to spend more time than their biographers would care to admit.

At the entrance of Kurfürstendamm, Kaiser Wilhelm II had built the monstrous Memorial Church *(Kaiser-Wilhelm-Gedächtniskirche)*, in whose shadow were the *Romanisches Cafe* (so called because of its round-arched arcades), a modern department store, and the zoo. By day, nursemaids walked their wards here to see the animals; by night, streetwalkers paraded their charms in this new neighborhood where the strutting new establishment displayed its wealth and its mores. Soon the philistines too were going to have their Saturday night excursions to "see the artists."

For here, at the corner of Kurfürstendamm and Joachimsthaler Strasse, was the *Cafe des Westens,* which poets, painters, and actors made their hangout. Ernst von Wolzogen used to come here after performances of his modernistic *Bunte Bühne*; here Herwarth Walden founded his Association for the Arts — *Verein für Kunst* — which promoted expressionist painters. His first wife, the ethereal and rhapsodical Else Lasker-Schüler, served as muse for the round table and as the galleon figure for the art shows. During the day, the cafe was occupied by earnest young men who were quietly reading, writing, or drawing; conversation was discouraged. But in the evening it filled up with characters sporting flowing locks and artists' cravats; the place was noisy with ardent discussions as new ideas were tried out, new enemies denounced, new votaries converted.

"It was the cafe of my friends and of my critics, also of my first affair," wrote Ernst Blass, the Dadaist. "What I was participating in, with anguish, was a literary movement, a crusade against the philistine . . . against the lack of feeling, against obtuseness and sterility, against traditionalism. In the cafe the soul was appreciated. The cafe was an institution to educate artists, a tough school of which I am still proud, a sanctuary, a parliament without parliamentary abuses. The timid learned to speak. We learned to be aware of what was really close to our hearts. It was an education to be truthful to our feelings." (Abridged translation)

The artists' contempt for the philistine, the *Spiesser,* was fully recip-

rocated. If the cafe was an attraction to the sightseers, the respectable middle class of the neighborhood was unhappy about its invasion by undesirable elements. Some papers asked whether the "swamp" was to be permitted in their midst.[4] Berlin was "the city with the heart of asphalt," indeed, as Else Lasker-Schüler had written. But the cafe remained, to protest against the cruelty, the loneliness, the vacuity of Berlin. The ground floor of the *Cafe des Westens* was a large room furnished with a number of small white marble tables. Glass plates covered those on which an idle draftsman had doodled a design or a painting. On the second floor there were chess and billiard tables. As German cafes must, this one also displayed a half dozen daily papers. Most bohemians read only the *feuilleton*, where they and their friends expected to be published, reviewed, or at least talked about. Some drama critics, like Alfred Kerr, Herbert Ihering, and Bruno Engel, were friendly to modern ideas. Anyway, to get all the news of goings-on in the literary world, one had to read all the papers. This was one important function of the cafe. To understand the rest, a few sociological details must be considered.

Most of the young artists, poets, writers, and critics came from well-to-do families which insisted that they attend the university. This was the age when grants or stipends were virtually unknown; nor did one work one's way through college. Young academics had to be supported by their fathers until a good many years after graduation. Also, in contrast to the present generation of rebels, few then majored in literature or history, for the cultural rebellion was directed precisely against — and was provoked by — the academic sterility of scholarship and the oppressive high-school teaching in these areas. Most studied law or medicine as a solid foundation for future income. They would not think of selling their pen (none used a typewriter yet). Also, publishers and theater producers considered avant-garde writing a work of honor and love that need not pay, or be paid for. Thus, Johannes R. Becher received a monthly check of 150 marks from his father, even when he was recognized as an up-and-coming poet and was doing editorial work for the publisher Heinrich Bachmair.[5] Only the established writers of the previous generation, like Hauptmann, Thomas Mann, Hofmannsthal, and other proteges of S. Fischer (the prestigious publishing house) could support themselves by their trade, and they were duly disparaged by the young rebels. These rebels had to live either with their rich parents — as some did even after marrying, naturally, in the "New West" — or in miserable furnished rooms.

And here two pieces of information should be kept in mind. The Berlin apartment, as viewers of *Cabaret* may have noticed, was laid out so that visitors had to pass through the parlor, where a zealous landlady (or parent) kept watch over the tenant's (or son's) virginity. "Storm-free pads" with direct access to the staircase were rare and expensive. For company in the evening, therefore, a young man had nothing but the cafe. Living arrangements were largely responsible for the mores of the age. But hardly any book discusses prostitution in terms of the geographical conditions of family living.

Then too, the mornings in every household were dedicated to the ritual of housecleaning, for which purpose men were supposed to vacate the premises. What was there but the cafe? Even if intellectuals had not been afflicted with the neurosis known to them as *Budenangst*, phobia of the pad, they would have fled the uncongenial home and sought refuge among fellow sufferers. Proximity to — and aversion against — the father's house, dependence on and liberation from it, determined the significance of the cafe as the locus of the counterculture.[6]

The cafe was a home away from home, a sanctuary from the world's paltriness, a working place, a meeting place for friends, a safe shelter from alienation. *Geborgensein*, being nestled, was a subject which at the time began to interest psychologists and philosophers. In 1914, *Die Aktion* published a poem by Yvan Goll entitled "Cafe":

> All the fellow humans in the city
> but dusty, pale lanterns
> reflecting alien light
> But here I found friends. . . .
> like music
> what they say
> radiates over the rustling of the cyclops city.

The six lines omitted compare the friends to the woods and to the animals, in the spirit of the expressionist painter Franz Marc.

"We could do without nearly everything, except coffee and the cafe," said Ferdinand Hardekopf, who has been called the king of Expressionism. But the coffeehouse was more than company (*Anschluss, Becher's term*). One met not only with friends but with first readers and helpful critics, editors, sponsors, and even mentors. The cafe was the "launching pad," as Else Lasker-Schüler said, not only in the material sense but in a deeply intellectual sense, too: "our best place to learn what is new," Stefan Zweig recalled; and Wolfgang Goetz confessed that the cafe was "school that taught us to see, to know, to think."

Paul Cassirer, whose gallery launched the expressionist painters in Berlin, once advised a lady, perhaps with tongue in cheek, to send her son to the cafe for six months in lieu of the university. For those who were seeking initiation, the cafe was an academy; for those who already belonged, it was "a fair" (*unsere Börse*, as Else Lasker-Schüler put the matter). New clubs and magazines were planned and founded, new *Richtungen* (tendencies) and fantastic new names for them were invented — *Neopathetiker, Neorhetoriker, Aeternist* — while roommates and sexual partners were swapped. It was a veritable game of musical chairs, a constant hustling and bustling. Everyone knew everyone else. And although individuals often ideologically realigned themselves, split with one another, sat at different tables, or refused even to speak, they all participated in one great comradeship: the community of those who had rejected the philistines, laughed at their *Kultur*, transcended their morality,

and knew that they were *die Kommenden*, the coming generation to whom the future belonged.[7]

"We were possessed. In cafes, in the streets and squares, in our studios we were marching constantly, driving ourselves to express the inexpressible,"[8] Johannes R. Becher was to write in his memoirs, which otherwise are by no means uncritical of the young rebels' exuberance but convincingly testify that exuberance was their most genuine product. Perhaps this assertiveness, this sense of extraordinary assurance, earned them the epithet *Grössenwahn,* which in the Berlin idiom sounds somewhat more mocking than "megalomania" or "delusion of grandeur." The artists and their writer friends have charged that the term was coined by some babbitts who hated them. But the bohemians accepted it, and to my ear it has the self-flattering ring of an intellectual's self-irony. Anyway, whatever the origin of the term, aficionados fondly referred to the *Cafe des Westens* in Berlin and to the *Cafe Stefanie* in Munich as *"Cafe Grössenwahn."*

These two places were populated largely by the same kind of people, or even by the same perambulating, ubiquitous individuals. Among them were Peter Hille, whom Else Lasker-Schüler called "the Good Lord"; poor John Höxter, who financed an expensive habit by being witty for half an hour in front of some curious nabob; the ugly, dwarfish poet Jakob van Hoddis, whose real name was Davidsohn; the chess-playing, uninhibitedly abrasive anarchist Erich Mühsam — and many, many more whose description would require a wealth of adjectives. Traveling poets and artists, too, were immediately introduced to these coffeehouses, there to be discovered and accepted as comrades-in-arms and invited to give readings and shows. The arrival of Kokoschka and Werfel were such great occasions.

No other cafe was ever honored by the title, "megalomania," except the *Romanisches*, which inherited it after 1921 when the *Cafe des Westens* had closed and bohemia was no longer a coherent crowd.[9] The *Romanisches* always had more voyeurs than artists; perhaps guests, some of whom had once belonged to *Grössenwahn*, now famous, would occasionally return to visit their former haunt. Although cavernous, the *Romanisches* never achieved the atmosphere of creative poverty and conviviality of the older cafe. That distinction, in the late 1920s, fell to a smaller place further down the Kurfürstendamm called *Die Lunte* because its owner, a short, squat lady who gave credit to artists, was forever chewing a cigar end, a *Lunte.*

Cafe des Westens and *Stefanie* were by no means the only bohemian gathering places. In Berlin, after his separation from Else Lasker-Schüler, Herwarth Walden held court for a while at the more distinguished *Cafe Josty* on Potsdamer Platz; other circles were fathered in the *Cafe Austria* and in *Dalbellis Weinstube.* The publisher and writer Munkepunke (Alfred Richard Meyer) had a luncheon table at a place code-named *Paris,* and a weekly table in Wilmersdorf in the *Biberbau.* Among his friends were Oskar Kanehl, Gottfried Benn, Rene Schickele, Rudolf Leonhard, Max Hermann-Neisse. But it is characteristic of memoirs of the period that these same names should also turn up on many other lists.

In Leipzig, the publisher Ernst Rowohlt had his luncheon table at *Wilhelms Weinstube* and passed his evenings at the *Kaffeebaum*, where visitors admired his boisterous humor and drinking capacity. He loved conviviality and was always accompanied by his faithful adviser Kurt Pinthus, future editor of the famous anthology *Menschheitsdämmerung* (Twilight of Mankind). Their work, which was most decisive in winning public acceptance for new authors, could easily be imagined without any coffeehouse connection, but of course they depended on communication with the *Grössenwahn* crowd in Berlin and Munich, and especially with Max Brod's circle in Prague (Kafka, Werfel, Hass, Weltsch). When Kurt Wolff split with Rowohlt, however, he did quite well without frequenting coffeehouses.

Leipzig was the center of the book industry, and writers in search of a publisher were always in abundance. But no circle was permanent, and no intellectual center of the modern movement could develop in that industrial city. Munich also had publishers who were interested in modern writing: Langen, Beck, Piper, Bonsels (himself a poet). But, as I said, Schwabing's great time was drawing to an end in the second decade of the century. With that, the crowds separated. The new establishment of the *Jugend* and *Simplicissimus* magazines met at the remote *Torgelstube* in near-exclusivity. Franz Jung, forever envious of success, referred to recognized writers as "*Torgelstube* types." Bohemians who tried to retain the image of the Parisian artist still gathered at *Stefanie* (Theresien- and Amalien-Strasse), or across the street at the *Cafe Bauer*. There they met Franz Blei, an excellent mentor for the younger artists and an editor-founder of many little magazines. Another center of attraction was the adventurous psychoanalyst Dr. Otto Gross, whose mysterious relationship with the Richthofen sisters has been uncovered only recently.[10]

The *Blue Rider* group stayed in Munich. But the painters who had constituted *Die Brücke* in Dresden had good reason to transfer their studios to the capital. I have already indicated why "the scent of Berlin," praised in a contemporary hit song, might have been most stimulating and why, in particular, the border area between the New West and the Old provided the audience for a new avant-garde that was no longer bohemian in any romantic, nostalgic, or even artistic way. Here was the most modern bourgeoisie and its critical, disgusted sons; here were the new vices of a disintegrating society; here the searing self-doubt of the entire *Kultur* business, the total rejection of society.

This becomes clear when we compare the *Grössenwahn* crowd with other critics and opponents of the empire and its culture. Basically, the Wilhelmine establishment was being attacked by two kinds of opposition: — that of the pub and that of the cafe. The socialists carried their agitation to the places where the workers would drink their beer and play their games of cards. Their meeting halls, obviously, were in the north, east, and south of the city. Their counter-kaiser had been August Bebel, the beloved leader of the Social Democratic Party, who however ruled his

party like a patriarch and who was anxious to appear respectable in the reactionary government's eyes. His immediate aim was to bring the masses more material comforts. To the artists, this meant making everyone into a *Spiesser* and perpetuating *Spiessertum* (babbittry). Although some socialist leaders also preached a new morality, socialism did nothing to promote a cultural revolution.[11] Richard Dehmel and Franz Pfemfert were the only ones who thought of combining the politics of socialism with the anti-politics of art (Gerhart Hauptmann had forgotten that once he hoped to do so). A few others were interested in both radical politics and radical art — like Paul Levi, later on a leader of the Communist Party — but took pains to keep their crowds separated.

The literary Naturalist of the preceding generation had pointed the finger, exhorted society to remedy its abuses, analyzed people's reactions, and offered them better mores with greater insights. The new generation of artists was not interested in improvements, nor in changes or revolutions that would only substitute new rulers and new rules for the old ones. Their purpose was to abolish society, not to improve it; to expose the hypocrisy of bourgeois *Kultur*, not to ennoble it. The genteel culture had reached its apex, inevitably to be followed by its doom; the artists' job was to announce, not to avert, a cataclysmic overthrow of the existing society.

Someone had called the coffeehouse a "waiting room" — presumably thinking of a career. The guests, as in a story by Conrad or Kafka, however, were waiting for a quite different event. Voluptuously, they visualized the destruction of Sodom and Gomorrah. The poet Jakob van Hoddis gained acclaim with an apocalyptic fantasy:

> The philistine's hat blows from his pointed head,
> the storm is here, the sea is rising.

His colleagues recognized this as bold, new language; they admired even more highly a similar poem entitled "War" by George Heym. When he read it to a large crowd at the *Cafe Austria*, in 1911, they heard him predict in stark, hammering words an end with a bang. We must be careful not to read it, with hindsight, as a forerunner of the anti-war poetry that came much later. It was a horror poem meaning to convey the sense of crisis and apocalypse, of that cultural doom which Heym welcomed no matter what might bring it on. Shortly before his tragic death in 1912, he wrote in his diary: "If only one were to start a war, even an unjust one! This peace is so rotten, oily and filthy." How closely life and death were connected for these Young Werthers is inadvertently revealed by Becher's "We were so seized with this lust of living that we would not have hesitated to shoot ourselves should this our life turn out to have been less than life-size."

Heym drowned at the age of twenty-five, trying to prevent a friend from committing suicide — but perhaps it was a double suicide. They were deeply mourned, for everybody loved and admired Heym as a

standard-bearer. In appearance, the handsome, blond Heym was the opposite of van Hoddis; but they shared this sense of catastrophe, as did many of their friends. Walter Hasenclever's first play was called *Nirvana — A Critique of Life*; Oskar Baum, who was blind, wrote *Existence on the Brink*. The closer Europe came to the world war, the shriller sounded the voices of despair among these radical writers. No way out, no compromise, no hiding place. When Kurt Wolff started publishing a series of books by new authors, he could think of no better title for it than *Der jüngste Tag* (Day of Judgement); each volume sold for eighty pfennigs.

Franz Pfemfert printed Heym's and van Hoddis' poems in his magazine *Der Demokrat*. His increasingly strident tone led to a break with his publisher, and in 1911 he was forced to start his own journal, *Die Aktion*. The title, which would scarcely have been possible a year earlier, was conceived in bed, according to Alexandra Ramm, his wife and permanent assistant. Pfemfert was interested in politics, or rather anti-politics (he eventually was to lead a syndicalist group), and did not commit himself to the expressionist program. But he published expressionist drawings and woodcuts regularly and exclusively, employing *Grössenwahn* artists as a rule; thus he provided outlets for expressionist poets, prose writers, and critics. His table at the *Cafe Grössenwahn* included Carl Einstein (married to Alexandra's sister), van Hoddis, Anselm Ruest (Ernst Salomon), Max Oppenheimer (whose cartoons were signed Mopp), Mynona (Salomen Friedländer), Heym, and Kurt Hiller. Moreover, he published Gottfried Benn, Alfred Lichtenstein, Oskar Kanehl, Else Lasker-Schüler, Ernst Stadler, Franz Jung, Claire and Yvan Goll, Johannes R. Becher, Walther Rilla, Erwin Piscator (the future stage director), Karl Liebknecht, Rosa Luxemburg,[12] and Charles Peguy on matters of political interest.[13] His courage and his insight were greatly admired, although he was irritable and given to sharp attacks on renegade friends. He was not on speaking terms with Herwarth Walden, although both were using the same cafe, publishing the same authors, and generally pulling in the same direction.

Herwarth Walden (Georg Levin) must have been a man of extraordinary qualities as friend, editor, and adviser. He had a knack for discovering and developing talents and, which is rare, he was able to keep their loyalty. Many have testified, after his tragic disappearance in Stalin's purges, how much they learned from him and how great his influence had been in the *Grössenwahn* circles. He founded, published, edited, merged, and revived more little magazines than anyone else, shading them a little to the left or to the right by giving the floor here to Mühsam, there to Dehmel, quarreling with sponsors and getting fired by outraged publishers until finally, in 1909, he decided to start his own weekly, *Der Sturm* (Tempest), whose title was taken from one of Else's poems. His aim was to provide a forum for unknown, unrecognized writers, for untraditional art and new values. His friends and contributors included the gamut of expressionist creators: Alfred Döblin, Heinrich Mann, Ferdinand Hardekopf, Alfred Mombert, Peter Hille, Walter Mehring, and Adolf Loos, who had built the "house without eyebrows."

Der Sturm arranged readings of new poetry and prose, exhibitions of expressionist painters, and happenings. In 1912 it invited Marinetti to open its show; he went at it with his customary sense of notoriety, flinging manifestoes from a taxi and shouting: "Down with galleries! Burn the libraries!" until the police stopped him. There was a yearly *Sturm-Ball.* The one held in the last year before the war was styled *Revolutionsball,* and everyone had to appear in a symbolic or historical costume. Of course this was nothing but a bohemian masquerade, but the name announced a change of climate. Walden had once placed art above all: "Art is inhuman, one must sacrifice humans for it"; at that time it was Pfemfert who felt that art must serve the revolution. Later their roles were reversed; Pfemfert stayed independent of Lenin.

The third personality we must mention as part of the expressionist coffeehouse scene was Kurt Hiller (poets called him "the doctor"), who in the 1920s was to become the major editoral writer of *Die Weltbühne,* the political organ of radical intellectuals (mostly Jewish) who could not decide between the Socialist and the Communist Parties. Hiller was credited with having the sharpest intelligence and the most polished style. In 1909 he had split away from a literary society to found his own New Club (*Der neue Verein*), exclusively devoted to contemporary works, which met weekly in the *Nollendorf Kasino,* Kleist-Strasse — a ten-minutes' stroll from the *Cafe des Westens.* But soon he found himself overrun by younger members led by Georg Heym; they split over Heym's Nietzschean antirationalism, and Hiller started a new club, *Das Gnu.* A gnu is a ruminant, looking half bull and half antelope — which seems an apt description of the *Neopathetisches Kabarett* and the neopathetic poetry it was supposed to serve (the term apparently was invented by Stefan Zweig and was used before "Expressionism" came to prevail.)

Hiller was one of those exciting people who turn up in everyone's memoirs but who do not leave a lasting mark. His table at the *Cafe Grössenwahn* was always attended by admiring adolescents, and he openly fought for his rights as a homosexual. He had many friends and was able to enlist practically all the prominent guests for his cabarets and readings. These were so well attended that he had to hire the large hall of the *Cafe Austria* in Potsdamer Strasse. There, Heym and van Hoddis read their epochal poems, Werfel was a visitor, and Hasenclever had his strident play, *The Son,* performed shortly before the war.

For the sake of fairness rather than completeness, we must add here a list of persons whose circles and activities overlapped with those most intimately involved in *Grössenwahn.* Above all, no history of Expressionism could be written without mentioning the work of Paul Cassirer as both owner of the gallery and publisher first of *Pan,* then of *Die weissen Blätter.* His editors were Wilhelm Herzog and Rene Schickele. The gallery was also used for readings of *Der Sturm, Die Aktion,* and *Gnu* groups. And credit should be given to the stage director Karlheinz Martin, whose *Tribüne* in Charlottenburg was the first theater-in-the-round and staged,

among other experimental and expressionist plays, Toller's *Wandlung*. An earlier theatrical venture was *Das junge Deutschland*, which could give only closed performances for invited guests. Max Reinhardt, however, generously placed his *Deutsches Theater* at its disposal.

We have seen that the coffeehouse culture was intimately related to the notable Expressionists' other activities: their clubs, shows, readings, exhibitions, cabarets, balls, papers, and book-publishing ventures. It was basically the same crowd that provided the various audiences for papers and happenings, and no matter how many factions they formed, they were constantly drifting around each other.

The interpretation, however, gets rather complicated when the participants' sidelines are treated on the same level as the major phenomenon, the counterculture. A *Stammtisch* is not coffeehouse culture. Not every publisher who held a table at some restaurant made a contribution to that culture. On the contrary, it can be shown that some went to *Josty* or to *Paris* in order to avoid their colleagues from *Grössenwahn*. Likewise, expressionist readings took place at the *Cafe Sezession* and elsewhere; this was a matter of convenience which is remarkable only if public readings are considered differently from private readings in a sponsor's house. Private readings were extremely rare, however; in the four years that preceded World War I, Expressionism had gone public and become a public affair. New magazines were being founded almost every month. Rene Schickele's *Die weissen Blätter* (under Cassirer's imprint) was perhaps the best publication of the era; Ernst Blass's *Argonauten* was drifting rapidly toward the right, while others proclaimed in their titles that they were veering to the radical left. *Freie Strasse* (Open Road), edited by Franz Jung; *Revolution*, edited by Hugo Ball, Richard Huelsenbeck, and Franz Jung; *Kain* (Cain — *Journal for Humanity*) edited by Erich Mühsam; and *Neue Jugend* (New Youth) by Wieland Herzfelde are examples.

The war put only a temporary end to these activities. Many of the papers emigrated to Switzerland, and their staffs reopened coffeehouse life in Zurich's *Cafe de la Terrasse* and *Cafe Odeon*; Dadaism was born in the *Cabaret Voltaire*. Even more than Expressionism, Dada had this coffeehouse character — the character of total nihilistic opposition. And, as was natural at that time, it was even more profoundly disillusioned with mankind.

The war paralyzed and decimated the bohemian movement, split it, and politicized it. The high point of *Cafe Grössenwahn* came when someone broke out in an enthusiastic cheer for the sinking of the *Lusitania* and Leonhard Frank sent him to the floor with a box on the ear. But *Der Sturm* stopped publishing, *Die weissen Blätter* went to Switzerland, and Pfemfert, to maintain his paper as a means of communication, made the intellectual sacrifice of self-censorship. Instead of political news and comment, he reprinted the silliest items from the patriotic press, hoping that the knowing would understand. The reality of the war soon taught futurists and apocalyptics that their destructive enthusiasm had been, to

put it mildly, misplaced and that Expressionism was no substitute for political action. Except in the safety of Switzerland, the coffeehouse counterculture could never again be the mold of revolution; nor could art and poetry be its form of realization. Confronting the catastrophe it had announced, the expressionist Geist proved itself bankrupt. It would, however, cause many tremors in the cultural field, producing a wealth of artistic creations which are still to be appropriated.

Notes

[1]Soon this was to win distinction as Europe's first "family" beach where the two sexes were allowed to enter the water together.

[2]The table where the "regulars" had their cafe get-together.

[3]Whether or not that is the correct derivation, the term was rapidly extended to include every *schlemiel*, artist or not, and it flourished in Northern Germany, too.

[4]Although the charge was not articulated, there may have been an anti-Semitic implication in the attack.

[5]This was quite generous, considering that Becher's furnished room cost 30 marks and a meal 1.50 marks.

[6]As Peter Gay has pointed out, this generation made hatred of the father a dominant theme. Moreover, in psychology, bohemia was the first to recognize Freud. Simmel's and Lask's studies of alienation were also discussed in the cafe, as is apparent from the writings of Kurt Hiller and Franz Jung. See Peter Gay, *Weimar Culture* (New York: Harper & Row, 1970).

[7]This was the first generation to take its name, not from the content of what it had to say, but from the mere fact of its newness — just like fashion.

[8]Only in translation does this point to the term "Expressionism."

[9]Its upstairs floor was later transformed into the *Kabarett Grossenwahn* under Rosa Valetti's direction.

[10]See the chapter by Arthur Mitzman in this volume.

[11]Even a radical like Rosa Luxemburg was conservative in her artistic tastes. See Stephen Eric Bronner's Introduction to *The Letters of Rosa Luxemburg* (Boulder: Westview Press, 1978).

[12]Becher, Rilla, Piscator, Karl Liebknecht, and Rosa Luxemburg were Spartacists in the war and revolution period.

[13]"Politics is for him [Peguy] not a business but the rustling of the blood."

3
Anarchism, Expressionism and Psychoanalysis

Arthur Mitzman

An alliance of anarchists and literary bohemians in Berlin was noted in German literary criticism almost seventy years ago. But systematic approaches to the phenomenon have appeared only in the past few years, in the work of Helmut Kreuzer and Ulrich Linse.[1] Particularly significant for this relationship were the expressionist subcultures of artists and writers in Berlin and Munich between roughly 1910 and 1920.

To these German cities, and a handful of others, flocked thousands of youthful aspirants to cultural immortality. In them, they lived by the principles of hostility to all external authority, liberation from the conventions of bourgeois society and frequently, in the circles they formed, by the somewhat contradictory impulses of communitarian brotherhood.

This was the cultural milieu from which arose the explosions of color and form that characterized the first groups of expressionist painters in Munich and Dresden around 1905 — *Der Blaue Reiter* and *Die Brücke* — and from which, a few years later, emerged also the first expressionist poets, essayists and novelists, with their unique devotion to the ideals of self-expression and their abjuration of the more representational ideals of literary naturalism. Thus it is understandable that Expressionists showed a degree of sympathy and support for anarchist ideas and movements

which were nowhere to be found in their attitude toward the far more powerful, but bureaucratized and to them philistine Social-Democracy.[2]

Once established in their cafe subcultures, the bohemian intellectuals tended to develop an autonomous aesthetic and intellectual dynamic, which led them along exceedingly daring lines of cultural, moral and intellectual innovation. In fact, some of the Expressionists, mixing Freud, Nietzsche, Stirner and Marx, developed a political concern with problems of authority and anti-authority, of sexual liberation and generational revolt that seems better suited to the social issues of the 1960s and 1970s than of their own day.

During World War I such concerns led a small group of Berlin intellectuals into a mixture of anti-art aesthetics and revolutionary anarchism which ultimately jelled into Berlin Dada, and which channeled their apolitical hatred for German society into apocalyptic visions at the end of the war. This can be seen with particular clarity in the social ideas expressed in 1919 by an intellectual triumvirate who contributed a total of eleven articles to the bi-weekly *Die Erde*. Franz Jung, during the war a journalist for business periodicals, had been before the war a member of the *Tat* group in Munich — the local branch of Gustav Landauer's *Sozialistischer Bund*. Raoul Hausmann was with Jung one of the founders of the Berlin Dada Group. Otto Gross was a wayward disciple of Freud, whose interaction with the anarchist movement began about 1910.

If Jung was the unifying central figure, whose personal evolution from the prewar anarchist movement through wartime Expressionism and Dadaism to the independent communist Left (KAPD) of the postwar period embodies and reflects much of the intellectual ferment of the era, Otto Gross, as Jung's guru throughout most of this evolution and a man capable of exerting a remarkable charisma among the Bohemian artists and outcasts in Munich, Berlin, Ascona and Vienna, must be considered the principal source of the ideas inspiring Jung and his friends in the decade before 1920. This chapter, then, will discuss first Gross' unhappy pilgrimage across the bohemian landscape of Germany between 1906 and his death in 1919, with particular attention to the central role played by Franz Jung from 1911 on; secondly, the parallel evolution of Gross' underlying assumptions about human nature, and how they laid the basis for a novel form of psychoanalytic radicalism during this period; thirdly, the views expressed by Gross, Jung and Hausmann in 1919, an effort to render the ideas of anarchism, Marxism and psychoanalysis jointly serviceable in a revolutionary crisis, which precedes by half a century similar attempts in the student upheavals of the late 1960s.[3]

In the autobiographical or biographical documents of his contemporaries, no one recorded an acquaintance with Otto Gross before 1906. In that year and the following two, half a dozen important figures from the worlds of scholarship and literature noted his presence, frequently as the charismatic center of a circle of literary and artistic free-love advocates in Munich.[4] Thus we know little about his earlier life. We do know that he

was born in 1877, the son of Hans Gross, a professor of criminal psychology at the University of Graz, that he became a physician and a psychoanalyst, probably under Freud's tutelage in Vienna, and returned to Graz as a *Privat-Dozent.*

Judging by his explicit willingness to follow his father in applying social-darwinist assumptions to the study of psychopathic inferiority, we can infer that the relationship to the father must have been relatively cordial while Otto Gross was still in Graz and perhaps for the first few years in Munich.[5] There must nonetheless have also been a good deal of antagonism arising from Gross' early teaching career at his father's university, and such an assumption would go far to explain why Gross, who came to Munich ostensibly as an assistant in the psychiatric clinic at the univeristy, quickly dropped out of respectable society into the company of bohemian outcasts who were virtually all at odds with their social origins,[6] and why the denunciation of despotic patriarchalism is prominent in the few articles he wrote for a broader public.[7]

When Leonhard Frank, an aspiring painter whose real talent was to lie in literature, arrived in Munich in 1906, he found Gross firmly established in the Cafe Stephanie. His friends and followers included Johannes Nohl, a friend of Erich Mühsam who was later to play an active role in organizing and financing Mühsam's anarchist circle in Schwabing, the painter Carlo Holzer, a woman who Frank called Spela,[8] a girl named Sophie Benz, a Swiss anarchist named Karl, a very tall Russian, an impoverished student dropout named Fritz and Gross' wife.

Frank was then about twenty years old, fresh from a miserable effort to earn a living as an itinerant painter and with an earlier experience as an apprentice locksmith.[9] Bewildered by esoteric discussions of Nietzsche and Freud in Gross' circle, he allowed himself to be matched with Sophie, like himself an aspiring artist, and promptly fell in love with her. After two years, Gross seems to have decided that their practically monogamous relationship was unhealthy for Sophie; he told her so, and offered her free therapy in the Cafe Stephanie, an abundance of cocaine, and Fritz, whom he now considered a more suitable mate. Either Sophie had been miserable with Frank (and he suggests only the contrary) or Gross must indeed have had charismatic power of persuasion, for she accepted all three offers. Frank's discovery of the psychiatrist's new prescription for Sophie's happiness almost brought Gross to an early end, for the future novelist, a revolver in his pocket, soon went to Gross' quarters with murderous intent, only to find that his quarry had left town, together with Sophie and Fritz. Two years later in Ascona, Sophie, weakened physically and emotionally by constant prescriptions of narcotics, died of an overdose of morphine, in Frank's bitter words, "the first sacrifice to the applied insights of Sigmund Freud, who has changed the face of the earth."[10] The day after hearing the news in the Cafe Stephanie from Mühsam's friend Nohl, Frank left Munich for Berlin.

Gross' cocaine habit produced unpleasant physical and psy-

chological effects, of which he himself must have been aware, since he
repeatedly institutionalized himself in vain efforts to end his habit.[11] Ac-
cording to Frank, Gross could write only under the influence of cocaine,
and Ernest Jones mentions an around-the-clock treatment of Gross by
Carl Jung in 1908, at the end of which they were both reduced to "nod-
ding automatons." (Shortly after, Gross fled the sanatorium and wrote
Jung to ask him for hotel money.)[12]

In 1909, Erich Mühsam organized a local branch of Landauer's
Sozialistischer Bund in the cafes of Schwabing, which called itself Tat-
Gruppe. Landauer, the only intellectual of stature in the German anarchist
movement, had separated himself from the more revolutionary Anar-
chistische Föderation Deutschland because of his stand for communitarian
rural experiments and had begun in that year to organize a loosely coor-
dinated network of anarchist groups around his journal, Der Sozialist.
Mühsam, a bohemian intellectual himself, had a confidence in the revolu-
tionary potentiality of young dropouts and lumpenproletarians not
altogether shared by Landauer, but the latter, from his base in Berlin,
nonetheless helped Mühsam hold his group together until 1912.

There seems to have been an underlying compatibility between the
theory of the Tat-Gruppe and the praxis of the circle around Gross, for
about half of the nineteen persons whose connection with the Tat-Gruppe
has been established[13] were also friends, supporters or adherents of
Gross' circle as well.[14] (Curiously, the anarchist theorist whose ideas were
most congenial to the organization of young bohemians and social out-
casts, Bakunin,[15] is barely mentioned in the literature concerning the Tat-
Gruppe or the Gross circle.)[16]

The key figure mediating between Gross and bohemian anarchism
was Franz Jung, who provided a semi-organized following for the psy-
choanalyst's ideas — and at times, a defense of his person — among the
political Expressionists in Munich and Berlin. Why Gross, who seemed
remarkably successful at running his own show before 1910, judging by the
accounts of Leonhard Frank, Ernest Jones and Marianne Weber, should
have needed Jung's assistance in maintaining a personal following after
1910, is probably comprehensible in terms of the disruptive impact of nar-
cotics on his personality,[17] and of his increasing exclusion from
psychoanalytic circles because of his doctrinal eccentricity, which accord-
ing to Franz Jung undermined the cohesion of Gross' personal following.[18]

In Munich and, from 1913 on, Berlin, Jung seems to have formed
around himself a small sub-group of writers and artists, who were
politically inclined to anarchism, aesthetically to Expressionism (and,
from 1917, Dadaism), and intellectually inclined to the psychoanalytic
theories of Gross.

When Jung arrived in Munich, Gross had already moved his follow-
ing to Ascona, which around the turn of the century had become a refuge
for free spirits of all sorts; anarchists, vegetarians, free-love advocates,
mystics, and poets.[19] There, according to Jung, he had intended "to

found a free college from which he thought to attack Western civilization, the obsessions of inner as well as outer authority, the social bonds which these imposed, the distortions of a parasitic form of society, in which everyone was forced to live from everyone else to survive."[20]

Gross' Ascona experiment was haunted from the beginning by the suicide of the girl Frank had loved; moreover, psychoanalysts' followers became involved in the saccharin smuggling operation between Zürich and Munich organized by anarchist artists and students.[21] Franz Jung, who met Gross and his followers on one of their numerous return visits to Munich in 1911 and 1912, developed a considerable respect for the psychoanalyst and a close friendship evolved. Meanwhile, Jung was living largely by selling his friend's books, particularly those of his rather intimidated younger friend, Oskar Maria Graf.[22]

Jung's activities in Munich were not entirely confined to sponging off his friends. Though he laments the fact that the Schwabing he knew was past its prime, the anarchist movement was not, and he records one febrile attempt to convert theory into praxis when the tiny syndicalist group tried to call a general strike in the building trades. Mühsam's effort to address a union meeting for this purpose ended in the near-lynching of himself and his frail following by muscular social-democratic construction-workers, a denouement which may have had something to do with the demise of the *Tat-Gruppe* in 1912 and Jung's departure shortly thereafter for Berlin, where he resumed his work as a trade journalist.[23]

While Jung had a promising literary career before him, Gross' fortunes were all downhill from 1910 on. In 1911, Landauer launched a bitter attack on his psychoanalysis in his journal, *Der Sozialist*, the thinly disguised object of which was Gross and the *Tat-Gruppe's* susceptibility to his ideas.[24] Gross wrote a reply to Landauer's attacks during yet another of his periodic cures in a sanatorium, but Landauer, who had personal reasons for disliking Gross, refused it publication, with the somewhat reluctant agreement of his editorial adviser Martin Buber.[25]

In April 1913, Gross published his reply to Landauer in Franz Pfemfert's *Die Aktion*. Probably eased into print through the mediation of Franz Jung, "*Zur Überwindung der kulturellen Krise*" ("On Overcoming the Cultural Crisis") was Gross' first publication in an expressionist journal, indeed his first programmatic article of any sort.

It stated in very general terms the importance for revolutionary change of the new psychology of the unconscious — which he attributed to Nietzsche as well as Freud — particularly insofar as this psychology undermined the authoritarian patriarchalism of the existing society, and it ended by declaring that the coming revolution would be a revolution for matriarchy (*Mutterrecht*). At about the same time Gross moved to Berlin, where he roomed a good part of the time with Jung, and planned with him the publication of a monthly. A notice published jointly by the two men in *Die Aktion* said that the new journal would start in July 1913, would deal with problems of cultural and economic life on the basis of an

individualist psychology, and would propagandize for a new ethic as the preliminary (*Vorarbeit*) for a social revaluation.[26]

The journal only appeared two years later, by which time Europe was plunged into the savagery of World War I; and Jung himself was the principal editor. Meanwhile, during the months that followed this initial notice, Gross labored at his "new ethic" under the watchful eye of Jung, Jung's wife and mother-in-law, and other new friends from the *Aktion* circle.[27] He also wrote replies to attacks on psychoanalysis directed at him in *Die Aktion* by one of the leading Berlin expressionists, Ludwig Rubiner.

On Nov. 9, 1913 this new life collapsed, when Prussian police officials arrested Gross, at the behest of his father, in Franz Jung's apartment, and deported him to Austria; there he was committed to an asylum on the basis of an affidavit describing him as a dangerous psychopath, which was signed by Carl Jung.

According to Franz Jung, the institutionalization of Otto Gross resulted from a conscious decision by his father — a well-known professor of criminology — to force him back to a respectable academic position or destroy him. Gross himself was convinced that his father meant to prevent him from publishing an article in a psychoanalytic journal which analyzed the examining magistrate in terms of sadism — about which his father had written an internationally known textbook — and referred to someone remarkably like his father as a prime example of this quality. (That Gross should have been convinced that someone close to him had sent a copy of this article to his father reflects a paranoia which Johannes R. Becher had also noted in Gross, particularly during his cocaine intoxication.) Erich Mühsam mentions a letter sent by one of Gross' patients to his father which contained information Gross had communicated to the patient about his own troubles in the course of treatment, apparently a blackmail attempt. Other reasons for his deportation advanced by the authorities when pressed by Gross' friends were his excessive use of cocaine and his lack of proper documents (remember, Gross was an Austrian citizen).[28]

Jung organized a highly effective journalistic campaign for Gross' liberation among his friends. Pfemfert repeatedly editorialized on the issue in *Die Aktion*; even Ludwig Rubiner, who had publicly polemicized against Gross, came vehemently to his defense. Franz Jung was able to take over the fifth number of a new (and short-lived) Munich journal, *Die Revolution*, in which he published an editorial of his own, protests from Ludwig Rubiner and Blaise Cendrars in Paris and Erich Mühsam in Munich, and literary contributions dedicated to Gross by Johannes R. Becher, Ernest Blass, Jakob van Hoddis, Alfred Lichtenstein, Rene Schickele, Else Lasker-Schüler and Richard Hülsenbeck. To attack Hans Gross on his own ground, Jung sent a thousand copies of his number of *Die Revolution* to cafes in Vienna and Graz, university addresses, libraries and bookstores. Mühsam took up the cudgels for Gross in *Kain* after some prodding from Pfemfert (and possibly counter-prodding from Lan-

dauer). Richard Ohring, one of Jung's new friends in Berlin,[29] used the *Wiecker Bote* as a platform to demand Gross' release.

There were two main approaches used by the Expressionists in the Gross case. Those trying to influence liberal and socialist opinion stressed the dubious legality and the dangerous precedent established by his arrest and deportation. But those from the bohemian underworld who empathized with Gross as a victimized son directed their indignation to their peers. The Gross case became a catalyst for the generational revolt exemplified in these years by the youth movement and Expressionism, insofar as it illuminated sharply the mutual support and mutual dependence of paternal and political authoritarianism. This significance of the Gross case to the younger generation emerged clearly in a defiant protest by his intellectual opponent Rubiner: "The throttling of Dr. Gross by his father is typical. We will destroy this type. . . . In the Case of Dr. Gross, a significant son, we take up the cause of the many insignificant sons, who unnoticed, are destroyed in broad daylight. We intellectuals, we sub-proletarians are strong — the professor in Graz is only anxious. . . . The madhousekeepers, administrators of property and state officials stick together. We, who have nothing to lose, stick together too. We are getting past them, annihilating their positions, burying their honor, destroying their wealth. Our pamphlets are more powerful than their connections."[30] Unquestionably the theme of the sons against fathers was a potent one among the Expressionists and it is likely that the institutionalization of Otto Gross lurks in the background of a number of the dramas and novels built around the theme of sadistic schoolmaster, father-son conflict and parricide between 1914 and 1920.[31] Nonetheless, the conclusion of the campaign organized by Franz Jung was no jacquerie of vengeful sons but rather a tactical retreat on the father's part. Hans Gross, after an attack on him in a Vienna newspaper, broke a long silence to say that it had all been a mistake; Otto was in the asylum voluntarily and could leave when he liked.[32] When Jung traveled to the asylum in the spring of 1914 to pick up Otto Gross, he found that his friend had been elevated from the status of incurably insane to that of attending intern.

Very little can be determined about Gross' activities during the years that soon followed his institutionalization. We know only that he joined the Austrian army as a doctor, was released for reasons unknown in the middle of the war, lived the concluding years of the war in Vienna, where he developed a new circle with Franz Werfel as his leading acolyte,[33] and returned to Berlin in December 1918, where he died a few months later of the combined effects of starvation and disease.

Nonetheless, Gross' impact continued to be felt most strongly not in Vienna, but in Berlin, where, though he must have been rarely if at all present in the war years, his ideas, mediated by the energetic Franz Jung, dominated the six numbers of *Die Freie Strasse* edited by Jung between 1915 and 1917, inspired the original Berlin Dada group of 1917–1919 and were heavily represented in 1919 in the journal *Die Erde*. I shall

discuss the *Erde* articles in a separate section; here I should like only to mention briefly the significance of *Die Freie Strasse* as a vehicle for continuing, under wartime conditions, at least a part of the anarchist tradition among the Berlin Expressionists.

With contributions by three former members of the *Tat-Gruppe*, Jung, Graf and Schrimpf, by Richard Ohring, the new Berlin disciple of Jung and Gross, by Gross himself and by Max Hermann-Neisse, an old friend of Jung who was one of the stalwarts of the Berlin expressionist scene, *Die Freie Strasse* often took recourse, presumably to avoid the military censors, to very cloudy discussions of moral and psychological questions, particularly the liberation of women and an ethical system based on psychoanalysis.[34] Indeed the nebulousness of much of the discussion in it — when compared with pre and postwar political Expressionism — suggests that, in general, *Die Freie Strasse* seems to have functioned primarily as a social refuge for wartime literary radicals while the holocaust raged outside, rather than as a serious effort at literary or political expression. Many of their comrades were being decimated in the trenches and it was only by simulating madness after induction that Jung and Graf managed to evade their fate.[35] Nonetheless, Ulrich Linse, a recent historian of German anarchism, has declared Richard Ohring's essay on "Compulsion and Experience" in *Die Freie Strasse* to be a classical example of the bond between anarchism and Expressionism, and since Ohring also provides an important clue to the intellectual evolution of Jung and Gross, its contents merit recapitulation.[36]

Ohring describes "experience" and "compulsion" as psychological antitheses. "Experience" represents the anarchic creative force of personality, the potentiality for which is innate. "Compulsion" is every external or internal barrier to the free development of experience. External compulsions exist in the laws of nature and in the laws, morals and customs of society. After infancy, the external compulsions become internalized through the attributes of obedience and obligation. Thus, "from the first month of our life (*Erwachen*), everything is aimed at establishing compulsion against our experience, against our tendency to self-expression, and at forcing us to fit into the existing scheme." Against this process of integration Ohring asserts that "every new doctrine, every alteration of the world is the breakthrough of a compulsion by free experience." To pose the question of freedom then, leads to a counterprocess of "breaking away, to a new enforcing of one's own experience against compulsion."

So far this is little more than a restatement of Stirner's individualist anarchism, which in fact had been quite popular among the literary and intellectual anarchists before the war[37] and was the anarchist doctrine closest to the prewar ideas of Otto Gross. Ohring, however, also had a commitment to the idea of community and, in a verbose incantation, tried to link the idea of a new community not to compulsion or social restraint, with which it was usually associated, but to individual ex-

perience: "When the yearning of belief calls forth the source of hidden communality from the dead landscape of compulsion, then the belief will become unshakable that all community is only that of experience." This shift in ground from Stirnerian individualism to a communitarian ideology, or rather the attempt to make the two compatible, also characterizes a fundamental turning point in Gross' ideas during the war, and is intimately related to the brief revival of Bachofen's matriarchal theory in the circles of Gross' followers after the war.

Gross' psychoanalytic writings were conditioned by his training as a neurologist and psychiatrist. For the most part they are only marginally related to his influence on the anarchist Expressionists and free spirits who became his personal followers. In his last, posthumously published, contributions to psychoanalytical theory, however, there is clearly an effort to transform psychoanalysis from an essentially conservative to a potentially revolutionary body of ideas through a fundamental revision of Freudian instinct theory.

Gross' line of attack was twofold. In the first place, he denied that aggressive behavior and the closely related phenomena of sadism and masochism were instinctual in the species and that therefore the suppression of instinct by reason and conscience was uniformly a precondition for civilization. Secondly, he denied the common tenet of Freud and his followers that innate differences in the nature of men and women accounted for the dominance of the aggressive-sadistic character in man and the passive-masochistic character in women. The apparent character differences of men and women, the widespread aggressiveness about which Freud passed such melancholy comment during and after World War I, as well as virtually all neurotic, anti-social behavior, Gross attributed not to instinct but to the deformation of instinct by the existing organization of society, which he viewed as modelled on the patriarchal family and as ultimately an instrument of male domination. But in undertaking this revision of Freudian precepts, Gross was also compelled to modify some of his own earlier ideas, which he had expressed in essays of 1907 and 1909. For in these earlier essays, the differences with Freud were not nearly so marked.

In these earlier studies, Gross had indeed already advanced the notion that the eternal conflict between the individual and society was more founded in the oppressiveness of society than in the iniquity of raw instinct. But he had nonetheless partly accepted both the Freudian characterology of male aggressiveness and female passivity, and the notion that the aggressive character of the male was basically anti-social. His latent differences with Freud in 1909 centered around two points. In the first place, basing himself on a blend of Nietzsche, Darwinism and vitalism, he saw only the degeneration of the species resulting from the increasing social sanctions against the expression of violent, anti-social

impulses. This point of view must have made Gross particularly well appreciated among the individualist anarchists who followed Nietzsche and Max Stirner. Secondly, he attributed to female sexuality a positive and active quality that Freud had rejected.

The late work sees a revision of instinct theory which postulates the compatibility of instinct with social organization, and rejects so completely the notion that masculine-feminine character differences are innate as to suggest an androgynous solution to the war between the sexes. This late evolution in Gross' work occurs in the framework of the gathering revolutionary storm in German society towards the end of World War I and has as its function the adaptation of Gross' ideas to the need of his followers for a libertarian communal ideology that might give some better justification for participating in and attempting to direct the emerging mass struggles than the Stirnerian individualism of the prewar years.

The first detailed formulation of Gross' ideas appeared in *Ueber psychopathische Minderwertigkeiten* (1909), where he tried to explain the phenomenon of psychopathic inferiority through a fusion of the then fashionable school of social Darwinism with the ideas of Nietzsche and Freud. The inevitable conflict between society and the inborn predispositions of the individual, he argued, results in pathogenic injury to the individual.

Since individuals internalize the standards of society, conflict does not, in general, occur openly between the individual and society, but rather within the individual psyche. (I shall follow Freud's later usage of the term superego to describe this internalized voice of society.) For women, but not for men, Gross sees the characteristic conflict between innate impulse and internalized convention and the corresponding repression of instinct by superego, as centering on the sphere of sexuality: "The suggestions which make up the ethical milieu of women from childhood on—this dominating set of values is incompatible with the strongest and most pressing drives and impulses." On the one hand, to the extent that repression of sexuality is effective, and he finds repression generally mandated by the monogamous family structure of his day, it has two effects. The forbidden sexual energies tend to find their way back into the conscious personality in the form of generally anti-social perversions, neuroses and inclinations to petty forms of forbidden or anti-social behavior, such as kleptomania, cruelty and the tendency to make oneself ugly. Furthermore, Gross notes that the dominant characteristic of the psychological development of women, particularly of the upper class, "is the incapacity to create a comprehensive and connected unity of the inner process, an uninterrupted continuity of psychological life" — again, because of the continual frustration and repression of the sexual impulses central to such continuity.[38]

On the other hand — and here Gross' use of social Darwinism is evident — if repression is ineffective, the woman prepared to behave according to the mandate of her nature, rather than that of society, finds herself

boycotted by men, and is unlikely to find a husband and have children. Thus, women equipped with the most powerful natural impulses are likely, by the principle of selection, to be ostracized by society and not permitted to reproduce, while those women who, from the standpoint of natural instincts, are most impoverished will be favored, cultivated and protected by society and thus become the dominant type. "Natural selection is repressed and replaced by *another new process* of breeding, whose tendencies and effects are precisely opposed to the natural selection of the strongest and most fit and result in a situation where a by nature abnormal and inferior (feminine) type has in the course of time become the norm."[39]

The characteristically masculine instinct is that of struggle or aggression, and it is inhibited by the moral disapproval of society in the same way that sexuality is in women. There is, however, a difference in the magnitude and degree of internalization of this inhibition. Aggressive desires are not so subject to the censorship of superego as are sexual ones, with the result that the internal psychic struggle between aggressiveness and restraints imposed by the social order may occur and be resolved more or less consciously. To the extent that this possibility of conscious conflict is curtailed by the intensity of internalized social inhibitions against aggression, the pathological character of the conflict increases. In general, the social code imposes ever stricter sanctions against the innate aggressiveness of man. Gross quotes Nietzsche's scornful definition of "progress" as the road to a condition where "nothing need any longer be feared," and comments that if Nietzsche is correct, then "the suppression of aggressive tendencies must become . . . an ever more abundant source of neurotic cleavages within the personality," a point which he immediately buttresses by reference to the most recent work of Freud.[40]

Shortly after this passage, Gross somewhat modifies his rather categorical statements about the different instinctual characteristics of male and female. He stresses that in the masculine case, the conflict is to be understood primarily in terms of strength of the aggressive impulse; in the female, in terms of the inhibiting power of an anti-sexual morality. (It is well to bear in mind that Gross' perceptions were undoubtedly in large measure a reaction to the moral code of central European society before World War I.) He also goes on to present more conventionally the notions of Freud concerning the repression of childhood sexuality. But it is in the passages presented above that we find the most original part of Gross' doctrine and the revolutionary core of his ideas, which cannot but have given a clearer sense of identity to many of the anti-social anarchists and bohemians to whom he administered daily doses of doctrine and therapy in the years before World War I.[41]

When Gross wrote *Ueber psychopathische Minderwertigkeiten,* he as yet acknowledged no overt disagreement with Freud. In his last publication, *Drei Aufsätze über den inneren Konflikt,* probably written between

1917 and his death in 1919,[42] he separated himself from Freud in his interpretation of instinct theory and moved closer to the psychoanalytic school of Alfred Adler.

In the *Drei Aufsätze*, Gross redefines his thesis that inner psychological conflict is the struggle of one's nature against the internalized values of society (*"der Kampf des Eigenen und Fremden in uns"*).[43] Most importantly, he redefines his notion of sexuality so as to make the innate sexual impulse an impulse toward contact with the other and in a larger sense, toward social community, and he removes from the primal Ego-drive for self-preservation any suggestion of an aggressive will to power or mastery over others. Thus he ascribes to Alfred Adler the psychoanalytic version of the will to power as "the driving principle of the individual to assert his Ego at all costs" and "to protest from the unconscious against external suppression." In Adler's terms, sexual neuroses are only the symbolic expression of "that revolutionary but also aggressive and violating" protest.

Gross now denies that this will to power, with its aggressive-violating tendency, is an innate characteristic. He considers it a secondary, basically pathological phenomenon; "it is a hypertrophied form, distorted by age-old suppression, of that original drive which I have designated as 'drive for the preservation of one's own individuality in its own established character'."

The source of this suppression, however, must for Gross be an inner conflict with another drive, and this is where the sex-drive enters his account. For it is in a deformation of the sex-drive — which Gross sees as originally based on a need for physical and psychological contact with others and in this original form as completely compatible with the healthy drive for self-preservation — that Gross sees the source of the deformation of the drive for self-preservation in the will to power. The initial deformation of the sexual contract-drive is masochism, and Gross sees it arising naturally from the total dependence of the child on his parents and the resulting tendency for the infant to surrender his own inclinations for the retention of the parents' approval and contact. "Because infantile sexuality internalized the impulse to surrender one's own Ego to others, to subjugate it for the purpose of avoiding isolation, it has become characterized by the masochistic impulse." And masochism after infancy signifies "the striving for the restoration of the infantile situation with regard to adults" (p.8). It is in necessary conflict with this passive masochistic sexuality that the originally defensive Ego-drive becomes the sadistic, aggressive-violating will to power.

Thus under the pressure of external circumstances two internally antagonistic hybrids — masochism and sadism — arise out of the originally harmonious instinctual duality, self-preservation and sexuality. Masochism emerges from the infant's need to dissociate its desire for contact from its own character and individuality in order to avoid isolation. Self-preservation of the infant as well as sexual contact can only be

obtained at the price of conformity to the demands of society, which fre-
quently dictates masochistic surrender of individuality. This surrender,
however, is opposed by the drive for self-preservation, which, in the
course of resisting masochistic surrender, comes to identify the maturity
of the dominating, seemingly secure adult with the opposite of
masochism, the society's ability to force sexual response and impose its
will on the helpless infant. In this way the drive for self-preservation is
distorted into the sadistic, dominating will to power.

Then there follows an analysis, irrelevant to our purposes, of the
fourfold relationship of heterosexuality and homosexuality to masochism
and sadism. We note that until this point in Gross' argument, which so far
covers the basic instinctual disposition as well as the process by which it
is transformed into the antagonistic duality of masochism and sadism, he
has made no mention of the masculine-feminine dichotomy with which
he had earlier identified the distinction between a basically aggressive
and a basically sexual character. Again paying homage to Adler, he now
reexamines the relationship of gender and character, no longer in terms
of instinctual inclination but strictly in terms of socially caused character
differences, and it is striking how similar the results of this reexamination
are to the views of contemporary feminists:[44] "The concepts 'man' and
'woman,' as a reflection of the existing institutions in society and family,
tend to assume the significance for the Unconscious of 'superior' and 'in-
ferior.' As a psychological result of existing conditions, the mutual rela-
tions of the sexes come to symbolize domination or subjection. . . . Both
sexes identify the leitmotiv 'masculine inclination' with 'Ego-drive,' will to
power and violation, sadism; they identify 'feminine inclination' with the
need for surrender and contact, the tendency to subjection and
masochism (in distinction to its original symbol, child-inclination). Thus
in the man, the sadistic component has a heterosexual orientation, the
masochistic, a homosexual one. In the woman, the masochistic compo-
nent is heterosexual; the sadistic, or more accurately, the active compo-
nent which aims at preservation of the personality, is homosexual."[45] In
short, Gross developed a theory of sado-masochism, of aggressive male
and submissive female character types, which found their roots not in
human instinct but rather in the deformation of instinct by the social
organization of the family.

There are three distinct solutions which Gross suggests as a means
of repairing the damage, of restoring the relationships between sex and
self-preservation as well as that between male and female to their original
healthy and harmonious potentialities. In the work under discussion, he
suggests that it might be accomplished by a therapeutic encouragement
of unconsciously motivated efforts to overcompensate for the socially
based masochism and sadism. For example, an emotional attachment
between a masochistic man and a lesbian — to the extent that it produced
some degree of identification of each partner with the other — would
"signify a striving not only for equalization but also for the *reversal* of the

existing relationships of domination and subjection." Whether this approach preceded or followed from Gross' intimate acquaintance with bohemian subcultures, there can be little doubt that it was the basis for his involved, manipulative and putatively therapeutic relationship to his followers.[46]

The second solution appears in a brief essay "On Loneliness," which deals with the child's need for contact and the way in which its manipulation to force his submission to the authoritarian family cripples his personality. To this problem, which precedes and underlies the difficulties analyzed in his longer article on sadism and masochism, he suggests a solution of radical permissiveness: "Love must be given absolutely unconditionally to the child, freed from any possible connection with demands of any sort, as a pure affirmation of individuality for its own sake and of every nascent originality." Gross has no hope that this recommendation will be followed in the near future because, he acknowledges, "it is incompatible with the principle of authority, in the family as well as elsewhere."

This pessimism withered rapidly in the intoxicating revolutionary climate that accompanied the collapse of the central powers in 1918 and it is not surprising that the rather self-contained psychoanalytic observations of the *Drei Aufsätze* exploded, in the last months of Gross' life, into an eschatological manifesto for a sexual revolution. Thus Gross' third prophylaxis for the problem of socially conditioned neuroses is best comprehended in the context of essays by his disciples Jung and Hausmann, which likewise mingle psychoanalytic insight with social chiliasm.

Gross' posthumously published *"Protest und Moral im Unbewusstsein,"*[47] intended for an unspecialized, political audience, supplements his *Drei Aufsätze* in a number of ways. In the first place his break with Freud here goes to the point of arguing that Freud and the classical psychoanalysts were unable to penetrate beyond socially deformed character types to their healthy instinctual substratum because the revolutionary implications of this basic nature, its implicit threat to the existing structure of authority, was equally a threat to the analysts' own status and authority.

In the second place he now makes clear the political implications of his earlier redefinition of the sex-drive as a drive for physical and psychological contact with others when he implicitly identifies this redefined sex-drive with Kropotkin's instinct of mutual help.

Furthermore we find a conception of history underpinning the notion that a revolution based on such a celebration of instinct is now — 1919 — possible. It is a three-stage eschatology in which a free, primitive golden age without patriarchy is thought to precede an agricultural epoch which enabled the subjection of wife and children to the father. This tyranny of the *paterfamilias,* however, loses its economic basis in an urban civilization and the result is the gradual disintegration of the moral order which prevailed in rural cultures.

Gross must have identified the Wilhelmian and Austro-Hungarian empires with this rural, patriarchal authoritarianism, because he seems to have equated the collapse of these empires with the transition to a new urban culture, with a new morality and new institutions, based on the liberation of the instincts repressed by paternal despotism. Among these new institutions he mentions the acceptance by society — rather than the family — of the economic costs of motherhood, and an educational system based on the principle of the rediscovery and preservation of "the innate, eternal values."

Gross concludes by acknowledging his "absolutely irreconcilable opposition to everything and anything that today in the name of authority and institutions of power and custom stands in the way of the fulfillment of mankind."

Jung's and Hausmann's versions of Gross' ideas are diluted by their simultaneous concerns with the ideological issues of the moment: in Jung's case, the arguments within the new Communist Party over the meaning of the class struggle raging in the streets of Berlin; in Hausmann's, a heated polemic with a position close to his own, the individual anarchism advanced in those tumultuous days by followers of Max Stirner.[48] What is common to both men is the conviction that the communist revolution then apparently in progress would remain dangerously incomplete if it did not expand from the economic sphere to the sexual. In Hausmann, the Freudian and the Marxian revolutions had to go together. "The world economic revolution alone is insufficient. The total condition of man in the psycho-physical (material) sense must be fundamentally changed The doctrine of Freud (and Adler) is ultimately as important a means for the understanding of petty-bourgeois individualist society as the economic doctrine of Marx-Engels."[49] And: "This revolution would be short, were it only a question of an economic transformation. It is long, it will be the greatest revolution ever seen on earth."[50] Hausmann viewed all sectors of this society — economic, political and familial — as characterized by a hierarchical, pyramidal structure of authority which was basically an instrument of male domination. ". . . The capitalist oppresses the workers; the general, the soldiers; the man, the woman, regardless of all rights and capacities of the oppressed. All are sick and crazy, because the suppressed and falsified spheres of life continually drive them to transgress their own laws And here the man alone is guilty The weakness of a tragic culture rests on a tendency to self-destruction . . . which is alien to woman. Organizational man will perish from this tragic cultural attitude if he is unable to liberate, in the course of the world revolution, the counterpowers" The counter-powers would appear to be the capacity for direct democracy represented by the council system ("the first state idea not based on stratification"), and Hausmann, who pleads for sexual as well as economical justice, believes women are better able to implement it than men. In fact the "transformation of bourgeois society" was inseparable from "the formation of a feminine society which leads to a new

promiscuity and also to matriarchy (against the patriarchal family of masculine imprint)." The family itself would shed its authoritarian character and would dissolve into voluntary groups, relationships and families; and feminine sexuality would cease to be defined by the masculine personality which had long subjugated it and would develop its own forms of friendship and comraderie.

Franz Jung was more politically involved than Hausmann in the early German communist movement. He organized a band of armed Spartacists in postwar Berlin, and when the revolt was quelled and the communists set about building a legal mass party on Leninist lines, he split from them — ever the heretic — for the left-oppositional Communist Workers' Party (KAPD).[51]

Thus Jung's four essays of 1919 on means and ends in the class struggle (*"Zweck und Mittel im Klassenkampf"*) have to be comprehended within the framework of an ongoing civil war which, for most of those on Jung's side had one meaning only: the life and death struggle of the revolutionary working class for the overthrow of capitalism. It is no wonder then that Jung is less focused than Hausmann or Gross on the sexual revolution, and that when he does discuss it, he does not argue, like Hausmann, that it must be simultaneous with the economic one. He nonetheless does insist that a number of anti-authoritarian "class struggles," not yet generally recognized as such, would remain to be fought out even after the victory of the proletariat, and he devotes most of his second essay to just this subject.[52]

Most important among these is the struggle of woman for liberation from man. "The history of this class struggle" writes Jung, "dates from the collapse of matriarchy, i.e., from the usurpation, from the property seizure of the family by the husband, which came to expression in the proclamation of patriarchy and the suppression of matriarchy."[53] The result, Jung claims, has been a general loss in the intensity of experience and the sum of happiness, and he is convinced that women are subconsciously aware of this loss.

A similar form of struggle is the generational, that of youth against age. Youth perceives injustice and "violation" (the word is one of Gross' favorites) in the educational system and the claimed superiority of the adult against the young.

Jung's last example of a not yet articulated "class struggle" is one which haunts the entire 50 years history of the movement whose birth pangs he attended behind the barricades of Berlin: "The struggle of those who are concerned with a knowledge of the conditions of their lives against those who are content to use a knowledge of authoritarian doctrines in order to defend their acquired positions from their opponents, the doubters, the anti-authoritarians. Naturally this can only occur through violent suppression, and the struggle of religion, of Church, of 'true believers' against the intellect, the free idea, displays uncounted examples of bloody suppression."

Nonetheless, Jung is certain that once the conflict of proletarian and capitalist has been overcome, and communism has guaranteed everyone's material existence, these new struggles for the rights of women, children and anti-authoritarians in general, with new forms of mass solidarity, will bring men closer to "the final struggle for the human community."

The phenomenon of Gross and his matriarchal ideology raises a number of questions about the social and intellectual history of twentieth century Germany.

In the area of intellectual influences, one would want to know first the magnitude of the debts, if any, owed by Gross to the Klages-Schuler matriarchal ideology, to Bachofen, to Morgan and to Bebel. One would like more clarity on the precise circumstances attending his fall from grace in the Freudian camp, on his intellectual and/or personal relations to Carl Jung and Alfred Adler, and particularly important, on his possible influence on Wilhelm Reich, whose theories come remarkably close to those of Gross at certain points. One would also like to know more about how his psychoanalysis affected the literature of his day. The impact is clearest in two of Werfel's stories from the immediate postwar period: *Die schwarze Messe* and *Nicht der Mörder, der Ermordete ist schuldig.* How much of the psychological insight of Leonhard Frank's early novels derives from his love-hate relationship to Gross? What, apart from Franz Jung's short story of 1920, *Der Fall Gross,* was the impact on the literary output of Gross' principal disciple? And what about Berlin Dada, which directly descends from *Die Freie Strasse*? Did Gross' influence go beyond the theoretical and political articles of Hausmann and Jung to affect the visual aesthetics of that movement?

The social and psycho-social questions are also legion. First of all, we need to know much more about Gross' own background. The available information to date is trivial and unreliable compared with what is known about Rathenau, Sombart, Scheler, Weber, or Simmel. What experience and what knowledge gave this man his charismatic power over so many of the talented youth of his day? What, if anything, did his adherents have in common? Kreuzer compares Gross' impact to that of Stefan George, but almost no one had heard of Gross, much less studies him, while the literature on the *George-Kreis* fills yards of shelf space.

The larger questions concern the general significance of Expressionism as a social movement. The vitalist irrationalism of Expressionism has not infrequently been associated with Nazi barbarism, despite the Nazi' denunciation of most Expressionists — certainly of the vast majority who refused to make the transition to *Blut und Boden* nationalism — as degenerate cultural bolsheviks. Indeed there is little but the accident of birth of some of their leading figures that can relate the anarchist Expressionists, with their contempt for flag and fatherland, to the *völkisch* na-

tionalism endemic to the *Mittelstand* that followed Hitler in the 1930s. For the *Mittelstand* movements, even when they were most rebellious against the "liberal" culture of the nineteenth and twentieth centuries, maintained a piety for precisely that traditional patriarchal morality which the Expressionists were determined to destroy, along with the bourgeois morality they viewed as subservient to it. Nor can we relate the expressionist movement to proletarian socialism, despite the enthusiasm of many Expressionsists for the revolution of 1918/19. Unlike the Naturalists of the 1890s, and their corrupt descendants, the later Socialist Realists, the Expressionists neither pretended nor attempted an "objective" indictment of social misery, but felt compelled to express the hell they felt in themselves, in their own mutilated lives, much though they believed the existing order of society to be responsible for that hell.

In this capacity for extrapolating introspection,[54] the Expressionists might best be viewed as part of the bourgeois consciousness of the Central European *fin-de-siecle*, provided we bear in mind the basic turning of bourgeois consciousness from its earlier western rationalist belief in progress to a highly sophisticated, introverted form of anti-modernism. The clear line of affinity, then could well be to the politically impotent bourgeois anti-modernism that one finds among the early celebrators of Dostoevsky, the poets of the *George-Kreis* and the critical sociology of Weber, Simmel, Sombart and Scheler.

A related problem is that of the long-term cultural significance of the matriarchal ideology of Gross and his group. It is simple to refute the matriarchal theory from an anthropological or historical standpoint; what nonetheless is cause for reflection is the significance of the idea as a modern myth.

The traditional matriarchal mythology, as well as the extant anthropological evidence, only confuse the issue if we try to see Gross' ideas in their terms rather than in the terms of his own situation. All the extant myths associate matriarchy with fertility, earth goddesses, early agricultural society, and Lewis Mumford has argued cogently that the city is the seat of patriarchal systems of domination. The explanation for Gross' location of patriarchy in agricultual civilzation and the dissolution of patriarcy in urban civilization must be found in his own condition and that of his bohemian followers.

Johannes R. Becher, though far from any Gibraltar-like reliability in his account of his youthful experience of Gross' Munich circle, does offer one extremely illuminating example of the city-mother connection which somehow has the ring of truth to it. Leonhard Frank, according to Becher, had a dream of moving into a three-room apartment facing the English Garden which Gross analyzed in the following terms:" . . . the three room flat which you think of as the beginning of a new life is the symbol of your return to your mother, as your associations clearly demonstrate. Munich. That was your mother when as a bricklayer you fled from your father in

Pirmasens to Munich. So you're about to celebrate marriage with your mother."

Very pat, very stereotyped, as Becher intends it to be. Yet it is a fact that youth of all classes did find the paternalistic authoritarianism of German society in this epoch a source of humiliation which drove the more spirited among them to personal revolt and sometimes flight from their homes; it is a fact that this oppressive patriarchal culture was epitomized in small town and rural society; it is a fact that wherever the revolt achieved the level of social organization of counter-community, this counter-community inevitably (because of the markedly patriarchal character of the authoritarianism that bedevilled the young) carried the mythical connotation of a form of sexual organization antagonistic *Männerbund* characteristic of the Youth Movement and the *George-Kreis*. Or it could carry the matriarchal *leitmotiv*, as in the Klages-Schuler split from the *George-Kreis*, or the circle around Gross.

Indeed, Klages' view around 1900 of the archetypical significance of Munich makes explicit what Gross saw as the latent meaning of Frank's fantasy. As one of the dominant symbols of Munich he identifies the color blue in the roof of the Frauenkirche: "Blue is — or was supposed to be — the mantel of the mother of God. In antiquity, cities had a feminine meaning. Today there are masculine as well as feminine cities: ie. Florence, Zürich and Berlin are masculine; Venice, Berne and Paris are feminine. Munich stood in the sign of the virgin mother."[55] The matriarchal symbolism thus suggests meanings highly relevant to the situation of Gross and his followers. It should be clear, however, that such bohemian circles related primarily not to a city as a whole, but rather to the artists and students' quarter, of which Munich's Schwabing was and is the closest equivalent Germany could offer to the *quartier latin*. In one sense, the relationship was a passive, dependent, oral one: all the accounts of the cafe life of these circles of aspiring artists and writers reveal the common themes of avoiding work, begging money from strangers, scrounging from friends, and endless talk, as much a means of securing one's berth in a small group as of communicating ideas. It was essentially a form of second childhood which these men were enjoying without the disturbing presence of the father. Munich, or rather Schwabing, *was* their mother, which nutured them without making demands.

In another sense, however, this blissful dependency was merely a supportive framework within which artists and intellectuals developed a sense of common purpose that led not only to some of the most exciting departures in modern art and literature, but to new and more egalitarian forms of community. From the revolutionary councils of 1919 to the Paris uprising of May, 1968, with its slogan *l'imagination au pouvoir*, to the Provo and Kabouter movements of contemporary Amsterdam, bohemian communities of outcasts have functioned as a libertarian yeast at moments of social ferment; while extrapolating from their own condition an alternative vision of society they have assumed the historical ob-

solescence of the struggle for survival and have demanded the replacement of authoritarian and bureaucratic social structures by self-governing communes. If this vision was doomed by the poverty and social chaos at the end of World War I, it has become a less unrealistic goal in recent years. For parallel with increasing dissatisfaction over the bureaucratic character of modern life has risen a great questioning, based on the coming ecological crisis as well as the continued menace of nuclear armageddon, of the whole ethic rational mastery and domination which has underlain the material progress of western man up to his present questionable condition. Nietzsche wrote in *The Will to Power*,"whoever pushes rationality forward also restores new strength to the opposite power, mysticism and folly of all kinds." Historians have noted the accuracy of this observation in particular to the recrudescence of witchcraft that followed the efforts of the Reformation to exorcise magic from Christianity. In fact, much of the chaotic social and cultural history of the twentieth century, reflecting the corrosive impact on local, traditional societies of the new industrial order and the rejuvenated bureaucratic state, also conveys the impression of a chthonic return of the repressed on a mass scale.

It is arguable that this return is inevitable and that where, as in the circles of free intellectuals of the kind this paper has discussed, people have devoted their lives to the great adventure of discovering and giving form to such forces in their work and in their relations to each other, it is less likely to lead to disaster when it becomes a social force than where it has been generally rejected by a social order bent either on the preservation of endangered tradition or on the execution of a presumably rational Realpolitik. The cafe literati of Munich, for example, including former followers of Gross and Mühsam, who rallied to the Council Republic in 1919, were in no sense the precursors of the Nazi barbarism; but the *Freikorps* volunteers who slaughtered them by the dozens in the name of traditional values were. The rebellious youth of the 1960s, so often responsible for turning their universities upside down and for evoking sentiments of anguish among their teachers, nonetheless, by their experimentation with new art forms and new forms of community, gave America visions of an alternative culture and alternative values which might have pointed the way to a viable, peaceful and creative society. Certainly in conventional politics the resort to what are supposed to be the unsentimental principles of rational statecraft, the attempt to establish the mastery of goal-oriented Ego over unconscious impulse and conventional morality, was less than a smashing success, whether applied to the quagmire politics of Southeast Asia or the cities of North America. Rarely has such well-advertised restraint and calculated reasonableness been accompanied by such rivers of blood and storms of violence.

I am in no sense suggesting a return to the hairy ape as the solution to our problems, nor would I attempt to argue the correctness of Gross' theories. I must, however, insist that they merit more than the total oblivion in which they have been shrouded for half a century and that, in

general, a closer examination of the libidinally rebellious underside of German thought in the early decades of this century, in particular the celebration of sexuality, femininity and childhood, may not only provide important clues to the underlying malaise of their culture, but might give us some useful ideas to chew over while considering the less than inspiring countenance of our own.

Notes

[1]Helmut Kreuzer, *Die Boheme: Analyse und Dokumentation der intellektuellen Subkultur vom 19. Jakrhundert bis zur Gengenwart* (Stuttgart, 1971), pp. 42-60, 269-352; Ulrich Linse, *Organisierter Anarchismus im Deutschen Kaiserreich von 1871* (Berlin, 1969), pp. 79-116.

[2]Kreuzer, pp. 292-4. Georg Fuchs, "Ein Vorschlag zur Bekampfung der Socialdemokraten," *Die Aktion,* III:7 (Feb. 12, 1913), 199-201.

[3]The sources used in this study are principally of three sorts: a number of recent monographs have added much value to our understanding of the general evolution of and relationships between literary Expressionism, anarchism and Bohemian subcultures. I think particularly of the works of Walter Sokel, *The Writer In Extremis* (Stanford, 1959), Linse and Kreuzer. Secondly, there are biographies, autobiographical novels or memoirs, and the letters of those who know Gross and Jung. These include Marianne Weber's biography of Max Weber (*Max Weber En Lebensbild,* 1916), which discusses Gross' impact on Heidelberg society around 1907, Ernest Jones' *Free Associations* (1959), Frieda Lawrence's *Not I But the Wind,* and *Memoirs and Correspondence* (1964), Erich Mühsam's *Unpolitische Erinnerungen* (1958), Gustav Landauer, *Sein Lebensgang in Briefen* (2 vols., 1919), edited by Martin Buber; Franziska zu Reventlow's *Briefe* (1928) and *Tagebucher* (1971), Oscar Maria Graf's *Prisoners All* (1938), Leonhard Frank's *Links wo das Herz ist* (1967), Franz Jung's *Der Weg nach unten* (1961), Johannes R. Becher's *Abschied* (1965) (rather unreliable, but in his youth he did know Gross in Munich), Franz Werfel's *Barbara, oder die Frömmigkeit* (1919), and Raoul Hausmann's autobiographical fragment "Club Dada" in Paul Raabe, ed., *Expressionismus: Aufzeichnungen und Erinnerungen der Zeitgenossen* (1965). Finally, there is the literature from the period itself: Gross' few professional articles and brochures (only one of his works exceeded a hundred pages; the rest are article size); his rather more relevant articles in the periodicals of his day, published,

with the exception of two unimportant contributions to *Die Zukunft,* in the expressionist journals *Die Aktion, Die Freie Strasse* and *Die Erde,* and articles dealing directly or indirectly with him in Landauer's *Der Sozialist, Die Aktion, Die Revolution, Kain, Wiecker Bote, Die Freie Strasse* and *Die Erde,* all with the exception of *Der Sozialist,* expressionist journals with an anarchist outlook.

⁴Ernest Jones supplies one of the rare, explicit references to Otto Gross in English in his autobiography *Free Associations* (pp. 173–4), where he describes Gross (whom he encountered in Munich cafe on a trip to the continent in 1908) as "the nearest approach to the romantic ideal of a genius I have ever met." In fact Gross, by his informal on-the-spot analysis of his friends among the Schwabing bohemians, gave Jones his first experience of psychoanalytic practice. Leonhard Frank in his autobiographical novel *Links wo das Herz ist* (pp.19–80), discusses his encounter with Gross in the years 1906 to 1910 at greater length, for he met — and lost — his first love through Gross' mediation. Erich Mühsam, the anarchist essayist who was with Gustav Landauer and Ernst Toller, one of the leaders of the first Bavarian Council Republic in April 1919, also dated his acquaintance with Gross, whose influence he acknowledged, from about 1906 (see Mühsam's contribution to *Die Revolution,* Dec. 1913, 5 and his *Unpolitische Erinnerungen,* pp. 303, 150, 184, 195); and Franziska Grafin zu Reventlow, a well-known phenomenon of turn-of-the-century Schwabing, records her initial acquaintance with Gross in her diary for July 1907. Max Weber and Frieda Weekley — D.H. Lawrence's first wife — also recorded encounters with Gross in 1907.

⁵See Otto Gross, *Ueber psychopathische Minderwertigkeiten* (Wien and Leipzig, 1909), p. 115

⁶Cf. Muhsam, *Unpolitische Erinnerungen,* p. 17: "I recall an evening in the old Cafe Des Westens, at the artists' table, which was full. Writers, painters, scupltors, actors, musicians, with and without reputation, sat together: then Ernst von Wolzogen raised the question, who among us came to his life-style as an artist without conflict and in harmony with his family. It turned out that we were all, without a single exception, apostates from our heritage, black sheep."

⁷Cf. Gross, "Zur Ueberwindung der Kulturellen Krise," *Die Aktion,* III (April 2, 1913), 386; "Protest und Moral im Uberwindung der kulturellen Krise," *Die Erde* (Dec. 15, 1919), 681-685. A translation is published in *New German Critique,* No. 10 (Winter 1977), pp. 105-110.

⁸Probably the Munich cafe singer of that name. See Richard Seewald, "Im Cafe Stephanie," in Raabe, ed., *Expressionismus.* With the exception of Gross himself, who Frank refers to as Dr. Kreuz, all the other names of those Frank lists in his circle seem to be genuine.

[9]Frank, *Links*, pp. 12–16.

[10]*Ibid*, p. 80, also Reventlow's *Briefe* (1928), p. 184 (to Franz Hessel, dated April 1, 1911); and Gross' letter printed in *Die Zukunft*, 86 (Feb. 28, 1914), 305.

[11]Frank mentions one cure in June 1908 (p. 53), Ernest Jones refers to another in 1908 or 1909, and Gustav Landauer implies another in 1911 (*Lebensgang in Briefen*).

[12]Jones, *Free Associations*, p. 173f. Frank claims that Gross wrote a brilliant synthesis of his ideas in 1906 during one of his cocaine intoxications, had a hundred copies printed, and asked his wife to send a copy to a rival psychoanalyst who seems, by Frank's description, to have been Carl Jung. The other 99 copies were traded in by Gross' landlady as wrapping paper to a butcher in return for a pork cutlet, but Carl Jung, according to Frank, made more elegant use of Gross' brochure and, unbeknownst to the world of science, "built his teachings, which in some points deviated from Freud's, on the early insights and decisive points of his one-time opponent, Dr. Otto Kreuz" (Frank, *Links*, p. 54). One of the advantages of wrapping hamburger in psychoanalytic treatises is that this problem is unlikely ever to become the subject of learned controversy. There is no doubt, however, that Carl Jung found Gross' early work of 1902, "Über cerebrale Sekundarfunktion," important, for he built a chapter of his massive *Psychological Types* on this essay with high praise for the author. Freud, who "distributed references to other analysts' writings on the same principle as the emperor distributed decorations," (Rank according to Jones quoted by Paul Roazen in *Brother Animal: The Story of Freud and Tausk*, New York, 1969, p. 193), refers to another of Gross early articles in *Wit and the Unconscious* (1906).

[13]Largely through police spies: See Linse, *Organisierter Anarchismus* (Berlin, 1969), pp. 93–94, fn 81.

[14]Mühsam knew Gross and generally admired him as "Freud's most significant disciple," whose "ideas...on the significance of jealousy and the authoritarian character of the father-centered family came quite close to my own." Mühsam, *Unpolitische Erinnerungen* (Berlin, 1958), pp. 150, 303. Mühsam's friend and fellow-organizer, Johannes Nohl appears prominently in Frank's account of the Gross-circle, and he defended psychoanalysis against Landauer in the pages of *Der Sozialist*, though he may also have kept from total involvement in it. Fritz Klein probably participated in both groups, and on the basis of Jung's account, we may assume Karl Otten, Ernst Frick and Eduard Schiemann also did. Two other members of the Tat-group were connected to Gross and his ideas primarily though Franz Jung: Georg Schrimpf, an artist, and Oscar Maria Graf, then a very young ex-baker's apprentice, who soon was to have some success as an expressionist poet and novelist.

[15]Cf. Paul Avrich "The Legacy of Bakunin," *The Russian Review* (1970).

[16]Cf. Jung, *Der Weg nach unten,* Graf, *Prisoners All,* Mühsam, *Unpolitische Erinnerungen* Linse, *Organisierter Anarchismus.* This could be because Bakunin was so obviously the bete-noire of the German authorities that interest in him was considered unnecessarily provocative before 1918. It could also stem from the non-violent and reformist inclination of Landauer's and Mühsam's organization. Gross, who shows little sign of political sophistication in the few articles he wrote for a more general public, never mentions Bakunin, though two of his less sympathetic acquaintances attribute to fictional representations of Gross an almost sterotypically Bakunist fascination with the prospect of total destruction (Johannes R. Becher, *Abschied,* Wiesbaden, 1965, pp. 360. Franz Werfel, *Barbara, oder die Frömmigkeit,* Berlin, 1929, pp. 471-72.

[17]Frank saw Gross' cocaine habit as so debilitating in 1910 that he sems to have forgotten that Gross survived until 1919, and writes in his autobiographical novel that after Sophie's suicide, "Der Doktor ging bald danach am Kokain zugrunde." (*Links,* p. 80)

[18]Cf. F. Jung, *Der Weg nach unten,* pp. 71-73. The destructive results of intellectual independence for those of Freud's disciples not powerful enough to establish their own schools like Carl Jung and Alfred Adler, have been strikingly presented in Paul Roazen's *Brother Animal: The Story of Freud and Tausk* (New York, 1969).

[19]Mühsam, *Erinnerugen,* Curt Reiss, *Ascona* (1964), Marianne Weber, *Max Weber.*

[20]Jung, *Der Weg nach unten,* p. 72. Though Jung was not part of Gross' original Munich circle, he quickly joined Erich Mühsam's Tat-group, and probably because of the increasing congruence of Mühsam's and Gross' groups, he soon became acquainted with four adherents of Gross. In any case, he knew three as members of the Tat-group: Karl Otten, b. 1889, a poet and essayist; Ernst Frick, b. 1881, and Eduard Schiemann, b. 1885, both artists. Cf. Jung, p. 71, Linse, p. 94. Otten edited a two-volume anthology of expressionist literature in 1957, in which Gross is mentioned, in Otten's introduction, with Freud and Alfred Adler, as one of the founders and elaborators of psychoanalysis who influenced his generation (*Ahnung und Aufbruch: Expressionistische Prosa,* Darmstadt, 1957, p. 14). The fourth adherent of Gross mentioned by Jung was Leonard Frank, who had already broken with Gross by 1910. Jung (p. 74f.) also mentions Fritz Klein, Otten's roommate, who, other evidence indicates, was affiliated to the Tat-group and was the "Fritz" mentioned by Frank in the circle around Gross (Linse, p. 94, Frank, pp. 19, 119).

[21]On participation of Gross' adherents, see Jung, p. 72. On anarchist involvement, see Linse, p. 113.

[22]Graf was 17 or 18 at the time. (See Graf, *Prisoners All,* pp.

65-67). Jung did not think enough of Graf to mention him in his autobiography, but judging by Graf's description of Jung in *Prisoners All*, and by the participation of Graf and his artist friend Schrimpf in the journal edited by Jung in 1915 and 1916, *Die Freie Strasse*, we can infer a certain dependency of Graf and Schrimpf on the more experienced Jung dating back to their common involvement in the Tat-group (Graf, pp. 108–10, 187–90). Graf writes that Jung rejected his contributions to *Die Freie Strasse* with such ill-tempered notes as "Send the product of your unequaled stupidity and your sexual repression elsewhere. We have nothing in common"; but the first issue of *Die Freie Strasse* (1915) does contain an autobiographical story by Graf, and one of his poems appears in the third.

[23]Jung, pp. 78–82

[24]Johannes Nohl, "Fichtes Reden an die deutshce Nation und Landauer's Aufruf zum Sozialismus,"*Der Sozialist (May 15, 1911), 84; Landauer, "Ausrufe," Soz.* (July 1, 1911); Ludwig Berndl, "Einige Bemerkungen uber die Psychoanalyse," *Soz.* (July 1, 1911).

[25]Gustav Landauer, *Sein Lebensgang in Briefen;* Letters to Buber of Sept. 1 and Sept. 18, 1911, pp. 381-84. Landauer's assertion that Gross wrote his reply "in irgendeiner Nervenanstalt" is indirectly confirmed by Franz Jung in *Die Revolution* (Dec. 20, 1913). Landauer's grudge against Gross, apart from a general aversion to Gross' rejection of monogamy, arose from Gross' attempt to prevent Margarete Fass-Hardegger, a close friend and associate of Landauer, from removing her daughter from his care. In Landauer's *Lebensgang in Briefen*, we discover that she is the parent Gross referred to in his article in *Die Zukunft* of Oct. 10, 1908 ("Elterngewalt," 78–80). Landauer's "Von der Ehe" (*Der Sozialist*, Oct. l, 1910 and *Der werdende Mensche*, Potsdam, 1921, pp. 56–69) contains a general argument against the use of matriarchal theory to justify free love and the dissolution of the family. For a brief description of German anarchist attitudes toward free love, see Linse, pp. 97–98.

[26]*Die Aktion* (April 16, 1913).

[27]Jung, pp. 88f. Gross had left his wife in Ascona, where she lived with her child and the Swiss anarchist Karl, known to us from Leonhard Frank's book. See Marianne Weber, *Max Weber*, pp. 494–502.

[28]See Richard Öhring, *Wiecker Bote* (March 1914). To strengthen the hands of the police, Hans Gross further alleged, in Franz Jung's words, "that his son has fallen into the hands of dangerous anarchist elements, presumably a band of extortionists who will use earlier investigations of Otto Gross on homosexuality to blackmail him — the father." (Jung p. 89).

[29]Graf, p. 109, Jung p. 94.

[30]Ludwig Rubiner in *Die Revolution*, 5 (Dec. 20, 1913), 2.

[31]For a discussion of the expressionist literature embodying this theme see Sokel, *The Writer*. The most obvious possibility was Walter Hasenclever's *Der Sohn,* the first important expressionist drama, written, according to its author, in the fall of 1913.

[32]Jung. p. 91.

[33]See Werfel's autobiographical novel, *Barbara, oder die Frommigkeit* (1929).

[34]I have only been able to examine the first and sixth numbers of *Die Freie Strasse*, both edited by Jung; but this is also the impression received by Jung's friend Graf, living in Munich at the time and one of the contributors. See his *Prisoners All*, pp. 188–89. According to Jung, publication was assisted by Franz Pfemfert, and much of the editorial work was done by Clare Öhring, then living with Jung. See *Der Weg nach unten*, p. 109.

[35]Cf. Jung, pp. 99–102; Graf, pp. 135–66. Indeed two future collaborators of Jung in the Dada movement, Georg Grosz and Johannes Baader were also dismissed from the army for psychiatric reasons (Jung, pp. 101–111). At least three other prominent Expressionists left the army for psychiatic reasons during World War I: Kurt Hiller (cf. Hiller's *Leben gegen die Zeit,* pp. 76-78); Jakob van Hoddis (*ibid.,* p. 85) and Ernst Toller (Sokel, *The Writer,* p. 182). Given this considerable presence of certified madmen among the Expressionists, it is not likely that Gross' repeated institutionalization for narcotic addiction prejudiced many people against him during his final surge of influence at the war's end.

[36]I follow Linse's summary, p. 103.

[37]Linse, p. 106

[38]Gross, *Ueber psychopathische Minderwertigkeiten*, pp. 49–52.

[39]*Ibid.,* pp. 117–18.

[40]*Ibid.,* pp. 53–54.

[41]The central importance in Gross' theory of the arguments above until at least 1914 is established by the fact that most of the eight pages in which it appeared were reprinted, with insignificant excisions, as an article in *Die Aktion*, shortly after Gross' arrest and institutionalization in 1913, presumably to represent his most important ideas. (The likelihood is that Franz Jung did the excerpting and arranged, through Pfemfert, for its publication.) See Gross, "Die Einwirking der Allgemeinheit auf das Individuum," *Die Aktion* (Nov. 22, 1913).

[42]*Drei Aufsätze uber den inneren Knoflikt*, a scant 39 pages, was published in 1920, the year after Gross' death. The argument for its prewar composition rests on the lack of any clear reference to World War I or to literature published after 1913. On the other hand, the references to Alfred Adler appear in

none of Gross' prewar writings; the treatment of homosexuality in the second part of the first essay "Ueber Konflikt und Beziehung" seems considerably more developed than the discussion in Gross' "Anmerkingen zu einer neuen Ethik," published in *Die Aktion* (Dec. 6, 1913), as his most recent work on the subject. The reference to Stekel's *Onanie und Homosexualitat* as "Das Meisterwerk" (p. 18) is probably to Stekel's book of 1917 rather than his essay of 1913. And there is a close line of continuity between the ideas in the *Drei Aufsätze* and his clearly very late essay "Protest und Moral im Unbewusstsein" (posthumously published in *Die Erde*, Dec. 15, 1919).

[43]*Drie Aufsätze*, p. 4

[44]E.g. Kate Millett, *Sexual Politics* (New York, 1969).

[45]Gross, *Drei Aufsätze*, p. 16.

[46]Cf. Franz Jung: "For me, Otto Gross signified the experience of a first and great, deep friendship; I would have unhesitatingly sacrificed myself for him . . . For Gross himself, I was perhaps no more than a figure on the chessboard of his intellectual combinations, which could be moved back and forth," *Der Weg nach unten*, p. 91.

[47]*Die Erde* (1919).

[48]Hans G. Helms, in his massive work on Stirnerian influence, *Die Ideologie der anonymen Gesellschaft* (1966), falsely reckons Hausmann to the Stirnerian camp on the basis of his "Pamphlet gegen die Weimarische Lebensauffassung" published in Anselm Ruest's *Der Einzige* in 1919. Hausmann accused Ruest of altering his article to make it conform to Stirnerian views in his "Der individualistische Anarchist und die Diktatur" (*Die Erde*, May 1, 1919, p. 276) and he fiercely denounced Stirner in his "Schnitt durch die Zeit" (*Die Erde*, Oct. 1, 1919, p. 542).

[49]Raoul Hausmann, "Schnitt durch die Zeit," *Die Erde* (Oct. 1, 1919), 542–43.

[50]Raoul Hausmann, "Zur Weltrevolution," *Die Erde* (June 15, 1919), 368.

[51]For a discussion of the KAPD and Jung's role in it, see Hans Manfred Bok, *Syndikalismus und Linkskommunismus von 1918–1923* (Meisenheim a.d. Glan, 1919), pp. 225-62.

[52]Franz Jung, "Zweck und Mittel im Klassenkampf, *Die Erde* (August 1, 1919).

[53]*Ibid.*, 428–29.

[54]Cf. H. Stuart Hughes, *Consciousness and Society* (1958), passim, and Carl Schorske, "Politics and the Psyche in fin-de-siecle Vienna: Schnitzler and Hofmannsthal," *American Historical Review*, 66 (July 1961), 930–46.

[55]H.E. Schröder, *Ludwig Klages: Die Geschichte seines Lebens. Erster Teil. Die Jugend* (1966), pp. 163–64. On Klages' and Schuler's use of Bachofen, see pp. 225, 230, 235, 237.

4
Sublime Ambition: Art, Politics and Ethical Idealism in the Cultural Journals of German Expressionism

Barbara Drygulski Wright

When we think of German Expressionism today, we are most likely to associate it with extraordinary innovation in the visual arts, startling lyric poetry and experimental drama. But studying these phenomena alone does not tell us very much about the common impulses from which they sprang or the higher mission they were all intended to serve. There are other dimensions to Expressionism beyond the popular appreciation of the movement's artistic or literary accomplishments, dimensions accessible only though the movement's journals and magazines. Like their cousins, the rebellious "little magazines" of England, France and the U.S.,[1] expressionist journals endured small circulation, limited capital and an uncertain future in order to champion an aggressively avant-garde aesthetic. Like the "little magazines," they formed the nucleus for an important artistic movement. And like those other "mayflies of the literary world,"[2] these journals — some 100 of them were published between the years 1910 and 1920[3] — were spawned and perished at a dizzying rate. But German periodicals turned their attention to political and social

issues earlier than most of those other publications, and for reasons unique to German intellectual history.

Throughout the expressionist movement, these periodicals function-ed as far more than mere proving grounds for the "real" artists and poets who graduated from their pages to reputable publishers and international exhibitions.[4] Year after year, in editorials, "glosses" and social commen-taries, in manifestoes, programs and polemics, these journals registered not only Expressionism's aesthetic credos, but its social and political am-bitions as well. The bulk of their pages was filled not with poetry and graphics, but with critical essays and other non-fiction prose. Much of this material was tortured, filled with revolutionary pathos and difficult to categorize — and while the essay did not really encourage such excess, it could accommodate it. As an "open" form, (etymologically not a polished jewel but an "attempt") the essay offered a flexibility which was most con-genial to expressionist thinking. The essay provided a vehicle through which the author could discover and experience his own subjectivity; yet at the same time it embodied a critical stance toward problems of the day: "a kind of higher relevance," as Fritz Martini calls it.[5] And that — defining and communicating their sense of "higher relevance" — was what expressionist periodicals were all about.

Expressionism, we have to remember, most emphatically did not view itself simply as an artistic movement — nor as a political one, either. Rather, it was the search for something more encompassing — and more intangible: a new reality, "a new sense of life"[6] and a new ethics of humanity. Most expressionist theorists rejected not only "art for art's sake" but also "politics for politics sake"[7] and then defined "true" art and "true" politics as overlapping subcategories of a philosophical ideal — "the ethical." Thus the essays, reviews, commentaries and other prose published weekly in expressionist magazines were certainly "relevant" — but on a vehemently "higher" plane. It was in pursuit of an elusive transcendental ideal, ultimately, that Expressionism's mayflies swarmed and sank away.

The poignancy of that inner contradiction cannot help but touch and intrigue us, even today. Sympathizers and critics of Expressionism alike, we find ourselves heir to a knotty complex of issues and implications, for expressionist thinking posited an intricate web of relationships between philosophy and politics, ethics and art, the artistic-intellectual communi-ty and society at large. The interplay of those issues in the pages of the movement's cultural journals lent German Expressionism its unique *Gestalt* — and at the same time short-circuited the movement's extra-aesthetic ambitions. In the following pages I would like to clarify those relationships, show their influence on several representative expressionist intellectuals, and, finally, suggest reasons why expressionist "politics" — in sharp contrast to expressionist art — was such a resounding failure. My own "attempt," however critical it is, thus builds on theirs.

German Expressionism was born in a spirit of conscious opposition, and the movement suffered no dearth of artistic, literary, social or

political trends to oppose. Reacting against the value-free sensibility of Impressionism and the surrender to "nature" implicit in Naturalism,[8] rejecting the materialism of modern science and the blatant self-interest of capitalism, yet bitterly critical of the Social Democratic Party, Expressionism confessed to a fervent ethical idealism which was unique, but not wholly without tradition or precedent. The expressionist passion to develop a distinctly ethical, socially-relevant aesthetic, while new in artistic circles, had in fact been anticipated and prepared to a large extent by the German Neo-Kantian revival around the turn of the century.[9] The task philosophers set themselves then was to find some underlying unity between what appeared increasingly as two utterly antithetical kinds of knowledge: the objective knowledge of empirical objects or scientific laws, and the subjective knowledge of ethical values. In the ranks of the expressionist movement, only a few years later, there were literally dozens who had received formal training in philosophy,[10] not to mention the countless others who became acquainted with contemporary problems in philosophy at second or third hand. Wearied and depressed by the role of perpetual pariah, yet inspired by Heinrich Mann's call for a rapprochement between Germany's "great men" and their society,[11] expressionist intellectuals attempted to fuse art and politics into a unity analogous to the one philosophers sought.

Within the Neo-Kantian revival, two major trends could be distinguished: a critical wing and a more speculative Idealist tendency. The critical wing was identified chiefly with the Marburg school, represented by Hermann Cohen and Paul Natorp; the Idealist branch, known as the Baden or Southwest German school, was founded by Wilhelm Windelband and Heinrich Rickert.[12] In the decades following 1890, these philosophies promised educated upper-middle-class Germans, along almost the entire spectrum of German politics, a last intellectual and ethical bulwark against the threatening aspects of modern life. Marburg Neo-Kantianism, for example, exerted a strong influence on socialist thought,[13] and in particular on the social revisionists led by Eduard Bernstein,[14] as well as on *völkisch* thinkers[15] and utopian socialists.[16] Fritz Ringer, in his book on German "mandarin" ideology between 1890 and 1933, demonstrates the close connections which existed between the German Idealist tradition in philosophy on the one hand, and notions of political legitimacy, the mission of *Wissenschaft,* cultural values and personal cultivation on the other.[17] As the school philosophy of German academe, Neo-Kantianism in one form or another permeated other subject matters as well — religion, education and law,[18] for example — and from there trickled into the popular consciousness in newspaper or magazine articles on such topics as the *Wandervogel* movement or feminism. So ubiquitous, in fact, is this filtered neo-Kantian influence, so seemingly self-evident its assumptions, so without distance from this conceptual apparatus are its practitioners, that it is hardly surprising the approach itself was seldom identified or questioned.

Expressionists, too, served themselves from this Neo-Kantian smorgasbord and produced their own characteristic mix of parallels and variations. The Marburg Neo-Kantians Cohen and Natorp had emphasized social responsibility and the inter-relatedness of ethics, politics and the human community — themes which complemented the expressionist concern for suffering humanity.[19] Under ethics, both Expressionists and Neo-Kantians understood something very similar: the reconciling of individual freedom with the requirements of the community — its highest goal and guiding "idea" was to place the ethical individual in harmony with the just society. Both groups insisted upon the need for a connection between ethics and action in the world, and both shared the same quarrel with Marxism: society could never be reorganized into a just human community "from the bottom up," from a material basis; only "from the top down," under the influence of an ethical ideal, could desirable change be effected, and the change must begin in the individual human consciousness, not in mass movements. The Marburgers' dynamic, functional conception of knowledge and their emphasis on relationships rather than specific contents profoundly shaped the expressionist perception of reality, as did the Neo-Kantian conviction of the dominance of thought over being, according to which the laws of knowledge actually shaped reality.

Yet at the same time Expressionists rejected the "critical" aspect of this critical Idealism, refusing to accept the notion that all knowledge was only relative. Instead, Expressionists clung to the hope that absolutes could be discovered via a different path, perhaps an irrational or affective one. Moreover, the Marburg Neo-Kantians posited a monistic interrelationship between all levels of pure reason, practical reason and will, which appeared to border on materialism. This suspicion seemed confirmed by Cohen and Natorp's sympathy toward the SPD. Expressionist theorists opted instead for a Hegelian distinction between *Verstand* and *Vernunft* and a clear subordination of nature to spirit. But in this way they severed the methodological connection which the Neo-Kantians had labored to establish between philosophy and the external world, between "pure" ethics and "applied" ethics, i.e. "politics." It was precisely the Marburg school of Neo-Kantianism, with its critical method and emphasis on "facts," which maintained the closest connection between philosophizing and political reform.[20] Yet for all their insistence upon the political responsibility of the artist or writer, paradoxically it was not Marburg Neo-Kantianism which exercised the greatest appeal for expressionist intellectuals.

The ethical Idealism of the Baden or Southwest German school of Neo-Kantianism, with its dualistic distinction between empirical phenomena on the one hand and cultural or humanistic disciplines on the other, corresponded far more accurately to the expressionists' experience of the world, their alienation from polite society, hostility toward nature and distrust of scientific reason, than did the Marburgers' insistence upon their unity. In ethical Idealism, the central issue was not the connection

between ethics and society, but rather the connection between ethics and culture. For Badeners like Wilhelm Windelband and Heinrich Rickert, basic values such as the good, the true, the beautiful and the holy, together with their normative force in the human soul, were fundamentally different from — and incompatible with — the laws of natural causality or man's intellectual perception of nature. The parallel which ethical Idealists drew between ethical values and cultural phenomena served to devalue the material world and harmonized with the expressionsts' own view of themselves as sovereign creators of culture independent of the material world. Through the dynamic *Tathandlung* Expressionism would retain the priority of form, function and relationship over mere objective content without sacrificing ideal absolutes, as the Marburgers appeared to have done. The notion of individual participation in immanent consciousness allowed at one and the same time for both intense personal subjectivity and for its elevation into a higher reality. Finally, the concept of a perpetual dialectical synthesis between the specific and the general, the subjectification of the objective world and the objectification of the subjective, suggested the possibility of "politics" on the very highest spiritual level — the only level upon which most Expressionists were interested in pursuing politics at all.

This fusion of cultural Idealism with Hegelian dynamism and the Fichtean moral choice could be applied to the Expressionists' role as creative artists with particularly gratifying results. If, as the Baden Neo-Kantians maintained, the study of history, literature and art and the judging of such cultural phenomena could lead directly to the perception of ethical values and thus enrich the soul of the student, how much more ethical must be the active *creation* of such cultural objects. Since the artist must create culture before others could be edified by it, he necessarily must commune more directly with the transcendental than other human beings. Consequently his art offered not merely mimesis but symbolic representation of the metaphysical and could not be judged by its conformity to nature or according to pragmatic criteria, any more than the metaphysical itself could. The expressionist artist could view himself as nothing less than the instrument of the absolute spirit or absolute will transforming itself into reality.

Thus the creative intellect could serve as the indispensible link between the empirical and the transcendental, the key to ethics, culture and society — and the catalyst for politics and revolution. Was not, after all, the act of artistic creation the supreme *Tathandlung,* and one's choice of the *kind* of art and culture one created the supreme ethical choice? Conversely, if the values of the prevailing culture proved wanting, was it not precisely the artist who must create alternative cultural artifacts as an expression of alternative values? From the expressionist perspective it was the unique responsibility of the artist under such circumstances, by offering these alternative values to the *Volk,* to revolutionize culture and society thoroughly and "from the top down," in accordance with an overriding

ethical ideal. But, before he could change the world, it was imperative for the creative artist first to change his own spirit and then the quality of his art. There was a definite order of priorities, and even for the most dedicated of activists, politics did not come first.

Expressionists believed it was as artist, poet or intellectual that the individual achieved the most direct and powerful transformation of consciousness into pure activity independent of objects. "Objectless" activity was activity untainted by "contents" or meanings which would refer back to the material world and thus limit the force or contaminate the purity of that activity. Pure activity signified the absence of error, for error was a function only of matter, never of spirit, in the expressionist view. And pure activity enjoyed absolute ethical validity as well. Thus when pure activity encountered the limitations, errors and depravity of the material world, the result, according to expressionist manifestoes, could only be destruction in the interests of a higher good through the agency of the artist: his higher level of consciousness became identical with pure activity, as pure activity it *must* manifest itself, and *could* manifest itself by definition only in correct and ethical ways. In other words, both exponents of pure activity — the artist/intellectual and the work of art or literature which he created — became vehicles for radical political change.

Expressionist essayists, writing in the journals of the movement, never tired of emphasizing that this new understanding of politics was not to be confused with the banality or practical actions of party politics. Instead they developed a highly rarified definition of politics as an activity in which *only* artists and intellectuals *as* artists and intellectuals could participate. Since "artist" or "writer" hardly seemed an adequate title for this newly discovered function, many Expressionists experimented with new epithets: "politician of the spirit," "Literat" or "Politerat." As these hybrid terms suggest, it is false and misleading to draw a rigid distinction between "true" Expressionists and "mere" activists, between artistic and political wings of the movement. Obviously the many members of the movement varied in the stress they placed on one aspect or the other; but it was fundamental to the expressionist view that these aspects were inseparably interrelated. Only one question divided them, essentially: whether it was not entirely sufficient to simply *be* an artist, or whether one need demonstrate that calling publicly. So-called activists claimed one should, while other Expressionists feared public involvement would compromise their ethical purity — and that in turn would lessen their power as spiritual revolutionaries. In other words, they debated maximum effectiveness, not the goal itself.[21] Moreover, the distinction turned out to be more academic than real, for with a few notable exceptions the "activists" never did in fact play a significant political role. In any case, the result of the expressionist redefinition of politics was not the politicization of art, but rather the aestheticization of politics.[22]

The interplay between philosphy and politics, between ethics, art and external society which I have just outlined becomes most readily apparent when

we turn to the pronouncements of such self-styled activists as Ludwig Rubiner and Kurt Hiller, though it was by no means limited to them — or to "activism." Ludwig Rubiner was one of Franz Pfemfert's oldest, closest and most highly valued collaborators. His manifestoes and essays appeared at regular intervals in *Die Aktion,* and in 1918 Pfemfert publicly endorsed

Umfang acht Seiten Einzelbezug 40 Pfennig

DER STURM

WOCHENSCHRIFT FÜR KULTUR UND DIE KÜNSTE

Redaktion und Verlag Berlin W 9 / Potsdamer Straße 134 a	Herausgeber und Schriftleiter HERWARTH WALDEN	Ausstellungsräume Berlin W / Königin Augustastr. 51

DRITTER JAHRGANG	BERLIN MÄRZ 1913	NUMMER 150/151

Inhalt: Für Kandinsky / Ein Protest / F. T. Marinetti: Supplement zum technischen Manifest der futuristischen Literatur / Alfred Döblin: Futuristische Worttechnik / Offener Brief an F. T. Marinetti / Günther Mürr: Gedichte / Guillaume Apollinaire: Pariser Brief / André Rouveyre: Fünf Originalzeichnungen

Für Kandinsky

Protest

Das „Hamburger Fremdenblatt" vom 15. Februar 1913 veröffentlicht folgende Kritik:
Kandinsky
Zur Ausstellung bei Louis Bock & Sohn, Hamburg
„ Bei Louis Bock & Sohn hat wieder einmal einer jener unglückseligen Monomanen ausgestellt, die sich für die Propheten einer neuen Malkunst halten. Wir sind schon mehrfach mit guten ästhetischen Gründen gegen die unsinnige Theorie dieser Leute und gegen ihre ganze Pfuscherei zu Felde gezogen, daß wir heute diesen Russen Kandinsky rasch und ohne Aufregung erledigen können.
Wenn man vor dem greulichen Farbengesudel und Liniengestammel im Oberlichtsaal bei Bock steht, weiß man zunächst nicht, was man mehr bewundern soll: die überlebensgroße Arroganz, mit der Herr Kandinsky beansprucht, daß man seine Pfuscherei ernst nimmt, die unsympathische Frechheit, mit der die Gesellen vom „Sturm", die Protektoren dieser Ausstellung, diese verwilderte Malerei als Offenbarungen einer neuen und zukunftsreichen Kunst propagieren, oder den verwerflichen Sensationshunger des Kunsthändlers, der seine Räume für diesen Farben- und Formenwahnsinn hergibt. Schließlich aber siegt das Bedauern mit der irren, also unverantwortlichen Malerseele, die, wie ein paar frühere Bilder erweisen, vor der Verdüsterung schöne und edle malerische Formen schaffen konnte: gleichzeitig empfindet man diese Genugtuung, daß diese Sorte von Kunst endlich an den Punkt gelangt ist, wo sie sich glatt als den Ismus offenbart, bei dem sie notwendig landen und stranden mußte, als den Idiotismus.
Man wird vielleicht finden, daß seien harte und ungerechte Worte. Ich finde, es sind die einzig möglichen. Der Versuch einer ernsthaften Kritik würde in diesem Falle, meine ich, ein bedenkliches Licht auf den Kritiker werfen. Die bloße Konstatierung der Existenz einer solchen Pseudokunst ist eigentlich schon zu viel.

Kurt Küchler

Den letzten Teil dieser Kritik lasse ich fort, weil er wesentlich neue Beschimpfungen nicht mehr bringt. Herr Kurt Küchler braucht nicht widerlegt zu werden. Man ist auch weniger empört über die Dreistigkeit eines Possenautors, als über die Tatsache, daß einem Unwissenden von einer großen Tageszeitung die Gelegenheit gegeben wird, sich an dem hochbedeutenden Künstler Kandinsky so zu vergreifen. Dieser Protest richtet sich innerlich mehr gegen den Mißbrauch, daß solche Leute auf Künstler losgelassen werden. Dieser Protest soll aber zugleich für Kandinsky eine Ehrung bedeuten und ihm zeigen, welche Achtung und Anerkennung seine Kunst bei künstlerischen Menschen findet. Ich bewundere ihn und sein Werk.

H. W.

Dr. Heinz Braune / K. B. Direktion der Staatlichen Galerien

... Immerhin bin ich der Meinung, daß durch solche Art von „Kritiken", mehr der Schreiber gebrandmarkt wird, als der Künstler. Wer mit Kot wirft, beschmutzt zunächst sicher seine eigenen Hände; der andere aber wird gewöhnlich so wenig getroffen, wie in diesem Fall Kandinsky, dessen lauteres, ernstes und unerschrockenes Vorwärtsstreben dadurch nicht zu irritieren sein wird.
Aus einem Schreiben an den Herausgeber der Zeitschrift

Richard Dehmel

Sehr geehrter Herr Walden
Wenn ich gegen die Dummheit des Federviehs jedesmal „etwas schreiben" wollte, wäre ich längst am Schreibkrampf verreckt. Lassen Sie dieses Kurt Küchlein doch piepsen; für solche Hühnergehirnchen zerbricht sich Kandinsky wohl nicht den Kopf.

Besten Gruß
Dehmel

Karl Ernst Osthaus

Museum Folkwang / Hagen i/W
Es verlohnt wohl nicht auf die Ausführungen des Herrn Küchler näher einzugehen. Die Tatsache, daß sich Arbeiten von Kandinsky im Folkwang-Museum befinden, wird Ihnen zur Genüge sagen, was ich von dem Künstler halte.

Hochachtungsvoll
Museum Folkwang
Hagen i/W
Osthaus

W. Steenhoff Stellvertreter Direktor des Reichsmuseums zu Amsterdam

Sehr geehrter Herr
Ich ließ Ihnen ein Exemplar meines Essays über Kandinsky in der Zeitschrift „De Amsterdammer, Weekblad voor Nederland" zusenden. In einigen Tagen erscheint eine zweite Besprechung dieses sehr bedeutenden modernen Malers in der Wochenschrift „de Ploeg", herausgegeben von der Wereldbibliotheek, Amsterdam. Ich höre, daß Albert Verwey, einer der ersten holländischen Autoren in der Wochenschrift „de Beweging" ein Gedicht über Kandinsky veröffentlicht. Uebrigens ist Kandinsky auch hier viel durch die Kritiker beschimpft worden. Aber was macht das!

Hochachtungsvoll
W. Steenhoff

Swarzensky

Der Direktor des Städelschen Kunst-Institutes / Frankfurt am Main
Sehr geehrter Herr
Wir leben in einer Zeit, wo jeder alles sagen kann; so ist also ganz selbstverständlich, daß Ansichten jeder Art gedruckt werden und ganz zwecklos, dagegen mit dem gleichen Mittel einer öffentlichen literarischen Gegenäußerung zu protestieren.
Empörend finde ich nur, daß es möglich ist, daß jemand, der berufsmäßig in einer angesehenen Zeitung Kritiken schreibt, eine derartige Expektoration als Kritik herausgibt, -- daß er die Sache, die er beurteilen soll in Grund und Boden verdonnert und dabei ungeniert eingesteht, daß er von den „Versuch einer ernsthaften Kritik" absieht, — ohne seine Ansicht als eine rein sachliche Äußerung zu charakterisieren. Ich kenne die Persönlichkeit des „Kritikers" nicht, und weiß deshalb nicht, ob und inwieweit diese seine rein persönliche Meinung als solche Ihre Entrüstung rechtt-

Rubiner's views, specifically identifying himself and his publication with them.[23] The prestige Rubiner enjoyed in this circle, together with the publication of his prose works under the title *Der Mensch in der Mitte*,[24] served to make him one of the most prominent and influential "Politerati" of the entire movement. Thus Rubiner provides a convenient point of departure for closer analysis and a useful reference when we proceed from him to other activists and to the Expressionists of the *Sturm* circle.

Born in Berlin in 1882, Rubiner began to publish at the onset of the expressionist movement in Alfred Kerr's *Pan,* which Wolfgang Rothe considers an "activist" organ,[25] as well as in Herwarth Walden's *Sturm* — undeniably one of the most significant periodicals of the movement, but one which Rothe excludes from his list of activist publications. Later Rubiner appeared with even greater frequency in the pages of *Die Aktion,* as well as in *Das Ziel, Tätiger Geist* and *Zeit-Echo,* which he edited during 1916. Though he is usually viewed as a textbook example of expressionist activist, his case clearly demonstrates the close relationship between activism and more purely artistic aspects of the movement.

The basic problem of alienation from objective reality, which Rubiner raised in 1910 in *Der Sturm*,[26] continued to occupy him in later, more explicitly "political" essays. Like other Expressionists, Rubiner unconditionally rejected the notion of "development" or "progress" in any material form: in science, technology or civilization, "progress" could signify only quantitative change, that is, a change in empirical reality; but never a truly qualitative change in human consciousness. But in what, then, did "politics" consist for him? Rubiner offered a number of definitions of "politics" and "things political" in his many essays, none of which, examined individually, is particularly illuminating.[27] Taken together, they reveal that for Rubiner politics was the expression of a sheer will to change the world for the better, quite apart from any specific blueprint for the new world which must emerge from that change. Similarly, his definition of the politician was kept quite abstract: the politician was above all "one who wills" and "one who demands," "acting, changing things . . . directly."[28] At the same time Rubiner lamented the lack of abstraction from individual identities or interests in his contemporaries: "We are still class conscious. We are economists, exploiters, the exploited; we believe in progress and invent symbols of the future. We are still heirs to the past. We are not yet politicians."[29] Obviously, Rubiner was not talking about politics as it is ordinarily understood or practiced; in his view, "the 'politics of the state' is just one special case in the domain of manifestations of the will in the world, i.e. in the domain of 'the political.'"[30]

Possibly the clearest passage on object-less politics and its relationship to ethics can be found in Rubiner's essay "The Poet Reaches Into Politics." There he wrote: "Politics is the public manifestation of our ethical intentions,"[31] and this emphasis on the ultimately ethical purposes which politics supposedly serves does not pose any particular difficulties as yet. More puzzling is Rubiner's definition of what, in turn, is "ethical": "I

know that there is only one ethical goal in life: intensity."[32] The reader, who expects some*thing* which might be designated "ethical," such as pacifism or brotherly love, personal freedom or equal distribution of wealth, is understandably confused. How can "intensity" alone be ethical, one wonders, when its correctness or incorrectness, its ethical worth, in other words, is dependent upon the activity or object to which it is joined? Intensity is ordinarily viewed as a qualifier of values, activities or psychic states, but not as a value in itself. What Rubiner had done was to subtract the concrete and specific object and leave the qualifier alone with nothing to qualify, in effect *creating an abstraction* of an emotive-cognitive process in consciousness. Rubiner formulated an abstract notion of politics as a state of intense consciousness, quite apart from any situation or principle, any conceivable object, in connection with which this intensity might manifest itself. For Rubiner, obviously, the important thing was the form or abstraction, "how" and not "what," and that is why his political manifestoes and declarations, like those of other Expressionists, yield little or nothing in terms of tangible issues. This non-committal abstractness also explains to some extent how Expressionism's political zeal could later flow in so many contradictory directions, from anarchism and revolutionary socialism to Fascism.

For Rubiner, intensity was *Geist,*[33] that mysterious spark of the transcendental. In his "Letter to a Revolutionary,"[34] Rubiner explained why he was attracted to the phrase *freier Geist* or "free spirit" as a kind of political slogan. It appealed to him not because it "said something" but precisely because it didn't: because it was "trite," "an utterly hackneyed expression," "which no longer holds any meaning for anyone."[35] As a meaningless and tautological catchword, *freier Geist* became self-defining, totally identified with the dynamic qualities with which Rubiner invested the phrase — "decision," "destruction," "transformation. . . into ultimate purpose"[36] — without diluting that activity through reference to external objects or meanings. *Freier Geist* did not *have* meaning; rather, it *was* meaning. In this way it could become a chiffre for Rubiner's notion of political activity: "At the moment when an act still signifies something," he wrote, "it has lost its driving force."[37] For "signification" indicated an alienation of the activity from its own immanent "meaning," a diminution of intensity and thus loss of ethical value. Intensity assumed absolute ethical primacy: it stood as an unqualifed good which admitted of no discussion or closer examination but rather was apodictically "evident" to the individual of proper spiritual disposition and knowledge. But while the "abstract" expression of *Geist* was regarded as an absolute good, the negative results to which the expression of *Geist* on the level of empirical reality could lead were accepted quite relativistically as necessary evils. Thus Rubiner maintained: "When we act, we often do wrong. It is a mistake to keep from acting for that reason. By not acting, by remaining isolated, we commit a far greater wrong."[38]

In discussing expressionist artists and their works, Rubiner repeatedly emphasized the same themes: the extraordinary intensity, will and

dynamic activity which the artist embodied, his unity with his own consciousness, and his unique ability to transmute all those qualities into an artistic or literary work, thus releasing "ethical energy"[39] into the phenomenal world. In addition, Rubiner continually sought new formulations for the "object-less" quality of the artist as well as his creation. The expressionist artist, refusing to become the object of surrounding reality, remained uninfluenced and uncorrupted by it.[40] Out of this primal purity the artist as "prophet" or "visionary" created "new worlds" on a spiritual plane. Supposedly the mere attempt to create spiritual dimensions was sufficient to "explode" the empirical world and disrupt the balance of power, thus making the artist a "politician." The traditional artist, on the other hand, was said to demonstrate a "capitalist" attitude toward the world, attempting to take possession of and exploit material phenomena through his representations of them.[41] For Rubiner, the ultimate accomplishment of true "creation," as opposed to mere "art" or "literature," was portrayal of "the jolting of human will by an event which is *higher* than the physical, one which is *utterly independent of the material world.*" (emphasis mine).[42]

Though there were important differences in personal style, Kurt Hiller's understanding of key problems — the nature of the "true" artist, the relationship of art and politics to ethics and the function of *Geist* — was remarkably similar to Rubiner's. Whereas Rubiner's language tended to become mystically solipsistic, Hiller affected a highly mannered and jargony idiom, using his training in philosophy to create elaborate explanations for his views. While Rubiner eschewed vitually all tangible issues, Hiller at least dabbled in issues, talked of founding a party and ultimately tried to put his ideas into practice, however unsuccessfully, as chairman of the Berlin *Rat geistiger Arbeiter* in 1918 and as founder of the *Deutsche Friedensgesellschaft* in 1920. He was involved from its inception in the activist wing of Expressionism, founding *Der neue Club* in 1909 and *Gnu* in 1911, as well as working with Pfemfert on *Der Demokrat* and contributing to early issues of *Die Aktion*. However in 1913 Pfemfert broke publicly with Hiller, repudiating his theory of an "aristocracy of the spirit" even before it had blossomed into full-scale "logocracy."[43] The break with Pfemfert, which at least on Pfemfert's side appeared to be deeply felt and irreversible, did not prevent Hiller from publishing as essay by Rubiner in the first volume of Hiller's *Zieljahrbücher*[44] or from endorsing Rubiner's *Mensch in der Mitte* in glowing terms. Though he, like Rubiner, wished to address the problem of the distance which separated and isolated the German intelligentsia from the nation's political concerns, he was loath to introduce intellectuals into the same political institutions in which other members of society participated. Instead, like Rubiner, Hiller tailored a highly idiosyncratic definition of the "highest" and "truest" form of politics to fit himself and his colleagues.

In his earliest essays, Hiller seemed to subscribe to a cult of personality and refined sensibility which was not very far removed from the

"decadence" of the preceding decade. He accepted the familiar distinction between "civilization" — which was synonymous for him with slavery to the (objective) "fact" — and "culture," a state of being which was "logically inconceivable" but which could be experienced emotionally.[45] By 1911, however, Hiller's point of view had become at least nominally political rather than cultural. He attacked that bugaboo of the decade, "blase, condescending, heartless, exhausted and ineffectual aestheticism,"[46] and exulted in the rediscovery of "politics" — but of a very special sort: "(politics) in the sense of a certain functional mode or form of Geist, in contrast to any kind of passivity."[47] Thus the contrast was posited not between aestheticism and "true" art, nor between "real" politics and "ideal" politics, but between aestheticism and the "ideal" politics which was synonymous with "true" art. Hiller conceived of both the latter notions as a form of intellectual endeavor or attitude of mind quite apart from specific content. Indeed, he deplored the fact that this form was often filled with mundane contents — questions of party and parliament, constitution, economics, transportation and the like — while it was considered "poor taste" to do battle for ideas which lay "in the realm of culture." Thus Hiller drew a distinction analogous to that between culture and civilization in the field of politics: the external affairs of the nation belonged to the sphere of the fact and "civilization," whereas "spiritual politics," which dealt with the truths of inner experience, was of an incomparably higher order: "Those issues for which Geist does battle — in philosophy, art and letters — are more important, more serious, more essential than all those issues which local organizations, columnists or political leaders quite rightly fight over."[48]

At the same time, Hiller drew an important distinction between art in its narrow, traditional sense and art in its higher, expressionist sense. "Just copying down the existing" in any form was "counter-revolutionary," a symptom of resignation and defeat in the face of static being.[49] Truly significant art, however, was not merely artistic; it provided a powerful image of the desired future world precisely "through the impetus of its acceptance or rejection, its glorification or condemnation."[50] For Hiller as for so many of his colleagues, it was axiomatic that the work of art in this dynamic latter sense offered the most effective means both for expressing one's own freier Geist and for realizing political goals. But what were Hiller's political goals, exactly? The sorts of issues which Hiller suggested as suitable material for "literary politics" in 1911 — "romanticism and classicism, naturalism and stylism, honesty and suppression; intellectualism and chaos, universalism and specialism, aphorisms and system, criticism and psychology, rationalism and historicism, ethicity and metaphysicism"[51] — did promise Delikatesse for the intellectual gourmet, but as the platform of a political campaign they were ludicrous in their abstraction.

Nevertheless, Hiller, like others who subscribed to the power of pure Geist, insisted that ultimately the benefits of "literary politics" must

trickle down to the world of civilization and party politics. The true "literary politician" or "Literatur-politiker," according to Hiller, was a "worldsaver" who struggled against such abuses as "the torments of the school system! The madness of the penal code! The misery of poor housing! Militarism! Asceticism! Historicism! Rule by idiots!"[52] Struggled, but indirectly, for Hiller recommended an attack not against the abuses themselves, nor against their political, economic or military causes, but against a specific kind of literature. Instead of "mindless descriptions" Hiller demanded a breathless "spurring on to new deeds" and dynamic "heroic optimism,"[53] which were endorsed as values in their own right, quite apart from any specific action which might be taken against the problems he cited. Thus although Hiller, unlike Rubiner, did touch on concrete issues, he merely prescribed a posture of opposition without any substantive policy behind it. With "literary politics" Hiller, like Rubiner, was on the way to an object-less politics.

In the course of the decade Hiller's program evolved from "culture" and then "literary politics" into "politics of the spirit" or *Politik des Geistes.* By 1916 he had become less individualistic in orientation, eschewed most of the arcane issues of "literary politics" and was willing to pursue "political" goals not only though literature but also through organization. In that year he formed the "Goal-Alliance" or *Bund zum Ziel* and began to publish the *Zieljahrbücher*. At the same time, however, his emphasis on *Geist* and "will" remained unequivocal. In a major statement of his position which introduced the new publication, Hiller outlined — with a great deal of fanfare and self-conscious bravado — eighteen points upon which his program of "logocracy" was based. He proceeded from protest against the most outrageous abuses against physical well-being in the present — the spectacular slaughter of war, the equally devastating suffering caused by the inequities of the economic system — through protection of life in the future; from the protection of *Geist* to the promotion of *Geist* in reformed institutions of learning; from struggle against forces which he believed militated against *Geist* — newspapers, parliament and traditional bourgeois scholarship — to the positive expressions of *Geist* possible in a reformed future state.[54]

All of Hiller's suggested reforms fell under the rubric *Geist* in one form or another: from the observation that physical conflict proved nothing about spiritual superiority, to the recommendation of "support for those who do intellectual work";[55] from the conviction that psychiatry promoted mediocrity and his concern for the intellectual vigor of youth to the obsession with Platonic philosopher-kings. With his juxtaposition of *Geist* to "Nature," Hiller believed he had gone to the root of society's problems. But in fact, he had conscientiously avoided the question of whose interests the worship of "Nature" — that is, the economic and technological domination of the material world — actually served. His recommendations failed to make even fleeting reference to class conflict and social elitism, or to the emancipation of the working classes, women and children in his envisioned utopia.

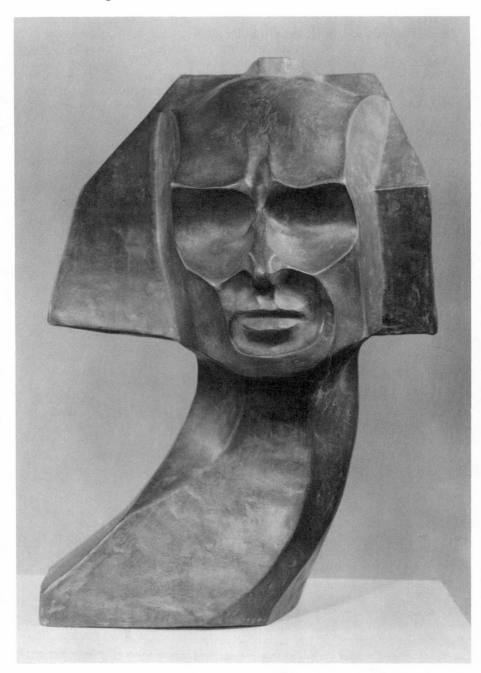

Though Hiller's alternative would distribute power along different lines, it remained at least as elitist, hierarchical and ultimately dehumanizing as the regime he was rebelling against. Of course Hiller was willing to grant material equality — "more equal distribution of *external* wealth" (emphasis mine)[56] — but only because he regarded material equality as relatively unimportant. What mattered far more was the distribution of *Geist,* of "inner wealth," and in this area, from his "select youths" to the "spiritual upper house" to the philosopher-king, there could be no talk of essential equality, only of the population's dependence on the wisdom of its spiritual leaders. Hiller denied that his vision of rule by logocrats signified autocratic exclusion of the people, yet his understanding of the relationship between leader and following was not particularly reassuring. For Hiller, the greatest spiritual height the nation could achieve was the realization that it needed the *Geistiger* to lead it.[57] Hiller assessed the representative function of *der Geistige* in far more presumptuous terms than any ordinary elected offical would dare to: "Indeed, he is the very living spark of the people: he plumbs their depths, he is their crown."[58] And the function of *der Geistige* as leader was literally to think for the people, who were presumably helpless and confused without his guidance: "In him the people become conscious of their needs; through him they think."[59]

The masses at the bottom of the social pyramid received enlightenment and guidance but were incapable of contributing anything of their own to the achievement of utopia: "The more powerful method is from the top down."[60] Hiller saw the relationship between *Geist* and "the masses" as one of inevitable confrontation and conflict, for "the masses" were unalterably "unspiritual"; hence the conviction that when one spoke to fifty students more was accomplished than by talking to five thousand workers. Because of his low estimation of the masses, Hiller warned his colleagues against democracy and the seductive "dream of playing tribune."[61] In fact, even if the masses did possess a spark of that elusive spirituality, Hiller's political hierarchy ensured that it could never flourish or be acknowledged. Instead he placed the people in a double bind from which it was impossible to salvage dignity or self-respect: if they elected a spiritual leader rather than a party hack, they were expected to deliver themselves utterly into his hands; if they didn't, they had merely proven once again that they were in thrall to baser instincts.

Herwarth Walden is usually viewed as the chief representative of an aesthetic orientation in Expressionism,[62] in contrast to those acknowledged activists who demanded the melding of art and politics into one dynamic unity. However this characterization is not entirely accurate. Since about 1901 Walden had indeed been active on behalf of avant-garde art. Because of this commitment his brief stints as editor of *Das Magazin, Morgen, Der neue Weg* and *Das Theater* had all ended in irresolvable conflicts with his employers, and by January 1910, Walden had become convinced that his only alternative was to found a publication of his own. The

first issue of *Der Sturm: Wochenschrift für Kultur und Künste,* published in March of the same year, clearly stated that Walden and his associates intended to continue their advocacy of a radical new art. But Walden's efforts extended to the fight against a stultifying and moribund cultural tradition, as well. The title of the magazine suggested the destructive yet purifying action of a storm directed at more than artistic cliches; in the words of his collaborator Lothar Schreyer, *Der Sturm* was "perpetual metamorphosis, renewal *from the roots up*" (emphasis mine).[63]

Both Schreyer and another early contributor, Rudolf Kurtz, suggested that at its core the artistic revolution Walden hoped to initiate possessed a deeper philosophical basis. Kurtz, who was associated with activist Kurt Hiller's *Neuer Club* and later published in *Die Aktion*, composed a manifesto for the first issue of *Der Sturm* entitled *Programmatisches* or "Notes on our Program." In it he attacked the middle-class view of reality, its intellectualism and vapid liberalism, and stated his intention to change that view: "We don't intend to amuse them. We intend to demolish insideously their comfortable, solemnly elevated view of the world."[64] The ascendency of Kurtz' view of reality was to lead to the establishment of a new culture in which humanity's instincts, its "dark powers," could develop unfettered by conventional morality or social dogma. Kurtz concluded with a thinly veiled cultural, if not specifically political, threat: "Gentlemen, we do not intend to be present at this wretched comedy merely as spectators."[65] Similarly, Lothar Schreyer regarded the confrontation between old and new art forms on a deeper level as a clash between opposing views of reality, one "spiritual," the other "earthly"; as a conflict "in which the reality of spiritual perfection encounters the infirmity and hope of earthly life."[66] Other contributions to early issues by such authors as Kurt Hiller and Salomo Friedländer carried the same promise of a new society and a new politics through a new art.

In short, *Der Sturm* did border on the political initially, though it never made politics an explicit part of its program. By the end of 1913, however, the format of the magazine had become more clearly delineated: essays on broad cultural and philosophical topics gradually became less frequent as Walden concentrated ever more exclusively on avant-garde literature and the arts. Walden's increasing specialization seems to have occurred at least in part as a reaction against the aggressively political line espoused by the rival *Aktion*. In response to the challenge posed by *Die Aktion*, Walden ridiculed the artistic quality of Pfemfert's lyrical selections, "they're all infatuated with whores, syphilis and excrement";[67] made light of his one-time contributor Kurt Hiller's poetic aspirations and reduced the title "politician" to an insult in evaluating Pfemfert's artistic judgement and editorial integrity.

Yet despite Walden's disavowal of politics, the development of the official literary style of *Der Sturm, Wortkunst* or "word-art," was much more than just a theory of poetics. As Roy F. Allen writes, "it was . . . the outline of an ideology, for it defines not only the principles of a specific

style of composition but also the 'spiritual' benefit which was to accrue to the reader of the work composed in the style";[68] it was to provide not merely aesthetic experience but "a spiritual experience." By shunning the "logic" of conventional imagery, poetic devices or syntactic structure, the work of "word-art" was supposed to be able to communicate directly, as the immanent manifestation of a new reality, as "the annunciation of a revelation."[69] Like others in the expressionist movement, Walden sought to disassociate art from empirical experience: "The Expressionist image in word-art gives us the simile without consideration for the world of sense experience; indeed, under some circumstances the simile may do without it altogether."[70] For Walden, conscious thought always had as its end an object, "that which is thought," whereas "true," non-representational art, as an unconscious activity "preceding thought," had none at its point of termination and thus could become pure activity: "The question of art is not fact but act."[71] Thus even Walden, though he resisted any association with explicitly political "acts" until the early twenties, did grant the "act" primacy as the *sine qua non* of great art.

Ludwig Rubiner, Kurt Hiller and Herwarth Walden are the most interesting examples for the purposes of this discussion, but they certainly did not stand alone in their understanding of art or politics. A whole series of definitions of politics and the expressionist politician appeared in *Die Aktion* and in other expressionist journals in the course of the decade. Though they varied among themselves, these definitions shared that characteristic longing for an absolute ethical ideal which was supposed to be more powerful and compelling the less it had to do with the empirical world. Rudolf Kayser interpreted Friedrich Hebbel in this sense, praising not only the "abstractness" of his characters but also the dynamic, open-ended abstractness of his thinking: "He didn't take any position on dead issues; instead he struggled foward."[72] Avoiding a specific position was synonymous with the purity, dynamic activity and future-directedness which characterized politics on the highest level for other Expressionists, as well. Franz Blei held this view, equating the representation of *something* with particularism and a diminished ability to be "totally" political: "If only everyone would stop believing in representatives or behaving like a representative and just act, each one for himself — that, it seems to me, would be real political education."[73] Paradoxically for our traditional view of politics, but not for the expressionist understanding of it, "representation" was not a part of politics at all but directly antithetical to it.

Rudolf Leonhard, like Rubiner and Hiller, shaped his definition of politics to fit the expressionist poet. He emphasized that politics was above all "energy" and "outlook,"[74] and only secondarily action or profession. Because the expressionist poet by self-definition possessed that energy and outlook to an outstanding degree, the poet must necessarily

become the politician *par excellence*. Going one step further, Leonhard revalued the poet's perpetual status as outsider: instead of trying to make the poet an "insider," as the traditional politician was, Leonhard proclaimed the outsider the highest kind of politician, namely a revolutionary. Leonhard's poet-politician had an abstracted, somewhat problematical relationship to his constituency: "Though he may bear some love for humanity in general, he feels a good deal of contempt for each one of the masses individually."[75] Leonhard's poet-politician was also uncommitted to any specific political goal: "He just wants *something* to happen, for the sake of the power contained in the deed"[76]; and he remarked approvingly that Rene Schickele's radicalism was more sheer passion than orientation on any specific issue. For Leonhard, ferment *an sich* was the "politics of poets," and he firmly believed the state could not do without it. In Paul Hatvani's opinion, too, art was not required to enter the fray directly; it became "political" merely by defining itself as the prime mover of all politics. Since the artist was the source of this art, which was "identical with the consciousness of the artist,"[77] he also became the source of the world which was shaped in the image of his consciousness as a result of his art. In this way the artist became not merely a politician but "ruler" of the new reality: "The ego (of the artist) arrives at dominion via a divinatory path."[78]

For Alfred Wolfenstein, the artist was the point of intersection between *Geist* and "life," God and ordinary man: "Like a good angel he mediates between all worlds."[79] His activity, his "composing" in all media, was an expression of love, which is to say that the artist was by definition the embodiment of an ethical function for Wolfenstein. Yet it was only *as* art that art was a true "act."[80] The artist was not synonymous with the politician; instead Wolfenstein argued that art anticipated real movement in the world. Ivan Goll resembled Ludwig Rubiner in the degree to which he redefined politics as an art form, emphasizing love, brotherhood and religious motifs. For Goll, the kind of pure activity which art represented was love; love evoked love in return; and in this way the connection from the work of art to the public was established and affirmed. However, Goll made the artist sound like a sort of spiritual social worker: "Today art has become an act of charity . . . therefore, artist, make a gift to us of your great heart. Come with your wings among the poor and the oppressed."[81] As it turned out, the artist's "love" for his fellow man was in no way motivated by the lovable qualities of the masses; on the contrary, the poet seemed to thrive on the challenge posed by their lack of appeal: "The simpler, the lower, the duller they are, the lovelier, loftier and clearer may your song be."[82] Thus although Goll's artist or poet did act upon the masses, he in no way became one with the masses.

In the "Introduction to My New Book of Verse,"[83] Johannes, R. Becher arrived at object-less politics via a different route. That is, Becher provided the reader with a direct, first-hand example of total, object-less verbal activity. For Becher, who believed "Today there is only

one way left to write: politics,"[84] politics had been reinterpreted to signify the formal manipulation of language:

> I'll build sentences (. . .here, read them. . .), infinitely com-
> plicated, wildly structured, steel-cable-like, dogmatic, irrefutable,
> in the frenzied rhythm of swarming cafes, of mad jazz bands (Oh,
> Szigo: Superstar: grim reaper of notes) —; intoxicating all of you.
> I'll hold brilliant political speeches (Saw! Hammer a rostrum! Enor-
> mous carousel-square bedecked with shreds of bunting). My
> posters, garish-eccentric-superb, will inspire you to the greatest of
> all evolutions (I swear it).

But what does this freedom to manipulate language in turn mean? It provides a demonstration of the sovereignty of *Geist* over the material world, with all its constraints and limitations. In a breathless rush which seems to suggest irresistible dynamism, Becher then gives specific examples, indiscriminately mixing the artistic, political, technical, mathematical and philosophical:

> I'll invent the swiftest aeroplane, I'll think up the most
> phenomenal automobile. Diplomatize. Conclude splendid treaties.
> Make peace among peoples. (Eternal Kantian peace.) I'll discover
> new poles, prove Fermat's Last Theorem, demonstrate the utter in-
> adequacy of the old order. My tragedies, celluloid flicks, will speak
> to millions, move millions.

These can be lumped together like this because they are all equally valuable and equally powerful manifestations of *Geist*, in Becher's view. At the conclusion of his manifesto, finally, Becher does cite some specific issues which he offers as his platform for the future, but they can scarcely be taken literally:

> Negro tribes, fever, tuberculosis, venereal epidemics,
> intellectual-psychic defects — I'll fight them, vanquish them.
> (Analysis! Analysis! Analysis! Island of despair, you'd vanish.
> Ithaca's silvery shores are shimmering: Oh thou island of pure
> deliverance). I'll teach you total physical abstinence. Herald of the
> intellectual, the mightily sublimated race.[85]

For Becher, the only real "issue" here is to identify and destroy all that is in his view sub-*geistig*, hence sub-human, including "Negro tribes" along with physical and mental disease. *Geist* alone, or in other words the application of a dynamic "higher" reason ("Analysis! Analysis! Analysis!") will lead to the shores of utopia — but only at the cost of total sublimation, an abnegation of nature and flesh which is infinitely more radical than the Freudian notion of civilization's origins or discontents.

From the beginning of the movement the authors cited above and countless others, "activists" and "artists" alike, flirted compulsively with the vocabulary of politics and political revolution, of struggle and liberation. Yet it is often far from clear whether such phrases were to be understood in a literal or a metaphorical sense, — or even ironically, as when the *Aktion* circle held "revolutionary balls" during the carnival seasons of 1913 and 1914. As politicians in any conventional meaning of the word the Expressionists have never made very good sense. In its narrowest and most prosaic meaning, "politics" normally refers to the conduct of political government; yet the Expressionists, with the exception of a minute handful,[86] never participated in any way in the activity of government before, during or after the November Revolution — nor did they play the role of the loyal opposition within the framework of an established party in parliament. They found political methods and tactics, party strategy and maneuvers, congresses, campaigns and platforms banal and philistine. There was a place for social questions and political bosses[87] — a distinctly secondary place — but as we have seen, Expressionists were loathe to associate themselves with this kind of activity.

The essential foundation for any form of political activity, whether "within the system" or outside it, is no doubt organization; and sporadic attempts were in fact made in the course of the expressionist decade. Franz Pfemfert's very first issue of *Die Aktion* , published in February, 1911, called for the formation of an "intellectuals' organization"[88] and in 1915 Pfemfert together with collaborators from the magazine clandestinely organized a new political party, the "Antinational Socialist Party/ German Branch."[89] There were Kurt Hiller's "Goal-Alliance"[90] and his abortive "Activist Party" of 1919 [91], as well as Wilhelm Herzog's plan for a "spiritual International."[92] None of these efforts ever really got off the ground. With the end of the war and the creation of soldiers' and workers' councils, there was a parallel movement among the members of the German left-wing intelligentsia; yet as Ernst Bloch observed as early as January, 1919, the members of the "Council of Intellectual Workers," unlike others, represented nothing and nobody but themselves. They were not elected but self-appointed, and thus their council could not be considered a political phenomenon in the same sense as the others.[93] While individual Expressionists joined the SPD, the USPD or KPD, their association with these recognized agents of political activity was tenuous and critical. The listlessness of these political endeavors contrasts sharply with the clubs, cabarets, periodicals, exhibitions, readings and countless other artistic activities which proved so fruitful for the development of individual artists and for the evolution of Expressionism as an artistic style. Obviously Expressionists were capable of organizing and willing to cooperate; purely political activities, however, did not stand very high on their agenda.

The most significant forum for the engagement of Expressionism in public life was no doubt supplied by the numerous periodicals founded

during the period, which carried explicit manifestoes as well as implicit statements of purpose in the choice of materials which appeared. Clearly the movement put a lot of energy into its journals. Not only was every phase of the movement introduced and interpreted in their pages; they, rather than political parties or other formal organizations, became the real focal point for the loose and overlapping circles of likeminded artists and intellectuals. But to publish a magazine is not necessarily a political undertaking in a direct sense. A degree of interaction with and shaping of public opinion is of course involved; this is presumably the primary motivation for founding such a publication in the first place. But influencing opinion or publicizing new ideas, while it can play an important part in informing the public, remains at once removed from the actual process of government, and the power that such a publication can wield is a fundamentally different kind from the power of those with direct access to the instruments of government. The fact remains that the street battles in Berlin which raged between the Spartacists and the adherents of the new Ebert government during the winter of 1918–1919 frequently centered around the offices of the Spartacist and SPD newspapers, which fulfilled an important communicative function during those turbulent weeks. But they were significant — like the radio and television stations which nowadays are prime targets of government coups — only as instruments of political parties, and not in and of themselves. It never occurred to anyone, despite Pfemfert's personal commitment to revolution or Walden's quietly changing point of view, to seize the offices of *Der Sturm* or *Die Aktion*. As political forces they were simply inconsequential. In 1913 Kurt Hiller had written: "Why make poems? Better to make history! And better to make bad history than good poems."[94] In the judgement of latter-day historians, however, the Expressionists did not make any history at all.[95]

Why not? Because what the movement was really after was a kind of metapolitics, and not politics at all. According to the movement's cultural Idealism, "true" revolution was not a matter of a new government or economic reform, but an ethical event. Ethics, in turn, was a transcendental ideal, and man's only access to ethics was through the intermediary of art. Thus the well-designed graphic and the well-written word were not merely the Expressionist's only legitimate weapons; by expressionist conviction, they were also the most powerful weapons available to anyone, and those who knew how to wield them were the natural leaders of the revolution. It necessarily followed, at least from the expressionist perspective, that the artistic forum provided by a cultural journal must be infinitely more effective than organizing rallies, instigating strikes or "playing tribune" in the street. The journal *was* politics for Expressionism, or at least as close to politics as most members of the movement ever came. The journals did not represent any specific cause as such; instead they *were* the cause: the immanent embodiment of artistic communication. No matter that the journals served a miniscule readership;

what was empirical quantity compared to spiritual quality? No matter that Expressionism armed for revolution with nothing more than paper and ink; who could withstand the ineluctible force of the ethical ideal? Here, in short, lies the ultimate significance of the journals for the movement: they were the expressionist politician's political *Ersatz*.

Such was the artistic political program which Neo-Kantian Idealism, the dominant philosophical trend of the late nineteenth and early twentieth century, suggested to the artists and intellectuals of the expressionist movement. This program could become a rallying point for the new generation not on the basis of its methodological rigor, but because it offered a tempting alternative to their alienation and impotence. The unity between ethics, culture and political reality which Expressionism postulated depended upon the central significance not of industrial magnates or labor leaders, of disreputable politicians or revolutionary masses, but upon creative intellects doing what they did best. Yet the program failed. It would be wrong to imply that Expressionism had nothing to offer the public at large: its internationalism, pacifism and anti-authoritarianism were all important and truly progressive values which opposed the conservative drift of Wilhelmine Germany. There is a core of genuine humanism, decency and compassion in Expressionism's political ambitions which we cannot help but admire. But there was a darker side to the coin, too. What Expressionism ultimately aimed at was not the end of authority, but the replacement of one authority by another, its own. Behind declarations of brotherhood lurked always a deeply elitist attitude toward ordinary people, toward women and other races. And the movement's pacifism was largely rooted in the conviction that the only really important battles took place in the ideal realm, anyway. Philosophically the expressionist program encouraged estrangement between the cognitive subject and the external object: Expressionists proudly and persistently refused to deal directly with the material world, concentrating instead on an intense, highly affective cultivation of pure consciousness and its expression in art and literature. And politically the expressionist solution failed because it refused to recognize the need for any platform or power base beyond the consciousness of the individual artist and his presumed alliance with transcendental forces.

Notes

[1] See for example the entry "Little Magazines" in William Rose Benet, *The Reader's Encyclopedia*, 2nd ed. (New York: Thomas Y. Crowell Co., 1965), p. 591, and C. Hugh Holman, *A Handbook*

to *Literature*, 3rd ed. (Indianapolis and New York: Odyssey Press, 1972), pp. 293–4.

²Frederick Crews, "The Partisan" *New York Review of Books*, Vol. XXV, No. 18 (1978), p. 3.

³Paul Raabe, *Die Zeitschriften und Sammlungen des literarischen Expressionismus*. (Stuttgart: J.B. Metzlersche Verlagsbuchhandlung, 1964).

⁴Other critics have viewed the periodicals as having only, or primarily, aesthetic significance. Compare, for example, Raabe's remarks in the introduction to the volume cited above, p. 12.

⁵Fritz Martini, "Essay" *Reallexikon der deutschen Literaturgeschichte*, Vol. I, ed. by Wolfgang Mohr and Werner Kohlschmidt. (Berlin: Walter de Gruyter and Co., 1958), p. 408.

It is interesting to note that Georg Lukacs, writing in 1910, said of the essay: "It [the essay] becomes a Weltanschauung, a point of view, a position taken viz a viz the life out of which it arises; it becomes a possibility to transform that life and create it anew." This is so because not "things" but "forms" are the stuff of which the critic creates his essay and his writing thus acquires "cosmic necessity." Georg Lukacs, "Über Wesen und Form des Essays: ein Brief an Leo Popper" in *Die Seele und die Formen*. (Neuwied and Berlin: Hermann Luchterhand Verlag, 1971), pp. 16–17.

Kurt Pinthus expressed a remarkably similar view only a few years later, when he argued that the expressionist critic was a more powerful "politician" than the expressionist artist; for the critic, in talking about art, was able to begin at one remove from empirical reality, whereas the artist was forced to work with the objects, colors and relationships of the material world. Kurt Pinthus, "Über Kritik" *Die Aktion* No. 20/21 (1917), col. 213.

⁶*Ein neues Lebensgefühl*, Otto Mann, "Einleitung," in *Expressionismus. Gestalten einer literarischen Bewegung*, ed. by Hermann Friedmann and Otto Mann. (Eidelberg: W. Rathe Verlag, 1956), p. 10.

⁷*Die Politik der Politik wegen*, Ludwig Rubiner, "Der Kampf mit dem Engel," in *Die Aktion* No. 16/17 (1917), col. 213.

⁸Expressionists were so united and so adamant in their rejection of both Impressionism and Naturalism that a full documentation of their attitudes here would be both tedious and pointless. For a sampling see: Barbara Drygulski Wright, *Expressionist Utopia: The Pursuit of Objectless Politics*. Dissertation, University of California at Berkeley (1977), pp. 8–13.

⁹I am indebted to Professor Martin Jay of the History Department at the University of California, Berkeley, for this reference to Neo-Kantianism and the significance of its impact on Expressionism. See also the passages dealing with philosophical influences in: Lewis D. Wurgaft, *The Activist*

Movement: Cultural Politics on the German Left 1914–1933. Dissertation, Harvard University, 1970.

[10]In the thumbnail biographies of contributors to *Die Aktion* which are included in the Kraus reprint, some thirty of *Die Aktion's* authors are cited specifically as having studied philosophy, including Johannes R. Becher, Gottfied Benn, Salomo Friedländer, Kurt Hiller, Jakob van Hoddis, Oskar Kanehl, Rudolf Kayser, Robert Musil, Anselm Ruest, Rene Schickele and Carl Sternheim. An even larger number studied law and German literature, both fields which were heavily influenced by philosophical trends of the day. Hans Staudinger, the son of Marburg Neo-Kantian Franz Staudinger, also contributed an essay in 1914 entitled "Individuum und Gemeinschaft" *Die Aktion* No. 6 (1914), col. 114-116.

[11]Heinrich Mann, "Geist und Tat" *Macht und Mensch.* (Munich: Kurt Wolff Verlag, 1919), p.7.

[12]Hermann Noack, *Die Philosophie Westeuropas.* (Darmstadt: Wissenschaftliche Buchgesellschaft, 1967).

[13]See: Karl Vorländer, *Kant und Marx.* (Tubingen: Verlag von J.C.B. Mohr, 1911).

[14]Hermann Lübbe, "Die politische Theorie des Neukantianismus und des Marxismus" *Archiv fur Rechts-und Sozialphilosophie* No. 3 (1958), pp. 330–50.

[15]Georg Mosse, *Germans and Jews.* (New York: Howard Fertig, 1970), p. 183. Kurt Sontheimer, *Antidemokratisches Denken in der Weimarer Republik.* (Munich: Nymphenburger Verlagshandlung, 1962), p.393.

[16]See: Gustav Landauer, *Aufruf zum Sozialismus.* (Berlin: Paul Cassirer, 1920).

[17]Fritz K. Ringer, *The Decline of the German Mandarins.* (Cambridge: Harvard University Press, 1969).

[18]Ibid., pp. 315–366.

[19]Speaking of Hermann Cohen's vision of socialism, Hermann Lübbe creates a description which is startlingly appropriate for Expressionism, as well. He writes: "Cohen's idealist socialism is a philosophy of political conciliation. . . .It (i.e. this socialism) stands in the middle as mediator of antagonistic interests and political ideologies. . .Cohen calls, idealistically, upon humanity, categorical imperatives, love of one's neighbor and human dignity. . ." He speaks, you might say, from a position above the fray. Herman Lübbe, *Politische Philosophie in Deutschland.* (Munich:DTV, 1974), pp. 108–9. The difference between Neo-Kantians and Expressionists lies in the fact that Neo-Kantians attempted to integrate their idealism with political practice, whereas Expressionists substituted idealism for political practice.

[20]"Die politische Theorie" op. cit., p. 336

²¹This explicit ambition to be "revolutionary," as Jost Hermand quite correctly points out, is the common denominator which distinguished Expressionism from other artistic and literary movements. Hermand then goes on to interpret the ultimate implication of Expressionism: he argues that it pointed not toward the "humanizing" of the world of nature and things, but rather to the reification of nature and humankind as a necessary step in the overcoming of feudal-bourgeois ideology — all invocations of humanity and cries of "O Mensch" notwithstanding. This is in sharp contrast to what we latter-day readers have normally had to say about Expressionism, and in glaring contrast to what Expressionists mostly had to say about Expressionism. See Jost Hermand, "Expressionismus als Revolution," in *Von Mainz nach Weimar,* (Stuttgart: Metzler, 1969).

Hermand's analysis is arresting and thought-provoking as a commentary on the twentieth century, but I have reservations regarding this bravura performance as an interpretation of expressionism. First of all, it is not necessary to deduce the expressionist hostility to nature and empirical reality in as circuitous and complex a fashion as Hermand does; the expressionist essayists said as much themselves, right up front. Second, Hermand makes frequent — and I fear misleading — use of the word *idealistisch* to describe the movement and its members. *Idealistisch* has essentially two meanings: it can mean "influenced by philosophical Idealism," or it can mean "believing in unrealistic, unachievable values or goals." This secondary meaning, moreover, often carries a strongly perjorative connotation. *Idealistisch* can appropriately be applied to Expressionism in either or both of these senses, with or without the perjorative judgement. Hermand, unfortunately, never tells us which meaning he intends, but the latter seems to be implied. This is unfair both to the reader and to Expressionism, for careless use of this term blocks our access to that component of Expressionism which is *idealistisch* in the primary, philosophical sense.

Third, Hermand's analysis of Expressionism as pointing toward reification puts too much emphasis on the thing, the product or *res*; and too little on process, the *act* of making or doing itself. In other words, he does not carry the tendency toward abstraction, which he correctly identifies as basic to the movement, far enough — perhaps because he has overlooked the philosophical underpinning for this development. Hermand's abstractions remain things or objects, whereas Expressionism reduced things and people, art and politics, even farther: to the dynamic act itself, so to speak above or before the production of objects. Finally, though he has an encompassing command of the expressionist movement, its characteristics, documents and representative authors, Hermand has inexplicably ignored the ethical component, openly proclaimed by activists and others, in all this — again, perhaps, because he has neglected the philosophical background.

Now, just as nineteenth century idealist philosophy pro-
vided the basis for Marx's devastating critique of capitalism and
for his theory of communism — the first real alternative in
modern times to what Hermand calls "feudal-bourgeois" society
— so, too, has Neo-Idealism in turn provided Expressionists
with the basis for a first genuine alternative to "feudal-
bourgeois" aesthetics. It seems to me, therefore, that Hermand's
treatment of Expressionism would be more complete and more
convincing if he had somehow been able to take these
philosophical backgrounds into consideration.

[22]This is perhaps best illustrated in Ludwig Rubiner's essay
"The Poet Reaches into Politics" *("Der Dichter greift in die
Politik")*. In this essay Rubiner describes a political rally at which
a "Politerat" speaks, electrifying the crowd and molding it to his
will. Clearly, what Rubiner is advocating is a kind of living can-
vas or living theatre in which the men and women of the masses
have become the ultimate artistic medium.

It is interesting to compare this tendency in Expressionism
with Walter Benjamin's discussion of the aestheticization of
politics in Nazi Germany. See: "Das Kunstwerk im Zeitalter
seiner technischen Reproduzierbarkeit," in Walter Benjamin.
Schriften, Vol. 1, ed. by Theodor W. Adorno and Gretl Adorno.
(Frankfurt a.M.: Suhrkamp Verlag, 1951), pp. 395-397. Ben-
jamin was of course describing a vastly more successful — and
sinister — attempt to aestheticize politics, but definite parallels
between it and Rubiner's vision do catch one's attention. For
both, aestheticization was a means of deflecting political agita-
tion by the masses from its legal and economic goals. The "ex-
pression" of the masses was substituted for tangible political
content, and in both cases the will of the masses was seduced by
a charismatic leader. But though political rallies played an ex-
tremely important role in the Nazi aestheticization of politics,
war represented the highest form of this phenomenon. This was
a step most Expressionists, as pacifists, never took, although
Der Sturm in 1912 did publish excerpts from manifestoes of the
Italian Futurists in which war and war machines were glorified.
Finally, of course, Expressionism never had the opportunity, as
Nazism later did, to turn its visions into practice.

[23]Franz Pfemfert, editor's note to "Möglichkeiten, Wege,
Förderungen" *Die Aktion* No. 11/12 (1918), col. 138.

[24]Ludwig Rubiner, *Der Mensch in der Mitte.* (Berlin-
Wilmersdorf: Verlag Die Aktion, 1917).

[25]Wolfgang Rothe, *Der Aktivismus 1915-1920.* (Munich:
Deutscher Taschenbuch Verlag, 1969), p. 9.

[26]Ludwig Rubiner, "Dichter der Unwirklichkeit" *Der Sturm*
No. 14 (1910), p. 107-108.

[27]For example, in "Poets Build Barricades" *("Maler Bauen
Barrikaden")* we read: "Politics is the greatest talent, highest will,
to make our uniqueness become organic in this world." (*Die Ak-*

tion No. 17 [1914], col. 353.) In "The Struggle with the Angel" (*Der Kampf mit dem Engel*) Rubiner defines politics as "changing the world" (*Der Mensch in der Mitte*, p. 54), which in turn is made posssible by "a monumental reconstituting of our consciousness." Elsewhere Rubiner emphasizes the aspect of human community: "Politics is the making possible of human community" or "a plan for the relating of people to one another" (*Der Mensch in der Mitte*, p. 53).

To be a politician, according to Rubiner's usage, is to accept the tension inherent in man's position in the world as neither beast nor angel but as mediator between those two planes of being ("Der Kampf mit dem Engel" in *Die Aktion* no. 16/17 (1917), col. 211) and to identify completely with the struggle of mankind to attain spirituality in this world.

[28]Ludwig Rubiner, "Die Änderung der Welt" in *Der Mensch in der Mitte*, p. 110.

[29]"Wir sind immer noch klassenbewusst. Wir sind Ökonomiker, Ausbeuter, Ausgebeutete, Entwicklungsgläubiger, Zukunfts-Symboliker. Wir sind ja immer noch Erben. Wir sind noch nicht Politiker." Ibid., p. 110.

[30]Die Politik des Staatslebens ist nur ein Sonderfall auf dem ungeheueren Gebiet der Willensäusserungen in der Welt: des Politischen." Ludwig Rubiner, "Homer und Monte Christo" in *Der Mensch in der Mitte*, p. 55.

[31]"Politik ist die öffentliche Verwirklichung unserer sittlichen Absichten." Ludwig Rubiner, "Der Dichter greift in die Politik" in *Der Mensch in der Mitte*, p. 38-40.

[32]"Ich weiss, das es nur ein sittliches Lebensziel gibt: Intensität."

[33]The reader should keep in mind that it is virtually impossible to translate *Geist* into English satisfactorily, since it unites the notions "spirit," "intellect" and to some degree "soul" in one word. There is no single English equivalent which covers the same range of meanings or evokes similar connotations. Therefore, whenever appropriate I have retained the German word.

[34]Ludwig Rubiner, "Brief an einen Aufrührer" in *Der Mensch in der Mitte*, p. 38-40.

[35]Verbraucht," "ein allerabgebrauchtester Ausdruck," bei(dem) keiner schon mehr was denken kann."

[36]"Entschluss," Zusammenhauen," Umstetzung in einen Endsinn."

[37]"Im Augenblick, wo eine Handlung noch etwas bedeutet, hat sie ihre Triebkraft verloren." Ludwig Rubiner, "Die Änderung der Welt" in *Der Mensch in der Mitte*, p. 103.

[38]"Wenn wir handeln, begehen wir oft Unrecht. Es ist falsch, darum vom Handeln abzulassen. Unsere Vereinzelung, die des

Nichthandelnden, begeht viel grösseres Unrecht." Ludwig Rubiner, "Aktualismus" in *Der Mensch in der Mitte*, p. 11.

[39]"Sittliche Energie" Ludwig Rubiner, "Der Dichter greift in die Politik," in *Der Mensch in der Mitte*, p. 28.

[40]Ludwig Rubiner, "Der Maler vor der Arche" in *Der Mensch in der Mitte*, p. 77.

[41]Ludwig Rubiner, "Maler Bauen Barrikaden" in *Die Aktion* No. 17 (1914), col. 355-6.

[42]"Die Erschütterung des menschlichen Willens durch ein Geschehen über dem Körper, das unabhängig von allem Material der Welt ist." Ludwig Rubiner, "Homer und Monte Christo" in *Der Mensch in der Mitte*, p. 57.

[43]Franz Pfemfert, "Die 'Wir' des Herrn Doktor Hiller" in *Die Aktion* No. 26 (1913), col. 617.

[44]Ludwig Rubiner, "Die Änderung der Welt" in *Das Ziel* Vol. 1 (1916), p. 99-120.

[45]Kurt Hiller, "Über Kultur" in *Der Sturm* No. 25 (1910), p. 197.

[46]"Der blasierte, hochnäsige, herzlose, müde und tatenleere Aesthetismus." Kurt Hiller, "Literaturpolitik" in *Die Aktion* No. 5 (1911), col. 138-9.

[47]"(Politik) im Sinne einer bestimmten Funktionsart oder Form des Geistes, gegensätzlich zu jeder Passivität." Ibid., col. 138.

[48]"Das, worum die Geister kämpfen in Philosophie, Kunst, Schriftum, ist wichtiger, ernster, wesentlicher als das, worum mit Recht Bezirksvereine, Leitartikler, Volksvertreter kämpfen." Ibid., col. 139.

[49]Kurt Hiller, "Philosophie des Ziels" in *Das Ziel* Vol. 1 (1916), p. 193.

[50]"Durch die Wucht ihres Bejahens und Verneinens, Verherrlichens und Verfluchens." Ibid., p. 192.

[51]"Romantik und Klassizismus, Naturalismus und Stilismus, Ehrlichkeit und Verhaltenheit; Intellektualismus und Chaotik, Universalismus und Spezialismus, Aphorismus und System, Kritik und Psychologie, Rationalismus und Historismus, Ethizität und Metaphysikertum." Kurt Hiller, "Literaturpolitik" in *Die Aktion* No. 5 (1911), col. 139.

[52]"Schulfolter! Strafrechtswahnsinn! Wohnungselend! Militarismus! Asketismus! Historismus! Idiotenregiment!" Kurt Hiller, "Zu Brods *Beer*," in *Die Aktion*, No. 31, (1912), col. 975-6.

[53]Ibid., col. 975.

[54]Kurt Hiller, "Philosophie des Ziels" in *Das Ziel* Vol. 1 (1916), pp. 214-7.

[55]"Versorgung derer, die geistig schaffen."

[56]"Gleichmässigere Verteilung der äuseren Lebensgüter."

[57]Ibid., p. 205.

[58]"Ist er doch das Lebendige des Volkes selbst, sein Tiefstes und seine Krone." Ibid., p. 205.

[59]"In ihm werden dem Volk seine Nöte bewusst, in ihm denkt es." Ibid., p. 205.

[60]"Die kräftigere Methode ist die von oben her." Ibid., p. 206.

[61]Ibid., p. 206.

[62]See for example: Roy F. Allen, *Literary Life in German Expressionism and the Berlin Circles.* (Goppingen: Verlag Alfred Kümmerle, 1974), p. 228.

[63]"Die immerwährende Verwandlung, die Erneuerung von Grund auf."

[64]"Wir wollen sie nicht unterhalten. Wir wollen ihnen ihr bequemes ernst-erhabenes Weltbild tückisch demolieren." Rudolf Kurtz, "Programmatisches" in *Der Sturm* No. 1 (1910), p. 2.

[65]"Wir gedenken nicht, meine Herren, dieser armseligen Komödie nur als Zuschauer beizuwohnen." Ibid., p. 3.

[66]"Indem die geistige Wirklichkeit des Vollkommenen sich mit der Hinfälligkeit und der Hoffnung des irdischen Lebens begegnet." Lothar Schreyer, Nell Walden, *Der Sturm; eine Erinnerung an Herwarth Walden und die Künstler aus dem Sturmkreis.* (Baden-Baden: W. Klein, 1954), p. 8.

[67]"Man schwärmt allgemein fur Huren, Lues und Exkrement." Herwarth Walden, "Der Maler ohne Dichter" in *Der Sturm,* No. 146/147 (1913), p. 262.

[68]Allen, p. 236.

[69]"Künde einer Offenbarung." Herwarth Walden, "Einblick in die Kunst" in *Der Sturm* No. 21/22 (1916) p. 123.

[70]"Das expressionistische Bild der Wortkunst bringt das Gleichnis ohne Rücksicht auf die Erfahrungswelt, sogar unter gänzlichem Verzicht unter Umständen." Ibid., p. 123.

[71]"Die Frage der Kunst ist keine Tatsache zwar, sie ist aber eine Tat."

[72]"Er suchte keine Ställungnahme zu Vergangenheiten, sondern strebte vorwärts." Rudolf Kayser, "Friedrich Hebbel" in *Die Aktion* No. 12 (1913), col. 353.

[73]"Das jeder an seiner Stelle und aus seiner Stelle wirke und aufhöre, an Repräsentanten zu glauben oder sich als Repräsentant zu gebärden, das, scheint mir, wanre Erziehung zur Politik." Franz Blei, "Erziehung zur Politik" in *Die Aktion* No. 13 (1913), col. 631.

[74]"Energie" and "Gesinnung." Rudolf Leonhard, "Die Politik der Dichter" in *Die weissen Blätter* Vol. 2 (1915), p. 814.

[75]"Er, der bei aller etwaiger Liebe zum allgemeinen Menschen einen gut Teil Verachtung gegen jeden ein zelnen aus duer Masse trägt," Ibid., p. 815.

[76]"Er will vor allem, das überhaupt etwas geschieht, um der Kraft in den Taten willen." Ibid., p. 816.

[77]"Identisch mit dem Bewusstsein des Künstlers." Paul Hatvani, "Versuch über den Expressionismus" in *Die Aktion* No. 11/12 (1917), col. 149.

[78]"Das Ich ist auf eine divinatorische Art zur Herrschaft gelangt."

[79]"Er bewirkt wie ein guter Engel die Vermittlung aller Welten." Alfred Wolfenstein, "Über Lebendigkeit der Kunst" in *Die Aktion* No. 22/23 (1917), col. 290.

[80]Ibid., col. 293.

[81]"Kunst wird heute zur sozialen Liebestätigkeit. . . Darum, Kunstler, schenke uns dein groses Herz. Tritt mit deinen Flügeln ins dumpfe, arme Volk." Ivan Goll, "Appell an die Kunst" in *Die Aktion* No. 45/46 (1917), col. 599-600.

[82]"Je schlichter und tiefer und dämpfer sie sind, desto schöner, höher und heller sei dein Gesang." Ibid., col. 600.

[83]Johannes R. Becher, "Einleitung zu meinem neuen Versbuch" in *Die Aktion* No. 45/45 (1915), col. 563.

[84]"Es kann heutzutage nur mehr eine Art geben zu schreiben: Politik." Ibid., col. 563.

[85]

Sätze werde ich bauen (. . . hier lest sie. . .), unendlich kompliziert, rasend gefügt, stahlseilenhaft, dogmatisch, unverrückbar, im brausenden Rhythmus wimmelnden Cafes, toller Kappellen (O Szigo: Primus: Tönemäher) —; euch alle berauschend. Ich werde glänzende politische Reden halten (zimmert! zimmert Tribünen! enormes Platz-Karussel mit Fetzen von Wimpeln besteckt). Meine Plakate, grell exzentrisch superb werden euch zur grössten aller Revolutionen begeistern (ich schwöre es). Erfinden werde ich den rapidesten Aeroplan, das phänomenalste Auto werde ich ausdenken. Diplomatisieren. Splendide Vertrage abschliesen. Frieden zwischen den Völkern stiften. (Ewigen Kantschen Frieden). Pole werde ich entdecken, den Fermatschen Satz lösen, die Unzulänglichkeit alter Einrichtungen restlos erweisen. Meine Tragödien, gekinntopt, werden zu Millionen sprechen, werden Millionen bewegen. Negerstämme, Fieber, tuberkulose venerische Epidemien, intellektuelle psychische Defekte werde ich bekämpfen, bezwingen. (Analyse! Analyse! Analyse! Insel der Verzweiflung du entschwändest. Ithakas Silbergestade schimmern: O Eiland du reiner Erlöstheit). Die grosse physische Abstinenz werde ich euch lehren. Verkünder

des intellektuellen, des enorm sublimierten Gesch-
lechts. (Ibid., col. 564)

[86]Those exceptions of course include Ernst Toller and Erich
Mühsam, as well as Kurt Eisner and Gustav Landauer on the
periphery of the literary movement.

[87]"Sozialpolitikusse" is Kurt Hiller's word for them. Kurt
Hiller, "Philosophie des Ziels" in *Literatur-Revolution
1910-1925*, Vol. 1 (Neuwied: Hermann Luchterhand Verlag
1960), p. 407.

[88]Unsigned editorial, *Die Aktion* No. 1 (1911), col. 9, as well
as cols. 583-86: 610; and 664-666 in the Kraus reprint for 1918.

[89]Allen, p. 295. See also: *Die Aktion*, No. 8 (1918) as well as
cols. 583–86: 610; and 664-666 in the Kraus reprint for 1918.

[90]Albert Soergel, *Dichtung und Dichter der Zeit: im Banne
des Expressionismus.* (Leipzig: R. Voigtländer Verlag, 1928),
p. 365.

[91]Allen, p. 201

[92]Eva Kolinsky, *Engagierter Expressionismus. Politik und
Literatur zwischen Weltkrieg und Weimarer Republik.* (Stuttgart:
Metzlersche Verlagsbuchhandlung, 1970), p. 92-95.

[93]Ernst Bloch, "Zur deutschen Revolution" in *Die Revolution*
No. 2 (1918), p. 92-95.

[94]Kurt Hiller, "Zur neuen Lyrik" in *Expressionismus. Der
Kampf um eine literarische Bewegung,* ed. by Paul Raabe.
(Munich: DTV, 1965), p. 26.

[95]At least we find no mention of political activity what-
soever, much less significant political activity, in the following
histories of the period.

Walter Bartel, *Die Linken in der deutschen Sozialdemokratie im
Kampf gegen Militarismus und Krieg.* (Berlin: Dietz Verlag, 1958).

Bruno Gebhardt, *Handbuch der deutschen Geschichte, Vol. 4:
Die Zeit der Weltkriege.* (Stuttgart: Union Verlag, 1959), pp.
77-88.

Hajo Holborn, *A History of Modern Germany, vol. 3,
1840-1945.* (New York: A.A. Knopf, 1969).

Golo Mann, *The History of Germany Since 1789.* (New York,
Washington: Frederick A. Praeger, 1968).

Koppel Pinson, *Modern Germany: Its History and Civilization.*
(New York: The Macmillan Co., 1954).

Arthur Rosenberg, *Die Entstehung und Geschichte der Weimarer
Republik,* ed. by Kurt Kersten. (Frankfurt am Main: Eupopaische
Verlagsanstalt, 1962).

A.J. Ryder, *The German Revolution of 1918: A Study of Ger-
man Socialism in War and Revolt.* (Cambridge: University Press,
1967).

In their cultural histories, the following authors all treat expressionist activism but reach the conclusion that as a political force it proved entirely peripheral and ineffective.

Istvan Deak, *Weimar Germany's Left-Wing Intellectuals.* (Berkeley, Los Angeles: University of California Press, 1968), pp. 72-81.

George L. Mosse, *Germans and Jews.* (New York: Howard Fertig, 1970), pp. 171-180.

Walter Struve, *Elites Against Democracy.* (Princeton, N.J.: Princeton University Press, 1973), pp. 205-206.

Lewis D. Wurgaft, *The Activist Movement; Cultural Politics of the German Left 1914-1933.* In: Transactions of the American Philosophical Society (1977). Wurgaft's work concentrates heavily on Kurt Hiller, whose thinking probably provides the most striking example of the contradictory ambition to be politically elitist without resort to violence.

5
Expressionist Reviews and the First World War

Jean-Michel Palmier

While the Socialist International was falling to pieces, and from both sides of the border the cries of hate grew louder, seducing workers as well as intellectuals, there were nonetheless a few men who were able to follow Karl Liebknecht in rejecting this barbarism and say "no" to the war. For pacifists, anarchists, Expressionists and Dadaists who were either exiled in Switzerland, or living in Berlin, their only artillery were their voices and their pens. It was in their leaflets and revues that they expressed their passionate refusal of the war, along with the terror, revolt and anguish that it caused them. As Johannes Robert Becher would later write, they screamed until it killed them. But their cries were stifled. It is only by looking through their revues that one today becomes conscious of their significance. In the middle of an outburst of hate, a small light of humanity still shone.

Of all the themes which haunt expressionist poetry, the war is one of the most constant and most obsessive. Well before its outbreak, the war was present in the work of the poets of *Menschheitsdämmerung* ("Twilight of Humanity")[1] which hovered over the world and over their lives. In his appeal "Expressionism is Dying," ("*Die Expressionismus Stirbt*") Yvan Goll

affirmed that "not a single expressionist was reactionary. There was not a single one who was not against the war. There was not a single one who did not believe in fraternity and community."[2] This judgement is correct,

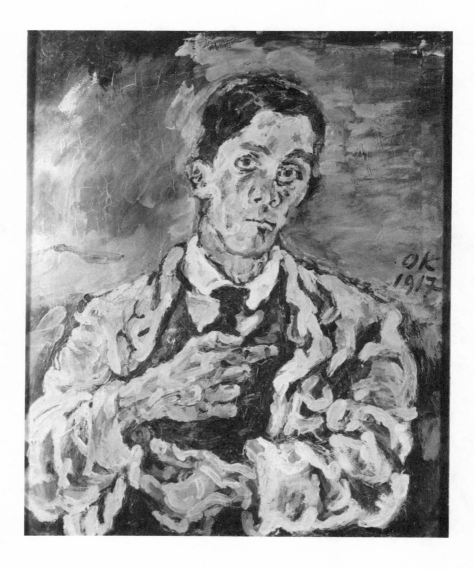

albeit a bit excessive, for many future pacifists, even Brecht and Toller, first passed through a nationalist phase. Was it a weakening of their political consciousness during the year which saw the affirmation of imperialism on the one hand and that of national frontiers on the other? This was clearly true, but it was also a desperate desire to break down both their own solitude and the structures of bourgeois society.[3] In many expressionist poems and texts written before 1914, the idea that salvation was possible only through a revolution or a war was reaffirmed.

When the International fell into ruins, the Expressionists were the ones to protest most violently against the war. The outbreak of the war signified not only the destruction of their messianic hopes, but also the materialization of their anguish. This "end of the world," this hint of the apocalypse that appears in their poetry, was about to be realized. They would tragically live through events at which they had only hinted in the visionary power of their poems and engravings.[4] It was the war which would orient many of them toward an increasingly radical political commitment in the 1920's, but we shall limit ourselves here to a study of the positions taken on the war by several expressionist reviews.

In order to understand the importance of the expressionist poets' opposition to the First World War, one must recall the nationalistic fever and the collective hysteria which the declaration of war aroused in many German intellectuals, including many of the most progressive. The imperialistic policies of Wilhelm II succeeded in rallying almost all German political groups to the *union sacree*; even the Social Democrats voted approval of war credits. During the first year of the war, a large majority of German intellectuals supported official propaganda. Max Weber and Georg Simmel, despite political ideas which were highly critical of German policy, taught their seminars wearing the full uniform of reserve officers, to the great disappointment of their students, including Georg Lukacs and Ernst Bloch, who belonged to their circles.[5] Even though Heinrich Mann, Hermann Hesse, Franz Pfemfert and Leonhard Frank had initially declared themselves hostile to the war and condemned it, a large portion of the German intelligentsia nonetheless rallied to it.

Two months after the war's outbreak, when Louvain had been plundered by German troops and destruction was increasing, the famous "Appeal to Civilized Nations," better known as the "Manifesto of the 93," appeared, signed by 58 university professors and by representatives from the world of art and literature. Describing the accusations against Germany as calumnies, they celebrated the war as a "just and good cause," and paid homage to Wilhelm II and his pacifism. They claimed:

> It is not true that our troops brutally destroyed Louvain. Treacherously attacked by a population in a fury, they were forced against their wishes to effect reprisals and bombard a portion of

the city. The city is for the most part intact. The famous Town Hall has been completely preserved: at the risk of endangering their own lives, our soldiers protected it from the flames. If, in this terrible war, works of art have been destroyed, every German will most certainly deplore their destruction. But while affirming the importance of our love for art, we categorically refuse to buy the conservation of a work of art at the price of a military defeat. It is not true that we are waging this war without consideration for the rights of other peoples. Our soldiers commit neither undisciplined nor cruel acts. In return, however, in the east of our country, the earth is soaked with the blood of women and children massacred by the Russian hoardes, and on the battlefields near the River Oise, our enemies' dum-dum bullets are tearing open the chests of our brave soldiers. The allies of the Russians and Serbs, who are not afraid of stirring up the Mongols and Negroes against the white race, thus offer the civilized world the most shameful spectacle imaginable and are certainly the last ones who may claim the role of defenders of European civilization.[6]

The appeal praised the German people as the inheritors of Goethe, Beethoven and Kant, affirming Germany's innocence and the sacred character of the cause she was defending — that of civilization itself. This undeniably chauvinistic text was signed by the most eminent representatives of German culture; among the writers, let us mention only Richard Dehmel, who at the age of fifty voluntarily joined the German army, Gerhardt Hauptmann and his brother Carl, Hermann Sudermann and Max Halbe. Max Reinhardt also signed, as did Aloïs Brandl, president of the Berlin Shakespeare Society. Several painters, including Max Liebermann, Hans Thoma and Wilhelm Truhner, signed as well. This appeal repeated all the themes of official propaganda, but — surprisingly — it also exhibited a racism which culminated in the opposition of Germans against other peoples and that of the whites against "Negroes" and "Mongols." That so many German intellectuals could sign this text indicates the weakness of their political consciousness and the fragility of their democratic convictions. If Thomas Mann did not sign the manifesto, his positions were hardly any better, and if he was not asked to sign it, it was without doubt because his critical attitude with regard to society was well known. Thomas Mann's positions on the war were first clearly expressed in an article in the *Neue Rundschau* in November, 1918, entitled "Thoughts on the War," and in his essay "Frederick and the great Coalition: Sketches for the Time and the Hour." Drawing from Nietzsche, he saw in the war a celebration of the "demonic" and "heroic" elements of the German soul. As with most of the official nationalists, he juxtaposed *Kultur* and *Zivilisation,* and saw the German advance as a veritable crusade. In his essay on Frederick, he also celebrated warlike virtues and developed the idea of German's encirclement by the Allies. These declarations by Thomas Mann were violently attacked by his brother Heinrich and also by Romain Rolland.

In his "Considerations of an Apolitical Man," Thomas Mann attempted to defend himself against these accusations of chauvinism by declaring that he was not a "patriot of the lower order," but that he had been enthusiastic only for the sake of history, for he envisioned a possible resurrection of the legacy of Frederick the Great. This book without doubt indicates a considerable progression of Thomas Mann's political consciousness, but it is nonetheless true that he, too, did not escape the fever of war in 1914.

German opposition to the war came from the most diverse horizons: sincere democrats, as well as those of the extreme left, poets who passionately rejected barbarism and reaffirmed an internationalism that was neither proletarian nor socialist, but was instead one of all youth who were going to be killed in a war that was not their own. A good number left Germany and sought refuge in Switzerland. Among the primary German pacifists, one must mention Heinrich Mann, Leonhard Frank, and Johannes Robert Becher. Heinrich Mann, in all his novels, and particularly in works such as *The Servant* (written in 1914) or *The Poor Ones* (1918), had made a violent critique of Wilhelmine society and its misery. Leonhard Frank, who had emigrated to Switzerland, affirmed his hatred of the war, denounced those responsible for it, and wrote his famous collection of stories *Man is Good*, which confirmed his pacifist convictions and his confidence in socialism. If Dehmel was affected by nationalist fever, Arno Holz at this time wrote several poems denouncing the ravages of the war in a small village. Little by little, other expressionist poems against the war began to appear; in addition to the texts published in *Die Aktion* (Action), one must also cite the works of Rene Schickele, Yvan Goll, Hanns Johst,[7] Albert Ehrenstein and above all, Johannes Robert Becher, who became a Communist in 1918.

Thus, at the beginning of the war there were only a few lonely intellectuals, in France and in Germany, who denounced the conflict. Romain Rolland had published his manifesto against the war, *"Au-dessus de la melee,"* in the *Journal de Geneve* on September 15, 1914. Hermann Hesse expressed similar sentiments. Soon thereafter, a colony of pacifists came into existence in Switzerland: Ernst Bloch lived there, and Romain Rolland ardently worked there writing letters, reports, and manifestoes; he was soon joined by Guilbeaux in Geneva, Rene Arcon and Pierre-Jean Jouve, who in 1915 published his collection of poems, *Vous etes des hommes* (*You Are Men*).

It was above all the Expressionists, however, that the war stirred to the greatest revolt. If some of them temporarily strayed toward nationalism, many immediately reacted through pacifism. From 1914–1915, Walter Hasenclever and Hugo Ball affirmed their hatred for the war. The almost ritualistic sacrifice that the war represented to the Expressionists must be emphasized. Alfred Lichtenstein was killed September 25, 1914, as were

E.W. Lotz and August Macke on September 26, and Ernst Stadler on October 30. Georg Trakl committed suicide on November 3 or 4, as did Hans Ehrenbaum-Degele in 1914. August Stramm was killed on September 1, 1915, Franz Marc on March 4, 1916, Wilhelm Mergner in August, 1917, Robert Jentsch on March 21, 1918, Geritt Engelke on October 13, 1918, and Franz Nolken on November 4, 1918.

From the beginning of the conflict, the *Aktion* circle, grouped around Franz Pfemfert, was resolutely opposed to the war. At the end of 1914, Hasenclever, Pinthus, Zech, Leonhard and Ehrenstein met at Weimar to discuss their position. Hasenclever asked Rene Schickele to begin republishing *Die Weissen Blätter*, (*The White Sheets*) which had stopped appearing at the war's outbreak. Official censorship had already affected several revues: Rubiner's *Zeit-Echo* (*Echo of the Times*) had to be published in Switzerland, as did the *Weissen Blätter*; Herzog's *Das Forum* had been banned. These revues did not fail to dedicate articles to "enemy" artists, hence the second volume of the *Zeit-Echo* (autumn, 1915) included a Picasso lithograph, and in the following issue, Franz Blei signed a list of mourners for Peguy. Franz Pfemfert dedicated an issue of *Die Aktion* to the poet and even to the painter, Andre Derain, who was presumed to be dead. The legend spread in Germany: Peguy and his translator Stadler had met before their deaths, and had also exchanged letters.

The pacifists' actions increased when Schickele's *Weissen Blatter* was moved to Zurich in early 1916. Switzerland then became a center of intense artistic agitation where German and French pacifists, activists, Expressionists and Dadaists intermingled. In 1917, Rubiner's *Zeit-Echo* also moved there. Yvan Goll lived in Lausanne. After 1916 other writers arrived in Switzerland and settled in Zurich: Ehrenstein, Hardekopf, Leonhard Frank, Richard Huelsenbeck, Hugo Ball and his wife Emmy Hennings. Wolfenstein came to see Romain Rolland. However, these exiles could not be considered as having formed a united front; Dadaists and Expressionists disagreed on the correct attitude to adopt toward the war. Yvan Goll, took an idealistic position — messianic and humanistic — and refused the senseless death as well as the sacrifice required by the war. For Tzara, the war elicited derision and a general rejection of bourgeois society. Consequently, Goll and Tzara hated each other, the former called the latter a "bastard" who had no respect for those who had fallen on the battlefield, and also criticized his nihilism.

The French and German groups often lived in the same cities, but otherwise had very few connections with each other. Romain Rolland's manifestoes were without doubt generally well known; certain German writers visited him, but their intercourse was limited. Claire Studler translated the poems of Pierre-Jean Jouve, and Romain Rolland introduced her to the man she would marry, Yvan Goll. Henri Guilbeaux, who had been condemned to death in France and had fled to Switzerland, was a connoisseur of German literature: he had published an anthology of German poetry since Nietzsche. In Paris he had been accused of launching his

revue, *Demain* (*Tomorrow*) with German money.[8] He had connections with Russian emigrants, most notably Lunacharsky and Lenin. In 1917, many of Europe's most notable authors could be found in Switzerland: Joyce lived in Zurich, and Arp, Stefan Zweig, Emil Ludwig, Tzara, Else Lasker-Schüler and Werfel also often stayed there. One of the most interesting French figures was without doubt, Marcel Martinet, a militant international socialist who, in 1917, published poems in Switzerland that had been rejected by the French censor; *Temps Maudits* (*Evil Times*)[9] had been begun in July, 1914, and would be published by Guilbeaux's revue, *Demain*. His poem, "*La Nuit*," (*The Night*) completed in 1919, would appear in 1922 with a preface by Trotsky, Marcel Martinet wrote poems against the war, which he dedicated to Romain Rolland and "the poets of Germany, our unknown brothers." Yvan Goll himself composed his "Requiem for those who have fallen in Europe," and Ehrenstein dedicated his poems to "Our murdered brothers." Poems, manifestoes, proclamations, stories; they were almost always works written by Expressionists.

Expressionist journals, thus played a fundamental role in the opposition to the war. It is impossible to examine them all, and so we shall limit ourselves to Pfemfert's *Die Aktion*, Schickele's *Weissen Blätter*, and Walden's *Der Sturm* (*The Storm*), and to their respective positions during the First World War.[10]

Almost immediately after the outbreak of the war, several literary revues suspected of pacifist leanings were subjected to censorship. Early in 1915, *Das Forum* was banned because of an anti-war article written by Wilhelm Herzog, its director. *Die Wessen Blätter,* whose publication has been suspended for several months, reappeared in Berlin, and after 1916, in Switzerland. The majority of artistic revues were obliged to avoid political subjects and above all any attack on the war. Those who refused to comply with the censor were completely banned after 1918. Rubiner's *Zeit Echo* did not originally take an anti-war stand, but attempted instead to discuss the war's effects on the artist's lifestyle, and to see how painters, writers, and poets experienced it.

However, Rubiner prudently chose to publish his revue in Bern and not in Munich. The only resolutely anti-war revue that continued to appear in Germany was *Neue Jugend* (*New Youth*), directed by Wieland Herzfelde, who has described in his memoirs how he managed to deceive the censor. Discharged from the army for insubordination, Herzfelde returned to Berlin where he met several artists who were hostile to the war but who were not really doing anything. He planned the publication of a revue against the war, and launched *Neue Jugend* in 1916; the revue was in theory published by the school boys of Charlottesburg. Since the censor banned it immediately, he asked the *Malik Verlag* to publish a novel by Else Lasker-Schuler, and in its place appeared the same revue with an "American format," in full color and in the size of a large newspaper.

Herwarth Walden's *Der Sturm,* however, apparently wanted to remain "above the conflict."[11] In her memoirs Nell Walden, who was Herwarth Walden's companion at the time, affirms that for him, there existed no rapport between art and politics, and that he was concerned with the war primarily because of its disruptive effects on relations between different avant-garde groups. It is known that Walden's politicization, his "Bolshevik writings," date from 1927, and that the only mention of the war in *Der Sturm* concerned the death of contributors, artists who had been killed at the front. While other revues were politicized or radicalized, *Der Sturm* seemed uniquely preoccupied with Stramm's theories of *Wortklang* (word-sound).

The position taken by Pfemfert's *Die Aktion* was completely different. The critical tendencies already present in the revue developed into an ardent critique of the war. At the beginning, Pfemfert claimed that during the war the revue would discuss only literature, but through other means he found the possibility of expressing his hostility to the nationalism and imperialism so exalted by official propaganda. In rereading issues of *Die Aktion* published during the war years, one finds poems written about the war such as Wilhelm Klemm's "Verse vom Schlachtfeld," ("Verses from Battle") which fully describe its horror. To avoid censorship, Pfemfert had the idea of publishing press clippings, under the heading "*Ich schneide die Zeit aus,*" ("I cut out the time") all of which formed a terrifying critique of the war and the stupidity exhibited by so many German intellectuals. The quotations were not accompanied by any commentary, but complimentary copies of these issues of *Die Aktion* were sent to soldiers at the front who, like Erwin Piscator, avidly read them in the trenches. In order to finance these free issues, Pfemfert printed several deluxe editions, and the profit from their sale went to pay for the cost of the others. Pfemfert especially hated chauvinism, in which he saw the greatest danger threatening humanity. He also devoted special issues to foreign artists and writers, whether from Russia, England, France, Italy, Poland, Czechoslovakia or Belgium.

While *Die Aktion* prudently and indirectly took the part of pacifists who had fled to Switzerland, *Der Sturm* criticized them; this brought on a campaign by Pfemfert against *Der Sturm* and Walden's mercantile penchants. It must be noted that *Die Aktion* and *Der Sturm* had only one contributor in common by 1918, Franz Richard Behrens, who published political poems in *Die Aktion* as "*Du darfst nicht töten,*" ("One May Not Kill") dedicated to Ludwig Rubiner, and non-political works in *Der Sturm.* In contrast, that same year *Die Aktion* and the *Weissen Blätter* had several writers in common — Yvan Goll, Max Hermann-Niesse and Albert Ehrenstein — while *Die Weissen Blätter* had no contributors in common with *Der Sturm.* Schickele's revue, prior to the war, had wanted to ultimately unite considerations of art and politics. After the *Weissen Blätter* had moved to Switzerland, their criticism of the war intensified. However, it must be noted that except for their common contributors,

there was no contact between Pfemfert and Schickele. It is moreover remarkable that all these adversaries of the war could never truly form a united front; when the famous "assembly" of authors hostile to the war met at Weimar in 1914-1915 because of Hasenclever's appeal, it included authors such as Leonhard, H.E. Jacob, Martin Buber, Albert Ehrenstein and Paul Zech. On New Year's Eve in Berlin, Hugo Ball invited his friends to shout "Down with the war!" from his balcony, but was answered with "*Prosit Neujahr. . . .*" Even after 1917, critics of the war were centered in small groups, Kurt Hiller included and never managed to form even a relatively united front, as would be the case among emigrants who were adversaries of fascism.

Die Aktion was definitely one of the most active revues in the anti-war campaign. In particular, it would dedicate symbolic *Sonderhefte* (special issues), often at the height of the war. The Christmas 1917, *Sonderhefte* contained a story on Herod. The king gives an order to kill children, but he is finally punished by God and led away by Death and the devil. The identification of the murdered children with European youth and of the king with the Kaiser, was obvious. Poems about the angels ended with hymns of peace, even if this peace was referring to Christ or the Blessed Virgin. The coming of Christ gave full rein to the Expressionists' messianic ideas on the coming of a better world. The newspaper clippings chosen by Pfemfert for the column *Ich schneide die Zeit aus* discussed the lack of coal in Germany and the Bolshevik revolution. For Easter 1918, Pfemfert entitled a special issue on the death of Christ "*Golgotha.*" Here again, political ones could be found behind the religious themes. The resurrection of Christ was a call for an end to the hostilities, while the madness which had led to His death was likened to the present era. Next to the tomb of Christ, there was the mud of the trenches as a shroud, and numerous poems describing life at the front. *Die Aktion* also continued to publish volumes of poetry which presented a particularly realistic vision of the war. Under the heading "*Verse vom Schlachtfeld,*" many poems describing the fixed positions, the trenches, and the soldier's desire to return home were published.

In different theoretical texts, Pfemfert did not hide his political convictions; he published articles on socialism and anarchism, Bakunin's letters to Herzen and a chapter from Franz Mehring's biography of Marx in 1917. He dedicated a special issue of *Die Aktion* to Marx, and sold copies of the *Communist Manifesto* for 80 pf. His choice of texts by Marx was symbolic — the critique of capitalism, and the possibility of ending a war through a revolution. Schickele's *Weissen Blätter* was hardly less active. After a year long interruption, the review reappeared in 1918 with articles by Svend Borberg which attempted to analyse the social and ideological situation of the pre-war years by showing how the war itself had been the solution to a crisis. The bourgeois world and imperial Germany were ruthlessly attacked. Borberg's considerations were not limited to the economic realm; he also analysed the moral crisis which had marked the war, and the opposi-

tion between technological progress and the soul, thus restating many themes belonging to the romantic anti-capitalism of Simmel and the expressionist poets. From this perspective, the war does not directly appear as a conflict between imperialist rivals, but as the result of a rupture which had marked Europe since the nineteenth century. Borberg's theses are also marked by an historic fatalism which leaves no room for political action. It is this, without doubt, that differentiates *Die Weissen Blätter's* ideological perspective from Pfemfert's; for the former, the war was only the result of conflicts belonging to the technical era, and was the apocalypse of a world which had forgotten the soul and sacrificed it to the machine. Thus, to combat the war was to combat the technological world — a theme which haunts numerous expressionist works, (particularly the *Gas* trilogy by Kaiser and Toller's *Maschinenstürmer* [Machine Wreckers]). *Die Aktion's* political positions fluctuated between anarchism and bolshevism, while those of the *Weissen Blätter* hardly went beyond the *Kulturkritik* of German sociology. Its articles never attempted to demonstrate the war's economic origins, but instead opposed spirit and matter, the soul and progress; it was with a defense of subjectivity that it attempted to struggle against barbarism. It is striking that, except for Rasputin's murder, the situation in Russia was never discussed, while the Russian Revolution itself was mentioned only in passing. After the German events of November 1918, Rene Schickele expressed his thoughts on "bolshevism" and condemned the October revolution because it has been accomplished with violence. Until the end, Schickele and the *Weissen Blätter* continued to exalt the spiritual revolution.

As for Walden, he effectively took no position during the war years, contenting himself instead with the thought that *Der Sturm* was the "organ of Expressionism." Faced with attacks by Pfemfert that labelled him a "business dealer," or a "merchant," *Der Sturm* responded with great scorn, claiming that "the revolution is not an art, but art is a revolution."

It was nonetheless the horror and revolt stirred up by this war that influenced the political evolution of a large number of expressionist artists and poets. Shot down by bullets and exploding shells, this generation of pacifists did not hesitate to work with the workers' councils in Berlin and Bavaria, hoping to play an active role in the November revolution. Without doubt *all* the Expressionists did not become militants, but Pfemfert, Herzfelde, Piscator, and Carl Einstein were radicalized because of the war, while others, including Kokoschka, Benn and Kornfeld, did not involve themselves in the struggle. Their ideologies were very different — Germanized bolshevism, messianic utopianism and socialism, anarchism, humanism — and were constantly overlapping, but Expressionism could not be understood without the war. In reality, this apocalypse that they had foreseen led most of them toward social reality. After 1918, it was difficult to still believe in "humanity," or in the possibility of changing the world with words, speech, or appeals, no matter how generous or rousing. The war had left little of the expresssionist

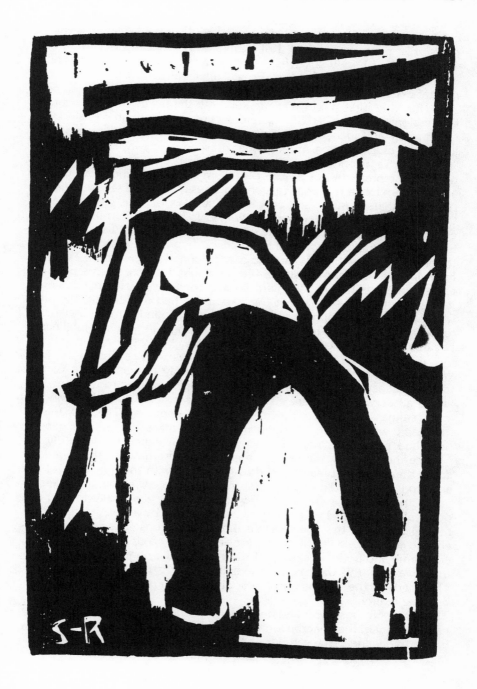

spirit intact. If Kurt Wolff, Barlach and Campendonk (a member of *Sturm circle*) had managed to have themselves cured, a large number of the Expressionist poets were killed. Kokoschka and Fritz Lang were wounded, while Kirchner barely survived a suicide attempt following a period of depressive crises and paralyses. Ernst Toller was sent to prison and to a mental asylum; Otto Gross went mad.

Thus, the First World War marked both the height and the agony of Expressionism. After 1918 it began to decline, even though it was growing in Germany and increasingly accepted — its initial revolt was dead. The long dirge of Expressionism no longer grasped reality. Kurt Hiller and the "activists" sanctioned the formation of workers' councils in which numerous representatives of Expressionism could be found. However, few among them had a real political consciousness. They still referred more to Nietzsche than to Marx, and only a few, such as Becher, really accepted Communism. Toller, even when he wanted to take part in military action, could not renounce his messianic socialism. The war would also radicalize Brecht, constitute the rebirth of Erwin Piscator, and indirectly push Lukacs toward Marxism with the beginning of the Hungarian revolution. The years following the war's end constitute without doubt the most intense period of expressionist political engagement. Even if Walden came to politics slowly, it was during these years that *Die Aktion* reached its summit; Pfemfert, whose revue would appear until 1932, would flounder more and more, following his break with the old Spartacist League, in an anti-intellectual position accompanied by a sterile dogmatism.

If the attitude of the expressionist revues with regard to the First World War merits real interest, it is not simply to specify this or that ideological aspect of an extraordinarily complex artistic movement. It is above all because nowhere else but in these articles does the grandeur and weakness of Expressionism become so apparent. The humanistic, messianic and utopian consciousness which characterized this generation, had pushed its members to reject the war and passionately denounce the barbarism in poems, appeals and dramatic works. But what could these words, these cries, do when faced with the hurricane of fire and iron which would massacre so many? Isolated, alone, strangers to each other even in suffering, they were, of course, unable to form a real political opposition in Germany or Switzerland. However, it was in this refusal of the war that their artistic and political consciousness was formed and affirmed. Even if they were incapable of clearly analysing the economic and political causes of the conflict, they understood in a confused way that this war marked the end of an era, the collapse of a world. The chaos of the visions and forebodings which had haunted them had become reality.

When all those who had been lucky enough to escape the slaughter had awakened, they had become adults. But the expressionist sensibility began to decline at the same time that it became popular. From then on, in many reviews, politics would take the place of art. These expressionist

reviews would also manifest an ideological turn in the German avant-garde. One sees here the collapse of old dreams and the birth of new hopes. By that time, however, they all knew that words alone could not realize them.

Translated by Deirdre O'Shea

Notes

[1] Title of the well known expressionist anthology published in the aftermath of the First World War by Kurt Pinthus. A critic and editor with the publisher Rowohlt, Pinthus had the idea of composing a symphony based on musical correspondences, using all the themes — from love to the anguish of decline, including also the horror of giant cities, the revolt against misery and the war — that haunted his generation.

[2] *Der Expressionismus Stirbt* in *Zenit.* Cited in P. Raabe, *Die Zeitschrift und Sammlungen,* p. 21.

[3] Thus Georg Lukacs; childhood friends, Bela Balazs, best known as a theoretician of the silent film, (*Theory of the Film*), would at first hail the war as a positive event, for he saw in it a way of escaping his solitude.

[4] Let us mention only Georg Heym's poems, which in apocalyptic terms evoke the dawn of the war, and the last paintings of Franz Marc (*Malheureu pays du Tyrol*) where the animals seem to be fleeing an invisible menace.

[5] Ernst Bloch confirmed, in an interview shortly before his death, that Simmel's attitude toward the war was at the origin of their split.

[6] Cited in the issue of the revue *Europa* devoted to the First World War.

[7] Hanns Johst would afterward become one of the literary lights of the Third Reich and an SS official. He was one of the rare Expressionists (Benn, Nolde, Bronnen) to compromise himself with the Nazis.

[8] On the activities of the pacifists in Switzerland, Cf. the memoires of Claire Goll, *A la poursuite du vent,* Paris, 1978.

[9] Marcel Martinet's works remain unknown; even in France. We welcome the republication of *Temps Maudits* (October 18, 1975).

[10] Cf. the study of Eva Kolinsky, *Engagierte Expressionismus,* Stuttgart. 1970.

[11] *Ibid.,* pp. 12-13.

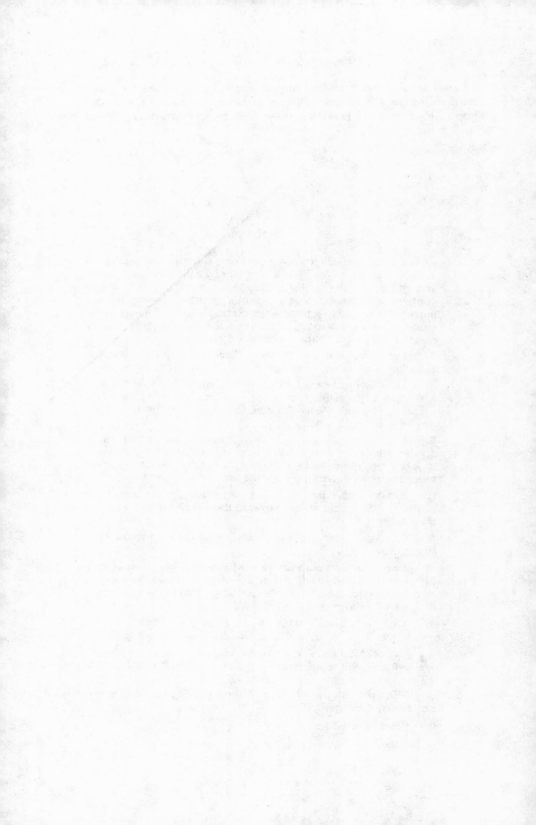

LITERATURE
AND THEATER

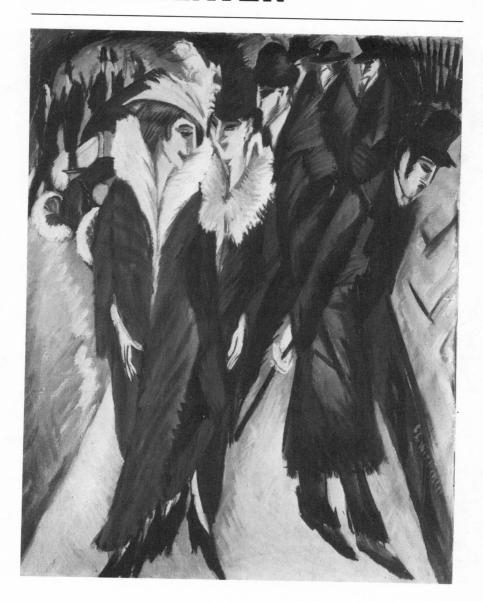

6
Wedekind's *Spring Awakening:* The Path to Expressionist Drama

Peter Jelavich

Although numerous literary historians tip their hats to both the innovative nature and widespread influence of Frank Wedekind's *Spring Awakening*, relatively few studies have examined the play in any detail.[1] This essay will attempt both to analyze the play and to place it in a historical trajectory. Theodor Adorno once noted that Wedekind "was astonishingly ahead of his time, because he was so far behind it."[2] This remark applies especially well to *Spring Awakening*, which is a model appropriation of literary tradition. The young Wedekind espoused ideals of individual freedom which he derived from German Classicism; yet in order to dramatize the betrayal and destruction of those ideals by social reality, he availed himself of very un-classical formal elements which were later emulated by the Expressionists and which ultimately anticipated Brecht.

Wedekind's initial basis for his defense of the individual resided in the German classical tradition. Like all major literary and artistic movements, German Classicism was subject to varied modes of interpretation and appropriation. Since it was essentially an attempt to defend humanist and individual values in an era of massive political and social

upheaval, it contained both revolutionary and reactionary, both bourgeois-democratic and aristocratic-elitist elements. The contradictions latent in the unstable classical synthesis became manifest in the three different heritages of Classicism which developed during the nineteenth century. The official version of Classicism, embodied in the humanistic *Gymnasia*, presented an "affirmative culture" which stressed the mental and cultural development of the individual at the expense of collective social and political activity.[3] This stood in marked contrast to the revolutionary tradition of Classicism, as espoused by men such as Wedekind's father, who considered it a movement of civic and political liberation and wrote hymns in praise of Schiller.[4] The young Wedekind opted for a third interpretation, insofar as he appropriated the "aesthetic paganism" which he saw most clearly expressed in the works of Goethe and Heine.[5] Despite their many differences, these two men shared the anti-Christian belief that man's body is as sacred as his soul, and that both should receive due hommage. They considered sexuality a necessary component of (rather than antagonist to) man's ethical and spiritual development. The most famous expression of this idea was to be found, of course, in Goethe's *Faust*, where the hero overcomes the dichotomy of the pure intellectuality of academic life and the animal sexuality of the Germanic *Walpurgisnacht* in the harmonious fusion of sexual and spiritual sensitivity that characterized the Helen episode and the classical *Walpurgisnacht*.

Whereas Goethe's rendition of the Faust story became the most lasting literary influence upon Wedekind,[6] his philosophical formulation of the issues involved derived from Heinrich Heine. As an adolescent, Wedekind read Heine's *On the History of Religion and Philosophy in Germany* (1834), which distinguishes between "two social systems", those of the "spiritualists" (also "Nazarenes") and "sensualists" (or "Hellenes"):

> We give the name "spiritualism" to the criminal presumption of the spirit *[Geist]*, which strives for exclusive glorification and which seeks to crush matter underfoot; and we affix the name "sensualism" to the opposition, which . . . seeks a rehabilitation of matter and a vidication of the rights of the senses, without denying the rights or even the supremacy of the spirit.[7]

This idea was echoed in "Aufklärungen" (1910), one of Wedekind's late essays in which he divided humanity into "two large classes", those who say "flesh remains flesh — in opposition to spirit," and those who contend that "flesh has its own spirit."[8] The same concern for rehabilitating the body as an equal and harmonious counterpart to the mind lies at the heart of *Spring Awakening*.

One of Wedekind's notes from the winter of 1890-91, when he wrote *Spring Awakening*, states

> The males as well as the females are all fourteen years old. The slender stalk has shot up, the heavy bud, bursting with sap,

threatens to snap it, the petals have not yet unfolded, but the calyx stands open.[9]

Both the rather obvious sexual imagery and the sense of uncertain expectancy — will the flower break, or will it be able to come to full bloom? — underscore the main themes of the play. Wedekind portrayed adolescence as the nodal point in personal growth, the time that determines whether a person will either be broken in to fulfill conventional social roles or be allowed to determine his life according to his own values and inclinations. Wedekind analysed this phenomenon in numerous ways, but at least four sets of concerns seem crucial for an elucidation of his argument: the separation of body and spirit; the hypocritical appropriation of the classical tradition by bourgeois institutions; the inability of conventional language to communicate emotional concern; and the dichotomy between individual inclinations and the necessity of forming a social consensus.

Spring Awakening dramatizes the ways in which the institutions of family and school attempt to suppress the nascent sexuality of young adolescents and to channel them into rationalized bourgeois professions. The success of this attempt is predicated ultimately upon the ability to drive a wedge between body and spirit, a practice which Heine characterized as the essence of "spiritualism". Wedekind made his case against "spiritualism" by illustrating the deleterious effects of the forced bifurca-

tion of body and mind. Moritz Stiefel and Melchior Gabor, friends yet polar opposites, are both victims of this process. Moritz is a scholastically weak pupil who feels tremendous parental pressure to succeed in school. He feels that his whole life is channeled toward his schoolwork, which becomes an obsessive mania: "One can't think about anything, without having homework get in the way" (I, 2).[10] The opposite, however, is likewise true: the "anything" about which Mortiz would like to think instead — namely sexuality — haunts him equally obsessively and disrupts his scholastic concentration. He "can't get out of (his) head" a story of the "headless queen", according to which a beautiful queen, born without a head, is conquered by a king with two heads that constantly quarrel with each other; thus the court magician transfers one of the heads on to the queen, and the royal couple lives happily ever after. This fairy-tale is a rather obvious allegory of the educational system which limits the education allotted to girls but over-emphasizes the intellectual training of boys, whereby "headless queens" and "two-headed kings" are produced.

The fairy-tale is furthermore used to illustrate the confusion of sexual roles generated by repressed eroticism. After telling Melchior of his obsession with the story, the sexually unenlightened Moritz exclaims: "When I see a pretty girl, I see her without a head—and then suddenly I appear myself as a headless queen." (II, 1). Moritz's inability clearly to comprehend his eroticism prevents him from defining his own sexuality. He vacillates between conventional male and female roles, but the latter dominates in the end.

Moritz's fascination with femininity becomes understandable if one recognizes that he cannot escape from the false dichotomy of conventional values. On the one hand, masculinity is equated with activity, intelligence, civilization, mental and physical strength, maintenance of selfhood; on the other, femininity is equated with passivity, sensuality, nature, mental and bodily submission, loss of self.[11] According to these equations, Moritz's failure in school — ultimately a product of his innate unwillingness to submit to a cold intellectuality that prevents communion with others and with nature — must also be seen as a loss of masculinity. Instead of questioning and thereby transcending the traditional system of sexual role definitions, Moritz suspects that his personal happiness might be found in the passivity and loss of self attributed to femininity, in the role of a "headless queen." Moritz eventually finds a solution to the dilemma of being a male attracted to femininity in the act of suicide, wherein active and passive roles are fused. Yet this balance lasts only as long as the moment of death, which is followed by a state of permanent passivity. By blowing his brains out, Mortiz becomes, quite literally, a "headless queen", who carries his head under his arm in the final scene.

Whereas Moritz adopts the loss of self inherent in the socially-defined female role and carries it to its logical but fatal extreme, Melchior draws the conventional male role to its equally logical and drastic conclusion. Melchior is portrayed as having both the mental and physical

presence that Moritz lacks: the teachers refer to him as the best pupil in the school (I,4), and Martha says to him: "That's the way I picture the young Alexander, as he went to study with Aristotle" (I,3). Melchior's intelligence has allowed him not only to discover (through books and observations of nature) the mechanics of sexual reproduction, but also to devise a philosophical system which reflects the essentially egoistical nature of bourgeois society that is hidden by moral facades. He combines the atomization of interpersonal relations depicted in the play with the conventional attributes of the masculine role to form a philosophical system which contends that every individual is motivated solely by personal inclinations. He tells Wendla that even supposedly genuine philanthropy is merely a product of the fact that certain people derive pleasure from helping others, and he concludes: "There is no self-sacrifice! There is no selflessness!" (I, 5).[12]

This relativization of morality — or, more precisely, its reduction to personal inclination — has drastic effects on Melchior's sexuality in both thought and practice. Since he sees egoistic motivations behind all actions, his internal restraints against giving free reign to his sexuality are weakened. He has neither intellectual nor moral arguments upon which he can base a restriction of his inner drives: indeed, to do so would, in his own eyes, be hypocritical. Thus his denial of all non-egoistical standpoints leads to a radical individualist position that rejects communality of emotional experience: all other human beings are reduced to objects which can be used according to one's own desires. The ultimate consequences of such a standpoint are made manifest in Melchior's roll-in-the-hay with Wendla. When the frightend girl protests against his advances and refers to love, Melchior responds: "Oh, believe me, there is no love! — Everything is self-interest, everything is egoism! — I love you as little as you love me —" (II, 4). Melchior's philosophy of egoism becomes a justification for the ensuing rape.

The figures of Melchior and Moritz carry the attributes traditionally ascribed to men and to women to their logical extremes: Melchior's "masculine" desire to dominate and his intellectuality (from which his philosophical egoism results) lead to rape, while Moritz's "feminine" longing for submission and emotionality leads to death. A solution to this diremption of "masculinity" and femininity," self and communion, mind and body, intelligence and emotionality was, of course, propounded by the classical ideal of the "whole" or "harmonious" human being who enjoys both inner and communal integration. Wedekind, however, saw that the self-proclaimed bearers of this classical humanist tradition — the *Gymnasia* — were in reality promulgators of the dominant patriarchal mores.[13] Perhaps the most bitter commentary on the school system in the play is the display of the busts of Rousseau and Pestalozzi in the teachers' conference room. Both Pestalozzi and Rousseau advocated an education that took account of the abilities and desires peculiar to each individual pupil and that included instruction in practical skills: but neither of those

goals were realized by the schematic intellectual training of the "classical" schools. The emphasis on predetermined and rigid rather than personalized and flexible education necessitated the exclusion of the most individual sphere, that of emotionality, so that the "classical" schools upheld the mind/body dichotomy which Classicism, in Wedekind's view, had sought to overcome.

The hysterical reaction of the teachers to Melchior's tract on sexuality (III, 1) underscores the inability of the school to confront the personal realm. Consequently, each pupil has to find his own solution to the conflicts of school versus private life. This dichotomy presents itself to Moritz in a dream-vision of "legs in sky-blue tights that mounted the teacher's desk" (I, 2). This marvelous image of the triumph of repressed sexuality over repressive intellectuality, which prefigured Heinrich Mann's *Professor Unrat* by fifteen years, remains a vain hope for Moritz, but it becomes a reality for his sexually deviant classmate, Hänschen Rilow. The two scenes where Hänschen plays a prominent role (his masturbation monologue, II, 3, and his homesexual enounter with Ernst Röbel, III, 6), are invariably the first scenes to be cut in any censored version of the play, yet they provide some of the best examples of Wedekind's satirical genius. As far as Hänschen is concerned, the "legs in sky-blue tights" have successfully installed themselves behind the teacher's lectern, inasmuch as he has been able to appropriate "high culture" for the satisfaction of his sexual fantasies. His famous masturbation monologue combines quotes from *Othello* with commentary on erotic "high art."

Significantly, Hänschen's lascivious appropriation of Western Civilization is not portrayed as an isolated or exceptionally perverse case: after all, he stole the Makart reproduction from his brother's notebook, and he had to abduct the *Ada* of van Beers "from the secret drawer of Daddy's desk in order to incorporate her into my harem." In fact, the historical record shows that from the 1860s on, the mass production and distribution of postcard-size reproductions of nudes by the great masters caused grave headaches among censors and police vice squads: "respectable" works of art which had formely been visible only in museums and as expensive reproductions — and thus were limited to a propertied and educated elite — could now be acquired by the lower classes and young people, who supposedly lacked the ability to view such works in a disinterested, non-erotic manner.[14] Characteristically, Wedekind hoped both to shock and to satirize the defenders of public morality by depicting dramatically their worst fears about what happened to classical nudes in the hands of immature youth.

Wedekind contended that the closet eroticism of both youths and adults was a product of the fact that discussion of sexuality was banned from the public sphere; even parents could not "speak about erotic questions, since they have not learned to talk seriously about such matters."[15] This inability to discuss sexuality — and the breakdown of interpersonal communication entirely — is an important theme in *Spring Awakening*. It

is presented most obviously in the scene where Wendla asks her mother to explain human reproduction to her. After great hesitation, Frau Bergmann can only stammer:

> In order to have a child — you have to *love* the man — to whom you are married — I say *love* — as only a husband can be loved! You have to love him *with your whole heart,* I can't tell you how! (II, 2).

Frau Bergmann literally cannot discuss such matters with her daughter, because she herself has never learned to speak of such things:

> To tell such things to a fourteen-year-old girl! I would have been more prepared to see the sun go out. I didn't treat you any differently than my dear good mother treated me. (III, 5).

Not only is the inability to speak about sexual matters perpetuated from generation to generation, but the merest mention of eroticism is immediately branded as "moral corruption" by the teachers, Pastor Kaulbach and Herr Gabor. These men constitute not only the keepers of the patriarchal moral order, but they are also the guardians of a system of language and thought which admits no consideration of personal, emotional or sexual matters: far from being a means of interpersonal communication, language becomes a smokescreen that obscures authentic human concerns.

Rektor Sonnenstich can easily dismiss any guilt regarding Moritz's suicide by proclaiming:

> Suicide, the gravest conceivable transgression against the moral order of the world, is the gravest conceivable proof of the existence of the moral order of the world, inasmuch as the perpetrator of suicide spares the moral order of the world the task of passing judgement and thus confirms its validity. (III, 2).

This and similar passages, in which rhetorical authority and formality of syntatical construction mask a total illogic of meaning, are largely humorous parodies of the grotesqueness of academic German. Less amusing, however, is the struggle between Herr and Frau Gabor over their son's fate (III, 3): indeed, this scene, which is modelled after "Trüber Tag, Feld" in *Faust,* is the only part of the play which Wedekind intended to be totally devoid of humor.[16] Melchior's father, a jurist par excellence, is so imbued with verbal formalism that his son becomes for him a foreign object which he judges and condemns according to criteria ranging from brutal adages ("Whoever is too weak for the march, falls by the wayside") to questionable forensic formulae ("moral insanity"). His wife screams back at him:

> One has to be a *man* in order to speak like that! One has to be a *man* in order to be so blinded by the written word! . . . One has to

lack all human understanding — one must be a totally soulless bureaucrat, or totally stupid, in order to see moral corruption in our son!

Empathy and communication are totally stifled by the "written word" which defends a "soulless" masculine and patriarchal moral order that is blind to human reality.

Wedekind proceeded beyond a recognition of the obscurantist function of language and sought for novel means of communicating emotional concern. The techniques that he developed in *Spring Awakening* prefigured and often directly influenced many of the linguistic devices that were to characterize expressionist literature. In contrast to the language of the teachers, where syntactical complexity masks conceptual illogic, stands the language of some of the children, where a total breakdown of syntax and logical sequence becomes a prerequisite for the expression of hardly expressible emotions. This becomes evident in the monologues of Wendla, Moritz and Melchior, the three major children of the play. In the following stream-of-consciousness monologue, Wendla tries to come to grips with her recent sexual experience with Melchior:

> Why did you slink out of the house? — To look for violets! — Because Mother sees me smiling. — And why can't you bring your lips together again? — I don't know. — I just don't know, *I can't find words.*
>
> The path is like a plush carpet — no pebbles, no thorns. My feet don't touch the ground. . . . Oh how I slept last night!
>
> They used to stand here. I'm becoming as serious as a nun at communion. — Sweet violets! — Quiet, Mommy, I'll put on my penitential gown. — Oh God, *if only someone would appear, so I could* throw my arms around him and *tell him everything!* (II, 6, italics mine)

Wendla's inability to find someone to talk to forces her, in the beginning of this monologue, to hold a dialogue with herself, to play the part of both questioner and answerer; monologue is thus a product of the fact that dialogue has been banished from a social context and is necessarily interiorized. Not only is the social context of communication lost, but conventional language also proves incapable of expressing emotions. In this and in other monologues Wedekind sought to resolve the problem of expressing the inexpressible by producing a disjunct series of thoughts and images, which the audience would have to imbue with a meaning on the basis of emotional empathy. The young Wedekind thus anticipated a major contention of Expressionism and, more radically, Dadaism, namely that logic and syntax are parts of the social order that harnesses self-expression; linguistic liberation is to be achieved by fragmenting language into a series of images which the recipient is forced to interpret emotionally because logical and syntactical structure is lacking.

Whereas Wendla gropes for images to express her inexpressible emotions, Moritz's despair requires a much more feverish verbal outlet. Shortly before his suicide, Moritz culminates his monologue with what may be considered the first expressionist scream in modern German literature:

> *ich werde Aufschreien! — Aufschreien! — Du sein, Ilse! — Priapia!!*
> *— Besinnungslosigkeit — Das nimmt die Kraft mir! — Dieses*
> *Glückskind, dieses Sonnenkind — dieses Freudenmädchen auf*
> *meinem Jammerweg! — Oh! — Oh! (II, 7).*[17]

This very unclassical scream is, paradoxically, a product of the betrayal of the classical erotic tradition by social reality. Although Wedekind's ideals were those of the "aesthetic pagan" strand of German Classicism, the brutal suppression of those ideals in everyday life led him to appropriate stylistic elements not only from *Faust,* but also from the critical realist subcurrent of German drama that was manifest in the plays of J.M.R. Lenz, Georg Büchner and Christian Grabbe.[18] From these works Wedekind derived not only the gnashing, thrashing and exclamation points, but also the entire anti-Aristotelian structure.

The "formlessness" of which *Spring Awakening* was often accused when it was first produced conformed to Wedekind's vision of social reality. The structure of classical drama had to be dissolved because society was fragmented. The separation between the generations, between the sexes, between body and spirit had progressed to the extent that the direct confrontations and inexorable chain of events upon which classical tragedy was based were no longer conceivable. There is no scene in the play where the older and younger generation clash as equals: indeed, the only scene where a direct confrontation begins to occur is in the teachers' conference, but Melchior's protests are immediately stiffled. Significantly, Melchior and his father — strong personalities, intellectual equals, and proponents of extreme forms of individual freedom and social conformity respectively — never confront each other in the play. Most scenes between parents and children are non-dialogues between representatives of totally different worlds of experience (Frau Gabor with Melchior and Moritz, Frau Bergmann with Wendla). The isolation of individuals implicit in this view of society necessitates the episodic structure of the play, which consists of short scenes, often monologues, that provide glimpses of the experiences of children who make up the collective protagonist of the play, yet who cannot form themselves into a unified and self-conscious collectivity vis-a-vis the elder generation.[19]

The fact that the fragmentation of individual and social experience has proceeded so far that a direct juxtaposition of opposites cannot occur necessitates the use of a bitterly humorous satirical-grotesque genre, which can at least underscore the contradictions inherent in individual and social attitudes. The use of morality as a facade for egoistical motivations made Wedekind turn to satire, with its emphasis on uncovering hid-

den contradictions. He used satire in a manner congruent with Schiller's definition thereof: "A poet is satirical when he makes the distance from nature and the contradiction of reality and ideal. . .the subject of his works."[20] Numerous scenes demonstrate the depraved nature of institutions devoted to "sublime" ideals: the inhumanity of the school belies the precepts of Rousseau and Pestalozzi; the pastor explicates Christian morality in a most un-Christian manner; and the correctional institution to which Melchior is sent to learn about "the Good" is a hotbed of sexual depravity. Yet all of the adults involved — the teachers, the pastors, and Melchior's parents who sent him to reform school — believe both that they personally are acting in accordance with valid moral formulae, and that the institutions in question (school, church, correctional school) are all performing their moral and social functions properly. The de-natured self-satisfaction of the adults, who cannot see individuals on account of precepts and institutions, reaches a satirical peak in the teachers' conference scene. Not only are the teachers unable to tolerate Melchior's discussion of natural impulses, but they cannot even decide to open a window, because "the [literally and figuratively stuffy] atmosphere leaves nothing to be desired." (III, 1).

Wedekind's satire is inextricably tied to the grotesque. His satirical unmasking of the contradictions between ideal and reality and his portrayals of bourgeois hypocrisy are genuinely funny, yet laughter is ultimately stifled by the fact that these absurdities lead to the deaths of Wendla and Moritz, and to the hounding of Melchior. The reality of this suffering allowed Wedekind to give his play the subtitle *"Eine Kindertragödie,"* but the work is no tragedy in a classical sense. Suffering is caused not by the character faults of the protagonists, or their insoluable conflicts with a rational or divine order: rather, it is the blindness and stupidity of the guardians of social convention that generate human misery. By portraying the distortion of ideals in the adult world in a satirical light, Wedekind made the resulting disfigurement of children appear all the more unnecessary and absurd. Whereas a classically tragic drama would portray the inescapability of suffering, the gratuitous nature of the misery in *Spring Awakening* seems grotesque.

The destruction of humanity not by God or nature, but by man himself constitutes the essence of the grotesque:

> Not a caprice of nature seems grotesque to us, but rather those disfigurations which drive both horror and ridiculousness to a climax, to an unbearable contradiction: the fabricated deformation of man, inhumanity perpetrated by man[21]

This human responsibility for the grotesque harbors, however, a ray of hope, inasmuch as it allows for the remediability of the conditions depicted. Wedekind's grotesque satire contains an implicit call for change which classical comedy and tragedy, with their respective notions of the vanity of all human endeavors and the inevitability of misery, both

lack. This fact makes Wedekind's theater "epic" in the Brechtian sense. Whereas the spectator of "dramatic" theater says, "That's natural. — That will always be that way. — The suffering of this man moves me, because there is no escape for him," the spectator of the "epic" theater says, "I wouldn't have thought that. — Things can't be done that way — That must stop. — The suffering of this man moves me, because there was a way out for him after all."[22]

Wedekind suggested a "way out" in a final scene of the play, when the satirical and grotesque elements reach a climax. *Faust* again served as a model for Wedekind, inasmuch as the Masked Gentleman's offer, which snatches Melchior from the temptation of suicide, has a clearly Mephistophilean ring:

> I'll open up the world for you I'll lead you among men. I'll give you the opportunity to broaden your horizons in the most marvelous manner. I will make you acquainted with everything interesting in the world, without exception.

The Masked Gentleman's offer stands in direct contrast to the principle of Herr Gabor, who states that his son should learn "what is *good* rather than what is *interesting,* and should act according to the *law,* rather than according to his natural disposition" (III, 3). Instead of seeing the good and the interesting, law and nature as mutually exclusive opposites, the Masked Gentleman offers a more subtle formula which admits the validity and reality of both standpoints: "I understand morality to be the real product of two imaginary quantities. These imaginary quantities are *obligation* and *volition (Sollen und Wollen).* The result is called morality, and its reality cannot be denied."

The "moral" of *Spring Awakening* is summarized in this aphoristic statement,[23] and may be paraphrased as follows: Morality — defined as the guidelines by which the individual leads his or her life — is a dynamic product of social expectations and individual inclinations. The course of the play demonstrates how the polarization of these concepts leads to disaster. On the one hand, Melchior's attempt to live according to a philosophy of egoism which recognizes only his own volition results in brutality toward others and consequently retribution by the superior forces of society at large. On the other hand, those that live according to social expectations — such as the teachers, Herr Gabor, and, in the final analysis, even Frau Gabor and Frau Bergmann — deny their human inclinations to the extent that they destroy their own offspring.

To overcome this rigid polarization of attitudes, Wedekind argued that the individual must perpetually balance the contradictory dictates of *Sollen* and *Wollen.* In a modern world marked by social change and revaluation of values, the classical notion of the harmonious man who enjoys stable personal and social integration must give way to a dynamic balancing of inner drives and communal demands.[24] This dynamism can best be maintained, according to Wedekind, by consciously loosening up

the rigid dichotomies of thought and perception that characterize con-
ventional morality, and by bringing traditionally polar opposites into
creative interplay: "masculine" and "feminine," mind and body, spirituali-
ty and sexuality are to be seen not as conflicting poles, but rather as com-
plementary pairs that exist in every human being. Realization of this fact
can only be achieved through a radical critique of language — of words,
syntax, conventional logic and systems of thought. Such a critique must
be achieved through deliberate attempts to bypass conventional
categories and to look instead at the changing reality embodied in
oneself and others, and to scrutinize constantly one's own desires as well
as the social expectations that one receives from and transmits to others.

Spring Awakening provides two (not wholly positive) examples of a
conscious balance between personal inclination and social expectation.
One possible model is provided in the penultimate scene of the play, in
the homosexual encounter between Hänschen Rilow and Ernst Röbel. In
typically Wedekindian fashion, the combination of idyllic atmosphere
(vineyard, setting sun, ringing church bells) and homosexuality is intend-
ed both to shock and to unmask the hypocrisy of the middle class au-
dience. After all, homosexuality is a rather logical outcome of a social
system that segregates the sexes during youth; and furthermore,
Hänschen and Ernst are simply emulating the form of eroticism preferred
by the Greek authors whom they are forced to read in school. As in his
masturbation monologue, Hänschen has been able to place the "classical
tradition" in the service of his erotic impulses.[25] Homosexuality is also an
obvious solution to the problem of overcoming the dichotomy of male
and female roles from which Moritz and Melchior suffer.

Hänschen and Ernst do not, however, see their homosexuality as a
defiantly anti-bourgeois stance. Both intend to integrate themselves fully
into bourgeois society, and Ernst even dreams of becoming a "reverend
pastor." Whereas Melchior, the fathers and the teachers take principled
stands either for or against *Sollen,* Hänschen and Ernst see through the
sham facade of bourgeois morality. Hänschen says: "Look, our old men
wear long faces in order to hide their stupidity. Among themselves, they
call each other numbskulls, just as we do. I know that for a fact."
Hänschen has, after all, abducted *Ada* from his father's desk, and hence is
unwilling to take moral lectures from the elder generation too seriously:
"Virtue is becoming, but it must be worn by impressive personalities." He
has every intent of keeping up an outward facade of bourgeois respec-
tability, yet will live his private life according to his own inclinations.

Another mode of balancing sexual inclinations with the demands of
bourgeois society may be seen in the figure of Ilse, who integrates herself
as a model and mistress into the artistic *boheme* (II, 7). This bohemian ex-
istence allows her to lead a life of uninhibited sexual freedom, thus mak-
ing her the erotically most vital child in the play: indeed, many commen-
tators have noted that Ilse is the Masked Gentleman's alter ego, inasmuch
as both are indirectly equated with life.[26] The ostensibly anti-bourgeois

boheme has, in fact, a symbiotic relationship with bourgeois society: the paintings and photographs for which Ilse models are, after all, the type of pictures that end up in the secret drawer of Herr Rilow's desk. Wedekind contends, in essence, that self-prostitution — the forming of com- promises with bourgeois society in some form or other — is inescapable: Ilse earns money as a model and mistress of the artists, while the artists earn money by creating sexually suggestive pictures for bourgeois con- sumption. Ironically, it is the hypocritical closet voyeurism of the repress- ed bourgeoisie that provides the financial base for the anti-bourgeois *vie de boheme*. Ilse, however, takes all of these compromises in stride, and she claims that she is happiest among her artistic friends. *Spring Awaken- ing* implies that the sexual promiscuity and the general *Bürgerschreck* at- mosphere of the bohemians are more natural and more respectable (because more self-consistent) than the guilt-ridden closet eroticism of the middle classes.

The end of *Spring Awakening* leaves the audience with a dynamic no- tion of social integration: it stresses the inevitability of compromising with bourgeois society as well as the rather wide possibilities for self- development open to those who treat social conventions as means rather than as ends. It is important to note that this concept is, structurally speaking, socially conservative. Although Wedekind hoped for a general revaluation of bourgeois values, the fact that he believed that this could be brought about only on an individual basis, and that therefore the in- dividual would have to make compromises with bourgeois society for the foreseeable future, left the basic structures of bourgeois society intact. Wedekind himself became increasingly aware of the implications of this fact, and he soon had to revise the optimistic vision which concludes *Spring Awakening*.

Wedekind's early works suggested that the greatest amount of in- dividual freedom was to be found within various sub- and counter- cultures that existed on the fringes of bourgeois society: in the artistic *boheme* (*Spring Awakening*), in the circus (*The Love Potion*, 1891), and in brothels (*The Solar Spectrum*, fragment, c. 1894).[27] During his im- poverished years in Paris, however, his frequent contacts with pro- letarianized artists, prostitutes and circus performers taught him the misery of such styles of life.[28] Thus already in the *Lulu* plays (first version, 1895), his previous forms of self-expression were negated: the painter Schwarz suffers from his financial enslavement to his bourgeois patrons; the circus performer Rodrigo Quast is a boorish exploiter of Lulu; and Lulu finds the role of artist's model degrading, and later experiences pros- titution as a tormenting and ultimately fatal profession.

Wedekind similarly came to realize that the struggle to maintain a balance between *Sollen* and *Wollen* was much more difficult than he had imagined. Seven months in prison (1899-1900) and several years of poverty and public disinterest were the prices he had to pay for his unwill- ingness to conform too closely to the artistic, moral and political conven-

tions of his time. This realization was reflected in his subsequent plays (*The Tenor*, 1897; *The Marquis of Keith*, 1900; *King Nicolo*, 1902; *Hidalla*, 1904), where the forces of society, usually embodied in the form of unscrupulous entrepreneurs, invariably triumph over the protagonists' attempts to live their lives according to their own values.[29] Wedekind came to see faithfulness to oneself and compromise (however tenuous) with bourgeois society as increasingly irreconcilable goals.

The young generation of expressionist dramatists had reached this same conclusion by the time their works began to be written after 1910: indeed, it was the question of the necessity of compromising with social realities that divided them most from Wedekind. Granted, almost all of the important early expressionist plays were written under the influence of Wedekind's works, and especially of *Spring Awakening*, which was performed throughout Germany following the Berlin premiere under the direction of Max Reinhardt in 1906. Both the themes (sexuality, generational conflict, limits of language) and the style (episodic structure, monologues, fantastic imagery) influenced such important early expressionist works as Reinhard Sorge's *The Beggar* (written 1911), Arnolt Bronnen's *Parricide* (1913), Walter Hasenclever's *The Son* and *Humans* (1913, 1918), and Hanns Johst's *The Young Man* (1916). The young expressionist playwrights were especially fond of paraphrasing the grotesque imagery of the final scene of *Spring Awakening*: at the beginning of *Humans,* a dead man rises from his grave and receives his severed head in a sack from his murderer, while at the end of *The Young Man,* the deceased hero witnesses his own funeral while sitting on a graveyard wall, then leaps forth into the audience.

It is important to note, however, that *Spring Awakening* was just one influence among many upon nascent expressionist drama. Although it remained the most significant theatrical portrayal of generational conflict, several prose works appeared after 1900 which treated the problems of youth (Hesse's *Under the Wheel,* Musil's *Young Törless,* Emil Strauss' *Friend Hein,* Friedrich Huch's *Mao,* Thomas Mann's short stories, etc.).[30] Indeed, it was not literature, but rather the rapid growth of the *Wandervogel* movement after 1900 that brought generational issues to the attention of society at large. Similarly, by 1900 numerous writers had begun questioning the ability of language to communicate emotional experience or, indeed, anything at all (cf. Hofmannsthal's "Chandos" letter).

Hasenclever's *The Son,* the first expressionist drama to enjoy public success, indicates well both the Expressionists' proximity to and their distance from Wedekind. The superficial similarities between Hasenclever's play and *Spring Awakening* are striking. The Son's imagination, like that of Moritz and Melchior, is fired not only by *Faust,* but also by Homer, Kleist, and above all Schiller's "Hymn to Joy" in Beethoven's musical setting. Like the Masked Gentleman, the Friend opens up the world to the Son, and even dons the black mask and tailcoat that Wedekind wore when he played that part in Reinhardt's production of

Spring Awakening. The Father plays the role of, and speaks lines strongly reminiscent of Herr Gabor: whereas the latter claims that Melchior is "rotten to the innermost core of his being" (III, 3), the former claims that the Son is "corrupted to the bottom of his character."[31] Furthermore, there are striking parallels with other Wedekindian plays (cf. *the Son,* act III and *Hidalla,* act IV).

Such obvious similarities should not, however, blind one to the great differences between the plays. After all, a rather irate Hasenclever wrote in 1918: "Many of my friends and foes compare me with Schiller or Wedekind. They are wrong. My name is Hasenclever."[32] The latter could justifiably stress his distance from Wedekind: indeed, by means of three obvious paraphrases of *Spring Awakening,* he might actually have desired to underscore the difference between that play and his own work and thus to criticize Wedekind. The first scene of Hasenclever's drama indicates that the Son has purposely failed his *Matura* examination: in contrast to Moritz, who strives desperately for scholastic success in keeping with his parents' desires, the Son consciously rejects the compromise with the educational system that passing the examination would symbolize. Secondly, in the nighttime scene in Melchior's study, Moritz dreamily looks out of the window and says:

> How the light of the moon suffuses the garden, so deeply, as if it went to eternity. — Under the bushes flower-bedecked figures appear, and they flit in a breathless bustle over the glade and disappear in the semidarkness. It seems as if a meeting is taking place under the chestnut tree. — Shouldn't we go outside, Melchior? (II, 1)

The latter, however, resists this temptation, and prefers to stay inside and drink tea. In contrast, during the second act of Hasenclever's play, which is similarly set in the Son's study overlooking a park, Moritz's dreamy apparitions acquire flesh, blood and ammunition: the Friend tells the Son that "many friends whom you don't know are prepared to help you tonight. They are standing with revolvers behind the trees in the park."[33] The Son takes advantage of this opportunity to escape from home. Finally, whereas Herr Gabor sends Melchior to reform school, the Father's threat to do likewise induces the Son to draw his pistol at the end of Hasenclever's play.[34]

In these parallel situations, Hasenclever's Son exemplifies a much more radical break with parental expectations and a turn to violence. Whereas Wedekind had depicted the maintenance of individuality as a precarious balancing act within the context of bourgeois society, the Son proclaims at the outset of the play his disdain for outward reality and his adoration of his inner self: "Can't you see, man: one lives only in ecstasy, reality would make one confused. How beautiful it is, to experience again and again that one is the most important being in the world!"[35] The Son grounds this self-confidence not only upon his individual self, but also

upon a transcendent dimension that finds expression through him. Unlike Wedekind's characters, he speaks frequently of "God," and he consciously tries to replace the "arbitrary" laws of bourgeois society with the divine law of which youth is the bearer.[36] The Son, strengthened rather than encumbered by this transcendental baggage, is able to resist reality and to mould it to his will through violent acts, such as the mass uprising of youths (acts III and IV) and ultimately parricide (act V).

Hasenclever, like other expressionist dramatists, sought to concretize utopia on stage, insofar as he portrayed the individual as a potent moulder of an infinitely malleable reality. By stressing the supposed inevitability of working within the context of bourgeois society, Wedekind had narrowed the options available for self-realization, and he himself was forced to conclude in his later plays that the individual who worked within bourgeois institutions would ultimately be crushed by them. Hasenclever and the other Expressionists could escape from this dilemma only by means of a utopian vision: "Since we cannot portray the impossible by means of the possible, let us at least renounce every possibility!"[37] This utopianism of the early Expressionists was encouraged by the fact that certain historical developments suggested that their "impossible" vision might be possible after all. The rapid growth of the youth movement after 1900 suggested that young people might in fact be able to organize themselves in opposition to parental society. Moreover, when war broke out in August 1914, it was greeted joyfully by many Expressionists who thought that bourgeois society was on the verge of destruction and that a new culture based upon innate human or divine laws could be constructed on its ruins.

Glorification of war was an example of a fundamental paradox latent in early Expressionism: namely, that the attempt to defend the individual against outside infringements and to make reality amenable to his will often led to an objectification of all other subjects. This becomes strikingly clear in expressionist attitudes towards women. The ideal of womanhood presented in early expressionist dramas is that of a self-sacrificing subordinate to the male *Ich* (cf. the Girl in *The Beggar* and the Miss in *The Son*). Alongside this ideal of selfless womanhood is the alternate image of woman as a chalice of animal sexuality (cf. the mother in *Parricide*). Wedekind's plea for a realistic image of woman as neither selfless servant nor lustful degenerate had fallen on deaf ears. Indeed, the Expressionists were so out of tune with Wedekind's notion of eroticism that Paul Kornfeld accused him of totally neglecting *Geist* in favor of animal sexuality.[38] Hasenclever in particular failed to overcome the traditional elevation of spirituality over sexuality: he regarded eroticism as valuable only insofar as it nourished *Geist*. The Son tells the prostitute Adrienne: "You awaken my slumbering talents. Since I have known you, I see many things clearer in me. The pleasure I derive from your sex stimulates thought. One continually finds a path back to oneself."[39] Sexual experience with the female Other is merely a station along a circular path that continually returns to the male *Ich*.

The sense of divine inspiration, the emphasis on individual *Geist*, the utopian vision of radically restructuring the world, and the call to violence combined to give the Expressionists a pathetic tone (and an oft-noted lack of humor) which distinguished them clearly from Wedekind. In contrast to the Expressionists, whom he described as "*Stringhügeln* and *Wedebabies*,"[40] Brecht regarded himself as the true inheritor of the Wedekindian tradition. War and revolution had demonstrated that social reality, although highly fluid, was not as malleable to immediate utopian solutions as the Expressionists had envisioned. Brecht proposed, in essence, an *Aufhebung* of the expressionist and Wedekindian positions. From Wedekind he accepted the idea that the individual's relationship with society was dynamic. Yet whereas Wedekind could not see beyond the contours of bourgeois society, Brecht came to agree with the Expressionists that a society radically different from the present one was a realizable goal. Successful realization of this vision was not, however, to be the immediate product of the religiously infused subject moulding a freely malleable society, but rather a result of laborious efforts on a day-to-day basis within social reality. The Expressionists envisioned a politics of clean souls, if not clean hands: yet Brecht recognized that progress could be achieved only by making calculated compromises with the bourgeois world. This fact, an important part of Wedekind's message, is what makes a character such as Brecht's Galileo a truly Wedekindian figure.

Brecht learned from Wedekind not only about the relationship between individuals and society, but above all about the necessity of creating new forms of theater that transcended the absolute stances implicit in traditional genres. Humor was necessary, but not the "sublime" humor of classical comedy which preached forgiveness of errors due to the vanity of all human endeavors; seriousness was required, but not the pathos of either classical tragedy or expressionist drama, which saw an immutable divine order embodied in, respectively, an external world governed by fate or a divinely-infused inner soul. In place of comedy and tragedy, Wedekind fostered the genres of satire and grotesque, which expressed much more realistically the mutable nature of both individual will and social reality, and thus opened the way for personal engagement outside of the auditorium. Moreover, inasmuch as satire and the grotesque underscored contradictions latent in conventional values and institutions, insofar as they made supposedly familiar thoughts and establishments appear estranged from their traditional purpose and meaning, these genres foreshadowed the *Verfremdungseffekt* which Brecht consciously formulated in his later years.

Finally, both Brecht and Wedekind — in contrast to classical tragedians and expressionist dramatists — regarded the theater as an institution for both entertainment and learning simultaneously. In contrast to the prevailing German attitude, neither of them believed that amusement and moral education were mutually contradictory: indeed, they agreed

that the institutions least suited to true learning and to serving life were pedantic schools and sublime theaters. Wedekind hoped that middle-class people would stop being bourgeois and start being *Lebenskünstler,* people who saw their lives as challenges, as constantly refashionable works of art, as joyful experiences. Although Wedekind increasingly despaired of the joyful nature of this enterprise, Brecht, himself acutely aware of the brutalities of everyday life, nevertheless held up hope when he wrote: "The theater of the scientific age is capable of making dialectics pleasureable. The surprises of progress as it logically strides or leaps forward, the instability of all conditions, the humor of contradictions etc., these are amusements derived from the vitality of people, things and processes and they enhance the art of life as well as the joy of living."[41]

Notes

I would like to thank the German Exchange Service (DAAD) for making research for this article possible.

[1]The best discussions of *Spring Awakening* are probably those of Friedrich Rothe, viz. *Frank Wedekinds Dramen: Jugendstil und Lebensphilosophie* (Stuttgart 1968), and especially the pronounced formulation of the social issues in *"Frühlings Erwachen.* Zum Verhaltnis von sexueller und sozialer Emanzipation bei Frank Wedekind," in *Studi Germanici,* vol. 7 (1969), p. 30-41. Other discussions of the play may be found in the two best German studies on Wedekind, viz. Arthur Kutscher, *Frank Wedekind: Sein Leben und seine Werke* (3 vols., Munich 1922-31), which is still the most complete biography of Wedekind, and Hans-Jochen Irmer, *Der Theaterdichter Frank Wedekind: Werk und Wirkung* (Berlin 1975), as well as in the two most extensive English-language studies, viz. Sol Gittleman, *Frank Wedekind* (New York 1969), and Alan Best, *Frank Wedekind* (London 1975). Another important work, which describes the stagings of Wedekind's plays, is Gunther Seehaus, *Frank Wedekind und das Theater* (Munich 1964).

[2]Theodor Adorno, "Frank Wedekind und sein Sittengemälde 'Musik', " in *Noten zur Literatur* (Frankfurt/M 1974), p. 621.

[3]For the concept of "affirmative culture" in nineteenth-century Germany, see Herbert Marcuse, "Über den affirmativen Charakter der Kultur" (1937), in *Kultur und Gesellschaft I* (Frankfurt/M 1973), p. 56-101.

[4]Cf. Friedrich Wedekind's hymn to Schiller, cited in Kutscher, *Frank Wedekind,* vol. 1, p. 6-7.

[5]For the concept of "aesthetic paganism," see Henry Hatfield, *Aesthetic Paganism in German Literature from Winckelmann to the Death of Goethe* (Cambridge, Mass. 1964). Heine's relation to this tradition as well as to Saint-Simonianism is the subject of Dolf Sternberger, *Heinrich Heine und die Abschaffung der Sunde* (Hamburg 1972). For the literary preferences of the young Wedekind, see Kutscher, *Frank Wedekind,* vol. 1, p. 50-56.

[6]Cf. Irmer, *Der Theaterdichter,* p. 195-214 ("Faust-Figur und Welt-theater"), and Hector MacClean, "Wedekind's *Der Marquis von Keith:* An Interpretation based on the Faust and Circus Motifs," in *Germanic Review,* vol. 43 (1963), p. 163-87.

[7]Heine, "Zur Geschichte der Religion und Philosophie in Deutschland," in Heine, *Beiträge zur deutschen Ideologie,* ed. Hans Mayer (Frankfurt/M 1971), p. 43.

[8]Wedekind, "Aufklärungen," in *Werke* (3 vols., Berlin 1969), vol. 3, p. 233.

[9]Cited Kutscher, *Frank Wedekind,* vol. 1, p. 235.

[10]Roman and arabic numerals in the text refer respectively to the act and scene numbers of *Spring Awakening.*

[11]The equation of feminity with the forces of exterior nature first occurs at the begining of I,3: Martha: "How the water seeps into my shoes!" Wendla: "How the wind whistles by my cheeks!" Thea: "How my heart is hammering!" The infusion of the girls with natural forces, the fact that they are walking arm in arm, and the subsequent discussion of the virtues of being loved by a man all point to a concept of femininity that values communion with nature and with other humans, to the point of submission and loss of self. This stands in direct contrast to the maintenance of selfhood in the masculine role, which takes an extreme form in Melchior (see discussion below).

[12]As an adolescent, Wedekind held a pessimistic world-view similar to that of Melchior (including atheism and the philosophy of egoism), which he eventually overcame due to a belief in the power of eroticism to transcend the isolation of the self. Cf. Kutscher, *Frank Wedekind,* vol. 1, p. 40-42, 89-95.

[13]Wedekind noted that many of the school incidents depicted in *Spring Awakening* actually took place. He was especially shocked by the suicides of two of his schoolmates: cf. Kutscher, *Frank Wedekind,* vol. 1, p. 38-39. In his poem "Santa Simplicitas" (1883), he described how the Rektor's funeral oration at the grave of one of the suicides turned into a tirade against the deceased: cf. *Werke,* vol. 2, p. 658-63. In later years, Wedekind claimed that the father of one of the suicides actually said, "That was not my son" ("*Der Junge war nicht von mir*"): cf. *ibid.,* vol. 3, p. 338. For a discussion of the impact of pupil suicides on the public consciousness during the Wilhelmine period, see Sterling Fishman, "Sex, Suicide, and the Discovery

of the German Adolescent," in *History of Education Quarterly,* vol. 10 (1970), p. 170-88.

[14]See the discussion of "Kunstkartenprozesse" in Ludwig Liess, *Kunst im Konflikt: Kunst und Künstler im Widerstreit mit der Obrigkeit* (Berlin 1971), p. 245-67. Postcards of nudes by Michelangelo, Palma Vecchio, Titian, Veronese, Giorgione, Corregio, van Dyck, Rubens and Ingres were frequently confiscated by the police.

[15]Wedekind, *Werke,* vol. 3, p. 234.

[16]Wedekind, *Werke,* vol. 3, p. 338.

[17]". . .I'll scream! Scream! — To be you, Ilse! — Priapia!! — Oblivion! — That's too much for me! — This happy, this radiant child — this *fille de joie* on my path of sorrow! — Oh! — Oh!" Cf. Hermann Bahr's famous definition of Expressionism, in *Expressionismus* (Munich 1920), p. 111: "Never had man been so small. Never had joy been so far away and freedom so dead. So anguish let forth a scream: man screams for his soul, the whole era becomes a single scream for help. Art screams too, deep into the darkness, it screams for help, it screams for spirit: that is Expressionism."

[18]For a discussion of the works of these dramatists and of their influence on Wedekind, Karl Kraus and Brecht, see Max Spalter, *Brecht's Tradition* (Baltimore 1967).

[19]Such a collectivity cannot be formed because even though all children go through a similarly constraining socialization process, many of them identify opportunistically with the school system and with the general values of the adult world: Cf. Rothe, *"Frühlings Erwachen,"* p.37-38.

[20]Schiller, *Über naive und sentimentale Dichtung* (Stuttgart 1975), p. 42.

[21]Arnold Heidsieck, *Das Groteske und das Absurde im modernen Drama* (Stuttgart 1969), p. 17.

[22]Bertolt Brecht, "Vergnügungstheater oder Lehrtheater?" (1936), in *Schriften zum Theater: Über eine nicht-aristotelische Dialektik* (Frankfurt/M 1957), p. 64.

[23]This phrase is the subject of an exchange of opinions in *New German Studies,* vol. 1 (1973): Keith Bullivant, "The Notion of Morality in Wedekind's *Frühlings Erwachen"* (p. 40-47), and Alfred D. White, "The Notion of Morality in Wedekind's *Frühlings Erwachen:* A Comment" (p. 116-18).

[24]Elsewhere, Wedekind used the image of a tightropewalker to stress this dynamic equilibrium: see "Zirkusgedanken" (1887), in *Werke,* vol. 3, p. 153-62.

[25]It is interesting to note that a reviewer of the Berlin premiere of *Spring Awakening* deplored the censorship of this scene, which he considered "a delightfully charming hellenic idyll, which only dirty minds can interpret in a dirty manner"

("ein Idyll von lieblichster hellenischer Anmut, das nur unsauberer Sinn unsauber deuten kann"): Karl Strecker in the *Tägliche Rundschau* (Berlin), n. 549, 23 November 1906.

[26]When the dead Moritz rebukes the Masked Gentleman for not having appeared to him before his suicide, the latter replies: "Don't you remember me? You too stood between *death* and *life* at the last moment." Moritz stood, in fact, before Ilse immediately prior to his suicide.

[27]For an interesting article that examines the elements of "epic theater" in this fragment, see Edward Harris and John Fuegi, "Frank Wedekind's 'Epic Theater' Model: *Das Sonnanspektrum* and its Indian Source," in Ralph Ley, et al., eds., *Perspectives and Personalities: Studies in Modern German Literature Honoring Claude Hill* (Heidelberg 1978), p. 125-34.

[28]See Wedekind's very interesting and sometimes (inadvertently) moving notebook entries: "Pariser Tagebuch," in *Werke*, vol. 3, p. 281-331.

[29]Elsewhere I have attempted to explain the development of Wedekind's critique of commercial capitalism in his later works as a response to his experience in the culture market: cf. Peter Jelavich, "Art and Mammon in Wilhelmine Germany: The Case of Frank Wedekind," in *Central European History*, vol. 12 (1979), p. 203-236. Whereas *Spring Awakening* influenced the early expressionist dramas, which were mainly concerned with generational conflicts, Wedekind's later plays influenced anti-capitalist dramas stretching from Sternheim and Kaiser to Brecht and Durrenmatt.

[30]For background on the theme of generational conflict in expressionist drama, see Peter Uwe Hohendahl, *Das Bild der bürgerlichen Welt im expressionistischen Drama* (Heidelberg 1967), p. 80-93.

[31]Walter Hasenclever, "Der Sohn," in *Gedichte, Dramen, Prosa* (Reinbek bei Hamburg 1963), p. 149.

[32]Hasenclever, "Kunst und Definition" (1918), *ibid.*, p. 504.

[33]Hasenclever, "Der Sohn," p. 124.

[34]*Ibid.*, p. 154.

[35]*Ibid.*, p. 103.

[36]Cf. Hasenclever's explication of *The Son* in "Kunst und Definition," p. 504-05.

[37]Hasenclever, "Das Theater von morgen" (1916), in Otto F. Best, ed., *Theorien des Expressionismus* (Stuttgart 1976), p. 213.

[38]Paul Kornfeld, "Wedekind" (1918), in *Revolution mit Flötenmusik und andere kritische Prosa 1916-1932* (Heidelberg 1977), p. 51-54.

[39]Hasenclever, "Der Sohn," p. 141.

[40]Brecht to Caspar Neher, June 1918. The full passage reads: "This Expressionism is awful. All feeling for beautifully

rounded and splendidly uncouth bodies withers away as the hope for peace. Spirit triumphs at every corner over vitality. It puffs itself up with mysticism, cleverness, consumption, bombast, and ecstacy, and everything stinks of garlic. They're going to kick me out of the heaven of these noble and spiritual people, these *Stringhügeln* and *Wedebabies*..." Caspar Neher, *Buhne und bildende Kunst im XX. Jahrhundert* (Velber bei Hannover 1966), p. 89, cited in Gerd Witzke, *Das epische Theater Wedekinds und Brechts: Ein Vergleich des frühen dramatischen Schaffens Brechts mit dem dramatischen Werk Wedekinds* (diss. Tubingen 1972), p. 6. This dissertation is by far the most extensive comparison of Wedekind and Brecht. Works in Engish on the subject include Max Spalter, *Brecht's Tradition;* and Sol Gittleman, "Frank Wedekind and Bertolt Brecht: Notes on a Relationship," in *Modern Drama,* vol. 10 (1967-68), p. 401-09.

[41]Brecht, *Schriften zum Theatre,* p. 173.

7
The Unfinished Legacy of Early Expressionist Poetry: Benn, Heym, Van Hoddis and Lichtenstein

Mark Ritter

"The heritage of Expressionism is not yet over, for it has not yet even been started."[1] With these typically cryptic words, Ernst Bloch attempted to put an end to the famous "expressionism debate" in 1938.[2] There is one group of Expressionists for whom the term "unfinished legacy" is especially apt: the lyric poets of early Expressionism. A number of these poets (Trakl, Benn, Heym and Stadler) are among the handful of Expressionists still known to other than specialist readers today. Benn was controversial his whole life, but the others tended to be eclipsed with the movement's demise around 1925 and were not rediscovered until the post-war period. In this sense their legacies were unfinished at the time of Bloch's essay.

It is also worth recalling that three of the four poets listed above (and at least half a dozen, less prominent, others) failed to survive the First World War.[3] Had they been able to continue their creative activity, there is

no doubt that literary Expressionism would have been considerably different, and probably better. In this sense, too, the legacy of Expressionism is unfinished.

But the most important aspect of the unfinished legacy of early Expressionism is its effects on later generations of writers. One would be hard pressed to find examples of actual copies by later poets, except for a spate of Benn imitations in the 1950s, but, consciously or not, later poets were working in territory staked out by the early Expressionists. This essay will seek to show that their primary contribution was a poetry of discontinuous and fragmented reality that reflected the fragmentations and upheavals of bourgeois society.

First, however, a caveat is in order. Many treatments of Expressionism, even a recent German survey for students, cultivate the assumption that Expressionism was a unified movement whose theoretical base is established in the manifestoes of Edschmid and others.[4] In fact these documents stem from a later date and have precious little to do with early Expressionism.[5]

One does much better to conceive of early Expressionism as a number of loosely connected circles, primarily in Berlin. The oldest of these is *Der neue Club*, founded in 1909 by a group of students led by Kurt Hiller. Members who became important poets of early Expressionism include Georg Heym, Jakob van Hoddis, Alfred Lichtenstein and Ernst Blass. From 1910 to 1912, the club presented a dozen or so "cabarets" in which members read from their works and those of poets they admired.[6] These were held in various cafes, which even more than for previous generations served as focal points of literary life.[7] In particular, the *Cafe des Westens* on the *Kurfürstendamm* served as the clearinghouse and literary stock exchange of Expressionism. There new arrivals to Berlin checked in, and there too, Franz Pfemfert and Herwarth Walden, publishers of the two leading expressionist journals (*Die Aktion* and *Der Sturm*, respectively), held court. Other publishers and literary figures built up circles in the *Cafe des Westens* and elsewhere, which were intricately interlinked and constantly changing and feuding with each other. The atmosphere in those years on the eve of the World War, by all accounts, was electrified.[8]

Beyond the feuding and the plethora of different styles, there are certain attitudes that all the early Expressionists share. All were opposed to contemporary Wilhelminian society in art as in life, but at this early date they were on the whole as apolitical as the middle class from which they came (Franz Pfemfert is a notable exception). Consequently one looks in vain in the works of these Berlin poets for utopian sentiments or appeals to brotherhood and love. Nor did the early Expressionists wholeheartedly condemn modern society's technology and cities. In a good many of their poems they betray a fascination with the urban landscape and modern means of transportation.

Perhaps the major tenet of this literary revolt was a conviction that the younger generation must restore honesty to a literature that had lost its way in sterile aestheticism or sentimental lyricism. Georg Heym's condemnation of Stefan George (whom he had imitated in his early years) and Kurt Hiller's polemic "Against 'Lyric Poetry'" illustrate different aspects of the same striving.[9] The clearest formulation of the ideal of honesty occurs in Ernst Blass's preface to his collection of poetry, *Die Strassen komme ich entlang geweht* (1912), probably the closest approximation to a manifesto to be found in pre-war Expressionism. Blass justifies his selection of poems on the grounds that all reflect moods of his: "My feelings this evening are not in any poem in this book — nonetheless, the poems in this book are my feelings."[10] These personal reflections soon give way to a discussion of the poetry of the future. Poetry must become intellectual: "One who understands while writing: that is what the poet of the coming decades will be."[11] Such a poet will not be able to ignore the mundane aspects of day-to-day existence:

> This will be in his strains: knowledge of the flatness of life, its ordinariness, dullness, idiocy, shame and nastiness. The strains of the coming poet will not be "pure" and "from the depths." He will not be just a blissfully potent primitive, but a person who realizes and admits that one is sometimes stuck in quite ordinary situations.[12]

Besides being honest in reflecting life as it is actually lived, the poet of the future must also be "someone who looks for the non-swampy ground for humanity's march forward, someone who struggles for progress (I know what I'm saying)."[13]

These views are strongly influenced by Hiller and they also reflect Blass' personal style.[14] Nonetheless, the preface expresses a general mood in literary circles of Berlin at the time. Not all poets adopted Blass's dry, urbane style, but most sympathized strongly with his call for poetry to deal with the real stuff of life rather than the artificial problems of aesthetes.

Nowhere was the trend to honesty more brutally apparent than in *Morgue* (1912), Gottfried Benn's first collection of poems. Benn was attempting on one level to come to terms with the harsh realities of his practice as a young doctor in a Berlin hospital, but his subject matter was just as clearly intended to shock the bourgeoisie. Consider, for instance, the parodies of traditional sentiments in "Kleine Aster":

> A drowned beer trucker was lifted onto the table.
> Someone had stuck
> a dark bright mauve aster between his teeth.
> As I was cutting out
> his tongue and palate,
> starting from the chest and working
> under the skin with a long knife,

I must have bumped it, because it slipped
into the brain nearby.
I packed it into his chest cavity for him
in the excelsior
while he was being sewed up.
Drink your fill in your vase!
Rest in peace,
Little Aster![15]

The poem's style and form must have been nearly as shocking at the time as its subject matter and crass tone. The original German has only two pairs of rhymes, which may or may not be intentional, and the lines have no fixed meter. Their length is determined by considerations of effect; particularly important words are reserved for line endings and beginnings. It might seem far-fetched to consider this poem a forerunner of Brecht's "rhymeless poetry with irregular rhythms," but it must be conceded that Benn's type of free verse is closer to the latter than to the hymnic or dithyrambic modes that largely dominated German free verse from Klopstock and Novalis to Rilke. Besides directly assaulting bourgeois sensibilities with the poem's content, Benn clearly intended to parody the literature of preceding generations. The final lines are plainly enough a persiflage of sentimental nature lyrics for Philistines; less obviously, the rather precious adjective, "dark bright mauve" ("dunkelhellila"), and perhaps even the poems' clinically precise descriptions, mock the "impressionism" and "realism" of the culturally leading classes.

Benn's contempt for the bourgeoisie of Berlin is revealed much more directly in "Night Cafe" ("Nachtcafe"):

824: The Love and Life of Women.
The 'cello has a quick drink. The flute
belches throughout three beats: his tasty evening snack.
The drum reads on to the end of the thriller.

Green teeth, pimples on his face,
waves to conjunctivitis.

Grease in his hair
talks to open mouth with swollen tonsils,
faith, hope and charity around his neck.

Young goiter is sweet on saddle nose.
He stands her three half pints.

Sycosis buys carnations
to mollify double chin.

B flat minor. sonata op. 35.
A pair of eyes roars out:
Don't splash the blood of Chopin around the place
for this lot to slouch about in.
Hey, Gigi! Stop!

The door dissolves: a woman.
Desert dried out. Canaanite brown.
Chaste. Full of caves. A scent comes with her. Hardly scent.
It's only a sweet leaning forward of the air
against my brain.
A paunched obesity waddles after her.[16]

The dominant device of the first six strophes, metonymy, is known from classical rhetoric; Benn's innovation is to apply it more radically and consistently than had been done previously, and with medical terminology. The denizens of this cafe thus lose their individuality and their actions acquire a grotesque typicality. Only the exotic woman and the poetic subject are exempted from depersonalization. Their fleeting relationship, and the vision it engenders, are abruptly terminated by the entrance of an "obesity," presumably her husband.

A *curriculum vitae* that Benn wrote in 1921 for what he promised would be his final collected works provides insights into his state of mind in the expressionist period.[17] He had experienced a crisis in his medical practice:

> I had originally been a psychiatrist, an assistant in an insane asylum, until at the age of 26 I began to notice an unusual phenomenon, which became more and more critical; in short, I was no longer able to muster any interest in an individual case.[18]

Benn turned twenty-six in 1912, the year *Morgue* was written. Just as the persona of those poems displays no compassion for the individuals on his autopsy table, the poetic subject in "Night Cafe" has no interest in the individuals he sees there. Using his scientific training, Benn attempted to discover the source of his curious malady:

> I delved into descriptions of that condition known as alienation or depersonalization of the sphere of perception. I began to recognize that the ego was a structure that was striving with a force, next to which gravity is like the pull of a snowflake, for a condition in which nothing that modern culture calls an intellectual faculty is important, but where everything civilization, led by academic psychiatry, had made disrespectable and labelled neurasthenia...admitted the deep, limitless, mythically ancient alienation between the ego and the world.[19]

Benn's realization of the disassociation of perception in bourgeois society is of central importance, both for his own poetry and for Expressionism in general.

Benn's concept of alienation is, of course, not that which is ordinarily used in sociology or political philosophy, but it is illuminated by the concept of "ego dissociation" used by Vietta and Kemper in their recent study of Expressionism.[20] In their view, this psychological condition

played as great a role in the development of Expressionism in general as it appears to have done in Benn's personal life. Doctor Benn's dilemma in fact expresses the crisis of subjectivity in bourgeois society.

At least as important for Benn as his alienation from the world is his belief that an overwhelmingly regressive force lurks within the modern civilized mind; the operative word in the passage quoted above is "mythically ancient." A large part of the woman's attraction in "Night Cafe" is her ability to call forth in the poet associations with Mediterranean antiquity ("desert," "Canaanite brown"). Benn depicted this "thalassic regression" in a number of his best known expressionist poems, such as "Karyatide" or "D-Zug," and in nearly all of his poetry from the 1920s and 1930s. He became progressively more obsessed with what he sometimes called "Ligurian complexes," that is, a series of visions of a blissful world of instinctual life and, often Dionysian ecstasy, in which the poetic subject can briefly overcome the fragmentation produced by modern intellectuality. "Songs" written in 1913, reaches what must be a peak in the glorification of the instincts (I quote only the first strophe):

> Oh, that we were our primal ancestors
> In a warm bog a little clump of slime
> That from our sap, mute plasm and blind spores
> Cool deaths, calm lives to viewless growth might climb.[21]

It was this celebration of the instincts and the concomitant denigration of rationality which led Benn briefly into the arms of the Nazis, and which rouse the justifiable anger of Marxists. There was an irrational component in nearly all expressionist works, but nowhere was it comparable with Benn's position. Significantly, Bloch defended Expressionism against Ziegler's attacks, but not Benn himself.

Benn's formal development was as distinctive as his formal evolution. Both "Little Aster" and "Night Cafe" are in free verse, as is typical of Benn's early work, but the excerpt from "Songs" already displays rhyme and regular meter in the original. In a strict form Benn found the opportunity for "artistic transcendence," which seemed to offer the only defense against nihilism.[22] Other Expressionists, to the extent that they underwent any formal development at all, tended to move away from traditional forms — either in the direction of experimentation (Stramm and other adherents of the *Wortkunst* propagated by Herwarth Walden) or of undisciplined rhetoric (Becher, Rubiner, and a host of others). None of them took up the dry, spare free verse of Benn's earliest work; that was left to the writers of the 1920's.

Georg Heym has become associated with the Expressionists because of the extraordinary power of his images, despite the fact that his poetry is formally very conventional. Born in 1887, a year after Benn, he died on January 12, 1912 when he fell through the ice while skating. Nonetheless, he left behind a large opus of poems which includes some of the most fre-

quently anthologized expressionist poems that have inspired a great deal of critical literature. His earliest poetry (from 1903) follows the prevailing neo-romantic style, although even as a schoolboy Heym reveals an unusual fascination with death. His actual breakthrough to an expressionist style occurs around the beginning of 1910. Heym's opus includes some surprisingly tender love poems and striking nature poems, but he is most famous for his demonic visions of modern industrial civilization and the city, and it is these which had the greatest impact on other Expressionists.

Heym's diary, as might be expected, chronicles in great detail his puberty crises and his conflicts with his authoritarian Prussian father, but it also offers some historical insights. The salient feature of the bourgeois Wilhelminian world for which he was being prepared in school and university was monotony, a monotony so crushing that any change would be welcome: "If only something would happen . . . If they just start a war. Even if it's an unjust one."[23] A contemporaneous text reveals a somewhat broader perspective: "Our disease is to be living in the twilight of history, in an evening that has become so stuffy one can hardly withstand the odor of its rottenness anymore."[24]

In Heym's mature poetry one constantly encounters references to the end of history (a theme he and Van Hoddis inaugurated in Expressionism). "Umbra Vitae," for instance, begins:

> The people on the streets draw up and stare,
> While overhead huge portents cross the sky;
> Round fanglike towers threatening comets flare,
> Death-bearing, fiery-snouted where they fly.[25]

The "fanglike towers" strike one as rather archaic, and illustrate how Heym transformed neo-romantic elements into modern poetry. The latent doom of "Umbra Vitae" becomes palpable in "War" ("Der Krieg"), of which I quote only the first strophe:

> He is risen who was long asleep.
> He is risen from beneath the vaulted keep.
> In the dark, unrecognized, huge, he stands
> And crushes the moon between his swarthy hands.[26]

The "he" is of course a personification of war, who rises up from the midst of society, the city, where he has been kept prisoner. For Heym, the vision is utmost; hence he is not bothered by the incongruity in his description of a giant who is big enough to block out the moon, but can manage to go unnoticed.

Heym's aesthetically most felicitous poem with a demonic personification is "The God of the City" ("Der Gott der Stadt"), written in December, 1910. Since, unfortunately, no poetic translation is available, the following literal, prosaic rendering will have to suffice for present purposes:

He sits sprawled atop a tract of houses.
The winds lay black around his brow.
He looks in anger out into the distance
Where the last houses straggle into the country.

The evening's red belly gleams at Baal,
The great cities kneel around him.
Enormous numbers of church bells rise up
To him like waves from a sea of black towers.

Wild as the dance of corybantes, the music
Of the millions rumbles through the streets.
The fumes of smokestacks, the clouds of factories
Drift up to him like bluish incense smoke.

The weather smoulders in his eyebrows.
Dim evening is stupefied into night.
Storms flapping around him like vultures
Gaze out of his hair, which stands on end in rage.

He sticks his butcher's fist into the darkness.
He shakes it. A sea of fire races
Through a street. And the glowing smoke roars
And consumes it, until the day dawns, late.[27]

The form of the original poem is quite conventional — iambic pentameter lines arranged into strophes with alternating rhyme — but its content was revolutionary in several respects. Heym's use of language is quite different from that of *fin-de-siecle* poets; throughout, he mixes words from the modern and the ancient, the sacred and the profane spheres, and his frequent use of active, even violent, verbs creates a dynamism that extends even to static objects. The purpose of this diction, like that of his descriptions generally, is visionary intensity rather than fidelity to nuances.

One is immediately struck with the matter-of-factness with which the poem announces the presence of the god; Heym is clearly operating on the visionary plane, where the logic of the dream or the hallucination is in force. This deity seems to be lord not only of the city (indeed, cities in general), but also of the weather. He has obviously antique and pagan features, but he is worshipped in a Christian manner by a modern city. The people in the city, or more precisely, their hectic activity as a crowd, are equally idolatrous, resembling the Dionysian dances of Greek Corybantes.

In view of past misinterpretations of this poem, it is important to note what it *does not* say.[28] The god does not invade the city, indeed we have every reason to believe he is a normal part of it. Neither does he destroy the city; his random blow consumes only one street, and in the context, that destruction too should be viewed as a normal part of city life. Heym's poem thus provides no support for those critics who interpret it as a prophecy of the destruction later visited on German cities.[29] Instead, Heym is personifying what he perceives to be the city's essence, what Schneider calls its "demonic excessiveness."[30] He may be correct in asserting that for Heym the city was essentially a concentration of energy,

life and sensations, but there are precious few signs of life in this particular poem. Much more prominent is the city's aggressiveness, not only in the form of self-destruction, but also in its anger at the remaining nature it has not yet incorporated (lines three and four of strophe one). In fact, the city has reached a stature equal to nature, or at least to the elements of the weather, which dwell on and around the god's head. Despite the images from antiquity, this is clearly an industrial city which shares many attributes with the "tentacular city" described by the Belgian poet Emile Verhaeren some fifteen years before Heym's poem was written. Heym's use of mythic imagery is not meant exclusively to glorify the subject, as was the case in some German naturalist urban poems.[32] The god of the city is in fact a critique of the rapacity of modern industrialization and obliquely, of the mad and destructive pace of urban life.

Still, the god of the city possesses a certain grandeur — the poet does not find him totally negative. Nonetheless, Heym is among the least ambivalent of Expressionists with respect to what the Germans call *Zivilisation*, that is technology, communications, industry and politics. His demonic images, his obsession with death (as manifested, for instance, in his cycle *The Homeland of the Dead* and his fondness for images of decay (as in *Ophelia*) all indicate his revulsion at the modern world. Heym also wrote a number of poems about the French Revolution, but he exploited it largely for its seemingly pointless violence (as in "Robespierre") and not as an attempt at liberation. His poetic universe is oddly closed; it is full of movement, but movement in a circle. He likes to depict violence, but it too is usually inconclusive and not truly apocalyptic. In "Damnation of the Cities I" an entire city is inhabited by sadists, who parade around ceaselessly, mutilating and violating each other. A glowering red sky threatens, but does not deliver, an end to the misery.

Some would call Heym's static universe mythic, and certainly images from myths and antiquity are very common in his work, but his poems do not explain as a myth should. The stasis in Heym's poetry owes more to his basic disposition than to any beliefs he might have held. Heinz Rolleke has shown how intensely visual his imagination was; he even wrote in his diary that he would have preferred being a painter to being a poet.[33] Heym's desire to fix in his poetry a number of images, some contradictory, some complementary, explains the stasis of his poems better than any philosophical conviction he might have held. Indeed, the very fact that he held no creed, except hatred for his Wilhelminian surroundings, accounts for the pervasive mood of hopelessness and doom that haunts his work. His poems are an attempt to put the nightmare of his own life into words.

Heym was well respected in Berlin during his brief career and earnestly mourned when it came to an untimely end, but his rival in *Neuer Club*, Jakob van Hoddis (a pseudonym for Hans Davidsohn), could claim the honor of having written the most celebrated single poem of early Expressionism. The publication in 1911 of his "End of the World" ("Weltend") caused an immediate sensation and soon inspired imitations.

"End of the World" strikes the modern reader as amusing, but hardly earth-shaking (the text is quoted in Chapter 1, "Expression and Rebellion"). And yet, Johannes R. Becher recalls: "These two stanzas, these eight lines, seem to have transformed us into different beings, to have carried us up out of a world of an apathetic bourgeoisie which we despised and which we did not know how to leave behind."[34] Such profound effects can hardly have been brought about by the poem's subject matter; only the first line makes any reference to the bourgeoisie, after all. What must have struck Becher and his colleagues in early 1911 was the poem's novel form. Its rhyme scheme is conventional and its rhythms almost monotonously regular; it is in fact consciously anti-poetic. Each line contains a distinct image, just as, with one exception, each line is a distinct syntactic unit.

Van Hoddis deliberately tries for disharmony within the poem, just as he consciolusy avoids the musical effects that, say, Rilke was able to achieve with flowing syntax. In this *Simultangedicht* ("simultaneous poem"), heterogeneity is raised to the organizing principle, and thus the individual elements are lowered to a common denominator. It was this to which Becher was referring when he said: "We seemed to be in the grip of a new universal awareness, namely the sense of the simultaneity of events."[35] "The End of the World," Becher continues, shows that ultimately everything in the universe is related to everything else.

Becher's interpretation is written from his position as a comfortably situated Stalinist bureaucrat, and the ultimate connection he alludes to is doubtlessly his ideology. It seems more plausible that an unbiased reader would conclude that there was no connection behind events, or at least, that there is no correlation between what happens in the world and what the "bourgeois" or "most people" think and do. Trains may be falling off bridges, floods rising, storms blowing, but the bourgeois is affected only to the extent that he loses his hat or catches cold. Thus a recent critic has suggested that this is not the end of the world, but the end of the bourgeois world.[36] Van Hoddis' affinities to Heym lie not in his vision of destruction, but in his conception of the world as something that was approaching a crisis people were powerless to avert.

Van Hoddis, oddly enough, wrote only a few more poems in the "associative style" (*Reihungstil*). His mind began to deteriorate soon afterwards, and he had ceased writing entirely by 1914. Alfred Lichtenstein, however, found the associative style exactly what he needed for his subject: life in Berlin. "Morning" ("Morgen"), written in 1913, provides an example of Lichtenstein's associative style:

All the streets lie snug there, clean and regular.
Only at times some brawny fellow hurries by.
A very smart young girl fights fiercely with Papa.
A baker, for a change, looks at the lovely sky.

The dead sun hangs on houses, broad as it is thick.
Four bulging women shrilly squeak outside a bar.

The driver of a cab falls down and breaks his neck.
And all is boringly bright, salubrious and clear.

A wise-eyed gentleman floats madly, full of night,
An ailing god... within this scene, which he forgot
Or failed to notice — mutters something. Dies. And laughs.
Dreams of a cerebral stroke, paralysis, bone-rot.[37]

The final strophe, with its cosmic perspective, is atypical of Lichtenstein in any respect except its irony. His poems in associative style (as distinct from his grotesques in simple, almost free verse) generally leave the disparate images unresolved.

The first two strophes, however, illustrate the connection between the associative style and urban experience. Ten years before this poem was written, the philosopher-sociologist, Georg Simmel, had worked out a brilliant analysis of "The Metropolis and Mental Life."[38] The fundamental fact of life in a great city is the chaotic flood of impressions to which the individual is subjected. The resulting psychic dislocations are responsible, in Simmel's view, for the excessive rationality, the blase attitude and all the other traits generally considered typically urban. Benjamin applied Simmel's urban theories to the poetry of Baudelaire, and recently Vietta has extended them to the analysis of Lichtenstein's poems.[39] He views the *Simultangedicht* (or associative style) as the formal analogue of urban dissociated perception.[40]

These first eight lines of "Morning" also illustrate other typical aspects of Lichtenstein's work. Like most other Expressionists, he preferred to represent "little people" like the smart young girl, the brawny fellow, the four fat women and the two workers or even social outcasts. This affinity for the non-bourgeois types reflects the poet's own highly tenuous and marginal position in bourgeois Wilhelminian society, although it was, at least at first, purely emotional and not political. The lines that introduce each of the first two strophes are also typical of Lichtenstein's very sparse descriptions of the physical setting. His personifications, like the dead sun here, do not serve to invest something dead with dynamic vigor, as Heym's personifications do, but to denigrate the object being personified. Thus, in another poem, Lichtenstein compares streets to dog bones bleaching in the sun, or the moon to a "fat, foggy spider." The total effect is to provide a formal correlative for the grotesque contradictions of modern urban life.

Van Hoddis and Lichtenstein also deserve recognition for their conscious inclusion of the Bohemian subculture of Berlin in their poems. Each man produced poems that rank among the very first in Germany to deal with the new medium of film.[41] Both authors were aware of and represented in their work the escapist functions of these media in modern society, but both were also too much a part of that society to deny the media's attractiveness (see Van Hoddis' "Variete"). The essential attitude in this case, as in so many others, is ambivalence, tempered in Lichtenstein's case by a healthy self-irony.

"The Patent Leather Shoe" (1913) expresses Lichtenstein's understated, sophisticated view of life in Bohemia:

> The poet thought:
> Enough. I'm sick of the whole lot!
> The whores, the theatre and the city moon.
> The streets, the laundered shirtfronts and the smells.
> The nights, the coachmen and the curtained windows,
> The laughter and the streetlamps and the murders —
> To hell with it!
> Happen what may . . . it's all the same to me:
> The black shoe pinches me. I'll take it off —
>
> Let people turn their heads for all I care.
> A pity though, about my new sock.[42]

The poet is in fact tired of the entire Bohemian subculture of bourgeois society in which he moves. The individual elements he lists vary from being unavoidable to being truly obnoxious, and hence his curse is ineffectual, for all the passion with which it is uttered. It too is a pose, as artificial as the world he abjures. Lichtenstein surely meant to criticize the poet's superficiality, but he does so with affection and even sympathy.

Lichtenstein's poems seem at first glance light-hearted, but they are significant in German literature for two reasons. First, Lichtenstein and Van Hoddis, more than any other Expressionists (more even than Benn), subverted the traditional "seraphic" concept of poetry, which had only recently been strengthened by George and Rilke (as a poet, not as the author of *Malte Laurids Brigge*). These two Expressionists cleared the way for later poets to write as directly as they cared to do about nearly any subject. The associative style was used, for instance , by Paul Zech in the 1920s for socially critical poems about Berlin.[43]

Secondly, they responded in an aesthetically significant way to fundamental changes in the structure of perception, as has been pointed out by Vietta and Kemper (following Benjamin's lead). In this respect, van Hoddis, and especially Lichtenstein, are fulfillments of Blass's prophecy that the coming poet would write "from the depths," but about "quite ordinary situations." Their work also could have served as the model for Bloch's attack on Lukacs' concept of objective reality:

> Perhaps Lukacs concept of reality itself still contains classical systematic traits; perhaps true reality is also interruption. Because Lukacs has an objectivistic, closed concept of reality, he objects in the case of Expressionism to any artistic attempt to undercut and eventually bring down a world view (even if it is the world view of capitalism). For that reason, he sees subjectivistic destruction in an art which utilizes destructions of the superficial connection of reality and tries to find something new in the gaps; that is why he equates the act of subversion with the act of decadence.[44]

No one seems yet to have found what lies in the gaps, but if present-day art is able to deal frankly and openly (and objectively) with modern phenomena, then it owes a debt to the unfinished legacy of such poets as Benn, van Hoddis and Lichtenstein, who subverted old artistic conventions and helped destroy old world views. Thus the unfinished legacy of early Expressionism remains open and challenging to poets today.

Notes

[1]Ernst Bloch, "Diskussionen über Expressionismus, in *Erbschaft dieser Zeit* (Frankfurt: Suhrkamp Verlag, 1962), p. 275; my trans.

[2]See Stephen Eric Bronner's study of the debate elsewhere in this volume, as well as the anthology edited by Hans-Jürgen Schmitt, *Die Expressionismus debatte* (Frankfurt: Suhrkamp, 1976).

[3]See John Willettt, *Expressionism* (New York: McGraw-Hill, 1970), p. 104 for a list of writers and painters killed in action.

[4]Otto F. Best, ed., *Expressionismus und Dadaismus* (Stuttgart: Reclam, 1974).

[5]See Silvio Vietta's illuminating critique of this fallacy in his (and Georg Kemper's) *Expressionismus* (Munich: Wilhelm Fink Verlag, 1975), pp. 17–18.

[6]Roy F. Allen, *Literary Life in German Expressionism and the Berlin Circles* (Göppingen: Verlag Alfred Kümmerle, 1974), pp. 165–204.

[7]See Henry Pachter's chapter, "Expressionism and Cafe Culture," in this volume.

[8]See especially the accounts by Heinrich Eduard Jacob, Armin T. Wegner and Ernest Blass in Paul Raabe, ed., *The Era of German Expressionism*, trans. J.M. Ritchie (Woodstock, N.Y.: The Overlook Press, 1974), pp. 17–34.

[9]Georg Heym, *Tagebücher*, Vol. III of *Dichtungen und Schriften*, ed. Karl Ludwig Schneider (Hamburg: Verlag von Heinrich Ellermann, 1960ff.)p. 139; Kurt Hiller, "Gegen 'Lyrik' " in *Die Weisheit der Langenweile*(Heidelberg: Richard Weissback Verlag, 1913, pp. 116–119.

[10]*Pan* III (1912), p. 119.

[11]*Pan* III (1912), p. 120.

[12]*Pan* III (1912), p. 120.

[13]*Pan* III (1912), p. 119.

[14]See "Gegen 'Lyrik'."

[15]Gottfried Benn, *Gesammelt Werke*, ed. Dieter Wellershoff (Wiesbaden: Limes Verlag, 1959), III, 7; my trans.

[16]Trans. Michael Hamburger in *Modern German Poetry, 1910–1960*, ed. Hamburger and Christopher Middleton (London: MacGinnon and Kee, 1966), p. 67.

[17]Benn, *Gesammelte Werke*, IV 7–9.

[18]Benn, *Gesammelte Werke*, IV,9; my trans.

[19]Benn, *Gesammelte Werke*, IV,9; my trans.

[20]Vietta and Kemper, *Expressionismus*, pp. 30–40 et passim.

[21]Trans. Babette Deutsch in *Contemporary German Poetry: An Anthology*, ed. and trans. Babette Deutsch and Avrahm Yarmolinsky (New York: Harcourt, Brace and Co., 1923), p. 186.

[22]See "Fanatismus zur Transzendenz" in Benn, *Gesammelte Werke*, IV, 235–7.

[23]Heym, *Dichtungen und Schriften*, III, 138–139.

[24]Georg Heym, "Eine Fratze," *Die Aktion* I (1911), col. 556.

[25]Trans. Christopher Middleton in *Modern German Poetry*, p. 155.

[26]My trans.; Heym, *Dichtungen und Schriften*, I.

[27]My trans.; Heym, *Dichtungen und Schriften*, I, 192.

[28]For instance, Walter Muschg, *Von Trakl zu Brecht: Dichter des Expressionismus* (Munich: Piper Verlag, 1961) and Werner Kohlschmidt, "Aspekte des Stadtmotivs in der deutschen Dichtung," in *Un dialogue des nations: Albert Fuchs zum 70. Geburtstag*, ed. Colleville et al. (Munich: Bueber, 1967), pp. 219–237.

[29]For an example of a particularly bad offender see Helmut Uhlig, "Vom Asthetizismus zum Expressionismus: Ernst Stadler, George Heym und Georg Trakl," in *Expressionismus: Gestalten einer literarischen Bewegung* (Heidelberg: Wolfgang Rothe Verlag, 1956), pp. 84–115.

[30]Karl Ludwig Schneider, *Zerbrochene Formen* (Hamburg: Hoffmann und Campe, 1961), p. 132.

[31]Emile Verhaeren, *Les villes tentaculaires* (Paris: Mercure de France, n.d. [1895]).

[32]See for instance Julius Hart's "Berlin" in *Deutsche Grossstadtlyrik vom Naturalismus bis zur Gegenwart*, ed. Wolfgang Rothe (Stuttgart: Reclam, 1973), pp. 61–63.

[33]Heinz Rolleke, "Georg Heym," in *Expressionismus als Literatur*, ed. Wolfgang Rothe (Berne: Francke Verlag, 1969), pp. 367–368.

[34]Raabe ed., *The Era of German Expressionism*, p. 44.

[35]Raabe ed., *The Era of German Expressionism*, p. 46.

[36]Silvio Vietta ed., *Lyrik Des Expressionismus* (Tubingen: Max Niemeyer Verlag, 1976), pp. 89–91.

[37]Trans. Michael Hamburger; in *Modern German Poetry*, p. 171.

[38]Georg Simmel, "Die Grossstadt und das Geistesleben," in *Die Grossstadt: Vortrage und Aufsatze zur Städteausstellung* (Dresden: von Zahn & Jaensch, 1903), pp. 186–206.

[39]Silvio Vietta, "Grossstadtwahrenehmung und ihre literarische Darstellung: Expressionistischer Reihungsstil und Collage," *Deutsche Vierteljahresschrift* 48 (1974), 354–373.

[40]Vietta, "Grossstadtwahrnehmung," pp. 358–359.

[41]See van Hoddis ' "Kinematograph" and Lichtenstein's "Kientoppbildchen," in *op. cit.*.

[42]Trans. Michael Hamburger; in *Modern German Poetry*, p. 167.

[43]See Rothe ed., *Deutsche Grossstadtlyrik*, p. 211. The late poet R.D. Brinkmann repeatedly expressed his feeling of kinship with Lichtenstein in conversation with the author.

[44]Ernst Bloch, "Diskussionen über Expressionismus" in *Erbschaft dieser Zeit*, pp. 270–271.

8
Expressionist Literature and the Dream of the "New Man"

Douglas Kellner

Many expressionist literary artists not only wanted to revolutionize art, but desired to transform human and social life as well. Much expressionist literature is guided by the ideal of a New Man which, in various works, signifies a range of ethical-social ideals that often emphasize an intensified and higher individuality and sometimes a transformed humanity.[1] Expressionist literature was infused with a sense of *mission* and a sense of the artist's *calling*. Expressionists took writing and literature in the broadest sense extremely seriously and sought to transform themselves in the activity of writing and to transform their audiences in the encounter with their literature. Expressionists literally expected *liberation* — and often *salvation* — from their writing and were perhaps the last avant-garde movement to believe that writing and the printed word could radically transform the artist and other human beings.

It is precisely this sense of mission and calling which infused expressionist writing with its passion and intensity. The ideal of liberating individuality and/or transforming humanity shaped both the form and the content of expressionist writing, driving it to transcend ordinary language, conventional literary forms and everyday experience. The em-

phasis on the "essential" human being, which dwelled beneath the dross of conventional behavior, made expressionist literature peculiarly abstract and philosophical. Its drive to "become essential" required abstraction and symbolism from the expressionist writer who was to elevate and depict the universal and essential in contrast to the fragmentary contingency and particularity of ordinary worldly affairs. The urgency of its goal created a certain pathos within expressionist writing and drove it to seek novel literary forms in order to express its vision of liberation. The new poetic forms — *Der Sturm* ("word-art"), the breaking of syntax in expressionist "telegramm style," the shattering of traditional dramatic form in expressionist theater, the strange symbolism of expressionist imaginative literature, the emphasis on the essay as a privileged form of self-proclamation — were all formal innovations inspired by the ideal of the New Man and new art. Throughout this essay, I shall argue that there is a fundamental unity of style and content in expressionist literature, condemning "formal" studies which solely focus on the "style," or "forms" of expressionist writing to irrelevancy.

The distinguishing feature of expressionist literature is that one cannot really separate the formal, the ethical-political, and the thematic dimension without violating the work's intent and spirit.[2] Expressionist literature is part of a broader project of artistic-social rebellion; passion and intensity characterize it from its creation to its desired reception. The pathos in this drive for transcendence and transformation is the source of the much-discussed qualities of exaggeration and distortion in expressionist literature and its frequently rhapsodic, and even frenzied, character. It fuses together a rather unique "worldliness" and "other-worldliness" that at once seeks to portray what is essential to human life, or a given society, and yet to transcend conventional life for a "new life" and higher reality. The other-worldliness resides in the attempt to depict "another world" and the "other" of liberation. In pursuing this goal, expressionist literature offers insights into existing reality whose deficiencies are contrasted with provocative ideals of human liberation and a "new humanity." This provides a sharp critical edge to expressionist writing and a moral-rhetorical quality that challenges the audience to transform their lives and society. The tension between the "is" and the "ideal" provides an impetus to seek a new life; this struggle for transformation itself sometimes produces an ecstatic transfiguration and sometimes a self-destructive collapse within expressionist writing (or both in sequence). In the next section, I shall characterize, in more detail, the expressionist ideal of the New Man and shall present some typical examples.

Nietzschean Individualism, The New Man and Transfigured Humanity

The expressionist project and pathos of the New Man was deeply influenced by Nietzche's ideal of the "superman" and Strindberg's "transfigura-

tion drama."³ Much expressionist literature was driven by the ideal of un-chaining all human and individual powers. This unrestrained individuality led to the wild and chaotic qualities of expressionist writing and led some Expressionists to affirm murder, parricide, rape, incest, or anything that would enable the individual to realize its drives and yearnings. Such em-phases and goals helped produce the frequently grotesque quality that in-forms so much expressionist writing. This ideal of total rebellion and the search for a radical alternative led to the desperate and contradictory forms and goals within expressionist writing, ranging from almost hysterical attacks on conventional behavior to an advocacy of a wide-range of revolt that often took bizarre, primitivist forms of regression and destruction.

For instance, in a play by Oskar Kokoschka, *Murderer the Women's Hope* (1907), extreme sexual passion explodes with cruelty and violence.⁴ A savage "Man in blue armor" arrives with his entourage of Men to lay siege to a city of Women. The Man confronts the Women in an encounter of primal lust and he brands her flesh with his "sign" (19). The Woman then traps the Man in a cage and as the Women move to the sides of the stage to engage in sexual rituals with the Men, the Woman creeps around the cage "like a panther" and proclaims her burning passion for the Man and need for release. The play ends with a ritual murder as the Man kills the Woman and walks toward the screaming Women, killing "them like mosquitoes" and leaving "red behind" (21).

This sexual atavism was not uncommon in expressionist literature. Gottfried Benn believed that liberation from both conventional morality and Western reason would enable an overly civilized humanity to return to a more primal existence.⁵ In his poem "Synthesis" (1917), he portrays a total regression to primitive instincts and polymorphic sexuality:

> Reticent night. Reticent house.
> But I am of the stillest stars,
> and I thrust out my self-made light
> out into my self-made night.
>
> I have returned home in brain
> from caves, heavens, filth and beast.
> Even what is still bestowed on woman
> is dark and sweet onanism.⁶

Many expressionists portrayed suicide in a positive light as eman-cipation from the horrors of existence, leading Walter Sokel to suggest a "death-wish" within Expressionism.⁷ The heroes of several of Ernst Toller's plays commit suicide, chillingly prefiguring his own suicide in 1939. Hanns Johst's drama *The Young Man* (1916) shows a rebellious stu-dent forced into suicide when his revolt fails. Other Expressionists por-tray extreme situations which justify anything which will free the strug-gling individual from stifling restrictions or any limitations on his creativi-

ty. In Paul Kornfeld's play, *The Seduction* (1913), a frenzied lover declares his love to a girl whom he just met and strangles her fiance whom he encounters a few minutes later. Walter Hasenclever's drama *The Son* (1914) depicts a son's murder of his tyrannical father who has literally imprisoned him. The grotesque exaggeration and almost formless chaos give the play a feeling of white-hot intensity that provides a cathartic release at the murder. In Arnolt Bronnen's drama *Parricide*, the sons kills his father and must escape from the incestuous advances of his mother in front of the slain corpse before he can escape to freedom. The artist-poet Grabbe, in Hanns Johst's *The Lonely One* (1917), refuses to work and support his old mother, even robbing pennies from her to buy liquor which he needs as the source of his inspiration. These expressionist dramas had a real-life parallel when Georg Kaiser was arrested for selling furniture and art works from a rented villa to support his writing and he defended himself in court with the claim that his superior artistic talents justified robbing a bourgeois house-owner.[8]

For many Expressionists, the artist was the highest form of humanity and stood the best chance of reaching the exalted expressionist goal. Here Expressionism was part of a Germanic tradition of "artist literature" and shared an idealized concept of the artist with other modernist avant-garde movements.[9] But — as usual — the theme peaked in expressionist writing and drove them to create new literary forms and strategies to realize the ideal. Expressionist poets rejected traditional lyric forms to express their visions and radically altered poetic language and idiom to find a suitable medium of expression.[10] The dramatical and theatrical quality of expressionist writing made the theater an appropriate forum for their ideals, but their chaotic rebellions and ecstatic visions shattered traditional dramatic forms and led to radical innovations within the theater. Few of the messianic, or "ecstatic" Expressionists had the discipline, or ability, to develop their visions in the form of the novel, although Kafka, Werfel, Döblin, Frank and others wrote novels that have been characterized by some critics as "expressionist."[11] Since expressionist writing was often didactic and even programmatic, the essay was also an appropriate form for Expressionists whose journals and yearbooks were full of essayistic attempts to delineate the expressionist vision of a new art and new humanity.[12] For the most part, therefore, the New Art and formal innovations of expressionist writing are inseparably connected with their quest for the New Man.

The sometimes wildly unrestrained individualism in much expressionist writing was sometimes tempered, or even replaced, by a more ethical ideal of a spiritualized individuality, or transformed humanity.[13] Here the process of transformation was often structured by the form of Strindberg's "station dramas" which would lead to salvation (or sometimes destruction). This process lent itself to religious presentations, or to a secularized religiosity. The word *Erlösung* was a favorite expressionist concept which signified at once "redemption," "release," or deliverence," and

thus had both religious and secular connotations. The release could be repressed sexuality (as in Wedekind), deliverence from conventional life and morality (as in Kaiser), or a highly charged, frequently religious, sense of "redemption" from suffering, guilt, or the restrictions of earthly life.[14]

The *Erlösung* was frequently purely individual in origin and focus, but sometimes took more social and communal forms. An ethical idealism, concern for humanity as a whole, and desire for community permeates much expressionist writing. Franz Werfel in his poem "To The Reader," which allegedly helped inspire expressionist poetry, concluded his work with the proclamation: "My only wish is to be related to you, O Man!"[15] Werfel's New Man was not just to cultivate his individuality in isolation from others as an end in itself, but was to communicate his heightened humanity to others, thus producing higher forms of human life. In his poem "The Beautiful Radiant Man" (1911), he writes:

> The friends, who converse with me,
> Cast off their bad spirits and radiate with delight,
> When they enjoy a stroll in the beauty of my features,
> Perhaps arm in arm, ennobled figures.
>
> Oh, my face can never maintain dignity,
> And gravity and composure cannot suffice it,
> Since a thousand smiles in renewed flights
> Eternally unfold from its firmament.[16]

Ernst Toller's works were driven by the hope that humanity could be radically transformed and that a new society and human community could be produced. A series of stories by Leonard Frank, *Man is Good* (1919), proclaim a belief in the goodness of human nature and the potentiality for humane behavior and moral transformation.[17] Frank's book concludes: "A few minutes later the officials at the Morse Code apparatus, who shortly before had flashed out notices, edicts, orders, sent warrants to the tormented masses, wired the names of the New Men and the news of the rise of freedom and love."[18] The quest for the New Man permeated expressionist writing yet took different forms and had varying effects in various literary genres, works and authors. In the following sections, I shall examine some of the more representative and influential articulations of the New Man before providing criticism of its premises, vision and ideological illusions.

Expressionist Theater, War and Revolution

Expressionist theater was an ideal medium to proclaim the New Man and to present the struggle for unrestricted individuality and/or the redemption of humanity. The theme of the New Man was intrinsically dramatic and theater provided a public forum for the clash of ideas and the presentation of change through a collective, ritualistic aesthetic experience. It was

believed in some artistic circles, since Schiller, that theater was the most suitable vehicle to create a new culture and to transform, dramatically, the spectator. The belief in the transformative power of the theater reached a high point in the work of Richard Wagner and was celebrated in Nietzche's *Birth of Tragedy*.[19] Various expressionist dramatists and theorists believed that theater could indeed help generate the New Man through the rapt attention and ritualistic social nature of performed drama.[20]

Reinhard Sorge in his play *The Beggar* (written in 1911, published in 1912, and performed in 1917) thematically presented the expressionist belief that dramatic literature had to be performed on stage to reach its desired impact.[21] Sorge's Poet is introduced, in the play, as a young playwright seeking his own theater to perform his radically innovative plays. He discusses with the Friend the possibility of a wealthy artistic patron funding his work and the Friend cautions:

> Just imagine! A theater of your own! And at your age! Despair brought you to that, but despair is precisely what should make you humble; in your situation one must be grateful for every penny. . . . If he merely paid for the printing of your last plays, you would be helped; you'd have a small income, you could live. You can't expect performances soon anyway; your plays are too strange and avant-garde for that. It would be better yet if he were to give you a permanent income, then once and for all you would be free of money worries and could develop undisturbed.(24)

The Poet, however, insists that he must see his plays performed, telling his Friend and the Patron that:

> the theaters reject my plays — so much in them is novel that they shy away from risking the experiment of a performance. . . . This impossibility of getting a performance is my greatest handicap. For me performance is a necessity, the one basic condition for creation. It is my duty toward my work. . . . I must be performed — I see my writings as the foundation and beginning of a rejuvenated drama; you yourself expressed a similar idea a moment ago. But this new drama can become properly effective only be being performed; the only solution is a stage of my own.(38–9)

The Patron believes that this goal is impractical at the Poet's young age and proposes instead providing a fixed income for ten years which would enable the Poet to mature and develop his art in a situation of financial security. The Poet rejects this generous offer, telling the Patron that his "mission" dictates "this one path," namely production for a theater which would enable him to realize his "calling" and present his "visions" to the public. He proclaims his goal in a passage that contains the distinctive intensity of expressionist dramatic writing and articulates the aesthetic-ethical goal of the "renewal of humanity" through expressionist art:

My work! My work! My work alone was master! How best to say it. . . . I want to show you images of coming things which have in me arisen in all splendor, visions that led me on to where I am to-day, and neither love nor lust has hitherto been able to displace them or even for one instant make them dim! You shall see what riches wait for you, what vast good fortune. Truly this will prove a gold mine! And no risk at all! Just listen now: this will become the heart of art: from all the continents, to this source of health, people will stream to be restored and saved, not just a tiny esoteric group!. . . Masses of workmen will be swept by intimations of a higher life in mighty waves, for there they will see from smokestack and towering scaffold, from the daily danger of clamoring cogs arise their souls, beauteous, and wholly purged of swarming accidents, in glorious sublimity, conquerors of gripping misery, living steel and spire soaring up in defiant yearning, regally. . . . Starving girls, emaciated bodies bent, toiling for their children out of wedlock born, in this shall find their bread and resolutely raise their little ones aloft, even though these lie already lifeless in their arms! Cripples, whose twisted limbs betoken the teeming misery of this crooked age, whose bitter souls ooze from their poor misshapen forms, will then with courage and from love of straight-limbed life repress their bile and toss to death the fallow refuse that was their lives. But men shall toughen their brows in sorrow and joy, and open their hearts to yearn — and renounce! Let woman excel in allegiance to man! Let his aim be: graciously to yield to her!. . . . To lofty birth let a highborn but in many ways corrupted age advance toward me; indeed, this age shall truly view itself in mirrors of omnipotence and lapse in silence when from the deep reaches of the skies issues the gracious vision of the anchor which holds us all inexorably, like rock-bound ore, to the bottom of divinity. (41–2)

This sort of rhapsodic monologue would be a characteristic feature of much expressionist theater that mixed symbolic vision, monologue, chorus, and dialogue which functioned as much to debate ideas as to advance the plot or develop character. The proclamation cited above alienates the Poet from the Patron and Friend who assume that he has taken leave of his senses, but the passionate outburst attracts a young Girl who attaches herself henceforth to the Poet. The scene is followed by a tableau of five fliers discussing the danger of flying too high and shattering their airplane — presumably a parable suggesting the dangers of the Poet soaring too high above humanity and shattering his personality. (42–5)

The Poet takes leave of his Friend and Patron and returns home to his family. Here we discover that the would-be liberator of humanity is constrained to live in an environment where his Father is hopelessly insane and his conventional Mother and Sister bear the burden in depressive grief and resignation. The solution is to shatter the bonds of restrictive convention by poisoning his Father and Mother, releasing them from their suffering and himself from the burdens of family life.

This event in the *The Beggar* cannot, however, be subsumed under the typical expressionist theme of generational revolt, as the Son-Poet is extremely solicitious toward both Father and Mother and actually puts them out of their misery at the Father's own request, thus resolving a hopeless situation. Consequently, although *The Beggar* sanctions murder to release the superior individual from restrictive chains, it does not attain the frenzy of ecstatic parricide found in, for example, Hasenclever's *The Son* or Bronnen's *Parricide*.

A subplot concerns the insane Father's visions of canals and new technologies on Mars which he wants to diagram and to build on earth. It appears that Sorge is satirizing here the faith that technology will radically transform the earth and create a new humanity through presenting the grotesque fantasies and pathetic behavior of the insane Father. Curiously — whether Sorge intended this or not — there is an uncanny parallel between the ineffectuality in actually realizing the visions of both the Father and the Poet-Son. We are given little evidence past the first act that the Poet has actually created literary works which embody his visions and have no idea what effects they might actually produce. In acts two to five of *The Beggar*, the poet gets bogged down in his family drama, takes on a conventional job in a newspaper which he soon gives up, and then tells the Girl — whom he had earlier urged to devote her life to raising her illegitimate child — to give away the child so as to be able to totally devote herself to him and his mission. Although the play ends by evoking the possibility of a new life and realization of his artistic calling, there has been no real embodiment of his ideal presented and therefore the concept of the New Man or New Art, is left vague — as the "object-less other" which Barbara Wright claims characterized much expressionist writing.[22]

Moreover, the most grotesque image of the Father's insanity can also be taken as a commentary on the Poet's own life and activity. One morning, the Father feels the need to finish his "work" and requires red ink; there is no more at home and the stores are closed, so the Father grabs a bird, kills it, and uses its blood as ink. This horrific image is parallel to the Poet's draining the lives of those around him to nourish his literary activity — a typical theme of expressionist writing which Brecht draws to its logical and horrifying conclusion in *Baal*.

The outbreak of war in 1914 and its subsequent carnage intensified the expressionist search for a New Man and new society. In *The Savior* (1915), Hasenclever reversed the vitalist-individualist thrust of the *The Son* — which exalted murder to liberate the individual from the confines of a stifling bourgeois existence — in order to advocate the need to affirm spiritual regeneration as the solution to the problems of humanity. In a debate with a military Field Marshall, Hasenclever's Poet argues: "We have been opponets from long ago. The caste of the sword versus that of the mind. This antagonism has never been greater than today. The victory of one of us will enslave the other."[23] In his play *Antigone*, Hasenclever utlizes the classical Greek conflict between Creon and Antigone to con-

vey his anti-war message.[24] The blind Oedipus reveals to Antigone a vision of human love and goodness and Antigone preaches this gospel to the masses. She reveals images of vast destruction which will ensue if the war continues and pleads with the people to stop blindly following their militaristic leaders and to create a society of peace and love. In typical expressionist fashion, Antigone sacrifices herself for her vision, hoping that a future humanity will redeem her suffering and construct a society without hate and war.

A similar plea for peace is found in Reinhard Goering's play *Naval Encounter* (1916). This highly emotional drama features seven marines sailing toward an inevitable battle and death. The crew debates war, peace, rebellion, and salvation in the mode of Socratic dialogue, punctuated by occasional monologues, full of expressionist pathos and vision. War is denounced as madness and crime and the bonds of humanity are celebrated over the divisions of nationality. When the debate appears to be leading to mutiny, an enemy ship appears and the crew is carried away with the excitement of battle. One crew member proclaims that the New Man will appear forged in the heat of violent action, but most of the crew is killed and the pacificist who survives asks himself why he did not try to carry out the mutiny which appeared about to erupt. Although the play has the fatality of classical drama, it suggests at the end that the individual must struggle against forces that are controlling him by suggesting that if the troops mutinied, they might have been able to avoid senseless death.

The expressionist drama of the New Man was given further impetus by the actual mutiny of German soldiers and sailors in 1918 which produced the November Revolution. A participant in these events, Ernst Toller, wrote plays which articulated the ethical-activist project of redeeming humanity from the suffering and evils of the past through creating a new humanity and new society.[26] Rather than emphasizing the need to liberate and unleash the individual, Toller stresses the ideal of serving humanity and creating a new society. In his early and deeply autobiographical play *Transfiguration* (1917–8). the main character goes through a series of transformations until he is finally liberated from his past ideological illusions and can proclaim his "message" to the masses and join at the end in cries of "Revolution, Revolution" (106). Toller premises his play on "faith in humanity" which once awakened will transform individuals who can then develop a new society.

In both *Transfiguration* and *Masses and Men* (written in 1919; published and produced in 1921), Toller's-heros oppose violent revolution and armed insurrection, calling instead for appeal to common humanity and brotherly love. Against an "Agitator" who calls for armed warfare against the rich, Toller's hero proclaims:

> let me warn you against the words of him who called on you to march on the rich, against the glittering half-truths of his words! His reasoning did not go very deep. Can't you see the man for what

he is? This opportunist agitator? Yesterday his talk was all of in-
dividualism, today he cries: "God is the people!" And tomorrow he
will cry: "God is the Machine!" Therefore the people are machines.
None the less he will delight in the swinging pistons and the whirl-
ing wheels, the smashing hammers. For him the people are the
masses: he knows nothing of the people as men and women. Have
no faith in him, for he has no faith in humanity. And before you set
out upon your great march you must have faith in humanity. It is
better for you to suffer want than to follow the precepts of this man
without faith. (97)

In *Masses and Men*, Toller's spokesperson (for once a woman) pro-
claims against those who wish to destroy machines:

Machines can never be undone.
Scatter the earth with dynamite
And let a single night of action
Blow factories to nothing —
Before spring comes
They will have risen again
More cruel than before.
Factories may no longer be the master
And men the means.
Let factories be servants
Of decent living;
And let the soul of man
Conquer the factories.(128)

In *Masses and Men*, the Woman opposes in vain violent revolution,
killing one's enemies and murder in the service of a better future. Her
pleas for forgiveness and love of humanity fall on deaf ears, for "Only the
masses count" (136) and the masses are persuaded that revolutionary in-
surrection is in their best interest. The Woman goes along with the violent
struggle; it fails and the revolutionaries are slaughtered or imprisoned. In
her prison cell, she debates social change with the "Nameless" who had
called for the violent uprising:

THE NAMELESS. Our Cause comes first.
 I love the people that shall be,
 I love the future.
THE WOMAN. People come first
 You sacrifice to dogmas,
 The people that are now.
THE NAMELESS. Our Cause demands their sacrifice.
 But you betray the Masses, you betray
 The Cause.
 You must decide today.
 Who wavers, helps our masters—
 The masters who oppress and starve us—
 Who wavers,
 Is our foe.

THE WOMAN. If I took but one human life,
I should betray the Masses.
Who acts may only sacrifice himself.
Hear me: no man may kill men for a cause.
Unholy every cause that needs to kill. (151)

Although offered a chance to escape, she refuses since her escape would require the murder of a prison guard. In this way, the Woman embodies her pacificist-revolutionary ideals in her behavior and sacrifices herself for the good of humanity. Throughout his works, Toller's ideal was to fuse a concern for the individual with concern for the liberation of humanity as a whole. He wished to unite ethical idealism with revolutionary social change in which the ultimate goals of the revolution — a new society — would already be present in the struggle itself. Although he himself participated in the revolutionary upheavels of 1918 and was imprisoned for his activity, Toller could not really identify with the party politics of the Left in Germany and remained politically isolated during the Weimar period. Even his early plays, in fact, were closer to the expressionist ideal of the New Man than traditional communism, and Toller remained a political outsider without a party or movement.

Georg Kaiser and the Expressionist Transformation Drama

Toller's emphasis on the need for the New Man to transcend mere individuality to serve humanity was anticipated in the plays of Georg Kaiser who, in many popular plays, presented various types of the New Man and criticized excessively individualistic, or ineffectual, forms of individual and social transformation. Kaiser's play *The Burghers of Calais* (written in 1914) presents the theme of the New Man in the form of a "transformation drama."[27] In this play, the town of Calais is besieged by the English who threaten its destruction. The King of England sends an Officer to inform the townspeople that the English will not destroy their city and newly built harbor if six citizens will surrender the keys to the city and sacrifice themselves. The military Captain of the French urges the citizens of Calais — who seemingly have no standing army or military training — to fight to the last man and burn the city if it is lost. Although the major, Jean de Vienne, appears to agree on this course of action, the town's richest merchant, Eustache de Saint-Pierre, says instead that they must preserve the fruits of their labors — the town and new harbor — and must seek volunteers who will sacrifice themselves for the common good. He insists:

you *must* take this path — there is no other! You hurtle breathlessly along it — as a fugitive pants for breath in flight — fleeing towards your deed. The deed awaits you there — to save you from the

desert around you — to raise you up from the void. . . . Today you
and your blood lie dead before your deed — but shall we not live
on in our filmsy robes until the brightness of a new dawn? (91)

The mayor calls for volunteers and Eustache de Saint-Pierre and six
other prominent citizens step forth. The French Captain, Duguesclins,
withdraws in disgust and goes off to serve as a mercenary for the English
King. His feudal ideals of honor and warlike valor are shown to be irrele-
vant to the construction and preservation of the emerging bourgeois-
industrial order which, in the play's symbolism, calls not only for hard
work and industry, but dedication to the common good and a sense of
community which may even require sacrifice. The play thus reflects on
the end of feudalism and the need for new ideals to guide the construction
of bourgeois-industrial society.

Since there are seven volunteers for the six sacrifical positions
demanded by the English King, lots will be drawn to determine who shall
be spared. Although the townspeople, the major and the other councillors
who had volunteered to die for their city demand an immediate drawing
to settle the matter, Eustache de Saint-Pierre postpones the decision with
lengthy speeches, a "last supper" and fake drawing which exempts no one
from the sacrifice. Instead, Eustache insists that they reflect on whether
they really want to sacrifice their lives and have made a conscious, well-
thought out decision, rather than a passionate gesture. He states:

> Today you seek the decision — today you deaden your resolve —
> today you let fever overwhelm your will to act. Thick smoke swirls
> about your heads and feet and shrouds the way before you. Are you
> worthy to tread it? To proceed to the final goal? To do this — which
> becomes a crime — unless its doers are transformed? Are you
> prepared-for this your new deed? It shakes accepted values —
> disperses former glory — dismays age-long courage — muffles
> that which rang clear — blackens that which shone brightly — re-
> jects that which was valid! — Are you the new men? — Is your hand
> cool — your blood calm — your zeal devoid of rage? Will you
> judge yourselves by your deed — do you measure up to it? (114–5)

The potential sacrifical victims have now had time to think about the
consequences of their action, to meet with loved ones whom they would
never see again and to consider the costs of laying down their lives for the
city. Now Eustache de Saint-Pierre suggests that they require yet more
time to reflect on their decision so as to fuse their will and deed in a
transformed personality, ready to act for the common good. Eustach sug-
gests: "Let us rest until the morning: at the first sound of the bell each of
you will set out from his home — and he who is the last to arrive in the
middle of the market place — will go free!" (116).

The next morning, the mayor and townspeople arrive at the market-
place early and await the tolling of the bell. They expect Eustache to ar-
rive first as he lives closest and is presumably the most resolute to

sacrifice himself and to become the New Man, but as the bells ring the other six volunteers arrive and the townspeople shout out in astonishment; "Is Eustache de Saint-Pierre not coming?!" (123). Just when they despair of his arrival and decide to seek him out, Eustache's father arrives with his son's body in a funeral bier. His father states to the excited crowd that his son has taken his life so that the others may proceed resolved and united in their deed; his son has prepared the way through his teaching and example and the Father cries out, "what I have witnessed I shall never forget: I have seen the New Man. This night He was born" (130).

At the climatic moment, an English officer arrives to inform the people that a son was just born to the English King and that "For the sake of this new life, the King of England will on this morning take no other life. Calais and its harbor are saved from destruction without need for penance!" (131). The six councillors raise the bier with Eustache's body to the church altar to prepare for the English King's arrival and in his final stage instructions, Kaiser writes:

> Light floods across the church facade above the door; its lower part represents a deposition from the cross; the frail body of the dead man lies limply in the sheets — six stand bowed over his litter — The upper part depicts the elevation of the dead man: he stands free and untrammeled in the sky — six heads are turned up towards him in wonder. (132)

In *The Burghers of Calais*, the New Man not only transforms the personality of the individual, but provides new possibilities for a new humanity and society. The incredible optimism of the hopes for a New Man are tempered, however, in Kaiser's play *From Morning to Midnight*, as well as in the *Gas* trilogy. In *From Morning to Midnight*, Kaiser presents the adventures of a bank cashier who attempts to transform his existence and lead a new life. The play takes the form of a Strindbergian "station-drama," although it parodies both the ideals of religious-messianic Expressionism and unrestrained individualism that gives full reign to individual passions. Such an ideal, Kaiser's play suggests, can be destructive and self-defeating.

The Cashier is engaged in his normal routine at a bank when a Lady enters, wishing to cash a letter of credit. The Manager is suspicious and refuses her request until he receives documents from her bank in Florence. The Lady's appearance, perfume and touch of his wrist excites the Cashier who decides to embezzle money from the bank and to run off with the Lady, who he imagines to be an adventuress. As it turns out she is simply a Mother and Woman of Virtue, travelling with her art-student Son and therefore refuses the Cashier's offer when he comes to her hotel with his proposition. This scene and the subsequent action intimates that the project of the New Man cannot be arbitrary, or a whim induced by external events. The rest of the play demonstrates the Cashier's folly and his eventual downfall.

Leaving the hotel in a frenzy, the Cashier has a vision in a snow-filled field of the possibilities before him now and ecstatically welcomes the new life ahead. Having broken with his place of work, he must next break with his family. He enters his house where his wife is preparing the usual lunch and his family is engaged in their usual routines. He reflects: "Dear old grandmother at the window. Daughters at the table, embroidering, playing Wagner. Wife busy in the kitchen. Family life — within four walls. The cosy comfort of togetherness. . . . In the end — you're flat on your back — stiff and white. The table pushed against the wall there — a yellow coffin laid across it, removable mountings — some crepe round the lamp — and the piano isn't played for a year." (44) Disgusted with this vision of life he walks out and his mother collapses with a heart attack when his wife shouts, "My husband has left me" (45–6).

In the succeeding "stations," the Cashier goes to the big city and undergoes a series of worldly pleasures with which he attempts to give form to his new life. At a sports palace, he offers bicycle racers extravagent sums to race in order to watch the crowd go into a frenzy. In a satire on the release of passion desired by some Expressionists, the Cashier explains that it is not important to him who wins; rather he seeks to observe:

> From the first rows right up to the Gods, fusion. Out of the seething dissolution of the individual comes the concentrated essence. Passion! All restraint — all differences melt away. Concealing coverings stripped off nakedness. Passion! To break through here is to experience.(51)

When the tired racers fail to exert enough effort to excite the crowd for the 10,000 mark prize he offered, the Cashier proposes upping the reward to 50,000 marks, but the arrival of the Royal Highness deflects his interest in the project and he takes his money and leaves in disgust. In the next scene, the Cashier enters a night club and tries to buy wine, women and pleasure, but the women turn out to be either too drunk or too ugly to excite him and he leaves again in disgust, putting money on the table which is stolen by the "Gentlemen" whose "Ladies" he had tried to buy, thus forcing the waiter into bankruptcy who was responsible for collecting the bill.

In the final scene, the Cashier enters a Salvation Army hall and listens to various derelicts, prostitutes and Salvation Army followers confess their sins and beg repentance. The Cashier wanders up to confess, telling of the events of the day:

> I have been searching since this morning. Something triggered this search off. It was a total upheaval with no possibility of return — all bridges burned. So I have been on the march since morning. I don't want to detain you with stations that did not detain me. They were none of them worth my decisive revolt. I marched on stoutly —

with critical eye, groping finger, selective mind. I passed it all by. Station after station disappeared behind my wandering back. This wasn't it, that wasn't it, nor the next, the fourth, the fifth. What is it? What is there in life really worth sacrificing everything for? This hall! Drowned in music, packed with benches. This hall! From these benches rises up — with the roar of thunder — fulfillment. Freed from dross it rises liberated aloft in praise — molten out of the twin glowing crucibles: confession and repentance. There it stands like a gleaming tower — sure and bright: confession and repentance! (71)

The Cashier then proclaims that money is the root of all evil and throws his notes and gold coins into the hall. A fierce battle for the money commences, suggesting that the religious confession and redemption is also a fraud. Totally alone and in anguish, the Cashier concludes that:

A little spark of enlightenment would have helped me and spared me all that trouble. So ridiculously little intelligence is needed! Why did I climb down? Why did I take that path? Where else am I still going? At the start he is sitting there — stark naked! At the end he is sitting there — stark naked! From morning to midnight I chase around in a frenzied circle — his beckoning finger shows the way out — where to?(73)

Kaiser criticizes here the excessive individualism in certain Nietzschean-expressionist concepts of the New Man, showing that an unrestrained individualism inevitably leads to destruction of self and others. In his *Gas* trilogy, he criticizes the more social-communal ideals of the New Man. The three plays *The Coral* (1917), *Gas I* (1918) and *Gas II* (1920) pit the utopian ideals of a Billionaire's Son, first against his Father who had devoted his life to production and profit, and then against the Engineer who represents the imperatives of industrial production and technical progress at all costs. These plays put in question the messianic hopes for a new society widespread in the aftermath of the German revolution and radically question the expressionist ideals of the New Man and the new society. In *Gas I*, the Billionaire's Son takes over his father's gas factory and in effect socializes the industry and shares the profits with the workers. Rather than carrying through the liberation of labor envisaged, this form of syndicalist socialism drives the workers to toil harder to increase productivity and to make more money. An explosion kills many workers and the Son now perceives that mechanized industry is itself the source of enslavement and destruction; he thus recommends building utopian communities in the countryside which will renounce heavy industry. The workers, however, seek a scapegoat for the explosion and do not want to give up industrial production. Their scapegoat, the Engineer, accepts blame and then debates the Son on the merits and demerits of heavy industry and technical progress. The Engineer's arguments sway the workers who follow him back to work.

Although the Son's daughter promises to bear the New Man at the end of *Gas I*, in *Gas II*, a destructive war is taking place and the Billionaire Worker — who a generation later is, by his own choice, a laborer in the plant — is unable to convince the other workers to stop producing the war materials which will eventually destroy them. The play ends in total war with a final apocalyptic destruction that uncannily anticipates the horrors of nuclear war.

In his plays, Kaiser has raised serious questions about the efficacy and viability of the expressionist goals of the New Man and new society, but was himself not really able to transcend the boundaries of Expressionism or to overcome its weaknesses. This task was accomplished, I believe, by Bertolt Brecht who more radically than anyone carried through in his early plays an important critique of expressionist theater and in his later plays developed a radically new type of political theater.

Baal and Brecht's Immanent Critique of Expressionism

The early plays of Bertolt Brecht stand in a curious relation to Expressionism. Although his play *Baal* was conceived as an anti-expressionist critique of Hanns Johst's play *The Lonely One*,[28] it shares the expressionist celebration of sexuality, nature and passion. Futhermore, it supports expressionist attacks on hypocritical and repressive social norms, values and behavior, thus effectively sanctioning the expressionist social rebellions. Brecht's early plays also contain formal features of the grotesque, wildness and distortion akin to the spirit of Expressionism. Yet *Baal* also provides an immanent critique of the expressionist notion of the unrestrained individual and the expressionist artist-hero, the Nietzschean superman and the expressionist transformation drama. In this section, I shall try to show that Brecht shares Kaiser's reservations about the expressionist ideal of the New Man, developing the critical tendencies in Kaiser and Wedekind to a high level of social and ideological critique.

Brecht began working on his play in early April 1918 and wrote to a friend on May 5: "I now have a (good?) title for *Baal: Baal eats! Baal dances! Baal is transfigured!*"[29] This characterization of his play, and the remarks on Expressionism in his theater reviews and notebook entries from the period, suggest that Brecht intended to develop an immanent critique of expressionist drama that at once appropriated its progressive elements and overcame its deficiencies.[30] In a passage from his notebook "On Expressionism," Brecht writes:

> Expressionism signifies crude exaggeration (*Vergröberung*). In cases where it does not deal in allegory (as in *Alciabides Saved, Gas,* and *The Son*), it deals with proclamation or overstatement of Spirit, of Ideals. It is (coincidentally) similar here in literature as in politics where there is a new parliament but no new parliamentary representatives; there is joy in ideas here but no ideas, and conse-

quently it becomes a movement that remains on the surface and external, rather than a revelation (*Erscheinung*); that is, instead of filling the body with spirit, they sell the (most colorful) skin for the body, and instead of showing the (as one complains: misperceived) soul in the body, they make the soul into body, thus crudely exaggerating it.[31]

Brecht then makes fun of the expressionist publications of the Wolff publishing firm and concludes with an interesting comment that the excessively bombastic Expressionism of authors like Johst misses the point of the better expressionist works of Sternheim and Kaiser — presumably their moments of satire, social critique and more disciplined use of language.[32]

Throughout the early 1920s, Brecht continued to grapple with Expressionism and developed a fairly consistent critique. From the beginning, he detested the crude exaggeration and "O-Mensch!" sentimentality of Expressionism and sought a more disciplined, critical theater which both entertained and instructed. He opposed the excessive idealism and subjectivism in Expressionism and emphasized instead body over soul, the material over the ideal, the concrete over the abstract. Brecht also questioned the unrestrained egotism in some expressionist plays and came in his own work to stress instead the need for correct social behavior and relations. Finally, Brecht opposed the expressionist theater techniques, which followed conventional theater, of identification, emotional manipulation, and the evoking of feelings of pity or terror. Brecht's critique of Expressionism will be illustrated in the following pages through a detailed discussion of his play *Baal*.[33]

Baal opens in the dining room of a restaurant where literary critics and bourgeois philistines are celebrating the work of a young Bohemian poet, Baal. The scene contains the typical expressionist thematic of the conflict of the creative artist with bourgeois society. But whereas Sorge's Poet in *The Beggar* and Johst's Poet in *The Lonely One* are misunderstood, unappreciated, and yet dedicated to the pure pursuit of their poetic ideals, Baal is more interested in eating, drinking and seducing the wife of a businessman who offers to publish his poems than in promoting — or even discussing — his poetry. From the beginning, Brecht rejected the sterile idealism so typical of Expressionism for a more sensual materialism.

Indeed, Brecht's Baal is the incarnation of the life-force and his play is a celebration of the body, its needs, passions and pleasures. The Phoenician god Baal is a god of fertility, symbolizing the procreative forces of nature.[34] Yet in Brecht's play, Baal the creator is also a destroyer, who, like the Phoenician god, is himself destroyed. The plot of the story traces Baal's decay and disintegration as he slowly, but inexorably, sinks into increasingly degenerate behavior. In this way, *Baal* goes against the movement of more typical expressionist theater which tended to depict the artistic and spiritual development of its main protagonists; *Baal* also

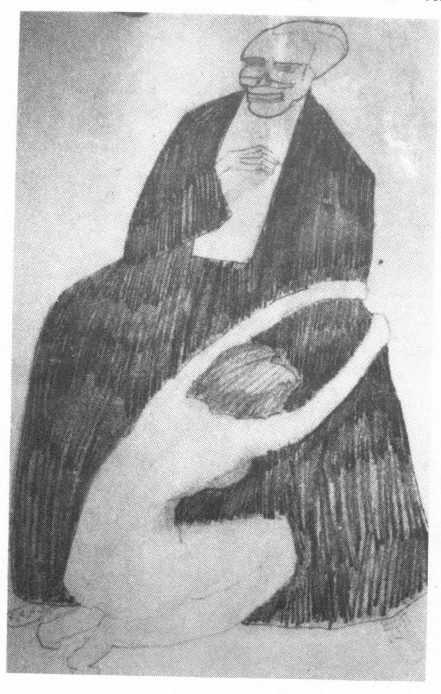

subverts the code of the expressionist "transformation drama" which posits a radical conversion and redemption of its main characters at the end.[35] Consequently, Baal's relentlessly carnal materialism and his complete denial of any transcendence differentiates the play from the sort of expressionist drama popular at the time.

The opening scene contains brilliant satire of both affected literary pretentiousness and the philistine ignorance of art. As students and literary critics praise Baal's poetry and read expressionist poems,[36] Baal continues to gorge himself on food and wine, responding to praise of his poems and comparisons with Whitman, Verhaeren and Verlaine with requests for "A little more eel. . . . A little more wine" (6). As the businessman Mech offers to publish his work, Baal turns to Mech's wife, Emily, asks her to play music, and strokes her bare arm while she plays. When Mech and the others suggest that Baal has had too much to drink and propose that he go to bed, Baal tells Mech: "Down with monopoly! Go to bed, Mech" (9). In response to Baal's outrageous behavior, the group, which had just celebrated him, now denounces him and leaves in a huff.

The anti-philistine satire is close to Sternheim's ironic dissection of the "heroic life of the bourgeoisie," but the character Baal is unlike any of Sternheim's (anti)heroes, who were never strong enough to overcome the pressures of conformity in the hated bourgeois society. Baal, on the other hand, incarnates a powerful life-force which is able to pursue its desires and pleasures despite all social barriers and opposition. Brecht, however, does not idealize Baal. Whereas the first scene establishes Baal as a rebellious individual who resists the pretentiousness, artificiality, conformity and hypocrisy of the bourgeoisie in a way that might evoke sympathy, or identification, Brecht soon "distances" his audience from his "hero." For instance, scenes two through five delineate a shockingly amoral character who consumes human beings with the same gusto and nonchalance with which he wolves down food and wine.

Brecht takes on here Wedekind's and other Expressionist's defense of sexuality and attacks on prevailing repression. Although some critics have claimed that Baal resembles Wedekind's Lulu, he is more aggressive and destructive than Wedekind's heroine. Baal's subsequent coarse descriptions of sexuality (10–11), his crude behavior with Emily, whom he has seduced away from her businessman husband (12f.), and his seduction of the virgin, Johanna, help create an uncomfortable reaction to Baal and make him a quite questionable character. While, on the one hand, Baal embodies a powerful life-force and vibrant sexuality, on the other hand, he is too unrestrained and insensitive. For instance, when Johanna exclaims, after her seduction, "Oh, what have I done! I'm wicked!," Baal replies, "Better wash yourself" (17). I suppose that Brecht approved of this practical response, but in the succeeding scene, Baal makes no effort to comfort or reassure her, and Johanna leaves, unconsoled, to commit suicide, while Baal prepares an orgy with his landlord's two daughters (18–20). In this scene, the play at once reveals the conse-

quences of a misguided idealism, which believes that pre-marital sexuality is evil and wicked, as well as Baal's excessive egotistic hedonism which is unconcerned with other people's feelings and social values.

Although the play is full of expressionistic symbolism, wild and grotesque behavior and lyrical passages, it also contains what in the light of Brecht's later plays might be called anti-expressionist "distancing devices" which provide criticism of various forms of behavior — and of certain expressionist values. Brecht's technique was to use short tableaux to present a play of ideas. Scene five, for example, contains a strange parable on religion. A drunken tramp affirms his love of Jesus on Corpus Christi day in an ironic satire on expressionist "transformation plays" and religious values:

> THE TRAMP (*transfigured*). To serve!! My Lord Jesus. I see the white body of Jesus. I see the white body of Jesus. Jesus loved evil.
>
> BAAL (*drinking*). Like me.
>
> THE TRAMP. Do you know the story about him and the dead dog? Everybody said: It's carrion, it stinks! Call the police! Its unbearable! But he said: He has beautiful white teeth.
>
> BAAL. Maybe I'll turn Catholic. (24)

Baal accepts evil, decay and death, but cynically and without hope of redemption. Religion and transcendence — two idols of many Expressionists — have no appeal for Baal, or the play's author. A religion that could find some beauty even in the stench of a dead dog, though, might provide insight into the unity of opposites. When it affirms, however, otherworldly transcendence or ideal values Baal/Brecht will have none of it. Indeed, the play suggests that there is no pure Beauty or Good; evil and good, ugliness and beauty, are intertwined, part of a nature that is at once fecund and destructive. This ambivalence of nature is expressed in scenes which alternate between portraying nature as a source of joy and pleasure (open fields, cool water, blue plum trees, etc.) in contrast to nature as a hostile, destructive force (cold, wet nights, decay and degeneration, howling wind, gnarled roots, etc.). Consequently, there is no nature worship, or glorification of atavistic regression to nature, of the sort affirmed in some expressionist literature and painting.

For Brecht, both nature and society were torn with contradictions and suffering. In *Baal,* society is portrayed in a particularly repulsive light. Baal sings obscene songs in a "small filthy cafe" for some schnapps, but becomes so disgusted with the sordid environment that he flees through the bathroom window to escape his obligation (scene seven). He can only take so much of the filthiness of society and returns to the "Green fields, blue plum trees" (scene eight). For much of the rest of the play, Baal wanders with his poet-friend Ekart, replaying the Verlaine-Rimbaud affair. This relationship — as well as their relationships with women — deflate

expressionist ideals of love, the soul, friendship: "My soul brother," Baal tells Ekart, "is the groaning of the wheatfields when they toss in the wind, and the gleam in the eyes of two insects that want to devour each other" (29). Baal and Ekart live for the moment. They love each other, women, each other's women. They are bound together by their lust for life, their pursuit of sexual pleasure, their interest in art and their joy in nature. But they are ultimately alone and curiously unconnected.

Baal is a consummate egotist. Other people only exist for his pleasure. His unrestrained individualism leads him to deceive country peasants; he tricks them into bringing their bulls to town with the hopes of selling them (scene nine). A priest berates Baal for his swindle and Baal justifies his actions by the splendid sight of so many animals together (31). In the next scene, he steals the schnapps from a dying man which he devours himself, rather than sharing it with the other woodcutters. Baal justifies his greed by the inspirations and ideas which the schnapps produces in him, saying that the liquor would have been wasted on the common folk. Yet since Baal's ideas and poetry really have little social significance, one is forced to question Baal's egotism. These scenes also question the expressionist belief in the superiority of the artist whose calling supposedly allows him to rise above humanity and use other people to serve his art.

As the play proceeds, Baal becomes more and more flaccid and degenerate. His eventual collapse deflates any affirmations which might have been derived from the earlier depictions of the passionate individual against a philistine society. The relentlessness of Baal's egotism and his total unconcern for other people is portrayed in scene 12 where Baal completely rejects the entreaties of Sophie, whom he has made pregnant; she now wants to go with him, but Baal sees her as a burden. We also discover that Baal has recently seduced two of Ekart's girlfriends simply to drive them away from Ekart. Once more Sophie begs Baal to stay with her and Baal answers: "Throw your swollen body in the river! You disgust me and it's your own doing" (39). As he continues to insult her, Ekart is led to denounce Baal as a "degenerate beast!" and wildly attacks him:

EKART *(wrestling)* Did you hear what she said? In the woods — and now it's getting dark? Degenerate beast! Degenerate beast!

BAAL *(pressing Ekart close)* Now I've got you close. I've got you. Can you smell me? It's better than women! *(Lets go)* Look, Ekart, you can see stars over the woods.

EKART *(stares at Baal, who is looking at the sky)*. I can't hit this beast.

BAAL *(putting an arm around him)*. It's getting dark. We need a place to sleep in. In the woods there are hollows where there's no wind. Come, I'll tell you about the beasts.
(He draws him away).

SOPHIE *(alone in the dark, screams)* Baal! (39-40)

Baal has his (last) triumph, but the rhythm of the play as a whole throws into question the expressionist ideology of the superior individual/creative artist who is beyond good and evil. Although Baal begins as an expressionist hero oblivious to social convention and bourgeois morality, he becomes increasingly repellent. As Baal sinks lower and lower, the expressionist ideal of the superior individual becomes more and more unattractive. Crucially, rather than transformation and redemption, *Baal* depicts decay and literal degeneration.

Baal's portrayal of nature, unrestrained sexuality and egotistical hedonism raises questions about expressionist ideals and values. His endless seductions of women may provide Baal momentary pleasure but they ultimately bring misery. Baal never shows any real affection or concern for any of the women outside of the pleasures of their flesh. Although Baal's rejection of society is total, his immersion in nature takes the form of surrender to the contradictions of a nature which is at once bountiful and destructive, as well as attractive and repulsing. The unity of life and death, vitality and decay, in nature renders it a questionable refuge from the evils of society. Baal, the wandering poet and seeker of sensual pleasure, can never escape society; the play alternates accordingly between his destructive social interactions and his escapes into nature, which in turn alternate between joyful affirmations and images of decay and darkness.

Unlike expressionist art which depicts the basic features of contemporary society and the transition to industrial capitalism, *Baal* is curiously pre-capitalist in its social environment. There is a slogan against monopoly in scene one and discussion of contemporary poetry, but otherwise the environment juxtaposes nature with taverns, huts, woodcutters, peasants and small towns. Brecht describes Baal as "not a particularly modern poet" and many commentators have noted that the environment reflects Brecht's Augsburg countryside.[37] In his later plays, Brecht would, of course, concern himself with depicting the social environment and its effects on human beings, but *Baal* does not really contribute to an understanding of the "asocial society" which Brecht would so vehemently oppose. Instead, it provides a somewhat moralistic critique of amoral behavior. In his 1918 Prologue, Brecht wrote: "The author has thought hard and managed to find a message in it: it sets out to prove that you can have your cake if you are prepared to pay for it. And even if you aren't. So long as you pay."[38]

Baal pays the price. Brecht's early play contains no expressionist affirmations and even borders on a sort of nihlism to which Brecht was attracted, but which he sought to overcome. It is, in a sense, a "learning play" which shows various forms of social (asocial) behavior and the consequences of certain values and actions.[39] Unlike the many expressionist plays that pitted the young artist against the family, reducing conflict to generational division, Baal's opposition to society is total.[40] A part of both nature and society, Baal is reconciled with neither. Baal eats, Baal

dances, Baal fornicates, Baal gets old and in the end Baal dies. In a moment of intoxication, Baal shouts, "I'm a child, I'm undefiled, always happy, always wild!" (29). Yet Baal is increasingly dirty and ugly and his wildness becomes the raving of a pathetic drunk. In a curious scene, which anticipates — and criticizes — the drama of Samuel Beckett, Baal rejects the celebration of nothingness and death of the wretched beggar Gougou (43–5):

> GOUGOU. (*to Ekart*) Best of all is nothingness.
>
> BOLLEBOLL. Shh! Now comes Gougou's aria. The singing bag of worms!
>
> GOUGOU. It's like the trembling air on summer evenings. Sunlight. But it doesn't tremble. Nothing. Nothing at all. You just stop. The wind blows, you're never cold. The rain falls, you never get wet. Funny things happen, you don't laugh. You rot, there's no more waiting. General strike.
>
> THE BEGGAR. That's the paradise of hell!
>
> GOUGOU. Yes, that's paradise. No more unfulfilled desires. All gone. You get over all your habits. Even the habit of desire. That's the way to be free.
>
> MAJA. And what happens at the end?
>
> GOUGOU. (*grinning*) Nothing. Nothing at all. The end never comes. Nothing lasts forever. .
>
> BOLLEBOLL. Amen.
>
> BAAL. (*has risen, to Ekart*). Ekart, stand up! We've fallen in with murderers. (*Holding on to Ekart by the shoulders*) The worms are swelling. Crawling decomposition. The worms are glorifying themselves" (43).

Baal seems to be totally disgusted with these Beckettesque characters and their philosophy; the irony is that Baal ends up in a pathetic state of decomposition and decay himself. At the end of the play, Baal is totally alone and in his death soliloquy calls out for his mother and Ekart whom he had killed earlier in a drunken brawl. While he is being pursued by policemen, he comes into a little hut in the forest to escape the rain and cold; the men inside mock him as he dies (55f.). He begs them to stay with him, but they go off to work. A man spits on his head and Baal licks it off: "It tastes good" (57). He then tells the last worker who remains momentarily with him: "It's been beautiful. . . . everything" (57), and asks him what time it is. The worker leaves and Baal utters his last words which express a mixture of fear, regret, and defiance:

> BAAL. He's gone. (*Silence*) One two, three, four, five, six. That's no help (*Silence*) Mama! Make Ekart go away. The sky is so damned

close now, close enough to touch. Everything is dripping wet again. Sleep. One. Two. Three. Four. It's stifling in here. It must be light outside. I want to go out (*Raises himself*) I will go out. Dear Baal. (*Sharply*) I'm not a rat. Outside it must be light. Dear Baal. At least I can get to the door. I've still got knees, it's better in the doorway. Hell! Dear Baal! (*He crawls to the threshold on all fours*) Stars. . . Hm. (*He crawls out*). (57)

Even while dying, Baal is greedy, stealing the woodcutter's eggs as his last act (58). Baal has now returned to nature. But Baal is no more. There is no hint of redemption or the transfiguration beloved by the Expressionists.[41] Although *Baal* affirms living life to the fullest and following one's desires wherever they may lead, the affirmation is an empty and asocial gesture that only leads to isolation and degeneration. Looking back on his plays, Brecht recognizes that *Baal* shows that "Humanity's urge for happiness can never be entirely killed" and describes Baal as "anti-social but in an anti-social society."[42] Brecht concludes his reflections: "I admit (and advise you): this play is lacking in wisdowm."[43] Rather than showing one how to live, *Baal* ultimately shows one how not to live.

The expressionist ideal of the New Man thus had no appeal for Brecht who came to see radical socio-economic change as the way to improve human life and reduce suffering. He was put off by the excessive individualism proclaimed by many Expressionists and the sentimental "O-Mensch!" humanism of others. In his view, expressionist plays tended to be too abstract and exaggerated in their pathos and rhetoric. Rejecting the emotional intensity and passion of their hyper-dramatic theater, Brecht resolved to create a more analytical, political theater that broke with both conventional Aristotelean theater and expressionist theater, which shared certain — in Brecht's view, false — premises about theater, human nature, and art.[44] For Brecht both traditional and expressionist theater were too "culinary" and induced emotional identification, passive consumption and enjoyment of a cultural spectacle. Such theater could not really, he believed, transform individuals in the way that the Expressionists hoped for. Consequently, Brechtian theater became, in a sense, more experimental and political than the expressionist theater which he had immersed himself in and ultimately rejected in his early plays.

Critical Reflections on the Expressionist Ideal of the "New Man"

The stabilization of capitalism in the 1920s helped deflate the expressionist enthusiasm for a New Man and a New Society.[45] Expressionist pathos was replaced by a "new objectivity" or "matter-of-factness" (*Neue Sachlichkeit*). The expressionist revolt had been tumultuous and feverish, but had obviously not produced the desired results. The triumph of fascism was to extinguish the expressionist dreams, as the fascists, in

perverse ways, assimilated moments of Expressionism, while attacking the movement as "degenerate art."[46] Expressionist writers themselves took various paths from the 1920s, some joining the communists, some the fascists, while many others were driven into exile, which drove some in turn to suicide.

The dream of the New Man was thus crushed by the weight of an oppressive historical reality. Given the internal contradictions of Expressionism and its ideological illusions, it is likely that Expressionism could not have realized its socio-ethical ideals in any case.[47] The expressionist vision of the New Man was extremely flawed, weakened by an excesive individualism, or messianic-rhetorical moralism, which tried to recycle old ideals of heart, spirit, love, brotherhood and the like when war, political upheavals and the relentless juggernaut of capitalist and Stalinist industrialization were destroying bourgeois culture.

Moreover, there was a fundamental contradiction at the heart of the expressionist ideals of liberation and the New Man. Whereas Expressionism began as an attempt to preserve individuality and to develop individual talents and possibilities, in the emphasis on the "renewal of humanity" and the concept of the New Man, individuality is undermined and the particular is lost in the universal. Toller, for example, stresses sacrifice of the individual for the good of humanity in his early plays, as does Kaiser in *The Burghers of Calais*. In more primitivist and atavist Expressionists like Benn and Nolde, there is glorification of the submersion of the individual in nature (see the chapters by Ritter and Bronner in this volume). Thus Expressionism as a whole was not really able to balance the needs to at once liberate and preserve individuality and to create a good society and renewal of humanity. While some Expressionists gravitated toward the pole of extreme individualism and others turned toward ethical idealism, no Expressionists created an adequate synthesis. Both poles, moreover, exaggerated the role of the subject: the individualist tendency wanted to unleash the subject which was, in effect, its own ground (Wedekind, the early Sorge, Hasenclever in *The Son*, Bronnen, Johst, etc.). The ethical idealist tendency wanted to create a renewal of humanity primarily through a transformation of the subject. Both tendencies therefore exaggerated the role of the subject in individual and social transformation and both failed to specify the complex mediating factors involved in socio-historical transformation.

The excessively elitist individualism in expressionist ideals of the New Man is most clearly portrayed in the dramas which depict the relationship between the superior individual and the "masses". In almost every play which raises this theme, the "masses" are depicted as faceless, characterless, passive robots, who are swayed first one way and then another by the superior expressionist hero (one can see this view of the "masses" as well in Fritz Lang's films). In Toller's *Transfiguration*, the masses are supposedly transformed by the rhetoric of the main character, exposing the Expressionist's naive belief that superior individuals

through the power of the Word could transform humanity.[48] In Kaiser's *Gas*, the workers are first persuaded by one antagonist and then another in the debates between the Son and the Engineer. Kaiser, in fact, uses a phrase from the Billionaire in *The Coral* as the motto for *Gas*: "But the deepest truth is always found only by an individual. Then it is so enormous that it cannot become effective!" — unless the superior individual can communicate it and thereby transform the lowly masses. The expressionist belief that only superior individuals could bring about social change and that the communication of their message to the masses was the appropriate vehicle for change was ineffectual in Weimar Germany where political organizations, economic elites and institutional forces controlled the political destinies of the people and provided insurmountable obstacles to the realization of the expressionist dream of the New Man.

It is also symptomatic of the flawed expressionist vision that *men* were generally the bearer of the expressionist ideal and women were usually merely their handmaidens, or accomplices.[49] The Girl in Sorge's *The Beggar* finds her mission in devoting herself totally to the Poet, while the Daughter in Kaiser's *Gas* is portrayed first as a prize to be captured by a successful suitor and then as the voluntary future bearer of the New Man. Women for Brecht's *Baal* are simply playthings who are to provide sensual pleasure for the play's hero and then are to be discarded. The atavistic fantasies of Kokoschka and Benn degrade women into objects of male lust who provide means for regression into primal nature. Rape and violence toward women are quite frequent in expressionist plays, taking the form of murder in Kokoschka's play *Murderer the Hope of Women*.

This sexism is deeply rooted in the expressionist belief that only superior men can produce a renewal of humanity and that women are inherently inferior.[50] Men stood in the center of the expressionist universe and women were for the most part supporting characters. Although some expressionists sentimentalized, or even glorified, women, others brutalized them. While Wedekind, for example, attacked conventional sexual morality, he himself tended to have quite conventional views of women's place and in his first published play *Children and Idiots* (1891) wrote a satire on would-be emancipated women.[51] Thus, the Expressionists on the whole were reactionary on the question of women's liberation and were far behind Ibsen and the Naturalists on this issue.

Furthermore, there is a formal emptiness and irrationality in the concept of the New Man which is akin to existentialism. The existentialist hero is to raise himself above the crowd, become "resolute", or "authentic", and, facing mortality, is to embark on some individual project; the content of the existentialist ideal is left open, so it is indifferent to whether its heroes become "authentic" poets, revolutionaries, or Nazis.[52] Expressionists stressed that this transformation took place in a dramatic breakthrough (similar to Kierkegaard's and Heidegger's "moment of vision") in which one suddenly radically transforms one's life and enters a

new existence. The ultra-individualist and "activist" expressionist-existentialist ideals, however, neglect the complex process of self-transformation which requires insightful growth and development and not just sudden rebellion in order to create new individual and social life. Exceptions here may be Toller and Kaiser who sometimes stressed an organic development, growth and a maturation process as necessary in creating a New Man. But all Expressionists tended to neglect completely questions of new institutional structures and political organization that might bring about the social changes which would make possible the creation of a new humanity and new society. It is usually an individual who is bearer of the New Man and although his power may fuse other individuals together, there is never real discussion which forges a consensus, develops non-hierarchical social relations, or any forms of participatory democracy.

In short, the Expressionists neglect completely developing new institutions and forms of social action which would enable individuals to interact together more cooperatively and to develop their own individual and social capacities. Expressionist subjectivity was so intense that intersubjectivity was neglected. Politics, therefore, became but a proclamation of ideals, or a process of persuasion where the expressionist hero manipulates the masses. At bottom, the Expressionist could solely perceive indivduals in rebellion as the vehicles for social changes. Although they put in question many aspects of bourgeois-industrial society, they really never developed revolutionary alternatives. Their belief in the redemptive powers of art and the superior individual is rooted in a subjectivist, romantic tradition that was not able to overcome the realities of twentieth century history. Expressionism was thus shipwrecked in the abyss that separated their ideals and dreams from a recalcitrant socio-historical reality.

Expressionism was to a large extent trapped in the ideological ideals of an earlier age. Surely, as Bloch, Marcuse, and others have argued, the expressionist ideals contain utopian moments of freedom, happiness, and traces of liberation, but the Expressionists never clearly perceived, or articulated, how the ideal could be realized in a hostile world. After Auschwitz, few believed that art could transform and redeem humanity and later avant-garde literature was more ironic, skeptical and "negative". Affirmative ideals of the New Man and New Society were passe. Yet despite its many flaws, there is something heroic and inspiring in the expressionist quests for liberation and a higher humanity which may well provide essential aspects of an emancipatory art.[53] If literature and art in the broadest sense are to be relevant to human beings in an age of media manipulation, global economic crisis, and political turmoil, it should concern itself with human liberation and should contain images, or traces, of a liberated humanity and new society. Expressionism tried to revolutionize art and life and perhaps its enduring appeal and interest are preserved in its attempts to liberate the individual and transform society

in an era that contained possibilities for a better life as well as threats of barbarism.

Notes

[1]For my feminist comrades of both sexes, I should note here at the beginning that I am not myself recommending use of male gender terms to represent the human species as a whole. There is no doubt but that expressionist writing *is* deeply sexist, not only in its use of the generic "man" — which was, after all, common practice — but in its utilizing, with few exceptions, males as the vehicles and archetypes of liberation. In this scenario, women were usually portrayed in conventional sex-roles and frequently served as the handmaiden of the males trying to realized *their* individuality, or to redeem humanity. Since the term the New Man is so widespread in expressionist literature, I shall use the term, but will also criticize the entire concept in the concluding section.

[2]Walter Sokel, for instance, separates more formalist-abstractionist Expressionists, who he believes carried out an important artistic revolution, from the rhetorical-messianic Expressionists who he believed fell prey to excessive rhetoric and produced inferior art. See *The Writer in Extremis* (Stanford: Stanford University Press, 1959), pp. 50, 89, 161, passim. Although this distinction can be made in regard to distinguishing certain types of Expressionists from other types, I shall argue in this paper that the formal-aesthetic innovations of many major Expressionists are inextricably interconnected with their social-ethical concerns and that the concept of the New Man deeply influenced construction of both the form and content of expressionist art.

[3]See my discussion of Nietzsche in "Expressionism and Rebellion" in this book. The following books on expressionist theater all contain discussion of the impact of Strindberg on Expressionism: Carl Dahlstrom, *Strindberg's Dramatic Expressionism* (Ann Arbor: University of Michigan Press, 1930); Richard Samuel and R., Hinton Thomas, *Expressionism in German Life, Literature, and the Theatre* (Cambridge: Heffer and Sons, 1939); and Sokel, *op. cit.*

[4]Kokoschka's play is seen by some critics as the first expressionist play and by others as at least "proto-expressionist" and a crucial precursor of expressionist theater. It is included in both the first two collections of expressionist drama translated into English. See Walter Sokel, editor, *An Anthology of German Expressionist Drama* (Garden City: Anchor-Doubleday, 1963)

and J.M. Ritchie, editor, *Seven Expressionist Plays* (London: Calder and Boyars, 1968). (page references in text to Sokel anthology).

[5]See the translations of Benn's works and the introductory essay by E.B. Ashton, *Primal Existence* (New York: New Directions, 1961) and discussions of Benn in Kellner, *op. cit.*, and Ritter, "The Unfinished Legacy of Early Expressionist Poetry" in this book.

[6]Gottfried Benn, "Synthesis", translated in Roy Allen, *German Expressionist Poetry* (Boston: Twayne, 1979). In "Songs", Benn articulates a longing to regress to "our primal ancestors" in the sea. See the translation and discussion in Allen, *op. cit.*, pp. 119f. and Ritter, *op. cit.*.

[7]Sokel, *Writer*, *op. cit.*, p. 99. In my opinion, Sokel tends to overly psychologize expressionist literature, all too often reducing its formal innovations and thematic content to the psychological states of its author's psyches, which Sokel often finds pathological.

[8]Most of the plays mentioned in this paragraph have not been translated. The works cited in note 3 provide bibliographic references to the German texts, and Toller and Kaiser will be discussed in this essay.

[9]On the German "artist-novel", see Herbert Marcuse's 1922 doctoral dissertation, *Der deutsche Künstlerroman* in *Schriften* 1 (Frankfurt: Suhrkamp, 1978), discussed in my forthcoming book *Herbert Marcuse and the Crisis of Marxism*.

[10]See Allen, *op. cit.*, and Ritter, *op. cit.*.The titles of the sections in Kurt Pinthus's anthology of expressionist poetry *Menschheitsdämmerung* (Hamburg: Rowohlt, 1959) articulate the pathos and yearning for a new life in poems categorized under *Sturz und Schrei* (Upheaval and Cry), *Erweckung des Herzens* (Awakening of the Heart), *Aufruf und Empörung* (Summoning and Rebellion), and *Liebe des Menschen* (Love of Humanity). As Roy Allen has argued, *op. cit.*, much of their work was directed towards creating a new art, new reality, new morality, new vision, new politics and new man. Obviously, traditional forms could not contain this drive for the new, or their messianic zeal, driving Expressionists to break with lyric poetry and conventional literary forms.

[11]On the expressionist essay and their journals, see Barbara Wright, "Sublime Ambition" in *The Expressionist Heritage*. The very titles of these journals (*Der Sturm, Die Aktion, Revolution, Aufbruch, Das Tribunal, Das Ziel,* etc.) suggest their revolutionary elan and belief in the power of the word and cultural journals to transform humanity.

[12]On expressionist novels and narrative fiction see Sokel, *Writer*, *op. cit.*, and the articles in this book by Vietta and Zimmerman.

[13]See Wright, *op. cit.*, and my discussion below.

[14]See the discussion of various usages of the term "Erlösung" in Roy Pascal, *From Naturalism to Expressionism* (New York: Basic Books, 1973), pp. 194–7.

[15]Franz Werfel, "To the Reader", in Pinthus, *op. cit.*, p. 279.

[16]Franz Werfel, "The Beautiful Radiant Man", translated in Allen, *op. cit.*, p. 119.

[17]Leonard Frank, *Der Mensch ist gut* (Potsdam: Kiepenheuer, 1919). Brecht, in the *Three-Penny Opera*, satirizes this belief in the song "Man is bad".

[18]Frank, *op. cit.*, p. 141.

[19]See Friedrich Nietzsche, *The Birth of Tragedy* (Garden City: Anchor-Doubleday).

[20]See the books on expressionist drama cited in note 3 and the manifestoes translated in Sokel, *An Anthology, op. cit.*, pp. 3–14.

[21]Reinhard Sorge, *The Beggar*, translated in Sokel, *op. cit.* Page references to this edition in text.

[22]Wright, *op. cit.*.

[23]Walter Hasenclever, *The Savior*, citation translated in Sokel *Writer, op. cit.* p. 172.

[24]Walter Hasenclever, *Antigone,* translated in *Vision and Aftermath,* edited by J.M. Ritchie (London: Calder and Boyars, 1969).

[25]Reinhard Goering, *Naval Encounter*, in *op. cit.*

[26]Toller was the first expressionist playwright whose works were translated into English and published in a collected volume. See Ernst Toller, *Seven Plays* (New York: Liverright, 1935). Page references to this edition in text. For information on the extensive translations and performances of Toller's work and a detailed bibliography on his reception, see John M. Spalek, *Ernst Toller and his Critics* (Charlottesville: University of Virginia, 1968).

[27]Georg Kaiser, *Five Plays* (London: Calder and Boyars, 1971). On the so-called expressionist "transformation drama", see Eberhard Lämmert, "Das expressionistische Verkündigungsdrama," in *Der deutsche Expressionismus*, editor, Hans Steffen (Gottingen: 1965) and Silvio Vietta and Hans-Georg Kemper, *Expressionismus* (Munchen: Wilhelm Fink, 1975).

[28]This story is told by Hans Otto Münsterer in *Bert Brecht. Erinnerungen aus den Jahren 1917–1922* (Zurich: Arche, 1963), p. 86. See also Dieter Schmidt, *'Baal' und der junge Brecht* (Stuttgart: J.B. Metzlersche, 1966). Schmidt's account of the origin of *Baal* is based on a careful study of material in the Brecht archives, memoirs of the period and interviews with Brecht's friends from the time. It is invaluable in recreating the environ-

ment in which *Baal* was produced and in analyzing the various stages of development of the text.

[29]Munsterer, *op. cit.*, p. 22.

[30]Brecht reportedly told his friend George Pfanzelt, to whom the play was dedicated, that he found *The Lonely One* to be "absolutely idealist"; cited in Ernst Schumacher, *Die dramatischen Versuche Bertolt Brechts* (Berlin: Rütten und Loening, 1955), p. 3l. Brecht's remarks on expressionist drama and reviews of expressionist plays are found in Bertolt Brecht, *Gesammelte Werke 15* (Frankfurt: Suhrkamp, 1967), pp. 3-70. Hereafter GW. Brecht published a laudatory memorial for Frank Wedekind, soon after his death, in the *Augsburger Neueste Nachrichten* on March 12, 1918 and one of his first theater reviews was a favorable reception of Kaiser's play *Gas* (*GW* 15, 3-4 and 8-9). His only reservations in his review of Kaiser's play was that in the third act, the theater company "allowed themselves to be too influenced by Kaiser" (i.e. presumably too expressionist). During the same period, he wrote more critical pieces on Kaiser and Expressionism in his notebook. In writing on "entertainment drama", Brecht wrote that Kaiser's plays failed to find concrete dramatic images to embody his ideas (*GW* l5 43ff.). Brecht complains of Kaiser: "his ideas are too extravagant, they have no limits, they have no face, they are formless like floating clouds, but they are too small for an entire heaven. Worst of all, they are clouds with propellers and steering wheels" (*ibid*). Brecht admired Kaiser's attempts to produce a theater of ideas which would challenge the existing society by providing moral instruction and criticism, but felt that the didactic function must be combined with the entertainment function, and that ideas should find embodiment in entertaining images and situations. On Brecht's relation to Kaiser, see Ernst Schürer, *Georg Kaiser und Bertolt Brecht* (Frankfurt: Athenaum, 1971).

[31]Brecht, *GW* 15, p. 44.

[32]Brecht, *GW* 15, p. 45. Brecht's most detailed published comments on expressionist theater are found in a December 14, 1920 review of a series of dramas, *Der dramatische Wille*, published by Kiepenheuer. This laconic summary shows that Brecht was thoroughly immersed in the dramatic literature of Expressionism which he found on the whole distasteful. I quote the review in full:

Kiepenheuer provides, printed in essay-form, contemporary dramas. It thereby contains a representative plentitude (*Gefüllsel*).
I.
The content of Rubiner's "The Powerless" (*Gewalltlosen*) would have been clearer, more likeable, and more comfortably readable, and thus more effectively expressed, in an essay. It is now, however, an essay corrupted through dramatization.

Trautners "Prison" (*Haft*) has content that is probably too long for a poem; it derives its dramatic qualities from Goering, who learned technically from Maeterlinck's "The Blind" (*Blinden*). Toller's "Transformation" (*Wandlung*), until now the clearest, takes its inspiration from Reinhardt, perhaps more than any other; it works with well-cultivated feelings, in a special way. At best, it is a poeticized newspaper. Weak vision, to be forgotten immediately. Thin cosmos. The human being as an object, as proclamation, instead of: as a human being. The abstracted human, the singular of humanity. Its subject matter lies in weak hands.

2.

More essential for the theater: Ivan Goll's "The Practical Joke" (*Posse*) The emancipation of the director. Strangely clear flashes of inspiration. Newspapers, ballad-singer lyrics, photography; extremely lively machines, a sign: "The expressionist Courteline". There is much good in it, childlike. There is more humanity in it than in Toller.

Kaiser's "Hell, Pathway, Earth" (*Holle, Weg, Erde*) is well constructed with penetrating technique, the sketch of a tragedy of spirit. One of Kaiser's best works (the development relentlessly proceeds like a film). An orgy of ethics. With an incomparable composition. Here is a poet, who develops albeit in the weighty elephantitis of conscience.

Andre Gide's *Bathseba* is unusually beautiful, a tender ivorylike painting with deep and moving spiritual foundation. Culture, poetry, and conscience produce here a wonderfully pure harmonious unity.

To sum up: books that one must read like a newspaper. All together (with the exception of *Bathseba*) they are proclamations of humanity without human beings; all together (with the exception perhaps of *Hell, Trail, Earth*), they exhibit a dramatic will without drama". Brecht, *GW* 15, 34–5.

[33]Studies which I have found helpful in discerning the relationship between *Baal* and Expressionism, in addition to those already cited, include Ulrich Weisstein, "The Lonely Baal: Brecht's First Play as a Parody of Hanns Johst's *Der Einsame*", *Modern Drama*, Vol. XIII, No. 3 (Dec. 1970), pp. 284-303) and Walter H. Sokel, "Brecht und der Expressionismus" in *Die sogenannten Zwanziger Jahre*, edited by Reinhold Grimm and Jost Hermand (Bad Homburg: Gehlen, 1970). In the following interpretation, I shall use the English translation by Ralph Manheim and John Willett in *Bertolt Brecht: Collected Plays*, Volume 1 (New York: Random House, 1971); page references will be put in parentheses in the text. This translation follows the German version published in the Suhrkamp *Gesammelte Werke 1* edition, *op. cit.*. These versions of *Baal* are based on the text published in 1920, which was edited by Brecht and Elizabeth Hauptmann in 1954; the first scene was elaborately revised and a last scene was restored from an earlier version in revised form.

On the various texts, see Schmidt, *op. cit.*. There is also useful information in the "Notes and Variants" section of *Collected Plays*, Vol. 1, *op. cit.*, pp. 343ff.

[34]Brecht was an inveterate reader of encyclopaedias and probably consciously chose the title of his play in accord with the feaures of the Phoenician god.

[35]See the sources cited in note 3, as well as Nicholas Hern, "Expressionism", in *The German Theater*, editor, Ronald Hayman (London: Oswald Wolff, 1975) and Paul Pörtner, "Expressionismus und Theater" and Horst Denkler, "Das Drama des Expressionismus", both in Wolfgang Rothe, editor, *Expressionismus als Literatur* (Bern/München: Francke, 1969).

[36]The expressionist poems by Becher and Heym found in the standard version of *Baal* were added by Brecht in 1954; see Schmidt, *'Baal', op. cit.*, pp. 151ff. Earlier versions contain a scene that portrays an interesting reception of expressionist poetry. While Baal is eating, the host announces that some poetry will be read. A young man gets up and reads a poem by A. Stramm. There is wild applause and the host asks Baal for his opinion:

BAAL. *(drinking)*. Excellent!

THE YOUNG MAN. *(hasty)* Permit me! *(Reads a poem by Novotny).* *(Heavy applause)*

CRIES. Genius! Genius! The latest! What passion! I find the verse completely heavenly! And how he presented it! Demonic, and yet with taste! Oh, tell us what you think master!

BAAL *(drinking)* Very pretty *(painful silence).*

THE YOUNG MAN. *(bites his lips, still standing, then presses on)* Very pretty? That, that . . . *(smiling)* Gentlemen, that is a strange judgement. But every new art form takes effort to penetrate through; indeed, our young honored master is an excellent example! *(sits down)*

BAAL. The main thing is that something is alive *(drinking).*

THE YOUNG MAN. *(also drinks)* Thank you, master. That was a great thought. Oh, permit me *(seeks notes)* *(reads a poem from A. Skram).*
(Heavy applause)

BAAL. *(after some silence, drinks and answers)*: That's nonsense *(Quatsch)*

THE YOUNG MAN. Gentleman!

A MAN. Unheard of!

ANOTHER. That's a bit too . . .

WOMAN. Strong.

Cited from the 1918 text in Schmidt, *Baal, Drei Fassungen, op. cit.*, pp. 14–15 (my translation). In the 1919 version, Brecht adds an even sharper attack on bourgeois values after the insults to the poetry (*op. cit.*, pp. 86–7). Although Dieter Schmidt thinks that Baal's description of Stramm's poetry as "excellent" is significant — presumably indicating a favorable attitude toward some expressionist poetry — (Schmidt, '*Baal*', *op. cit.*, p. 109), Schmidt fails to note the irony in Baal's terse remarks and the context of the scene as a whole in which Baal's continual drinking, the young reader's nervous responses and the subsequent development of the scene put in question whether Brecht/Baal had much sympathy at all for expressionist poetry.

[37]See Brecht's Prologue to the 1918 version, translated in *Plays*, Vol 1, *op. cit,*, p. 343 and Hans Mayer's description of Brecht and Augsburg in "Brecht and the Tradition", in *Steppenwolf and Everyman* (New York: Crowell, 1971), pp. 51ff.

[38]Brecht, *op. cit.*.

[39]On Brecht's "learning plays", see Reiner Steinweg, *Das Lehrstück* (Stuttgart: Metzler, 1972) and my discussion in "Brecht's Marxist Aesthetic", in *Bertolt Brecht: Political Theory and Literary Practice,* edited by Betty Nance Weber and Hubert Heinen (Athens: University of Georgia Press, 1980).

[40]Earlier versions of *Baal* contain several scenes with Baal and his mother — parallel to Johst's Grabbe-drama–but they were cut in later versions. Even the earlier versions depicted the misery of Baal's mother over her son's dissolute ways, rather than any real conflict between them.

[41]Interestingly, the Phoenician god Baal was the one god of fertility who received no resurrection. Although Baal was dismembered by his followers, like Dionysius and Osiris, resurrection never followed dismemberment. Furthermore, Baal was often considered a false god. These facts may have been known to Brecht who may well have chosen the name of his dramatic protagonist with these (anti-expressionist) features in mind.

[42]Brecht, "On Looking Through My First Plays", in *Plays*, Vol. I, *op. cit.*, p. 346.

[43]*Ibid.*

[44]Kellner, "Brecht's Marxist Aesthetic", *op. cit.*

[45]On Expressionism in the 1920s, see Samuel and Thomas, *op. cit.*, pp. 171ff. and on late expressionist theater, see Benjamin Daniel Webb, *The Demise of the 'New Man': An Analysis of Ten Plays from Late German Expressionism* (Goppingen: Alfred Kummerle, 1973).

[46]Samuel and Thomas discuss some of the ways in which fascist art took over elements of Expressionism and note similarities and differences between expressionist and fascist art, *op. cit.*, pp. 180.

[47]See my discussion in "Expressionism", *op. cit.* and Wright, "Sublime Ambition", *op. cit.*.

[48]For explicit formulations of expressionist belief in the transformative powers of the Word and Spirit, see Wright, *op. cit.*.

[49]A seeming exception is Hasenclever's *Antigone, op. cit.*, but in fact she gets her "message" from the blind Oedipus and is thus but a mouth piece for his revelations. One of the few expressionist heroines appears in Toller's *Masses and Men, op. cit.* The role of women in late expressionist drama is discussed in Webb, *op. cit.*

[50]For a critique of sexism in expressionist writing, see Barbara Wright's Ph.D. dissertation, *Expressionist Utopia: the Pursuit of Objectless Politics* (University of California at Berkeley, 1977).

[51]Pascal, *op. cit.*, p. 208.

[52]See Martin Heidegger, *Being and Time* (New York: Harper and Row, 1962) and my Ph.D. dissertation, *Heidegger's Concept of Authenticity* (Columbia University, 1973).

[53]See Stephen Bronner's discussion "Expressionism and Marxism: Toward An Aesthetics of Emancipation" in this volume for an elaboration of this point.

9
Franz Kafka, Expressionism, and Reification

Silvio Vietta

The themes of reification and personification appear as literary phenomena in expressionist prose and emerge more inscrutably than anywhere else in the prose of Franz Kafka. To be sure, assigning Kafka to Expressionism is not unproblematic. Paul Raabe, in his essay "Franz Kafka and Expressionism,"[1] has correctly noted that although Kafka's works fall temporally in approximately the period of Expressionism — Kafka's most creative period began in 1912 and extended until his death in 1924 — and although he also had connections with expressionist writers, above all Franz Werfel, that, nonetheless, the "dynamic, activist expressionist stylistic tendencies with typical contemporary features in lyric, drama, and prose" are all lacking in Kafka. Kafka therefore belongs to Expressionism, according to Raabe, only "in a passive sense" (*ibid.*). In fact, Kafka lived marginally as an employee of the "Worker's Accident Insurance Company" in Prague; he observed, to be sure, the development of contemporary literature, but experienced at the same time disgust over the clamor of the literary market and over the rhetorical puffery and noisy forms of expression and living conditions of some Expressionists. In a conversation with Gustav Janouch over a book of poetry by Johannes R.

Becher, Kafka stated: "I don't understand these poems. There is so much noise and jumble of words here that one cannot detach oneself from it. . . . Words do not solidify into language. It is simply screaming. Period."[2] Concerning the anthology *Menschheitsdammerung*, Kafka stated: "The book makes me sad. The poets reach out to humanity. Humanity, however, does not see friendly hands, but cramped, closed fists aimed at the eyes and heart."[3]

Kafka could not stand the expressionist "scream" and their obsessive search for the human which appeared in a variety of artificial linguistic poses. "Kafka's sensitivity to noisy clamor and the expressionist scream — these opposites exclude each other."[4] Kafka's reticent, somewhat purist, language was clearly shaped by the isolation of the German language in Prague and the dry, official government style. Consequently, the sort of wild vollies of words and emotional-pathetic rhetoric which second and third rate Expressionists inflated into poetry could only provoke Kafka's aversion. Thus, he frequently rejected offers of collaboration with circles of expressionist writers.

It is the thesis of *Expressionismus*, a book I co-authored with Hans-Georg Kemper, that the bombastic, marginal symptoms of Expressionism do not constitute the essence of this epoch.[5] On the contrary, these symptoms — puffed-up rhetoric and a multifaceted, pompous activism — have rather alienating and shallow effects today. The essential features — such as the multifaceted disassociation of the subject, the epistemological insecurity, and the loss of metaphysical consolation — which we could demonstrate in various forms in such superior authors as van Hoddis, Heym, Benn, Trakl, Kaiser, Toller, and Sternberg, mark as well the work of Franz Kafka. Nonetheless, the differences in the forms of experience and presentation should not be levelled out. On the contrary, we shall attempt to work them out, but under the historical-analytical aspects of Kafka's close kinship with Expressionism. This will allow us to see in the literary work of the "outsider," Kafka, the fundamental and radical presentation of the specific problematic of the epoch.

In this study, we shall deal with the concept of reification. There are in Kafka striking examples of the reification of persons, such as the story "The Metamorphosis," published in 1915 in Rene Schickele's *Die weissen Blatter*. It begins with the sentence:

> As Gregor Samsa awoke one morning from uneasy dreams he found himself transformed in his bed into a gigantic insect.[6]

This is a form of "metamorphosis" that goes far beyond the reification of the "split personality" in van Hoddis, the de-substantialized subject in Heym, or the mere becoming "flesh" in Benn. In those other Expressionists' works, there is always a reference to the person, even when, as in Benn, it is pure corporeality and is deformed as a symptom of decay. The deformation consists there in the provocative reduction of the subject to its gross corporeality. Gregor Samsa, however, is an "insect."

This "metamorphosis" occurs as a sudden, unforeseen, and unimaginable event that has, so to speak, fallen on Gregor Samsa from "out of the blue." It is as surprising as the imprisonment through a mysterious court in Kafka's novel *The Castle*, which fell upon the bank employee Josef K. Persons in Kafka's tales, like Josef K. and Gregor Samsa, are confronted with totally alienated situations, which are not anticipated and which they have not willingly produced, but into which they are inexplicably thrown. In the attempt to master the situation, a tension arises immediately between the reflection of this "hero" and its alienated situation. For example, Gregor Samsa cannot really grasp his new, extremely strange situation; he cannot understand his "metamorphosis", he does not seriously investigate it, but rather represses the situation and attempts to gloss over it and to continue thinking in the framework of his earlier world. From this inexorable divergence between reflection and an alienated situation arises — even more than from the transformed situation itself — the grotesque effects, which have been observed so often in Kafka-research.

Thus, Gregor Samsa, transformed from a travelling salesman into an insect, simply attempts to go back to sleep: "What about sleeping a little longer and forgetting all this nonsense, he thought" (89). He represses the estranged situation itself as "nonsense", but is constantly brought back again to his situation through his transformed corporeal reality. For instance, Samsa can no longer sleep, as usual, on the right side, because his deformed condition will not allow it: "He tried it at least a hundred times, shutting his eyes to keep from seeing his struggling legs, and only desisted when he began to feel in his side a faint dull ache he had never experienced before" (89).

Closing his eyes and thinking about his occupation are forms of repression, of attempting to fix upon the normal forms of existence and thought in order to gloss over his own bizarre form, both for himself and for others. The others: they are at first Gregor's family; his sister, father, and mother, who knock on his door and ask him with concern:

> "Gregor," said a voice — it was his mother's — "it's a quarter to seven. Hadn't you a train to catch?" That gentle voice! Gregor had a shock as he heard his own voice answering hers, unmistakably his own voice, it was true, but with a persistent horrible twittering squeak behind it like an undertone, which left the words in their clear shape only for the first moment and then rose up reverberating around them to destroy their sense, so that one could not be sure one had heard them rightly. (91)

There occurs a disintegration of human communication with his environment through the deformation of the voice suggested here. At first, the family, not aware of what happened, is satisfied with his answer, even if they do not understand it and Gregor also "looked forward eagerly to seeing this morning's delusions gradually fall away. That the change in

his voice was nothing but the precursor of a severe chill, a standing ailment of commercial travelers, he had not the least possible doubt" (92).

The situation becomes more dramatic, however, as the consequence of the arrival of the head clerk from the firm. His queries and threatening inquiries through Gregor's door sharply increase the anxiety of Gregor Samsa for his position in the firm and for his very existence, since his entire family lives off his wages. In his growing anxiety, he lets loose with a cascade of palliative apologies, mobilizing an extreme amount of cunning assessment of his situation — which is completely unreal and completely underestimates its gravity — "A slight illness, an attack of giddiness." (97) But in attempting to save the situation in his way, he gives himself away: " 'That was no human voice', said the chief clerk in a voice noticeably low beside the shrillness of the mother's." (98)

When, after much exertion, he turned the key in the lock with his mouth and the door opened, the others reacted to his appearance through mechanisms of repression: his mother fainted, his father "knotted his fist with a fierce expression on his face", and the chief clerk moved away toward the exit door, "as if driven by some invisible, steady pressure." (100) Gregor, still composed, was prepared to pack his "samples" and take off for work. He moved into the next room to detain the chief clerk who was fleeing from him and encountered his father who savagely hissed at him and drove him back into his own room. Henceforth, he was not considered fit for human communication.

After the shock of the metamorphosis in the first part of the story, there follows a phase in which the family tries to make the best of the situation and begins to adjust to it. The sister regularly brings Gregor his feed, as one feeds a house pet, without, to be sure, growing accustomed to Gregor's looks. Consequently, Gregor regularly hides under a couch upon her arrival. The father soon finds another job and while the family begins to hope vaguely for an improvement of its life, Gregor's metamorphosis consolidates itself: "for mere recreation he had formed the habit of crawling crisscross over the walls and ceiling. He especially enjoyed hanging suspended from the ceiling; it was much better than lying on the floor; one could breathe more freely." (115)

As the family, out of consideration for Gregor, wants to move out the furniture, in order to create more room for these excursions, he explodes and — as in "The Judgment" — is attacked by his father, who has himself suddenly been transformed into a stronger and more powerful person than before who not only drives Gregor back, but bombards him with apples: "An apple landed right on his back and sank in." (122)

In the third and last part of the tale, Gregor's loss of memory and embittered wasting away is described. In this situation, Gregor constantly dreams that the "next time the door opened, he would take the family's affairs in hand just as he used to." (125) The increasing exclusion of Gregor from the human sphere manifests itself, however, when a new, rather gruff, maid no longer perceives him as a being belonging to human

society and refers to him instead as a dung-beetle: "Move along, then, you old dung beetle!" (127)

Near the end, Gregor threatens to drive away three new tenants with his appearance, out of consideration of his sister, whose piano playing they first requested and then rejected. After they threaten to leave the house, the sister herself calls Gregor a "beast" and attempts to convince the parents:

> "He must go," cried Gregor's sister, "that's the only solution, father. You must try to get rid of the idea that this is Gregor. The fact that we've believed it for so long is the root of all our trouble. But how can it be Gregor? If this were Gregor, he would have realized long ago that human beings can't live with such a creature, and he'd have gone away on his own accord." (134)

The final repudiation of family life is carried out by Gregor himself, similar to Georg Bendemann who carried out his father's "judgment". The first to find him is the house-maid: "Just look at this, it's dead; it's lying here dead and done for!" (136)

Christoph Bezzel has stressed that the conclusion which pictures the final repression and casting off of the "metamorphosis" — and the seemingly hopeful new beginning of the family — should not be naively read as an affirmative "happy ending". The idyllic picture of the family out for a stroll on a warm spring day "is in truth the making visible of a catastrophe anticipated from the beginning. The picture is a desperately ironic image of the highest explosive force under the mask of objective description".[7] Indeed, this picture once again conveys in compressed form the facade-character of conventional forms of thought and behavior in view of a ghostly and unarticulated repressed situation of alienation.

The question quickly arises which is so often posed: what does this all mean? If one wants to come close to an answer to this question, it makes sense to review, at least briefly, the numerous interpretations in the secondary literature on Kafka.

Wilhelm Emrich sees in the story, on one hand, the basic conflict between the work-world and everyday world and, on the other hand, the alienated and distorted "self" of the subject:

> His own inner life remains alien to him. Consequently, Kafka portrays it as an alien being, namely, as an insect which threatens in inconceivable ways his rational existence. That is the meaning of the remarkable fact that Kafka constantly portrays the inner life, indeed, what is "authentically" the most inner and personal aspects of the human being, in the forms of shockingly alien things or animals which threaten destruction, or in the forms of absurd bureaucratic authorities who demand control from people over their own self.[8]

Moreover,

> the self is in no way an "individual", intelligible, internal being; it
> must instead take the form of something external, something
> alien, which explodes the laws of the external, empirically rational,
> everyday world. This is the completely logical and artistically
> legitimate consequence of the modern process of alienation and
> reification." (121)

The alienated form of an insect as the self-alienated, reified form of
the subject: from whence, however, does such reification arise? Emrich
refers to the portrayal of the family-idyl, whose seeming happiness rests
on "deception and concealed manipulative calculation" (123). It is thus a
mirror of an alienated business-world that is directly represented through
the head clerk and is constantly present in the reflections of Gregor Sam-
sa. One could read other stories by Kafka as well, especially the great
novels *The Trial* and *The Castle*, as the presentation of the alienated,
calculating and bureaucratic business-world which completely under-
mines the existence of the private I.

Such a direct "social critique" interpretation finds sufficient points-
of-contact in Kafka's work. Such interpretations, however, appear forced
and not completely appropriate to his work. The term "reification", for ex-
ample, is primarily an economic-philosophical concept which stems from
a specific tradition. It is developed in Georg Lukacs' magnificent early
work *History and Class Consciousness* in reference to Marx's analysis of
the commodity. The concept of reification, which Lukacs develops from
Marx, signifies the alienation of social labor to thinglike activity, sub-
jugated to an alien object — the alienation of subjectivity to domination
by an objectivity that is alien to the subject and which stands over and
against one. "Reification" characterizes a process already described by
the early Marx:

> The more the worker spends himself, the more powerful becomes
> the alien world of objects which he creates over and against
> himself, the poorer he himself — his inner world — becomes, the
> less belongs to him as his own.[9]

Lukacs attempts to demonstrate that the alienation of labor from the
subject, as alienation of humans among each other, is already rooted in
the labor-process itself, in so far as work proceeds according to rules and
processes which are alienated (i.e. alien to the subject). The principle
which governs this process is "calculating rationality"[10] — a principle
taken over from Max Weber's concept of "calculation". "Calculation" for
Lukacs is the principle of reification itself.

Lukacs points to reification everywhere. In the practical labor-
process, it appears in the division of the unity of labor-activity and what-
is-worked-upon, and in the constitution of the totality of the labor-
process, it appears in the fragmented segments which follow each other

sequentially, like a montage; reification appears in bureaucratic ad-
ministration, as well as in theories which replace qualitative forms of
thought by quantitative forms and thereby transform qualitative content
into quantitative, calculable relations. Throughout, the principle of a
systematic, quantifying, and rationalizing calculation defines — crudely
put — the economic-philosophical concept of reification in Lukacs.

If Emrich, probably in reference to Adorno's analysis, uses the con-
cept of reification less clearly defined than Lukacs — seeing in Kafka's
work, a presentation of modern economic reification — then, this occurs,
as noted, not arbitrarily, but with support from many references in
Kafka's work. On the other hand, it remains a question why Kafka himself
does not describe in "The Metamorphosis" the work-world as the authen-
tic source of reification. Here one must above all show how Gregor Samsa
is employed, agitated, and consumed by the division of labor and the
bureaucratic rationality of his occupation, and is in this sense "reified".
One has, to be sure, in the form of the head clerk, as well as in Gregor's
reflections, reference points concerning Gregor Samsa's business world,
but the total rupture into the form of an insect is so bizarre that one can
only forceably read the "metamorphosis" as the allegory of the alienation
of the self in the modern labor-process. One must consequently avoid
measuring Kafka's work by the economic concept of reification because
he does not either clearly present the source of this reification, or
describe it in any detail.

How, then, can one understand this bizarre story? Walter Sokel
presents the thesis, in his book *The Writer in Extremis*, that "The Metamor-
phosis" is a dream-symbol presentation of repressed representations of
drives and wishes. Sokel sees in the novel-fragment "Wedding Prepara-
tions in the Country" an earlier stage of the metamorphosis. In that story,
the hero Rabin wants to be able to split himself into two parts in order not
to have to visit his fiance in the country. His self, transformed into an in-
sect, wants to stay in bed. What appears there as a day dream, however,
becomes Gregor Samsa's fate. The story is thus, in this reading, an ab-
solute metaphor for the realized wish of a parasitical existence:

> Gregor Samsa wished to abdicate his power in the family, together
> with the intolerable burden of hard work which his position entail-
> ed, and regain the love his parents once bestowed upon him before
> he had replaced his old father as the breadwinner and head of the
> household. At the same time he wishes to turn the tables on his
> family, who have parasitically exploited his drudgery, and to live
> himself like a parasite in simultaneous liberty and dependence.[11]

According to Adorno, Kafka studied "as in an experiment. . . what would
happen if the findings of psychoanalysis were not taken metaphorically
and psychically, but corporeally".[12]

These interpretations of Kafka's story as a "dream symbol" which
lays bare psychological mechanisms can certainly register a series of

arguments for itself. One can directly connect Kafka's representation of psychological problems in dream-symbols to Kafka's own experience as an artist. One can read the complex of insect-images as the expression of the problematic of the artist, as Kafka himself existentially lived it: the role of the outsider who is not smoothly integrated into everyday com-

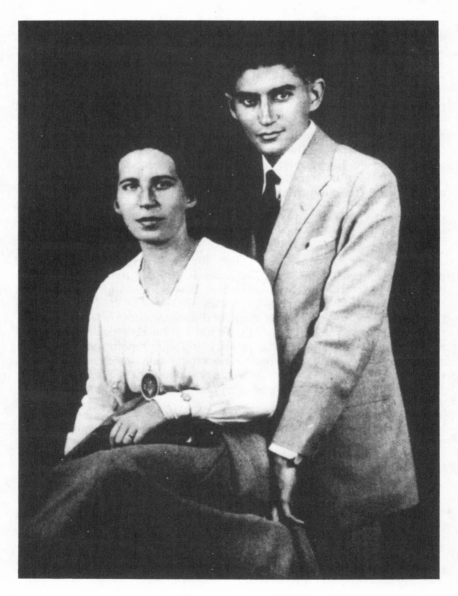

munication has, in his eyes, something of the characteristic of a social outcast. Kafka's letters and notebooks confirm this. Heinz Politzen has in this sense, and with good arguments, interpreted the form of the insect as a cipher for Kafka's artistry.

The problematic of the artist is closely connected in Kafka with father-conflict — Hans-Georg Kemper shows this in his analysis of the story "The Judgment" which is structurally similar to "The Metamorphosis".[13] It is the father who confronts Gregor with overpowering authority, who bombards him with apples and thereby wounds him, leading directly to his death. We note only in passing that the motive of conflict with the father is a bridge to other expressionist writing (for example, Walter Hasenclever's *The Son,* or Arnolt Bronnen's *Patricide*).[14]

Thus, the psychological and psychoanalytical interpretation can also muster up for itself a number of textual references and, above all, autobiographical documents. They illuminate, in fact, an essential level of meaning in Kafka's work. However, it too does violence to Kafka's work in its totalizing claim to explain everything, because essential levels of the work are consequently not grasped.

In the 1960's, Kafka-research opened the way to a strictly immanent interpretation. This type of research has worked out Kafka-interpretations on a comparatively solid foundation of textual readings, but its presuppositions too are problematical. Not only does it smuggle in frequent value-judgments which are not immanently developed, but, moreover, its "ontological" presuppositions of interpretation — that fixate essentially on textual elements and internal relations — are quite problematic in regard to Kafka. Jost Schillemeit has correctly made this point in regard to the novel *The Trial*: "It is manifestly the question...whether this novel is really a presentation of 'objects', even properly described fictional ones".[15] Schillemeit arrives from his analysis at the result that in the central levels of meaning in the novel one discovers in place of objects, a "hollow space".

Even the concept of "picture signs" (*Bildzeichens*), which has played an important role in this type of research, indicates that what one encounters in the work are not isolated signs, but rather a contextually mediated totality that transcends an immanent referential context of the work which would justify a textually immanent interpretation.[16] This brief outline does not in any way exhaust the reservoir of Kafka-interpretations. There are also a whole series of quasi-theological, religious interpretations that read Kafka as the poet of a hidden salvation, or even of the absurd — only to mention one more of the main currents of Kafka-interpretations. Without discussing in detail the multiplicity of interpretations of the story "The Metamorphosis", we can say in summary: there is no other author within Expressionism — and perhaps in the entire twentieth century — who is considered through so many multifaceted and divergent interpretations.[17]

However, one cannot simply be satisfied with an additive sum of these interpretations. The real question is and remains: from whence do

such a large number of interpretations arise? Precisely, and only here a subtle analysis can make clear that the text consciously leaves open an in-determinate play-space for reading (*Spielräume des Lesens*) and that the multiplicity of meanings results from the lack of a single and binding representation. I directly refer to the analysis of Hans-Georg Kemper, whose conclusions I presuppose here.[18] Reflections on "The Metamor-phosis" lead to the discovery that the central event — the "metamor-phosis" — cannot really be grasped and conceived from one rhetorical figure. The alienated situation certainly sets in motion a process of reflec-tion, but it takes the form of defensive reactions, mechanisms of repres-sion, reflections which deflect attention and thus are not genuine critical reflections. The tension between the consciousness of the character and his given alienated situation also sets in motion, however, a process of reflection in the reader who sees the events from the perspective of the protagonist without being allowed to identify with him. Precisely because the reader is confronted with a literary scene whereby the characters are totally unable to interpret their situation, one's own interpretation is demanded.

I believe that, above all, early Kafka research has made the mistake of simply following this impulse to seek a single meaning for the story and has therefore carried on, as it were, the "trial" in which Kafka's characters themselves are implicated. When Gregor Samsa cannot understand what is happening to him, when Josef K. does not know who is behind him, the academic German scholars have wanted to be able to clarify the situation, at least retrospectively. The castle in the novel named after it, the court of justice in *The Trial*, and the "metamorphosis" all shatter the impulses of Kafka's heroes to grasp their meaning. The mistake thus consists in directly identifying with the perspective and the compulsion for meaning of the hero.

On the other hand, one must grasp that in Kafka's stories "meaning" itself is thematized. This aim is indicated in the "empty spaces" concrete-ly analyzed by Kemper in "The Judgment"[19] and corresponds to the discrepancy consciously worked out in Kafka between the reflections of the protagonists and a state of affairs in which he can no longer simply absorb himself. The objection that might be raised against this seemingly simple point is that it is precisely here that a meaning is being given. Does not such a meaning correspond to the compulsion for meaning of the hero and can one really believe that one has a solution to the situation that the protagonist could not find? In fact, this meaning is no real "solu-tion" and essentially refers to other novels. It takes place no longer from the perspective of the heroes, but conceives of precisely this signifying reflection as an essentially unending, incomplete process.

It would be naive and false to say that Kafka's "metamorphosis" signifies something determinate — Kafka's tales are not simple allegories for abstract states of affairs; rather, the text refers to a situation that can-not be fully grasped in subjective meanings. The hero is caught in a total-

ly alienated situation that he is not able to penetrate conceptually. The alienated character of reality that can no longer be fully comprehended in subjective meaning constitutes — according to this interpretation — the basic outline of Kafka's stories. The almost total helplessness of the characters' reflections in grasping their real situation belongs to this character of alienation.

The text thus thematizes alienation itself as a form of consciousness whereby one cannot clearly grasp or articulate a state of affairs. This confrontation with radical estrangement troubles the reader and knocks away the foundation of familiar representations — already in the opening sentence of "The Metamorphosis," a man becomes an "insect" — in order to leave the reader alone with his disordered world of representations. One sees here how the seemingly appropriate claim to limit interpretation to what is immanent in the text is unjustified and against Kafka's own work. Every interpretation, even those which point beyond the text, must themselves be rooted in the text, but purely immanent interpretations, solely entrenched within the text, neutralize precisely the appellative demands of the text. A book for Kafka should act as a blow on the head of the reader. One must take seriously this intention which surely points beyond the text itself.

The interpretation provided here does not indicate that we can dispense with the multiplicity of individual interpretations. On the contrary, the individual interpretations are themselves components of a process which the text wishes to set in motion in the reader and which it nourishes through constant hints of meaning, as well as the "empty spaces" referred to earlier. What is decisive, however, is that the reader does not — like Kafka's "heroes" — remain on the level of immediate meaning, but moves beyond this concept to consider "meaning" itself within a specific theoretical and historical context as an infinite process that never comes to conclusion. Kafka's texts expose states of affairs which in the beginning demolish through "progressive regression" the meanings suggested by the author himself, so that the situation becomes all the more mysterious and the meanings all the more confused. "Every sentence says: interpret me and yet none will permit it" (Adorno).[20] Beda Allemann describes the structural form of Kafka's stories as an "arrested storm" — using a term coined by Kafka himself.[21] This notion provides a key to distinguishing Kafka's stories, and especially his short parables, from traditional parables to which they are often compared: no positive, intelligible, universal meaning springs from the story — rather, the meaning remains obscure. This remaining-obscure-of-the-meaning (*Dunkelbleiben des Sinns*) is — to use a paradoxical formulation — itself meaning.[22]

The problem of reification and social critique is completely displaced to another level. Social alienation and reification are not directly criticized — although there are sufficient elements of such a critique in Kafka's works — instead, the critique exists in the presentation of the

situation of alienation itself. This is, to be sure, neither exhausted by con-
ceptualizing what is interpreted nor through the philosophical-economic
concept of "reification." When Kafka transfers a subject into a situation
through radical estrangement which cannot be grasped by its normal
forms of thought and behavior, then this alienated relation of the situa-
tion to reflection in the text also necessarily touches the interpretation of
the text. The congruence between thought and being that has collapsed
for the protagonists cannot be subsequently re-established by the inter-
preter. An interpretive reflection, including that of the literary scientist,
will no longer be able to penetrate through "subject" and "object," to use
these traditional concepts, but will be endlessly sundered from the
alienated situation. Naturally, the reflections of the interpreter only in
rare cases operate on the level of the "hero" in "The Metamorphosis" —
namely, the level of repression — but the certainty of an established
system of interpretation, or concepts, which will dissolve all complica-
tions and solve all riddles, will also be shattered by the story. The inter-
preter of the story knows as little as Kafka's heroes about what the situa-
tion portrayed "really" means. Thus, all the interpretation can do is to
reflect on this situation and possibly come to understand the situation of
alienation itself and discover its epistemological presuppositions.[23]

In Kafka's stories, the alienated situation returns the subject to itself
because its reflections are distorted. Kafka portrays pathological ap-
pearances of solving problems that lead in fact to physical death. Many of
Kafka's heroes perform this operation on themselves. No other author
describes so devastatingly, in a literal sense, the process of dissociation of
the I as the subjective reflex of a totally distorted relation to reality as
Kafka. The existential life-experience of Kafka obviously provides a
presupposition of such presentations, but one cannot reduce this to the
biography of a person within a contemporary, general historical situation,
even with such a sensitive man like Kafka. Gregor Samsa stands for more
than the unhappy artist-existence of Kafka, just as the unhappy existence
of Kafka signifies more than the unharmonious fate of an individual Franz
Kafka in Prague.

Kafka's literature can be conceived of as a radicalization of positions
which can also be found in other Expressionists. Thus, his distorted
animal metaphor is the most extreme form of alienation of a subject: the I
as insect. From here, the shock effect of his texts goes beyond that ob-
tained by Benn or Heym, with their advances into the realm of the
aesthetics of the ugly. Above all, Kafka is more substantial because he is
less transparent. Kafka's metaphors cannot be reduced to a handy con-
ceptual scheme, including that of negative madness (*Negativfolie*). From
the radicalization of alienation stems what has been called "absolute
metaphor" in the literature on Expressionism: the absolutizing of images
that do not correspond to anything within a given system or model of
reality. When Sternheim refers to a figure with the name "louse," then its
conventional meaning is carried over in his metaphor to its object. The

destruction of conventional forms of thought intended by Kafka — including conventional metaphor — must, however, lead to absolute metaphors.

One should not assume, though, that the absolute metaphor destroys the relation to reality. The form of alienation of the subject presented in absolute metaphor — that conceptualizes the alienation of subject and the object which suppresses the subject — and the destruction of current systems of interpretation which it produces designate themselves a crisis of reality, a real condition that therefore suspends the current mediation (*Vermittlung*) of thought and being, subject and object. In this way, the meaning of reality itself becomes problematical and is presented as an unending process. Parables like "The Top," "The Cares of a Family Man," "An Imperial Message," "On Parables," and "Prometheus" really just say one and the same thing over and over: that the "ground of truth" (*Wahrheitsgrund*) itself lies in "obscurity" (*Unerklarlichen*) and that all human forms of speech only circle around this ground of truth without even reaching it. Thus, Kafka's much-interpreted Prometheus-legend becomes a legend about the unsayability of truth: "The legend tried to explain the inexplicable. As it came out of the ground of truth it had in turn to end in the inexplicable."[24]

A legend and saying (*Sage*) about sayings (*Sagen*) and the meaning of meaning are portrayed in the concrete form of an enigmatic coding. The truth of speech as indication of the unclarity of this truth is concretely worked out in the text.[25] Another essential factor plays a role here that in fact provides another connection between Kafka and Expressionists like van Hoddis, Benn, Trakl, and Heym: critique of metaphysics. An aphorism of Kafka's says:

> Er ist ein freier und gesicherter Burger der Erde, denn er ist an eine Kette gelegt, die lang genug ist, um ihm alle irdischen Raume frei zu geben, und doch nur so lang, dass nichts ihn uber die Grenzen der Erde reissen kann. Gleichzeitig aber ist er auch ein freier und gesicherter Burger des Himmels, denn er ist auch an eine ahnlich berechnete Himmelskette gelegt. Will er nun auf die Erde, drosselt ihn das Halsband des Himmels, will er in den Himmel, jenes der Erde. Und trotzdem hat er alle Moglichkeiten und fuhlt es; ja er weigert sich sogar, das Ganze auf einen Fehler bei der ersten Fesselung zuruckzufuhren. (Translation follows)

> He is a free and secure citizen of the world, for he is fettered to a chain which is long enough to give him the freedom of all earthly space, and yet only so long that nothing can drag him past the frontiers of the world. But simultaneously he is a free and secure citizen of Heaven as well, for he is also fettered by a similarly designed heavenly chain. So that if he heads, say, for the earth, his heavenly collar throttles him, and if he heads for Heaven, his earthly one does the same. And yet all the possibilities are his, and he feels it; more, he actually refuses to account for the deadlock by an error in the original fettering.[26]

This aphorism describes a situation without a way out. The hopelessness results from the between-position of human beings as "citizens of earth" and "citizens of heaven," as well as from its being chained to two regions of being which both hinder its integration into the other at a given time. The one-as-much-as-the-other becomes a neither-nor, the seeming freedom becomes a chain. "He," one can paraphrase, is neither a "free" citizen of heaven, nor of earth, because he is contained in both at the same time.

Being between metaphysical grounding and this-worldliness, around which many aphorisms and stories circle, signifies — in spite of the mythic form of presentation — an historical-philosophical situation. A situation of "transcendental homelessness" of the subject is indicated, which, moreover, knows that it is itself anchored in a metaphysical ground: "The word 'being' signifies in German both existence and belonging to it."[27]

The uniquely labyrinth-quality of Kafka's world and the corresponding blocking of all ways out until death is illuminated by the metaphor of light, which the man from the country in the parable "Before the Law" perceives as a weak flicker. The metaphor of light signifies in the form of a literary metaphor, among other things, a final metaphysical anchoring of the subject, which is, however, no longer positively determinable. It also points to the peculiarly blocked character (*Entzugscharakter*) of Kafka's stories. Kafka himself has seen into this specific historical experience as such when he says that he has "powerfully appropriated" the "negative" of his time.

> I was not, to be sure, led into life by the already sinking hand of Christianity, like Kierkegaard, and am not prisoner of the extreme edge of a Jewish prayer-coat that is flying away, like the Zionists. I am beginning or end.[28]

The boundary situation which is grasped here historically as the end of an "already heavily sinking" Christianity and a Jewish religious tradition which is "flying away" is dialectically at the same time describable as a beginning. The "or" in the formula "end or beginning" does not signify any indifferent exchangeability, but an essential historical dialectic.

The literary work of Kafka also has its place in this historical boundary situation. Adorno writes that

> Kafka's work holds fast to the striking of the hour. Pure belief appears here as impure, demythologizing reveals itself as a demonology. He remains an Enlightenment figure, however, in his attempt to rectify the myths which he produces . . . the variations of the myths found in his literary remains testify to his efforts at such corrections."[29]

The antinomy of critique of myth itself carried out in mythical garments is similar to the mythologizing critique of metaphysics in Heym

and with the critique of metaphysics in general in Expressionism. Here it is essential that Kafka himself does not — as do other Expressionists — prescribe new forms of metaphysics like the New Man. Consequently, while still anchored in metaphysics, he has himself conceptualized the withdrawal (*Entzug*) of its positive determinations. Even the form of his critique is not so direct as, for example, in Benn, but is much more mediated. Kafka's critique of society and civilization thus takes place in the final instance from a metaphysical position and this too is an essential characteristic of the social critique of Heym, Benn, van Hoddis, Trakl, Kaiser, and other Expressionists.

Notes

This study of "Kafka, Expressionism and Reification" by Silvio Vietta is taken from *Expressionismus*, co-authored by Hans-Georg Kemper (Munchen, 1975). Translated by Douglas Kellner.

[1]Paul Raabe, "Franz Kafka und der Expressionismus," *Zeitschrift fur deutsche Philologie*, Vol. 86 (1967), p. 166.

[2]Gustav Janouch, *Gespräche mit Kafka* (Frankfurt und Hamburg, 1961), p. 53.

[3]*Ibid.*, p. 86.

[4]Raabe, *Franz Kafka*, p. 171.

[5]See Vietta and Kemper, *Expressionismus*.

[6]Franz Kafka, "The Metamorphosis." Translator's note: I have used the translation by Willa and Edwin Muir in *Franz Kafka, The Complete Stories* (New York:Schocken Books, 1971), pp. 89-139. Page references in the text refer to this edition.

[7]Christoph Bezzel, *Natur bei Kafka. Studien zur Asthetik des poetischen Zeichens* (Nürnberg, 1964), p. 70.

[8]Wilhelm Emrich, *Franz Kafka* (Frankfurt, 1960), pp. 120ff.

[9]Karl Marx, *Economic and Philosophic Manuscripts of 1844*, in Marx-Engels, *Collected Works*, Vol. 3 (New York, 1975), p. 272.

[10]Georg Lukacs, *History and Class Consciousness* (Cambridge, 1971).

[11]Walter Sokel, *The Writer in Extremis* (Stanford, 1959), p. 47.

[12]T.W. Adorno, "Aufzeichnungen zu Kafka," *Prismen* (München, 1963), p. 256.

[13]See Hans-Georg Kemper, "Gestörte Kommunikation. Franz Kafka: 'Das Urteil' ," in *Expressionismus*, pp. 286-305.

[14]See Vietta and Kemper, *Expressionismus*, pp. 176ff.

[15]Jost Schillemeit, "Zum Wirklichkeitsproblem der Kafka-Interpretation," *DVjs*. 40 (1966), p. 588.

[16]On this literary-theoretical concept, see Jan Mukarovsky, "Die poetische Benennung und die ästhetische Funktion der Spräche" in *Literaturtheorie*, edited by Silvio and Susanne Vietta (Munchen, 1973). The Prague structuralist Mukarovsky speaks about a "naming of a higher order" which is conditioned by the immanent referential-signification of a literary work by means of which the literary text as a whole relates to a non-literary reality. Mukarovsky attempts, on one hand, to be faithful to the relative autonomy of the text and, on the other hand, to be faithful to the non-literary referential-signification of the text.

[17]Hans-Georg Kemper shows much more accurately and in much more detail than is possible in this context that the multiplicity of interpretive perspectives not only arbitrarily apply pre-conceived concepts to the text, but throughout fill definite empty-spaces and thus lead to a multi-perspective understanding of the text. See Kemper in *Expressionismus*.

[18]*Ibid.*

[19]*Ibid.*

[20]Adorno, "Aufzeichnungen," pp. 249ff.

[21]Beda Alleman, "Von den Gleichnissen," *Zeitschrift für deutsche Philologie*, Vol. 83. Sonderheft (1964), pp. 97-106.

[22]This interpretation corresponds in many points with the Kafka-interpretation of Krusche which first reached me after completion of this book; see Dietrich Krusche, *Kafka und Kafka-Deutung* (Munchen, 1974).

[23]See the development of this point in *Expressionismus*, pp. 134ff.

[24]Franz Kafka, "Prometheus," in Willa and Edwin Muir, *Complete Stories*, p. 432.

[25]See the articles by Beda Alleman, *op. cit.*; Ingrid Strohschneider-Kohrs, "Aufsatz über Kafka's Gleichnis 'Von den Gleichnissen' " in *Probleme des Erzählens in der Weltliteratur*, edited by Fritz Martini (Stuttgart, 1971); and Klaus-Peter Philippi, "Parabolisches Erzahlen," *DVjs*, Vol. 43 (1969).

[26]Franz Kafka, *Parables and Paradoxes* (New York, 1961), p. 31.

[27]Kafka, *Hochzeitsvorbeitungen auf dem Lande und andere Prose aus dem Nachlass* (Frankfurt: 1970), p. 44.

[28]Kafka, *Parables*, p. 121.

[29]Adorno, "Aufzeichnungen," pp. 277ff.

10
Expressionism and Döblin's
Berlin Alexanderplatz

Ulf Zimmermann

Alfred Döblin, like most great writers, was adept at assimilating and adapting the literary past as well as the latest artistic innovations, and one can fittingly apply terms to him ranging from Baroque to Brechtian.[1] It is not surprising, therefore, that the relationship between his work and Expressionism is neither simple nor fully agreed upon in the critical literature. In a 1972 monograph on Döblin's work through *Berlin Alexanderplatz*, Klaus Müller-Salget points out that while at least one leading scholar identifies Döblin as the sole outstanding writer in the expressionist spirit, one of the most prominent studies of German expressionist literature does not mention him at all.[2] Although that situation has changed somewhat in favor of an increasing (re-)identification of Döblin's work with Expressionism, Müller-Salget himself considers his writings of the twenties, which culminate in *Berlin Alexanderplatz,* distinctly naturalistic.[3]

Insofar as there is any critical consensus, it is that Döblin's novel in fact combines naturalist and expressionist[4] — along with a wealth of other — elements. A "Proteus in Protean time,"[5] Döblin was, after all, living and writing in a time and a place alive with change and invention, in technology, politics, and the arts, and these changes took especially in-

tense form in Berlin, a preeminent capital of Modernism. Like his contemporaries, Thomas Mann and Rainer Maria Rilke, Döblin grew up between the respective literary generations of Naturalism and Expressionism, sharing the experiences and concerns of both. Socially rooted in a childhood of poverty, and psychologically torn between detesting his father for abandoning the family and admiring him for his artistic ambitions, Döblin acquired first-hand the socio-economic experience central to Naturalism along with the psychological background of generational conflict and artistic aspiration specific to Expressionism.[6] The combination of these two tendencies, viewed broadly, can be seen to structure Döblin's work, and it is with this born in mind that I would like to examine the Expressionism of *Berlin Alexanderplatz.*

Expressionism has unquestionably proven a phenomenon of inexhaustible vitality. The most elementary meanings of the word "express" — to press out, bring out what is inside and to set forth, communicate — succinctly characterize Expressionism's two most vital distinguishing elements: the emphatic new concern with the inner individual and the radical new forms of communication necessitated by that concern. Together, these imply the new human community projected by Expressionism. For in reaching as deeply as possible into the inner individual, the Expressionist not only gets to the bottom of his own self but he also taps that universally human essence. It is thus that Expressionism seeks both to regenerate the individual and to reunite him with his fellows in a new community.[7]

To accomplish this, the individual clearly must be stripped of the vestiges of his old existence, the excrescences of everyday reality. The specific reality that stands in the way of such individual and communal fulfillment is, of course, the modern (bourgeois-capitalist) world of technology and industry, commerce and profit. It is, in short, the world most commonly adumbrated in images of the modern metropolis. As the city itself first began to take on its modern form, the Romantics, who first observed this process, were as fascinated by it as they were fearful of it. For insofar as the city represented the expanding industrial society of their times, it was aesthetically antithetical to their own stronger impulses towards individualism and nature, and these impulses became stronger in reaction to the growth of the city. Thereafter, in the course of the nineteenth century, German writers found themselves increasingly isolated, voluntarily or involuntarily, from their society. Commensurately, their image of the city, as the core of that society, assumed more and more negative aspects. These negative aspects became even more exaggerated because of the disproportionately rapid urban growth resulting from Germany's belated and hence intensely telescoped industrialization.[8]

By the end of the nineteenth century, these developments had produced whole new social strata and new forms of urban life. And to the extent that such developments informed the writing of the times, Naturalism was the first broad literary movement that genuinely

attempted to keep abreast of modern social conditions and urban reality. Coming to Berlin in 1888, Doblin thus entered that urban reality at the same place and time that the Naturalists were exploring its lower reaches. Like the class and quarters of the urban poor that he shared, the poverty and misery he experienced here cried out to be made public. And since these had not hitherto been considered *literaturfähig*—subjects that were the proper province of literature—they constituted a dramatically reveal-ing, even shocking new content, much of which may still be observed in the locale and the language of *Berlin Alexanderplatz.*

Yet while the Naturalists' use of the city—confined to these specific urban classes and quarters—introduced into literature new levels of con-tent and vocabulary, it did not by and large produce comparably substan-tial alterations in literary form. This remained for the next generation, the Expressionists. While they took over the urban setting and its vocabulary from the Naturalists, they were impatient with the latters' endless minute-ly detailed depiction of mundane urban social reality, the slice-of-life cut off from the rest.[9] This never seemed to them to get to the heart of the matter—the inner impact that the whole of this new urban reality had on the individual confronted by it.

To reproduce such vivid personal experience, such an inner world, in place of detached observation and imitation of the outer world,[10] the Ex-pressionists therefore replaced the earlier partial, sequential representa-tions of the city with holistic aggregations of discrete but juxtaposed ur-ban images. In this process, the city remained central, but its literary role changed from providing a vehicle for describing a social world to one for projecting the individual self. While this transformation is most clearly observed in expressionist poetry, the novel that perhaps best documents it is Rilke's *Notebooks of Malte Laurids Brigge.* In this work, the narrator describes, in sometimes morbidly "naturalistic" detail, certain phenomena of Paris that strike his attention. The resulting array of im-ages of disease, death, and decay, it is imperative to observe, clearly does not comprehend the whole actuality of the city; rather, it constitutes a one-sided selection, a subjective deformation, of Paris that reflects the wretched state of the narrator's mind.[11]

Yet the unilateral urban experience of Rilke's Malte was not to re-main an isolated case. For as the progress of modernity accelerated dur-ing the early part of the twentieth century, and as the attainability of Malte's dreams of pastoral retreats became more and more remote, in-dividuals found themselves increasingly disoriented and diminished in the massive urban context. It was therefore partially in order to assert their individuality, their sense of human self-importance, that expres-sionist writers projected their own experiences in clashing concatenations of urban images. And insofar as Expressionism sought to obliterate the distinction between the inner and the outer world,[12] these metaphoric ex-pressions of the inner self could be, and were, read empathically as depictions of the outer situation. It is not surprising, therefore, that

among broad segments of the intellectual community—in the arts as in politics, in critical writing as in speculations on *Kultur*—the city became all too crudely equated with chaos.

In accord with such thinking, Döblin's novel has thus often been read as a typical story of the individual soul virtually destroyed by the shock impact of that chaotic mass metropolis.[13] And the full title of the novel, as well as its sequence—*Berlin Alexanderplatz: The Story of Franz Biberkopf*—may be taken to suggest as much. Moreover, its first part, in identifying the city and the specific locale, echoes the titling of much expressionist poetry, and the second part, in naming a particular man and promising his story, emphatically singles out the individual. But contrary to the expectations of such a reading, in which the chaos of the city would extinguish individual existence, neither Biberkopf's relation to the city nor his story comes to such a conclusion. Instead, he returns to the city as an "assistant door-man in a medium-sized factory," having "learned his lesson" and being thus "reborn."

Certainly rebirth is a seminal expressionist motif, but to be "reborn" merely as a "door-man" seems almost anticlimactic and quite lacking in the transcendent dimension otherwise associated with the New Man of Expressionism. Correspondingly, the same sobriety that keeps Biberkopf from being inflated to heroic, superhuman proportions likewise keeps Berlin from being mythicized or given monstrous attributes.[14] Perhaps it could therefore be concluded that Döblin purposefully retained the edge of these expressionist motifs—the impact of the metropolis and rebirth as a New Man—only to reshape them towards new ends. By such a novel

recasting of these mofits, Döblin has, I would argue, given the city a role which is ultimately positive, and thereby made rebirth a very down-to-earth, practically political act.

In this sense, then, the arrangement of the book's full title not only imples that Berlin exerts an influence on Biberkopf, but that the story of Franz Biberkopf is exemplary of many that the city holds. This much Döblin tells us in his prefatory synopsis:

> This book reports the story of Franz Biberkopf, an erstwhile cement- and transport-worker in Berlin. He has just been discharged from prison where he has been doing time because of former incidents, and is now back in Berlin, determined to lead a decent life.
>
> And, at first, he succeeds. But then, though economically things go rather well with him, he gets involved in a regular combat with something that comes from the outside, with something unaccountable that looks like fate.
>
> Three times this thing crashes against our man, disturbing his scheme of life. It rushes at him with cheating and fraud. The man is able to scramble up again; he is still firm on his feet.
>
> It drives and beats him with foul play. He finds it a bit hard to get up, they almost count him out.
>
> Finally it torpedoes him with huge and monstrous savagery.
>
> Thus our good man, who has held his own till the end, is laid low. He gives the game up for lost; he does not know how to go on and appears to be done for.
>
> But, before he puts a definite end to himself, his eyes are forcibly opened in a way which I do not describe here. He is most distinctly given to understand how it all came about. To wit, through himself, that's obvious, through his scheme of life, which looked like nothing on earth, but now suddenly looks entirely different, not simple and almost self-evident, but prideful and impudent, cowardly withal, and full of weakness.
>
> This awful thing which was his life acquires a meaning. Franz Biberkopf has been given a radical cure. At last we see our man back on Alexanderplatz, greatly changed and battered, but nevertheless bent straight again.
>
> To listen to this, and to meditate on it, will be of benefit to many who, like Franz Biberkopf, live in a human skin, and, like Franz Biberkopf, ask more of life than a piece of bread and butter.[15]

While a preface of this sort has an expressionist character in that it abstracts Biberkopf and makes him something of an Everyman, its style is un-expressionistically sober and reductive. Plainly, then, the monstrous thing "that looks like fate" and might be seen as evilly embodied in the city only seems so to Biberkopf "through himself," thus reasserting—albeit negatively for the moment—an expressionist emphasis on the individual.

That the source of this "thing" is within him is promptly illustrated in Biberkopf's exchange of the prison cell for the city street:

He wandered down Rosenthaler Strasse past Wertheim's department store, at the right he turned into the narrow Sophienstrasse. He thought, this street is darker, it's probably better where it's darker. The prisoners are put in isolation cells, solitary confinement and general confinement. In isolation cells the prisoner is kept apart from the others night and day. In solitary confinement the prisoner is placed in a cell, but during his walks in the open air, during instruction or religious service he is put in company with the others. The cars roared and jangled on, house-fronts were rolling along one after the other without stopping. And there were roofs on the houses, they soared atop the houses, his eyes wandered straight upward: if only the roofs don't slide off, but the houses stood upright.[16]

Just as an expressionist poet would mount violently different images side by side, Döblin has here assembled a montage of different styles and points of view. He has moved from the conventional omniscient narrative of Realism to impressionist interior monologues and then on to a documentary reproduction of the official rules of the prison running through Biberkopf's mind. The passage climaxes in the cinematically familiar expressionist vision of the street,[17] the soaring roofs overhead signaling Biberkopf's anxiety, but it ends with the authorial reassurance of their stability. Through the montage technique, a clear distinction is thus made between the actual city and a given individual's perception of it. Biberkopf's point of view here is still the inward one stemming from his experience of confinement, and it suggests that he is not quite ready for the freedom and the comparative "sensory overload" offered by Berlin. Yet he adjusts soon enough, since the city is not really inimical nor alien to him. It is, in fact, his "turf," and for a while he does well enough peddling various wares in the busy Alexanderplatz area.

For a short while Biberkopf and Berlin seem to be in accord. Yet he soon falls out of harmony with the city as he is separated from it successively by each of the "three blows of fate" that strike him.[18] Let us therefore review these individually with an eye to the city's role in the "blows," and isolate some of the expressionist elements involved in this interaction.

In the first of the "three times this thing crashes against our man," Biberkopf finds himself deceived by an acquaintance, Luders. But he sees only Luders' deception of him and overlooks entirely his own ultimate responsibility. Having heard Biberkopf brag about a "conquest" he made on his peddling rounds, Luders immediately attempts to gain the same favors from the woman involved. Rejected, he robs her instead, and she of course refuses Biberkopf entry the next time he appears, since she knows that he alone could have told the other man about her. This arouses Biberkopf's "loathing for the world and his disgust"[19] and he withdraws from the evil city, as it appears, by holding up in a room and beclouding his mind completely in an alcoholic stupor. Having thus sealed himself off, almost as he had been in prison, he comes out, when he finally sobers

up, much the same as upon his discharge from prison and "stands again where he stood before, . . . has not understood anything, nor learned anything more"[20]—as Döblin's rhymes underscore.

This failure makes it all the easier for him to fall in with the Pums gang of thieves. Döblin's treatment of these criminals, somewhat comparable to Brecht's in *The Threepenny Opera,* if not as trenchant, amounts to a satire on capitalist society. He condemns the bourgeois business world by crediting the criminal gang with all of capitalism's prized principles, organization, and "respectability."[21] He almost extends this equation of robbery and business to the absurd in Reinhold, a member of the gang who applies the methods of the mass market to his sex life.[22] To sustain his "capitalist overproduction" (or, rather, "consumption") of a girl a month, he engages Biberkopf in a "spirited trade in girls" by getting him to take them off his own hands as he tires of them. Being a steadier sort, and not as "capitalistically" inclined, Biberkopf soon tires of maintaining this assembly-line pace, and he conspires with some of the women Reinhold had turned out previously to teach him the virtures of staying with one woman. When this seems to work, as Reinhold continues with the same woman well beyond his usual month, Biberkopf lets himself be blinded by his apparent pedagogical success. This blindness of pride in turn allows him to become involved with Reinhold and the Pums gang in what, to his surprise, turns out to have been a burglary in which he was unwittingly acting the lookout. Even as the police are pursuing them, Biberkopf is smiling smugly in the knowledge of his moral superiority over Reinhold and of his actual innocence in the burglary. Sitting beside him in the getaway car, Reinhold sees this and, grasping the reason for it, surreptitiously opens the car door and suddenly pitches Biberkopf out. The car in pursuit runs over him and mangles his right arm.

This second of the three blows administered by something "that looks like fate" convinces Biberkopf—easily deluding himself—that honest work does not pay. He quickly acquires a new girlfriend who supports both of them on her earnings as a prostitute. As he tires of doing nothing—except going indiscriminately to various political rallies—he finally falls in with Reinhold again. Biberkopf is now mainly concerned to show Reinhold that he has learned his lesson from the burglary incident and, above all, to show him that he is man enough to take it. With the same bluster he also brags, much as he had done with Luders, about his new girlfriend, and of course Reinhold—who, unlike Biberkopf, is not about to let bygones be bygones—immediately resolves to take her away from him. Here the possessiveness and competitiveness of the social system in which they operate reach new heights as Biberkopf secretly tries to show off his "property" to Reinhold and as Reinhold then destroys that "property" when he cannot possess it. The "property," Biberkopf's girlfriend, Mieze, had disapproved of his criminal associations and had decided to acquaint herself with the Pums gang in order to see how she could disentangle Biberkopf from it. She therefore accepts an invitation from Reinhold, made soon after Biberkopf's attempted display of her, and

goes for a drive and then a walk in the woods with him. When she rejects the advances he makes here, he turns brutal and tells her how Biberkopf had lost his arm. And failing to intimidate her into submission with that, he finally kills her.

Döblin's contrapuntal execution of this scene, combining a dramatic, earthy realism of description with a kind of ironically lyrical commentary, wryly recalls what Sokel terms the musical structure prevalent in so much expressionist writing:

> He kneels on her back, his hands are around her throat, his thumbs in the nape of her neck, her body contracts, contracts. Her body contracts. There's a season, to be born, and to die, to be born and to die, to everything its season.[23]

Yet the murder motif, already familiar from literature of the era, even more immediately recalls contemporaneous films and their structural techniques. Examples of this compounding of sex and murder extend from, say, Wedekind's Jack the Ripper and Lulu to the mad murderer and his child victims in Fritz Lang's *M*, respectively, a forerunner of expressionist drama and a highpoint of expressionist film. Not unlike these murderers, Reinhold is both compulsively maniacal and coldly mechanical in his action, and his victim Mieze partakes of both Lulu's pure sensuality and the child's innocence. Consequently, both Reinhold and Mieze, though more individualized than many such figures, can be seen as examples of expressionism's predilection for types. Reinhold might be called a personification of the "banality of evil" and, as such, considered a prototype of the Nazi.[24] Mieze, for her part, is one more sympathetic incorporation of the prostitute with the heart of gold who, from Romanticism to her heyday in Expressionism, sacrifices herself for others.

Her disappearance throws Biberkopf into an emotional slump, but he does not find out what happened to her until several weeks later when he sees his own picture, and Reinhold's, in the paper — both sought on suspicion of murder. This third blow now strikes him and sends him wandering about the streets, to Mieze's grave, and finally on a mad and futile search for Reinhold (who has been clever enough to hide out by getting himself jailed on a minor charge). Biberkopf ends up in a bar just as it is being raided and shoots at a policeman who approaches him. Taken into custody, he neither talks, eats, nor moves, and he is finally put into the Buch asylum for observation. The attending experts are puzzled — Paralysis? Catatonic stupor? Psychic trauma? And in one of the most entertaining passages of the book, Döblin, who had gotten his early medical and psychiatric experience at this very institution, mocks his fictive colleagues' discussions and diagnoses, pre- and post-Freudian alike.

While as a doctor Döblin may find one or another of these diagnostic terms fitting enough, he mocks them as a writer — and a *Naturphilosoph* — who can draw much more deeply upon the symbols and archetypes that he finds at the core of all existence. And at that level he gives voice to

a momentous vision of Death, a voice which rises, since Biberkopf still cannot seem to see the significance of what has been happening to him, to "rage immeasurable, rage uncontrolled, insensate rage, wholly immeasurable, ravening rage."[25] For it is Death that has inflicted these three blows on Biberkopf; but instead of heeding them as warnings and opening his eyes, Biberkopf has only taken Death "for a mere talking-machine, a phonograph to turn on, whenever you please."[26] Döblin's revival of the medieval allegorical figure of Death and his discordant association of it with the modern image of the record player constitute expressionist juxtaposition at its best.[27] But the Berlin dialect and the directness of Death's indictment of Biberkopf would seem to go somewhat further:

> You didn't open your eyes, you poor fool! You curse and swear about crooks and their doin's, but you never look at people, and you don't ask about the how and why. What a fine judge of men you are, where are your eyes? You've been blind, and pretty cocky at that, turning your nose up at the world, Herr Franz Biberkopf of Swankville, asking the world to be exactly like you'd like [it] to be. It's different, m'boy, and now you notice it.[28]

Death is here condemning Biberkopf's twofold blindness — to the actual outside world and to his real inner self. He has neither ventured outside himself to see that world or perhaps gain an outside perspective on himself, nor has he probed deeply enough inside himself to recognize the real Biberkopf and his bonds to his fellow humans. (It is thus that Doblin repeatedly argues against the blind-alley extremes of either Naturalism or Expressionism and for a mutual interpenetration of their respective material and spiritual, social and individual, and factual and imaginative elements—to limit it to just those terms.)[29] And now Biberkopf wishes to die, stubbornly avoiding such a recognition and still blaming the outside world for his misfortune. So obsessed is he with the misery it seems to have bestowed on him that he even forgets the selflessness of love that others have shown him. In order that Biberkopf may "know and repent" all that he has been blind to, Death now conjures these others to pass in review before him. The last of these is Mieze who, as Death confirms, died to save him:

> And finally Mieze... [s]he came to you, a lovely girl, protecting you and was happy with you, and you, what did you care about a human being, a flower-like human being; why you go and brag about her to Reinhold.... It gave you pleasure to fence with Reinhold, and to show your superiority, and then you went and got him excited about her. Now think it over, isn't it your fault she's dead?[30]

Acknowledging at last that it is he who is "guilty," who is "not a human being," but "just a beast, a monster," and finally repenting, this Franz Biberkopf dies.[31] And now "another man lay in the bed," and

Döblin concludes that he will "append a report about the first hours and days of a new man, having the same identity papers as [Biberkopf]."[32]

With the death of the old Biberkopf, moreover, the evil image of the city also disappears, as the next chapter proclaims: "Exit the Evil Harlot. . . . The whore of Babylon has lost."[33] The final confirmation that the image of the city as chaos is solely a reflection of Biberkopf's mental chaos comes the moment he reenters Berlin; now that he has been put right, the houses are nothing but upright: "But, lo and behold, as he gets out at Stettin Station . . . nothing moves, nothing at all. The houses keep still, the roofs lie quiet, he can move securely below them"[34] While Biberkopf is now going to his new job as an assistant door-man, Doblin proceeds to a figurative recapitulation of his story, corresponding somewhat to his programmatic preface, which connects Biberkopf's "way of knowledge" with the lighted street:

> We have come to the end of our story. It has proven a long one, but it had to unfold itself, on and on, till it reached its climax, that culminating point which at last illuminates the whole thing.
> We have walked along a dark road, at first there was no street lamp burning, we only knew it was the right road, but gradually it grew bright and brighter, till at last we reached the light and under its rays were able to make out the name of the street. It was a process of revelation of a special kind. Franz Biberkopf did not walk along the streets the way we do. He rushed blindly through this dark street, knocking against trees, and, the more he ran, the more he knocked against trees. Now it was dark, and, as he knocked against the trees, he shut his eyes in terror. And the more he knocked against them, the greater became his terror, when he shut his eyes tightly. His head all banged up, almost at his wits' end, at last he reached his goal. As he fell down, he opened his eyes. Then the street lamp shone bright above him, and he was able to read the sign.[35]

Now that we have seen one particular city image function as the reflection of one individual consciousness, turning from negative to positive with Biberkopf's mental regeneration, I would like to indicate briefly how this turnabout is actually effected by Döblin's larger use of the city in his book. Just as the urban images of the street-lamp and the sign above hold a positive value for Biberkopf, Döblin, in writing about Berlin elsewhere, credits the city with great power to inspire, to animate; and for him the excitement of its streets, stores, cars is "the gasoline his motor runs on."[36] He, too, calls it chaotic, but for him this signifies, positively, the infectious movement of people in the city and the sporadic development of the city that communicate its stimulating impulses to him and compel his participation.

Considering Biberkopf's happy reintegration into Berlin in the light of these positive effects of the city, one might conclude that Döblin had translated these effects into literary techniques that promote such an end.

He would then have been concerned, in creating his literary city, to find styles and forms that conveyed those changing impulses and the sense of participation engendered in him by the city. To do this, Döblin had, in addition to utilizing the treatments of the city usually identified with Naturalism and Expressionism, to reach beyond these. He therefore availed himself of a number of other modernist techniques, such as those associated with Futurism, Dadaism, and with the film (all of which can, of course, at least partially be derived from and directly related to Naturalism and especially Expressionism—or some combination of these).[37] His mastery in switching and coupling such techniques will be best illustrated by sampling another passage from his text.

When, at the beginning of the book, Biberkopf has just been released from prison, he is understandably terrified for the moment to confront the outside world. He presses against the prison wall, backing away from the streetcar that would take him directly into the center of that world, the city proper. Finally resolved to plunge into it, he leaps onto the streetcar — "right among people":

> He turned his head back towards the red wall [of the prison], but the car raced on with him along the tracks, and only his head was left in the direction of the prison. The car took a bend; trees and houses intervened. Busy streets emerged, Seestrasse, people got on and off.[38]

While common enough in Expressionism as well, such movement, dynamism, and simultaneity, particularly in depicting modern urban and mechanical life, are primary characteristics of Futurism,[39] and here in the first sentence we see them at work in the speeding streetcar which takes Biberkopf from the prison. At the same time that this movement changes his physical reality, we see a more expressionist emotional or mental reality asserted in the "head. . .left in the direction of the prison."

The second sentence, by way of the car's swaying—which the reader follows as Döblin shifts him to Biberkopf's point of view—takes all eyes off the prison and thus takes the mind off associated thoughts. For the moment, then, only purely visual images are taken in, as objectively as claimed by Isherwood's "I Am A Camera"—though in this case it is a moving one attached to the streetcar, simply recording what comes towards it. The cinematic style that results can be seen as either putting the reader next to Biberkopf on the streetcar or, as the descriptive adjective here suggests, as putting Biberkopf among the cinema audience watching these images arise on the screen.[40] But as more and more people enter the picture, Biberkopf's placidity is shattered:

> Something inside of him screamed in terror: Look out, look out, it's going to start now. The tip of his nose turned to ice; something was whirring over his cheeck. *"Zwölf Uhr Mittagszeitung," "B.Z.," "Berliner Illustrierte," "Die Funkstunde."* "Anybody else got on?"[41]

The extreme of the "expressionist scream" is followed by a similarly extreme (if conventional) metaphoric contraction of the nose turning directly to ice, and now he seems set upon by that outside world. The vague whirring sound is drowned out by several shouts from newspaper vendors and one from the streetcar conductor. An aural dimension is thereby added to the visual and mental modes of perception, and the world of the text becomes more nearly isomorphic to the real world.

This more palpable reality is the outgrowth of Döblin's *Tatsachen-phantasie* which, instead of describing everyday phenomena, transmits these — such as the actual titles of newspapers and magazines shouted out — to the reader directly. Though not unrelated to Expressionism, such unmediated presentation is more akin to cubist collage or dadaist construction, especially insofar as the material presented is either ready-made or documentary. A like directness, similar also to that of expressionist metaphor, obtains in the onomatopoeic introduction of streetcars and the steam pile-driver: "Boom, boom, the steam pile-driver thumps in front of Aschinger's on the Alex."[42]

Aschinger's, the name of the restaurant here, like the titles of the newspapers (and Alexanderplatz, which Döblin's publisher objected to because it merely named a streetcar stop),[43] is another small-scale example of the almost innumerable preexistent or preformed units of language abounding in *Berlin Alexanderplatz*.[44] Larger ones include news items and crime sensation; medical data, case histories, and the laws of physics; documents and statistics of the city; playbills and advertisements, political or commercial, with their jingles and slogans; and even the phone book. As Döblin's graphic presentation of the emblems of Berlin's various municipal departments clearly illustrates, these elements all mean to keep before us the whole multiplex diversity of the city in all its breadth. In a comparable fashion, he also gives Berlin an equally rich dimension of depth in having the text resound with echoes from widely varying sources more or less literary: there are verses from the Bible along with ones from street ballads; and garbled quotations from Schiller compete with folk sayings that alternate with snatches of hit tunes. In their unaltered form, these are the authentic elements of everyday life such as the Dadaists had first incorporated into their collages.

In combining all these elements, in being "decidedly lyrical, dramatic, even reflective in the epic work,"[45] as he put it, Döblin is certainly exercising to the full the artistic freedom that was of such importance to Expressionism. Yet this does not mean he abandoned reality or sacrificed his critical faculty. Rather, in letting the "facts" and the "imagination" of his oxymoronic *Tatsachenphantasie* interplay judiciously, much the way the "objective" world of Berlin interacts with the "subjective" consciousness of Biberkopf, he clearly realizes a much more encompassing validity as well as a much deeper critical penetration than either a merely subjective vision or a simple objective report could afford. Constantly confronting them with one another, the book, in other words,

grasps the world as much as it does the individual. The single term best embracing the technique — and effect — involved here is that of montage. Its significance in *Berlin Alexanderplatz* was first articulated by Walter Benjamin, who saw montage as the composition principle of the novel as a whole.[46] In his review he stressed the deictic intention of the montage's documentary materials and the shattering effect that it has on traditional forms.

Both this intention and this effect are to be found in Expressionism as well. Expressionism also meant to render objects of experience immediately, though it was more concerned to find concrete external equivalents for inner states — frequently by treating metaphor as fact (as indicated above and as Sokel puts it in regard to Gregor Samsa's metamorphosis).[47] But in following dadaist practice, Döblin's montage incorporates authentic data into the work of art, and this creates a new context of meaning and hence promotes a critical reexamination of the whole. Such novel juxtapositions have their shock value, and Expressionists had of course long since thrived on shocking their audiences by shattering the traditional structures and thereby exposing a fragmented, chaotic vision of existence. Döblin, however, uses the shock technique of the montage to juxtapose this sort of vision, represented at its extreme of short-sighted subjectivity in Biberkopf, with that more objective factual context of his own many-sided authorial view.[48] Thus, just as Death shatters Biberkopf's illusions by confronting him with a tightly concerted assemblage of all the people and things he has failed to see, Döblin uses the combinations of the montage, with its sudden cuts and stark contrasts, to effect a form of *Verfremdung* which gives the reader a critical distance on and hence a more illuminating view of the individual and society.

By bringing together the constricted mind of Biberkopf with the boundless diversity of Berlin, the montage thus exposes the respective ills of the individual and of the society to the reader.[49] While the ills of society have been illustrated by the example, among many others, of the Pums gang and in particular Reinhold, the latter's single-minded obsession with himself also reflects the ills of Biberkopf. But in the end, his inability really to see beyond as well as into himself is cured, not through the experience of the many shocks and blows of life alone but through what we may call their expressionist recapitulation by Death who, as an authorial voice, abstracts and presents them to Biberkopf as a meaningful "artistic" whole.[50] When Biberkopf leaves the Buch clinic to return to Berlin, he therefore recognizes that:

> He is no longer alone on Alexanderplatz. There are people to the right, and people to the left of him, some walk in front of him, others behind him.
> Much unhappiness comes from walking alone. When there are several, it's somewhat different. I must get the habit of listening to

others, for what the others say concerns me too. Then I learn who I
am, and what I can undertake.[51]

He has learned not only to see the others and to distinguish among them,
but he has also learned to see himself in relation to them, as part of a
larger whole.

Through this recognition, Döblin gives Biberkopf's individual cure a
social dimension. Moreover, he gives it a political direction when he has
Biberkopf realize the value of joining forces with others: "If there are two
of us it grows harder to be stronger than I. If there are ten of us, it's harder
still. And if there are a thousand of us and a million, then it's very hard, in-
deed."[52] Like Biberkopf's "rebirth" as a New Man, this political implica-
tion also originated in the powerful expressionist urge towards change.
Following Döblin, a changed world will evolve out of the numerous
changed individuals of whom Biberkopf is but one example. Beyond
those individuals contained within the book, there are, however, also
those "many who, like Franz Biberkopf, live in a human skin,"[53] to whom
this book is addressed. To them Döblin has palpably demonstrated, by
Biberkopf's example, that profound individual change is possible—and
hence more as well: For with "the rehabilitation of the mind" of Biber-
kopf, Döblin has emphatically reasserted the possibility of "reaching out
and transforming the minds of all men, changing the face of society from
within."[54] And while this is one of the paramount goals of Expressionism
Döblin renders it more practical by returning his representative man to
his society, where he can reach out to his fellows. One can conclude,
therefore, that while he has doused the excesses of individualistic intox-
ication in the "shower bath of Naturalism" — to use his own phrase[55] —
and thus approached the "New Sobriety," Döblin has nonetheless sustain-
ed the social and political spirit of Expressionism.

NOTES

[1] Coming around the turn of the century, Döblin's literary
apprenticeship acquainted him with many of the prevailing *isms*
— such as Symbolism, Impressionism, Neoromanticism, as well
as Art Nouveau — before he joined his friend Herwarth Walden
in the founding of the expressionist journal, *Der Sturm*, in 1910.
In its pages he then published, for a number of years, what many
consider the best prose works of Expressionism.

[2] Klaus Müller Salget, *Alfred Döblin. Werk und Entwicklung*
(Bonn: Bouvier, 1972), p. 10. He is referring to Fritz Martini's
essay in *Deutsche Literatur im zwanzigsten Jahrhundert*, ed. Her-
mann Friedmann and Otto Mann, Vol. 1, 5th ed. (Bern: Francke,
1967), p. 324; and Walter Sokel's study, *The Writer in Extremis:*

Expressionism in Twentieth-Century German Literature (Stanford University Press, 1959). Döblin is, however, one of the writers Sokel later takes up as prime examples for "Die Prosa des Expressionismus" in *Expressionismus als Literatur,* ed. Wolfgang Röthe (Bern: Francke, 1969).

[3] But as will be stressed below, this results largely from Döblin's reinterpretation of Naturalism into his own "Naturism," which is both literarily and philosophically permeated by expressionist elements.

[4] While writers on Döblin, from the first reviewers of *Berlin Alexanderplatz* on, have observed some such combination, Godfrey Ehrlich emphasized early the specific compounding of Naturalism and Expressionism in "Der kaleidoskopische Stil von Döblins *Berlin Alexanderplatz,*" *Monatshefte,* Vol. 26, No. 8 (1934), pp. 245-253; as did Fritz Martini in his chapter on the novel in *Das Wagnis der Sprache* (Stuttgart: Ernst Klett, 1954), pp. 340-341.

[5] Joseph Strelka, "Alfred Döblin: Kritischer Proteus in protaischer Zeit," in *Zeitkritische Romane des 20. Jahrhunderts,* ed. Hans Wagener (Stuttgart: Reclam, 1975), pp. 37-53.

[6] Here I am following both Müller-Salget above and Roland Links, *Alfred Döblin. Leben und Werk* (Berlin: Volk und Wissen, 1965).

[7] Sokel, *Writer in Extremis,* pp. 91, 137, *et passim.*

[8] For an excellent discussion of this development, see the chapter on "Culture and the Metropolis" in Roy Pascal's *From Naturalism to Expressionism: German Literature and Society 1880-1918* (New York: Basic Books, 1973), pp. 124-160.

[9] Döblin likewise found such Naturalism, with its dry materialism, all too lacking in spiritual content. For him, all that is material is really permeated by *Geist,* and consequently he combines Naturalism and Expressionism. Thus he can revel in the concrete, as he does in *Berlin Alexanderplatz,* precisely because he dynamically "spiritualizes" it. See, for example, Leo Kreutzer, *Afred Döblin. Sein Werk bis 1933* (Stuttgart: Kohlhammer, 1970), pp. 81ff., for a discussion of this.

[10] R. S. Furness, *Expressionism* (London: Methuen, 1973), pp. 17-21.

[11] See Ralph Freedman, *The Lyrical Novel* (Princeton: Princeton University Press, 1963), particularly its introductory comments on *Malte Laurids Brigge.*

[12] Sokel, *Writer in Extremis,* p. 45.

[13] Examples of such readings are too many to enumerate (though Müller-Salget has made a beginning, in a footnote, p. 294), ranging from Günther Anders' "Der verwustete Mensch: Ueber Welt und Sprachlosigkeit in Döblins 'Berlin Alexanderplatz,'" in *Festschrift zum 80. Geburtstag von Georg Lukacs,* ed. Frank Benseler (Neuwied: Luchterhand, 1965) to

Theodore Ziolkowski's in *Dimensions of the Modern Novel* (Princeton: Princeton University Press, 1969). After repeatedly referring to the "chaos of the city," Ziolkowski does, however, acknowledge that this actually represents only Biberkopf's experience of the city. pp. 111-112.

[14] What mythic or monstrous proportions Berlin takes on, such as those of the "Whore of Babylon," are thus likewise functions of Biberkopf's perspective, as Hans Dieter Schaffer also points out in "Naturdichtung und Neue Sachlichkeit," in *Die deutsche Literatur in der Weimarer Republik,* ed. Wolfgang Rothe (Stuttgart: Reclam, 1974), p. 365, following Friedrich Sengle's seminal "Wunschbild Land und Schreckbild Stadt," *Studium Generale,* Vol. 16, No. 10 (1963), pp. 619-630.

[15] Alfred Döblin, *Alexanderplatz Berlin: The Story of Franz Biberkopf,* trans. Eugene Jolas (New York: Frederick Ungar, n.d.), pp. 1-2. All further references will be to this edition, abbreviated *BA.*

[16] *BA,* pp. 6-7. As will be seen below, these soaring roofs recur and may be taken as a leitmotif indicative of Biberkopf's state of mind, as Muller-Salget (p. 329) and others have noted.

[17] Such visions became a staple of expressionist film, from Karl Grune's *Die Strasse* (1923) on. For a discussion of such "street films," see *Siegfried Kracauer, From Caligari to Hitler* (Princeton: Princeton University Press, 1947), pp. 157-160 *et passim.*

[18] For a more detailed summary, see Ziolkowski, *Dimensions of the Modern Novel,* pp. 112ff.

[19] *BA,* p. 190.

[20] *BA,* p. 215.

[21] James H. Reid, *"Berlin Alexanderplatz* — A Political Novel," *German Life and Letters,* Vol. 21 (1967/68), p. 218.

[22] Absurd in the sense of the "Theatre of the Absurd," which is in a number of respects closely akin to Expressionism, as documented by Walter Sokel's anthology of German expressionist dramas, subtitled "A Prelude to the Absurd."

[23] *BA,* p. 188.

[24] Ziolkowski, *Dimensions of the Modern Novel,* p. 125.

[25] *BA,* p. 603.

[26] *BA,* p. 603.

[27] As Godfrey Ehrlich puts it in his article, cited above on Döblin's style, only Expressionism could create such a figure that is at the same time "a febrile dream and a spiritual reality, a phantom and a state of consciousness" (p. 249). It is, moreover, this "super-real" aspect that elevates Biberkopf to the level of an Everyman, as Volker Klotz suggests in the chapter "Agon Stadt: Alfred Döblins *Berlin Alexanderplatz"* of his *Die erzählte Stadt* (Munich: Hanser, 1969), p. 401.

[28] *BA,* p. 604.

[29] Though Döblin's prescriptions for writing, like his practice of it, alternate in their emphases between more objectivity, more Naturalism, and more subjectivity, more Expressionism, they never wholly neglect one for the other. In an early essay, for example, the "Berliner Programm" of 1913, "An Romanautoren und ihre Kritiker," he calls for the elimination of the author but at the same time he encourages a kinetic imagination and "Tatsachenphantasie" *(Aufsätze zur Literatur,* ed. Walter Muschg [Olten: Walter, 1963], pp. 18-19). Conversely, in "Der Bau des epishen Werks" of 1929 he stresses, after acknowledging his infatuation with facts and documents, his discovery of his self and the paramount importance of such an authorial "I" in the epic work. But by this he does not mean to push the facts aside and give free rein to authorical confabulation; instead, the facts should remain, but the epic writer is not only to present them to penetrate them to present the truth in and beyond them *(Aufsätze zur Literatur,* pp. 107, 113, 114, *et passim).*

[30] *BA,* pp. 604-605.

[31] *BA,* p. 617.

[32] *BA,* p. 617.

[33] *BA, p. 618.*

[34] *BA,* p. 624.

[35] *BA,* p. 632.

[36] Alfred Döblin, "Berlin und die Kunstler," in *Die Zeitlupe. Kleine Prosa,* ed. Walter Muschg (Olten: Walter, 1962), p. 58.

[37] As Axel Eggebrecht aptly observed in his 1929 review of the novel in *Die literarische Welt,* "Alfred Döblins neuer Roman," Döblin uses every style like a streetcar; he never rides too far; when he comes to where he wants to go, he jumps off. Reprinted in *Materialien zu Alfred Döblin Berlin Alexanderplatz,* ed. Matthias Prangel (Frankfurt: Suhrkamp, 1975), p. 65.

[38] *BA,* pp. 4-5.

[39] Walter Muschg credits Futurism with Döblin's enthusiasm for the city and calls *Berlin Alexanderplatz* the "ripest outgrowth of Berlin Futurism" in his *Von Trakl zu Brecht: Dichter des Expressionismus* (Munich: Piper, 1961), p. 221. But his characterization of it as an art of movement, simultaneity, and dynamism, much of which he also attributes to Expressionism, clearly shows Futurism, at least so far as its stylistic aspects are concerned, to be fundamentally an accelerated form of Expressionism.

[40] These aspects are covered comprehensively by Ekkehard Kaemmerling, "Die filmische Schreibweise," in Prangel, *Materialien.*

[41] *BA,* pp. 4-5.

[42] BA, p. 216.

[43] Döblin, "Epilog, "*Aufsätze zur Literatur,* p. 390.

[44] It is through such elements that the city "narrates" itself, as Wolfgang Mieder suggests in his study of one of these preformed language units, proverbs, "Das Sprichwort als Ausdruck kollektiven Sprechens in Alfred Döblins *Berlin Alexanderplatz,*" *Muttersprache,* Vol. 83 (1973), p. 407.

[45] Döblin, "Der Bau des epischen Werks," *Aufsätze zur Literatur,* p. 113.

[46] Walter Benjamin, "Krisis des Romans. Zu Döblins *Berlin Alexanderplatz,* in Prangel, *Materialien,* p. 110.

[47] Sokel, *Writer in Extremis,* pp. 51-52.

[48] As Theodor Adorno put it, it is precisely the purpose of montage, as applied in modernist forms including Expressionism, to reject the appearance of continuity obtaining in subjective experience. *Aesthetische Theorie, Gesammelte Schriften,* Vol. 7, ed. Gretel Adorno and Rolf Tiedemann (Frankfurt: Suhrkamp, 1970), p. 233.

[49] This way of opening the view to, exposing the elements of reality it is working with, is what Adorno requires of true montage. *Aesthetische Theorie,* p. 90. For further detail and examples see Manfred Beyer, "Die Entstehungsgeschichte von Alfred Döblins Roman *Berlin Alexanderplatz,*" *Wissenschaftliche Zeitschrift Friedrich-Schiller-Universität Jena, Gesellschafts-und Sprachwissenschaftliche Reihe,* Vol. 20, No. 3 (1971), pp. 407ff., as well as Kaemmerling above.

[50] That Döblin himself speaks to Biberkopf through the voice of Death has also been argued by Müller-Salget (pp. 308-310).

[51] *BA,* pp. 632-633.

[52] *BA,* p. 633.

[53] *BA,* p. 2.

[54] H. MacLean, "Expressionism," in *Periods in German Literature,* ed. J. M. Ritchie (London: Oswald Wolff, 1966), p. 265.

[55] Döblin, *Aufsatze zur Literatur,* p. 18.

PAINTING

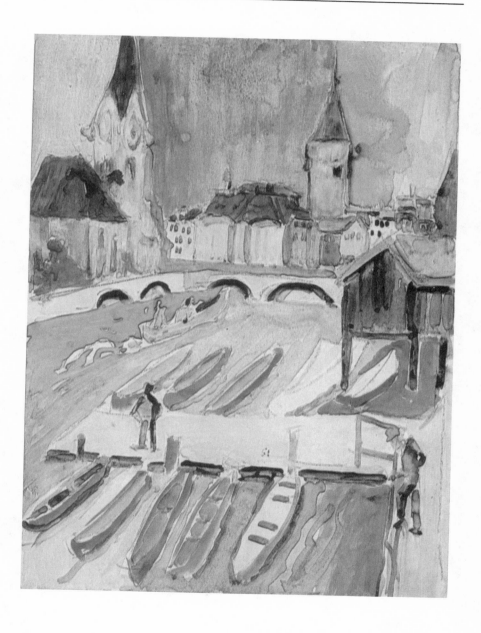

11
Expressionist Painting and the Aesthetic Dimension

Stephen Eric Bronner
and
D. Emily Hicks

The Expressionist Problematic

With the rise of ever more complex modernist and subjectivist forms of art in the twentieth century, the demands upon the audience have grown. The viewer has been forced to become an active, rather than a passive, observer. Indeed, the distortion of the object — whether still existing within the boundaries of the representational or whether having become fragmented through pure abstraction — has goaded the viewer into examining the painting through a conscious, visual effort. In this "modern" form of art, color and construction supercede subject matter *per se*. The viewer can no longer lapse into comfortable reminiscences about familiar scenes, nor can he accept a prefabricated social order without question. Once the eye has noticed the mutuability of "objective reality" as well as the fantastic and psychological dimensions of reality which representa-

tion does not exhaust, presentiments of the new and dissatisfaction with the existent may well occur in emancipatory terms.

As the German manifestation of an international modernist trend in painting, Expressionism retains a two-fold aesthetic problematic. Where on the one hand it would develop into a break with representational realism, on the other hand it would continually seek to project an alter-

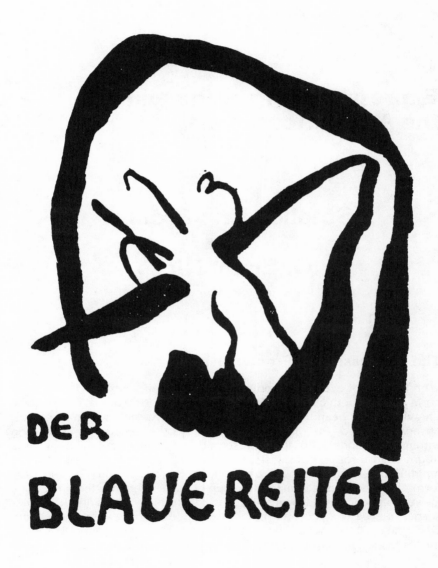

native to the repression of the dominant socio-economic processes. Despite the socio-political pretensions of various artists, the revolt which this dual problematic expresses is of an aesthetic sort; that is to say, its content underlies and shoots beyond any directly political proscriptions. If one were simply to collapse the aesthetic evaluation into a *directly* political judgment, the Expressionists would not be worth considering. But, if their art gives voice to often unrationalized hopes and possibilities for an emancipated future — or, to put it another way, serves as an impetus to build the potential consciousness for change — then it is a different matter. Thus, whatever its defects, expressionist painting — by bringing forward the mutability of reality, by teaching the viewer to "see" differently, and forcing him to exert his subjective faculties — creates the aesthetic *possibility*, the subjective *openness* to a change in consciousness which underlies any demand for an emancipated social order.

In this sense, Expressionism attempts to create a dynamic transcendence (*Überschuss*) which projects what Ernst Bloch has called "the Novum" — the *new* which breaks forth throughout human history in cultural and political attempts to visualize an unalienated relation between human beings that is unactualized in reality. This desire, which creates "traces" of utopia, is manifest within expressionist painting. In these terms, the issue is not with what exactitude these traces can be portrayed or whether the Expressionists see any social agent for bringing this new world about: indeed, such questions are external to the aesthetic dimension *per se*. The real issue involves the ability of the Expressionists to force a confrontation with social reality so as to unleash the repressed imaginative faculties of their audience.

This confrontation will occur through the revitalization of pre-capitalist forms as well as through an intensified use of color that will burst the shackles of a pre-constituted "objective" reality which is too often reified in the mind's eye. Line will therefore be progressively subordinated to color and the entire tradition of representational art will be called into question. But, this itself will be based on a use of distortion that will undercut what is taken for granted and so expand both the aesthetic horizon and the possibilities for a critical consciousness.

To be sure, there are proto-fascist tendencies within expressionist art: mysticism, irrationalism, attempts at various forms of regression, etc. Often enough, these will subvert the emancipatory potential of the aesthetic problematic. But, it will never liquidate this potential entirely. The Nazis understood this insofar as it was precisely what may be considered as the utopian and prefigurative qualities of Expressionism which they despised. These utopian elements — whether they involved the wondrous resurrection of nature or the transformative possibilities of distortion and the non-representational — were necessarily a threat to Nazi kitsch and the fascist belief that Germany was already an ideal society. To the extent that the expressionist artists provided an aesthetic space for subjectivity and the freedom of the imagination, they would ultimately

prove intolerable to the Nazis. Of course, there are clearly points of convergence between expressionist painting and the ideology of German fascism on the rise. But, by pointing beyond the existent, by momentarily unleashing the imaginative hopes of the individual from objective constraints, the works of expressionist art inherently threaten the attempts to implement complete conformity and obedience — or those pre-requisites for any regime in power that seeks to make itself totalitarian.

Worpswede and Other Influences

The technology and urban explosion of the nineteenth century's last decades engendered a response. By the turn of the century, numerous art colonies were to be found in the rural suburbs of major German cities which sought to provide an escape from the alienation of the city, academic restrictions, and the bourgeois way of life. The most important of these colonies that dotted the German landscape was probably Worpswede, a little town on the outskirts of Bremen, whose name would come to define a group of artists that would include Fritz Mackenson, Otto Modersohn, Carl Vinnen, Heinrich Vogeler, and Clara Westhoff, a fine sculptress in her own right who would ultimately marry Rilke.

Along with *Jugendstil* and the Naturalism of artists like Käthe Kollwitz, certain of these little groups — and in particular the Worpswede circle and its most famous representative, Paula Modersohn-Becker — would gain popularity and so help pave the way for the development of expressionist painting. Most of those who remained in the artistic colonies, however, were isolated and trapped within the provincialism of village life. They were unaware of those international tendencies which would later so profoundly influence the entire development of German Expressionism.

Gauguin and Van Gogh, the Symbolists and the Nabi group, Gustave Moreau and the fantastic Odilon Redon, would prove of extraordinary significance. These artists realized that there were psychological, unconscious dimensions of reality that deserved to be aesthetically investigated. They also sought to convey that painting should be an expression of the intuitive and the imaginary, and they called the primacy of the represented object into question. Thus, Maurice Denis — a member of the Nabi group — could already say in 1890: "It should be remembered that a picture . . . is essentially a flat surface covered with colors which are assembled in a certain order."

This position would be taken up by Modersohn-Becker and become a fundamental tenet of Expressionism: the primacy of color over line. The expressive quality of her later works often invites comparison with the style of *Die Brücke,* while *The Good Samaritan* offers a striking similarity to some of Kandinsky's Murnau landscapes. Indeed, Modersohn-Becker sought to experience and transmit nature in its most direct and pristine

qualities. Thus, she even came under criticism from her former mentor, Mackenson, for her use of flat color areas (i.e., *Portrait of Rainer Maria Rilke*) which provided a fundamental step in the development of the representational to the non-representational in expressionist art.

None of the Worpswede group ever achieved the emotive breakthrough of Edward Munch, whose works — like *The Cry, The Kiss,* and *The Dance of Life* — would arguably constitute the single most important impetus for the development of Expressionism; none of these artists would express the anguish of the subject in the face of modernity with the same power, or provide existential-psychological insights of equal depth, or engage in Munch's modes of radical distortion. The starkness, the anger, and the fantastic vision were all lacking. By the same token, none of the Worpswede group took the subjective moment to the dynamic extremes of Van Gogh — there is nothing to compare with the dynamic use of color and impasto in his later works — or explored the relation between the "primitive" and modernity with the same precision as Gauguin.

Nevertheless, the best of the Worpswede group typified a new concern with the emotive qualities of the unfettered individual and, in a German context, called into question the objectifying calculability that is part and parcel of bourgeois rationality. Most often this was accomplished through a type of sentimental romantic look for a past that had been lost, as well as through an emphasis upon those who have either been preserved from — or crushed through — the industrialization process. Indeed, Else Lasker-Schüler's typically expressionist notion of a "poor little humanity" comes to mind in Modersohn-Becker's paintings of peasants, mothers and children, inmates of the Worpswede poorhouse, and individuals who supposedly stand in an uncontaminated union with nature (i.e., her *Self Portraits*). Moreover, Modersohn-Becker was especially uninterested in simply imitating nature, and she expressed her concern with penetrating the inner quality of nature with the famous words: "the object itself is feeling."

Though it is possible to over-emphasize the importance of the artistic colonies for later developments, when seen within a broader context of influences, Worpswede and Modersohn-Becker's obvious interest in a new union between man and nature, the aesthetic experiments with color and the rising sense of intuitive introspection, at least provide a hint of the new consciousness that was growing amongst the German avant-garde.

Die Brücke

From the crucible of experimental tendencies, inchoate desires, and multiple influences which burgeoned in Germany around the turn of the century, *Die Brücke* was formed in 1905. The name itself speaks to the vision. For this group saw itself as "the bridge" that would unite the

disparate avant-gardists and also serve as the transition to a new relationship between art and life.

Under the prodding of Ludwig Kirchner, a motley collection of artists came together in Dresden. Kirchner, Erich Heckel, and Fritz Bleyl would be joined by some of those who would become major luminaries of the expressionist movement: Karl Schmidt-Rotluff, Max Pechstein, Otto Mueller, Emil Nolde and others. Their artistic innovations were numerous, but — particularly through the auspices of Kirchner — a new emphasis began to manifest itself: a conscious concern with African and early Medieval art. Where those in the artist colonies left their aesthetic bond with nature in the abstract, the *Brücke* group consciously attempted to juxtapose the pre-modern to the modern in the construction of their works. In this way, the past came to be transvalued into a new tradition while the aforementioned juxtaposition itself became a hallmark of "modernism."

Kirchner and others like him attempted to re-create the organic unity between art and life which had existed in pre-modern societies. These were not painters who had been trained in the academy; they took pride in the unfettered voice that they could give to their innermost feelings and in the fact that they were uncorrupted by the establishment. So, too, they sought to overcome the modern division of labor through what may be seen as a new dilettantism. They sculpted and wrote plays, turned out manifestoes and poetry. In fact, many exhibited a personal aesthetic range that became a fundamental feature of the expressionist movement in painting, as is the case for Schoenberg, Klee, Kokoschka, Kandinsky, and a host of others.

This revitalized organicism presents itself in the aesthetic products as well. Nolde, through his emphasis upon color, goes the farthest in searching for a unity between man and nature. But, following Munch, *Die Brücke* gave a new importance to the woodcut and to handicrafts as such. Moreover, the use of a simple line to split the painting into planes, as well as the emphasis upon angularity — which brings to mind the works of Grünewald and El Greco — serve to highlight the experience of *"Angst"* and of those constraints upon the subject which modernity produced in "everyman."

Truly, the Blochian attempt to transvalue the unrecognized possibilities of the past in terms of an unactualized Novum was crucial to the entire enterprise of *Die Brücke*. For, though the subject matter of *Die Brücke* was figurative and humanistic, in their breakdown of the figure-ground distinction, these artists presented a new aesthetic possibility: what Henry Pachter termed "the conquest of the ugly."

Existing forms and perceptions would therefore either be turned against themselves or juxtaposed to one another in a contradictory manner. What appears as the particular can turn into the universal, what initially appears as ugly to the philistine becomes beautiful in the eyes of the annointed, precisely because it retains what Adorno has called an

aesthetic "truth-content" (*Wahrheitsinhalt*). Where modernity had produced a crisis within the individual, *Die Brücke* sought to convey the validity of its experimental context. In this manner, the distorted grasps the truth of this experience as against realistic forms of representation. If one considers Kirchner's numerous street scenes, which emphasize the disorientation and chaos of city life through rapid brush strokes and "unnatural" color combinations, this becomes apparent. By the same token, the woodcuts and sculptures of Kirchner, Barlach, and Heckel employ the simple line as a backdrop for that "clenched scream" (Munch) which threatens to burst the objective barriers that constrain the subjectivity of the subject; thus, it is the ugly, the distorted, that achieves the status of what Marcuse called the "beautiful image." The "truth-content" of this image lies in the critical reminder of the price that is paid for civilization.

As was realized by the famous avant-garde aesthetician, Wilhelm Worringer, such an emphasis upon distortion and the objectively non-representational necessarily brings with it a demand for empathetic participation on the part of the viewer. In this respect, the painters parallelled their literary counterparts. For what ties the viewer to the work, as well as to the artist, is the primordial — the universal — that is inherent in every individual. Some found it in the religious experience of the godhead, others in nature, others in "Being," but whatever the formulation the universal was non-objectifiable and intuitive. This was what allowed for the further break with representation to the extent that this primordial, subjective element could only be tapped by stripping away the "unessential" encumbrances of instrumental rationality and civilization in order to reveal humanity's inner core and unity. Thus, the work of art could be conceived as the medium which would link the particular to the universal through the heightened experience which would break through the world of "appearance" in order to grasp man's "essence."

Whatever the mystical traces in these formulations, still, by refusing to collapse humanity's possibilities into the given order, a critical element and a hope for the future arise within expressionist art. Ultimately, the basis of this hope and the terms of the criticism remain confused. Yet at least these painters sought to reveal the link between everyday life and spiritual renewal. Not all of them, it is true; the use of the mask may even be seen as marking the boundary between the falsity of appearances and the truth of the inner essence. But, for artists like Heckel, Pechstein, and Schmidt-Rotluff, the spiritual is prefigured in the colors and the forms of everyday life — as experiences of the most horrific or the most light-hearted sort.

The work of *Die Brücke* contains contradictions which seize the viewer. Such contradictory transvaluations of everyday life may be seen in the work of a particular artist like Heckel if one compares the wonderfully sensuous use of red in *Pechstein Sleeping* with the cataclysmic foreboding and sense of chaos in his famous *Day of Glass*. By the same token, contradictions often receive technical expression in the same

work. Thus, in paintings like Pechstein's *Evening in the Dunes* or Schmidt-Rotluff's *Red Dunes,* there is a union between the figure and the natural forms which provide the backdrop. Yet, the stasis of the figure-ground stands in sharp contrast to the intense emotion produced by the particular use of color: the result is vibrant hue contrast.

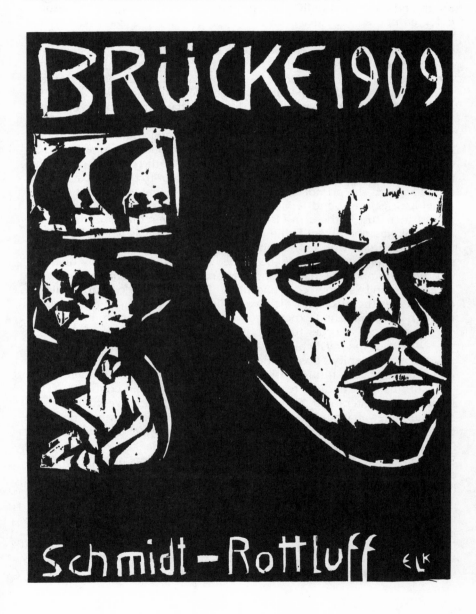

These contradictions often heighten that emotional pitch which will crack appearances in order to reveal the "essence" of humanity. But, here, a basic problem presents itself in terms of the irrational and elitist strains within the avant-garde. For there must be the personal openness to experience that cannot be expected from everyone in a mechanized and brutal world. Moreover, precisely because it is not a matter of education that is involved, but rather an intuitive experience which one either has or does not have, an arbitrary and self-serving conception of the avant-garde arises. Thus, because they believed that they were experiencing the world in a new way and had achieved their own individuality, *Die Brücke* could see itself as a vanguard, even though it had no program and despised the philistinism of the masses. In this regard, the title of the group's journal — of which only one issue appeared — gives an insight into the self-perceptions of the membership and their broader social views: *Odi profanum (vulgas)* [I hate the common herd].

The universal that they sought thus proved itself illusory. It was undermined by an elitism that was intrinsically connected with the arbitrariness and irrationalism of the avant-garde. These qualities only enhanced the attraction of mysticism and religiosity which supposedly served as oppositions to the rationalism and materialism of the modern world. In fact, the universal that would underlie the New Man was nothing other than the self-perception of the avant-garde writ large.

But, despite all this, the atavism of *Die Brucke* was not one-sided. This group paved the way for a new appreciation of primitive art's hitherto neglected aesthetic legacy. It also aesthetically justified distortion; the mutability of the existent was recognized and the critical moment of aesthetic hope was preserved as the barriers of objective representation began to totter. Indeed, it is fair to say that *Die Brücke* pushed the aesthetic values of the old world to the brink; they would be toppled by the most famous tendency of German expressionist painting: *Der Blaue Reiter*.

Der Blaue Reiter

Expressionism is only one manifestation of that transnational phenomenon that can be called Modernism. In different countries, for different socio-economic and cultural reasons, different avant-garde movements developed. Though these movements often wished to promulgate qualitatively different values — i.e., the Futurists as against the Fauves — each saw itself as a vanguard to attack the world of the bourgeois, and this created a certain fraternity amongst the memberships.

By the First World War, there was an enormous influx of foreign painting into Germany — Cezanne, Picasso, Kokoschka, Schiele, Braque, Derain, Delauney, etc. — under the auspices of famous collectors and dealers like Walden, Cassirer, and Kahnweiler. When Marinetti first came to Germany, he caused a sensation; Kokoschka — the "Austrian terror" —

was becoming a legend and, with few exceptions, German artists were turning their gaze to Paris. This intertwining of modernist works caused great confusion for the public at large and for critics as well. In fact, as late as 1914, the well-known critic Hermann Bahr could include Matisse, Braque, Picasso, along with certain Futurists and Fauves within Expressionism.

As Franz Marc put the matter: "the wasteland of 19th century art was our nursery." The European avant-garde of the twentieth century grew to maturity together. Thus, the numerous "Secession" movements that would be organized against the artistic establishment in Dresden, Munich, Berlin, and Vienna were not only a protest against imperial taste, but also a conscious attempt to make connections with the avant-garde movements of Europe and Russia. Sometimes explicitly, sometimes implicitly, there was always the idea of a new, universal, "modern" style that would still allow the extreme variations. This was particularly the case with *Der Blaue Reiter,* a group which always exhibited an international spirit that would fundamentally demarcate it from the "blood and soil" philosophy of the Nazis.

Already in 1909 Gabriele Münter had bought a house in Murnau which lay to the south of Munich. There, she and Kandinsky painted the countryside and studied *Hinterglass Bild* — painting the reverse side of glass. The dominant interest of the German avant-garde in the pre-modern and handicrafts is evident. But, here, the concerns of *Der Blaue Reiter* would extend well beyond even *Die Brücke.* Kandinsky himself would take the new organicism to the point of attempting to create — following Wagner — the *Gesamtkunstwerk,* in his "The Yellow Sound." But *Der Blaue Reiter* Almanac would include Russian folk art, embroidery, Japanese and German woodcuts, votive paintings, children's drawings, and Egyptian shadow play figures as well as *Hinterglass.*

Those who visited the couple in Murnau — Alexei von Jawlensky, Marianne von Werefkin, and Alfred Kubin — would, along with Franz Marc, become the core of *Der Blaue Reiter.* From their first exhibition as the *Neue-Künstler-Vereinigung* this over-riding concern with the pre-modern was linked to the international avant-garde movement. Thus, at this exhibition of 1910, the works included those of Vlaminck, Rouault, Von Dongen, le Fauconnier, and a host of other foreigners. Truly, this was a major exhibition of "the modern" which transcended any particular movement; one year later, the first *Blaue Reiter* show took place.

The name came about — or so the story goes — during a discussion over coffee where Marc noted that his favorite color was blue and Kandinsky mentioned his frequently used horse and rider motif. Thus, *Der Blaue Reiter* was born. Obviously, it is virtually impossible to rigidly define what united the major artists of this expressionist tendency. But there are fundamental tenets which not only link the artists but which also relate the tendency to other expressionist groupings. There is clearly the concern

with the pre-modern as well as with the exotic; indeed, Klee's works during his Tunisian travels — which shocked the Berlin audiences through their extraordinary interplay between color and light — are vivid examples. By the same token, there is the emphasis upon color over line; in this regard, the Fauves, along with Delauney — through the planes of transparent color which were employed in his St. Severin and Eiffel Tower studies — had a pronounced effect upon Marc and Macke. Furthermore, with Kandinsky and Marc, color took on a metaphorical content of its own; painting came to be seen as quintessentially related to music and each color was conceived as retaining a particular emotive quality equivalent to the musical tone. In the same vein, Schoenberg could claim that the enduring element of a portrait derives from the expression of the artist who reveals a new reality, rather than from the appeal of the person who is depicted. But, more than that, the Cubist deconstruction of the object, along with the Russian Suprematists' non-representational experiments and the dynamism of Futurists such as Boccioni, were fused within the ultimate primacy that was given to color; and the effects of these movements were not only felt by *Blaue Reiter* artists such as Kandinsky and Marc, but also by other artists who belong within the expressionist camp, such as Meidner and the young Feininger.

In terms of the expressionist movement, the major artists of *Der Blaue Reiter* gave a new aesthetic credence to those dimensions of existence which had been preserved from the industrialization process. Of course, this is not the case with all of the *Blaue Reiter* artists. But, it is interesting to note how Klee and the much underrated August Macke could stress that children create directly from their immediate perceptions rather than imitate mimetically; indeed, Macke even compared this immediacy with the art of the aborigines. So, too, there is the aura of simple faith and a consciously fairy-tale quality that emerges from the paintings of Gabriele Münter.

It is therefore in the beautiful image of *what is not* predominant in industrial society that an unacknowledged utopian hope becomes evident — a utopian content which it is too easy to dismiss cynically. The shock of such paintings, the effects of the new color distortion, and the demand to see the world differently is best expressed in a story which Bloch once told. When Franz Marc's *Blue Horse* was first shown, it caused a scandal and one viewer was to have exclaimed: "How can he paint a horse blue? There is no such thing!"

Today, it is possible to say that these were the words of a philistine. But, this only shows how far we have come; those words amply expressed the dominant aesthetic sentiments of the time. The sheer radicalism of a painter like Marc cannot be over-emphasized. He too wished to emphasize what was preserved from industrialization, and so he turned to animals. In what can only be conceived as an incredible hermeneutic attempt to expand the range of experience, he called upon the viewer to imagine how an animal perceives the world in order to create a new har-

mony between man and his world, and so raise the status of nature to that of a subject.

Inspired by folk art, Marc attempts to redeem one of the oldest dreams of humanity. At the same time, however, Marc consciously paints for a world that does not yet exist. Thus, he gazes backwards and forwards simultaneously. To be sure, Marc mystifies reality. Indeed, he even believed that his paintings should be placed on the altars of a future religion of

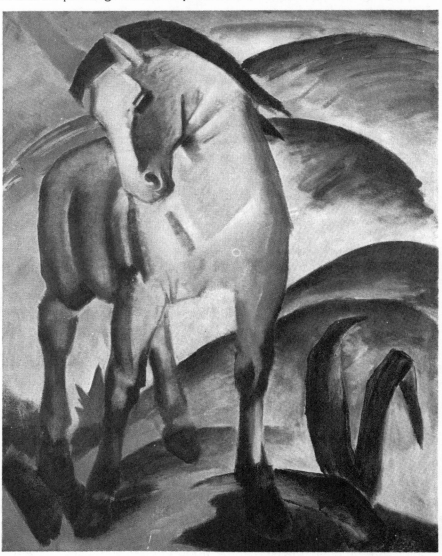

the spirit. Yet, in the sheer joy of works like *The Yellow Cow,* he aesthetically projects a vision of utopian splendor which demands the new conceptualization of nature that Bloch would later philosophically elaborate.

This sense of joy is also apparent in works like *The Sunny Path* by August Macke. In this work, through the distortion of an everyday park scene by deep primary colors, Macke reiterates the prefigurative qualities of everyday life. Clearly influenced by Delauney, the painting is broken into primary color planes that create a delightful inner tension between the pensive mood of the characters and the unacknowledged dynamism of their surroundings. Here, as with Marc, distortion shows its utopian visage; the conquest of the ugly is turned into the projection of the beautiful.

Taking expressionist painting as a whole, an intrinsic development appears, a progression which results in an ever more dynamic projection beyond the existent that culminates in the works of Kandinsky. Indeed, it is probably with this artist's non-objective works that the expressionist spirit achieves its fulfillment. The moment of wonder, the primacy of color that itself presents a dynamic movement, projects an experience of subjectivity which stands beyond all objectification.

To be sure, the break with representation — and so the break with the existent — assumes an indeterminate character. Perhaps Kandinsky projects the end of an era, the explosion of the First World War and the chaos of barbarism. Some have chosen to see his work in this way, but there were others — like Marc and Nolde — who gave a much clearer voice to that rising tide which would culminate in mass destruction. Then again, others viewed this break as a projection of those utopian hopes for salvation which would later be placed upon the newly born Soviet Union.

But to argue from either of these perspectives is ultimately to miss the point. Such an analysis chains Kandinsky's works to an existent that he continually seeks to transcend. Nothing can be analyzed in determinate formulations unless it is to some extent actualized in reality. By breaking down line completely, by piercing the object entirely and allowing for the free play of subjectivity, Kandinsky not only shatters representation but engages the viewer in a Faustian quest for fulfillment. Indeed, the onlooker will be forced to reconceptualize the painting and so become an artist himself. Here, the expressionist call to exert one's sensibility in the service of the Novum takes its most extreme form. For the objective articulation of this Novum is impossible in a society of repression — where there is only the hope, the traces of its articulation. Here, at last, what the Expressionists always sought begins to become manifest. This is the truly non-objectifiable that can only exist for a subject, the absolute that is always denied complete realization because it is conditioned by necessity, the goal which has always glittered through the marshes in which humanity has found itself mired: freedom.

12
Kandinsky: The Owl of Minerva

Marian Kester

Kandinsky (1866-1944) was one of the foremost philosophers of the abstract expressionist movement in painting. He was an artist of unsurpassed lucidity who refused to choose for the "analytical" against the "mystical/lyrical," and successfully *materialized* his vision in oils, watercolor, and graphics. At once artist and intellectual, he was the common point of a number of creative vectors, among them Dada, Surrealism, German Expressionism, the Bauhaus, Constructivism, and the many other lively trends in early Soviet art. For example, as a poet, Kandinsky contributed to the Dada review *Cabaret Voltaire* in 1916; he was instrumental in introducing the *Neue Sezession* group of Berlin to the Munich *Neue Kunstlervereinigung* and to the Russian Suprematists and Rayonnists: his nephew was Kojeve, the professor of philosophy who introduced Hegel to the Generation of 1905 in Paris; he was a major figure in the Bauhaus and personally recruited a number of participants to that unique experiment. In effect Kandinsky formed an individual center of gravity around which the ideas of revolutionary art revolved in the 1910-1933 period, a living symbol of what those ideas sought to embody.

Kandinsky's background and character were very unlike those of most of the young artists involved in the new movement. He was born

into a well-to-do Russian family which at one point had been transported to Siberia for anti-czarist activity. His father, after financing the son's lengthy course of study in political economy and law at the University of Moscow, still proved willing to support Kandinsky's belated decision (at age 30) to study painting in Munich.

In contrast to most of his younger, less disciplined colleagues, Kandinsky's relationship to art was always that of a scholar, experimenter, and publicist — almost a technician. His theoretical writings on the nature of painting and the meaning of abstractionism are among the most comprehensive and striking of any modern artist. Moreover, his work was never conducted in romantic isolation, but always in the full light of journalistic publicity, association, cultivation of a hoped-for mass "audience," and the sort of quasi-political organizing efforts typical among movements of the period (Futurism, Constructivism, Dada, and so on).

The year 1912 was the cutting edge: a new "spiritualism," like the social revolution, was springing to life simultaneously in different fields and cultures, and individuals embarked upon greatly varied projects were to recognize *affinities of spirit* with one another's efforts. In Russia the mass strikes were building like a wave, soon to topple centuries of stonelike social edifice. To Western Europe came the calm before the storm: not even the war proved able to consume the energies about to burst forth in this period.

The most sensitive gave voice to — or "mirrored" — the underlying longings for transcendence, immediate appropriation of technology's potential, the freeing of man from labor and squalor, the transformation of everyday life according to the laws of beauty and the "luxury" of art. This longing for *realization* was, paradoxically, the ideological motive for the turn toward nonobjective, nonrepresentational, abstract art — a turn led by Kandinsky.

Art had been steadily evolving, mediated by the capitalist market, into an existential racket, perpetrated in the self-interest of its practitioners and their speculator patrons. Perhaps the most piercing whistle blown on this "Art" was Dada, a revolt which ripened most fully in France and Germany, and culminated in the temporary entry of the Surrealist Group into the French Communist Party, and in the politicization of Expressionism in Berlin and Munich. With what savage joy Dada and its offspring attacked "art for art's sake," the "integrity" of the *objet d'art*. How little they cared for purity, for the confinement of art to the mirrored palace of contemplation. Escaping from Axel's Castle[1] only to be forced back into the hovel of Art, the European avant-garde carried out a series of artistic revolts, often with strong political overtones.

> Today, more than ever before, *the liberation of the mind*, the express aim of surrealism, demands as a primary condition, in the opinion of the surrealists, *the liberation of man*, which implies that we must struggle against our fetters with all the energy of despair. . . . To-

day more than ever before the surrealists entirely rely for the bring-
ing about of the liberation of man upon the proletarian revolution.[2]

This spirit of revolt destroyed forever the possibility of good conscience
in Art. What Hegel had foreseen — namely, *the end of representation* and
the passage of Mind to increasingly direct knowledge of itself — had
reached a point of no return, a point which coincided with the post-World
War I social explosion against the outgrown forms of capitalist order:
money, parliamentarism, laissez-faire market relations, the factory, and
other alienating hierarchies of production for profit (all of these, too, be-
ing kinds of representation). "Representation," according to Hegel, was a
product of the alienation of the Subject from its own content or powers,
the historical emergence of the split between being and appearance.
Speaking generally of Mind, he stated:

> In pressing forward to its true form of existence, consciousness will
> come to a point at which it lays aside its semblance of being
> hampered with what is foreign to it, with what is only for it and ex-
> ists as an other; it will reach a position where appearance becomes
> identified with essence[3]

Relating this conception specifically to art, he wrote of its passage
through the symbolic, classical, and romantic phases, culminating in

> the falling to pieces of Art, a process . . . which was due to an imita-
> tion of the objects of Nature in all the detail of their contingent
> appearance[4]

That is to say, Art-as-representation would come to an end when it had
fully contemplated the world and made it a part of itself, when it was no
longer seduced and "divided" (in Blake's sense) by appearance, but could
penetrate the living mystery of its own experience. This demystification
was, moreover, in Hegel's view, an ineluctable development.

How does one locate the work of Wassily Kandinsky within the
general premise of the "end of representation"? It is our thesis here that
Kandinsky may be said to have done for art (and oil painting in particular)
what Hegel attributed to the great philosophical systems:

> When philosophy paints its gloomy picture, a form of life has
> grown old. Only when dusk starts to fall does the owl of Minerva
> spread its wings and fly.[5]

The Significance of the Abstract

It is well known that photography provoked a severe crisis in easel
painting. The effect was not instantaneous or total, but slowly, surely,
the nature and aims of art had to be rediscovered and reconsidered. (A

similar problem was faced by the theater with the advent of cinema). The camera simply caught more, from every angle; every pore and shadow, every cloud and wave could be eternalized. Thus the surface of things, whose reproduction had come to be seen as painting's *raison dl'etre,* was looted once and for all by the mechanical competitor.

Notes for what was to become Kandinsky's abstractionist manifesto, *Concerning the Spiritual in Art,* as well as studies for what were to be the first purely nonobjective canvases ever produced, date back to 1901, although neither was to achieve full-fledged expression until 1910. Up to that point, Kandinsky had been obsessed with variations, increasingly free-form, on a horse-and-rider motif, a symbolic working-out of his personal struggle to resolve the reason/unconscious duality: "The horse bears the rider with strength and speed. But the rider guides the horse."[6]

In *Concerning the Spiritual in Art,* Kandinsky argued that abstraction was the necessary next step, the *revolutionizing perspective* which could free art of the false consciousness that had initially led to the crisis over photography's superior ability to represent reality. While recognizing that other artists would continue to fear "excluding the human" from their work,[7] since for them immateriality possessed as yet no "precise significance," Kandinsky considered abstraction to be the "left wing" of the new art movement, an "emergent great realism," a departure more radical than any figurative mode, however "expressive." It is not hard to understand why he thought so: the entire tendency of post-Impressionism had been to abolish the primacy of the material object, the thing, in order to reveal that inner force which was the sole true "subject" of artistic knowing.

> The love visionaries, the hungry of soul, are ridiculed or considered mentally abnormal.... In such periods art ministers to lower needs and is used for material ends.... Objects remaining the same, their reproduction is thought to be the aim of art.[8]

Relinquishing the object offered the artist undreamed-of new freedom. *Concerning the Spiritual in Art* refers constantly to the image of a world choking on dead matter, on reifications which must be superseded in order to reverse the hardening process and release the dammed and vital flow of creative energies. Pure abstractionism for Kandinsky was primarily an intensification of man's struggle with matter. That this concern was not "escapist" is confirmed repeatedly in his own writings. The four chief works[9] — *Concerning the Spiritual in Art (Ueber das Geistige in der Kunst),* "On the Question of Form" ("Ueber die Formfrage"), "Reminiscences" ("Rückblicke"), and *Point and Line to Plane (Punkt und Linie zur Fläche)* — radiate an ecstatic sense of history and a serene (if Manichean) confidence in the victory of "the white, fertilizing ray" of creativity over "the black, fatal hand" of blindness, hatred, fear of freedom, and insensate materialism. What animates these writings is the desire that all evolving "new values" be *materialized,* and then — because

"we should never make a god out of form" — that they should give way before still newer values.

It was also important to create an art freed of literary associations, of that oppressive narrative quality that stifled the potential development of visual language by tying it to readymade verbal categories. Painting was no longer to be a branch of conventional literature, telling a "story in pictures," but a world of its own.

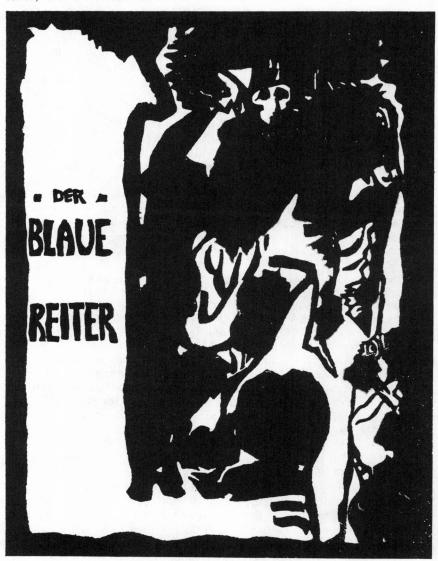

Klee put it thus, writing of the tendency of modern art toward abstraction:

> [The artist] is, perhaps unintentionally, a philosopher, and if he does not, with the optimists, hold this world to be the best of all possible worlds, nor to be so bad that it is unfit to serve as a model, yet he says: "In its present shape, it is not the only possible world."[10]

Abstractionism was to enable the artist and audience to experience alternative realities, a different order of things, another possible cosmos. By stepping outside the given and offering an unanticipated perspective, nonobjective painting played its own role in the disintegration of old verities which characterized the death throes of the nineteenth century.

There can be no doubt that Kandinsky was conscious of this broader, world-historical significance of his abstract Expressionism. He alluded repeatedly (as did his collaborators on the 1912 *Blaue Reiter Almanac*) to "a great awakening," a "new religion arising" as yet without prophet or leader:

> Today is one of freedom such as characterizes great germinative periods. . . . And sometimes when the human soul is gaining greater strength, art also grows in power, for the two are inextricably connected and complementary. Conversely, at those times when the soul tends to be choked by materialist lack of belief, art becomes purposeless, and it is said that art exists for art's sake alone. . . .
>
> The causes of the necessity to move forward and upward — through sweat and suffering, evil and torments — are obscure. . . . The path often seems blocked or destroyed. But someone always comes to the rescue — someone like ourselves in everything, but with a secretly implanted power of "vision."
>
> He sees and points out. This high gift (often a heavy burden) at times he would gladly relinquish. But he cannot. Scorned and disliked, he drags the heavy weight of resisting humanity forward and upward.[11]

To our ears these words perhaps sound archaic and naive. It is difficult to imagine the (relative) innocence and confident teleology of this former time, much less to tolerate the application of Christian imagery to the problems of art. Nonetheless, the content or spirit of such passages endures, if one is willing to look beyond their outmoded form.

As art is precisely the *sensuous* mediation of self-consciousness;[12] let us now turn to the paintings in which Kandinsky made his vision concrete.

The Work Itself: Theory and Materialization

Kandinsky's work went through at least six distinct phases. First came canvases reminiscent of Russian folk and religious art, then impres-

sionistic studies and landscapes, already notable for their fascination with color and disinterest in human subjects. Studying in Munich at this time, he recalled "wandering about with a paintbox, feeling in my heart like a hunter." Natural phenomena, which aroused in him strong emotions, communicated themselves as bright, inchoate, yet distinct visions: visual metaphors.

There followed a rather Fauvist period: brilliant-hued towns, animals, fairy-tale figures on horseback in transfigured night. But the practice of rendering particular objects in themselves began to strike him as absurd and pointless. What he wished to capture was the ontological ground in which these particularities participated and upon which they moved and reveled in their being. The last of Kandinsky's conventional works were done while he was already, with a mixture of patience and impatience, experimenting with creating his own autonomous forms in a series of "improvisations," first in pen and ink and aquarelle, and later in lithographs and oils. The "objects" they depicted, although obviously suggested by a richly *lived* and observant life, seemed increasingly to refer to nothing beyond themselves. From *Point and Line to Plane*, written in 1926 to serve as a Bauhaus educational text, it is clear that Kandinsky studied many varied forms — crystals, star clusters, architectural drawings, construction frameworks (e.g., the Eiffel Tower), flowers, microorganisms, alphabets. The new forms were meant to suggest the energy state of matter which, though just as real as mass, was rarely *seen* by man as he sleepwalked (or rather, did a forced march) through existence.

By 1910, Kandinsky felt himself "ready at last" to make a complete break with the final vestiges of representation in his work. The horse and its rider, the slant of a village roof, the curve of blue mountain in the distance — these forms freed themselves entirely from verisimilitude and took flight with visible joy. The ability to make this break he ascribed to a *maturation of the spirit of the age* within himself; indeed, that Kandinsky became the first pure abstractionist was a matter of chance, as others like Franz Kupka and even Arthur Dove were following closely upon the same path. Yet Kandinsky's work is especially revealing of this "dematerialization process": one can *see* the objects and their fixed associations twist and turn upon the canvas in convulsive beauty, seeking liberation.

Several works after the "spiritual turning point" of 1910 were entitled "Improvisation" and given a number. But Kandinsky's method remained constant throughout: before each completed composition came numerous preliminary sketches, "Impressions," in which each individual element of the whole was painstakingly arranged and rearranged until the proper harmony was achieved. *Point and Line to Plane* is a veritable encyclopedia of the various types of lines, forms, colors (by themselves or in combination), and other configurations which must be put into resonant relationship with one another on the canvas:

> Only by means of a microscopic analysis can the science of art lead
> to a comprehensive synthesis, which will extend far beyond the

confines of art into the realm of the "oneness" of the "human" and the "divine."[13]

He begins by dissecting the Point, defined wth a certain mathematical poetry as "the highest degree of restraint which, nevertheless, speaks, . . . the ultimate and most singular *union of silence and speech.*" Then he proceeds, uncannily like a natural scientist, "to determine wherein the living conforms to law" in painterly composition. Such a highly deliberate method of composition could not be more foreign to the romantic theory of "genius." Yet the finished works of this fourth period have about them a look of spontaneous and natural existence, of internal *necessity*, that makes their actual laboratory-style genesis seem implausible.

The fourth period in particular, longest of the six, saw the emergence of most of the typical and distinctive forms comprising Kandinsky's "language of the eye." They swim or float about some unseen center of gravity: powerful black lines and curves, translucent amoeba-like creatures, jagged rainbows of color, spheres (often deep blue), triangles, swirls reminiscent of gas clouds, targets, orbiting planets, arrows, chessboard grids. More metaphorically, they resemble the tracks of subatomic particles, power lines, cityscapes viewed from above, untranslatable hieroglyphs, engineering blueprints, and in particular the notational systems of certain modern composers.

Kandinsky may not have been aware that he had converged, from the opposite direction, upon the same symbols at which modern music had arrived as it distanced itself from the assumptions of classical tonality. In any event, Kandinsky, the voluptuary of color, was himself a frustrated musician; like Klee, he had first experienced his creativity as a musically-talented child, and ever afterward regretted that his own metier could only *suggest* the total immateriality of which music was capable. He often spoke of painting in musical terms, referring to "the inner sound" of a work:

> Color is the keyboard, the eyes are the hammers, the soul is the piano with many strings. The artist is the hand that plays, touching one key or another purposively, to cause vibrations in the soul.[14]

While at the Bauhaus he experimented with the *Gesamtkunstwerk* — for instance, "The Yellow Sound," which was a kind of tone poem enacted within a three-dimensional painting, integrating color, words, music, and drama.

Colors, instead of music, turned out to be Kandinsky's medium as an artist, but he continued to hear as well as see them:

> Blue is the typical heavenly color; the ultimate feeling it creates is one of rest. When it sinks almost to black, it echoes a grief that is hardly human. It becomes an infinite engrossment in solemn moods. As it grows lighter it becomes more indifferent and affects us in a remote and neutral fashion, like a high, cerulean sky. The

lighter it grows, the more it loses resonance, until it reaches complete quiescence, in other words, white. In music a light blue is like a flute, a darker blue a cello; a still darker blue the marvelous double bass; and the darkest blue of all, an organ.[15]

The serene blue sphere to be found in most of the "Improvisations" and "Compositions" represents a sort of celestial vantage-point from which the spectator gazes down at these systems of color and energy as upon an "ideal plane." The "subject" of each canvas is the universe itself viewed from a different angle and in a different energy state.

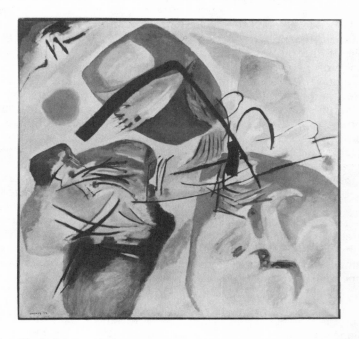

Kandinsky's search for the laws of the soul and senses culminated during the 30's in a cool geometric style, his "Bauhaus period"; the glowing radiation had lessened, like planets slowly crystalizing out of clouds of glittering dust. The compositions no longer appear to have been spontaneously improvised. This is considered by some to be the "reification phase" of Kandinsky's vision. In terms of the social reality to which that vision was hypersensitive, such crystalization mirrored the growing *stasis* of the postwar revolutionary movement, from Weimar Germany to the USSR. The new style further reflected, in its rigidity and almost excessive self-containment, the *implosion* of that movement. This fifth phase is severe, mechanical, inorganic. For his part, Kandinsky felt the "coldness" to be the coldness of *necessity*, a necessity which his undertaking was meant all along to unearth.[16]

But it would be unwise to make of Kandinsky's development a mere mirror of general events. His sixth and last period, arising out of Parisian exile, has been called a "great synthesis," and witnessed the reintroduction of motion, warmth, organicism, playfulness, and grace, while retaining the clarity and definition of form attained during the Bauhaus years. Such works as "Relations" and "Sky Blue" resemble delightful microscopic worlds where tiny beings sport in harmony, and this vision can hardly be said to "reflect" society during the Nazi occupation of France. At a certain point Kandinsky's project became transfixed, as it were, and it is at such points that the autonomous development of the individual can be said to overcome external determination.

Spiritualism vs. Technology

Kandinsky and his collaborators may certainly be considered prophets and leaders of *art's* spiritual awakening, but what the *Blaue Reiter* seemed further to be pointing toward was an awakening of the entire social organism, hence toward some political manifestation as well. What sort of political movement did these prophecies presage? Did they, too, express the sort of vitalist, irrationalist revolt that led so many artists sickened by modernity to the dream of fascism? There are several ways of approaching this problem, but an analysis of the following quotation from Victor Aubertin, a typical prewar protofascist utterance, will help develop a "political" interpretation of where Kandinsky stood:

> Art is dying of the masses and of materialism. It dies because the land it needs is all built up, the land of naïvete and of illusions. . . . On each national holiday a joint toast to art and science is proposed; perhaps they mean one and the same to the idiot. But they are deadly enemies; where one of them exists, the other flees. . . .[17]

Perhaps a wiser formulation might be, "Where one advances, the other recedes." Wiser still, to point out that the knowns and unknowns of the universe are not finite, like a glass either half full or half empty, so that an activity does not have to be seen as *either* art *or* not-art, but as a process whereby both known and unknown develop and extend one another, ad infinitum. At any rate, it can be granted: art is not the same as science. And what of this? As though art does not act precisely to make the unknown *known*, conscious, "scientific"; as though there were no intimate historical relationship between the two. Or perhaps, as the quotation suggests, the role of art is to *keep* the unknown unknown, to make sure the stone of mystery remains unturned to light? If so, one can no longer speak of freedom as a property of art: rather, of willful blindness, the enforcement of mystification.

Such static notions as the art/science (technology) dualism derive in the end from what might be called the resentment of consciousness. Humans are conscious: this is the Fall, the human tragedy. The religious *Weltanschauung* gradually degenerated from a fertile sense of wonder to a stifling refusal to take responsibility ("usurp divine power") for the pre-eminent role of humanity within evolving nature. To recognize and affirm this role constitutes, for all mysticism, the sin of pride, the Original Sin. Hence the dark wish to keep things veiled: the mystic shuts his eyes to save his feckless innocence. What art (the creative process) has unearth-ed, he forcibly relegates to the superstitious backwaters of the brain. It is an act of bad faith.[18]

The core of Kandinsky's art and philosophy could not possess a nature more antithetical to the sentiments of a mystic like Aubertin. The evidence is everywhere in his writings and canvases; it is almost always "internal" evidence, however, as Kandinsky gave scarcely a thought in his life to politics as such. But a consideration of his itinerary suggests (at worst) a mere desire to work in peace, and a principled commitment to the free development of his ideas and their communication to others through active associations of like-minded artists.

On the relation of art to scientific knowledge or technology, Kandin-sky was always crystal clear:

- The blind following of scientific precept is less blameworthy than its blind and purposeless rejection. At least the former produces an imitation of material objects which may have some use.
- Thought, which although a product of the spirit can be defined with exact science, is material, but of a fine and not a coarse substance.
- The ideal balance between the head (the conscious moment) and the heart (the unconscious moment, intuition) is a law of crea-tion, a law as old as the human race.
- The final abstract expression of every art is *number*.

Such statements tend to cast doubt on the opinion held by some that in philosophy Kandinsky was a complete Bergsonian, for despite Bergson's attempts to integrate "the analytical" into his theory of creative evolution, he persisted in viewing intuition as the one true wellspring of creation.

In Kandinsky's earlier years he had feared, as had many of his con-temporaries, that science would become wholly subservient to the dead bourgeois concept of matter, but

in the 20's and 30's Kandinsky saw that science had moved away from positivism, its concerns were with synthesis and process, and had thus come closer to what artists since 1910 had been concern-ed with.[19]

He spoke in "Reminiscences" of the tremendous impact that the splitting of the atom had had upon him, how it confirmed his belief that "nothing is absolute," that all lies in the relations among dynamic forces. Writing in 1912, he noted that:

> The theory of electrons, that is, of waves in motion, designed to replace matter completely, finds at this moment bold champions who overstep here and there the limits of caution and perish in the conquest of the new scientific fortress.

Whatever the allusion to "perishing" may mean here, it is clear Kandinsky felt he had allies in the new physics. Still later, writing for *Cahiers d'Art* in 1935, he stated that modern (relativistic) physics was seeking "to rediscover forgotten relationships between the smallest phenomena, and between these phenomena and first principles...."

It was precisely the *relativity* of the new physics which the National Socialists found especially distasteful and "Jewish," and it is no accident that the Bauhaus — along with Jewish organizers, intellectuals, academics, and writers — was among the first to feel the wrath of "true German" restoration of the Absolute.[20] Kandinsky perfectly symbolized, in fact, the sort of "rootless cosmopolitan" and "restless element" the fascists feared. This passage from *Point and Line to Plane*, on the mission of the Bauhaus, reveals an attitude that was expelled from Germany in 1933:

> It can be maintained altogether without exaggeration that a science of art erected on a broad foundation must be international in character: it is interesting, but certainly not sufficient, to create an exclusively European art theory.

Thus, whereas a central tenet of fascist ideology held that science and the scientific method, by their very nature, violated the necessarily irrational basis of life, Kandinsky's two-sided approach merely noted that "perpetual corrections are necessary from the angle of the irrational," lest perception become overdetermined and formalized. For him, art *conveyed thought to the senses*. "To speak of mystery in terms of mystery. Is this not content?...Man speaks to man of the superhuman — the *language* of art." On the pseudo-question of whether man is "permitted" to apprehend the universe, then, Kandinsky was quite sure that he is.

One further note: Kandinsky's passing interest in Theosophy has nourished the interpretation that his thought lies well within the mystic-spiritual tradition. Further definition is required here. First, there exists no hard and fast division between "materialism" and "spiritualism" when one is dealing with dialectical thought.[21] For this reason Hegel by no means needs to be "stood on his head" in order to deliver himself of profound insights into the material development of society. Dialectical thought entirely transcends such a dichotomy, which is then seen to be a derivative problem. It derives from the real distinction, that between dialectics and reification.

Second, Kandinsky's was not the only enthusiastic mind to have been seduced by the totalizing power of an essentially *static* dialectic. The static and dynamic dialectics in fact complement and even provide correctives to one another. Yeats, indeed, displayed a movement which is the reverse of Kandinsky's: drawn initially to the socialism of William Morris, he repudiated it as a vanity of vanities and embraced the timeless antagonism of what he termed the "primary" and "antithetical."

Finally, Kandinsky's involvement with Madame Blavatsky's Secret Doctrine was never thorough or long-lived. In his own writings we find scarce mention of it. Perhaps this hesitation was due to his characteristic mistrust of organized movements; at one point he refers to his skepticism regarding Theosophy's "excessive anticipation of definite answers in lieu of immense question marks."[22] Certainly the bitter infighting and mean-spirited squabbles over doctrine that plagued the Theosophical Society cannot have appealed to him. In any case, too much has been made of the connection.

Internal Necessity

There is a further dimension to Kandinsky's itinerary: the backward Soviet Union demanded an art that was explicitly practical, a dynamic architectural and mechanical art which reflected the urgent need of the new state to industrialize before it was overcome by internal and external pressures. Kandinsky was a highly-educated middle-class man at the moment of the Revolution; he thought it "revolutionary," on the contrary, to be unconcerned with "practical-useful applications," and abhorred the tyrannical, technocratic implications of "production for use." The point, he felt, was not to subordinate creativity to utility, but to *gain control* over the creative process. Like the German Idealists, whose philosophical systems better reflected the achievements of the French Revolution than did the writings of their French contemporaries, Kandinsky had already gone beyond the aesthetic sensibility hegemonic in the young USSR.

This sensibility, in great part a breathlessly condensed and millenarian version of Renaissance-Industrial Revolution ideology, itself initially took the form of the strictest abstraction, but demanded a "constructive," task-oriented, utilitarian commitment from the artist. In *Isms of Art*, El Lissitzky declared:

> The Constructivists look at the world through the prism of technology. . . . The shortsighted see therein only the machine. Constructivism proves that the limits between mathematics and art, between the work of art and a technical invention, are not to be fixed.[23]

Although sympathetic to the abstract enthusiasms of the Constructivists, and indeed influenced by them, Kandinsky refused in the end to subordinate his project to that of Soviet urbanization, and it is not surprising that Lissitzky was his chief critic during Kandinsky's Soviet sojourn.

Founded, however heroically, upon *scarcity*, the Soviet aesthetic already contained the seeds of that most virulent of isms, Socialist Realism. In the advanced industrial nation of Germany, on the other hand, a more immediate leap to the transcendence of oppressive materiality could be attempted, both in theory and practice.

Nevertheless, Kandinsky made a substantial contribution to the brief flowering of the Soviet cultural scene. Working directly under Lunacharsky, from 1918 to 1921 he was successively Professor at the Moscow Academy of Fine Arts, Director of the Museum of Pictorial Culture in Moscow, Professor at the University of Moscow, founder of the Institute of Art Culture (a "union of the arts" experiment which foreshadowed the Bauhaus), and founder of the Russian Academy of Artistic Sciences. As mentioned earlier, after a resignation forced by anti-Lunacharsky forces (forces which were soon to support the Trotskyist purges), Kandinsky moved on to the Bauhaus in Weimar, where his own ideas were being implemented. There he continued his second vocation, teaching, and made a tremendous impact, both as a man and an educator, upon the radical young artists drawn to that experiment.

In a rare moment of semipolitical enthusiasm, Kandinsky styled himself an anarchist, and wrote that "anarchy is regularity and order created not by an external and ultimately powerless force, but by *the feeling for the good*."[24] In "Reminiscences" Kandinsky described his involvement in Russian student unrest over the oppressive University Law of 1885, during which he directly experienced the mass "spontaneity" that was to touch the lives of most Europeans in the course of that brief new world we call the mass-strike period. The experience moved him to the following observations on political organization:

> Every individual (corporative or personal) step is full of consequence because it shakes the rigidness of life — whether it aims at "practical results" or not. It creates an atmosphere critical of customary appearances, which through dull habit constantly deaden the soul and make it immovable. Thence the dullness of masses about which freer spirits have always had reason for bitter complaint. Corporative organizations should be so constituted that they have the most open form possible and incline more to adapt to new phenomena and to adhere less to "precedent" than has hitherto been the case. Each organization should be conceived only as a transition to freedom, as a necessary bond which is, however, as loose as possible and does not hinder great strides toward a higher evolution.[25]

However, for Kandinsky such an observation merely served as an extension of his critique of reification and formalism in the arts, and the passing mention ends with, "Luckily politics did not ensnare me." He did, however create a more elaborated "triangle" paradigm in *Concerning the Spiritual in Art*: this triangle, "the movement of cognition," depicts human society moving ahead

> slowly but surely, with irresistible strength moving ever forward and upward. . . . Where the apex was today, the second segment will be tomorrow; what today can be understood only by the apex, is tomorrow the thought and feeling of the second segment.

The key word in Kandinsky's rudimentary symbolic account of how "the abstract spirit" progresses, is *necessity*. For Kandinsky, who expressed his "basic principle" as "internal necessity," this concept bore several related meanings:

- The effect of internal necessity and the development of art is an ever-advancing expression of the eternal and the objective in terms of the historical and subjective.
- In real art, theory does not precede practice but follows it. Everything is at first a matter of feeling.
- This absolute liberty [of abstractionism] must be based on internal necessity, which might be called honesty. . . .

And we have already quoted the passages where he implied that "the causes of the necessity to move forward and upward. . . are obscure," and where he spoke of "regularity and order created not by an external and ultimately powerless force, but by *the feeling for the good*." This "good" is defined in purely human terms: that which increases the freedom of humanity in its struggle against the entropic material world.

Thus internal necessity is an evolutionary principle whose content is "feeling," both objective and subjective. "New values," the subjective force as borne by the artist, are described thus: "This is the positive, the creative. This is goodness. The white, fertilizing ray." The objective "obstacles," which are described in an equally simple Manichean manner as "the black, fatal hand," try

> with every available means to slow down the evolution, the elevation. . . Obstacles are constantly created from new values that have pushed aside old obstacles.[26]

In other words, what initially sounds like a mystical force emanating from within is actually a progressive idea, not a demand for absolute order.

> The strife of colors, the sense of the balance we have lost, tottering principles, unexpected assaults, great questions, apparently useless striving, storm and tempest, broken chains, antitheses and contradictions — these make up our *harmony*.[27]

Kandinsky, unlike the growing fascist intelligentsia of his time,[28] *embraced* the transformations he could feel occurring around him, though he did not give them the standard political names. Like all original thinkers, he developed his own universe of discourse. He understood that the abstract spirit, the force of human creativity, took hold of a people ir-

resistibly and gave birth to great social movements. In light of this, he observed that "One should not set up limits because they exist anyway"; the sole imperative he would admit was "Open feeling — to freedom."

This is a libertarian spirit, affirmative and anti-authoritarian. True, it partakes of a certain "vitalism" in the air of the period, but there is a difference between Kandinsky's faith in "the winding path of instinct" (Yeats) and Lawrence's hysterical condemnation of modernity or Eliot's dry dismissal of it. These latter two critics of modern capitalist society arrived at a one-sided refusal both of its achievements and of its crimes. Kandinsky, on the other hand, was acutely aware of the real progress which had prepared and which underlay the ongoing "advance" he allied with:

> True form is produced from the combination of feeling and science. . . . An important characteristic of our time is the increase of knowledge; aesthetics gradually assumes its proper place.

As for his own task, the attempt

> to banish external artistic elements [objects] from painting . . . is possible *because we can increasingly hear the whole world, not in a beautiful interpretation, but as it is.*[29]

In such passages throughout his writings, Kandinsky reproduced Hegel's prophetic notion of the end of representation.

Kandinsky was far from being the only artist to respond to the quickened atmosphere of the pre- and interwar world; many did. It may be argued that the major contributions to a great art of our time originated during the revolutionary process that brought much of the Northern hemisphere to the brink of socialism by 1919. The art schools of the present—op, pop, kineticism, luminism, Happenings, Environments, found-objects, assemblagism, mixed media, conceptual and minimal art, concrete poetry, serial music, modern Abstract Expressionism — represent little more than the cannibalization of this earlier period, banal exercises stumbling through absurdity and ending in silence. . . .

Modern art has been unable to consummate itself — although the material *basis* for transcendence, for the utter transformation of social identity, was and remains very palpably in existence — because the necessary social revolution has failed to materialize. The "surreality" and "immateriality" so passionately espoused by the movements of the early twentieth century were premised on the expectation of an imminent supersession of classes, wage labor, coercion — in short, all the evils born of scarcity.

The Critique of Commodity Fetishism

The Expressionists in general and Kandinsky in particular viewed themselves as a vanguard — but advancing toward what? In "On the

Question of Form" Kandinsky located the two aspects of "the modern movement" as:

- Disintegration of the soulless, materialistic life of the 19th century . . . and
- Construction of the spiritual and intellectual life of the 20th century that we experience and that is already manifested and embodied in strong, expressive, and distinct forms.

What characterized this modernism was its cultivated ability to hear "the inner sound" directly, as a child, unburdened by sad experience, is able to "ignore the external." There is no contradiction, Kandinsky asserted, between modern realism and modern abstractionism:

The "representational" reduced to a minimum must in abstraction be regarded as the most intensely effective reality.

In other words, internal necessity is more "real" than external appearance or form: the emphasis is constantly on *content*.

What is this content? It is, once again, "the feeling for the good," the unfailing guide of emotional honesty. Only relearning how to "open feeling to freedom" (Blake's "organiz'd Innocence") permits the acquisition anew, by the overfamiliar, "disenchanted" world, of its lost *inner resonance*.

In condemning "the soulless, materialistic life of the 19th century," Kandinsky echoed a well-established rhetorical tradition. On this question, at least, sections of the left (the Frankfurt School, Tucholsky, Paul Nizan, Sartre, the Surrealists, the Philosophes, Sorel, de Man, etc.) and the right could unite: the positivistic, utilitarian concept of progress that accompanied the rise of a secular bourgeois economy had proven both empty and destructive. The most insightful spokesmen for this tradition, Kandinsky included, foresaw a great mechanized disaster as the only possible culmination of that rise — what was to be World War I. Some glorified in the "release" of warfare: Marinetti, Georg Heym, Gabriele D'Annunzio, Charles Maurras. But for Kandinsky the war was pure evil, "the black, fatal hand" in all its life-negating malevolence.

The socialist movement, in particular its communist wing, has historically called itself "materialist," and in many cases attacked any critique of materialism as at best antimarxist and at worst fascistic. But what Kandinsky clearly meant to criticize was crude, mechanistic materialism of the same variety refuted by Hegel and Marx themselves. While "spiritualism" meant, to a thinker like Mussolini, that man did not live by bread at all, Kandinsky was precisely concerned with the necessary moment of *materialization* — in beautiful forms corresponding to their internal necessity — of those realities which man could as yet barely experience, much less express, due to his dulled state of "incompletely developed feeling." The marxist art critic John Berger poses the problem very well in *Ways of Seeing*:

Oil painting did to appearances what capital did to social relations. It reduced everything to the equality of objects. Everything became exchangeable because everything became a commodity. All reality was mechanically measured by its materiality. The soul, thanks to the Cartesian system, was saved in a category apart. A painting could speak to the soul — by way of what it referred to, but never by the way it envisaged. Oil painting conveyed a vision of total exteriority. . . .

When [Blake] came to make paintings, he very seldom used oil paint and, although he still relied upon the traditional conventions of drawing, he did everything he could to make his figures lose substance, to become transparent and indeterminate one from the other, to defy gravity, to be present but intangible, to glow without a definable surface, not to be reducible to objects.

This wish of Blake's to transcend the "substantiality" of oil paint derived from a deep insight into the meaning and limitations of the tradition.[30]

In his belief that abstraction was more real than representation, that the dream of the ideal is more real than what passes for real life, Kandinsky recreated the critique of commodity fetishism, that vise of ideology which Marx considered the *sine qua non* for reproducing the alienated "capitalist type" among individuals.[31]

For the person in bourgeois society, manipulated and ruled by appearances, separated from his own activity by the intervention of money and the labor market, the constant struggle is to *recover the content of existence.* This is exactly what Kandinsky proposed as the task of his art.

Artist and Audience

A sober technical endeavor such as *Point and Line to Plane* demonstrates the difference between early Expressionism and the later, matured sensibility of the Bauhaus. The Bauhaus, committed to synaesthesia and an operative fusion of art and technology (form and function), appealed immediately to Kandinsky's deep-rooted purposiveness, his sense of art as "labor" which aimed to communicate the capacity "for infinite experiences of the spiritual in material and in abstract things."[32]

If art is not an arbitrary or superfluous luxury but a necessity, that fact must somehow be expressed in a social response: if art has no audience, then it is not art. The great trial of the modern artist has been staged by the indifference or ridicule of society in general vis-a-vis his vision of "necessity." In part, this gap has resulted from the failure of the social-revolutionary thrust mentioned earlier to do more than awake incredible, unquenchable desires in a handful of visionaries, but it also derives from the extreme difficulty inherent in trying to change, virtually overnight, the entire visual language of a society.

Very broadly speaking, two major strategies arose to deal with this

disturbing rift: Socialist Realism, which proposed to deliver Art to the People in readily accessible — virtually predigested — forms; and a reincarnation of the old avant-gardist aestheticism, typified by the Second Vienna School, whose contempt for the masses was so striking.

Kandinsky's argument against Socialist Realism was rarely made explicitly, but his departure from the Soviet art scene expressed eloquently enough his feelings on the subject. It was not that he insisted, out of some dogmatic fervor of his own, that representation be banned from painting, or that figurative modes were completely impotent; he simply doubted their power to convey the real in all its revolutionized new possibilities:

> Since form is only an expression of content, and content is different with different artists, it is clear that there may be *many different forms at the same time* that are *equally good*. . . . One should discard nothing without making an extreme effort to discover its living qualities.[33]

In his flexibility and tolerance for ambiguity and diversity, Kandinsky exemplified the position of the Bauhaus on the question of "audience": a synthesis of *concern* for popular comprehension and participation, on the one hand, and principled *commitment to working from an advanced standpoint,* on the other, rather than capitulating to the prevailing "materialist" limits on the imagination. That is to say, the masses would not benefit from having artistic conceptions degraded to their existing level of comprehension; only the *exemplary* presentation of new and higher forms of consciousness could be either effective or honorable. Klee also struck his balance at the end of his statement "On Modern Art":

> We have found the parts but not the whole!
> We still lack the ultimate power, for: the masses are not with us.
> But we seek a people. We began over there in the Bauhaus.
> We began there with a community to which each one of us gave what we had. More we cannot do.[34]

It is ironic that although both during and after his *Blaue Reiter* collaboration, Arnold Schoenberg saw himself as wholly sharing Kandinsky's vantage-point, he actually misunderstood that vantage-point. For example, in his essay "The Relationship to the Text," Schoenberg debunked the notion that music deals with ideas; while poetic art may, he wrote, be "bound to matter" due to "the poverty of concepts," music deals purely with "the language of the world, which perhaps has to remain unintelligible. . . ." He dismissed as unprofound "the language of men, which is abstraction," and loftily declared:

> There are signs that even the other arts, which apparently are closer to the subject matter, have overcome the belief in the power of intellect and consciousness. . . . Kandinsky and Oskar Kokoschka paint pictures in which the external object is hardly

more to them than a stimulus to improvise in color and form and to express themselves as only the composer expressed himself previously.[35]

The reference to Kandinsky's ability to compose with elements of his own choosing was essentially sound, but on the whole Schoenberg had missed the point. Not only did Kandinsky embrace "the power of intellect and consciousness," but his conception of internal necessity, the wisdom expressed by the artist-seer, was above all social. Abstractionism might signify that *man has soared beyond material necessity* (in consciousness, as well as potentially in social practice), but it still signifies *purposive* play, oriented toward the creation of higher orders of Freedom/Necessity. Kandinsky never let his dialectic collapse or lapse.

The early writings of Kandinsky's young collaborator Franz Marc evince similar confusion over this question, as well as a great deal of emotionalism of the sort often encountered in the imperious, passionately obscure, and vaguely threatening genre of the Manifesto. Both Marc and Schoenberg seemed at a loss as to how an audience for modern music and painting might be developed. Marc, whose notion of abstraction was that it slyly created "*symbols* . . . behind which the technical heritage cannot be seen," announced that "the artist can no longer create out of the now-lost artistic instinct of his people," thereby implying unintelligibility and isolation to be the artist's inescapable fate.[36] Schoenberg professed himself unperturbed by the problem, and refused to assume what he called "guilt" for the failure of the Second Vienna School to move any significant fraction of the masses.

Though neither resigned *nor* petulant, Kandinsky and the Bauhaus generally can themselves hardly be said to have resolved what Breton had called "the crucial misunderstanding which results from the apparently insurmountable difficulties in objectifying ideas." (see note 33.) The so-called audience problem is just another way of musing upon the fate of the social revolution — a fate which, while still unsealed, has yet to be satisfactorily addressed or explained.

The End of Representation

Kandinsky called the final phase of the abstraction process "monumental," "absolute," or "concrete" art; it would be the point at which all of life was deliberately composed in a single language of beauty, continuously renewing itself at the call of internal necessity. Gropius himself expressed the same rather hazy idea:

> Our ultimate goal, which is still far off, is the unified work of art, the "great work" in which no distinction between monumental and decorative art will remain.[37]

Since Kandinsky's death in 1944, it seems the reverence — indeed, the love — he received while alive has only grown. He is constantly being "rediscovered" in his capacity as visionary, champion of articulate beauty, and creator of vividly beautiful images. Diego Rivera, who can scarcely be accused of harboring mystic impulses, wrote of him in 1931:

> I know of nothing more real than the painting of Kandinsky — nor anything more true and nothing more beautiful. A painting by Kandinsky gives no image of earthly life — it is life itself. . . . He organizes matter as matter was organized, otherwise the universe would not exist. . . . Some day Kandinsky will be the best known and best loved by men.[38]

Yet it is perhaps this beauty for which he is so beloved that poses the greatest problem: it too can get in the way of necessity, as Kandinsky well knew. Beauty is easily "recuperated": it would come as no surprise to see Kandinsky motifs turn up on frocks at the next Paris rag fair. There is no aspect of knowledge about how people perceive the world ("the laws of the soul and senses") that is immune to perversion in the service of the market. How color, line, and form affect the viewer emotionally, how they play in concert upon the piano of the soul — all this passionately interested Kandinsky with regard to his project of creating "a new humanism and a truly popular culture" (Marc). The same knowledge becomes just another technique of advertising and behavioral control in the hands of a society driven to turn every native impulse against itself as a means of self-preservation.

The road to the Absolute has turned out to be the road to the obsolete, after all. Kandinsky himself situated the dilemma as early as 1913: "The danger of ornamentation was clear, yet the dead make-believe of stylized forms could only frighten me away."[39] He rightly turned away from dead make-believe, but could do no more. Abstraction calls "painting" itself into question: the end of pictorial *representation* points past itself, perforce, toward the real thing: toward a resolution which lies well beyond the canvas and the colorful death agonies of art. Kandinsky either did not or could not realize this:

> The general viewpoint of our day, that it would be dangerous to "dissect" art since such dissection would inevitably lead to art's abolition, originated in an ignorant underevaluation of these [artistic] elements thus laid bare in their primary strength. . . . [The] "injurious" effects are nothing other than the fear which arises from ignorance.[40]

Kandinsky, born in the old world, maintained a delicate, immovable balance on the cutting edge of the new. At the precise moment that art could no longer resist pointing beyond itself, he turned its secrets inside out, revealed all its ruses, and located its demise within that vast sweep of

history which was already putting a *practical* end to "representation." "We have before us," he wrote, "an age of *conscious* creation."

To revivify modern art actually presupposes a renewal of the social movement for mass democratic control of the means of life, which must now be conceived as a struggle for absolute control of "nature." But this is no more than a glib statement. For if Kandinsky's work is prophetic, it is also a warning: the right, too, opposes the status quo of modern capitalism; its populist and libertarian posturings must be taken at least as seriously as its nostalgic, Social Darwinian, and mystical aspects. What happens during the radicalization of a people in crisis periods to swing the balance in favor of the right's "alternative revolution" is, quite simply, *the fatal hesitation and abdication of the socialist vision.*

The distinction between left and right is quite real and must be preserved. Innumerable historical examples exist where the *style* of fascist and socialist formations — what Kandinsky would have termed their external form — proved so indistinguishable that youth in Italy, Germany, and France found themselves shifting with vertiginous frequency between the two. How, then, can one ascertain the *content* of a given "radicalism"? What in the end can be depended upon to pierce through the infinite rationalizations and grandiose verbiage to the objective inner meaning?

"The feeling for the good"; the spirit open fearlessly to all possibilities; the belief in the unfettered creative process and in the divinity of *man,* against all those, fascist and stalinist alike, who would force humanity back into "stale repetitions of a world already too well known"[41] — this vital spirit Kandinsky both expressed and embodied. It is the content of his work: *being,* generosity, transparency. It is what one can learn, or rather relearn, from that body of work. Only a genuine, active commitment to the development of free, purposive human creativity could have expressed itself in an aesthetic achievement of such value, such substance as Kandinsky's farewell to art as we have known it. Only of such achievements can no mistake be made.

Notes

[1]See Edmund Wilson's treatment of the dilemma of aestheticism in *Axel's Castle* (New York: Scribner's Sons, 1969).

[2]Andre Breton, *What is Surrealism?* (London: Faber & Faber Ltd., 1936), p. 49.

[3]G.W.F. Hegel, *Phenomenology of Mind* (New York: Harper & Row, 1967), p. 145.

[4]"We have, however, no reason to regard this simply as a

misfortune which the chance of events has made in-
evitable, one, that is to say, by which art has been over-
taken through the pressure of the times, the prosaic
outlook and the death of genuine interests. Rather it is the
realization and progress of art itself, which, by envisaging
for present life the material in which it actually dwells,
itself materially assists on this very path . . . to make itself
free of the content that is presented. . . . Spirit only con-
cerns itself actively with objects so long as there is still a
mystery unsolved, a something unrevealed. . . . A time
comes, however, when Art has displayed, in all their many
aspects, these fundamental views of the world. . . . There
is, in short, no material nowadays which we can place on
its own independent merits as superior to this law of
relativity; and even if there is one thus sublimely placed
beyond it, there is at least no absolute necessity that it
should be the object of *artistic* presentation. . . . In this
passing away of Art beyond itself, however, Art is quite as
truly the return of man upon himself. . . . by which process
art strips off from itself every secure barrier set up by a
determinate range of content and conception, and unfolds
within our common humanity its new holy of holies, in
other words, the depths and heights of the human soul
simply, the universal share of all men in joy and suffering,
in endeavor, action, and destiny." From G.W.F. Hegel,
Philosophy of Fine Art, Vol. II (N.Y.: Hacker Art Books,
1975), see especially pp. 388-401.

[5]Hegel, Preface to *The Philosophy of Right* (London: Ox-
ford University Press, 1975), p. 13.

[6]Wassily Kandinsky, "Reminiscences," *Modern Artists on
Art* (New Jersey: Prentice Hall, 1964), p. 33.

[7]Kandinsky, *Concerning the Spiritual in Art* (New York: Wit-
tenborn, Schultz, 1947), p. 48.

[8]*Ibid.,* p.28.

[9]Kandinsky's writings are sufficiently brief and "of a
piece" that particular ideas and even phrases need not be as-
cribed to a single source. Rather than litter this article with
references, I will occasionally dispense with citation.

[10]From Paul Klee, "On Modern Art," *Modern Artists on Art,*
p. 87.

[11]Kandinsky, *Concerning the Spiritual in Art,* pp. 72, 74, 26.

[12]For Hegel, all human activity is mediated: that is, Mind
only acts on reality via some medium or mediator (Other). Art
he defines as sensuous, while philosophy, for instance, is
mediated through concepts.

[13]Kandinsky, *Point and Line to Plane,* (New York: Solomon
R. Guggenheim Foundation for the Museum of Non-Objective
Painting, 1947), p. 21.

[14]Kandinsky, *Concerning the Spiritual in Art*, p. 45.

[15]*Ibid.*, pp. 58-59.

[16]Exhaustive descriptions and reproductions (in quality ranging from completely distorted to dazzling) of Kandinsky's work are to be found in Paul Overy's *Kandinsky: The Language of the Eye*, Willi Grohmann's *Wassily Kandinsky, Life and Work*, the Guggenheim Foundation's several retrospective collections, and *Homage to Kandinsky*, an anthology of tributes to the artist.

[17]From "Introduction," *The Blaue Reiter Almanac*, edited by Kandinsky and Franz Marc (New York: Viking Press, 1974). Quoted from Victor Aubertin, "Die Kunst stirbt," 1911.

[18]Does the phenomenological symbolism of a Blake lose its charm when recognized for what it is — a clairvoyant contribution, predating Hegel, Marx, Nietzsche, and Freud alike, to the understanding of desire, repression, and society, the limits of formal logic and Newtonian physics, the fraud of Natural Religion, and other positivistic excesses of the Enlightenment? Is it a violation of the discoveries of Delacroix or the Impressionists concerning color's emotive properties when these discoveries are found to apply to the science of optics? Where, after all, lie the origins of science, if not in magic, art, religion, and early philosophy — all equally "scientific" endeavors in the context of their proper epochs? (See Paul Feyerabend, *Against Method*, London: NLB, 1975).

[19]Paul Overy, *Kandinsky, The Language of the Eye* (New York: Praeger, 1969), p. 31.

[20]See George Mosse, *Nazi Culture* (New York: Grosset & Dunlap, 1966), pp. 197-234.

[21]See Joseph Gabel, *False Consciousness: An Essay on Reification* (New York: Harper & Row, 1975).

[22]Kandinsky, *Concerning the Spiritual in Art*, p. 33.

[23]El Lissitzky, *The Isms of Art*, reprint (New York: Arno Press, 1968).

[24]Kandinsky, "On the Question of Form" in *The Blaue Reiter Almanac*, p. 157. (emphasis in original). His biographer Overy calls him a "Christian anarcho-syndicalist."

[25]Kandinsky, "Reminiscences," p. 24.

[26]This image is from Kandinsky, "On the Question of Form," pp. 149.

[27]Kandinsky, *Concerning the Spiritual in Art*, p. 66.

[28]Among the many sources on this subject: John R. Harrison's *The Reactionaries*, Peter Gay's *Weimar Culture*, William M. Chace's *The Political Identities of Ezra Pound and T.S. Eliot*, W.B. Yeats' *A Vision*, D.H. Lawrence's *Apocalypse*, Patrick Bridgewater's *Nietzsche in Anglosaxony*, Ezra Pound's *Jefferson and/or Mussolini*, and Alistair Hamilton's *The Appeal of Fascism*.

[29]Kandinsky, "On the Question of Form," pp. 161-162 (emphasis added).

[30]John Berger, *Ways of Seeing* (London: BBC & Penguin Books, 1977), pp. 87 and 93.

[31]See Marx, *Early Writings* (New York: McGraw-Hill, 1964), p. 189, pp. 193-194. See also Marx's 1843 letter to Ruge: "The world has long possessed a dream of things which it need only possess in consciousness in order to possess them in reality."

[32]Kandinsky, "Reminiscences," p. 42.

[33]Kandinsky, "On the Question of Form," pp. 150 and 187 (emphasis in original), Andre Breton composed a masterful critique of Socialist Realism, a propos of abstraction in literature, in a broadside against the "childish, declamatory, unnecessarily *cretinizing*" style of *L'Humanite:*

> Nothing here seems to me to contribute to the desirable effect, neither in surface nor in depth. . . . I say that the revolutionary flame burns where it lists, and that it is not up to a small band of men, *in the period of transition we are living through,* to decree that it can burn only here or there. . . I have no leisure to publish "short works of fiction" even in *L'Humanite.* I have never written stories, having neither the time to waste nor to make others waste. The genre, I believe, is exhausted. . . Today, in order to write, or to read, a "story," one must be a poor wretch indeed. . . . For it is indeed *substance* that is involved, even in the philosophical sense of a fulfilled necessity.

> The fulfillment of necessity alone is of a revolutionary order. Hence we cannot say of a work that it is of a revolutionary essence unless. . . the "substance" in question is not entirely lacking. . . . What is thought (for the mere glory of thinking) has become incomprehensible to the mass of men, and is virtually untranslatable for them. . . . The whole meaning of my present critique is here. I do not know, I humbly repeat, how we can hope to reduce in our times the crucial misunderstanding which results from the apparently insurmountable difficulties in objectifying ideas.

(From Maurice Nadeau, *History of Surrealism* (New York: Macmillan, 1965), pp. 242-251.

[34]From *Modern Artists on Art,* p. 91.

[35]*The Blaue Reiter Almanac,* p. 102.

[36]Essays "The 'Savages' of Germany" and "Two Paintings" in *The Blaue Reiter Almanac,* pp. 64 and 68.

[37]Quoted in Marcel Brion, *Kandinsky* (New York: Harry N. Abrams, 1961), p. 57. Brion has observed that the "concrete," as Kandinsky preferred to call abstractionism, signified

"primordial reality," out of which unprecedented beings were coaxed to the canvas as though ex nihilo.

[38]Quoted in Peter Selz, *German Expressionist Painting* (Berkeley: University of California Press, 1974), p. 232. And Andre Breton's accolade: "I know of no art since Seurat with more philosophical foundation than that of Kandinsky. . . . [His] is the eye of one of the first and one of the greatest revolutionaries of vision." (From the compendium *Homage to Kandinsky*.)

[39]Kandinsky, "Reminiscences," p. 32.

[40]Kandinsky, *Point and Line to Plane*, pp. 17-19.

[41]Brion, *Kandinsky*, p. 83.

13
The Dual Vision
of Paul Klee's
Symbolic Language

James P. Bednarz

The most insightful account of German expressionist painting was written during its struggle for recognition by the eminent painter and friend of Paul Klee, Franz Marc. In the autumn of 1911, Marc composed an article entitled "*Die Wilden Deutschlands*," which spoke of his generation's "great battle for a new art" as a war waged by spiritual "Savages" of "a new and dangerous vitality" against the standard of Naturalism perpetuated by the "old, well-organized power" of the conservative academies of art. In using the word "*Wilden*" to describe these artists, Marc consciously employed a cognate for the French word "*Fauve*" in order to stress the international nature of this esthetic revolution. He further noted that the battle in his own country was waged on three fronts: in the city of Dresden, by the artists of the *Brücke*, such as Kirchner, Heckel, and Schmidt-Rotluff; in Berlin, by the members of the *Neue Sezession*, which included Austrians like Kokoschka and Schiele; and, finally, in Munich, by the supporters of the *Neue Künstlervereinigung* and the *Blaue Reiter*, in whose circle Kandinsky, Klee, and Marc himself prominently figure.

The purpose of this movement, according to Marc, was to extend the boundaries of expression through a recognition of "the infinite freedom of art." It marked a distinct turning point in the history of art, which "simply cannot be explained as a logical development and transformation of Impressionism." It was the first time in contemporary history that artists eliminated the illusion of pictorial realism "to create symbols for their age . . . concerned with the deepest things." The manifestoes of these groups resolutely subscribe to the doctrine that artistic form is prompted by inner necessity. In 1906, Ernst Ludwig Kirchner literally carved the philosophy of *Brücke* on a wooden tablet, commemorating his impulse both "to wrest freedom for our gestures and for our lives from older, comfortably established forces" and "to claim as our own everyone who reproduces directly and without falsification whatever drives him to create." The catalogue of the *Neue Sezession* exhibition in the spring of 1911 announces that the work of art "aims, not at an impression of nature, but at the expression of feelings," as "science and imitation disappear once more in favor of original creation."

In spite of this apparent unity of intention, however, Paul Klee, whose talents came of age through his contact with the artists of the Munich-based *Blaue Reiter*, achieved a form of expression that differs substantially in conception and tone from the most characteristic work of the *Brücke* and the *Neue Sezession*. Whereas the Dresden and Berlin groups produced works that are powerful renderings of grotesque distortion, embodying alienation and pain, Klee and his colleagues in Munich moved consistently away from the creation of satirical and tragic images of human horror. They emphasized, instead, the need to harmonize expression with

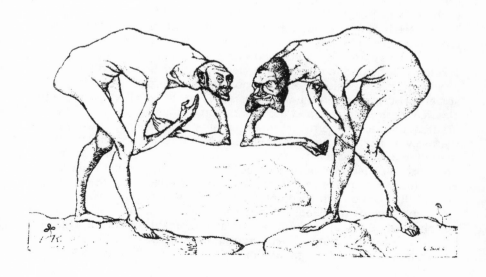

the workings of an inner world that is at once benign and mysterious. They invariably supplanted the powerful esthetic of the grotesque that had been the most potent force in revolutionary German art since the nightmare visions of Edvard Munch were first displayed at the *Berlin Sezession* in 1902. And while they acknowledged their place in the heritage of expressive freedom won through the "scream" that Munch felt "pass through nature," for them, a forceful means of expression did not necessarily end in the lineaments of despair or in a melancholy genius. This crucial difference between the esthetic extremes of German Expressionism crystallizes in the astounding disparity that exists between the savagely grotesque series of etchings Klee produced from 1903 to 1905 and the profoundly enigmatic watercolors he perfected in 1914.

From 1903 to 1905, Klee, turning his attention to the graphic arts, issued ten etchings that reveal a particularly caustic vision of contemporary society. Six of these, displayed at the *Sezession* in Munich in 1906, mark the beginning of his professional career. Here, Klee's work reveals a scathing anatomy of social decadence, traced with derision and black humor. A print depicting naked, hideously elongated figures bent in sycophantic adoration of each other attacks the concept of status and social differentiation based on hierarchy. It is satirically entitled: *Two Men Bow, Each Thinking the Other is of a Higher Rank*. The world of class distinction, symbolized in the form of monstrous submission, finds its virulent critique. In *Hero with a Wing*, the emblem of the social ideal, the hero, is drawn as a pathetic figurine whose pants slip down between his legs. A small wing attached to one of his shoulders is a symbol of hope, but his leg, gripping the ground, defines the hero's tragic limitations. A broken arm, set in a splint, betrays the punitive consequence of aspiration. These works are suffused with the uncanny terror that Klee admired in the prints of Goya and Ensor and the writings of Baudelaire and Poe. They place him unquestionably in the tradition of despair that was given renewed impetus by the example of Edvard Munch.

Klee was extremely concerned with the shrinking audience for his art and felt that he had to confront his viewers with their depravity at a time in which artistic achievement was no longer accorded a central role in society. Touring Italy in the winter of 1901, he realizes that the art of the classical period was allotted a cultural significance far greater than that granted by the moderns. Modern artists, he explains, must defend themselves from a scornful audience by mocking potential critics, thereby defusing criticism that is itself a symptom of social decay. "In order not to be laughed at," he writes, "one must make others laugh even at the image of themselves." After viewing the Renaissance masterpieces of the Uffizi, he notes in his diary that he left, "deeply moved, feeling very small and shaking my head." An artist subjected to neglect, placed on the periphery of culture, Klee launched an attack on society through his first series of satirical etchings. These etched "experiments" that respond to a hostile audience indicate the way in which an artist who creates forms of

"inner necessity" (as Kandinsky called them) also calculates the emotive and hermeneutic effect of his work. The etchings illustrate a period in which Klee linked expression with provocation. In these works the emotive drive is reconciled with a specifically determined social function: they act as an affront to the hopelessly impoverished sensibilities of their obtuse viewers. However, the main body of Klee's work from this point onwards registers a valiant attempt to transcend the domain of the grotesque, to create a form of art poised between representation and abstraction, and to establish a mode of expression that involved rather than shocked its viewers.

During 1914, the traumatic eruption of World War I caused Klee to shift his attention from social reference to self-reference. It was as if the war, like the Gorgon's head, had made society too horrible to contemplate. The war itself was an act of social satire far beyond the limited talent of artists. The immediate effect of this change in esthetic focus was the sudden and permanent loss of the antagonistic attitude he had previously assumed toward his viewers. As a social satirist, Klee developed a meticulously exact grotesque naturalism. As a self-reflexive painter, he discovered the emotive resources of human potential that enabled him to balance despair with a renewed sense of his own value as an individual and an artist.

Klee had done his best to appropriate the styles of Van Gogh and Cezanne, in, respectively, *Garden Scene with Watering-Can* of 1905 and *Girl with Jugs* of 1910. But, in 1914, journeying through Tunisia with August Macke and Louis Moilliet, Klee mastered his control of color. He excitedly writes in his diary, "color possesses me," and adds, "It will possess me always. . . . That is the meaning of this happy hour: color and I are one." He had finally achieved the technical breakthrough that had involved more than a decade of intense preparation and study. The brilliant colors of the Tunisian desert light prompted him to experiment with the effusive hues he had already seen in the Fauve exhibit in the *Salon d' Automne* during his first, and in the radiant Orphic Cubism of Robert Delaunay's canvases during his second, excursion to Paris. But, more importantly, the journey to Kairouan afforded Klee an opportunity to put into practice the theoretical approach to artistic abstraction advanced by Wassily Kandinsky and Franz Marc, the nucleus of the *Blaue Reiter* group, formed in 1911. Thus, Klee left his native city of Bern for Munich in 1906 and, having made the acquaintance of Kandinsky and Marc in 1912, was invited to participate in the second Munich exhibition. This, in turn, led to the display of his works in the prestigious *Sonderbund* in Cologne and the *Sturm Gallerie* in Berlin. Affiliation with the Munich *avant garde* was crucial to Paul Klee's invention of a symbolic language written in a code composed of color and form relationships that are independent of objective representation. Within the first two years of the war, Franz Marc and August Macke, two of Klee's closest colleagues and pioneers in abstraction, had been killed in combat. The deep anguish that Klee felt upon

hearing of their deaths provided yet another incentive to continue the tradition established by his deceased friends.

In 1911, Kandinsky and Marc had seceded in protest from the *Neue Künstlervereinigung* to form the *Blaue Reiter*, after the rejection of Kandinsky's *Composition V* for exhibition. The new group also assumed that art was the expression of an essential drive to create. However, Kandinsky, its intellectual leader, argued that the illusion of pictorial representation which dominated the movement of German Expressionism was distracting and superfluous. In his famous essay, *Concerning the Spiritual in Art*, he records the moment of revelation wherein he perceived "an indescribably beautiful picture drenched with an inner glowing . . . of which I saw nothing but forms and colors." Kandinsky then notes his own shock upon finding that the canvas was actually one of his own, which he had inadvertently turned on its side. Art, for Kandinsky, was the projection of a significant internal reality, the essence of which was defined by the logical relations forged by the physical properties of color, form, space, and line. Indeed, between 1910 and 1914 this idea was set forth not only by Kandinsky but also by Kazimir Malevich and Piet Mondrian.

This esthetic theory had a profound effect on the maturing Klee. In fact, by 1914, Klee was pursuing an art based on the process of abstraction, although his compositions often integrated elements of abstraction with figuration. From this duality of form, Klee constructed a symbolic language that represents the ambiguities of existential self-reflection. This formal dualism in Klee's artistry unquestionably reflects the binary mimetic theory propounded by Wilhelm Worringer in his influential volume, *Abstraction and Empathy*, published in Munich in 1908. Kandinsky and Worringer composed the two most widely read documents in the history of German expressionist art. *Concerning the Spiritual in Art* and *Abstraction and Empathy* are the most explicit, detailed, and penetrating analyses that the movement produced. Kandinsky sanctioned abstraction by attributing a redemptive function to artistry. This determination turned creation away from the imitation of objects to a specific correlation between internal, invisible reality and its external, visible projection. But Worringer's approach to art, which left a profound mark on Klee's work, allowed for the balance of contrary motives in esthetic objects. Worringer viewed empathy as the effort sympathetically to transcribe and preserve the phenomenal world. Our empathic bond to social and material experience, he concludes, is responsible for acts of mimetic recreation. Every recognizable object in art attests to its creator's drive to memorialize a subjective relation to the external world. It symbolizes the artist's passionate concern for empirical reality.

This concept of empathy is the axiom of expression, the fundamental term in the theory of emotive projection. Its range includes the spectrum of possible reactions to physical existence. Empathy, however, is only one part of Worringer's dialectical interpretation of art. For empathy's logical opposite coexists with its antinomy. These coincidental

extremes establish the axes of creation and, consequently, define the axes of exegesis. In opposition to empathy, Worringer posited the existence of an abstractive function by virtue of which the artist declares a detachment and alienation from external reality. Abstraction, in this sense, is the denial of the empathic motive, since its form is inherently anti-mimetic. It is the external manifestation of an internal drive to transcend attachment and the contingencies and limitations of the phenomenal realm. Dissatisfaction triggers a will to perfection that leads the artist inward, away from the insufficiency of the perceptible and toward a recognition of what Worringer calls the "crystalline forms." The most important consequence of the alignment of abstraction and dissatisfaction is the fact that it introduces the notion of abstraction as a destructive power — as a force that destroys mimesis. Klee's belated arrival at abstraction in 1914 permitted him to adopt and modify the theory and practice of an artistic movement already in progress. We know, for instance, that Klee had carefully studied *Abstraction and Empathy* and had derived from Worringer a profound conception of abstraction as a principle of negativity. Yet, Klee came to realize that abstraction itself was empathic and that it included within its domain both the acceptance and rejection of nature and society. This perception of the fundamental ambiguity of abstraction enabled him to use it as a technique for portraying the strained psychological crisis of the "double bind" that permeates his mature work.

Under a Black Star of 1918 may serve as a symptomatic detail of this conflict between the constructive and destructive sides of visual abstraction. The background contains a wide range of pastel tints applied with varying densities to an irregularly-cut burlap surface. Each of these tranquil hues has been modified by a white base, causing the colors to radiate with the same visual ease found in the earlier Tunisian watercolors. These muted tones also evoke those which dominated the palettes of the Impressionists. But more importantly, they reflect the achievement of an abstractive sublimity, a sense of exuberant self-acceptance. Over this pastel background Klee has traced the small figure of a man, standing with his hands raised in wonder, under the ominous shape of a large black star. The figure stands terrified at the edge of a crudely suggested horizon line between images of the Star of David and the Cross. The stick-figure should be, in Worringer's terms, the source of empathy, the motif in the work which facilitates identification. Yet the figure is also a complex synthesis of representation and abstraction. We recognize its significance in prompting empathy, but it is apparent that Klee, unlike Worringer, was cognizant of the empathic qualities inherent in abstraction. In creating a mimetic image, Klee exercises a primitive style that evokes the simplified formula for mankind universally present in children's art. His drawing is thus abstracted to recall the mixed feelings of wondrous naivete and threatening helplessness through a visual echo of primitive forms. His childish abstraction of humanity, as a result, moves in two opposing directions. It paradoxically excites and assuages our feeling of terror.

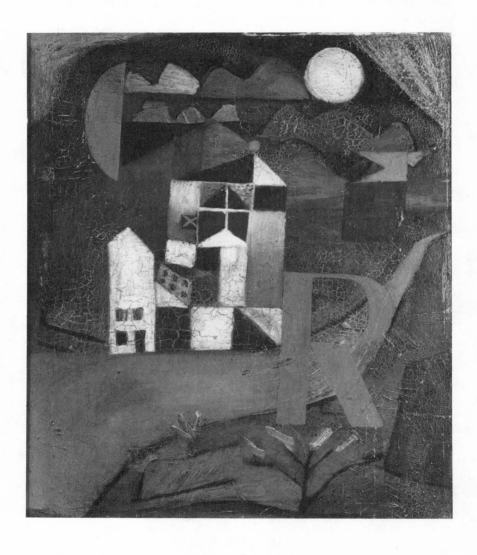

Under a Black Star epitomizes the ethos of Klee's most impressive works. These are not testimonies to *angst*, but rather expressions of a paradox wherein comedic and tragic perspectives ambiguously vie for our attention. They combine an entrenched sense of Munchian despair with the drive to construct "a cosmos of the imagination," a crystalline world of gratified desire. Here we find the remarkable metamorphosis, typical of the evolution of Expressionism in Munich, from an esthetic of satire and denunciation to an esthetic of paradoxical ambivalence. Klee's esthetic of paradox is based on two antagonistic principles in his thought which precipitated the double bind from which he could never extricate himself: his desire to achieve a means of expression "which is one with the universe" and his conviction that the human condition is naturally divided against itself. Thus, in his most optimistic statements, he declares that the artist is capable of perceiving the essences of nature, of understanding its hidden symbolic order, as when he writes:

> I place myself at the remote starting point of creation, when I state *a priori* formulas for men, beasts, plants, stones, and elements, and for all whirling forces. A thousand questions subside as if they had been solved. Neither orthodoxies nor heresies exist there. The possibilities are too endless, and the belief is all that lives creatively in me.[1]

According to this view, the artist reaches for mysteries concealed "in the womb of nature, at the source of creation, where the secret key lies guarded." The artist's goal is to explore his unconscious mind in order to recover meaningful symbols that restore dignity and value.

Yet, in spite of his confidence that artists could penetrate to the region of a "secret place" to possess "primeval power," Klee simultaneously exposed a genuinely tragic sensibility that brooded on human catastrophe. Having completed *Hero with a Wing*, he etched a brief comment on its plate that serves as a caustic critique of all untempered optimists. "Specially provided by nature with only one wing, he took it into his head that he was intended to fly, and that was his undoing," the artist ironically observes. Man's richly tragic destiny is strikingly emphasized throughout Klee's philosophical writings. The artist continually asserts that aspiration is severely hampered by the contingency of being, which we are unable to resist. He states in the *Pedagogical Sketchbook* that

> the contrast between man's ideological capacity to move at random through material and metaphysical spaces and his physical limitations is the origin of all tragedy. It is the contrast between power and prostration that implies the duality of human existence. Half-winged-half imprisoned, this is man! Thought is the mediary between earth and world. The broader the magnitude of his reach, the more painful man's tragic limitation.[2]

Klee's esthetic reveals an identity suspended between expression and experiment. Expression, in his hands, became a progressive series of formal experiments, which include more than 9,000 works. The purpose of these works was to establish contact with the source of creation and acknowledge the desperation and pain that accompanies the artist's descent into himself.

Klee was an optimist haunted by pessimism, who embarked on a voyage to discover the origin of creation — of that which is nearest to and furthest from understanding — and found what Michel Foucault in *The Order of Things* calls the "empirico-transcendental doublet." Klee's paradox is a recognition

> that he is within a power that disperses him, draws him away from his own origin, but promises it to him in an imminence that will perhaps be forever snatched from him; now this power is not foreign to him; it does not reside outside him in the serenity of eternal and ceaseless recommended origins, for then origin would be effectively posited; this power is that of his own being.[3]

"The father of the arrow is thought," Klee ventures, and this issue of paternity leads him to the paradoxical injunction: "Be winged arrows aiming at fulfillment and goal, even though you will tire without having reached the mark." This fundamental ambivalence is repeated in the oracular message that serves as his epitaph. Derived from a poem he composed to memorialize his successes and failures the inscription ends, suspended between attitudes of union and separation.

> I Live Just as Well with the Dead
> As with the Unborn.
> Somewhat Closer to the Heart
> Of Creation than Usual
> But Far From Close Enough.

Klee's esthetic consequently defines a definite shift in the artistic motive of German Expressionism. His search for identity and meaning in creation became a quest to eliminate the social and psychological displacements found in the most powerful images in the tradition of Munch, presented in such masterpieces as Max Beckmann's *Large Deathbed Scene* of 1906 and Ernst Kirchner's ravaged self-portrait, *The Drinker*, painted in 1915. However, Klee's epistemological uncertainty and native pessimism caused his symbolic language to be interfused with the very elements he hoped to transcend.

The economic and social turmoil that culminated with the First World War prompted intellectuals to develop defensive tactics enabling them to come to terms with their historical crisis. The cultural masks of satiric denunciation and relentless introspection were opposite manifestations of the same latent defense strategy. We have already seen how Klee admits that his earlier, satiric "experiments" were designed to

protect him from criticism through the use of aesthetic ingenuity. Klee's concern with the elements of symbolic form was manifested in his study of visual communication, which he conducted for the purpose of perceiving the essential order that determines acts of creativity. Inversion provided a trajectory of escape from external chaos. But it also paradoxically forced Klee to come to terms with an identity fractured by social tension and reduced to fundamental ambiguity. In an essay entitled "On Modern Art," he wrote that the true artist "places more value on the powers which do the forming than on the final forms themselves" and reminded his audience that his methods of composition were "always combined with the more subconscious dimensions of the picture."[4]

Klee was convinced that a picture was an *a priori* formulation. But, like Sigmund Freud, his near contemporary, he was equally impressed by the fundamental ambiguities of thought that constant self-analysis brought to light. Freud's study of "the means of representation in dreams," an attempt to understand the language of the unconscious, led to the conclusion that each dream-thought is "invariably accompanied by its contradictory counterpart, linked with it by antithetical association."[5] Freud was convinced that the language of the unconscious shows "a particular preference for combining contraries into a unity or for representing them as one and the same thing," and he concluded that "there is no way of deciding at first glance whether any element that admits of a contrary is present in the dream-thought as a positive or a negative." In a 1911 footnote to these observations in *The Interpretation of Dreams*, Freud highlights his interest in linguistic ambiguity by referring to his review of Karl Abel's *The Antithetical Meaning of Primal Words*. Abel had shown to Freud's satisfaction that ancient languages contained words that "describe the two contraries at the extreme ends of a series of qualities or activities (e.g. 'strong-weak,' 'old-young,' 'far-near,' 'bind-sever')." Freud confirms the theory of primal words by quoting the philosopher Bain, who states that in periods of transition "every experience must have two sides; and either every name must have a double meaning, or else for every meaning there must be a double name." Klee's art continually shows the desire to develop new forms of expression able to encompass this union of opposites, coded in a language of doubles generated by the unconscious mind.

Klee's paintings are primal images, paradoxes suspending the viewer between logical alternatives. They participate in a negative dialectic, always antithetical and never resolved. His works, moreover, are remarkably unified experiments in ambiguity: the same self-contradictory themes continually appear from the time of Klee's possession by color in 1914 to his haunting reflections on imminent death from sclerodermia in 1940. Two fundamental motifs expressed throughout are those which I designate by the terms *sparagmos* and *logos*. By closely examining the way in which these themes acquire an antithetical meaning in Klee's paintings, we will be better able to perceive the pattern of oppos-

ing impulses that contribute to the dual vision of Klee's symbolic language.

The ancient Greek word *sparagmos* refers to the ritual dismemberment practiced by the followers of Dionysos. Euripides, for instance, portrays its ritual significance in *The Bacchae*. Applied to Klee's work, the term acquires a double meaning, having both a positive and a negative context. The image of dismemberment, in a positive context, is a metaphor for the "glorious transport," "the essence of the Dionysiac rapture" that coincides with "the shattering of the *principium individuationis*," examined by Nietzsche in *The Birth of Tragedy*.[6] In a negative context, however, *sparagmos* entails the body's violation and the mind's fragmentation. It is the symbol of terror, alienation, and pain. In *Fragment from a Ballet for Aeolian Harp* (1922), a dancer's head tears away from his body and melts upward into darkness. His hands reach helplessly toward his exploding forehead, while a second dancer, a spectator to *sparagmos* as well as its victim, cut in half by the picture's edge, raises his hand and gapes in wonder. The image's positive context is reinforced through the allusion to the Aeolian harp of classical mythology, a harp that played a naturally harmonious tune when the wind blew through its strings. The Aeolian harp is a romantic emblem of the unconscious element in artistic creativity and an affirmation of the bond linking man to nature.[7] The painting's negative context is indicated by the word "fragment" in its title. This word refers to the fact that the moment Klee has captured has been taken or "cut" from the ballet. It may also refer to the painting as an artifact of fragmentation.

Sparagmos signifies the presence of the self-analytical mode of thought. It combines antithetical motives and occurs when the drive away from naturalism to abstraction coincides with the need to render an empathic image of the human body. In *Fragment from a Ballet for Aeolian Harp*, the balanced earth tones create an intense esthetic facade that purifies anger and reduces empathy. The world of visual perfection eases terror. If we consider this painting to represent the metamorphosis of the empathic image into a transcendent abstraction, it appears to be informed by Worringer's emphasis on the search for symbols of an immaterial reality. But if we recognize the threat abstraction poses to human identity, then Franz Marc's emphasis on the artist's need to derive creation from "organic rhythms" becomes Klee's concern as well. In December of 1908, Klee's close friend outlined his determination to create what Jean Arp would later call "biomorphic" images:

> I try to heighten my feeling for the organic rhythm of all things, try to feel myself pantheistically into the trembling and coursing of the blood in nature, in trees, in animals, in the air. . . . I see no happier means to the animalization of art, as I like to call it, than the animal picture.[8]

According to Marc, the pantheist empathy of the *Wilden* would permit artists to dance to the native rhythms of the Aeolian harp. This primitive dance of life is a commonplace of this period which frequently occurs in the paintings of Emil Nolde and Henri Matisse. In Klee's painting, however, the dancer is disfigured and this disfigurement is accompanied by a sense of anxiety as the image melts into abstraction and the symbol of reason, the head, is obliterated. The lyrical, childlike quality of Klee's drawing allows for innocence and wonder at the onset of life's catastrophes. This empathic bond intensifies the painting's tragic effect by depicting an act of physical violence directed at an innocent natural form.

If at the origin of German Expressionism in the *Brücke* and the *Neue Sezession*, we find a firm commitment to images of estrangement, Klee's achievement can be seen as both remarkably similar to and extremely different from the work of most of his predecessors. It is important to remember that the artists of Berlin and Dresden were capable of forging an expressionist sublime. Not every work was ignited with the fierce horror of Munch's *Evening on Karl Johann Street, Oslo*, which is filled with the sinister presences of urban skeletons. Pechstein's *Summer in the Dunes* of 1911, Heckel's *Day of Glass* of 1913, and Kirchner's *Moonlit Winter Night* of 1919 attest to the ecstatic and luminous side of expressionist naturalism. A notation in Kirchner's diary describes the *Brücke* as a group of artists, "whose ways of life and work, strange as they were in the eyes of conventional people, were not deliberately intended to *epater les bourgeois*, but were simply the outcome of a naive and pure compulsion."

As far back as 1904, Kirchner had appreciated examples of African and Oceanic sculpture; study of primitive forms also led to Heckel's notion of a hieroglyphic art. But as long as the tradition of a psychologically tortured naturalism dominated these alliances, Egon Schiele's emaciated self-portrait of 1910 and his *Death Agony* of 1912 would typify the movement's most powerful masterpieces. The spirit of a constructive primitivism was never strong enough to undermine the expressive violence that informs the vacuous horror of Max Beckmann's *The Night* (1918), in which a man and woman are sadistically beaten by a gang of their fellow citizens.

A second compelling use of the *sparagmos* paradox appears in a painting that Klee referred to as *Prince Sau Before His Salvation*, created almost sixteen years after *Fragment from a Ballet for Aeolian Harp*. This work contains a decorative arrangement of arms and shanks clustered around the Prince's ripped torso and decapitated head. It is highlighted by the open hand and still pondering head of the victimized monarch, bathed in brilliant shades of blanched white and fiery red. The inspiration for this picture comes from the Old Testament account of the dismemberment of Saul, leader of the Israelites in the thirty-first chapter of The First Book of Kings. The Biblical tale relates how the Philistines destroyed the army of King Saul, who, left to bear the full weight of the attack, killed

himself, so that "he would not have uncircumcised foes kill him with outrage." When the Philistines found the body of Saul, they cut off his head and hung his body on the walls of their city, Bethsan, until the Israelites removed it, burned it, and carried off the bones for burial in the woods of Jabes. The Israelite prince's mutilation is duplicated in Klee's name "Sau" which is a brutalized version of "Saul." It is a name from which the "l," shaped like a human limb, has been disjoined. The idea of salvation, like that of the Aeolian harp, supplies a redemptive or integrative element to the scene of slaughter. Dissected nature is eulogized and memorialized by abstraction. The vivid colors that radiate from the canvas contradict suffering and assume an iconic function similar to that found in Byzantine mosaics. Yet, we cannot ignore the cathartic reaction of pity and terror induced by the picture of a great king's mangled body. The tragic perspective is not completely translated into comedy but relates Klee's sense of powerlessness, one extreme of "the contrast between power and prostration that implies the duality of human existence." Because it signifies mutually exclusive attitudes towards abstraction's erasure of the self, *sparagmos* constitues a "primal" concept in Klee's symbolic vocabulary. The motif, like the Freudian dream-thought, contains opposing contexts linked by antithetical association.

Klee's vocabulary of form — the language composed of all visual elements of a painting — contains two kinds of self-consciousness. *Sparagmos* is self-reflexive, calling attention to the question of human identity, while *logos* is metalinguistic, being that part of language which comments on the value of language. Under the rubric of *logos* I include the presence of letters, calligraphic signs, and words in Klee's work. Each of these linguistic units calls attention to the meaning of cognition and acts as a self-analytic component of thought in Klee's symbolic language. An early example of the *logos* motif occurs in *Villa R*, an oil on cardboard, painted in 1919. On the left side of this picture a brightly colored and imaginatively decorative castle appears in a dark landscape. And on the right side, a large, green, stenciled "R" confronts the viewer with a fundamental element of language: the letter. The letter represents, in turn, antithetical attitudes concerning the ability of language to define experience adequately. It suggests the presence of a symbolic system in which sign and referent are inextricably related. The two-dimensional letter placed in a three-dimensional landscape seems to be reality's objective distillation. The title, *Villa R*, is accordingly a formula uniting object and sign in a painting where the world is a book to be read like a universal and public manuscript and where the book of life assumes a material existence. However, once we notice that the letter, "R," has no specified significance in itself, Klee's commentary appears to describe language as being inherently arbitrary and solipsistic. The letter poses a problem of interpretation that cannot be satisfied by the painting's contents. We cannot determine the principle of selection by which "R" was chosen for this specific context. "R" represents the unknown, that which cannot be deter-

mined by rules of logic. It expresses the essence of unintelligibility as *logos*, introducing an awareness of nonidentity which simultaneously portends and prohibits meaning.

Letters frequently materialize as objects in Klee's paintings, but what is even more remarkable is the presence of works that reveal the artist's invented writings in such calligraphic experiments as *Picture Script* (1918), *Water-Plant Script* (1924), *Page from a Town-Book* (1928), and *Plant Script* (1932). Perhaps the most profound example of the *logos* paradox is presented in the imaginative ciphers of *Document*, composed in 1933. *Document* is a painting of a red surface in the middle of which is placed a sheet of strange symbols arranged in orderly columns. The painted sheet and its mysterious characters have the look of antique authenticity: its paper has browned with the passage of time. This baffling document resembles a Rosetta Stone, the key to which has been permanently misplaced. We know that Klee was interested in Chinese poetry at this time, which probably accounts for the rows of strange pictograms recorded in unquestionable detail. The pictograms allegorize the hidden language of the unconscious, while the word, "document," creates an illusion of history to prove the manuscript's authenticity. It reassures us that meaningful forms, the laws of which are beyond the scope of reason, are archetypes imbued with inherent value. This epistemological idealism can be related to Klee's tenure at the Bauhaus, which extended from 1921 to 1931. There, he and Kandinsky committed themselves to the concept of "functionalism," espoused by the school's founder, the architect, Walter Gropius. Unconcerned with ordinary ideas of utility, however, Klee set out to discover the function of expressive elements in art. His *Pedagogical Sketchbook*, written during this period, consequently assigns metaphysical and psychological significance to pictorial elements.

Nevertheless, Klee's linguistic optimism is countered by the absurdist view of language enunciated in 1917 by the Dadaists of the Cabaret Voltaire in Zurich. Moholy-Nagy writes that Kurt Schwitters showed his audience a poem containing only the letter "W" on a sheet of paper. From this, Mies van der Rohe assumed that Schwitters was distressed at the possibility of denotative reference.[9] During this period, Hugo Ball invented "sound poems," which he read through the slit in a cubist mask, while dressed in a colored, cardboard costume. One poem begins: "gadgi beri bimba/glandridi lauli lonni cadori. . . ." The very name "Dada," picked at random from a German-French dictionary, reflected the linguistic nihilism of the esthetic revolt in Zurich. Kandinsky was on intimate terms with Hugo Ball, with whom he had contemplated founding an expressionist theatre in Munich. And in 1917, Klee's pictures, along with those of Kandinsky and Marc, were exhibited in the Zurich Dada Gallery. The language of the Bauhaus and the language of Dada interpenetrate each other in Klee's enigmatic document. He and Kandinsky embraced the extremes of Bauhaus and Dada because they were capable of identifying themselves with both precise, intellectual order *and* explosive, passionate

disorder. Kandinsky in *Succession of Signs,* painted two years before Klee's *Document,* transcribed four lines of pseudo-hieroglyphics that express a tense counterpoint balanced between meaning and nonsense. The ideogrammic method in the work of both artists presents the paradox of *logos,* an internal debate on the definition of language, suspended between transcendent certainty and opaque absurdity.

In *Dada Fragments* (1916-17), Hugo Ball writes that Klee "always presents himself as quite small and playful. He always remains quite near first beginnings and the smallest format. The beginning possesses him and will not let him go." "What irony," he concludes, "even approaching sarcasm, must this artist feel for our hollow, empty epoch." To this we should add that Klee's interest in minutiae is also a symptom of his despair at the cultural unimportance of modern art. This notion appears in his early letter to his father from Rome. It appears as well at the end of "On Modern Art," where the artist discloses that, "Sometimes I dream of a work of really great breadth." "This, I fear, will remain a dream," he ruefully concludes. Klee's comment demonstrates how he had internalized his ironic view of culture by transforming social criticism into self-criticism. The smallness of his work shows a positive concern with origins, but is also a retreat into his own private world before the menacing scrutiny of its viewers. His confidence in a transcendent interiority was contradicted by his suspicion that he had failed to bring forth monumental forms, worthy of the spirit's full magnitude. Doubt and a cultivated sense of irony allied Klee with the passionate rage of the Berlin and Dresden Expressionists and the strident anarchy of the Zurich Dadaists. Klee never preserved himself from his own negativity and never excluded an understanding of the compelling forces that drew him away from unity, subjecting him to an ideological double bind.

The hard-line Dadaists, who styled themselves as political activists, criticized the therapeutic side of the Munich Expressionists: Richard Hulsenbeck described them as "those famous medical quacks who promise to 'fix everything up,' looking heavenward like the gentle Muse." They are mystical esthetes, he argues, who "pulled people by the sleeve and led them into the half-light of the Gothic cathedrals, where the street noises die down to a distant murmur." For Hulsenbeck, introspection was a turning away from reality that "implied the whole weariness and cowardice that is so welcome to the putrescent bourgeoisie." Hulsenbeck's statement would be inaccurate if applied to Klee's esthetic because Klee, who turned his attention to self-reference and metalanguage, never lost touch with the sense of rebellion and horror outlined in his early etchings. His discovery of color and abstraction allowed an inward vision to mature; but when Klee looked within, he found the psychological fragmentation acutely sensed by the modern world. His self-division mirrored the chaos of social history, and as long as the "scream" found a place in his dialectical masterpieces, the need to rebel coincided with the passion to create images of a new beginning.

During his career, Klee fused the explosive passion of the *Wilden* with the intellectual mastery of the Bauhaus and the disjunctions of Dada and Surrealism. But we should always think of him primarily as an Expressionist who had opened himself to the most vital ideas of his age.

After a lecture given at the Museum of Modern Art by Marcel Jean on the subject of the death of Surrealism, I asked Marcel Duchamp, who was in the audience, if, in fact, Surrealism was dead. Suspended between profundity and cliche, Duchamp replied: "Death, death, what is death?" On this, the eve of the hundredth anniversary of Klee's birth, we can confidently say that through his efforts, Expressionism had a brilliant but evanescent climax, which allowed it, simultaneously, to participate in the movements destined to replace it historically. In a now-famous diary notation, Klee wrote with trepidation: "I, the crystal, I die? I die?" It was perhaps, in the final analysis, the paradoxical union of idealism and despair that preserved Klee against either extreme in his dual language. And it was this union that allowed German Expressionism to leave its mark on future cultural history.

Notes

[1]*The Diaries of Paul Klee* (Berkeley: University of California Press, 1964), p. 345.

[2]Paul Klee, *Pedagogical Sketchbook,* (New York: Fredrick Praeger, 1953). p. 54.

[3]Michel Foucault, *The Order of Things* (New York: Vintage Books, 1970), p. 334.

[4]"On Modern Art" in *Modern Artists on Art,* ed. Robert L. Herbert (Englewood Cliffs: Prentice-Hall, 1964), p. 90. See also "Klee and the Creative Unconscious" in Norbert Lynton's *Klee* (London: Spring Books, 1964). Lynton quotes Klee's remark that "paintings come into existence without conscious control."

[5]Sigmund Freud, *The Interpretation of Dreams,* trans. James Strachey (New York: Avon Books, 1970), p. 353.

[6]Friedrich Nietzsche, *The Birth of Tragedy,* Trans. Francis Golffing (New York: Doubleday, 1968), p. 22.

[7]"I am well acquainted," Klee writes, "with the Aeolian-harp kind of melodies that resound within. I am well acquainted with the ethos of this sphere. I am equally well acquainted with the pathetic region of music and easily conceive pictorial analogies for it." (*The Diaries,* p. 239)

[8]Quoted from Marc's letter to Reinhard Piper in Bernard Myers, *The German Expressionists: A Generation in Revolt* (New York: Fredrick Praeger, 1957), p. 219.

[9]The Dadaists' attitude toward language is touched upon in Robert Motherwell, *The Dadaist Painters and Poets* (New York: Wittenborn, 1951), pp. xviii-xxiv.

14
Emil Nolde and the
Politics of Rage

Stephen Eric Bronner

An aura surrounds Emil Nolde. By virtue of his extraordinary artistic out-
put and his four volume autobiography, as well as through the critical ac-
claim of friends and admirers, an almost mythical quality has come to be
associated with this brilliant painter who was a major figure in the Ger-
man expressionist movement.[1] But, where there can be no question as to
his rank as an artist, the myth deserves to be shattered. For, in his own
writings, as well as those of his interpreters, Nolde appears as a solitary
genius, an uneducated peasant, who somehow knows what the educated
cannot know, who sees what the prophet sees, who feels what others can-
not feel. A man obsessed by his urge to create, unconcerned about the
public and the social whirl, the servant of an inner demon that guides his
art — such is the image of Emil Nolde.[2]

Sometimes the myth has been fostered by an aesthetically honest, if
confused, wonder before the great power of his painting. At other times,
the myth is clearly used to diminish the fact that Nolde was a charter
member of the North Schleswig branch of the Nazi Party and a supporter
of the movement through its seizure of power.[3] Of course, it is true that
dogmatists of the left simply reduce his art to his politics. But, in attempt-

ing to preserve his painting from the rot of his ideas, others only end in placing Nolde the "artist" above the barbarism that he encouraged as a man. The myth of the artist is therefore extended to the art, which in turn justifies the man who produced it.[4]

On a certain level, it makes sense to equate the man with the painter. For Nolde always portrayed himself as a simple man of the earth, inspired by art's calling. Consequently, in much the same way as the extraordinary expressionist poet Gottfried Benn, who was also an early advocate of fascism, Nolde could later seek to divorce his paintings from politics. Simultaneously, however, both Nolde and Benn could claim that theirs was a "German art" and even express a measure of amazement that the Nazis should attack them once the movement had gained power.[5]

It is true that anti-Nazi critics have shown a certain discomfort when confronting Benn's poetry. But, this discomfort can be alleviated when it comes to Nolde's painting since it is colors and not words that are under consideration. The sociological problem seems to resolve itself. For, after all, how can political values and ideological tendencies reveal themselves in landscapes, watercolors, paintings of masks and the dance? Besides, even if certain social tendencies become evident in Nolde's religious paintings, what is the possible difference anyway since these paintings affect the viewer in an immediate manner and therefore can be enjoyed by people who are ignorant of the import of these influences?

Especially in painting, where the arena of potential associations is even broader than in prose or poetry, the issue is a difficult one. Naturally, there is always the possibility that certain tendencies in an age may be illuminated by treating the work as a product of a given social complex. But, there is also another issue involved; real justice cannot be done to the work if it is examined purely in terms of arbitrarily conceived formalistic categories or in terms of the way it is simply "experienced."[6]

To be sure, the fact that an immediate response can be elicited by a work is a measure of artistic success. Unfortunately, however, the response loses any specificity when an attempt to comprehend the ideological values that underlie it comes to be denied. On the other hand, a purely technical analysis can never really question why the artist made the aesthetic choices that he did, since this would necessarily involve an extra-formal discussion. The experience of the work as well as the elements of its formal execution are both bound to the work itself. Thus, for example, many painters have relied on color as the basic vehicle of their art. But, Nolde's emphasis upon color — and a palette that grew starker and simpler through the years — actually becomes the technical expression of his attempt to find a grounding principle of unity between man and nature, the individual and the collectivity.[7] In uniting the content to be expressed with the form that expresses and defines it, a painting comes to be caught within history. No less than any other work of art, it becomes a fragment of living history; as experienced by a changing audience, it retains a past that the present often wishes to efface.

Impressionism came late to Germany, at a time when Nolde had already embarked on his path, and it was a pallid affair. But, it did take on a peculiarly German flavor. Embraced by artists such as Lovis Corinth, Max Slevogt, and Max Liebermann — whom Nolde was to consider a bitter enemy[8] — the German painters emphasized a certain subjective yearning which stood in contrast to the French who emphasized light, atmosphere, and the moment of sensation. Yet, Nolde never believed that these artists could provide an alternative to the French impressionist masters who influenced them so profoundly. Thus he saw the need for a new "German" art which would fundamentally break with the French and their "foreign" sensibility — a sensibility which formally manifested itself in the artistic desire to dissolve color into light and in the "sweetness" and "superficiality" of the Impressionists' canvasses.

In Nolde's view, this was all the more important given the general state of German painting. Where Liebermann's group could safely consider itself as the most popular avant-garde contingent around the turn of the century — far better known than the aspiring artists of Expressionism who opposed them — traditional German painting was anchored in the academicism of von Stuck and the sentimental naturalism of Ferdinand Hodler. Despite certain individual efforts of essentially conservative artists like Adolf von Menzel, or the more progressive Meyerheim, German painting never gave birth either to a radical modernist, or a socially committed realist, tradition.

Such was the artistic situation during the *Gründerzeit*,[9] when Emil Hansen was born in 1867, in the town of Nolde in Schleswig Holstein. Coming from a traditional and religious environment, which had just undergone a Pietistic revival, the affinity that Nolde was to hold for mysticism, nature worship, and primitivism, is not difficult to understand. These tendencies, however, were only exacerbated by the social transformation that Germany underwent during those years. For, the last three decades of the nineteenth century was a time of tremendous industrial expansion and urbanization. It was during this period that one could begin to speak about the rise of a modern working class movement, the beginnings of "mass society," and the growing predominance of a bureaucratic-operationalist mentality.

In short, the *Gründerzeit* marked the start of Germany's entry into modernity, which initiated the subversion of the traditional life and values of those peasants and artisans whom Nolde claimed as his own. These classes felt themselves threatened by both a vigorous bourgeoisie and an emerging proletariat; where they feared being ruined by the one, they feared becoming like the other. This fear extended to the worldviews that reflected the values of the dominant classes: capitalism, materialism, rationalism, and all the philosophical as well as social values that arose from the Enlightenment and the French Revolution — including the unbounded faith in the powers of science and a certainty about progress — were anathema to those pre-modern classes with their traditional religious and folk values.

It is not surprising then that Nolde's worldview should have stood in opposition to these "modern" modes of thought, or that a fundamental emphasis upon primitivism should have marked the "modernism" which he espoused. Indeed, his painting must be seen in the context of that broader cultural movement that sought to attack rationalist idealism on the one hand and materialism on the other.[10] Nietzsche and Bergson, Barres, the vitalists and others viewed the individual and his experience, the power of creation and the force of nature, as being buried beneath the onslaught of civilization, material progress, and an undifferentiated "herd" that had lost its spiritual identity.[11]

The crisis was deeply felt by the provincial irrationalist Nolde, who changed his name at the turn of the century to tie himself to the town and land of his birth. Throughout his career, themes would emerge that were similar to those that can be found in the works of Nietzsche, Dostoyevsky, Gide and a host of others: the individual standing alone, the prophet confronting the masses, the need for ritual, and the search for a fulcrum of faith.

Devoured by the city, abandoned among the masses of industrial production, fragmented by the division of labor, and in danger of losing his unique attributes through the levelling of bureaucratic rationality and a growing "mass" culture, Nolde — like so many others — would search for "something to hold on to" (Brecht).[12] Split off and alienated from so much, it made sense that Nolde should seek a "ground" wherein the unity that was being fragmented could be regained. It is in his attempt to grasp such a "ground" of experience — the essential character of existence which unifies diverse experiences and appearances — that Nolde's art takes root. Thus, he can write that:

> the place in a man where the most varied qualities, raised to their highest powers, harmoniously unite is the ground upon which the greatest art can blossom forth: at once a natural man and a man of culture, simultaneously divine and an animal, a child and a giant, naive and sophisticated, full of feeling and full of intellect, passionate and dispassionate, gushing life and silent calm.[13]

Initially, such a ground appears in nature itself and it is there that Nolde begins his project. Where such an emphasis obviously links him to certain strands within the expressionist movement, the focus of his concerns immediately pushes him beyond the progenitors of German Expressionism like Paula Modersohn-Becker and the Worpswede group. They sought to return to nature, and emphasized the gentleness of the primitive life and sensuousness, through a softening of bright primary colors, as well as through a rejection of Classicism and the "true to life;" the best example is to be found in Modersohn-Becker's *Self Portrait*, where these qualities are brought to bear along with a dreamy gaze that emphasizes the languor and pleasure of a supposedly "natural" mode of existence.

From the first, Nolde was more radical in his aesthetic quest. In contrast to the Worpswede group, Nolde was unconcerned with the "return to nature." His vision had nothing to do with placing the city dweller in a rural environment where his inner goodness, or internal peace, could reach fruition. Instead, Nolde sought to capture the immediacy of the dynamic that links the individual with nature. Where harmony is the goal, this harmony appears in the dynamic experiential moment; the individual does not simply blend into nature and assume his natural state in the manner of Modersohn-Becker, but rather experiences himself through his intuitive grasp of what ties him to nature. In this sense, Nolde's friend Gustav Schieffler is correct when he characterizes the artist's work as "quite absolute but also quite subjective."[14]

Thus, Nolde was fundamentally concerned with "the regeneration of man" — a central theme in the expressionist worldview — which would be led by the "modern" artist who breaks with the present. This becomes evident in an early set of postcard drawings, through which the previously impoverished Nolde was able to earn enough money so that he could put an end to learning artisanal crafts and concentrate on his painting. These postcards, such as *Der wilde Pfaff* and *Nordabhängige im Lötschental*, became quite popular. They combine a peculiar blend of *kitsch*, caricature, and modernism. In these works, where hikers are portrayed in a simple jocular fashion and overshadowed by the Alps out of which faces emerge, Nolde's early search for the link between man and nature becomes quite blatant. He was cognizant of the developments in Munich and Vienna so that, in the first postcard, a *Jugendstil* element appears in the faces of two women that emerge from the craggy mountain cliffs; these are beautiful women, asleep, their vibrancy lying dormant, encompassed by the Alps, and yet separate. In the other postcard, the ruddy, robust face of a peasant is juxtaposed to the smiling face of a sophisticated woman; the contrast is purposeful, the modish hat of the woman as against the peasant cap, the perfect teeth as against the weatherbeaten face, the alluring look reciprocated by the frowning stare.

In the first postcard, the hikers are climbing to these women and, along their trek, they assume slightly different poses; beneath them and the mountain, a candle brightly burns. In the second postcard, the hikers are walking away from the sophisticated city woman with regimented movements. Thematically, these postcards speak for themselves, and Nolde's values become obvious. But, beyond his own particular values, what initially appears as a rather superficial anthropomorphism is in actuality nothing other than the beginnings of the search for that ground of unity.

Still, the interaction between man and nature remains static; one image is artificially transposed on to another, while the aesthetic vehicle for the actualization of unity has not yet been found. This will await the single picture that marks Nolde's breakthrough, his small watercolor, *Sunrise*.[15] In this work that highlights a bleeding red sun — a literary image that is first found in Büchner's *Woyzzeck*, a favorite of the Expressionists, and

then also in Brecht's *Drums in the Night* — color becomes the fulcrum for the extraordinary scope and vitality of the image. It is not nature, but nature emerging in the grandeur of a movement that is only incarnated by the red sun and red streaks in the brown sky, which marks the rendering of the landscape.

For Nolde, the contrast of nature's portrayal in this work to the modern urban reality is striking. Torn from his roots in nature, a nature that must be dominated and made calculable for modern production, the individual exists alone and anonymous in the large city that has become the focal point for the "modern" artist's opposition to modernity.[16] Unlike Simmel, who recognized the benefits of cosmopolitanism and cultural expansion to be gained from the city despite its negative features,[17] Nolde chooses to ignore the importance of the cosmopolitanism of the cities for his own artistic development. Instead, though Nolde himself travelled extensively, cities only appear as the negative forces that undermine "real" values.

For Nolde real values include simplicity, faith, intuitive wisdom, and the "rootedness" of the individual in a community that derives its inspiration from the land. "Deracinated" (Barres) by the forces of modern capitalism and rationalism, deprived of his roots by city life, again and again Nolde speaks of how the land marks its inhabitants and how the visages of the inhabitants mark the land. This is where one can situate the *Blut und Boden* beliefs that will predispose Nolde to the Nazis. For, none of this can be demonstrated. It need not be; for Nolde, it need only be felt. In the same way as to God, one must give oneself to nature; then, like a mother and her child, nature will embrace her own product. Reaffirming that unity, proclaiming the experience of singularity as a oneness with nature, surrendering to nature's dynamism, such is the basis of Nolde's development as an artist who will manifest in his work the "pulsebeat of the entire world."[18]

This, however, will involve bursting asunder the shackles of a rationality that calls every experience before the bench of analysis, and that inherently seeks to undermine faith. Ineluctably, Nolde will begin to extrapolate on to nature the very values that oppose the ones which were already rendering rural life obsolete. Such a development begins with the anthropomorphism of nature and the naturalization of man, which will then demand the aesthetic exposition of the dynamism that grounds these processes in a unity.

In turn, this necessitates the primacy of the intuitive moment through which nature is experienced;[19] Nolde states the matter clearly in a conversation where he differentiates "German" art from that of the French:

> We do not want to reproduce Nature. That is just what we do not want. We want to put color and light in the picture in the way people feel color and light. Neither do we want to reproduce space, but to unite everything in a plane.[20]

It is indicative that the experiential grasp of nature should mark

"German" art. To the German nationalist, the French were traditionally seen as the purveyors of a rationalist, superficial, decadent, "civilization" in contrast to the "deeper," more spiritual, German *Kultur.*[21] In opposition to such rationalism, Nolde emphasized the irrational while seeking out the primitive and the childlike whose original bond with nature remain uncorrupted. This concern with the uncorrupted is a theme that runs through German Expressionism, receiving elaboration in Klee's children's drawings and Marc's animals.

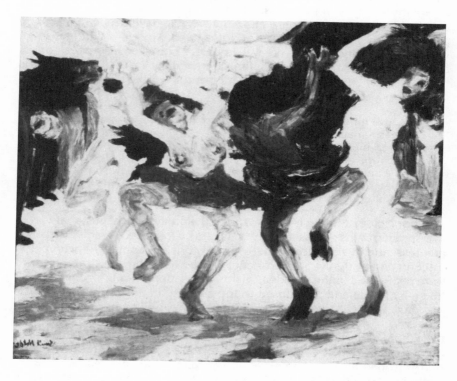

The lack of corruption, based on an innocence preserved from civilization, allows for an immediacy of experience that gives birth to joy, fantasy, and exaltation of a dynamic sort. Thus, in the quick brush strokes that mark *Wildly Dancing Children*, the dance takes on the frenetic abandonment of a ritual dance — while another child stands outside, happily looking on, holding an infant. In the dabs of the brush from a broad palette, the colors interpenetrate, while the circular motions of the dance define the paintings movement beyond the painter's strokes. The child holding the baby has no fear of the dynamic movement that confronts her, no less than the little girl who curiously looks at an enormous threatening bird in the charming, yet equally haunting, woodcut entitled

The Big Bird. The innocent has nothing to fear; her lack of corruption draws her to experiences from which the sophisticated might shrink. Happy, open, or overcome by the mood that nature incarnates at a given instant, the child takes on the romantic quality of those pre-industrialized populations of primitive societies.

A link thus occurs between the art of primitive societies and the new "German" art where "it is as if the primeval springs were flowing once again."[22] These primordial forces serve as the inspiration for a modern creativity which is akin to that of the primitives whom the "civilized" despise. Thus, it is no accident that Nolde should have been fascinated by primitive art; his expeditions to China and Africa — like those of Gauguin, Klee, and Marc — are well known.[23] The attempt to break out of a narrow confined tradition, a routinization of daily life and the city, in the name of "new" experiential possibilities and forms of life, is continually emphasized by Nolde himself. Thus:

> the love for the extraordinary which existed in me at that time has always remained with me. My interest in what is foreign, primeval and primitive was especially strong; I had to get to know the unknown; even the nocturnal, depraved inhabitants of the great city stimulated me like something exotic, and the Jewish types in my later religious pictures may have come into being in part from my following this drive.[24]

For Nolde, it is precisely the turn to the pre-historical past that marks the "modern" insofar as the "new" art is to oppose a tradition that is quintessentially historical. These pre-historical peoples — whom the Enlightenment thinkers up to Hegel viewed as without history and who were denigrated in the name of "historical" nations — were consequently taken by Nolde and juxtaposed to the civilized in a positive manner.

But, where Nolde believes he is being revolutionary, he is actually employing traditional conceptions while giving them a neo-romantic twist. For Nolde views these primitive peoples as retaining those essential human qualities that degenerate in history. The immediate, pure, interaction with nature comes to serve as the fulcrum for the regeneration of Germany; art will be the vehicle through which Germany can step beyond the relativizing, fragmenting, process of history. For, the new "German" art will re-establish the *Ur* quality of the race through the exploration of its immediate, experiential, interaction with nature. In this way, by linking German art to the qualities expressed in primitive art through the experience of the individual artist, the new art will be both fully German and absolute since it will be bound to the primordial. Thus, it is in terms of the very unity that he seeks that Nolde views these primieval peoples. For:

> primitive men live in their nature; they are one with it and part of the entire universe. I sometimes have the feeling that only they are real people, while we are something like deformed marionettes, artificial and full of presumption.[25]

For such reasons, it has sometimes been remarked that Nolde was an opponent of imperialism. Illustratively in his 1901 work, *Urmenschen* — there is also a drawing with the same title from 1895, which harbors a different theme — two naked savages peek into the distance with an anguished amazement as the woman holds her child tightly to her. Chaotic lines of color — somewhat reminiscent of Munch — testify to their anxiety. It is obviously the world of modernity which lies in the distance; this is the world of fear, an imperialist world that will undermine all that they are.

Indeed, Nolde understood that the years surrounding the turn of the century were marked by imperialism. Thus, he could write:

> We are living at a time when all primitive conditions and primitive peoples are perishing; everything is being discovered and Europeanized. Not even a small area of original primitive Nature with primitive people remains for posterity. In twenty years everything will be lost. In three hundred years scientists and scholars will ponder, torture themselves and dig, groping to grasp a tiny part of the treasure that we had, the unspoiled spirituality that we so thoughtlessly and shamelessly destroy today.[26]

Nevertheless, his opposition to imperialism must be seen from within the context of Nolde's worldview and work. For he is not opposing the "excesses" of imperialism from the vantage point of the liberal who believes that the oppressed deserve the benefits of progress and bourgeois freedom, nor does he oppose imperialism from the standpoint of socialist revolution. Instead, his opposition is based on a neo-romanticism that emphasizes the qualities which the "primitive" — not the oppressed — is presumed to retain from the past in contrast to the civilized man of the twentieth century. The oppression of the past — disease, hunger, brutality, the nightmare quality of myth — are disregarded in terms of the oneness that the savage displays in his bond with nature. For Nolde, it is not a question of the oppressed attempting to build a better life through struggle, but of idealizing the primitive for his primitiveness. Where the imperialist views the primitive as the beast of burden, Nolde sees the savage as the incarnation of what is primordially human; both accept this "savage" as he supposedly *is* and so, because the categorical imputations are arbitrary to begin with, both can derive different consequences while starting from the same assumption. In this way, Nolde's critique of imperialism is carried out from the standpoint of an imperialist mentality. For, like so many avant-gardists, he is defined by what he opposes.

Nolde's infatuation with the primitive, however, should not obscure the fact that he was deeply religious in his own way. Many of the Expressionists attempted to oppose rationalism and materialism with vague yearnings after God and salvation. They were not concerned, however,

with the ritualistic trappings of formal religion. Instead, they wished to preserve the exalted moment of mystical experience. In the same vein, Nolde could write:

> It makes no difference whether one is a heathen, Christian or Jew, Mohammedan, or Buddhist — or should a few external things and forms, a little more, one way or the other, really be what is essential in religious life.[27]

This "essential" quality is nothing other than the experience of immanent transcendence. In this moment, the unity of man with God, with the *Ur* of his being, appears and it is in this sense that Nolde's great religious paintings of 1909-11 must be seen. The ability of the simple man to know the holy, the moment of exaltation, is the point of departure, and it is basically correct to argue that Nolde breaks the tradition of Christian religious representation.[28]

As Nolde succinctly put the matter: "I believe in the religion above all religions."[29] This is the quintessence of religion that allows Nolde to link the pagan's experience of myth with the Christian's experience of God. In his view, the experiential ground of religion — in instinct, intuition, belief and fantasy — allows for the interpenetration of Norse fairy

tales, exotic rituals, and Biblical settings. Magnificent works such as the *Maria Aegyptica*, *The Lord's Supper*, and *The Entombment*, are only possible from the pressupositions of this worldview which allows Nolde to fuse the sobriety of the Gothic with the moment of ecstasy.

Two traditions come into focus in this regard. The first is that of *Die Brücke*, whose major artists such as Kirchner and Heckel could look back to Grünewald and El Greco. From these artists, as well as from their acquaintance with primitive art, the *Brücke* painters took their inspiration for simplicity and the linear distortion of reality. The severity of their woodcuts are important in this respect, but no more so than their use of planes in pictorial composition and the stark expressive quality of their figures. In 1906, Nolde was invited to join the group and he worked with them for about a half year, deciding to quit when he felt his individuality threatened by his perceived similarity of the members' works, as well as by their collective practice and discipline.[30] The other tradition is that of the post-Impressionists including Van Gogh, Gauguin, Munch and Ensor. Nolde always viewed Van Gogh and Gauguin, in a line descending from Manet, as the dynamic strain within French art that opposed the sweet and sentimental works of Renoir, Monet, and other Impressionists. Undoubtedly, it was the immediacy of their vision and emphasis on color, until it became the decisive factor in their painting, which so impressed Nolde. Thus, in both *The Lord's Supper* and *The Golden Calf*, the works are reduced to a few color planes in which the colors balance one another to render a uniform effect. At the same time, in *The Lord's Supper*, the sense of a mass crowding around the Master's table seems to emphasize Christ's own Gothic spirituality which lifts Him beyond the flesh. Where, in this work like in *Doubting Thomas*, the Gothic and the ecstatic fuse to emphasize the extraordinary and almost theatrical drama of the moment, in *The Golden Calf* — as Haftmann correctly points out[31] — the reproduction of nature is overcome in the name of the free play of dynamic color so that it becomes the very ground of the painting.

As Sauerlandt admiringly notes, in paintings like *The Golden Calf* or *Candle Dancers*, the figures are in fact "puppets come alive."[32] They are activated by the frenzy that overtakes them. Similarly, the inanimate is transcended by the movement of the spirit in the religious pictures where the light-giving colors only render starker the fact that the individuals are frozen in their emotive experience.

This emphasis on the "inner expression," which marked the period in Nolde's development shortly before the First World War, is clearly set off from physical reality as is the spirit from the flesh. It is this inner illumination of the spiritual ground of existence that Nolde continually demarcates from the body which undergoes everyday life.

Such a demarcation is central to the woodcuts of *Die Brücke*, but it is also symbolically actualized in Nolde's use of the mask. To the audience there is a frozen similarity in the faces that Nolde portrays in his religious works. From the outside, there is only distortion; the inner energy, freed

from the constraints of the body, crystallizes as a glowing mask. Behind the mask, the inner truth of the subjective experience resides; the singularity of the figure's experience must then be empathetically felt by the onlooker *through* the figure's external appearance. The mask, therefore, becomes the path to the figure's inner experience. This, however, is only possible given the inner unity of disparate particularities within a universal absolute, which is then individuated in those particularities. The standpoint is essential to Nolde from the first, and Max Sauerlandt remarks on it in writing about the impression that the primitive masks made on the artist:

> From the beginning what made the modern artist in Nolde take these wild grotesques so deeply seriously is the mystical power of feeling that leads, in the best of these carvings, to a baroque intensification of expression far beyond any banal form of reality, an intensification that touches something common to all mankind, beyond any individual connection.[33]

The fascinating artistic display, by which Nolde integrates and transvalues opposing traditions, betrays his own desires. For it is in the

artistic constellation that he produces, and not in the moment of the particular's apprehension of some universal — located in the illusory "Religion über allen Religionen" — that the greatness of his paintings becomes evident. For the absolute becomes the color that serves as the grounding principle of his compositions. Yet, Nolde still pays a price for his theories. Choosing the absolute, his paintings are devoid of becoming or the possibility of growth. As soon as this is perceived, it becomes clear that Nolde never achieved what he truly wanted — the ground for unifying experience and the individual who is tied to that ground. For, in his own terms, the two are mutually contradictory. Bound to this experiential ground, individuality is extinguished. Ripped from the processive context of history — individuals and societies making and remaking themselves — the moment of ecstasy is reified. Exaltation becomes a fetish; the individual is deprived of his becoming, of his true individuality, and instead is content to be individuated in the stasis of a ground that defines the moment of frenzied experience. On the other hand, were the individual to take center stage, his actual possibilities — his frozen moment within a continuum of possibility — would have to emerge. The ground of individuation would then have to be sacrificed to the history of individuality, which would necessitate a reflexive moment in the comprehension of the actual possibilities within history.[34]

Here lies the seductive danger of Nolde's art; the onlooker is expected to give himself over to an unquestioning moment of ecstatic belief. In this moment a singularity will be bestowed on him, which will simultaneously be taken back: for, in the moment in which this singularity attempts to be comprehended, it is already lost. In this way, the proto-fascistic aspect becomes clear; the fulfillment of individuality is its abandonment and the achievement of singularity involves its loss.

But, if reactionary and proto-fascistic elements pervade Nolde's work, why should the Nazis then seek to repress it? This is the question that remains to be answered, which demands that the Nazis' own views on art be considered. To begin with, from the totalitarian point of view, it is not enough to espouse certain themes or oppose certain enemies. It must be done in a particular way that assures conformity with the political line. Thus, the very singularity of Nolde's work immediately poses a threat insofar as it militates against that philistine whom the Nazis praised. They were interested in the "heroic," the pseudo-classical, and *kitsch*. Here the values of the new German Reich could immediately and graphically be understood in a positive manner. Nolde, however, sought to employ distortion in order to highlight the sublime individual destiny. But, the distortion remained and the moment of anguish became a scar on the body of what the Nazis saw as a healthy contented *Volk*.

Also, it is important to note that Nolde was not a nationalist in the conventional sense. Even during World War I, there is hardly a word of

political patriotism to be found in his autobiography. Nationalism, for Nolde, was not political per se. It was an arbitrary prejudice that was experienced and which emerged in cultural creation. Thus, though Nolde sought to create a "German" art in contrast to that of the French, there is a certain problem with regard to the Nazi position on racial determinants insofar as primitivism plays such a vital role in his work.

From the start, the confusion was all on Nolde's part. In the first place, he misunderstands his own position artistically. For his affinity to primitivism and even to color is anything but German. Certain of the French and the Italians also emphasized color and dynamism in their own ways while the influence of primitive art may well have been *the* decisive hallmark of an early modernism that was a trans-European phenomenon. Secondly, Nolde misconstrued the Nazis in their own terms. For, presumably, Nolde was open to the Nazis pseudo-revolutionary rhetoric precisely to the extent that it corresponded to his own confused ideology and insofar as it seemed similar to his own former fight with the impressionist establishment.

Then there is the matter of the Jews. In Nolde's work, they are equated with the pagans, the unwashed, but their locus in the formation of Christianity is retained. By viewing the Christian experience in the figure of the uncivilized Jew, Nolde only recapitulates his presentation of modernity in terms of the primitive. But, though all this has nothing to do with recognizing the Jew as a civilized individual of the present in his own right, it is already too much for the Nazis. For the Nazi, there can be no ambiguity; the Jew must be painted black and the Germanic ideal must be painted white. The very distortion of the Jew in the past — a horrible and often mean distortion, which appears in some of Nolde's greatest paintings — denies the possibility of seeing him *unambiguously* as absolute evil incarnate in the present.

There is also the issue of modernity itself. Though Nolde always liked to note the admiring comments of his simple townsfolk to the works that he produced, there can be little doubt that his art is on a different plane than what endeared itself to the peasants and the petty bourgeoisie. When the Nazis were on the rise as a pseudo-revolutionary movement, artists like Nolde or Benn were useful in terms of their anti-bourgeois stance and in the climate of opinion which they helped to create through their works. But, once the Nazis were in power, they sought to consolidate the values of the German *Volk* and encase their paganism within a technological dynamic. Given their petty-bourgeois tastes, and the fact that these artists were no longer useful in a revolutionary sense, they could be dispensed with quite easily. The Nazis could not understand (or saw very clearly) the potential, in distortion, the fabulous colors of Nolde, fantasy, and the exertion of the subjective faculty in transforming social and artistic traditions. After all, the Nazis too could transform traditions by taking works and symbols out of context; it is no accident that Goethe's oak tree should have stood in the middle of Buchenwald. But, to allow this to an individual is

another story: the exertion of the imagination, the use of fantasy, the unfettered creativity of the individual always poses a threat to totalitarian regimes. Precisely to the degree that Nolde opens up new perceptions and aesthetic possibilities, to the degree that he turns the religious objects of primitive societies into an art in its own right and frees the subject from the constraints of the existent, *in their own terms* the Nazis were right in viewing him as "decadent" and "degenerate."

None of this condones Nolde's behavior. The fact that he was legally hounded to abstain from painting says little; others died in concentration camps, and even Nolde's persecution — which has become part of the myth — must be put into perspective. The Nazis own stupid barbarism does not cleanse the reactionary, proto-fascistic, elements from his art. They are there and remain there — even in the wonderful watercolors, the "unpainted pictures," which Nolde composed in secret.

The regeneration of Germany through its *Volk*, which Nolde had espoused, came about — but not in the way that he would have liked. So, like Benn and others, Nolde went into an "inner emigration." In the best of his later works, individuals disappear in favor of landscapes and flowers. Color surfaces more strikingly than ever, as in *Great Poppy (Red, Red, Red)* where the object of the work is obviously color itself. In paintings such as this one, and in the finest of the watercolors which he completed during the war, Nolde still seeks to grasp the absolute, the spirit of nature and man, but this time through the final, unobstructed purity of color.

During these years, he will achieve a congruence between technical means and metaphysical content. The possibility appears for transvaluing these works through one of the most radical aesthetic calls for a "resurrection of nature" in terms of its utopian potential for enjoyment within an emancipated social order. But, for Nolde himself, the delusions remain. The mysticism, the irrationalism, the emphasis upon instinct, the attempt to merge with the dynamic force that supposedly sways nature and man in his most primitive emotions — he still believes in it all. The tragedy of Nolde is that, at the moment of his greatest achievement, he has learned nothing from the past or from his own persecution. Truly, in a way that his friend Max Sauerlandt would never have understood, Nolde — a great artist and perhaps a greater fool — "is who he was and was who he is."

Notes

[1]Nolde always disliked being called an Expressionist; his singularity was part of his mystique. This is reinforced by Martin Gosebruch who writes: "He towered above us like someone from another world, affecting us all the more deeply by the testimony

of his life and work." *Nolde: Watercolors and Drawings* edited and with an introduction by Martin Gosebruch, translated by E.M. Kustner and J.A. Underwood (New York, 1973), p. 7.

[2]Even Klee uses other-worldly imagery to describe Nolde — as an "elemental spirit" and a creature of the "lower regions" — in his contribution to the *Festschrift für Emil Nolde: Anlässlich seines 60, Geburtstages* (Dresden, 1927).

[3]Peter Selz, *German Expressionist Painting* (Berkeley, 1974), p. 124.

[4]In this regard, Werner Haftmann can approvingly cite "Valery and Gottfried Benn [who] have told us that an age is not represented by its rulers, but by its artistic results." *Emil Nolde, Unpainted Pictures* (New York, 1965). The consciousness of the aesthete becomes immediately apparent. As if Nolde's art could serve as the criterion for an age in which countless millions died; as if Nolde's magnificent 1,300 watercolors, which comprise the "unpainted pictures," can be discussed as equal in importance to the gas chambers.

[5]See Nolde's letter to Goebbels where he writes: "When National Socialism also labeled me and my art 'degenerate' and 'decadent,' I felt this to be a profound misunderstanding because it is just not so. My art is German, strong, austere, and sincere." edited by Victor Miesel, *Voices of German Expressionism* (New Jersey, 1970), p. 209.

[6]One way to save Nolde's art from social reality is to state, as does Dr. Alfred Hentzen, that: "Certainly, the significance of a work of art is absolute and independent of the circumstances under which it was created." *Unpainted Pictures: Emil Nolde 1867-1950* (New York, 1966). Unfortunately, however, this simply reifies both the work and the experience of it. Like the objectification, the experience of it retains a dimension that is social and value-laden; it is easy and often dangerous to ignore this dimension in the name of pure aesthetic pleasure. Note the way in which Nolde described the experience that his pictures should elicit: "Do you know, my highest wish would be that people were swept away by my work, like children running after a military band. Like that, in a roaring exultation, I would like to sweep people away from me" Quoted in Hans Fehr, *Emil Nolde: Ein Buch der Freundschaft* (Köln, 1957), p. 54.

[7]Haftmann is correct in noting that, in Nolde's "Marginal Notes" to the "Unpainted Pictures," there is the continuous emphasis upon how to develop forms from color alone. Where, for Nolde, "every color harbors its own soul," color serves as the ground of painting from which drawing can be derived.

[8]It is from his battle with Liebermann, Paul Cassirer and other stalwarts of the Berlin Secession of 1910 that Nolde takes the title of the third volume of his autobiography: *Jahre der Kämpfe* (Berlin, 1934). These "years of struggle" were directed

against the "foreign and Jewish" influences that were undermining "German" art and its development. Foolishly, Werner Haftmann and others argue against Peter Selz that Nolde was not an anti-semite since he had a few Jewish friends and painted Christ and his disciples as Jews. In the context of Nolde's primitivism, the second assertion misses the point entirely. The first misunderstands the issue. For, it is not a matter of having a few Jews as friends — or even having a certain strained religious tolerance. Haftmann simply collapses political and cultural anti-semitism into religious and parlor anti-semitism. Throughout *Jahre der Kämpfe* — which, after all, appears following the Nazi seizure of power — Nolde speaks about the need for keeping the races separate, warns against miscegenation, and approaches the "foreign" and "Jewish" influence upon German art in a way that is comparable to a conspiracy theory and Nazi anti-semitism. In combination with his belief in "German" art — a belief that Nolde held until he himself was the victim of cultural persecution — and his "blood and soil" outlook, there is no other possible consequence of his thinking than that the Jews *as a race* should be oppressed.

[9]"The period from 1871 to the turn of the century, the *Gründerzeit*, with its economic boom, was fateful for the more refined old cultural and popular values; they were ignored, squandered, destroyed." Emil Nolde, *Das eigene Leben: Die Zeit der Jugend 1867-1902* (Flensburg, 1949).

[10]"Idealism and materialism face each other like opposite poles of a magnet, attracting and repelling each other." Nolde, *Jahre der Kämpfe*, p. 124.

[11]"There is no doubt, however, that Nolde's contempt for rationality contributed subliminally to the popularity of his pictures. His appeal to the instincts has become a threat to his art. For one would misunderstand the work itself if one were to take it only as the testimony of a blind, eruptive painter." Emil Nolde, *Gemälde aus dem Besitz von Frau Jolanthe Nolde* text Dr. Jens C. Jensen. (Heidelberg, 1969), p. 12.

[12]"I walked around in the city, a stranger, with blue-black glasses, and often could hardly find the streets. Life seemed as if lost to me." Nolde, *Das eigene Leben*, p. 270.

[13]Emil Nolde, *Brief aus den Jahren 1894-1926* edited by Max Sauerlandt (Berlin, 1927), p. 35.

[14]*Festschrift für Emil Nolde*, p. 16.

[15]"This early watercolor is also important in determining Nolde's place in the history of European art. Werner Haftmann's repeated assertion in his *Painting in the Twentieth Century* that Nolde's style did not crystallize until around 1905, when he came into contact with French Post-Impressionism, is true enough as regards execution or realization — that 'working himself up' to his true level of which we have been speaking — but it is certainly not of the essentials of his painting, which were

anticipated in the *Sunrise* watercolor long before Nolde had any knowledge of the achievements of the Post-Impressionists." Gosebruch, *Watercolors and Drawings*, p. 18.

[16]On the day of the Kaiser's birthday celebration, Nolde writes: "Once again I'm walking around here; everything is repugnant to me. This metropolis — no one is close to my heart, I'm more lonely than ever before. These straight, long, fog-choked streets — I don't like being here." Nolde, *Briefe aus den Jahren*, p. 38.

[17]Georg Simmel, "The Metropolis and Mental Life" in *The Sociology of Georg Simmel* translated, edited, and with an introduction by Kurt H. Wolff (New York, 1950).

[18]Rudolf Probst, *Festschrift für Emil Nolde*, p. 12.

[19]As Nolde quite succinctly puts the matter: "Instinct is ten times more important than knowledge." *Das eigene Leben*, p. 200.

[20]Quoted in Fehr, *Emil Nolde*, p. 62.

[21]Even someone as intelligent as Thomas Mann could make this distinction in a nationalistic manner; see his *Betrachtungen eines Unpolitischen*.

[22]Nolde, *Briefe aus den Jahren*, p. 164.

[23]In particular, see Nolde's *Welt und Heimat: Die Südseereise 1913-1918* (Koln, 1965).

[24]Nolde, *Das eigene Leben*, p. 197.

[25]Nolde, *Briefe aus den Jahren*, p. 99.

[26]*Ibid.*, p. 98.

[27]Nolde, *Das eigene Leben*, p. 199.

[28]"Psychic and natural forces that the germanic middle ages drove from its sanctuary and banished outside, as chimeras and grotesques on roof ridges and towers, fill this world as if there had never been a Cross. Not until Emil Nolde does German art take possession of its germanic/nordic heritage, a great hope of the earth, nipped in the bud more than a thousand years ago and buried under Christian-oriental and antique material. Christian piety here — humanism, classicism, Weimar and the Greek spirit there — between both poles glides the German, passionately grasping, turning abruptly back and forth in fulfillments that ebb away, because his own history prevents him from taking possession of a sunken heritage." Heinrich Zimmer, *Festschrift für Emil Nolde*, p. 35.

[29]Nolde, *Das eigene Leben*, p. 200.

[30]Nolde, *Jahre der Kämpfe*, p. 90ff.

[31]Werner Haftmann, *Emil Nolde* (New York, 1959), #4.

[32]Max Sauerlandt, *Emil Nolde* (Munchen, 1921), p. 58.

[33]*Ibid.*, p. 55.

[34]Achieving this does not require a "realist" aesthetic on the part of the artist. True, this moment of frozen possibility appears in Courbet or Daumier, but it also appears in Cezanne in his use of perspective, or in the works of the cubists which involve the active participation of the onlooker in reconstructing the work, or in Kirchner's street scenes, Marc's *Fate of the Animals*, and the works of the surrealists as well.

MUSIC AND DANCE

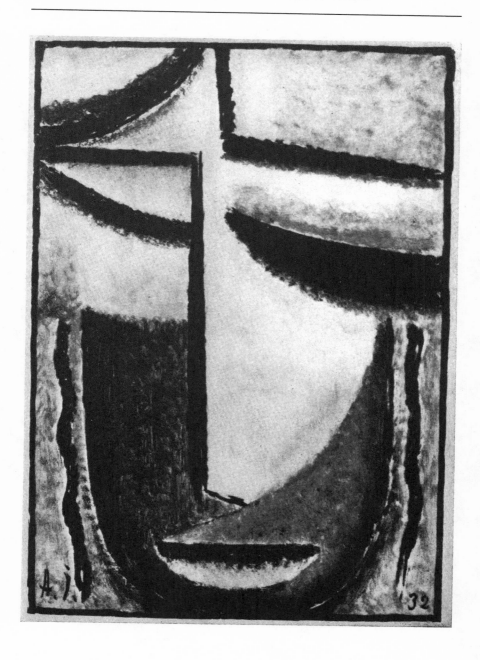

15
Musical Expressionism in Vienna

Henry A. Lea

Musical Expressionism evolved in Vienna in the first decade of the twentieth century. Its chief composers, Arnold Schoenberg (1874-1951), Alban Berg (1885-1935) and Anton Webern (1883-1945), all began with highly romantic works but soon found this style exhausted and irrelevant. The chromatic and hyperemotional elements of the romantic style, found most notably in Wagner's *Tristan und Isolde,* led inevitably to the dissolution of tonality. It is this so-called atonality — the lack of a tonal or key center as an anchor for melody and form — that chiefly characterizes expressionist music, just as the lack of causality and logical sequence typifies expressionist art and literature.

The works that Schoenberg wrote between 1908 and 1913 — following his late-romantic compositions, such as *Verklärte Nacht, Gurrelieder* and *Pelleas und Melisande,* before he reorganized music on the basis of the twelve-tone scale — are the primary examples of musical Expressionism. Its chief characteristics are the suspension of tonality, emotional extravagance, formal freedom, and an atmosphere of existential anxiety. Berg and Webern who shared Schoenberg's musical and spiritual outlook composed similar music, with Berg remaining predominantly expressionist while Webern moved quickly on to serialism. All three composers admired

Gustav Mahler (1860-1911) as a visionary and musical nonconformist who anticipated certain stylistic and technical features of Expressionism.

Mahler's music is highly emotional and uses an extremely wide dynamic and instrumental spectrum. He likes to use instruments and voices at the outer limits of their range, which gives the music an irregular or distorted sound.[1] It is a music of sudden contrasts in harmony and melody, pace and rhythm, tone and mood. Using a minimum of ornamentation and transition, it combines the earthy and the exalted, often simultaneously. Mahler writes intensely subjective music, expressing the full range of the composer's feelings in such a way that his music becomes a statement about the human condition.

Generally speaking, Mahler spiritualizes the external by transforming it into inner landscapes. Even when he uses the full orchestra the sound is not descriptive of outer reality, as in Strauss' tone poems, but otherworldly, as in Kokoschka's cityscapes in which the subject is projected into a cosmic perspective. A good example is Mahler's use of cowbells in the *Sixth* and *Seventh Symphonies*. A comparison with Strauss' cowbells in the *Alpine Symphony* shows that Strauss paints a realistic scene of cows grazing on a mountain meadow, whereas Mahler's cowbells, lacking such a context, are symbolic, transfigured sounds that are literally not of this world. Strauss' cowbells are specific and localized; Mahler's are disembodied and suspended in cosmic space. Strauss describes a day in the Alps; Mahler gives an expressionist synthesis of the Alpine spirit.

Closely related is the lack of a specifically national identity in expressionist works, since their setting is usually undefined in time and place. In Mahler, this tendency shows up in the increasingly free use of tonality and in the transformation of marches, dances and folksongs. One of his earliest works, *Waldmärchen* (Part I of *Das klagende Lied*) begins in harmonic ambiguity, with the orchestra playing in two keys simultaneously and thereby undercutting the firm harmonic foundation so characteristic of national music.[2] In some of the later symphonies (Nos. 4, 5, 7 and 9) he abandons the idea of a basic key for an entire symphony altogether, and *Das Lied von der Erde* ends on an open chord, analogous to the open form of expressionist paintings and plays.

Mahler's treatment of marches, dances and folksongs shows a similar tendency to universalize what is inherently specific or regional. The grotesque funeral march in the First Symphony, based on the children's canon "Frere Jacques," monumentalizes this popular, cheerful little ditty by transforming it into a dirge. The piece exemplifies expressionist magnification and distortion: the orchestration is highly unorthodox, particularly in the use of high wood winds and percussion, while the sudden shifts in pace and rhythm and the use of syncopation make this composition a unique mixture of pathos and irony. By integrating the piece into a symphony, with the connotations of nobility and grandeur associated with that form, Mahler elevates this thrice-familiar tune into a "statement" and extends the emotional and stylistic range of the symphonic form.

A more extreme example of this mentality is Schoenberg's use of the well-known German song "Ännchen von Tharau" as the theme for a variation movement in his *Suite* (op. 29) — more extreme because the variations of this simple song, being atonal, remove the song even further from its origin by divesting it of its firm harmonic setting and stylizing it beyond recognition. What is expressionist about this piece is the anti-realist stance, the highly subjective point of view, the strong distortion and the estrangement of the simple-minded, comfortable, familiar and trivial.

Mahler and the Expressionists also radicalized dances, mainly the *ländler* and the waltz. Mahler's scherzos are to an increasing degree demonizations of these popular dances. Most of them begin diatonically, with a few instruments, but soon grow to enormous proportions and literally break open harmonically and rhythmically. An example is the Scherzo of the Fifth Symphony which Mahler makes the pivotal section of the entire work and in which the *ländler* becomes a metaphor for the human comedy; similarly Berg, in his opus 6, transforms the waltz into a dance to the abyss.

In the third movement of the *Third Symphony* an offstage posthorn transmutes a Spanish dance (*jota aragonesa*) into a haunting, lonely melody that suggests a lost paradise. Even in Mahler's wide-ranging work this episode is a remarkable evocation of cosmic musical dimensions. By transforming a popular national dance into an ethereal chant heard at a great distance and placing it at the center of a vast symphonic cosmos, Mahler anticipates certain expressionist tendencies: the inclusion of widely disparate elements in a work of art, the denationalization of folk art, and the extreme disaffiliation of the artist from mimetic art.

Similar thoughts pertain to the march. Mahler's marches — insistent, vehement, distorted — are important not only as critiques of military music but as an integral structural device suggesting that man's course is a march to heaven or hell, or that life on earth is a martyrdom, in the manner of expressionist passion plays. These marches have stereophonic dimensions of time and space. Most of them are apocalyptic processions or at least suggest a fateful event; some of them, like the Frere Jacques march, are grotesque; all of them are extravagant; they predominate even in Mahler's songs. Marches pervade his music to an extent that exceeds all previous composers, with the possible exception of Tchaikovsky whose view of the march somewhat resembles Mahler's. Noteworthy is the occurrence of marches in opening movements, which is rare in earlier composers. Five of Mahler's symphonies open with marches (nos. 2, 3, 5, 6, 7), and the first movements of his other symphonies have a strongly processional character. His preoccupation with the threatening aspect of the march suggests a prophetic vision of war which also haunted many expressionist writers, especially Georg Heym, Georg Trakl and Albert Ehrenstein.

What sets Mahler's marches apart from those of earlier composers, even Tchaikovsky, is the built-in ironic note: they often sound like parodies of Central European band music. Being socially speaking an

outsider, like many Expressionists, Mahler was skeptical about such music because he did not identify with the community which it served. An example is the gigantic march in the first movement of the *Third Symphony* which, as Mahler himself suggested, was influenced by Prussian and Austrian marching bands;[3] but by comparison with their marches, Mahler's march abounds in irregularities: repeated shifts in tempo and harmony, off-beat accents marked "raw!"[4], muted brass, satiric countermelodies in the high woodwinds, a massive array of percussion instruments, and an ever-quickening pace that escalates the march to bedlam proportions before it collapses. Intentionally or not, it sounds like a band-music extravaganza gone wild, a march that has left military or patriotic or ceremonial considerations far behind; or in expressionist terms, a grotesquely heightened processional that raises the march to a metaphor of worldly tumult and simultaneously calls it into question. The closest expressionist example is the march in Berg's *Three Pieces for Orchestra* (op. 6), a truly Mahleresque work that sounds the death knell of the march.

Another link between Mahler and Expressionism is his conception of the symphony as the record of a spiritual quest. Like an expressionist artist, Mahler "invests forms with spiritual significance."[5] With their ascending structure, from the worldly to the exalted, and their expressed or implied program, his symphonies, notably the metaphysically aspiring *Second, Third, Fourth* and *Eighth Symphonies,* resemble the expressionist *Stationendrama* or pilgrimage play which centers on the protagonist's search for salvation and identifies his soul struggle with the spiritual crisis of the age. As in Expressionism, the loneliness of the quest and the mood of upheaval in these symphonies make the negative examples of this form (the *Sixth* and *Ninth Symphonies* and *Das Lied von der Erde*) artistically more convincing. Mahler shares with the Expressionists an atmosphere of cataclysm, but while in literary Expressionism this is a necessary prelude to a New Man or a new world order, for Mahler it is the end of an era.

Mahler's symphonies and song cycles are the existential statement of a solitary man. As an idealist who fought against philistinism in art and life Mahler struggled largely alone, whereas the Expressionists formed communities, issued pronouncements and even took part in political action. This would have been foreign to Mahler, yet he was artistically speaking an activist. Violating accepted standards of beauty, harmony, balance and restraint, he wrote music of such naked emotional force and arrestingly vivid sound that its expressive weight overburdens the traditional form and harmony he used. One might say that it is unassimilated music, in the sense that it is not in the mainstream and lacks any trace of virtuosity or showmanship. It has something uncomfortable, exaggerated, larger-than-life, "traumatic,"[6] which constitutes Mahler's main affinity with Expressionism.

After he heard Mahler's *Third Symphony* under the composer's direction in 1904, Schoenberg wrote to Mahler: "I have seen your soul, naked, stark naked. . . . I saw a man in torment struggling for inner harmony; I sensed a man, a drama, truthfulness, the most relentless truthfulness!"[7] Schoenberg revered Mahler's unsparing commitment as man and artist, his all-embracing music and his sense of mission, but there were also more specific relationships. Mahler had met Schoenberg early in 1904 at a rehearsal for the premiere of *Verklärte Nacht* which made a deep impression on Mahler. When shortly thereafter, in March 1904, Schoenberg and Alexander von Zemlinsky formed an "Association of Creative Musicians" in Vienna to promote the performance of contemporary music, they persuaded Mahler to serve as honorary president and guest conductor. During its first and only season (1904-05) Mahler introduced Strauss' *Sinfonia Domestica* and his own *Kindertotenlieder* and *Wunderhorn* songs, and Schoenberg conducted the first performance of his tone poem *Pelleas und Melisande*. His comprehensive study of harmony, *Harmonielehre* (1911), is dedicated to Mahler's memory.

A compositional link between Mahler and Schoenberg is their effort toward a more sparing, more individualized instrumentation to clarify textures and differentiate the various musical lines from each other. The lines themselves become increasingly angular and intense as they detach themselves from the underlying harmony. The goal is precision and sharpness of definition in opposition to lush writing, just as expressionist painters and writers are at pains to express themselves boldly by using strong, contrasting colors and exclamatory, unlyrical language. Expression of emotions and ideas preempts form and technique. This explains the avoidance of the usual generic forms (sonata, symphony, concerto) with their repetitions and sequential patterns — conventions that clash with the music in Mahler's symphonies. Expressionist music lacks for the most part the emotional and rhetorical argument so typical of romantic and late-romantic music. And it has no relation to nature, in contrast to Mahler's music, and completely lacks the expansive and pictorial quality of romantic music. Unlike Romantics and Impressionists, Expressionists do not depict; they create inner worlds.

The shift from Romanticism to Expressionism is palpable in Schoenberg's *First Chamber Symphony* (op. 9; 1906), a fascinating transitional work that Stuckenschmidt calls "the last tonal work of his early years."[8] Though written in E major the work is so chromatic that the few pure chords sound utterly incongruous.[9] Apart from its unresolved dissonance, the expressionist aspects are the emotional intensity, the abrupt contrasts, the wide intervals in the musical line, the lightness and sharpness of its scoring, its uncompromising somberness, and the combination of high-voltage music and carefully wrought polyphony. Schoenberg writes music of intricate texture which brings together many disparate voices in an asymmetrical structure.

The *First Chamber Symphony* demanded much of performers and listeners. Many listeners hissed and left the hall during its first perfor-

mance in Vienna on February 8, 1907.[10] Its eerie blend of Romanticism and Expressionism shows Schoenberg on the way to a new style that is far more radical, at least for the listener, than any previous development in modern musical history.

The *Second String Quartet* (op. 10; 1907-08) is listed as being in F sharp minor. The first movement is written in this key and the quartet ends in an F sharp major chord, but the last movement does not have a key designation — the first piece by Schoenberg without an identified key. Schoenberg wrote that the quartet contained tonal chords at major structural points, but that "the overwhelming number of dissonant sounds can no longer be balanced by the occasional use of such tonal chords as are commonly employed to express a tonality."[11] His reference to "the Procrustean bed of tonality"[12] expresses his impatience with traditional composition and his compelling need to transcend it. The last two movements of the quartet are settings of two poems from Stefan George's *Der siebente Ring*, "Litanei" and "Entrückung." "Entrückung," describing the poet's withdrawal from familiar surroundings to uncharted regions, characterizes Schoenberg's search for new musical horizons.

Early in 1908 Schoenberg had begun the setting of a self-contained cycle of fifteen poems from Stefan George's *Buch der hängenden Gärten* and completed the work in the following year. The choice of George seems odd: his aristocracy of style and form seems antithetical to Schoenberg's vehement expressiveness. George's elitist aesthetic is the opposite of Schoenberg's volatile music which democratically gives equal value to all notes. The composer later said that these highly structured poems served to give structure to his music.[13] Actually his music is more moderate in this work, in keeping with the dour tone of the poems which deal with the waxing and waning of a love. There are only a few expressionist outbursts, for example, toward the end of the fourth song when the glance of the beloved first reaches the lover. The very brief fourteenth song is one of those ghostly aphorisms which Adorno finds expressionistically bold, abstract and unstructured. Citing Schoenberg's essay "Das Verhältnis zum Text" with its emphasis on freely improvising on a poem rather than illustrating or depicting its content, Adorno concludes that Schoenberg composed against or away from a text.[14]

In view of the repeated choice of *fin-de-siecle* texts by Schoenberg, Berg and Webern, the question arises whether they intended to set them off against the music or whether these poems simply appealed to them. Though the bleak atonal music does set off the rich imagery of the poems, the latter seems more likely, because this music possesses a similar *fin-de-siecle* quality, except that it is more searing and less resigned, which has to do with the difference in medium and the composers' less passive temperament. Moreover, expressionist poems began to appear somewhat later. Another difference is that the atonal music conveys none of the poems' nature symbolism. What it does convey is the interiority of George's lyrics and their declamatory style. Rosen notes that the Schoenberg-George cycle has an "implacably hostile view of the exterior world."[15]

About the George songs, Schoenberg wrote that he was aware "of having broken all bonds of a bygone aesthetic" and that he was "following an inner compulsion which is stronger than upbringing."[16] The year of

their completion, 1909, was astonishingly productive for Schoenberg. He also composed the *Three Pieces for Piano* (op. 11), *the Five Pieces for Orchestra* (op. 16) and the opera *Erwartung* (op. 17).

The *Five Pieces for Orchestra* are Schoenberg's first non-programmatic work for full orchestra. The title suggests an "unsymphonic,"[17] more concise work that lacks the traditional sonata form because it lacks the tension between tonic and dominant which is the basis of sonata form. This tension is replaced by continual variation of motivic material and instrumental color. Pertinent to Expressionism is the brevity of motifs and their deployment. This resulted, as Rosen well explains, from the rejection of large, formula-type units — "blocks of prefabricated material"[18] — such as ends of sections and accompaniment figures in classical and romantic music. These procedures, having lapsed into mechanical repetition, now sounded stale and superfluous, as in the last movements of Mahler's *Sixth* and *Seventh Symphonies.* This left the composer with only very brief units of music which had to carry the emotional and structural weight of much larger units. Perhaps this is the essence of expressionist music: brief motifs invested to the breaking point with musical intensity.

This intensity is evident in the first and fourth pieces, the shortest, fastest and wildest of the set. They abound in ominous brass snorts, sudden bursts of dissonance, heavy offbeat accents, piercing woodwinds, abrupt breaks, leaping intervals, extreme and sudden dynamic shifts. The other three pieces are quietly atmospheric: the extreme contrast among the five pieces is itself a mark of Expressionism. The most famous piece is the third with its brooding mood and subtly shifting tone color — so different from the impersonal tone painting of the Impressionists. The last piece has the rhythm of a *ländler,* but this is often obscured by the absence of a first beat, either because of a pause or a tie to the previous note. In general, expressionist music notably lacks rhythmic impulse.

The first publication of the *Five Pieces* (1912) had no titles. His publisher then asked Schoenberg to add a title to each piece, evidently to make them more acceptable to the public. The composer yielded reluctantly, making sure that the titles would be too general to give any clue to the music.[19] Expressionist composers seek to avoid programmatic titles and descriptions, in the belief that the music should speak completely for itself. Also, by remaining unspecific, they can elevate the particular to the symbolic — a major tendency of Expressionism.

Schoenberg next composed two one-act stage works, *Erwartung* (op. 17) and *Die glückliche Hand* (op. 18). *Erwartung* was written in 17 days in 1909. A monodrama lasting about half an hour, it has only one character, an unnamed woman whose interior monologue is set to fragmented and overwrought music. Its Expressionism lies first of all in its undefined plot, place and character and its unreal atmosphere. The woman is searching for her lover and finds him murdered, but few details are given. Schoenberg has suggested that it may be an anxiety dream.[20]

The lack of realistic detail is matched by the lack of musical development which has traditionally determined structure and sequence in music. The music follows the broken phrases and jagged emotions of the woman with an even more unstructured score. All the traditional elements of musical form are missing. There are no recognizable themes, there is no tonality, no development, no continuity, no repetition, no variation, no rhythm, and above all, no "sense of cadence."[21] It is an improvisatory work that communicates the woman's fear and memory with unprecedented immediacy, that is, without having undergone a shaping or sublimating process. Like most expressionist works, *Erwartung* is open-ended: after the last words "I was searching. . ." the music fades out in a chromatic scale, as if the woman's fantasy would continue.

In its theme, form and Freudian ambience, *Erwartung* invites a comparison with Strauss' *Salome* (1904-05), that helps define Expressionism. Oscar Wilde's libretto for *Salome* has a luxuriant eroticism that is lacking in Marie Pappenheim's text for *Erwartung*. Strauss writes appropriately lush, "culinary" (in Brecht's sense) music for characters that are bound by their particular identifiable circumstances. Marie Pappenheim's Woman is an existential figure, and the emphasis in her text is on dream versus reality, rather than on good versus evil, as in *Salome*. Schoenberg's music goes far beyond the non-expressionist text to create a work of extreme dissociation. In sum, *Salome* is a post-Wagnerian opera of rich, late-romantic, extroverted music for a well-defined theatrical plot with a beginning, climax and end that presents no musical problems for the listener; *Erwartung* is a Strindbergian outcry that makes severe demands on musicians and listeners and has not been assimilated even after seventy years.

Even more Strindbergian[22] is *Die glückliche Hand* (op. 18), a "drama with music" written between 1910 and 1913. It is more concise than *Erwartung* and more fully formed and continuous. Though there are three characters and a chorus of six men and six women, the plot is again centered in one person, an unnamed Man, the only solo singing voice, who in this case is the Artist. Schoenberg himself wrote the libretto whose title refers to the good fortune of being artistically gifted. In true expressionist manner this work has a message, given by the chorus at the beginning and end: the artist must live for a higher truth rather than for earthly happiness, such as love of woman. Though a woman betrays him, he cannot overcome his desire for her, thereby ignoring his artistic mission. In expressionist terms he fails to achieve spiritual purification.

The staging and scenery for which the composer has given detailed instructions are expressionistically dreamlike and involve elaborate lighting symbolism. The music is highly dissonant and agitated, though somewhat less so than in *Erwartung*. Again it goes far beyond the banalities of the text and raises the question whether Schoenberg needed this kind of text to inflame his musical imagination. Since this is his own text, it is hard to argue, as Adorno does regarding the George cycle, that he is composing away from the text. What can be said is that

Schoenberg's music radicalizes the text by abandoning the formal and syntactic conventions which the text still retains. He imposes expressionistic music upon a romantic text, in contrast to Berg whose chosen librettos for *Wozzeck* and *Lulu* already exhibit the dissociation so typical of Expressionism. In *Die glückliche Hand* the combination of literary cliche and searing music creates a work which is curiously out of joint.[23]

The superiority and isolation of the artist in *Die glückliche Hand* is neo-romantic rather than expressionist, but this mixture is also found in contemporaneous expressionist plays by Sorge and Hasenclever, among others, where it develops into a savior complex. The vulgar off-stage music representing the crowd in opposition to the artist's dramatic on-stage music — a device used by Mahler in *Das klagende Lied* and elaborated by Berg in *Wozzeck* but with different assumptions — creates a multi-level perspective characteristic of expressionist art. Undoubtedly *Die glückliche Hand* would make an impact on stage that it cannot have on a recording, but it is performed even more rarely than *Erwartung*. With these two stage works musical Expressionism reaches its farthest point.[24]

The breaking open of a neo-romantic poem by expressionist music occurs in the song "Seraphita" (Stefan George's translation of a poem by Ernest Dowson), one of the most extreme of expressionist works. Set to a mystical, symbolist poem, this song, the first of the *Four Orchestral Songs* (op. 22), was written between 1913 and 1915 and is set for soprano and a huge orchestra which is, however, used in a way to set one group of instruments off against another. Since the opening melody contains every note in the chromatic scale,[25] this work provides a bridge to Schoenberg's serial works which began to appear, after a silence of seven years, with the publication of the *Five Pieces for Piano* (op. 23) in 1923. With these pieces Schoenberg began to organize and systematize atonal music, making possible large-scale works but sacrificing much of the free-flowing, improvisatory, unfettered quality of the expressionist works.

Toward the end of his life the composer returned to the expressionist vein in a group of serial works of passionate intensity inspired by political events. The most dramatic of these works is *A Survivor from Warsaw* (op. 46; 1947), a short piece (less than ten minutes) for narrator, men's chorus and orchestra. It is an account of a group of Jewish prisoners about to be killed by the Nazis. As they are ordered by a sergeant to count off, they chant the Hebrew prayer Shema Yisroel. The highly concentrated, deeply moving work evokes the same macabre, nightmarish mood of the expressionist works, but in a topical context that is more characteristic of literary Expressionism. In subject matter it is closely related to Paul Celan's famous poem "Todesfuge," but in contrast to the poem's regular form which seeks to rationalize the irrational and at the same time to show the disparity between long-honored forms and their destruction, Schoenberg's work has the abrupt, jagged, eruptive quality of expressionist art that is appropriate to this eyewitness account. The clashing sounds, vivid orchestral effects and stark contrasts between the victims'

screams, the sergeant's shouts and the religious chant make this work a striking example of Expressionism. It is a typically direct, unmediated expression of Schoenberg's feelings. As an outcry against inhumanity it recalls such anti-war poems as Trakl's "Grodek" and Werfel's "Der Krieg." In this work Schoenberg returned to the impassioned Expressionism of his earlier years.

Of the major expressionist composers, Alban Berg is the most accessible. Even his serial works are not strictly atonal, which explains why he has established greater rapport with the public. He met Schoenberg in 1904 and was his student from 1904 to 1910. By comparison with Schoenberg, Berg is musically more sensuous, more rhapsodic, less severe — in short, more romantic. His style is less angular and less contrapuntal, his rhythm more traditional, his tone less forbidding than Schoenberg's or Webern's. Of these three composers who constitute the so-called Second Vienna School, Berg is musically closest to Mahler and the *fin-de-siecle*. He stylizes marches and dances similarly, but compresses his material to a much greater degree. He uses similar tonal and rhythmic symbolism. And he shares Mahler's sense of personal and cultural catastrophe.

As his operas *Wozzeck* and *Lulu* show, Berg has a sense of theater. Unlike Schoenberg's operas which tend to be soliloquies or dialogues with an ideological program, Berg's are settings of highly dramatic plays of literary merit and human interest, with music that matches the text. In sum, Schoenberg is a more committed theoretician and advocate of the

new music who had ties to the expressionist painters, while Berg, being temperamentally less austere, is the less doctrinaire composer of a more literary sensibility.

Of Berg's early work the *Three Pieces for Orchestra* (op. 6; completed in 1914 and dedicated to Schoenberg) is an outstanding example of musical Expressionism. It consists of "Prelude," "Rounds" and "March" — innocent-sounding titles for awesome pieces written for a very large orchestra. Since this work is not atonal — a strong C minor reference persists in "Prelude" and "March" — it is not difficult to listen to. Moreover, by comparison with Schoenberg's expressionist works it retains considerable impetus that recalls romantic music. It also has recurring themes and recognizable endings; quotations from Mahler and Debussy create another link with the past.[26]

As usual in expressionist orchestral music, the instrumentation includes a large number of woodwinds and percussion instruments, including a hammer which is struck at the climax of the March and on its last note. Going beyond Mahler, Berg explodes and disintegrates the waltz and the march. *The March* which was completed on August 23, 1914, shortly after the outbreak of World War I, is a particularly dark work: recalling both symphonic and popular marches it destroys the march as a viable form of music. After the shattering climax (measure 126) only fragments remain.

Adorno, who was a student of Berg, reports that the composer distinguished sharply between symphonic works and character pieces.[27] These are character pieces in the sense that they dispense with sonata form and offer perspectives on particular genres. Adorno interprets "Rounds" and "March" as grim commentaries on nineteenth century genre pieces that had degenerated into banality. He states further that Berg's "incorporation of the banal" into his music explains the "panic," "chaotic" tone of these pieces.[28] This apt description takes account of the expressionist tendency to combine the elevated and the vulgar, yet Berg's pieces are so large in conception and somber in mood that he must have felt, like Mahler, a strong affinity for these forms. The sheer frequency and formal integration of dances and marches in these composers' music show a special kind of affection for these popular forms of music which are so much a part of everyday life in Central Europe — the affection of the sophisticated who are unable to identify with them and prophetically view them as symbols of a dying civilization.

The doom-laden mood and monumentalization of dances and marches recur in Berg's opera *Wozzeck* (op. 7; composed between 1917 and 1921 and dedicated to Alma Mahler). This work, a stark drama about a poor soldier who kills the woman he loves, is steeped in military, folkloristic and religious imagery which is distorted by Wozzeck's perspective. Büchner's play, written in 1836, is pre-expressionist in the sense that the realistic small-town background is preempted by the protagonist's visions and fantasies and by the caricatured portraits of his tormentors who

are expressionist types without names. The resulting distortion is fully con-
veyed by the typically hypertrophied music, as for example in Wozzeck's
end-of-the-world phantasms[29] that recall the terror of the woman in *Erwar-
tung*. Wozzeck's antagonists are overdrawn by wildly leaping vocal lines
and falsetto notes.[30] The march announcing the Drum Major's appearance
recalls Mahler in its mixture of pathos and grotesque.[31] But the most
Mahleresque, multi-level music occurs in the tavern scene in Act II. There
are two separate musics: one played by the main orchestra, the other by the
dance orchestra on stage which plays *ländler* and waltzes for the carousing
soldiers and apprentices. As Wozzeck watches Marie dance with the Drum
Major to the tavern music, he neither speaks nor sings with the dance or-
chestra, signifying that he does not join the carousal. Between dances, a
chorus of apprentices and soldiers bursts out with a romantic German
hunting song ("Ein Jäger aus der Pfalz")[32] which resembles the original set-
ting in rhythm but is harmonically so distorted that one can almost speak
of a Brechtian *Verfremdungseffekt*.

The Brechtian atmosphere is heightened by the instrumentation of
the tawdry stage music which consists of two fiddles, a clarinet, an accor-
dion, two to four guitars and a bombardon (bass tuba). The difference be-
tween Expressionism and the more realistic Brecht-Weill aesthetic lies in
the function of the music and the attitude of the composer. Berg's opera
is not didactic and follows no ideology; he does not distance himself from
the music or from the text, as Brecht and Weill do. Furthermore, Berg's
music is not a critical comment on the text and is not basically satiric.
Berg shares Wozzeck's agony; when he introduces the hunting song he
does not satirize it as such, but shows the gulf between the singing
carousers and the suffering protagonist who is one of the world's hunted.
The combination of the intensely dramatic main orchestral music, the
cheap tavern music, the distorted folksong and the mostly spoken voice
of Wozzeck is a classic example of the dissociative aspect of Expres-
sionism and its tendency to bring together extreme disparities. And final-
ly, Berg appeals to a much more limited audience than Brecht-Weill.

Much of the text of *Wozzeck* is declaimed in a *parlando* voice that
makes the words more clearly audible, while retaining the emotional in-
volvement that Brecht dismissed as "culinary." The score is extremely
complex and uses traditional formal devices, such as passacaglia, fugue,
sonata, rondo, theme and variations, but as in other expressionist works
these cannot be detected on hearing the music and are probably used to
control the extreme expressivity of the music. Because it is a stage work of
intense human emotions and because text and music are so well matched,
Wozzeck is probably the most accessible work of musical Expressionism.

A more contained expressionist work is Berg's *Violin Concerto*
(1935). As a piece of absolute music in a traditional form, it is a more
composed work; as a personal memorial to a dear friend and as his last
work, it has a transfigured quality unique among expressionist composi-
tions. Its inner program deals with life, death and resurrection, a familiar

pattern in expressionist works. As in much expressionist music there are dissonant climaxes[33] that mark a crisis, but in this work the first crisis leads to a chorale and the second to a serene close. The chorale is quoted from Bach's *Cantata No. 60,* with words written into the score by Berg that promise release in heaven from earthly woes. After the solo violin's intense variations on this theme, a reminiscence of a Carinthian *ländler* from the first movement is heard "at a great distance but much more slowly than the first time;"[34] the chorale returns and leads to the work's conclusion on an open chord, like the chord at the close of *Das Lied von der Erde,* that suggests musical and spiritual infinities.

This work, too, though serial, is not fully atonal. Its instrumentation is more modest; exceptions are an alto saxophone (also used by Berg in the opera *Lulu* and the concert aria *Der Wein*) and the large number of percussion instruments that include a high and a low gong. The music ranges from jagged brass outcries to the peaceful opening and closing pages. In combining a Bach chorale with a Carinthian folksong, the composer encompasses the religious and the secular, the exalted and the popular in a remarkable and moving synthesis that marks the swan song of musical Expressionism. The circumstances of this rhapsodic work, its haunting music, the composer's imminent death and the engulfing political catastrophe in Expressionism's home base make the Berg *Violin Concerto* a retrospective and prophetic work in the history of modern music.

The link with Romanticism is very strong in musical Expressionism. The wide instrumental, dynamic and emotional range, the leaping phrases, the lack of rhythmic variety, the preference for vocal settings and the element of the fantastic show a close kinship with German romantic music. The big difference is the lack of tonality in expressionist music. It is the conflict between the recognizable provenance of this music and its extremely dissonant setting that makes it so strange to listen to.[35]

Tonality in music may be likened to realism in literature and perspective in painting, but it is more deeply ingrained than either of them. Its abandonment is therefore a more radical development than the abandonment of realism. Giving up tonality makes music, the most abstract art, even more abstract. It is for this reason that expressionist music is harder to understand than expressionist literature and art. An important factor is the difference in medium. One can look at an expressionist painting or read an expressionist poem more easily because their representationalism does not depart from previous art or literature as greatly as works of musical Expressionism do from their predecessors. Furthermore, a painting or poem can be apprehended more directly — without the mediation of performers or previous technical knowledge — than a musical work.

Tonal music is in some way, no matter how distantly, derived from or related to folksong or dance. This is not the case with expressionist music

which is both harmonically and rhythmically far removed from the pulse and spirit of folk music. Unlike the music of Bartok and Stravinsky, whose relation to folk music is more direct, expressionist music is highly stylized, lacking in rhythmic drive, and forbiddingly esoteric. It is extremely sophisticated music, being highly thought out and texturally complex. Having said this, one must also acknowledge its expressive power. At its best it reaches deep into the psyche; beginning with the piercing outburst in the first movement of Mahler's unfinished *Tenth Symphony,* this music is a cry from the depths. It expresses terror, agony, anguish, chaos, shock. More than expressionist art and literature which have an ecstatic dimension, expressionist music is somber and foreboding. It is music of unrelieved grimness.

For these reasons it remains a difficult stumbling block for listeners and even performers. Its importance lies in greatly extending the expressive and technical range of music, in its power to communicate spiritual torment. In contemporary music this influence can be heard in the compositions of Luciano Berio, Krzystof Penderecki and George Rochberg, to name only a few. While Expressionism has been most successful in the plastic arts, its impact on music has been the most radical.

Notes

[1] In her memoir of Mahler, Natalie Bauer-Lechner quotes the composer as follows: "When I want to produce a soft, restrained sound, I don't assign it to an instrument that can play it easily, but I give it to one that can produce it only with effort and strain, in fact often with overexertion and by going beyond its natural range. Basses and bassoons must often squeak on the highest notes, the flute must puff deep down below." Natalie Bauer-Lechner, *Erinnerungen an Gustav Mahler* (Leipzig-Vienna-Zürich: E.P. Tal and Co. Verlag, 1923), p. 151.

[2] See measures 7-16 in the orchestral score published by Belwin-Mills Publishing Corporation (New York, 1973).

[3] Henry-Louis de La Grange, *Mahler,* Vol. 1 (Garden City, New York, 1973), p. 375.

[4] Measure 545 in the score edited by the Internationale Gustav Mahler Gesellschaft and published by Universal Edition (Vienna, 1974).

[5] Charles Rosen, *Arnold Schoenberg* (New York: Viking Press, 1975), p. 14. The quotation is not literal.

[6] Theodor W. Adorno, *Mahler* (Frankfurt/Main: Suhrkamp Verlag, 1960), p. 38.

[7]Willi Reich, *Arnold Schönberg oder der konservative Revolutionär* (Vienna-Frankfurt-Zürich: Verlag Fritz Molden, 1968), pp. 64-65.

[8]H.H. Stuckenschmidt, *Schöpfer der Neuen Musik* (Frankfurt/Main: Suhrkamp Verlag, 1958), p. 166.

[9]See measures 375, 381, and 412 in the version for full orchestra published by G. Schirmer, Inc. (New York, 1963).

[10]Eberhard Freitag, *Arnold Schönberg in Selbstzeugnissen und Bilddokumenten* (Reinbek bei Hamburg: Rowohlt, 1973), pp. 39-40.

[11]Reich, *Arnold Schönberg,* p. 48.

[12]Ibid.

[13]Freitag, *Arnold Schönberg,* pp. 42-44.

[14]See his comments at the end of the score published by the Insel Verlag (Wiesbaden, 1959), especially p. 76.

[15]Rosen, *Arnold Schoenberg,* p. 14.

[16]Freitag, *Arnold Schönberg,* pp. 53-54.

[17]Malcolm MacDonald, *Schoenberg* (London: Dent, 1976), p. 114.

[18]Rosen, *Arnold Schoenberg,* p. 20.

[19]The titles as they appear in the revised version of 1949 (New York: Henmar Press, Inc., 1952) are: 1. Vorgefühle — Premonitions; 2. Vergangenes — Yesteryear; 3. Sommermorgen an einem See (Farben) — Summer Morning by a Lake (Colors); 4. Peripetie — Peripetia; 5. Das obligate Rezitativ — The Obligatory Recitative.

[20]Josef Rufer, *Das Werk Arnold Schönbergs* (Kassel: Barenreiter-Verlag, 1959), p. 15.

[21]Rosen, *Arnold Schoenberg,* p. 45.

[22]Specific parallels between *Die glückliche Hand* and Strindberg's *To Damascus* are pointed out by Karl H. Wörner in his book *Die Musik in der Geistesgeschichte. Studien zur Situation der Jahre um 1910* (Bonn: Bouvier, 1970), pp. 149-153. One common theme is the pride of the creative individual and his search for redemption. Strindberg and Schoenberg are subjective, confessional artists whose early interest in the battle of the sexes yielded later on to a concern with religious questions. When Mahler advised Schoenberg and his students to spend less time on counterpoint and more time on reading Dostoyevsky, Webern replied that they had Strindberg. (See Adorno, *Mahler,* p.96).

[23]A technical innovation used in *Die glückliche Hand* is the vocal declamation known as *Sprechstimme.* It lies between song and speech and requires the singer to touch on the indicated pitch but immediately slide away from it. Schoenberg's song cycle *Pierrot Lunaire* (op. 21; 1912) is written entirely for *Sprechstimme,* accompanied by a small instrumental ensemble.

This declamation which constitutes another radical step away from traditional music sharpens the meaning and impact of words and music.

[24]During this period Schoenberg was also active as a painter. An exhibition of 47 oils and water colors by him opened in Vienna on October 10, 1910. His painting was concentrated in the expressionist years and shows the same qualities as his expressionist compositions. They are visionary, distorted, stormy works usually painted against an abstract background. The mood is distinctly Gothic. Schoenberg was in touch with Gerstl, Kokoschka and Kandinsky, and contributed an essay, the song "Herzgewächse" (op. 20) and two paintings to *Der Blaue Reiter* (1912). For a concise discussion of Schoenberg as a painter, with examples of his work, see Freitag, *Arnold Schoenberg*, pp. 56-66.

[25]MacDonald, *Schoenberg*, p. 78.

[26]The slow movement of Mahler's Sixth Symphony is quoted in measures 99-101 of the March; Debussy's piano piece *La Cathedrale engloutie* is quoted in measures 110-112 of Rounds. Reference are to the score published by Universal Edition (Vienna, 1954).

[27]Willi Reich, *Alban Berg* (Vienna: Herbert Reichner Verlag, 1937), p. 56.

[28]Ibid., p. 55.

[29]Measures 266-302 and 435-441 of Act I in the full score, bilingual version, revised by H.E. Apostel in 1955 and published by Universal Edition, Vienna.

[30]Measures 134-136 of Act I, 216-222 of Act II.

[31]Measures 326-363 of Act I.

[32]Measures 560-77, 580-590, 636-640 of Act II.

[33]Measures 125 and 186 of the second movement in the score published by Universal Edition (Vienna, 1964) (Philharmonia Score No. 426).

[34]Measures 201-214.

[35]See Constant Lambert, *Music Ho!* (London: Faber and Faber, 1945), pp. 205-206.

16
Ernst Bloch and
Musical Expressionism

Tibor Kneif

It is possible to characterize the first two decades of the century as the age of Expressionism. But these years which were filled with unrest and uprooting pathos, and which included many unrecognized intellectual-artistic phenomena, did not stand exclusively in the service of inner expression. The general cultural-historical term signifies only that the expressionist movement molded the spiritual countenance of this brief but eventful epoch more deeply and energetically than the other currents such as Impressionism which was still alive and Jugendstil which was dying; then there were the incipient neo-Classicist and Futurist movements which were fighting for recognition along with numerous other tendencies.

But the difficulty in considering Expressionism historically, of unambiguously understanding its goals and means, is not only due to the multiplicity of parallel and contradictory movements. Even those works which were perceived by their creators as expressionistic, and which were characterized as such, exhibit considerable differences — indeed, more or less open oppositions of style and standpoint. The heterogeneity within the movement, the fact that almost every influential group of artists and writers possessed their own understanding of it, contrasts Expressionism

with its predecessor and nominal counterpart. In this sense, according to its aesthetic program and according to the works of art which bear its features, Impressionism can be seen as the final, objective-universal "modern" style — if one understands "modern" in this broad sense as against elevating the absence of a unifying style to a characteristic of the modern. Unlike its predecessor, Expressionism remained unclear to the last, even in its theoretical grounding, despite the ideological vehemence with which it was presented and justified.

Expressionism remained unclear because particular types of art — painting, literature, music — often exhibited differing points of connection, differing goals, and stylistic revisions, corresponding to their own development. It also remained unclear, however, with regard to the fundamental ideas where agreement was supposed to reign. In the attempts at intellectual self-understanding which stemmed from the pens of personally engaged authors, Expressionism appears sometimes as a glowing ecstasy, sometimes as a process of abstraction with devices and rules that can be learned. Sometimes it expresses an intellectual despair which, in the face of a collapsing world that was supposedly fixed and firm, searches for salvation in sublime dissolutions of form. Sometimes, in retrospect, we become aware of a predominantly ethically aligned and thus aesthetically indifferent, even anti-artistic, movement of social renewal directed to humanity as a whole.[1]

The utopian idea was at home in the intellectual life as well as in the art of Expressionism. It certainly shines through in the writings of Hiller, Kurt Pinthus, Alfred Wolfenstein, and others. Above all, a thesis by Gustav Landauer exercised considerable influence on the contemporary understanding of history; namely, that the collective development of humanity consists in the succession of "Topie" and "Utopie," of the establishment and dissolution of social and ideological structures (*Gebilde*) within history.[2] However, the utopian idea received its most enduring impact from Ernst Bloch.

His first work, *Spirit of Utopia* (*Geist der Utopie*), as well as most of his later ones, indicates that Bloch's basic philosophical problematic is rooted in the concept of utopia. In Bloch, the elaboration of the concept of utopia employs the same abstract Man which was peculiar to contemporary notions of reform along with those dichotomies which colored the entire expressionist movement. The same, vaguely sketched, image of man in Bloch's problematic enables a great longing for a better, ethically more purified future to appear and makes possible a grand expectation: the visionary image of the "self-encounter of humanity." Since Bloch's image of man was neither historically oriented nor grounded, the longed for man of the future necessarily had to be visualized without further specification, without being concretely embedded in the social and historical environment. This circumstance accounts for that harsh juxtaposition between the intended radicalism and the actual ineffectiveness of Bloch's philosophical "*Grundmotiv*," a problematic which flows from the dichotomy in the expressionist image of man himself.

As against the temporally conditioned one-sidedness which was connected with the earlier visions of the future by More and the so-called utopian socialists such as Saint-Simon, Fourier and Owen, Bloch's utopia brought with it a claim for universal human validity.[3] By avoiding any more precise description of content, Bloch is able to avoid becoming entangled in the narrow, historical perspectives which were peculiar to the earlier utopian demands unleashed by social and governmental abuses; in fact, Bloch rejects these as "utopian" precisely because of their short-lived actuality. But this generally comprehended utopia thereby not only loses its plastic vividness, but also that creative force which — by promoting the movement of broad social strata — made the utopias of the past important socio-historical factors.

Accordingly, from the beginning, the new utopia was to be based on a contentless formula. It arose in the following way: the utopian idea as such was separated from its historical embodiments and rendered autonomous as a mere thought-model (Denkmodell). The content remained unrealized as the presupposed utopian framework — the projection of a never to be realized future — thereby assumed primacy. The future as a formula of thought, divorced from all substantial reality and as a temporal dimension of the "not-yet existing" (Noch-Nicht-Sein) thus obtains a decisive categorical significance. This is essentially no different than with Kurt Pinthus. Though he lacks Bloch's painstakingly observed conceptual as well as linguistic differentiations, in the most welcome candor he can write: "When I say 'future,' I mean the future in itself, the future as idea — the eternal future which, from any point, from each point of the spatio-temporally named eternity, extends before man variably."[4]

The same alignment towards the future, towards the "future in itself," determines the thought of Bloch. If, nevertheless, certain forms of the past emerge here and the memories of collectively known earlier utopias is called forth — corresponding to the demands which Gustav Landauer presented in his cited work on the continually recurring breakthrough of the spirit — those historical occurrences appear as utopias in their formal peculiarity without regard to their different, unique, and incomparable contents. In this way, Bloch can jointly relate the expectations of the future held by mystics, social reformers and the numerous religious sects throughout history simply on the basis of their common way of thinking that was indebted to the future; thus, collectively, he can count the Waldensians, the Albigensians, as well as Thomas Münzer, Rousseau, Kant, and Tolstoy as members of the "underground history of the revolution."[5]

It is easy to see that even this peculiar selection of presumed revolutionary forefathers is rooted in the expectations of the expressionist period. One thinks simply of the fact that in his poetry Georg Heym conjures such incommensurable "revolutionaries" of society and spirit as Columbus, Savonarola, Robespierre, and Napoleon. The drastic critique of Expressionism by Robert Musil — namely that it brought no enrichment

of spiritual content and never got beyond a kind of "gruff harangue of ideas"[6] — rests upon the observation of this formalized, motto-like thought concerning history. Similar to Expressionism, whose defenders were inflamed by abstract images — Musil speaks of suffering, love, eternity, goodness, greed, whore, blood, and chaos[7] — the reigning impulse in Bloch feeds on earlier utopias that were alienated from their historical context. This general peculiarity of Bloch's thought enables him to place revolution beyond once revolutionary ideas, utopia beyond earlier utopian ideals, and last but not least, art beyond present works of art.

Of course, this position traverses a longer epoch of recent intellectual history than the expressionist age. It was already increasingly noticeable in the nineteenth century. Its lack of content, however, exposed itself in all clarity exactly in the expressionist years. This feature indicates that those bearers of intellectual life increasingly lost any insight into the rising demands of social reality. The intellectual stratum of that time found itself in a spiritual as well as political no-man's land, enclosed on several sides by narrow boundaries which it dared not break through. Thus, on the one hand, this stratum dissociated itself from the offical ruling tendency of political conservatism but, on the other hand, it could not make the step to support the new, dynamic forces. Instead, the group lived its own pale ideals that were distilled from the rich tensions of social reality and still retained a certain sympathetic relation to the liberals — though, of course, in an equally abstract way. Its participation in the political events around the First World War and in the twenties, so decisive for the future fate of Germany, exhausts itself for the most part in the fact that it inflated certain emotionally colored ideas through pointed and excessive formulations — through just such a kind of "gruff harangue of ideas" — undermined them and rendered them meaningless.

During the Expressionism debate of the thirties, Georg Lukacs made a sharp critique of the political and ideological background, as well as the final artistic outcome of this movement. But, it was not only against Lukacs' all too simplistic claims that Bloch took his oppositional stance. There was more at stake: his entire conception of utopia, the continually recurring primary motif of Bloch's philosophy. He acknowledged once again at that time the fertile soil from which his utopian philosophy grew, particularly its most original observations and conclusions. In point of fact, the new utopia was unable to deny its reliance upon the conceptual baggage of the expressionist years. It derived from the same source as the expressionist movement, from an image of man that was drafted in an historically neutral fashion and projected into the eternal future. If the Blochian conceptual setting for utopia secures it a perspective that is free from any temporally conditioned, contingent content, and so fills it with an ethical sobriety — if it justifies the high pathos and the decisive grasp for the "unconditional" — in the final analysis its historical inadequacies undermine its philosophical consistency.

Above all, the prophetic obscurity of the language results in conceptual ambivalences. The complete lack of sharpness, precision, and plasticity cannot be traced back to Bloch's personal inabilities. Rather, these inadequacies ultimately testify to the original vagueness of the conception of man that lies at the foundation of the theory.

The numerous reasons why the notion of utopia was nevertheless able to exert considerable influence during the expressionist years can only be sketched here. Above all, many contemporaries saw the concept as more radical than the appeals of the socialists.[8] In addition, Bloch's opposition to the scientism of the preceding century — which was indifferently stigmatized by the Expressionists — was similar to his rejection of the exaggerated aestheticism and historicism that was developed by Ranke and the Romantics.

Accordingly, important themes of the expressionist movement coincide fairly exactly with Bloch's thought. This reciprocal influence not only explains the influence of utopian philosophy, but also its limits. In contrast to the Entente powers, for whom the consciousness of historical continuity was retained after the war, the notion of utopia found favorable soil in Germany where the military defeat and the collapse of political, social, and religious institutions supported by a blind faith in authority, allowed the call for a general renewal to spread. That artistic Expressionism in Germany could conquer more ground than in France — although the new art was propagated in other European countries and in America as well — rests upon this same difference between Germany and these other countries. Beyond this, France looked back in the areas of painting, literature, and music to an impressionist form which, around 1910, was stil quite influential. In Germany, despite the continuation of a naturalist movement that was clearly on the wane, a certain vacuum existed.[9]

It lies outside the scope of this analysis to follow the echoes of this notion of utopia — initially strong, but fading by the middle of the 20's. In any case, it is superfluous to prove further that Bloch's utopia bears the stamp of ethical formalism. Bloch may have become richer with respect to content in his later, thorough concern with Hegel. He may, in the meantime, have revised his understanding of objective irony in history — and that certainly implies an understanding of the kernel of Hegelian dialectic in general which, in *Spirit of Utopia* he still calls "reactionary." But, the outline of the projected problems and the direction for their solutions remains unaltered even though the somewhat petty-bourgeois opposition of "good" and "evil" — with which the usually fastidious Bloch judged so many forms of human conduct — gives way to more nuanced points of view.[10]

Numerous cases can be cited where the original vagueness of the utopian idea, conditioned by the circumstances already mentioned, takes possession of the analysis of Hegel and prevents the possibility of drawing any clear profit from that thinker's dispassionate views. To cite only one example, in his *Tübinger Einleitung in die Philosophie*, the dialectical progression which molds the *Phenomenology of Mind* is connected with mythical

representations of early social structures.[11] For that reason, it is possible to say that Bloch's later in depth confrontation with Hegel is far more revealing as an assessment of Bloch than as a scientific study of Hegel.[12]

Indeed, the more Bloch seeks to find an affinity with Hegel, the more Hegel emerges as his intellectual opposite. The impatient support for the utopian conception, over and against existing reality, itself proves to be the main hindrance standing in the way of a real kinship of the two thinkers. For their affinities prove to be of subordinate significance: the highly sensitive subjectivism, a kind of lyricism of the soul, which fills all the labyrinths of utopian philosophy and which often helps it to reach creative heights of linguistic expression.

It is this relationship to the "I" which also allows the dialectical process to depart from the solitary soul and end with it again after a campaign of conquest through the manifold richness of the external world. Hegel and Bloch: were not the comparison inappropriate for other reasons, there is the fact that Bloch's utopian philosophy culminates in postulating the unconditional "I" in its interiority. This is a position which ultimately leads to ethical solipsism since:

> The question regarding ourselves is the only problem and the disposition, disclosure, solution of this problem of the self — and the "we" in everything — is ultimately the only important goal, result, and idea; it is the pole and the basic notion of utopian philosophy.[13]

The extensive middle portion of Ernst Bloch's first great work, *Spirit of Utopia*[14] is concerned with a philosophy of music. Even if one leaves out of consideration the later, less noteworthy, utterances of the author — like an essay on the mathematical and dialectical essence of music, or shorter glosses on Brecht's *Three Penny Opera* and Stravinsky, along with the decisive and corresponding section of his encyclopedic main work, *The Principle of Hope*[15] — one would still be justified in breaking through the general and persistent lack of recognition which Bloch has been accorded in the field of music. For Bloch is one of the few who has taken an interest in music from the standpoint of philosophical reflection and who has given it a more or less systematic grounding.[16] That up until now only Paul Bekker — the reviewer of *Spirit of Utopia* — has given closer consideration to Bloch as a philosopher of music can only partially be explained in substantive terms. To those who have stubbornly persisted in excluding him from consideration, it must be emphasized that Bloch's ideological and political position can hardly be unequivocally clarified — in any case, it certainly cannot be associated with the crude conceptual schemes of a sluggish (Marxist) consciousness that is permeated with slogans.

An iridescent ambiguity adheres to Bloch's relationship with Marx. In regard to this sore point, it is downright surprising how comparatively

late it was before communist orthodoxy openly accused Bloch of "revisionist Marxism." For, not only Hegel, but also the equally impersonal thinker Marx, was only partially taken up and assimilated by Bloch's utopian philosophy. In fact, this assimilation was based more on a fundamental ethical intuition than on an epistemological viewpoint. To the young Bloch, Marx was essentially nothing more or less than, say, Thomas Münzer, the prophet and noble-minded dreamer who visualized a purified communal life of man which would be saturated with goodness and which would confront the petrified social structure of the existing order. Bloch, the ethical romantic, from the beginning emphatically rejected the sociological approach of Marx in favor of the so-called higher — spiritual (*geistigen*) and artistic — sphere. Indeed, Bloch was critical of Marxist doctrine during the expressionist years even though a considerable portion of the German intelligentsia looked to the socialists' endeavors with high hopes.[17] In short, even political prejudice should not delay the confrontation with Bloch's philosophy of music any longer.

Of course, there are also substantive hindrances which render access to Bloch's thought difficult. One of them involves the multiplicity of intellectual tendencies which are collected in the crucible of Bloch's utopian philosophy. At the same time, however, it is precisely the rich possibilities for various orientations which forms one of the most original features of this mode of thought. The early work already presents a kind of historical *Bildungsphilosophie*; there are various and strong reminiscences of the Kabbala, of the gnostics, of sectarian religious ideas that arose during the Middle Ages, and not least of that world of ideas which was portrayed by German Romantics like Novalis, Schelling, and Friedrich Schlegel. It is worth noting that it was precisely those who politically and ideologically turned toward the past, the "reactionary" advocates of the romantic spirit — to put the matter ironically — who most colored Bloch's philosophy of music. It is sufficient for the time being to remember the doctrine of the wandering souls in *Spirit of Utopia* in which certain themes from *Heinrich von Ofterdingen* shine through in a characteristically ethical re-interpretation. Bloch even harks back to the mystical doctrines and the chiliastic expectations of the Orient and connects them with certain embodiments of Restoration Romanticism.

Unmistakable, and important for our purposes in particular, is the affinity with Schopenhauer. This initially occurs not in Bloch's form of expression — as is well known, Schopenhauer formulated his thought in a clear and plastic language — but certainly in his form of thought. In the preface to the first edition of his main work, *The World as Will and Representation*, Schopenhauer wrote that his philosophy was like a living organism in which the part mirrors the whole and the whole conditions the smallest part. As Schopenhauer suggests, the work involves a single thought which continually recurs in a constantly altered shape and in manifold aberrations. A similar relation of individual thoughts and their relationship to the idea of utopia also characterizes the early work of

Bloch and his later works as well, a relation which is more nearly of an organic than of a logical derivation. If one attempts to impose the straightforward modes of discursive understanding upon the sinuous paths upon which the goal is to be sought, one will come away empty handed. With a naive disregard that is proper only to one who is ethically self-sufficient, Bloch forces upon his reader the gift, almost forgotten today, of presentiment and divination. If the reader does not surrender the rationally tried and tested mode of inquiry, then the inner richness of that "unique thinking" will reveal itself to him — if at all — only after repeated attack; it was not for nothing that Schopenhauer conveyed the advice to read his work twice.

The fact that musical art (*Tonkunst*) assumes a central place in *Spirit of Utopia*, also points to an affinity with *The World as Will and Representation*. As is well known, the overemphasis on music within the Romantic's experiential and intellectual worldview takes on a cosmological justification with Schopenhauer. In his view, which derives from Plato, music is not a copy of the ideal like the other arts, but rather a copy of a different world-principle (*Weltprinzip*), of will, from which ideas are derived. From an analogy — couched in terms of Being — which he draws between the world that is built up in strata and the four overlapping voices of the musical sentence, Schopenhauer concludes that an eventual conceptual explanation of music will ultimately be no different than an explanation of the world and the divination of its secrets.

The philosophy of music is for that reason the key with which general philosophy can unlock all the riddles of our world. According to the third book of Schopenhauer's major work,

> assuming that we manage to give conceptually a perfectly correct and complete explanation of music by delving into its particulars — a detailed reiteration of what it expresses — we would also immediately have a sufficient reiteration and explanation of the world in concepts or such a one that is quite consonant with this. It would therefore be the true philosophy.[18]

To be sure, for Bloch, this interpretation of music is too reasonable, too cold, and too easily abstracted from human beings. Nevertheless, music remains for him the highest of all the arts because it is the one which can lead man to his only salvation, to his inherent core, and his most inner being. The philosophy of music thus forms the hinge around which the questions of general philosophy can turn. Consequently, if further additional roots become visible in *Spirit of Utopia* that are embedded in the intellectual soil of German Romanticism, the admission of a chapter on the philosophy of music is to be understood not only as an after-effect of Schopenhauer's speculative thought, but rather — and perhaps even more — by the inherent "unique thinking" of utopian philosophy.

In the future "self-encounter of humanity," which Bloch had in mind above all, music appears as the medium through which the human soul

can express itself most purely and most immediately; that is to say, in a manner that is free from any compulsion due to alienated forms of understanding. Incidentally, the old German spirit holds sway even here; the notion preached by the romantic apologists of musical art and which was picked up by Wagner, namely that music begins at the point where the everyday language of the understanding fails, is given a utopian extension. One sees that, for Bloch, the relation between the central questions of philosophy is perhaps even more "organic" than with Schopenhauer and it is fair to say that all the important issues of utopian thought are contained within this inserted meditation on music.

Of course, the affinity which becomes apparent between the Blochian utopia and the romantic world of ideas does not result in a complete identity. It will be seen that music obtains a primarily ethical function in the total context of utopian philosophy that stands in contradistinction to the romantic theory of art where — in Novalis, Jean Paul, and the Saint-Simonians — music served as the preferred example and demonstrable object of a new epistemology and aesthetics of creation that was directed against the preceding rationalism.

A second distinction, however, is even more important. Bloch's philosophy of music mirrors the composition-praxis current at the time, which more or less was based on the principles of Viennese Classicism and which manifested an immanence of form. This was not the case with the Romantics who opposed a predominantly fantastic musical ideal — which was aligned with the aesthetics of genius — to the actual music which fundamentally contradicted this ideal. A close agreement therefore exists between Bloch's view — namely that music was increasingly relinquishing the chains of accepted forms — and the stylistic features of musical Expressionism which had already produced some representative creations by 1915-1917, the time in which *Spirit of Utopia* was born.

In fact, one can say that it was precisely the stylistic direction of expressionist developments that made it possible for Bloch to incorporate music as a utopian art *par excellence* into his wide-ranging theoretical construction. The primarily ethical and anti-formal expressionist ideal of humanity was incorporated into contemporary music around the turn of the century. This was what allowed Bloch to say that:

> There is rising a new, less conscious, archetypal emphasis of a having-something-to-say which does not at all fear the reproach of diletantism. Indeed, with diletantism, the *a priori* diletantism, the pure "aesthetic of content," attains a metaphysical level insofar as the intrinsic shoddiness of individual poverty, of the negative expression, is kept at a distance: the postponement of all enjoyment, the victory of self-expression over the work, the moral nominalism against all that is relatively autonomous and indirect.

In regard to the utopian demand of unconditional self-expression and the self-encounter of humanity, the other arts prove too mediated —

language is too relatively autonomous — not excepting the ecstatic self-revelation in the novels of Dostoyevsky that still revealed something like a metaphysical abyss of the soul for the expressionist generation. Only music can fully construct the bridge to the utopian aim.

> Earlier when one was closer to oneself — that is, before the eyes had thickened, before there was the modern style, stylization — there were winged bulls, higher columned places, the mystery of the transept, fairy tales, the transcendental connections of the epics. One had in these cultural forms the godly life itself in contrast to an artistic-descriptive view. It is the same which now — close to us in the narrow space of subjectivism — differently, with more melancholy, with more of the evening mist, more warmly illuminates itself; it is the same thing which allows us to form the Dostoyevskian and Strindbergian sphere of a pure reality of the soul, of a pure, moral "transcendence" of the encounters, the conflicts of hate, the fullness of love, the fully supersocial human-like. Colorfully, in this reflected splendor, we have this life, this sermon. But if one looks into the hidden sun itself, then it is no longer art as an ever formed, virtually reverting value symbol. Rather, it is "I"; the inner, imageless, indeed quite genuinely work-less searching for God in which the objective so little appears as a useful construct that *only* I alone, the re-birth, the contrivance of the heart, appears as the work. We have a morality and a metaphysics of inwardness (*Innerlichkeit*), a new, mediumless stance in the existence of subjectivity which clearly separates the immanence of the artistic object from the transcendence of that posited or religious object.[19]

Ignoring the social as well as the specific causes which led to the gradual atomisation of formal elements in the post-romantic history of music, Bloch sees in music the metaphysical language of the New Man. According to him, music will adequately express the deep inwardness of man, his essence and inherent core, when it throws off formal shackles. Music will resound when the possibilities of a merely rational comprehension — in Bloch's words, interpretation, explanation and mimetic gesture — break down in the face of the "unconditional."

From this standpoint — Jean Paul expresses similar thoughts in his novels *Die Unsichtbare Loge* and *Flegeljahre* — Bloch sees himself verified by the more recent musical developments. For him, the expressive content of this art — what he calls the genuinely musical — increasingly realizes itself in the contemporary history of music. It is significant that Bloch even further sublimates the already abstractly represented Man of Expressionism who is reduced to a concept that is divorced from any historical-rational relation to the external world. Like Bergson, and following his doctrine of the *duree vraie*, Bloch considers the unarticulated and unconscious, the "not-yet-conscious" as the true and genuine form of human existence. As a consequence, Bloch will evaluate

past expressions of musical style — which like Mozart's form of composition exhibit a clear immanence of form negatively. Objective form in music, according to Bloch, conceals what is essential. Only after its liberation from form will music — as the unconditional expression of the "I" — become "musical" in the sense for which, again according to Bloch's understanding, Mahler paves the way.

More than in Schoenberg whose crucially important works like *Erwartung* and *Die Glückliche Hand* were already written in 1909 and 1913 respectively, but which were only performed in 1924, Bloch sees in Mahler the culmination of the expressive impulse. For Bloch, the composer of hymn-like closing phrases and the *Lied von der Erde* reveals aspects of an unsuspected, visionary music. Indeed, Mahler plays a role on the horizon of Bloch's philosophy which is similar to the one which Dostoyevsky played in Georg Lukacs' *Theory of the Novel*. "The decline of our days is," Bloch writes, "that the pure, soul-like, musical expression demands to be an ornament." He says about Mahler, "No one has hitherto been carried closer to heaven in the power of the most soulful, thundering, visionary music than this holy, hymn-like man full of longing."[20]

Thus, it becomes apparent how closely the presentiment of artistic renewal is entwined with the peculiar atmosphere of the second coming in this expressionistic credo. The idea that it is incumbent upon the new music to purify man, to lead him to himself, and to prepare him for the reception of a mystical Messiah, impregnates the work of Bloch in numerous places, even in his metaphorical language.

As natural as it may appear to immediately derive this mystically stamped understanding of music from Bloch's entire philosophical endeavor — particularly from the influences of Jewish mysticism, the gnosis, and Hassidism — so little can the continually manifested undervaluating of conceptually communicated intellectual content be understood as merely a personal idiosyncrasy. The rejection of the rational foundations of music is connected in the closest way with that turn towards the irrational, spiritual regions which characterized the intellectual life of the pre-war period. It emerged partially as a countermovement to the dogmatic empiricism and positivism of the expiring nineteenth century. At the same time, it is also a symptom of the fact that the mechanisms of economic and social change — so rich in multi-faceted relations, yet ever more ignored in immediate life-experience — appeared to the contemporary consciousness as ultimately inexplicable, rationally incomprehensible, as a matter of fate. To give only one example, which at first glance may appear arbitrary, let me cite an essay written in 1909 by the philosophical author Keyserling: "We must accept as an ultimate fact the framework in which the inherited nature, the universal course of events, and pure chance have placed man; it is not for our concepts to ground this framework."[21]

Bloch gives expression to the same basic attitude with the following words: "The causal nexus of this world is so arbitrary and foreign to us —

we ourselves are in the middle of it, roughly, unsettlingly implicated a thousandfold and abandoned to the affinities of chance, of which one says a great deal when one calls it chance."[22] It was already a consequence of this consciousness regarding the unknowability of the "general course of events" (which nevertheless manifests itself in and through man) that numerous powers of the unconscious, the metahistorical and particularly psychical foces were made responsible for humanity's fate.

Prepared by Schopenhauer and Eduard von Hartmann's *Philosophy of the Unconscious*, the inexplicable and unconscious became deeply moving experiences for the generation of 1900 to 1920. This was so, whether it made itself felt in Gauguin's injunction "soyez mysterieux" or in the mystical philosophy of du Prel, whether in the strange prescriptions for the performance of Scriabin's piano sonatas or in Steiner's theosophy, whether in the psychology of Freud, or in the ethical subjectivization of life. It is characteristic that during this period, Meister Eckhart, Jacob Böhme, Angelus Silesius, Baader, and Kierkegaard became popular philosophers. Neo-Kantianism and the Hegel renaissance remained more or less academic concerns. Not them, but rather Schopenhauer, Nietzsche, Bergson, Simmel, and, in America, William James determined the spiritual orientation of the intellectuals.[23]

All these different colorings of the irrationalist intellectual current led seamlessly to the express denial of the relevance of social and economic connections for the destiny of humanity. Even where the Expressionists — the culminating point of this development — acted particularly true to life, "vitalistic" and "activistic," they retained their belief in the fundamental inexplicability of external reality; indeed, many times it was the withdrawal from reality which motivated activism for action's sake. The decisive feeling which the Expressionists had of the chaotic condition of the outside world is clearly expressed in the following theses of Kurt Pinthus:

> Nature is everything existing outside, everything which surrounds and is against man, the chaotic, unknown; the strongest bulwark against the ordering, self-realizing force of the spirit. . . . Reality is not outside us, but rather in us. . . . All the great ideas of mankind did not engender themselves through the force of the facts, not through the demands of reality, but rather immediately out of the self-creative, future-directed spirit of man.[24]

This feeling of life also lay at the base of the slogan of "heroic optimism" which circulated at that time; Bloch's later formulation of "optimism with mourning crepe" more or less expresses the same attitude.[25] This experience of chaos was even explicitly viewed as the presupposition for artistic creation: "It is not possible to know the deepest essence of forms without the experience of nothingness. . . . Form is the bulwark which defends our life against the chaotic. Form is the weapon which grips the dark and pushes it back."[26] It is quite similar with Max Picard,

who applies a thesis of Worringer's to a characteristic stylistic means of poetic Expressionism:

> Out of the chaos in which things hardly have a name, in order that they above all can be able to call out to everyone, out of this *nameless* chaos the new, expressionist man summons the thing itself. He invokes the things by their *names,* saying "you, forest" and "you, city," in order that the forest and the city will be once again put in order out of the chaos.[27]

The discovery of the unconscious which the intellectual life of the pre-war period viewed as taboo was soon recovered in music. In this regard, Kurth's energetic method played a pioneering role. It arose originally, of course, out of the necessity to overcome the one-sidedness of Riemannian intellectualism. Nevertheless, in its final form, and according to its effect, it endeavored forthwith to replace the entire aesthetics of music with an apparently exact psychologism. The new appreciation of Bruckner's music also stands predominantly in the service of irrational intuitions. When August Halm, one of the main adherents of this revaluation attempted in all seriousness to establish the superiority of Bruckner the phrase-technician over Beethoven, this over-valuation — conditioned of course through his own taste — was less symptomatic and much more a "timely" way for Halm to objectively justify his personal predilections. In his informative work on the symphonies of Bruckner, he writes:

> We experience something like a pre-time, something nearly atemporal; time and even the event itself are initially granted to us only gradually. With Bruckner, for the first time, we feel totally the holiness of the primordial; we believe we are breathing something like the air of creation when we are bathed in the first notes of his seventh, ninth, and fourth symphonies [i.e. Bruckner's]. We sense it: a piece of music does not begin here; rather, music itself commences. The classicists were able to introduce us only to momentary pieces of music. In rare cases they offered us at least an intimation of a genuine musical beginning. . . . Bruckner begins with what is necessary for history to occur.

It is no accident that Halm considers the unique formal quality of the classical musical work a defect. In his book on Beethoven, he speaks of music as a "fully irrational, not logically deducible phenomenon" and as a "mystical being."[28] The concept of the "willing of form" (*Formwillens*) is also most effectively championed by Halm. This will-to-form is no different than Kurth's tone-will (*Tonwille*) or Schoenberg's "willing of a tone" (*Wille eines Tons*) or Bloch's "will of key" (*Wille der Tonart*); it is supposed to explain the developmental features of historical epochs of music or melodic and harmonic solutions within a single work. The tone is thereby granted an independent role in the creative process and, in this misunderstanding, genuine composition appears as essentially nothing more than a kind of

discharge of the tone will (*Tonwillens*). It is no mistake to see in this favorite notion of that time a counterpart and supplement to the emphasis upon fate characterized above; what results is a fetishism of tonal processes which are, of course, induced by the composers themselves even though they are seen as essentially independent of it.

Bloch's view of music can, in no small part, be traced back to the ideas sketched above. The ruling tendency in his understanding of music comes to light insofar as he follows not Hanslick and Riemann, but rather Schopenhauer, Halm, and Kurth. The fact that he draws his information not from musical historians, but from already finished musical interpretations is also characteristic for him. This can be observed again and again in his expositions and also explains the many generalizations — such as the view, first expressed by Halm, that with Beethoven detail is wholly unimportant and, in contrast to Bruckner, only the plan for the whole has meaning. Bloch even "improves" upon these aestheticians. For, as practical musicians, they always bear in mind the rational point of view from the standpoint of their craft, and so occasionally avail themselves of analyzing musical form. Thus, Bloch asserts against Halm: "He does not know or recognize the naive, expressive music making (*Musizieren*) which is inaccessible to formal criticism and which mirrors a man and not a form of work."[29]

In all these perspectives on music literature during the expressionist years, it is not a question of some purely personal perference for the so-called mystical aspects of the musical art. Instead, these ways of posing questions and their effects upon musical aesthetics were the result of a broad cultural-historical movement. This movement increasingly led to the prevalence of irrationalistic interpretive attempts, again not so much within the scientific research at universities as in the half-scientific and popular literature which was tailored to the interests of the numerous bourgeois and, above all, petty-bourgeois admirers. Thus, it is no exaggeration to claim that musical aesthetics in the first quarter of the century made a contribution to the predominant occultism of the expressionist epoch with regard to interpretations of cultural, economic, and social phenomena.[30]

Objectively considered, this growing irrationalism in musical aesthetics conjoined with those ideological and political forces which were guiding Germany down the path to 1933, even where directly political viewpoints did not play a role in leading musical aesthetics in that direction. It would, however, be no less nonsensical to maintain that these perspectives on music had anything directly to do with the preparation of the Third Reich. In this respect, what comes most quickly to mind — like the statements about the new Reich, the anticipation of the thousand year Reich, and a future messiah — retains more of an unintentionally macabre significance than a prescient power of prophecy for the later reader.

The temporally conditioned hopes and expectations which precipitated expressions of this sort were, in addition, also implied by Halm, Hermann Scherchen and others in visions of a rousing, redeeming,

future music. Such expressions, to which a later generation can react with understandably keen hearing, can better be understood in their cultural-historical context; that is, when one brings to mind that in the general confusion and reigning helplessness unleashed by the great events of that time, the cry for a commanding leader resounded everywhere. In that atmosphere of longing and unfulfillment — to use one of Bloch's terms — every salon held a cup of tea ready for the messiah.

Nevertheless, the fact that the utopian view of music could not resist the darkening of the intellectual horizon is not easily dismissed. Bloch's philosophy did not unambiguously oppose the mythification of life, which Nietzsche had introduced in a more exacting fashion. On the contrary, it freely supported the mythification on aesthetic soil which culminated in the shabby "myth of the twentieth century."[31]

Basically, this problematic remains unchanged by the fact that the *Kulturpolitiker* of the Third Reich attacked Expressionism along with every other artistic tendency that did not correspond to petty-bourgeois Nazi notions of spiritual health. Just as little is altered by the fact that Bloch had to leave Germany later. Here, he only shared in the lot of those who had themselves formatively participated in a process whose fateful outcome they did not suspect and did not want. Like Fritz Lang, in whose *Metropolis* of 1926 the hazy image of "man," of "brother," returns in an instructive way only to be mixed with syndicalist, even pre-fascist social theories, Bloch's rejuvenation of certain speculative romantic notions stems from the same inclination toward false depth. This also includes the cold, even impatient attitude towards the Renaissance and particularly the century of Enlightenment, which Bloch disparagingly calls a corner in western Europe. Bloch candidly surrenders Voltaire — the Enlightenment's most significant, although not always deepest representative — to the well rooted hatred of certain institutions in order to gain a more reconciliatory attitude on the part of the Catholic Church toward Kierkegaard.[32] Stimulated by the aesthetic works arising at that time which, in music, exposed more the mystical than the formed and concretely historical, Bloch coined the formula which governs his comprehension of music; namely, that music "is not there for the purpose of protecting or being protected from the mystical."[33]

Translated by Randall C. Hickman

Notes

[1]For a self-interpretation of the various directions of this time, compare Paul Portner, *Literaturrevolution 1910-1925*.

Dokumente-Manifeste-Programme. Zur Begriffsbestimmung der Ismen, Hermann Luchterhand o. J. (the Mainz series, v. 13, II).

[2]Gustav Landauer, *Die Revolution*, Frankfurt on Main 1907 (*Die Gesellschaft*, a collection of social-psychological monographs, ed. Martin Buber, v. 13).

[3]An author in the collection *Ernst Blochs Revision des Marxismus—Kritische Auseinandersetzungen marxistischer Wissenschaftler mit der Blochschen Philosophie* (Berlin 1957) reproaches Bloch for overemphasizing the individuality of man and falling as a result into idealism. Some of the authors of this collection have distanced themselves from Bloch, who obviously grossly misunderstands the anthropological departure point of Marxist thought and also distinguishes himself, moreover, through primitive simplifications.

[4]Kurt Pinthus, "Rede fur die Zukunft," in *Die Erhebung, Jahrbuch für neue Dichtung und Wertung*, ed. by Alfred Wolfenstein, Berlin 1919, p. 398.

[5]Ernst Bloch, "Vom Anbruch gemeinsamer Meinungen," in *Die Erhebung* 2, Berlin 1920, p. 253.

[6]*Der neue Merkur* VI, 1922.

[7]See Georg Lukacs, " 'Grösse and Verfall' des Expressionismus," (in *Schicksalswende — Beiträge zu einer neuen deutschen Ideologie*, Berlin 1948, p. 180ff.) and Ernst Bloch, *Erbschaft dieser Zeit*, Frankfurt 2/1962, p. 255ff.

[8]See for example Arthur Holitscher, "Das Religiöse im sozialen Kampf," in *Die Erhebung* 2, p. 325.

[9]It is no less characteristic of the German Expressionists that they interpreted themselves as bearers of a renewal "of a primordial affinity [*urverwandten*] with the German being." As a result of this they made their self-understanding more difficult. Bloch wrote in 1918 that "the expression, the great raging, singing, commanding, passion — plunged into the depths — for the what, the content, the goal is of a primordial affinity [*urverwandt*] with the German being and here comes to an open, Gothic exuberance."

[10]Not only did Bloch earlier place Kant high over Hegel, rather he applied the cited pair of concepts as a criterion with respect to Hegel. He was of the opinion: "For whom it goes well, it is easy to be good. Even Hegel does so, but in the wrong place, not being good, but rather finding everything good, in order not to have to be good."

[11]*Tübinger Einleitung in die Philosophie* 1, Frankfurt 1963, p. 98.

[12]*Subjekt-Objekt. Erläuterungen zu Hegel*, Frankfurt 2/1962.

[13]*Durch die Wüste. Frühe kritische Aufsätze*, Frankfurt 1964, p. 114.

[14]Munich and Leipzig, 1918. When not noted otherwise, in the following notes, reference will always be made to the second edition (Berlin 1923), because Bloch himself considered it as the definitive form of the earlier developed ideas.

[15]See *Von neuer Musik — Beiträge zur Erkenntnis der neuzeitlichen Tonkunst*, Cologne 1925, pp. 5-16; *Erbschaft dieser Zeit*, loc cit., p. 230ff. and *Das Prinzip Hoffnung*, Frankfurt 2/1959, pp. 1243-1297.

[16] Schilling's *Versuch einer Philosophie des Schönen in der Musik* (1838) comes to mind here above all, which presents nothing more than a kind of general doctrine of music and eclectically reiterates the thoughts of that time — Schelling, Bouterweck, Hegel, Solger, etc. — concerning the aesthetics of music. In any case, the works of Mazzini, Fetis, and Beauquier in consideration, measured by the result produced, are too excessive by far in their titles.

[17]See for example *Die Erhebung* 2, p. 252.

[18]Arthur Schopenhauer, *Sämtliche Werke* I, Wissenschaftliche Buchgesellschaft, Darmstadt, 1961, p. 369.

[19]*Geist der Utopie*, 1918, p. 182ff.

[20]*Geist der Utopie*, p. 20 and 83.

[21]Graf Hermann Keyserling, "Das Schicksalsproblem" in *Philosophie als Kunst*, Darmstadt 1920, p. 144.

[22]*Geist der Utopie*, 1918, p. 384.

[23]See Heinrich Rickert, *Die Philosophie des Lebens — Darstellung und Kritik der philosophischen Modeströmungen unserer Zeit*, Tubingen 1920, for the spiritual situation of this epoch.

[24]Kurt Pinthus, "Rede fur die Zukunft" in *Die Erhebung* 1, p. 410/412.

[25]*Philosophische Grundfragen I. Zur Ontologie des Noch-Nicht-Seins. Ein Vortrag und zwei Abhandlungen*, Frankfurt 1961, p. 39.

[26]Wilhelm Michel, "Tathafte Form" in *Die Erhebung* 1, p. 348/349.

[27]Max Picard, "Expressionismus" in *Die Erhebung* 1, p. 332.

[28]August Halm, *Beethoven*, Berlin 1927.

[29]*Geist der Utopie*, p. 115.

[30]See for example Fritz Stege, *Das Okkulte in der Musik — Beiträge zu einer Metaphysik der Musik*, Münster 1925. The work combines the telluric, cosmic, magical and spiritual aspects of music and is, characteristically, dedicated to the members of the society of the German Rosicrucians.

[31]To mention it only as a curiosity, in the first edition of *Geist der Utopie* the Prussian-military form of life and the person

of Wilhelm II are warmly praised. Polemic is even directed there against "the liberal carelessness of the western states, toward the mess [*Schlamperei*] of their democracies, toward the irresponsible diletantism of their freethinking" (*Geist der Utopie*, 1918, p. 297).

[32]*Geist der Utopie*, 1918, p. 268.

[33]*Op. cit.*, p. 132.

17
The New German Dance Movement

Manfred Kuxdorf

The significance of dance as part of the expressionist movement has long been ignored. In particular, German Dance, the interpretative form which began at the turn of the century, spawned an entire movement known as the *Neudeutsche Tanzbewegung*. This movement shared basic concepts with both the visual and the literary arts that spanned the two decades of Expressionism; the most striking agreement can be seen in the goal of the creation of a New Man, the regeneration of humanity. Beginning with an overview of the interaction of literature and dance, this essay sets out to elucidate some of the major tenets of the New German Dance Movement, by showing its impact on other Expressionists, and by discussing its critical reception.

The temptation to trace the history of dance back to the culture of antiquity is tempting, but would far exceed the confines of this chapter. Gottfried Herder recognized that for the ancients the art of dance constituted the assembly of all the arts, an idea that found a receptive echo in the New German Dance Movement. Herder's concept of dance, however, as the *Versammlungspunkt der Künste* would be unequivocally endorsed by the protagonists of modern dance:

From the art of sculpture, dance borrows beautiful bodies; from painting beautiful positions; from music arduous expression and modulation; to all this it adds lively nature and movement.[1]

It may come as a surprise to learn that the role of dance, both as a motif and as a topic of discussion, has not been dealt with in any systematic way in German literary history. One needs only to look at the dance of death in medieval times, the *Reyen* in the drama of the baroque period, and the function of dance in Grimmelshausen's *Simplicius Simplicissimus*, in order to recognize its importance in the field of letters. An abundance of examples could be listed ranging from Reuter's *Schelmuffsky*, to "Klingsohrs Märchen" in Novalis' *Heinrich von Ofterdingen*; or one might think of Gottfried Keller's *Tanzlegendchen* and Heinrich Heine's *Die Heilige*. Wolfdietrich Rasch has pointed out how decisive dance became at the turn of the century as a dramaturgical tool, as a means of emancipation, and as a symbol of life.[2] He singled out as examples the works by Henrik Ibsen, Gerhart Hauptmann, and Hugo von Hofmannsthal.

Hofmannsthal is known for his deep seated skepticism about the communicative value of the word, in particular of poetry. In the fictional "Letter to Lord Chandos" (1901)[3] literary historians have seen the culmination of Hofmannsthal's crisis of language from which he moved to seek expression in dance-oriented dramatic productions. Evidence of this can be seen in his work with Grete Wiesenthal on a pantomime or his plans for a dramatic creation based on the Salome motiv, a work which he had planned expressly in admiration for Ruth St. Denis, a dancer who appeared in Germany from 1906 to 1908. The superiority of dance as artistic expression, as a "language of gestures," *Gebärdensprache*, is stressed in Hofmannsthal's essay of 1911, "Über die Pantomime." Through pantomime and in turn the "rhythmic repetition of movements . . . a state of mind more compressed and more significant can be conveyed than through language."[4]

Hofmannsthal expresses, in this essay, a sentiment which found a wide-spread echo among those adherents of a newly founded rhythm culture. German youth in search of a more meaningful life had turned to the ersatz religion of Wilhelm Bölsche and Ernst Haeckel, a popular philosophy derived in part from German Idealism and in part from English Darwinism, allowing, among other things, greater awareness of the body. The *Wandervogelbewegung*, the *Turnerschaften*, and the New Dance Movement were all part of this multi-faceted, secular oriented philosophy, often totalitarian in its aspirations. At first, around 1900 to 1910, these movements were concerned with the aesthetic man, then gradually they shifted to a social and revolutionary orientation around the German Revolution of 1918 and the early twenties.

A rising awareness of the significance of art, and the need for a re-evaluation of the concept and purpose of art, led the younger generation to a multitude of experiments in the visual as well as in the performing

arts. In Germany it was the school of Rudolf von Laban that brought forth significant personalities and followers in the field of dance and choreography. What had started at the turn of the century with the veil and serpentine dances of Isadora Duncan and Loie Fuller — both had originally come from the USA — spread across Europe and helped create an awareness of this new type of dance form which later became known as expressive, or interpretative dance (*Ausdruckstanz*). In the English speaking world of the thirties this phenomenon was described as "New German Dance."

The towering figure of the New German Dance was Mary Wigman whose technique was taught at the Wigman Central Institute at Dresden, founded in 1920. In contrast to ballet, she favored angular symmetrics, stark costumes, and music that consisted mainly of percussion rhythms. Her somber, almost demonic dances hinted at the primitive drives of human nature by always appealing to the instincts. Often wearing a mask, Wigman felt that she was in contact with primordial forces which took hold of her. She was born in Hannover in 1886 and studied the rhythm-movement methods of Emil Jaques Dalcroze and later became a pupil of Rudolf von Laban, a pioneer modern dancer and innovator of the dance script now in world wide use called Labanotation. Laban and Wigman together codified the laws of physical expression which they called Eukinetics. Wigman's first tour of London (1928) and of the United States (1930) left a profound impact, especially in America, where one of her major assistants, Hanya Holm, opened a branch of the Wigman school in New York. Holm subsequently departed from the Wigman style and set dances for such well known musicals as *Kiss me Kate* and *My Fair Lady*.

While hardly known in Germany in 1919, Mary Wigman soon outstripped her teachers both in fame and influence. Her choreographic dance creations — she insisted on calling them "absolute dance" — were so idolized by the younger generation in Germany that she soon became an institution. Harald Kreutzberg, Yvonne Georgi, and Gret Palluca were her foremost pupils, who faithfully adhered to the expressive dance method, until in the thirties they succumbed to the temptation of integrating expressive dance with traditional ballet. This had also happened in Moscow where the ballet king Diaghilev had enriched his ballet by introducing certain features of the expressive dance.

In contrast to the traditional dance form, significantly determined by ballet, modern dance favored rhythm over clear cut movement. Souful expression instead of physical and technical perfection was stressed. This explains why it was called "expressive dance" and how it was linked to the general movement of Expressionism. This movement did not merely overlap chronologically with Expressionism, it shared many of the aspirations expressed in literary manifestoes and by groups of artists. Franz Marc, an important painter of the *Blaue Reiter* group, had revealed that in his painting he did not represent *a* horse or *a* forest, but that he showed them in "their absolute essence."[5] Georg Kaiser demanded that the vi-

sionary dramatist show the need for, and the possibilities, of man's regeneration: "One leaves the theater — and one knows more about the possibilities of man."[6] In this vein, we can understand the demands made on the expressive dance, that the very soul, the essence of man, should be revealed just as a plant reveals the soul by opening its blossoms. Flower and blossom like figures frequently became part of the interpretative dance, whereas the musical clock of precision effect of ballet was repudiated by this movement.

Enthusiasm for this new dance form seized both female and male dancers and individuals as well as groups and schools. In several German cities choreutic societies, such as the famous *Hamburger Bewegungschor,* were founded which were based on the teachings of Rudolf von Laban (Laban Art of Movement centers still exist in London and California).

From a cultural-historical point of view it was a fascinating development. In reviews and assessments of contemporary critics, the new dance was described both in glowing colors and in sober statements. Emil Utitz in his study *Die Überwindung des Expressionismus* makes the observation that what had begun with a concern for hygiene — basically an offspring of the naturalistic-vitalistic awareness — became instrumental in the coinage of the New Man. According to this concept, man was no longer seen as a rational being who would cleverly guard the body, but as one who would receive characterological impulses of a decisive nature through his physical activity.[7]

Rudolf von Laban stressed idealistically that one could see in this new dance not only a union of all muses — an idea very close to the earlier mentioned statement by Herder — but that man himself could become ennobled through dance.

> Whereas poetry is the language of the healthy and culturally restrained intellect, and whereas music springs from the realm of our feeling, so dance complements both of these art forms in that it ennobles by means of the interacting will and by assisting in rounding out the thinking and feeling process, thereby forming a person into a culturally valuable whole. Dance expresses things which cannot, or at least cannot be expressed as fully, by word, drama, or even music.[8]

The duality of human nature is touched upon repeatedly in critical literature of the first three decades of this century. For example, a struggle between the intellectually conscious ego and the physical body is depicted in Alfred Döblin's *Die Tänzerin und ihr Leib* (1913). However, the idea of unity of body and mind gains credence in such representative writers as F.H. Winther, who stresses that the totality of mind and body can be achieved through dance. For him, dance serves the function of preparing the fertile soil for what he terms "racial hygiene," a decisive ingredient in the development of *Führer und Volk.*[9] Conceived in a similar vein is the pronouncement by Arnold Schmieder, who emphasizes the

unity between body and soul, but who also sees in dance a possible reactivation of the nordic man, or what he terms the "five dimensional man" who has been liberated from the yoke of the dualistic antipathy as derived from the southern religions.[10]

While one may recognize in these trends significant antecedents of fascist thinking and the subsequent rise of National Socialism, not only "Volkstümler" and "Rassehygieniker" saw in dance a means for the salvation of society. In a remarkable article published in the social-reform oriented journal *Die Tat*,[11] Artur Jacobs passionately extolled the inherent virtue of dance as an instrument for providing mankind with genuine pleasure as opposed to the suffocating pseudo-existence which contemporary society offered. Jacobs identified the curse of mankind as the mechanized system, the empty intellectuality, the atmosphere of futility and hollowness, the all-pervading smell of fraud and self-deception in which all spiritual values become either instances or objects of gratification, and in which so-called ideas serve predominantly as symbols in the interest of commercial profit.[12]

Proceeding from his observations of contemporary society, Jacobs emphasized the changes that could be brought about through collective education in rhythm and dance. All other art forms would stand to benefit, including the study of philosophy and the discipline of epistemology (*erkenntniswissenschaft*). Jacobs failed to indicate how this new "Copernican revolution" could come about in practical terms.

Frank Wedekind could be counted among those who have attempted to find practical applications for the idealism expressed by the dance movement. While being imprisoned for *lese majeste* in the fortress Königstein in 1900, Wedekind wrote a work entitled: *Mine-Haha or On the Physical Education of Young Girls*. He created a utopian setting in which young girls, by way of rigorous training in isolation from society, become beautiful human beings through the medium of music and dance. Some of these ideas later found their way into the teachings of Rudolf Steiner in whose schools an education in rhythmic consciousness became the cornerstone for those devoted to the muses.

There is a general consensus among those who wrote about the dance movement that dance has the capability of harmonizing the forces of *Geist*, *Körper*, and *Seele*. Rudolf von Laban goes one step further when he argues that there exist some areas of cognition which are only open to the dancer, that for the dancer there is a certainty regarding the things of the world not open to a non-dancer.[13] This almost mystical quality of dance could bring about a more soulful existence, an idea quite prevalent in Expressionism and also in the writings of Walther Rathenau.[14]

It is not surprising that this preoccupation with the mystical and with the inner life prompted yet another reaction, namely the *Girlkultur*, which refers to the revue dancers, the Tiller-, Ziegfeld-, and Hofmann-Girls-troupes, which adhere to mechanical and military precision in their presentations. In these groups rigor and exactitude replaced the interpretative nature of the New German Dance.

The New German Dance Movement

Warnings against the danger of burdening the dance with philosophical encumbrance were uttered by Ernst Blass. Dance, he maintained, should not be the representation of a world view, *getanzte Weltanschauung*. This would stifle the freedom of expressiveness and would undermine that heightened feeling of exuberance which dance can give.[15]

The theater critic Hans Brandenburg added his opinion in two different contributions, one on the decline of the art of dance ("Das Ende der Tanzkunst") the other on the promise of this movement ("Die Zukunt der Tanzkunst"). Brandenburg faulted the exodus of many teachers and artists from Germany during and after the war while recognizing in retrospect that the dance movement, as he saw it in 1919, had been an emancipationary achievement of the woman:

> It is her veritable emancipation, far bolder and more radical...than woman's entry into politics....With dance the woman has given mankind her third and last gift of redemption: the female dancer steps up next to the woman as lover and as mother.[16]

Touching on aspects of the future, Brandenburg expressed the hope that just as the Greeks had become a nation of theater goers, or as the unmusical Germans had become a nation of music lovers, so it would be desirable that an awakening to the art of movement might bring about a development which could turn the Germans into a nation of dancers. In paraphrasing Mephisto in Goethe's *Faust*, Brandenburg hopes that this elevation of dance might help the Germans to overcome their *Hinter- und Übersinnlichkeit* and bring about a lasting and extreme sensuality.[17]

A more recent assessment of the dance movement by Aurelio Millos (1965) admits that it had provided the much needed basis for the freedom to unlock those unfathomable possibilities for artistic creation. Millos deplores only the lack of fixed choreographic records which would benefit today's dancers. Even though the freedom of personal expressiveness must be seen as the very essence of the individual dancer, this critic reproaches Isadora Duncan for having basically been an anarchist and a demagogue who has been unable to leave behind a true school of followers. Wigman's abstract-elemental contributions to Expressionism are also lost because of lack of choreographic notations, Millos laments.[18]

The prominent dramatist of Expressionism, Georg Kaiser, more than any other literary figure, became occupied with the dance movement. Apart from parodistically referring to "Miss Isidora Buttersemmel" in his drama of 1923, *Nebeneinander*,[19] Kaiser wrote an entire drama, *Europa*, (Spiel und Tanz in 5 Aufzügen, 1914/15) in which he takes aim at the contemporary dance scene.

In his youthful work *Schellenkönig* (1895-96), Kaiser had mocked that form of dancing which was derived from the era of Louis XIV. Gracious stepping and stilted dancing according to etiquette were seen as symbols of an artificial society. Similarly in *Europa*, he presents men who have lost

their natural grace and robustness and who subsequently move about in an effeminate dance-like fashion, thereby representing a society which they ironically consider to be of the highest order:

> AGENOR: Dance represents the final step. In dance we have eradicated all of our coarseness to the core. In dance we found an expression of the complete restraint of the impulses. We have reached it, it should be the pinnacle.[20]

In a satirical exaggeration, dance comes to be regarded as an expression of total restraint of all human drives: "Dance as soul and soul as dance — dance as language of the soul."[21] Kaiser enacts here a realm where a supreme level of education has supposedly been achieved through dance. Yet in the final analysis and in its application, he portrays this idealism as ludicrous. Transposed into Greek mythology, Zeus appears in human disguise as a wooer of the young woman Europa. While assuming the same dancing manner of the other men in human society, he is laughed at and fails to awaken the passions of Europa. Only when he reverts into the well-known figure of the strong steer can Zeus become successful. The artificial stance of the men in Agenor's court is later contrasted further with the introduction of the robust warriors, who win over the passions of the girls at the court and who symbolize unbridled strength and healthy naturalness. Genuine life is identified as strong life: "Echtes Leben ist starkes Leben."[22]

Kaiser's drama also deals critically with the idea of weightlessness and the idea of the communicating soul in dance. Heaviness has been overcome and is vanquished through dance, King Agenor maintains.[23] Here, one should not overlook the striking similarity in vocabulary and thought that are evident in Nietzsche's *Thus Spake Zarathustra*.[24] While Zarathustra in "The Dance-Song" reveals himself to the dancing girls as an admirer of dance: "Cease not your dancing ye lovely maidens!"[25] he also stresses that in contrast to himself the devil is a representative of the spirit of heaviness.

Moreover in "The Spirit of Gravity"[26] we are shown the need to overcome heaviness: "He who wisheth one day to fly must first learn standing and walking and running and climbing and dancing."[27] Nietzsche's *höhere Menschen* are to avoid all those who are still captives of the spirit of heaviness: "Go out of the way of all such absolute ones! They have heavy feet and sultry hearts: — they do not know how to dance. How could the earth be light to such ones!"[28] Other quotations express similar appeals: "Lift up your hearts, my brethren, high, higher! And do not forget your legs! Lift up also your legs, ye good dancers....Ye higher men, the worst thing in you is that ye have none of you learned to dance as ye ought to dance — to dance beyond yourselves!"[29]

In the face of failure, Kaiser's dancers asked themselves whether they had shaken off sufficiently their earthbound heaviness.[30] Then in the final act of the play *Europa*, it is Zeus who prepares a dance unlike any that

Europa might have seen before: "Away with all floating — striding — rocking and flattering."[31] In this pronouncement we can see Kaiser's final verdict which might also be applied cautiously to the German Dance Movement and to its excesses which he derides.

Still stronger polemics emanated from Klaus Pringsheim's review of a premier performance of Albert Talhoff's *Totenmal*, a work in which Mary Wigman starred. Pringsheim speaks of the nonsense of the New German Dance Art Movement which, from his viewpoint, had lost all the possible goodwill of the public by its use of such "horribly soft-soaped sentimental jargon," or by assuming an untoward role: "Never has the art of dancing had such little resonance as today when it plays up its importance as dance-art."[32] Singling out the idea of the rediscovery of the soul through dance, Pringsheim questions the novelty of this. Had it not existed in the sacred dance of prehistoric times, or in the legs of Nijinsky — not to speak of the toes of Pavlova — he wonders. In all of these, he counters, there existed more soul than could be found in a dozen of New German Dance troupes.[33]

While one is surprised by the harshness of Pringsheim's criticism, one is similarly awe-struck by the exuberant idealism which was invested in this art form by its protagonists. As an aesthetic movement, today, we would be inclined to grant this form of dance its legitimate place in the world of the performing arts, stripping it, however, of its absolute ideological demands. Kaiser's criticism, on the other hand, is not basically concerned with the question of idealistic encumbrances on art per se, but with those attached to dance alone. For during his expressionistic period, he extolled similar ideals in regard to the purpose of the writer and his drama.

The enthusiasm for dance as a virulent force of change faded with the general movement of Expressionism. Ballet has absorbed many of the interpretative dance features, and even Mary Wigman had a brief come-back in the fifties. Dance today is alive in the performing arts, Expressionism is alive as an object of critical investigation, the renewal of mankind, however, remains a task to be re-conceptualized as a desideratum and ideal.

Notes

[1]"Von der Bildhauerkunst entlehnt sie schöne Körper; von der Malerei schöne Stellungen; von der Musik innigen Ausdruck und Modulation; zu allem tut sie lebendige Natur und Bewegung hinzu." Quoted in: Wolfgang Nufer. *Herders Ideen zur Verbindung von Poesie, Musik und Tanz.* Germanische Studien,

Heft 74 (1929), p. 94. The English translation of the quotation as well as subsequent translations are my own.

²Wolfdietrich Rasch, "Tanz als Lebenssymbol im Drama um 1900," in *Zur deutschen Literatur seit der Jahrhundertwende* (Stuttgart: Metzler, 1967), pp. 59-77.

³Hugo v. Hofmannsthal, "Der Brief des Lord Chandos," *Gesammelte Werke*, V. 9 (Frankfurt a.M.: Fischer, 1959), pp.7-20.

⁴Hugo von Hofmannsthal, *Werke*, V. 10 (Frankfurt a.M.: Fischer, 1959), p. 46. ". . . Eine rhythmische Wiederholung von Bewegungen [kann] einen Gemütszustand zusammenfassen. . . gedrangter und bedeutsamer als die Sprache es vermochte. . . ."

⁵Marc in *Pan,* March 7, 1912.

⁶Georg Kaiser, "Formung von Drama," *Werke IV*, ed. Walther Huder (Frankfurt, Berlin, Wien: Propyläen, 1971), p. 574. "Man geht aus dem Theater — und weiss mehr von der Möglichkeit des Menschen."

⁷Emil Utitz, *Die Überwindung des Expressionismus* (Stuttgart: Enke, 1927), p. 104. Elisabeth Klein in her dissertation, "Jugendstil in der deutschen Lyrik," interprets dance in rhapsodic terms reminiscent of the messianic aspirations of the Expressionists. Linking the dance-like gestures as presented by the art nouveau painters Hodler and Klimt to the role of dance in the poetry of Richard Dehmel, she states: "In poetry and representation, dance stands for one of the symbols which represent the transposed state of enrapture from the finite to the infinite realm of mystical experience. It is also the naive expression of an attempt to take hold of a new paradise."

"In Dichtung und Darstellung ist der Tanz eins der Symbole fur das Entrücktsein aus der Zeit in die Ewigkeit des mystischen Erlebens, steht aber auch für den naiven Ausdruck der Besitzergreifung des neuen Paradieses." "Jugendstil in der deutschen Lyrik," Dissertation, Koln, 1958, p. 47.

⁸Rudolf von Laban, "Vom neuen Tanz," *Hellweg* (1925), p. 315.

⁹F.H. Winther, *Körperbildung als Kunst und Pflicht* (München: Delphin, 1919), pp. 78-80.

¹⁰ Arnold Schmieder, "Tanz und Seele," *Neue Bahnen,* Heft 34, Vol. XXXIV (1925), p. 99.

¹¹The periodical *Die Tat* underwent some significant changes in its political and social orientation. Commencing its publication in 1909, it was subtitled, "Wege zum freien Menschentum," from 1913 on, "Sozial-religiöse Monatsschrift für deutsche Kultur," and beginning with 1915, "Monatsschrift für die Zukunft deutscher Kultur." *Die Tat* was founded by a group of popular-pedagogically oriented activists who were opposed to the undermining forces of individualism. Before its

final turn to the political right their supporters attempted to salvage the declining culture by publishing essays professing a monistic-religious world view. Cf. Fritz Schlawe, *Literarische Zeitschriften 1910-1913.* (Stuttgart: Metzler, 1962), pp. 81-83.

[12]Artur Jacobs, "Arbeiternot, Kulturnot und die Erneuerung durch den Rhythmus," *Die Tat*, Heft 9, Jg. 14 (1922), pp. 648-656.

[13]Rudolf von Laban quoted by Emil Utitz, *Die Überwindung des Expressionismus*, p. 110.

[14]For this consult the introductory chapter in Manfred Kuxdorf, *Die Suche nach dem Menschen im Drama Georg Kaisers.* (Bern u. Frankfurt a.M.: Lang, 1971). See also: Walther Rathenau, *Zur Mechanik des Geistes oder Vom Reich der Seele.* In: *Gesammelte Schriften*, Bd. II. (Berlin, 1918).

[15]Ernst Blass, *Das Wesen der neuen Tanzkunst* (Weimar: Lichtenstein, 1921), p. 7.

[16]"Es ist ihre wahre Emanzipation, weit kühner, radikaler und zukunftserobernder als etwa ihr Eintritt in die Politik. . . Mit den Tanz gibt die Frau der Menschheit ihr drittes und letztes Erlösungsgeschenk, die Tänzerin tritt neben die Liebende und neben die Mutter." Quoted from: Hans Brandenburg, "Das Ende der Tanzkunst," *Der Bücherwurm* (1919), p. 81.

[17]Hans Brandenburg, "Die Zukunft der Tanzkunst," *Die Tat*, Heft 11, Jg. 13 (1922), p. 830.

[18]Aurelio Millos, "Das Erbe des Expressionismus im Tanz," *Maske und Kothurn*, Jg. 11 (1965), pp. 329-43.

[19]Georg Kaiser, *Nebeneinander*, in: *Werke* II, Hrsg. Walther Huder (Berlin: Propyläen, 1971), p. 306.

[20]Georg Kaiser, *Europa*, in: *Werke* I, Hrsg. Walther Huder (Berlin: Propylaen, 1971), p. 602. "Der Tanz ist die letzte Stufe. Im Tanz ist unsere Rauheit bis auf den Kern gelöst. Der Tanz ist der Ausdruck fur die vollkommene Mässigung der Regungen. Wir sind so weit, es sollte der Gipfel sein—."

[21]*Ibid.*, pp. 619-620. "Das ist Tanz und Seele — Seele als Tanz — Tanz als Seelensprache."

[22]*Ibid.*, p. 651.

[23]*Ibid.*, p. 614.

[24]H.W. Reichert, in his paper, "Nietzsche and Georg Kaiser," *Studies in Philology*, 61 (1964), 85-108, informs us that Kaiser became well acquainted with Nietzsche's work through the influence of Kurt Hildebrandt, he did not notice the similarity in thought and vocabulary that exists between Kaiser's *Europa* and *Also sprach Zarathustra.*

[25]Friedrich Nietzsche, *Thus Spake Zarathustra*, edited by Manuel Komroff, translated by Thomas Common (New York: Todor, 1936), p. 111. Subsequent Nietzsche quotations refer to this edition.

[26]*Ibid.*, pp. 205-209.

[27]*Ibid.*, p. 209.

[28]*Ibid.*, p. 317.

[29]*Ibid.*, pp. 318-319.

[30]Kaiser, *Europa*, p. 619.

[31]*Ibid.*, p. 630. "Nichts mehr von Schweben-Schreiten-Wiegen und Schontun."

[32]Klaus Pringsheim, "Der Unfug der neudeutschen Tanz-kunst," *Der Querschnitt*, Heft 9, Jg. 10 (1930), p. 604.

[33]Pringsheim, p. 605.

FILM

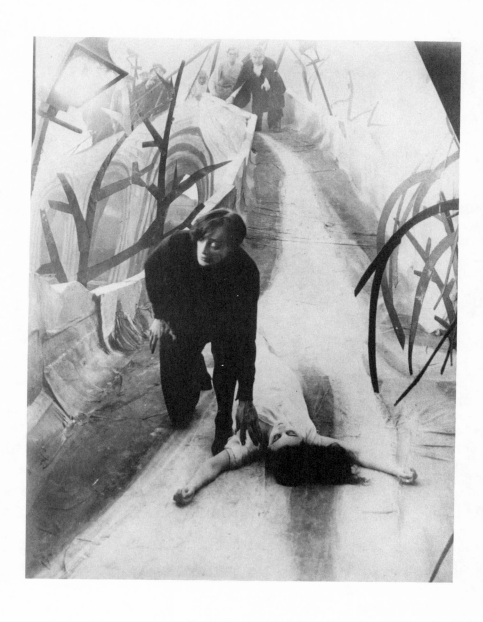

18
Caligari and the Rise of Expressionist Film

Lenny Rubenstein

From 1919 to 1925, expressionist techiques dominated the German silent film and through this national industry influenced the imagery and techniques of the world's infant cinema. Although Expressionism wasn't new in 1919, and several early silent films had been made of expressionist plays, Robert Wiene's *The Cabinet of Dr. Caligari* (*Das Kabinett des Dr. Caligari*) not only heralded the emergence of German film as an important new art form, but was also the harbinger of a theme and a number of cinematic devices that have left their marks on literally hundreds of films that came after it.

Seen today, *The Cabinet of Dr. Caligari* may appear almost primitive; the performers' exaggerated gestures, their peculiar eye-makeup, and the flatness of the painted set (although strikingly done) appear a bit comic and archaic. However, the stage set with its elongated streets radiating out in all directions, the trapezoidal houses with matching doorways and windowframes seem however a fitting environment for the major antagonists Dr. Caligari, (Werner Krauss), and his sleepwalker, Cesare, (Conrad Veidt) with their mad head movements and peculiar gaits. The film is much more the terrain of its villains, than of the erstwhile protagonist,

Francis, (Friedrich Feher), who begins his story in the autumnal garden of a lunatic asylum. Krauss' Caligari and Veidt's Cesare are the more interesting characters to contemporay audiences which have not only accepted their performances in this film, but have continued to accept the latest permutation of the Caligari character whether as Dr. No in the James Bond film or as Dr. Strangelove in Stanley Kubrick's satire on nuclear war. All the mad scientists and obsessed tyrants of film are preceded by this 1919 production from Berlin's Decla Film studio which first introduced the character to movie-going audiences with an iris-in on the top-hatted individual with glasses and cloak who jerkily wanders through the carnival grounds at Holstenwall searching for a spot to display his creature.

The revolt in *Caligari,* however, was not only scenic, it was meant to be political, as well. In his classic study of German film, *From Caligari to Hitler,* Siegfried Kracauer has already detailed the story of how the original screenplay by Hans Janowitz and Carl Mayer was significantly altered to include a framing device, placing "reality" in Francis' lunatic asylum tale, thus undercutting to some extent the original attack on murderous authorities hidden within a rigidly hierarchical society. Both Janowitz and Mayer had learned to distrust governmental officials during the war, and their script could be seen as an open attack on a society that had countenanced murder by senseless people led by "respectable" leaders. Although the framing device reduced their attack to a madman's fable, the film still contains elements of social rebellion. The first example curiously enough is Caligari's confrontation with traditional, civil authority, the town clerk, in his effort to get a license to display his somnambulist. Seated on a tall stool decorated with legal and mystical symbols, the clerk disdains to recognize the hypnotist who cringes and schemes in his corner of the office; this is the visual realization of the famous quip by the Weimar Republic's prime satirist, Kurt Tucholsky, that it was the longing of every German to sit *behind* a desk, while it was their fate to stand *before* one. Hat in hand, bowing, Caligari endures the clerk's scorn, while already plotting his revenge. The clerk is the first victim in a series of murders engineered by Caligari with his nearly perfect weapon, Cesare who moves with the precision of a trained dancer, at once both graceful and ominous and emerges from his coffin-shaped box at the command of Caligari who brandishes his cane like a field marshal's baton—a gesture not lost upon a German audience in the years following the First World War, the *Nachkrieg.* Caligari's appearance is a study in contrasts; he wears the top hat and caped-cloak of a nineteenth century Biedermeier figure with the wire-rimmed glasses and wild white hair of an academic-gone-mad. Indeed the film takes many of the benevolent stereotypes of Germany and reverses them, just as the sets invert the normal geometry of house and street to create its disordered universe of bent streetlamps and truncated trees.

The protagonists, Francis and Alan, (Hans Heinz von Twardowski), a thinker and a poet, are also figures from a pre-Bismarckian Germany, who are seen amid their books and papers in garret apartments dressed in the appropriate nineteenth century styles for scholar and Bohemian. It is the poet, Alan, who rashly asks Cesare, his future, only to learn that he will die before dawn, a prophecy Caligari has his somnambulist make good. Alan's murder, not only prompts Francis to investigate the mysterious hypnotist, but also adds a new device to film: the off-screen act shown only in a shadowed-silhouette, one of the great expressionist legacies to the cinematic form. Following this sequence, all the distortions and incongruities of the set designed by Hermann Warm, Walter Reimann and Walter Röhig become less comically intrusive and part of the world in which Caligari can stalk his victims. Part of the horror of these designs is not even linked directly to Caligari or Cesare, but to the local policemen whose flowing moustaches and pillbox caps make them appear as Central European Keystone Cops, until we see one of their prison cells. With its tapering walls, monstrously huge ball and chain, and cruel narrow window, the cell is not only an exemplary piece of expressionist design, but a hint of the tyranny beyond the confines of Caligari's show-place tent. Although many critics thought the stage-set an expres-

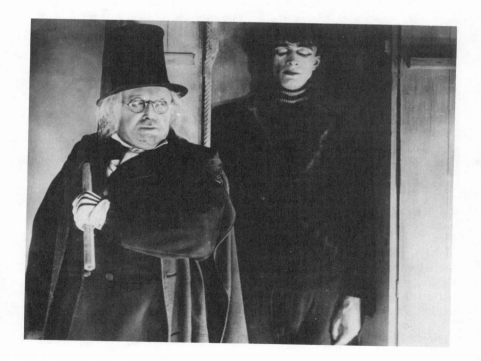

sion of Francis' lunacy — the visual representation of his subjective mood — Kracauer has noted that many of the design motifs remain even after the revelation of the narrator's madness.

That set was, of course, the lucky accident of its age — the Decla Film Studio had expended its rationed supply of electric power, so the trio of designers suggested painting in the perspectives and shadows to eliminate the need for expensive lighting and carpentry. The painted sets with knife-edged rooftops, chimney pots at oblique angles and houses drawn from a wild geometry text have an eerie beauty that impressed a small body of esthetes and film pioneers in both Europe and America, but

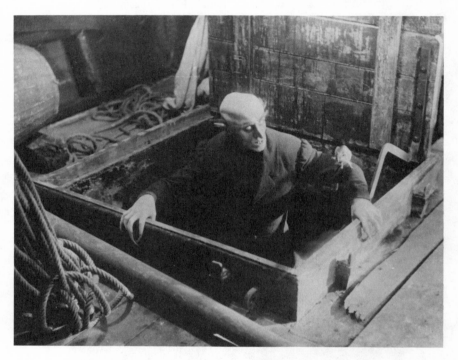

the real terrain for expressionist successes were the Gothic and horror films that emerged from Germany in the first half of its Golden Age of film. *The Cabinet of Dr. Caligari* has become the acknowledged first film of this amazing output, and some of that production's themes and formalist exercises appeared again and again in *Nosferatu, Waxworks, Vanina, The Golem, Raskolnikov* and *The Student of Prague.* Many of the performers and directors, as well as set designers and cameramen, who worked on these films found themselves the targets of lucrative offers from the American film industry, and Hollywood became one of the richest heirs of the Weimar Republic's cultural heritage.

Expressionist writers glorified the "demonic man" whose longings could never be assuaged, and German's silent films are replete with images of the demonic character — whether he is dressed in the heavy clothing of the nineteenth century bourgeois or the trappings of the fabled demon, the vampire. Directed by Friedrich W. Murnau in 1922, from a script by Henrik Galeen, *Nosferatu* used the shadow of the evil Count Orlok, (Max Schreck), to intimate his attack on the helpless insurance agent, Hutter (Gustav Von Wangenheim), and one sequence used *negative* exposure to convey the otherworldly evil of the Count's estate, (a device most recently employed in the televised PBS version of *Dracula*). In lieu of distorted painted sets, Murnau used abandoned mansions and a studio-built castle to create the backdrop for his story of evil and love. With his fanged teeth and claw-like hands, Orlok was the next stage in monstrousness after Caligari, whose gestures anticipated many of Orlok's, and his long fingers seemed only a more open threat after the white gloves ceremoniously worn by the made hypnotist. Mad ghouls and tyrannical psychiatrists may have appeared as cinematic fictions far removed from the actual society a few miles outside the Neubabelsberg studios, and indeed the political implications of much of expressionist works were almost lost amid the finely crafted stage-sets and lighting patterns which earned universal acclaim, but there were occasional links to real authority and actual monarchs, if not to social types prevalent in Weimar Germany.

Nosferatu was followed, in 1922, by *Vanina* which supplanted the vampire with a sadistic royal governor who not only imprisons and tortures his daughter's lover, the leader of an abortive rebellion, but then allows her to believe he has relented and will permit their marriage to take place. Both rebel and daughter die, he at the gallows and she from a broken heart, a curiously apt allegory for the German Revolution of 1919. Directed by Arthur von Gerlach from a script by Carl Mayer, *Vanina* not only reversed the optimistic ending of *Nosferatu* where love destroys an evil creature, but appended the ruler's final cruel revenge. Besides the veteran script-writer, *Vanina*'s other link to *Caligari* was the set designer Walter Reimann who here emphasized the lovers' fated doom by an emphasis on long, menacing corridors through which the pair attempt to flee. Malevolence and authority seem to co-exist ideally in these films, even when that authority is exercised for an ostensible noble cause.

Paul Wegener's *The Golem* (1920) retells the ancient Jewish legend of a man-made creature with super-human powers in a film that borrowed lightly from the expressionist armory of devices, but which highlights the sense of powerlessness in the hands of fate. In an effort to dissuade the Hapsburg emperor from expelling the Jews from medieval Prague, the ghetto's wiseman, Rabbi Loew constructs out of clay an indestructible creature animated by mystic forces summoned by the Rabbi's alchemical and astrological skills. The free-floating mask of the demon and the walls of fire from which the Rabbi must protect himself and his assistant, as

well as the smoking letters which serve as the titles for this sequence, are some of the expressionist features in this film. More intriguing perhaps are the twisted, onion shaped rooms and stairways designed by Hans Poelizig which lead the eye from the dark, cavernous laboratory to the huge blacksmith's fire which dominates many of the alchemical scenes. Lotte Eisner, in her recent study of German film, *The Haunted Screen,* has termed the major influence in *The Golem* impressionist rather than expressionist given its emphasis on texture and light, instead of abstracted, distorted designs. *The Golem,* however, still shares with *Vanina* and *Caligari,* an interest in the abuse of power and authority. Although the Golem does succeed in dissuading the emperor from expelling the Jews, Loew's creation, unleashed by his bungling assistant, turns on the ghetto and specifically on Loew's daugher. Having nearly destroyed the ghetto he was designed to save, the Golem is unstoppable, even by his creator, until he reaches the ghetto gates where amid the sunlight and flowers he is toppled by a group of garlanded blonde girls who toy with the magic amulet on the golem's chest. Authority, even the religious power wielded by Rabbi Loew, has its darker side, the film implies, and it is only childish faith that reduces the rampaging golem to a lifeless clay object once more.

A more pointed use of expressionist themes and formats can be seen in Paul Leni's 1924 film *Waxworks (Das Wachsfigurenkabinett)* which stars three of the German silent screen's biggest stars: Emil Jannings, Conrad Veidt and Werner Krauss. They play murderous historical figures whose images in a carnival wax museum conjure up three stories in the mind of an unemployed writer who was hired by the museum curator to compose a tale about each of them. The first story is about Haroun Al-Raschid, (Jannings), a grotesque onion-shaped despot whose very castle mirrors his own body with its sinuous towers and elastic looking walls and is peopled with cringing servants in over-sized turbans. A traditional parody of a moody and arbitrary tyrant, Al-Raschid condemns to death in one gesture and then tearfully regrets his decision the next. The second episode centers around the thin, stark Ivan the Terrible, (Veidt) who is not subject to such relief. The Czar, in Leni's film, is a murderous madman whose evil is highlighted by his regal stature. At one point, the Czar is seen flanked by the painted icons of a doorway, and the murderous ruler in his robe and crown seems to fit in with them. Besides watching the torture of his victims from a secret window, Ivan has his greatest pleasure in presenting his quarry with an hour-glass inscribed with his name so that he would know when the administered poison would take effect. The appropriately lighted hour-glass becomes the means by which Ivan is driven mad, since he finds one with his name on it and begins to insanely rotate the glass in an effort to stop time. A gift of religious art to the film-maker, the hour-glass has become a virtual symbol of ancient horror and it is certainly no accident that it is by a large, ornately-carved hour-glass that the Witch times Dorothy's life in the *Wizard of Oz.*

The final episode in *Waxworks,* however, is not removed in time or space like the previous two, but brings a modern killer, Jack-the-Ripper, (Krauss), into the life of the writer and his lover. The third killer pursues the protagonist through the darkened, abandoned carnival grounds, with all the emphasis on shadows and distortions of space. This ending implies the reality of tyrannical murderers, since there is no resolution posed for the protagonist and his lover, the museum curator's daughter. The chase through the carnival grounds, the contemporary terrain for the film's story, as well as a symbol in German films for the chaos of modern life, brings the threat of lunatic murders into 1920's Germany. The image of the mass murderer, seen in the paintings by Georg Grosz and Max Beckmann years before the Nazis were actual political threats, or in films like *Waxworks* or Fritz Lang's *M,* had its basis in the actual reports of apprehended criminals who had lured any number of young men and women to their homes where they were cruelly killed.

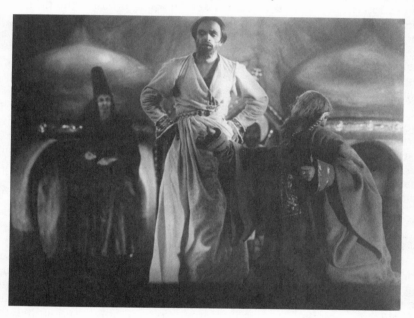

Another Robert Wiene film, *Raskolnikov,* examines the protagonist of Dostoyevsky's *Crime and Punishment* to arrive at an understanding of the "demonic man" compelled to kill. Using sets designed by Andrei Andreiev, Wiene succeeded in overcoming the flat, one-dimensional look of the *Caligari* set, by constructing his shadows and oblique angles to match the disordered universe seen by the young student and to show the complementing effect of the protagonist's madness on the distorted environment. A later Henrik Galeen film, *The Student of Prague,* used a studio-

fabricated forest to convey the sensation of impending evil and latent doom. In this familiar, old tale of the split-personality, a young student, (Conrad Veidt), is persuaded to sell his soul to another of those Biedermeier characters who seem to possess unnatural powers. Set amid the twisted trees of a wind-swept plain, the stranger (Werner Krauss), carries his umbrella like some sort of weapon or magic staff, and his silhouetted shadow haunts the student at critical points in the film's plot, until the tragic conclusion when the victim confronts his own image in a duel-to-the-death.

One of the problems in any discussion of the expressionist influence on German silent films is the conflict between the subjective experience of the character as caught by the camera and the objective view of the same sequence by the audience. In *Caligari* the set is seen as the world viewed by a madman rather than as an abstracted view of a society on the brink of lunacy. The use of wispy letters in place of printed inter-titles and the various tinted scenes, no longer seen in most prints of the film, reinforce the latter argument. In the expressionist canon, the actual world is seen as ajar, not the characters. This aspect was rapidly lost in film as many of the expressionist devices were used to convey purely subjective states, for example the collage of distorted, laughing faces in Murnau's *The Last Laugh,* or to serve decorative purposes as in Fritz Lang's *Nibelungen (Siegfried)*.

Arthur Robison's 1923 film *Warning Shadows (Schatten),* however, is more purely expressionist. There is real confusion for both the audience and the main character concerning whether they are mad or whether it is their situation which is insane. Seen as ambiguous shadows, a series of infidelities, betrayals and murders cures a jealous Count of the suspicion that had been ruining his marriage. The film is basically a therapeutic role-playing in silhouette, so that the characters can have a peaceful resolution to a possibly murderous dilemma.

From 1925-1930 the expressionist devices entered the wider world of international film production. Paul Leni's *Cat and the Canary* (1927) is a Hollywood comic-thriller replete with all the trappings of a German horror classic: the long, dark corridors are haunted by peculiar breezes and mysterious creatures, while the film's mood of entrapment is constantly re-created by the cameras filming through stairway uprights and the slats of old-style chairs. Distortion for mere effect, not to underline the society's irrationality or to highlight a character's emotional instability, became an excuse for cameramen to film through refractive lenses, jars of water and clouded windows. Other film-makers with period plots could create countryside sets enshrouded in mist to provide their Wagnerian heroes with the appropriate backdrops. With improvements in camera equipment, film-makers were soon taking their performers and crews up mountain peaks for a popular kind of German film that helped launch Leni Riefenstahl's career (*The Blue Light*).

The decline of the expressionist film in the mid-twenties was mirrored by a period of relative stability in German society and government; the excesses of the inflation, as hinted at in Fritz Lang's *Dr. Mabuse,* or of the possibilities for dictatorship in Hitler's abortive putsch were old memories by 1925-6. The order beloved by a martinet was conveyed in cinematic terms by Lang's use of people as geometric formats in *Nibelungen* or *Metropolis* where individuals exist only as facets of a wonderously choreographed regimental whole. The expressionist theatrical chorus had been converted into a silent procession — while the only voice it was allowed, in *Triumph of Will,* was the Nazi Party's "German" greeting.

In one notable film, *The Revolt of the Fishermen,* directed by the famed veteran Erwin Piscator in a Soviet theatrical production, left-wing uses were made of expressionist devices, i.e. the geometric grouping of extras is used as a dramatic device to comment on the action, the strike by a number of improverished fishermen. The film also has several remarkably staged sequences, such as a night-time brawl between strikers and strike-breakers, an appropriately murky scene illuminated faintly by moon-light in which class conscious workers fight it out with their less enlightened brothers. A later scene revolves around the denunciation of religious pacifism when troops attack the strikers at a funeral. Made in exile, *The Revolt of the Fishermen* was the last German film to merge distortion with a message of rebellion; the studies at Neubabelsberg were busy churning out the musical comedies and war films that were to become a staple of the Third Reich's film industry. Even before Hitler's appointment as *Reichskanzler,* however, the German film had turned almost wholly away from the traces of revolt that had once motivated its writers and directors.

The city, like the expressionist carnival, had become a symbol of conflict for directors; it was seen as a dangerous terrain dominated by criminals and corrupt geniuses, men like Lang's Mabuse and Haghi, the spy master. The number of urban tragedies that dot German cinematic history is indicative of the foreboding with which the modern industrial city was seen; *The Street, The Joyless Street, Asphalt, Tragedy of a Street* and *The Last Laugh* depict the doom that awaited the unwary, and of course Lang's futuristic morality story took its title from a synonym for a large cosmopolitan city. Like the American gangster film or the contemporary "disaster" epic, the German silent "street" films catered to the audience's interest in, and obsession with, the worst aspects of urban life: crime, drug usage and sexual license. Only a few consciously political films attempted to show urban life from the viewpoint of the average worker, *Mother Krausen's Journey to Happiness, Berlin Alexanderplatz* and *Kuhle Wampe* are probably the three most famous. However, except for an interesting sequence of multiple bicycle wheels shown racing against the symbols of continued joblessness — closed factory gates with signs that no-one need apply — the Brecht-Dudow film *Kuhle Wampe* is not very different from

any number of street films about the plight of the impoverished bourgeois. The emphasis on the collective life of the political characters in the film seems a forced, optimistic after-thought. Both Kracauer and Eisner, who tend to differ sharply on their interpretation of the silent films, agree on the similarity between the leftist-youth in *Kuhle Wampe* and any similar Nazi group. Both Nazi and Communist films from the 1930's share a similar realism in style, and even end up with a similar image — the marching column. The Nazis made no distinction between the war they waged in the Berlin streets and the one that their spiritual antecedents had waged in the trenches in Flanders. This copy-book version of patriotism was voiced in one of the most successful early Nazi films, *Hitler Youth Quex, (Hitlerjunge Quex)*, which contrasted the regimented Nazis with the rowdier Communist youth group. Films like *Kuhle Wampe* and *Mother Krausen's Journey to Happiness* ended with the heroine alongside her Communist lover in a protest demonstration march. The clash of rival marchers was to ruin Europe for more than a decade.

Like all legacies, the expressionist heritage in film has been shared and misspent by a veritable army of heirs. The Soviet film-makers borrowed heavily from the collection of madmen and killers in regal or bourgeois dress for their films, and it was certainly no whim that made Sergei Eisenstein arm his middle-class ladies with parasols in *October,* parasols with which they kill a young Bolshevik in the film's July Rising sequence. The early Soviet film-makers never hesitated to display their enemies as brutes with a thin veneer of middle-class culture, an image curiously enough well represented in the silent German cinema. Pabst's *Love of Jeanne Ney* featured Fritz Rasp as a particularly squalid example, while Kracauer cites the elegantly dressed Ivan the Terrible in *Waxworks* who gleefully watches his torturers at work. Besides the Russians, Hollywood was not only quick to borrow expressionist devices, but imported directors, performers, and cameramen as well. Even in the Germany that emerged from Hitler's "national revolution" there were strong hints of the silent film's contribution to Nazi stage-craft. Fritz Lang's heraldic display played its part in the filming of the Nazi Party's 1934 Party Day in Nuremberg, where all the devices of the entertainment film — cloud formations and an actual gothic city, the night sky punctuated by hand-held torches and anti-aircraft search lights, the imperious leader atop the reviewing block and the serried ranks of marching uniformed faithful — could be used in a documentary film extolling the German rebirth. Riefenstahl's *Triumph of the Will, (Sieg des Willens)*, provided an ideal matrix for all the elements of the German film tradition, just as the political ideology it glamorized was the perfect combination of the need to rebel within a hierarchical framework with the desire for socialism without any consideration of economics or democracy.

While the Soviets adapted some of the expressionist film techniques and the Nazis adopted the decorative grouping and use of shadow (in many Nazi wartime newsreels the sense of victory was conveyed by the

shadow of the advancing tanks cast on the roadway) the Americans utiliz-ed the atmosphere of the early silent films in horror films that have never been equalled: *Dracula, Frankenstein, The Invisible Man, The Mummy* and *The Bride of Frankenstein.* In each of these films the emphasis is always on the creature, never the protagonist, although both must operate and act in a universe shaped by the abandoned towers, gloomy mansions or deserted village streets designed by the film's artistic director. These sets owe as much to the German silent films from the early twenties as do the presentations by the performers. The look of half-mad cunning and menacing tyranny so frequently cast by the expressionist actor was developed, along with the proper vocal tone, by those Hollywood per-formers with whose names the early sound-horror films are inextricably linked: Boris Karloff, Bela Lugosi and Claude Rains, while a host of other performers personified the reluctantly obsessed scientist, the evil genius and the clumsy assistant: Colin Clive, Ernest Thesiger and Dwight Frye. Even today's films owe a serious debt to Decla's 1919 production, since the appropriate setting and garb for many a Hammer studio horror film is the nineteenth century with its heavy clothing and deceptively polite manner — just the atmosphere for Caligari.

19
Industry, Text, and Ideology in Expressionist Film

Marc Silberman

The rapid evolution of film as mass entertainment in Germany during and after the First World War led to the particular set of circumstances which fostered the creativity of expressionist filmmaking. It is striking how both anecdotal and academic commentators often ignore the fact that the "classic" German films are products of a capitalist system of production undergoing enormous changes after 1918. Such films as *Caligari, Der letzte Mann* or *Metropolis* are not exceptions to the rule; they are products of an industry which pushes cinematic possibilities to the limit in order to achieve maximum profits.

The two standard English-language commentaries on German films of the twenties — Eisner's *The Haunted Screen* and Kracauer's *From Caligari to Hitler*[1] — already indicate in their titles the assumption that Expressionism represents a continuation of an entrenched tradition of German irrationalism. Eisner is primarily concerned with formal questions and theatrical elements in film dramaturgy. She finds evidence everywhere for the mystical, spirtitual quality of expressionist film, which then becomes absolute for her in defining expressionist atmosphere. Kracauer, on the other hand, focuses on the political content of film. In-

asmuch as his study has become not only a handbook of this period of German filmmaking but also a pioneering work in the methodology of anti-subjectivist film analysis, it is important to characterize the premises of his argument.

Kracauer's brilliant insights into film genres and specific films derives from a normative notion of realism as the true cinematic style based on the authenticity of the film image. Despite its subtitle, the study presupposes an anti-psychological and anti-modernist model of aesthetics. Although Kracauer explicitly rejects a purely mimetic relationship between film and reality, he returns again and again to the idea of film as a mirror of reality. For Kracauer, each film is regarded as a document of history, as a key to understanding the conscious and unconscious desires of the public. Moreover, because film entails a highly collective organization for its production, it represents for Kracauer a privileged medium as a seismograph of social and psychological currents. For expressionist films in particular, this means that Kracauer draws a parallel between the dominance of mystical, supernatural motifs and the false consciousness of the mass public. By relying, then, on content analysis of plot and significant motifs, Kracauer gives priority to the *what* rather than to the *how* of filmmaking.

Such an analytical model presents several problems. First, Kracauer's one-sided emphasis on the decline of democratic content produces a momentum of inevitability which parallels the very ideology of fatalism in the films that he criticizes. To this extent, he shares with Lukacs both a conviction about the cultural decline in his own historical period and an anger at the irrationalism which he witnessed.[2] Second, Kracauer's model implies a simplistic and unmediated correspondence between social and cultural phenomena, with the result that social facts are frequently reduced to psychological facts. Finally, in arguing his case, Kracauer resorts to the most innovative and artistic films of the period, yet his evidence is aimed at the mass of entertainment films which he then views as the social conscience of the public. Hence, he can neither explain which films appealed to which part of the public nor can he integrate organizational and aesthetic innovations as components of the ideological development he traces.

Kracauer's study revealed for the first time the power of film as an instrument of political manipulation through his discussion of how German films anticipated and prepared a climate for the triumph of fascism. In this chapter, however, I shall shift attention from film as an instrument of ideological-political content to examine the function of film as an ideological vehicle in both cinematic content and form. I propose to investigate the nature of economic developments within the film industry, and subsequently to examine how specific ideological forms become operative within mass culture. In other words, I want to consider the continuing fascination with expressionist film in the context of how film produces images and structures that have an impact on a particular public within a given institutional framework.

Any investigation of the phenomenal, but short-lived, blossoming of German filmmaking in the early twenties must take into consideration the structural changes which the film industry was undergoing. Until World War I, Germany's development in the film sector had consistently lagged behind that of France, Italy, Denmark and the United States. Ideologically and economically, the German bourgeoisie was not attracted to the film market — in part because of the traditional commitment of its capital to the highly sophisticated communications media in the press and book publishing market, and in part because cinema could not appeal to the aesthetic tastes cultivated by the bourgeoisie. The market's commercial needs were satisfied to a large extent by foreign imports. As a consequence, technological development in the film sector was left to small and medium-sized businesses.

Whereas German theatre of the twenties was decisively marked by the events of the November Revolution in 1918, the crucial stimulus to the development of film must be traced to World War I. Institutions such as schools and churches had become active prior to 1914 in a cinema reform movement aimed at influencing the kind of films provided for mass consumption. It was not until 1916, however, that the transition of film began to take place, from market-oriented people's entertainment to its role as an important lever for presenting and representing the political and cultural hegemony of the bourgeoisie. In that year, 1916, the foundations of what was to become the giant UFA corporation (*Universal-Film-Aktiengesellschaft*) were laid by General Ludendorff of the Military High Command. Together with the leading banks, he established a state film company with its own newsreels and "cultural" films for the purpose of counteracting enemy propaganda. After Germany's surrender and the defeat of the November Revolution, Geman film companies found themselves in a particularly opportune position to expand. Due to rapid inflation, foreign films became too expensive to import, and the vacuum in the domestic market was filled by German companies with *kitsch*, literary adaptations and low-brow entertainment films. This economic situation meant that for the first time international trade entered the picture because German companies were at an advantage in exporting (not to say dumping) their films cheaply on the European and North and South American markets.[3] Furthermore, the expanding flow of capital opened the door to a number of artistic and experimental films which were able to ride the tide of general popularity. The industry was quick to note the benefits. First, to a large extent, German cinema's breakthrough to the bourgeois public was achieved precisely by means of adapting literary material to film. Second, quality films were essential for penetrating the international market. The restructuring and concentration of the film industry — completed by 1925 — brought with it, then, important changes in marketing strategies.

Although after the war UFA no longer engaged in the production of propaganda films, its semi-military origins continued to mark its intentions, at least during the years of Germany's rise to film fame. Indeed,

UFA was one of the few imperial institutions which outlived the *Kaiser-reich*, and, as such, its loyalties clearly were not directed toward the new republican state but toward its capitalist financiers. It is not surprising that, for example, no UFA film ever dealt explicitly with the November Revolution. Yet even UFA began to serve the market for artistically demanding films (e.g., Lubitsch's historical pageants), and in 1921, UFA purchased Decla-Bioscop, the company which had produced many of the experimental expressionist films. At the same time, the film industry as a whole was becoming much less sensitive to the specific demands of the public (in contrast to earlier nickelodeon days), and found it advantageous to serve what it increasingly perceived as the "general" interests of society. Consequently, after 1920, the 1½-to-2-hour feature-length fiction film became the dominant industry product, with themes such as military and national honor and with values celebrating established authority and the bourgeoisie.[4]

Expressionism in film cannot be considered either as a school or a movement, but as a shared complex of themes, stylistic traits and aesthetic effects. The relationship between film and Expressionism lies not so much in specific cinematic forms as in an aesthetically grounded position of rebellion against traditional cinematic forms. Such elements as decor, set, lighting and acting techniques — traditionally identified by formalists as distinctive traits in expressionist films — were present as a unified set of effects really only in *Caligari*. German expressionist films, in other words, should not be defined merely by a phantasmagoric atmosphere or by demonic themes, as is often the case, for we find these both in films with fantastical tendencies or even with realistic tendencies. Yet the relationship between expressionist stylistic traits (including symbols, editing techniques, narrative structure) and what can be called the ideologies of Expressionism is crucial for understanding the power of these films.[5]

In the broadest sense, expressionist film marked an attempt to break with dominant cultural, institutional and artistic values. This rebellion was accomplished by means of various distancing effects, the most popular being the shock or surprise effect. But as with their literary associates, the filmmakers' posture of confrontation was aimed at the "soul," not at society, and therefore it frequently led to introspection. As in literature and the fine arts, these ideologies of introversion, individualism and subjectivism were juxtaposed with visions of renewal: the New Man, a new society, a new sense of freedom. The use of supernatural figures — *Doppelgänger* and magicians, for example — attest to the Expressionist' hopes of uncovering an alternative way of life beneath the surface of "civilization." In a world conditioned to the rational, goal-oriented organization of bourgeois society, these extraordinary characters

represented one way for them to assert the singularity of individuals and things. For many Expressionists, the aesthetic effect of shock was meant to lead to the discovery of the unexpected in everyday life. The fantastical, it was felt, could resist the anonymity of urban life, it could sensitize the viewer who was otherwise subjected to numbing ideologies of happiness defined by rational management and increased consumption.

The expressionist rebellion was not without its popular intentions. The film medium, in fact, was regarded by many intellectuals as *the* vehicle for reaching the masses and for renewing art beyond the prejudices of the dichotomy between high and low culture.[6] The vision of reaching a mass public through popular media was never entirely realized by expressionist films. The filmmakers may have subverted bourgeois forms of cinematic representation, but they neglected to account for the functioning of their art in bourgeois institutions, and they failed to understand their own position within the political structures. It is reported, for instance, that a gala presentation of Murnau's *Der letzte Mann* (*The Last Laugh,* 1924) for the deputies of the Chamber of Commerce was greeted as a "social event of the highest order."[7] This film — read by Kracauer and others as a statement on the inhumanity of the (petty) bourgeoisie toward the progressive degradation of an aging hotel porter — was received, at least by this group, not as a critique of their own social class and values but as an enriching contribution to German culture. Here the

legitimating function of the culture industry cited by the Frankfurt School operates blatantly: when politics becomes an explicit aesthetic issue, the commitment expressed by a work of art is threatened with neutralization by the bourgeois institution of art itself.

The visual dimension of film offered to the Expressionists a particularly fruitful means for subverting bourgeois codes of representation. The notion of objectivity and laws of reality as defined by bourgeois standards could only limit the imagination. Thus, the stylized architecture of the *Caligari* sets, the blurred distinctions between the real and metaphorical in *Nosferatu*, the distorted perspective shots in *Der letzte Mann*, manifest a refusal to acknowledge the hegemony of "normal" perspective. The film image — as a synthesis of literature, painting, theatre and architecture — became an essential tool in the hands of expressionist filmmakers in their two-pronged attack on the dominant tradition of film. They began to generate new artistic means of representation at the same time as they sought ways of nurturing the ability of the viewer to respond to the sensuality of the image. Several film techniques were perfected specifically to emphasize the priority of subjectivity and to sustain the emotional tension of shock and irrational fear within the composition of the image: exaggerated mime and gestures, special lighting effects and distorted sets were conceived by expressionist filmmakers as elements reinforcing the subjective and fantastical content of the film image. Besides revealing the artistic validity of this kind of plasticity, they learned how to use camera perspective (close-ups and medium shots) and editing in order to clarify the movement of the plot and to expose the "inner" process of the characters. Murnau in particular was successful in creating completely new visual effects in the drunken sequences and in the scenes where the porter confronts his neighbors from the film *Der letzte Mann*. He constructed the narrative with such visual momentum that there was no need for titles. Lupu Pick worked toward a similar narrative compactness in *Scherben* (*Shattered*, 1921) and *Sylvester* (*New Year's Eve*, 1923) by reducing the number of characters and by symbolically animating objects such as clocks.

The inordinately high regard for innovative strategies and aesthetic effects did not necessarily correspond to innovative thinking about social and political content. Filmmakers like Murnau and Lang were concerned with the possibility of developing new ways of seeing which are specific to the cinema. Conversely, they utilized stereotypes, formulaic plots, melodramatic emotions and sentimental situations which could ensure a high degree of recognition among the public. In order to achieve the mass distribution and maximum profits sought by the industry, commercial films of this period could not fundamentally threaten the power and ideology of the bourgeois state. As a commodity produced for mass consumption, these films, on the one hand, engage in a process of transfor-

mation of social and political anxieties by means of familiar narrative resolutions and illusions of harmony; on the other hand, they dramatize precisely the internal contradictions of social experiences. The triumph of Good over Evil in *Nosferatu,* the narrative framing device of *Caligari,* the burlesque turn-around of a pathos-laden tragedy in *Der letzte Mann,* the pact between the head and the heart in *Metropolis* — these are all narrative cliches for resolving conflicts. They are myths which condense contradiction and conceal conflict either in a new harmony of narrative closure or in the projection of ideological antinomies (utopian visions or fantasies of disaster). This transformation of reality into a familiar pattern of narrative coherency, into a "story," brings into play important levels of cultural and ideological determination which then permeate the specific film down to the stylistic microstructures.

Robert Wiene's *Das Kabinett des Doktor Caligari* (1920) provides a prototypical example of this process of transformation into a coherent narrative structure. Whether Kracauer's explanation of how the framing story became part of the film is apocryphal or indeed true, it nonetheless demonstrates how narrative closure can contain images of revolutionary potential.[8] The framing structure we find in *Caligari* is a popular literary device which — in Germany — harks back at least to the romantic tales of Ludwig Tieck, Goethe and Kleist. It serves to create distance between

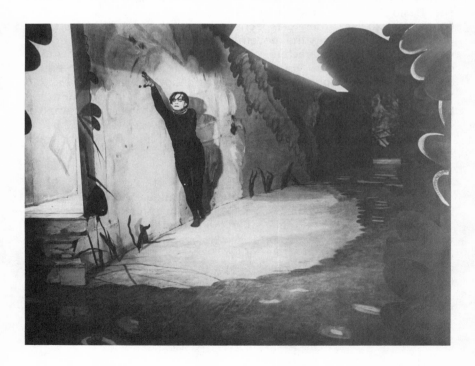

narrative time and the time of narration, as well as between the chaos of the past and the renewed stability of the present. Kracauer argues convincingly that in his reading of the film reason triumphs over authority and its irrational power. He criticizes the frame because it inverts this progressive message into a conformist one in which authority is glorified and the young rebel Francis is revealed to be mad. Yet, this literal interpretation, which on one level is in fact possible, ignores the dimension of irony and shock inherent in such a framing device. For, if we conceive of the story within the story as a nightmare or the demented vision of a madman, then the viewer shares in the difference, in the ambiguity between what is shown (the demasking of authority) and what one is supposed to believe (Francis as madman). The strategy behind the frame is one of reflexivity. It allows the audience to perceive something beyond the literal presentation. In other words, there is a dialectical process functioning between the two levels of the film: the projection of Caligari's terrible powers with their demystification as the product of irrational authority, and the reestablishment of paternalistic authority by reducing these projections of fear and anxiety to the level of madness. In a primitive manner, then, *Caligari* employs the sort of (auto-)reflexivity so characteristic of the modernist novel, the strategy which presents narration as artifice. The rhetorical principle of irony functions here in a way that focuses attention on the *action* of difference.

Ambiguity — here conceived as the process of actualizing difference — is a distinctive trait of expressionist films on the narrative level. The subversion of traditional bourgeois codes of narrative realism allows the articulation of contradictory and opposing images/ideologies. At the same time, this multiplicity is itself distinctly ideological, for it also allows social and political anxieties either to be contained as seemingly natural or reduced to purely personalized, subjective conflicts. Paul Wegener's *Golem* film (1920) presents an example of the way in which a symbolic construction generates secondary images of rebellion and conformity that are ultimately resolved on the plane of the human predicament, suspended between fate and free will. The Golem is a clay figure imbued with life through black magic. True to its legendary sources, the narrative shows how catastrophe ensues when mortals tamper with the divine power of creating life. This Golem, however, is not only a monster but also a projection of human fears of alienation. It embodies the desire to love and to express emotions freely, features which, in the confines of the ghetto/city and under the pressures of rejection/presecution, unleash perversion or destruction. The conclusion of the film proposes to the viewer a choice between the freedom of Christian charity and the demonic fate represented by the stars and astrology.[9] Thus, the contradictions struggling within the Golem symbol are folded back into a transcendental, "naturalized" conflict outside of historical specificity.

One should not conclude hastily that the corporate boards of the film industry or the producers and directors of entertainment films had clear

and conscious intentions of manipulating the mass film audience in a partisan political manner. The film industry, like any other capitalist enterprise, was first and foremost out to make profits. Through the examination of strategies for achieving narrative closure, it is possible to disclose ambiguities or ruptures inherent in the process of transforming social and political anxieties into visual images. On the textual level of film narrative, ruptures manifest themselves in the duality of conformist and emancipatory moments. For, if film is to successfully manage or "repress" social and political anxieties, then those anxieties must have a *presence* in the text. Authentic social and historical content must be tapped and expressed in one way or another if it is to become the object of successful transformation and manipulation on the narrative level.[10] Thus, it is possible to conclude that expressionist films function as a vehicle of ideology *because* they had to deal in some way with real contradictions in order to be popular. They had to provide a shred of content attuned to the genuine needs of the audience as a bribe to the public.

Fritz Lang was a master in achieving exactly this kind of impact. The technical and artistic perfection of his visual images in films like *Der müde Tod* (*Destiny*, 1921) or *Siegfried* (1923) and *Kriemhilds Rache* (*Kriemhild's Revenge*, 1924) creates a multi-faceted reality in metaphorical and symbolic scenes. It is not a question of content conveying the message so much as the mise en scene aiming to affect the diffuse sensibilities of desire and vision in the audience. The Germanic myth of Lang's Nibelungen tale was understood as a political argument by a public who felt that its national pride had been grievously injured. Yet it was not in the plot but rather through the aesthetic grandeur of the images themselves — what Kracauer calls "ornaments"[11] — that the myth took on a life of its own outside the historical context. To that extent, Lang (unintentionally) contributed to the arsenal of images later employed by the propaganda machines of the Third Reich. Kracauer's retrospective reading of a proto-fascist ideology in his films fails to account for the complexities of content and form. In other words, the illusions of harmony and the projections of disaster constructed by expressionist filmmakers were nourished by vague, collective fantasies — fantasies of freedom, renewal, hope and rebellion against oppressive traditions. Although the films do give voice to these deep and fundamental hopes, the legitimating function of the film industry itself became a decisive factor in their reception. Thus, the ideological impact of film can not be read only out of its content, or even its form, for such a method fails to encompass the ambiguities inherent in production and reception of the medium. It is rather the combination of these together with the institutional framework in which film "functions" and is consumed by its audience that determines its impact.

Notes

[1]Lotte H. Eisner, *The Haunted Screen, Expressionism in the German Cinema and the Influence of Max Reinhardt* (Berkeley/Los Angeles: University of California Press, 1969), and Siegfried Kracauer, *From Caligari to Hitler, A Psychological History of the German Film* (Princeton, New Jersey: Princeton University Press, 1947).

[2]Martin Jay, "The Extraterritorial Life of Siegfried Kracauer," *Salmagundi* 31-32 (Fall 1975/Winter 1976), p. 53.

[3]Of particular interest in this context is the "contingency law" which ruled that every film a distributor imported had to be "balanced" by a domestically produced film. For background on the development of the German film industry, cf. Jürgen Spiker, *Film und Kapital, Der Weg der deutschen Filmwirtschaft zum nationalistischen Einheitskonzern* (Berlin: Volker Spiess Verlag, 1975), pp. 9-46. Julian Petley, *Capital and Culture, German Cinema 1933-45*, pp. 29-46, presents a summary of this information in English.

[4]The most notable, but certainly not the only, example of this type of film is the *Fredericus Rex* series. Cf. Kracauer, pp. 115-119, 265-269.

[5]Cf. Douglas Kellner's remarks on the ideologies of Expressionism in the Introduction to this volume. Rudolf Kurtz, *Expressionismus und Film* (Berlin: Verlag der Lichtbildbuhne, 1926), reprint Zurich 1965 (Filmwissenschaftliche Studientexte, Vol. 1) and Lotte Eisner, *The Haunted Screen*, articulate these ideologies most clearly (and uncritically) vis-a-vis film.

[6]Kurt Pinthus, *Kinobuch* (1914), quoted in Jost Hermand and Frank Trommler, *Die Kultur der Weimarer Republik* (Munich: Nymphenburg, 1978), p. 272.

[7]Klaus Kreimeier, *Das Kino als Ideologiefabrik* (Berlin: Arsenal, 1971); *Kinemathek* 45, p. 3.

[8]Kracauer, pp. 62-76, especially pp. 66-67.

[9]Cf. Seth Wolitz's comments on *The Golem* in this volume.

[10]I am indebted to Fredric Jameson's ideas on the notion of mass culture and transformation as he explains them in "Reification and Utopia in Mass Culture," *Social Text* 1 (Winter 1978), pp. 130-148, especially p. 144.

[11]Kracauer, pp. 54-55 and 149-150. Cf. also Kracauer's theoretical comments on the notion of mass ornament in "The Mass Ornament," *New German Critique* 5 (Spring 1975), pp. 67-76.

20
The Golem (1920): An Expressionist Treatment

Seth L. Wolitz

Der Golem: Wie er in die Welt kam
(The Golem: How he came into the world)

Credits:

Produced by: Universum-Film-Aktiengesellschaft (Ufa)
Directed by: Paul Wegener, with Henrik Galeen and Carl Boese
Scenario by: Henrik Galeen, adapted from Gustav Meyrink
Camera Operators: Karl Freund, Guido Seeber
Designed by: Hans Poelzig
Costumes by: Rochus Gliese

Cast:

Rabbi Low	Albert Steinruck
The Golem	Paul Wegener
Miriam	Lydia Salmonova
Famulus	Ernst Deutsch
Rabbi Jehuda	Hans Sturm
Tempeldiener	Max Kronert
Emperor Luhois	Otto Gebuhr
Florian	Lothar Muthel
Rose girl	Greta Schroder

The Plot:

Reading in the stars that the Jews will be expelled, Rabbi Low creates an automaton called the Golem to help defend the Jews in their plight. Leading the Golem to the Emperor, Rabbi Low forces the Emperor to rescind the expulsion. A new crisis, however, soon develops. Miriam, the rabbi's daughter, in love with Knight Florian is discovered by her suitor Famulus, who sets the Golem upon Knight Florian. The Golem becomes sensate and desires Miriam himself. He goes beserk, killing people and destroying property. By chance an innocent child, unafraid of the Golem, removes the star from his chest rendering the Golem inert. She has saved humanity.

When the film posters of *The Golem* went up in Germany of 1920, the film producers, UFA, could count on an audience which had some notion of the Golem legend.[1] There had already been two film versions by the same film director, Paul Wegener: *Der Golem* (1914) and *Der Golem und die Tanzerin* (1917). In 1908, Max Reinhardt's theater, performed Arthur Holitscher's drama, *Der Golem,* and in another theater, the Golem lumbered about in Johannes Hess's *Der Rabbiner von Prag* (1914). But the most famous treatment of the motif was Gustav Meyrink's novel, *Der Golem* (1915), which continues even today to enjoy an occult success.[2] The producers were taking advantage of a public enthralled with the supernatural, the intensely dramatic, and the ecstatic, as well as the violence, exoticism, the grotesque, and *kitsch.* These predispositions provided the incentive for the UFA horror films in which homunculi, mandrakes, golems and other variants of artificial men lurch about with such "natural" man-monsters as vampires and werewolves.

The Golem is the Jewish contribution to *automata.* It differs from the mechanistic structures (Talos of Hephaestus, E.T.A. Hoffmann's Olympia, or Capek's robot) in that its method of creation depends on ritual and magical intervention. In the traditional Jewish legend, to create a Golem, a learned rabbi molds earth or clay into the shape of a human being. Then, at the completion of an esoteric rite, the rabbi applies a magical Hebrew word to its body and it miraculously comes to life. Beginning as a tame, mute servant of the creator, the Golem inevitably provokes a crisis due to its physical prowess. To make it inert, the rabbi removes the magic formula and the Golem returns to dust. The German film audience in 1920 vaguely knew the contours of this motif and expected a *nouveau frisson* when the lights went out.

As the credits and cast were flashing by, the "informed" reader and viewer would notice that many of the names reappeared from earlier stage and film productions of similar genre.[3]

Paul Wegener, according to Lotte Eisner, denied having an intention of making an expressionist film. Begging the question, she blames Poelzig's sets for the "misinterpretation" of the film as expressionist.

By the very nature of the Golem motif, artistic representation in whatever mode excludes a purely mimetic imitation. In *The Golem,* film, the most mimetic of artistic modes, reveals its ability to compete with the written narrative in the genre of fantasy. Each non-mimetic shot is composed for visual wonderment (the fantastic image) and for maximum evocatory intensity. This "cinematic lyricism," coined by Wegener (Eisner: 33) permits the visualization of the "inner world" of man, the state of his soul, a dream sequence or science fiction. The Golem motif in Wegener's film not only re-works the legend but infuses the film — on both the visual and diegetic planes — with expressionist *angst,* isolation, and desperation even as it offers a possible solution.

The film quickly ushers the viewer into the world of fate and misfortune. The stars that frame the first shots and the final one, metonymically symbolize the world governed by astrology, a world where free will seems banished and man is the plaything of the gods. This is the world of cosmic catastrophe so dear to the Expressionsts. The encircling of the linear narrative, the Golem legend, by the stars underscored the entrapping fatalistic cosmos. The starry frame, however, cues the viewer to the legendary or non-mimetic world he is to observe, in which the viewer, superior to the fated victim, is ultimately led to recognize his free will. An important binary relationship is immediately established which dominates the entire film: the zodiac world is to the world of men in the film as the film's worldview of fate is to the audience of free willed viewers.

The magic circle of fate, metonymically realized by the star imagery, structures the world view of the film. If it surrounds the narrative action and denies man freedom inside the film, it also places the linear narrative structure in contradiction to the encircling imprisonment. The *denouement* of the plotline leading back into the stars returns the narrative to the initial position. The eternal return negates the uniqueness of the events which are ever repeatable.

Significantly, the film provides a possible solution to the eternal return. With the frame of stars equating fate as the macrocosmic circle, the narrative with its binary symmetry provides two microcosmic circles inside the narrative at crucial events: the birth of the Golem, and the death of the Golem. The birth necessitates black magic, the conjuring of Astaroth, a demon, from inside a magic circle. This central scene, a spectacle to the eye, reveals Rabbi Low as intercessor in the metaphysical world — an unnatural world for men and the source of his continued victimization — in order to obtain the magic force to be placed on the star on the Golem's chest. The death of the Golem is preceded by the only "natural" scene in the film, the daylight scene where children dance in a perfect circle of communal happiness. As the Golem approaches, one innocent child saves mankind by naively removing the lifegiving star from the Golem's chest. The innocent act fuses the microcircle of "white magic," communal *agape,* with the macrocircle of astrology represented by the stars by returning the Golem's Star of David to the firmament.

The clay circle on the Golem's chest reflects not only the macrocircle of fate but Rabbi Low's circle of black magic. The "Star of David" placed upon the Golem's circle completes the black magic rite when Rabbi Low turns the telluric matter of the clay star into an animating spirit through the intervention of metaphysical forces. The "Star of David" on the Golem is to the stars as the Golem's circle is to the macrocircle of fate. The continued presence of the animating star on the Golem represents the presence of occult forces upon man and man's desperate effort to appease fate by tampering with its powers. Yet, the innocent hand which removes the star proffers the hope of redemption from the oppressor of fate.

When the "Star of David," at the end of the film, returns to the constellations above, the film concludes with a question: must this fated cycle rebegin or can we expect salvation heralded by the "Star of David" transmuted into the Star of Bethlehem? Linearity means escape from the circle of fate and salvation permits history through the Christological option. The audience is left with an ambiguous ending which places it in a position to choose.[4] These two images, then, one concrete, the star, a metonymy of fate, and the other, abstract, the circle, the metaphor of fate, together maintain a constant — if not oppressive — role as representatives of the supernatural which impinge on man either as personage or as passive viewer. The images integrate this fatalistic world into the narrative process.

The film's narrative is double plotted like a Renaissance English play and maintains the binary intent of opposing the supernatural with the natural. The Golem legend occupies the foregrounded plotline, but in clear counterpoint a love story functions in the background to heighten the legend and its meaning. The Golem motif can be divided into basic events or motifemes which structure the legend and permit variants in the agglomerates of the motifemes. The four central events are: 1. birth, 2. service, 3. catastrophic crisis, and 4. death. Wegener's consciousness of these elements can be seen in the title of the script he published in 1921, *Der Golem, wie er in die Welt kam, erdacht und ins Werk gesetzt* (The Golem, how he came into this world, was conceived and used).[5] Wegener's original use of the material does not rest with his creating his own film adaptation, but in organizing the context of immanent disaster, a world in disjunction, in order to speed and infuse the events with urgency and meaning.

Against the supernatural and indeed unnatural material of the Golem, a weak love plot develops involving Miriam and Knight Florian, the intent of which is to pose the universality of love and its naturalness. Unfortunately Miriam seems to be the *Doppelgänger* of Shylock's Jessica and Knight Florian, an uncivil *petit marquis*, both unable to evoke any sympathy. Rosenfeld aptly called the subplot *kitsch*.[6] But it points to the "popular" dimension of the film in which Wegener attempts to play off love against the supernatural and human barbarity. The subplot also prepares the holy innocent who tenders love to the beserk Golem at the

denouement. The knitting of the two plots under the motifeme of crisis occurs when Famulus, jealous of Knight Florian's success with Miriam, transgresses by reviving the Golem. By seeking unnatural means to combat an enemy for mere personal gain, Famulus brings new disaster upon the Jews and mankind.

Chaos is at the heart of both plots. Cosmic misfortune rains down political disaster and emotional disjuncture. The Golem, as personification of chaos, stands at the juncture of these plotlines. In the first part of the film, dealing with the political encounter between Jews and Christians, the viewer observes the Golem as an instrument of Rabbi Low's will. In the second part of the film, treating love and its configurations, the Golem emerges as the central protagonist. These two functions of the Golem reveal the general fusion of two strands of the Golem material.

The societal or political conflict begins with the imperial decree expelling the Jews. Although Kracauer is correct in insisting that Rabbi Low performs the only free willed and rational act in this universe of fate by creating a Golem, Wegener presents Rabbi Low in the ambivalent light of necromancer and prestidigitator.[7] The emperor, blinded by his secular power may have erred in expelling the Jews, but Rabbi Low's use of black magic transgresses his spiritual powers. Both men are in a state of hubris and the Golem as chaos becomes an agent of nemesis for both of them. Wegener *et al.* manipulate the viewer from having any empathy with the Jews in the film. All visual expressionist distorting effects — the crooked gables, the tortured gothic arches, dark shadows and bizarre costumes — symbolically echo the cosmic catastrophe of the Jews, intensify the oppressive atmosphere of doom and present the ghetto as exotic though stifling and ultimately dehumanizing. The Jews are depicted in broad caricatural strokes that seemingly draw on popular antisemitic stereotypes: they appear foreign, unruly, indulging in odd rites and clinging to their separateness in the dank ghetto. The camera, tilting down, presents the Jewish masses in terms of a *tachiste* vision that provides a Gothic apocalyptic coloring, but, more importantly, metamorphoses the ghetto inhabitants into earthly representatives of the netherworld.

In contrast, the world of the court with all its pomp and vanity breathes life and joy. The play of heavy shadows and brooding chiaroscuro of the ghetto yields to lightness: foregrounded ghetto walls and crippled arches give way to balanced architectural forms; narrow twisted lines of walls and stairs are swept away into palatial expanses. An exuberant Renaissance scene unfolds: dancing, splendid gowns, bright faces in the Rose Festival paean to life. Flowers bedeck the heads — the only intrusion of nature — as portents of goodliness and naturalness. From this happy world, Knight Florian rides off for a love adventure with the rose of life — and seduction — gripped in his teeth like an icon for his name. These same flowers will circle the heads of blond children at the *denouement.* The flower circles, like haloes, allude to a happy destiny in contrast with the yellow circles patched on the Jews' chests as the mark of cursed fate.

The viewer, if not sympathetic, can more easily identify with the court's world. The visual expressionist techniques of heavy distortion, which disfigure the ghetto, vanish in the court scenes. Into this soft world, the Jew as necromancer advances and with his conjurations like those of Moses before Pharoah, brings destruction to the court while backmailing the Emperor into rescinding the decree. The Golem as blind Samson fulfills his role as servant and defender of the Jews by blocking the doors as the banquet hall collapses. In the power struggle between secular overbearingness and spiritual distortion, the Jews unfairly exploit their demonic powers. The Golem is the mishapen Jewish arm against the flower of knighthood. Expressionist distortion is ironically used by Wegener to represent negativity.

The love subplot of Miriam and Florian, paralleling the political plotline, continues the Jewish-Christian encounter. Love, the abstraction, appears as a positive instinct within this gloomy world. But in the particular, can this view consider the love relation of the Christian Florian with the Jewess Miriam — within the context of an expulsion — as a normal, positive relationship? Can the love relationship serve merely as a plotting device to provoke the jealous Famulus, a new creation of Wegener *et al.* in the motif, as pivot to reawaken the Golem?

Hidden in the Florian-Miriam tie is the negation of the "unnatural" separateness of the Jew. Even before the evil decree is read, Rabbi Low objects to his daughter eyeing Florian. Besides shaming Rabbi Low by her behavior, Miriam threatens the principle of Jewish separateness by her "natural" passion for the handsome Gentile. Wegener skillfully exploits the generational conflict of father and daughter — a strong element in the contemporary expressionist theater as Sokel has noted. The restrictiveness of the father and his rabbinic world view is contrasted with the liberating power of love heralded by the Christian vision in the person of Florian. Bathed in warm, bright lighting, splendidly garbed, modishly coifed, Knight Florian, according to *pastorale* convention, can proceed to his "natural" right/rite of seduction. Miriam, insofar as she yields to her "natural" inclinations, is shielded from appearing morally compromised in spite of knowing about the expulsion decree. The sympathies of the film director are entirely on the side of the "lovers."

Famulus, garbed in black, the associate of Rabbi Low's necromancy, appears as the interfering, jealous suitor in this typical love triangle. Although he is the "legal" suitor, Famulus becomes the nasty opponent of "true love" in the film. Subsumed in this plot is the superiority of "natural" Christian love (*eros, philos,* and *agape*) to "unnatural" Jewish law. Famulus further sullies himself by resorting to the illegal secular use of the Golem to defend his "legal" rights — an act both unchivalric and by extension, unchristian.

The reappearance of the Golem from inertness — unique in the Golem motif literature — complicates the love triangle and adds the element of Grand Guignol: a monster in love! Holitscher can claim credit for

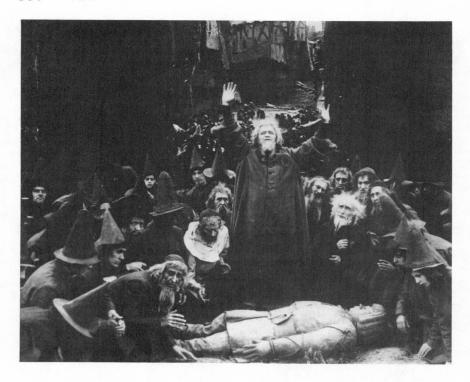

this plot invention.[8] Wegener *et al.* refocus the neo-romantic yearnings for emotional fulfillment from the throes of isolation underpinning Holischer's *Golem* into an expressionist drama of telluric lust — and revolt. The Golem pure *id*, lust incarnate, the personification of chaos, demands human rights. The Golem, the monstrous image of man incomplete, becomes, as in Meyrink's *Golem,* a negative *Doppelgänger* — but not of just one man, rather of mankind.[9] The Golem in love is man regressing to a primitive state bereft of form and morality. Expressionist fascination with the libidinous drive informs the personage of the Golem.

The etymology of the word *golem* means unformed substance in Hebrew. As man is a marriage of earth and God, so the Golem is a marriage of earth and man; the Golem reflects man in his shared earthiness and underlines man's impossibility to reach that divinity whose creation he is. Love is the divine spirit which man possesses and the gift he cannot provide in daring to imitate divine creation. The Golem, lacking speech, archaic proof of the living spirit, and lacking love which moves the spirit to articulation, remains the incarnate image of man's creative impotence so that Rabbi Low must ultimately call upon the devil to animate the earthen human shape.

The film, insisting on the Golem's netherworld origins reinforces his

demonic nature. By contrast, the incantation in the original Jewish legend could never have called upon the devil because the very animation of the Golem depended upon godliness. The film, therefore, links the creation of the Golem to the Jews as devil worshippers. An insert in the script notes, "Astaroth will take back his creature. The dead clay will scorn its Master and destroys him and all living things" (G.: 44). This insert reinforces the impinging misfortune.

The source of the Golem's sentience is a result of his secular misuse. The film shows the Golem chopping wood, drawing water, collecting herbs in the apothecary shop; these tasks — while seemingly innocuous — become violations in the Jewish folktales of an interdiction against using the Golem for personal advantage. In the film, however, this "living experience" of the Golem initiates consciousness through his imitation of human behavior and leads to revolt. The filmmakers, accordingly, insist upon the hostility of the Golem from his earliest awakening toward the "hated assistant" (G.: 29). Hate is the first emotion of the Golem. This negative feeling is, in binary form, the opposite of love in man, the distinguishing divine gift. The hate in man resides, then, in his primitive, telluric origins, which are captured in their violent chaos by this projection of man — the Golem. The Golem motif, in short, provides Expressionism with a dynamic concrete metaphor of man's primitive drives.

Man's hubris, in trying to imitate God's creation, brings nemesis upon the instigator. Jealousy drives Famulus to deploy the Golem for personal gain against the Christian under the guise of Jewish defense. The transgression triggers the disaster. The Golem, who had already sought to elude Rabbi Low before being rendered inert, now strengthened in hate goes beserk. Faced with the violence of the Golem, Famulus backs away in stereotypic cowardice while Florian, with true knightly virtues, tries to defend Miriam and dies. Lust and cruelty join hate to produce senseless violence. The Golem, unable to wrest love from Miriam, to know love as a human, wanders, dazed, destroying all in his path. A man, conversely, unable to truly love, becomes a Golem — surely a message of the film.

The innocent child who approaches the Golem, unafraid, proffers human love, in the form of food — a most basic expression — which conquers hate, soothes violence and incarnates the Christological response to the world of fate.[10] *Agape* can break the astrological circle and bring man freedom, linear growth and free will. This is the choice offered the viewer: the star of redemption through love or victimization. The scene of the innocent children, the presence of open nature through bright lighting, white flowers in the garlands like haloes on blond hair, all set outside of the black ghetto walls with all its negative implications, offers a clear definition of the salvation from chaos and telluric forces: Christian love.[11] The innocent, unaware of evil, overwhelms the Golem who experiences the first sense of sharing. *Näivete* removes the unnatural life-giving force, the "Star of David," — the metonymy of the negativity —

before its ambivalent metamorphosis, and casts it off symbolically free-
ing man from his evil inclinations, and hopefully restoring equilibrium
and the natural order. The white costume of the child, set off against the
black wall, underscores blatantly the theme of good and evil.

The return of the Golem's inert body inside the "curved walls" (G.:
51) insists on the evil that continually lurks ever ready to return. The last
sequence of the film returns to the mass scenes of the ghetto where the
Jews, still indulging in their strange ways, seemingly pay homage to
necromancy. The flickering, distorting chiaroscuro contrasts negatively
with the harmony of children dancing with flowers. The tilts and close-ups
of the camera angles in the ghetto scenes increase distortion and
negative comment whereas the long shots and medium long shots of the
"apple" scene place the viewer at eye level for greater empathy. In the
final sequence, the Jews have not learned the truth. Instead of destroying
the Golem as originally planned (G.: 44), the Jews move the body back in-
to the ghetto and thereby reincorporate latent hate and chaos into their
world of circularity. Not having recognized the innocent child as a sur-
rogate of the Christ child, the Jews are doomed to isolation and exile.[12]

The city, the central image of modernity for so much expressionist
poetry, emerges in this film as the massive Golem itself, unnatural, un-
finished, incomplete, alone. The ghetto is the synecdoche of the city. It
reflects the urban labyrinth circled by physical and mental walls, and seal-
ed off from nature. Exotic, fascinating, it symbolically becomes modern
urban life; suffocating, uncontrollable, repulsive. The celebrated sets of
Hans Poelzig with Boese's and Freund's lighting and Glieses' costuming
are integrated in a conscious patchwork of triangles to produce the
aforementioned states. The crooked triangular roofs, the windows, hats,
beards, even the crosshatching of the wooden beams, the "gothic" ar-
chings, including the shaping of so many shots themselves, intensify not
only gothic tonality and texture, but structure inchoate yearnings and ef-
forts of the inhabitants as well. The triangular shapes may imply incipient
Christological significance, but more likely they suggest the broken,
isolated triangles of the true Jewish six-pointed Star of David which is
made whole only by the overlapping of opposing isosceles triangles.[13]
The latter cannot occur in the film for that would suggest harmony and
the Jews represent disharmony. The jostling autonomous triangles im-
pose an over-determined expressionist visual unity, based on simplifica-
tion of form and distortion, which mirrors the urban confusion and plight.
The city, ghetto, and its inhabitants, like the Golem itself, emerge as the
overwhelming negation of nature, love, harmony, and goodness. About
the city, visual expressionist techniques fuse with expressionist ideology.

Is redemption possible for the city and its residents? The Golem's
"Star of David" resting on the black walls encircling the fated city fuses
the chaos of triangles microcosmically into a white harmonious star of
unity returning to the "darkness of the heavens" (G.: 51). The film aban-
dons the city to its fate but the film viewer has free will to follow the star
to Christian salvation and freedom.

Lotte Eisner's reticence to dub Wegener's *Golem* an expressionist film in her book, *The Haunted Screen,* is based not only on Wegener's own comments but in opposing *The Golem* to *The Cabinet of Dr. Caligari* (1919), the sets and personages of which she perceives as truly conforming to expressionist conceptions (Eisner: 24). Her objection to Wegener's *Golem* as expressionist can be reduced to its visual representation. Wegener's film is "never broken by clashing or exaggerated Expressionist brio" (:56). Leaning on Kurtz's book, *Expressionismus und Film* (:58), to support her case, she argues that Poelzig's sets are not sufficiently abstract and the lighting based on Reinhardt's effects is too fluid and subtle for Expressionism. She admits, however, "from time to time [to] Expressionistic shock lighting effects (:59)." Kurtz, significantly, does not deny Wegener's film a place of respect in expressionist cinema. He notes that *The Golem* and other such films having a "literary origin" oriented Expressionism to the material (Kurtz: 83). *The Golem* is a perfect example of the latter.

What greater contrast can there be between the expressionist ghetto sequences and the "mimetic" sequences of the "flower children?" The set abstractions of *Caligari* persuasively express the harsh distorting mentality of a madman. But just as effectively do the distorted sets and protagonist in *The Golem* reinforce the "message." Expressionism is a method with a social apocalypic vision, but not an end in itself. Unfortunately, Eisner used *Caligari* more as a paradigm than as a representative example of Expressionism, which, therefore, undermines the value of her theoretical formulations.

The Golem securely takes its place within the expressionist wave of films. It shares the same environment of Germany in 1920 with *Caligari* (1919) and *Nosferatu* (1922). It poses the same questions of good and evil in a world haunted by cosmic catastrophe and human despair seeking salvation. It uses the same techniques of distortion, simplification and exaggerated intensity. In the expressionist manner, personages are treated not as individuals but rather as types: the Good, the Lover, the Envious, the Monster, etc. The Golem typically objectifies, as do the other *automata,* the negative forces and qualities so concretely presented on the screen, with its folkloric appeal to black magic and the supernatural. The fantasy scenes of magic, the anti-naturalistic sets and acting, the escapist fascination with the exotic and legendary material, even the banal plotting based on lust and the simplistic solutions to redemption, all place Wegener's *Golem* within the filmic confines of expressionist creativity of post World War I Germany.

Obviously the film in general did not share the subtlety or depth of vision that a Heym or a Stadler brought to expressionist poetry, or Kaiser and von Unruh brought to expressionist theater, or Kirchner and Schmidt-Rottluff to painting. But it shared the same vision and techniques and conquered a new art form only now receiving academic respect.

When *The Golem* (1920) is compared diachronically to *Le Golem* (1937) of the French filmmaker, Julien Duvivier, the differences between an expressionist and a "socialist realist" treatment of the same motif becomes sharply defined. Whereas the German version structures the Golem as a *Doppelgänger,* the nexus of human primitive forces that haunts man psychologically and spiritually, the French version portrays the Golem as the fantasied yet necessary symbol of the Jewish people's political and social will to freedom from enslavement to their real enemies — the fascists. The Wegener version insists on the automaton as an evolving creation, a monster growing more demonstrative, more humanly expressive, the center of the viewer's attention. The Duvivier version insists on the victimization of the Jews and their determination to fight back by the use of a messianic robot. Wegener uses personages as objective, depersonalized types which is also true in his treatment of the Jews. Duvivier enriches the motivic personages with distinct personalities and makes the Jewish masses vibrant. *The Golem* (1920) builds its oppressive atmosphere by stylization, distortion, and chiaroscuro lighting; *Le Golem* (1937) creates tension by alternating incidents of indignation with comic relief. The audience leaving Wegener's *Golem* receives a traditional religious message entwined with atavistic attitudes and reactionary platitudes as ways of resolving the problems of man's condition. The viewer leaving Duvivier's film emerges demanding justice for the Jews and punishment of the oppressors. Duvivier's film, however, pays homage to Wegener's effort. Although he scrupulously avoids all the fantasy and magical effects of Wegener, he absorbed the basic plot line and the weak subplot reinterpreted in his own ideology. He learned how to handle the mass effects and animate the Golem. Duvivier rejects Wegener's expressionist techniques and *volkist* ideology, but he does so as a conscious heir to the Golem motif and its most successful filmic treatment until his time.

I do not wish to leave this essay without insisting on the dehumanization of the Jews in Wegener's film. Duvivier's portrayal is so philosemitic — even using Yiddish when the Jews converse — that I cannot doubt that he sought to reverse the image of the Jew in Wegener's film. Wegener accomplished the complete Christianization and Germanization of this Eastern European legend. Since Achim von Arnim introduced the Golem into German literature in his short story, *Isabella von Egypten,* the Golem has been an evil *Doppelgänger,* always created by an unsavory Eastern European Rabbi. Wegener, however, makes the Jews, their Rabbis, the Golem and the ghetto itself as the source of disturbing exotic emanations.[14] The Jews and their traditions are distorted — not stylized — in order to provoke humor and derision. The stereotypic presentation cannot be justified as "expressionist" distortion or mere caricaturing. The Jews are sharply contrasted to the Gentiles and are even cinematically placed among shadows. They appear as worshippers of the demonic, if not adherents of the anti-Christ. Their reprieve from expulsion is not an

act of justice but a display of "negative power," blackmail, through the use of evil forces. The Jews are dehumanized and condemned as a people. Celine always urged that he never meant to attck the Jews *per se*, but the Jews as symbols of evil capitalism. Nevertheless, the title of his most viciously satiric book, *Bagatelles pour un massacre* (1937) is not without meaning. Kracauer's thesis that the German expressionist films were presentiments of the future deserves to be taken seriously. Is it accidental that Wegener was one of the very few expressionist film directors to remain in Germany after the Nazis came to power?

Notes

[1]The script of *The Golem* (1920) which I refer to in this essay, henceforth as G., appears in *Masterworks of the German Cinema* with an introduction by Dr. Roger Manvell (New York: Harper and Row, 1973).
There are two excellent treatments of the Golem motif. Gershom Scholem, in his chapter "The Idea of the Golem" in *On the Kabbalah and its Symbolism* (New York: Schocken, 1965), the English translation by Ralph Mannheim of *Zur Kabbale und ihrer Symbolik* (Zurich: Rheim-Verlag, 1960), discusses the Hebrew and Jewish religious sources of the motif. Beate Rosenfeld in *Die Golemsage und ihre Verwertung in der deutschen Literatur* (Breslau: Verlag Dr. Hans Priebatsch, 1934) in the series *Sprache und Kultur der Germanisch-Romanischen Völker*, Germanische Reihe, Band V, provides a thorough diachronic study of the Golem motif in German literature until 1926. Also helpful are: S. Ansky, "Ritualnije Naveti V Evreiskom Narodnom Tvorchestvo": in *Russkoe Bogatstvo*, (Jan.-Mar., 1912), vol. I, p. 57-92 and *Dichtungen und dokumentem über Golems, Homunculi etc.*, ed. Klaus Völker, (München, dtv, 1976).
The three studies of Expressionism and cinema I have found most useful are: Lotte H. Eisner, *The Haunted Screen* (Berkeley: University of California Press, 1969) which is the revised English version of *L'Ecran Demoniaque* (1952); Siegfried Kracauer, *From Caligari to Hitler* (Princeton: Princeton University Press, 1947); and Rudolf Kurtz, *Expressionismus und Film* (Berlin: Lichtbildbuhne, 1926).
My thoughts and conceptions of Expressionism draw on: Armin Arnold, *Die Literatur des Expressionismus* (New York: Oxford University Press, 1972); Ilse et Pierre Garnier, *L'Expressionisme Allemand* (Paris: Andre Silvaire, 1962); R. Samuel and R. Hinton Thomas, *Expressionism in German Life, Literature and the Theater 1910-1924* (Cambridge: Heffer and Sons, Ltd., 1939); Richard Sheppard, "German Expressionism" in *Moder-*

nism, edited by Malcolm Bradley and James McFarlane (Middlesex: Penguin Books, 1976); and particularly Walter H. Sokel, *The Writer in Extremis* (Stanford: University Press, 1959).

²Armin Arnold, *Prosa des Expressionismus* (Stuttgart: Kohlhammer, 1972), p. 121

³Today, *The Golem* appears as a *Who's Who* of German expressionist cinema. Paul Wegener, the director, and his colleague Hans Poelzig, the designer, were long matriculated from Max Reinhardt's theaters (the latter as a design-architect of the Grosses Schauspielhaus and the former as an actor at the Deutsches Theater.) Henrik Galeen, the script writer, (for *Nosferatu* as well) had previously helped direct and performed in *Der Golem* (1914). Guido Seeber had also been the cameraman in earlier Wegener films and helped direct a film called *Alraune Und Der Golem* (*Mandrake and the Golem*). Other 1914 Golem veterans were Rochus Gliese, who not only costumed the personages but created the fantastic images, and Lyda Salmonova (Miriam), Wegener's wife at the time. Impressed by Carl Boese directing Lyda Salmonova and Otto Gebuhr (the Emperor) in a film, Wegener asked them to join him in remaking the *Golem* (1920). Boese directed the special effects. And Karl Freund, considered today one of the greatest cameramen, was already appreciated as a master when he joined Wegener. *The Golem* of 1920 was made, then by a professional team not only well versed in the particular motif but who shared a common concept of cinema and its possibilities. Their training and previous creations fused the lighting and staging innovations of Max Reinhardt with an expressionist vision and new cinematic techniqes. *The Golem* is as much a technical triumph as it is a cinematic success.

⁴One can continue this Pierceian chain of signification. The darkness of the screening room with the flickering shadows on the screen is by analogy the world of fate, if not man's inner world of imagination or superstition which yields normally when the lights of the theater are tuned on to reason and linearity.

⁵Rosenfeld, *Die Golemsage,* p. 145. I have never seen this book which is cited by Rosenfeld; nor does Dr. Manvell mention the German text used for the translation in his introduction to G.

⁶*Ibid.,* p. 149

⁷Kracauer, *From Caligari,* p. 113.

⁸Rosenfeld, *Die Golemsage,* p. 145.

⁹In 1920, the Yiddish poet and dramatist, H. Leivick, wrote his version, *The Golem,* in which the Golem becomes a positive *doppelgänger,* the image of unredeemed suffering man, desperate for love and meaning but trapped in isolation like the Jews themselves.

¹⁰The possibility of interpreting the little girl as baby Eve tempting a pre-Adamic figure with the apple of love/lust adds an

ironic texture to the scene. The physical and emotional needs of man expressed through the act of sharing (the apple offering) differentiate an Adam from the Golem. A Golem does not eat, talk or share; and it lacks any mons. It can serve or demand, but it cannot participate. However, the smile of the Golem, the first emotive response, follows logically his wending towards manhood. Unconsciously Wegener *et al* had stumbled on the parallel Talmudic exemplum, see *Sanhedrin* 38b, that Adam was a Golem (unformed mass) before God made him a full human being. That the Golem dies unexpectedly at the hands of the naive child at this epiphany, heightens the ironic tone. Perhaps it augments the ultimate Christological position of the film, that man, like the Golem, conceived in sin, can be saved only through *agape* and grace.

[11]This pastoral scene stirs thoughts of "intertextuality," specifically of Goethe's *Faust II*, the closing scene:

Seliger Knaben
Seh ich bewegte Schar,
Los von der Erde Druck,
Im Kreis gesellt,
Die sich erlaben
Am neuen Lenz und Schmuck
Der obern Welt.

Both texts share the images of roses, innocent children "Freudig zum Ringverein" in springtime renewal, metaphors of the Christological theme of spiritual rebirth. Without implying that *Faust II* is the actual source of *The Golem* children sequence, we cannot discount its resonance. "Regt euch und singet/Heil'ge Gefuhle drein" — a noble "subtext."

[12]When Rabbi Low projects in the Emperor's presence (G.: 41) the image of the Christ child in flight to Egypt coupled with Jewish wandering, the oblique allusion seems to be that the rejection of the Christ is the source of Jewish wandering, suffering, and hubris. The young innocent, like the Christ child, saves the Jews from the Golem (chaos and evil) and goes "unrecognized."

[13]Hans Poelzig knew that a Star of David is six pointed as can be seen in his sketches reproduced in Lotte Eisner's book, *op. cit.*, p. 60. Why the Star of David became five pointed, and thereby not Jewish, remains a mystery. Another inconsistency is Florian's hair which appears blond in the first part of the film and becomes black in the love scenes.

[14]Germany in 1920 had just witnessed the Spartacus Revolt and other unsuccessful revolts. The country was in political turmoil. Are the Jews being equated with disorder or the source of chaos?

21
Fritz Lang and German Expressionism: A Reading of *Dr. Mabuse, der Spieler*

E. Ann Kaplan

A good deal of confusion surrounds Fritz Lang's relationship to German Expressionism, partly because of his own ambiguous statements about the influence of the movement,[1] partly as a result of interpretations of Lang's films focused on Siegfried Kracauer's persuasive *From Caligari to Hitler* (1947).[2] Despite the obvious problems with Kracauer's methodology and tone,[3] his book reveals certain themes evident in expressionist and other films made prior to Hitler's election, focusing on the preoccupation with death, madness and tyrannical power that characterized the period, and which he suggests helps account for Hitler's success.

In the post-World-War-II period, when the full extent of Hitler's deeds was known, it was easy to simplify Kracauer's thesis and to see all filmmakers in the pre-Nazi period as tainted with fascism. It became commonplace to say that Lang was, at best, indifferent to the tendencies of his period (many critics believed that he ought to have been), and this kind of critical perspective, strongly influenced by Kracauer, has been continued

in the work of East Berlin critics, but also by some American writers (like George Huaco[4]).

The distorted interpretations of Lang's films from this perspective stem from two main causes: first, Kracauer's film theory (articulated in *Theory of Film*) leads him to value the realist style as the one that reflects the central aspects of authentic cinema, while other styles, including Expressionism, are seen as unhealthy, decadent and perverse; second, he largely sees Lang's films as *reproducing* rather than *commenting upon* the irrationalist and asocial tendencies of his period, which created a climate hospitable to the rise of fascism. The following quotation provides an example of this kind of critical approach:

> Instead of making *Dr. Mabuse* reflect familiar surroundings, Lang frequently stages the action in settings of pronounced artificiality. Now the scene is an expressionist club-room with painted shadows on the wall, now a dark back street through which Cesare might have slipped with Jane in his arms. Other decorative forms help these expressionist ones to mark the whole as an emotional vision. *Dr. Mabuse* belongs in the *Caligari* sphere. It is by no means a documentary film, but it is a document of its time.[5]

Kracauer claims that *Dr. Mabuse* is only a "document of its time" because it celebrates anarchic fantasies, culminating in tyranny, and does not make "the slightest allusion to true freedom."[6] Eckart Jahnke, and other East Berlin critics clearly influenced by Kracauer, are even more condemnatory. Writing about *M*, Jahnke blames Lang for not seeing the historical necessity of what was taking place in Germany and for falling under the influence of pessimistic philosophers like Spengler and Schopenhauer. Jahnke criticizes Lang's inability to provide a scientific analysis of society. In a similar manner, Rolf Hempel criticizes Lang for not objecting to the social system as a whole and for being a propagandist for the bourgeoisie.

To condemn Lang for being politically a Liberal (at the time in Germany, that meant to the right of the Social Democrats), for not including all political perspectives in his film, and, finally, for not showing the Communists as the only viable alternative, is to miss the point of what he was doing. Such a narrow view applied to *Dr. Mabuse, der Spieler,* prevents critics from appreciating the progressive aspects of Lang's stance and from responding to the film as art. Lang uses narrative juxtapositions, subtle camera work, lighting effects, and editing to subvert the dominant forms of bourgeois cinema and to analyze critically bourgeois consciousness and life.

Far from being only an "emotional vision," the film exposes and critically dissects the consciousness of the period through carefully arranged cinematic strategies. The expressionist retreat from realism, anticipated already at the turn of the century, was not the result of escape into fantasy but manifested a deliberate attempt to undercut the dominant

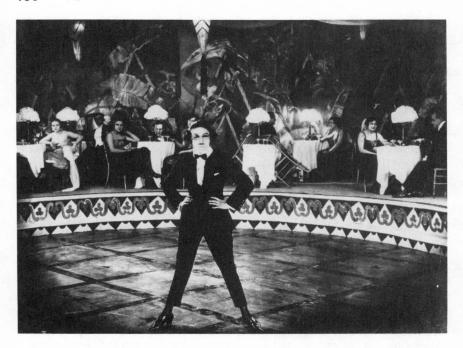

modes of representation that reflected bourgeois values rather than the "truth" about capitalist society. When the movement began to influence film in the 1920s, the expressionist filmmakers, also in revolt against bourgeois values, aimed to replace traditional images with their unique, subjective ways of seeing. *Caligari* and *Raskolnikov* — with their painted sets, distorted perspectives, dramatic light/dark contrasts and subversive themes — typify the kind of new, non-realist film art. *Caligari*, the first expressionist film and the one that influenced an entire generation of filmmakers, breaks deliberately with all the main film codes of representation and narrative that dominated realist literature for two centuries. Transparence and the illusion of continuity are subverted in the film.[7] In this reading, expressionist film is part of the modernist revolt against traditional forms, begun in literature and painting.

The cinematic techniques that Lang employs in *Dr. Mabuse, der Spieler,* show at times a similiar rejection of traditional film codes of representation and narrative. Lang sought to undercut the comfortable bourgeois images of reality and to expose the nightmare world that lay beyond the illusions which the bourgeoisie had carefully constructed to make themselves feel safe and virtuous. But Lang also played with traditional representations, using them to reveal the dangerous tendencies of the time. He does all he can to distance us from characters and events, forcing us to identify with a figure like Mabuse, whom we abhor. Through

editing techniques, he creates a disjointed narrative so that we are never allowed to stay long enough with one group or action to become fully involved; and in specific scenes and with specific characters, he uses expressionist visual techniques to create a sense of unease, of things unbalanced, not normal. We are thus enabled to *think* about what is going on, to stand apart and evaluate the world Lang presents.

One of the predominant aspects of this filmic world is its lack of viable, solid and enabling institutions. Structures that we normally associate with successful capitalism are either crumbling or simply absent; thus, the Stock Market is seen as highly unstable (Mabuse is easily able to create havoc), the Ruling Classes are bored, depressed, devoid of energy, and normal Family Life is strikingly absent for all classes. The erosion of accepted social forms creates a climate of chaos in which the tyrant can easily gain control. Lang's world reflects the oscillation between chaos and tyranny that Kracauer found characteristic of films of the period. But far from glorifying this, Lang is at pains to expose the danger of a world view limited to these polarities. He uses an effective combination of expressionist and realist cinematic styles to create a filmic universe dominated by alienation and confusion.

Each of the two main worlds of the film is presented through images that convey emptiness, loneliness and desperation. The first world consists in representatives of the ruling class—Edward Hull, banker and industrialist; the Tolds, aristocrats, with whom industrialists re-allied; Von Wenk, the detective, who mixes comfortably with the Tolds, symbolizing the collusion between state authorities and the ruling class. All of these people are alienated and isolated: Hull, a bachelor, lives alone in his luxurious, spacious house; Von Wenk, like all detectives, leads a solitary life and is always seen either in clubs, visiting Hull or the Tolds, or in his office. He apparently has no private life; the Tolds, obviously bored with each other, are rarely together—promiscuity and infidelity seem to be the norm for them. There are no children in their even more luxurious house, and Countess Told, beautiful and narcissistic, clearly exists only for decoration and adoration—empty of meaning for herself, she stands as a passive object of male desire. She submits listlessly to Von Wenk's amorous advances, and later on is helplessly captured and locked up by Mabuse.

The absence of the family, source of traditional sex roles, indicates disturbance, in these traditional roles, particularly in relation to the men. The decline of the old-style governmental authority in the state is reflected in the decline of the traditional, patriarchal family; ruling class men no longer function as old style patriarchs, but have instead become passive, weak, effeminate. Hull, while puffed up with self-importance and arrogance, has a slender, effete appearance, and is easily hypnotized by Mabuse. Told, even more effeminate, has a blank, bored expression, and the same small, slender body as Hull. The lack of any sexual relationship with the Countess and his dedication to art suggest homosexuality. Von Wenk, the most vital of the three, is still a dandy looking for sensual

pleasure rather than an official dedicated to his task of unravelling the mystery of Mabuse's identity and whereabouts. He, nevertheless, is the only ruling class man to resist Mabuse's hypnotism (a kind of castration), and in the end he does manage to overcome Mabuse.

As already noted, Countess Told defines herself totally in terms of sexuality and represents the negation of the mother image. Her beauty and extravagant clothes do not conceal her boredom; her manner is cool, her gestures slow and self-conscious. Her rich gowns, chosen and arranged with studied care, attest to her deliberate projection of an image. All the ruling class people are characterized by a debilitating lack of energy, recalling here Nietzsche's analysis of aristocrats in *The Will to Power*. Countess Told seems barely able to support her slight frame, and is always on the verge of dropping into a chair; Count Told betrays nothing spontaneous, vital or uncontrolled and for the most part seems extremely depressed; Hull has a brief surge of energy when he falls romantically in love with Cara, but, rejected, lapses into gloom.

Lang deliberately chooses expressionist mise en scene for the aristocrats to convey specific meanings in relation to them. First, the sharp angles and distorted designs suggest a class out of touch with reality, creating an artificial world of its own rather than relating to the society

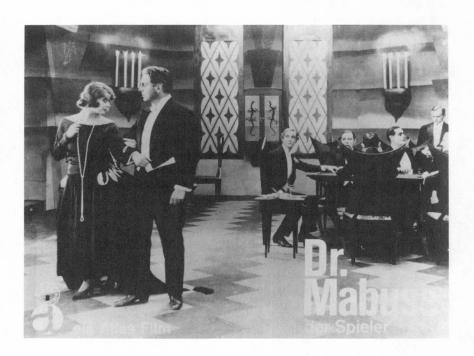

that exists. The beautiful but unreal realm gives a false sense of security, and the people seem unaware of the dangers lurking beneath the apparently ordered surface of things. Second, the elaborate expressionist designs in the private houses and clubs threaten to overwhelm the people. Their smallness within their luxurious spaces makes them appear insignificant, and this undercuts their arrogance. The beautiful sets acquire a life of their own, emerging as far more interesting and alive than the reserved, bored, and emotionless people they surround. The enclosed existence of the rich, rarely seen outside in the streets or in nature, reflects a world based on material comfort and elite culture. It is a world deprived of transcendence through passion, belief, or commitment.

Set against this world is that of the lumpen-proletariat and various workers and petty-bourgeois types. The absence of the family works out differently in this world. These people, disconnected from main-stream institutions, are drawn to Mabuse precisely because he offers a patriarchal refuge for them; his image is that of a powerful father whom they can trust and who will bring about their advancement in society. Through him they will acquire the importance and significance they lack on their own. The absence of the family in this world of the lumpen proletariat enables Mabuse to create a kind of perverted "family" where the people are linked, not by a sense of solidarity or dedication to a cause, but by self-interest and thralldom to Mabuse. The physical images of the people in this second world are strikingly different from those of the rich: instead of

smooth elegance, the people have ungainly shapes and often some kind of physical or psychological flaw. Georg is fat and lazy, while Pesche is nervous and jumpy. Spoerri, effeminate and thin like the ruling class men, parodies them in being a cocaine addict. Cara Carozza, the dancer and the only attractive person in Mabuse's world, is marred by her thralldom to her leader. The couple who manage the counterfeit factory are sullen and weary, while the workers in the factory are, significantly, blind.

Lang uses an entirely different mise en scene for this world: instead of the elaborate expressionist sets we have more realist ones suggesting that, unattractive and pathetic as they are, these people at least live in the daily society. They are seen on the streets, and even occasionally in nature (as when some rob the courier at the start of the film), and their rooms have a realist decor. Even though unhappy, they are at least busy and struggling, and there is something engaging, if horrifying, about a passion like Cara's for which she will lay down her life.

The contrast between vitality and listlessness is highlighted in the juxtaposition of Cara and Countess Told. We see Cara dancing energetically on the stage, while Mabuse stares at her from his box, whereas we meet the Countess in one of the clubs, entering languidly and draping herself, as if unable to stand, on a day-couch to *watch* the players. While Cara is active, both as a dancer and as one of Mabuse's most useful agents, the Countess has nothing to do, and remains a passive observer of life. When Cara is arrested, she is defiant and rebellious, and struggles against her captors, finally committing suicide to protect her leader. But Countess Told is whisked away from her home without any apparent struggle.

The scene where Countess Told comes to Cara in her prison cell is beautifully shot so as to highlight the contrast between the women: Countess Told has dark hair, wears a smooth, black cloak and is extremely beautiful. Her manner is reserved, controlled and cool in stance and manner. Cara has fair hair, a chunky form and a passionate, rebellious stance. The scene is expressionistically lit, with dark shadows on the prison walls, but Cara's head is surrounded by a halo of light suggesting a kind of innocence as against Countess Told's obvious world weariness and decadence.

Mabuse ultimately controls both women, and in fact stands between the two groups they represent, manipulating them in different ways. He is the only one explicitly connected with society as an economic and political organism—a kind of machine. It is because Mabuse knows who he is and what he stands for, because he understands how to manipulate the social machine, that he gets as far as he does: he disrupts the ruling class control of the economic system by manipulating the stock market, by manufacturing false money and by carefully planning burglaries of important commodities. He has exploited the ruling class neglect of their disaffected classes, using them to advance himself. Blind arrogance and

assumption of superiority nearly cost the ruling class their system. Stand-
ing outside the class structures that bind everyone else in the film and
condition their behavior, Mabuse moves freely between worlds, donning
many disguises and playing roles.

Lang deliberately manipulates the spectator's response so as to pro-
duce the ambivalences and contradictions that give *Dr. Mabuse* its com-
plexity and status as critical-expressionist art. While the surface images of
the rich seem to grant status and power to this class, the narrative of the
film—structured, as we have seen, around Mabuse's deceptions and
manipulations (Mabuse alone holds the key to all the enigmas in the
film)—enables us to see how unstable and vulnerable is the society por-
trayed. The people ostensibly in power, who believe that they control
everything, are seen as being used and manipulated by Mabuse. The
spectator is made anxious since the ruling class would normally provide
the focus of identification. Meanwhile, Mabuse's pathetic crew earns our
pity through their sad dependence on a leader whose wild fantasies have
led them astray.

Lang has thus challenged our usual patterns of identification, but
even more disturbing is the identification with Mabuse himself that the
narrative structure encourages. Mabuse's power within the text of the film
is undeniable: this is partly caused by his placement above the other
groups. But he is also the locus of energy, vitality, action and intelligence.
We are drawn to him because he stands out in a world of a bored, listless
and passive upper class and a frightened, powerless lower class. The iden-
tification is, however, problematic, since Mabuse stands for negative
characteristics of harsh exploitation, greed, hunger for power, and
ruthless manipulation. We are cornered in a series of contradictions: the
people we would be expected to identify with are incompetent, weak, and
living an unreal existence; the figure who controls everything and pro-
vides the energy and intelligence in the film is morally abhorrent, even
mad. While the deterioration and emasculation of the ruling class seems
pitiful, the rich appear to have earned their victimization by a figure who
has revived old-style patriarchal modes that the ruling class traditionally
used to preserve their power. Mabuse's energy is attractive but destruc-
tive; in not offering the spectator anything positive with which to identify
or to posit against the decadent old world, the new order appears simply
as an underground, more powerful version of the order that is being over-
thrown. We are caught between two equally undesirable ways of being,
two worlds, neither of which offers us the comfort, security, peace and
community symbolized by the old, stable social structures. We are torn
between regret for the invasion of the elite, cultured aristocratic world by
philistines and barbarians (a la Matthew Arnold), and a degree of reluctant
and ambivalent admiration for the energy of those very barbarians.

It is significant that Lang, after defying traditional narrative codes in
Dr. Mabuse (non-continuous editing, disruption of linear cause-effect rela-
tions and of time-space constructs), concludes the film in a conventional

moralistic manner. Mabuse is finally de-legitimized in a traditional cops-and-robbers ending, with Von Wenk and the police trapping him in his lair. Seeking to escape through underground tunnels, Mabuse reaches his hide-out only to go completely mad. The last images show him raving and tossing his money up in the air.

For the most part, however, Lang's film is far from conventional. He presents us with a complex, ambiguous, haunting (often disturbing) filmic world. The form of his film—with its disjointed narrative cutting between polarized worlds, its mise en scene brilliantly expressing the values of the characters, its chiaroscuro lighting creating an eerie, unsettling, ominous effect—provides an aesthetic correlative for a critical view of Germany in the 1920's.

From a political point of view, however, the film is interesting in reproducing the central contradictions of Expressionism. Kracauer and the sociological critics may go too far in assimilating Lang to fascism, but they are correct to point out the limitations of the expressionist vision. On the positive side, politically, *Dr. Mabuse, der Spieler* negates bourgeois codes in order to reveal their inadequacy and vulnerability to subversion from dangerous, tyrannical forces. Lang's vision here is useful in pointing out the danger of permitting only two possibilities—chaos or tyranny —neither of which Lang espouses. On the negative side is the very fact that the gap between the two extremes of chaos and tyranny is left open, i.e., not "filled in" with some notion of democratic interchange (although such an alternative is not ruled out by the film). The gap encourages nostalgic images of a mythic, idealized past (pre-dating capitalist industrialization and urbanization) as the only "solution."

While Lang brilliantly presents in *Dr. Mabuse* a set of oppositions similar to those plaguing Germany in this period (and which have plagued societies before), we can also see the limitations of what he, and other Expressionists, were trying to do. Attacks on bourgeois codes of rationality are an important aspect of Expressionism, manifested in rejection of logic, scientific causality, and instrumental reason. But by defining themselves in opposition to bourgeois codes, the Expressionists were unable to move beyond them. Although the de-legitimation of instrumental rationality was progressive, and the assertion of love, passion, and concern for the human person defied egotistic-individualistic bourgeois codes, Lang's films neither pose the problems completely nor provide adequate solutions. From the position of revolt against bourgeois "reality," which involved the two poles of tyranny and chaos, the Expressionists either chose chaos in a mad attempt to have everyone go down together, or, tired of chaos, found themselves, like Lang, suddenly attracted to bourgeois law and order. Expressionism, like the rest of the avant-garde of the period, was the dying gasp of bourgeois subjectivity, rather than something totally new. That Lang and others could not offer a critique within the confines of their situation does not implicate them in Nazism; but it does alert us to the need to constantly question our basic assump-

tions in our art, politics, and society. *Dr. Mabuse* documents its period correctly, from a critical standpoint, and should have served to warn Germans of what was before them. But in not opening up alternative ways of seeing that transcended familiar polarities, Lang was unable to move his audience beyond a sense of hopelessness. We can learn a lot from this.

NOTES

[1]In many interviews, Lang denied having been influenced by Expressionism, partly, perhaps, because he realized the links that people easily made between the movement and Nazism, but also because he hated to admit to taking anything from anywhere else. Cf. annotation of books and interview in E. Ann Kaplan, *Fritz Lang: A Research and Reference Guide* (Boston: G.K. Hall, 1981).

[2]Kracauer's text is fascinating in its discussion of the predominant character types and the main themes evident in pre-Nazi films, but he gets into difficulty when he attempts to interpret the underlying psychology in terms of German social and political history. Even the title of the book—*From Caligari* (a film character) *to Hitler* (an historical figure)—is misleading in the appropriation of representation to actuality. While Kracauer was himself presumably keenly aware of the complex interaction between art and society, culture and history, the terms in which he talks about the film-world characters misleads in appearing to make little distinction between representations and actual historical figures. This enabled critics to assume that the filmmakers who represented certain types of people and themes were themselves involved in an attitude to the world that later on enabled Hitler's election.

[3]The limitations of the sociological approach to film criticism has been thoroughly explored in recent film theory, especially in the British film journal *Screen,* in *Cahiers du Cinema,* in the American *Camera Obscura* and (to a lesser degree) *Jump Cut.* For analyses of Kracauer's methodology, cf. John Tulloch, "Genetic Structuralism and the Cinema: A Look at Fritz Lang's *Metroplis,*" *Australian Journal of Screen Theory,* No. 1, (1976); Roger Manvell, "Introduction," in *Masterpieces of the German Cinema* (New York: Harper & Row, 1975); and Marc Silberman's chapter in this book. For a comprehensive summary of theories of ideology which underpin the new film theories see Douglas Kellner, "Ideology, Marxism, Advanced Capitalism," in *Socialist Review,* No. 42 (Vol. 8, No.6) (November-December, 1978), pp. 37-66; and Stuart Hall, "The Hinterland of Science: Ideology and the 'Sociology of

Knowledge,'" *Working Papers in Cultural Studies,* No. 10 (1977), pp. 9-32.

⁴Cf. George Huaco, *The Sociology of Film* (London, 1965); Eckart Jahnke, "Fritz Lang's *M*," *Film* (East Berlin), No. 6 (1965), pp. 169-180; Rolf Hempel, "Fritz Lang-Mythos—für wen?," in Horst Knietzsch, ed. *Prisma* (East Berlin, 19), pp. 236-251. For more moderate exploration of Lang's politics, see Eric Rhode, *The Tower of Babel* (London, 1966); Heinz Ungureit, "Fritz Lang, das Unbekannte und Verkannte," *Frankfurter Rundschau* (16 May, 1964); Jörg Ulrich, "Der Mann mit den 1000 Augen," *Münchner Merkur* (4 August, 1976); David Thompson, "Lang's Ministry," *Sight and Sound,* Vol. 46, No. 2 (Spring, 1977), pp. 114-116.

⁵Siegfried Kracauer, *From Caligari to Hitler* (Princeton: Princeton University Press, 1974) p. 82.

⁶Kracauer, *From Caligari to Hitler,* p. 82.

⁷Cf. Noel Burch and Jorge Dana, "Propositions," in *Afterimage* (U.K.). (Spring, 1974), pp. 43-44.

AESTHETIC
AND SOCIAL
IMPLICATIONS

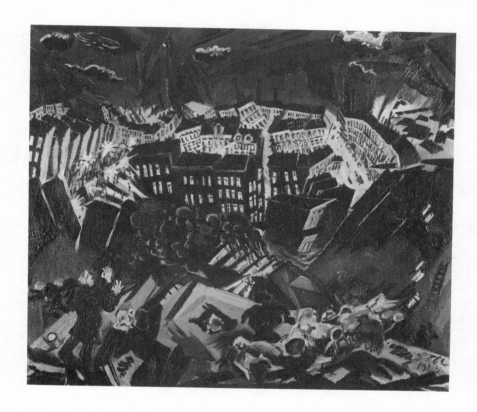

22
Expressionism and Marxism: Towards an Aesthetic of Emancipation

Stephen Eric Bronner

Expressionism and the Thirties

The thirties, a period of indescribable horror, witnessed one of the major aesthetic controversies of modernity. This extraordinary debate was carried on within the Marxist camp, and the ostensible issue was Expressionism. Paradoxically, however, by the mid-thirties the expressionist movement was long dead and the Stalinist counterrevolution was a reality.

The counterrevolution would define the official Soviet position on Modernism, for art was seen as one instrument among others to help in uniting the masses behind Russia's wholescale effort to industrialize. This course toward industrialization actually began with Stalin's "left turn" in 1929. The turn "left," however, was anything but a step towards liberation. The institution of the Five Year Plan and the slogan of "socialism in one country" were not signals to revolution, but rather testaments to the stabilization of capitalism. Moreover, with the "consolidation" of the Party behind the drive toward industrialization, intraparty democracy was

destroyed, authoritarianism became the method of imposing "discipline," and the theory of Marxism itself became reified into the dogma of "diamat."

Following the advent of fascism in Germany, these trends were intensified — not just in the political sphere, but in terms of cultural and social mores as well. Along with the rise of a police state in the Soviet Union, divorce and abortion, once again, became difficult to obtain. Furthermore, as the emphasis upon the family became more pronounced, Stakhanovism was introduced. Indeed, a cultural puritanism became dominant in the communist movement that extended to the artistic arena. Art was to be made accessible to the masses and directly related to the Party's political needs. In contrast to the radical modernist experiments of the first two decades of the century, "socialist realism" became the official cultural line of the Party[1] — not only for artists in the Soviet Union, but for communists abroad as well. Thus, "socialist realism" remained the ideal, but "bourgeois" realism was viewed as superior to Expressionism and Modernism that were regarded as decadent products of capitalism during its imperialist phase.

The true importance of this policy only becomes clear if the "popular front" line is taken into account. The new emphasis upon realism became the aesthetic extension of this policy. Communists were to align themselves with all anti-fascist forces and they were told that, far from destroying bourgeois culture, it was necessary to inherit the "progressive" aspects of that culture and employ them against those "decadent" elements that led to fascism.

The anti-fascist congress that took place at the Paris Mutualite in 1935 was the showcase for the extension of the popular front to the arts.[2] This congress was a gathering of great names: Malraux, Gide, Plivier, Huxley, Ehrenburg, Benda, Döblin, Feuchtwanger, Bloch, Madalaine Paz, Brecht, Seghers, Waldo Frank, and others. But, although the congress did express the unity of the anti-fascists, it also left many participants with the bitter feeling that dogmatism was running rampant, and that those who had not accepted the new line — or who believed that no line should be imposed — were unwelcome.

It was in this political atmosphere that the so-called "expressionism debate" took place.[3] Indeed, it is even in a sense ironic that it was labelled thus, for it might have been just as appropriate to call it the "socialist realism" debate, the debate which — in one way or another — took its content from the first attempt to stamp a uniform orientation on socialist art and culture.

The debate itself has achieved an almost legendary status among intellectuals of the European left, since its major disputants were philosophers and writers of the magnitude of Georg Lukacs, Ernst Bloch and Bertolt Brecht. There were, however, other famous contributors as well: Alfred Kurella, one of the most influential communist critics of the thirties; Johannes R. Becher, expressionist poet and later cultural com-

missar of East Germany; Anna Seghers, author of *The Seventh Cross* and presently a major figure in East German cultural politics; and then there was Alfred Durus, Rudolf Leonard, and many others. Thus the stature of the participants, the context in which the debate developed, as well as the intellectual depth of the arguments themselves, all contributed to the aura that would surround the expressionism controversy.

Crucially, the debate raised the question of what constitutes a revolutionary or "progressive" art, and produced the beginnings of a *Marxist* response to the crudity and dogmatism of Soviet aesthetics. In fact, the debate shows that — against the reality of Stalinism — there existed a struggle to revivify Marxism in terms of its liberating possibilities. Thus the controversy over aesthetics called for a reconsideration, not only of the legacy of bourgeois culture, but of the very road that socialist culture should take.

The debate, however, also reflects the intellectual re-evaluation of the cultural forces that helped lead a "civilized" nation to turn towards barbarism. In fact, it was this — as much as Stalinist politics — which necessitated the theoretical inquiry into the tradition of bourgeois culture and how it was to be appropriated. For their part, the Nazis wanted nothing to do with a movement that had gained enormous popularity in the hated Weimar Republic. Originally, however, certain segments of the avant-garde had supported the fascists such as the Futurists, Ezra Pound, and Expressionists like Emil Nolde, Gottfried Benn, Ernst von Salomon, Hanns Johst, and others. But, once in power, the fascists retreated from much of the pseudo-revolutionary politics and rhetoric that they had used while their movement was on the rise and which attracted certain disaffected artists and intellectuals. As the *SA* gave way to the *Wehrmacht* and the *SS,* as order came to rule, the fascists' tolerance for these bohemians waned; the artists themselves either caved in to the Nazi machine entirely or came to be looked on with a disfavor that culminated in the famous "Degenerate Art Exhibitions."

Despite the Nazis' attack on Expressionism, which parallelled the position of the communists in certain respects, the concern with Expressionism on the part of the participants in the debate is obvious. For Expressionism had certainly been the dominant avant-garde tendency in Germany, reaching its high points just before and just after World War I.[4] These were the years of *Die Brücke* and *Der Blaue Reiter,* of the transformation of theater by figures like Ernst Toller, Hasenclever, and Kaiser, and of the revolution in music by Schoenberg.

Whatever the differences among Expressionists, they all manifested similar feelings: the alienation from established society, the yearning for a better world, the idealistic protest against a rotten materialism, the validity of the inner emotive response to a sterile rationalism, and the metaphysical despair over the "death of God." The roots of this response against bourgeois complacency had started with the Naturalists and the bohemian-impressionist generation fifty years before the rise of Expres-

sionism; it had gained momentum through Symbolism, Fauvism, Cubism and Furturism, and came to generate ever more vehement statements of secession from the constraints of the existent in ever accelerating cycles. The modernist movement had fought hard for its triumphs, withstanding ridicule and staunch opposition during those periods in which its most radical aesthetic innovations were developed. And, in aesthetic terms, they were successful. Even before their final demise, it was obvious that almost everything associated with the traditional role of art had been called into question: its subject matter, its modes of representation, its public and even its very boundaries.

It can be argued, however, that the years of aesthetic vitality are not necessarily the most important years for a movement in terms of its relation to the broader cultural context. It is in this sense that certain major participants in the debate could center upon the socio-cultural effects of Expressionism. For it was only in the early and middle twenties that Expressionism began to forge its dominating influence on all cultural modes, from painting to poetry to drama and even to prose.

Where, like the other modernist movements, Expressionism had initially been confined to a small group of bohemian artists and intellectuals, by the late twenties it was already being assimilated by that same bourgeoisie that it had originally opposed. Whatever the intentions of the artists involved, to the degree that this occurred, Expressionism became integrated into the given order and played a role in shaping the ideological and cultural climate of the period.[5]

There are concrete reasons to which this may be attributed: the economic dislocation and disillusion following the First World War, the existence of a democracy in which few segments of the population actually believed, and a pervasive sense of decay which permeated the society. All this served to create the preconditions for building a somewhat broader public to receive Wedekind and Munch, Kirchner, Becher, Kandinsky, Hasenclever, and others. Indeed, it is indicative that Oskar Kokoschka — who, before the war, had been called the "Austrian terror" — should have received his professional chair and that Alban Berg's *Woyzzeck* should have been performed by the State Opera during the time in which Expressionism's aethetic rebellion was being socially incorporated into that cultural constellation which the bourgeoisie had defined. Among that thin strata of the "modern" bourgeoisie who voted Democratic, snorted cocaine, and underwent psychoanalysis, Expressionism was "in" — but its effects went further. Bankers paid thousands of dollars to have their portraits done by expressionist painters. In fact, the director of the modern division of the National Gallery, Dr. Justi bought paintings by Marc, Barlach, Pechstein, Kirchner and others, while the *Neue Pinakothek* bought Kandinskys and Cezannes — all excellent investments.

Satirical papers had fun with this symbiosis of wealth and self-laceration. On the other hand, the Nazis denounced modernist art as "cultural bolshevism" and morally "degenerate." In their view, such

degeneracy was part of a design by the Elders of Zion to demoralize the German people. Their own populist protest against the machine age had found its expression in folkisch *kitsch*, "heroic realism," and sentimental lyricism — even though many Modernists would themselves become fascists.

It is important to note, however, that the organized labor movements of the pre-Stalin period had little sympathy for Expressionism either. The individualist abstract art of such a modernist movement could not serve a pedagogic function in the manner of Zola, Anatole France, Tolstoy, or Gorky. Indeed, the labor movement pointed proudly to Courbet, who had been a member of the Paris Commune, to Millet, to Käthe Kollwitz, and even to Heinrich Zille — both of whom had become communists. But Cezanne, not to speak of Matisse, were alien both to the socialist and communist press. If a few intellectuals like Paul Levi appreciated modern art, it was by accident of personality not through ideology. Clearly, the major expressionst journals *Der Sturm* and *Die Aktion* found their audience among ultra-left bohemians and intellectuals rather than in the masses of the large labor organizations.

Expressionism and Modernism seemed to hang suspended between the major classes and the existing political formations. This is what made its political message and its social effects so difficult to decipher. The subjective thrust of Expressionism was clearly to unmask a degenerate hypocritical bourgeois reality; yet the question could be raised whether the works of the movement adequately reflected any reality at all except the one which was subjectively experienced. Furthermore, where the Expressionists wished to resurrect the validity of the spontaneous individual experience in the face of the mechanistic bureaucratization of existence, it could be argued that their aesthetic experiments only served to reify the individual's confrontation with objective reality from a different perspective. The expressionist demand for liberation from outmoded social mores was obvious: still, it could be asked whether or not the freedom which these bohemians sought was not simply a state of license which would create the conditions of chaos necessary for the rise of fascism. Lastly, it was open to debate whether the critique of bourgeois society which the Expressionists forwarded immanently led to the need for proletarian revolution or rather to a call for an irrational apocalypse that would be realized by fascism. Thus, in fact, it could be asked whether Expressionism itself did not help to create the climate that fostered the barbarism which would supplant the Weimar Republic.[6]

Such questions reach to the very core of cultural production, to the relation between a sociology of art and the concerns of aesthetic emancipation, as well as to the terms in which art should be judged. Consequently, particularly in America where Marxian aesthetics is still in its infancy, a basic relevance emerges within this theoretical controversy of the past. In fact, from this particular debate among Marxists — carried on in a period of defeat, exile and despair — parameters are set in which a new

aesthetic of emancipation can be formulated. Thus, in the following pages, the contributions of Lukacs, Bloch, and Brecht will be analyzed in terms of the expressionism debate and how their arguments lead to a renewal of Marxian aesthetics for the present.

Georg Lukacs: Expressionism and Critical Realism

In 1934, Georg Lukacs set the stage for the debate in his article "'Grosse und Verfall' des Expressionismus" which appeared in *Internationale Literatur.* Lukacs sensed cultural decay which he believed had permeated bourgeois culture in the form of twentieth century Modernism.[7] Consequently, Lukacs attacked Expressionism and argued for the vitality of a different tendency: bourgeois realism. In fact, Lukacs defended bourgeois realism as an inherently progressive art against what he viewed as a decadent Expressionism.

Grounding himself within the tradition that begins with Walter Scott, and which finds its greatest twentieth century proponent in Thomas Mann, Lukacs sees a work of art as growing out of a given society and "mirroring" that society. But this "mirroring" is not simply based on the artistic accumulation that facts, impressions and experiences. Rather, the realist work is seen as "mirroring" society in its dialectical "totality" of mediations, contradictions and interconnections. In this way, the realist work exposes the processes of social interaction that underlie the existence which individuals subjectively experience. Thus, through realistic art, the ideological veils of the existing society are stripped away as the difference emerges between the way society *actually functions* and the way it *merely appears.* This issue involves the distinction between *essence* and *appearance,* a distinction which goes back at least to Plato. The point, however, is that this categorical differentiation is central to the thought of the most progressive representatives of the rising bourgeoisie. Thus, as will become evident, philosophically and artistically, Lukacs sought to place himself squarely within a tradition upon which Marx himself relied and which, Lukacs believes indispensable for the revolutionary proletariat.

It was Kant who first gave the essence-appearance relation its modern epistemological expression. For Kant, appearance — the phenomenon — takes on a dual meaning. On the one hand, it becomes an "object of empirical intuition" and, on the other, the product of an essence — a noumenal *thing-in-itself* — which remains closed to rational investigation. Thus a cleavage results between appearance and essence. For Hegel, however, the essence at once underlies appearances and yet becomes manifest in those appearances over time; thus the essence emerges within history, though the essence remains an "Idea" or "Spirit" which holds history together and gives mankind its purpose: a realm of freedom. In Marx's thought, the idealist trappings fall away; the essence still emerges in history, but is is no longer an "Idea." Rather, it is the

historically specific system of production which gives rise to objective class contradictions and which will be resolved by socialist revolution. These class contradictions determine, and in turn are effected by, the way in which society *appears* in its particular aspects. It is from the analysis of this "essence" that the potential for a free, classless society becomes manifest. The basic point is that, for dialecticians like Marx and Hegel, the essence of reality can only be discovered rationally through a concrete analysis of the socio-historical complex in its totality; only in this way can the particular manifestations of this reality be properly understood. These manifestations must then be seen in their mediated relation to a social totality which always takes primacy over its particular expressions; the essence of social reality must take precedence over the immediate experience of this reality. In this context, the prime purpose of literature reveals itself for Lukacs:

> If literature is indeed a special mode of mirroring objective reality, then it is of the utmost importance that it comprehend this reality as it is actually constituted and that it not limit itself to a rendering of that which immediately (*unmittelbar*) appears.[8]

It is precisely the articulation of the social totality that Lukacs finds in the work of the great Realists. In Tolstoy, for example, the characters and their interactions — the changes which they undergo and the opinions which they form — are seen as emerging within the context of a changing social whole. It is this comprehension of particular aspects of reality, within the context of the social totality, that Lukacs believes is lacking in Expressionism. Instead Lukacs finds in Expressionism in particular, and in Modernism generally, an emotive, unreflective, irrational and subjectivistic mode of apprehending reality. This is what Lukacs believes lies at the center of the expressionists' creative method and, thus, from the very first, Lukacs champions objective and realistic aesthetic forms against the subjectivism of Modernism. Although Lukacs understands the importance of the inspirational element in artistic creation, he realizes that the inspirational factor cannot be considered by itself and that in itself it becomes worthless. The point at which inspiration becomes artistically viable is when it becomes a "moment" within the cognitive process as a whole. Thus, for Lukacs, the relation between the inspirational experience as a moment of the creative process and the singular appearance in relation to the social totality is very similar:

> The formative depth (*Gestaltung*), the breadth and durability of a realistic writer's effectiveness depends largely on the extent of his awareness — formally speaking (*gestalterisch*) — of what the manifestations described by him actually represent. This conception of the relation of a significant writer to reality does not in any way exclude — as Bloch believes — the realization that the surface of reality manifests ruptures (*Zersetzungen*) and accordingly reflects itself in the consciousness of men.[9]

This conceptualized comprehension of society as a whole whose material conditions can be aesthetically expressed, is what fundamentally serves to separate the Realist from the Modernist. For Lukacs, without this explicit dialectical relation of the particular and the social whole of which it is a part, a cogent, rationalist worldview is impossible.[10] In fact, it is precisely the Modernists' inability to achieve this knowledge of the social whole which marks the decadence of their aesthetic in relation to the Realists who preceded them.

Consequently, for Lukacs, in Expressionism the inherent relation between essence and appearance breaks down; the interconnection between the way the world is subjectively experienced and the way that this subjective experience is itself tied to objective socio-economic forces is sundered. Furthermore, for Lukacs, this philosophical discrepancy has political consequences. Where the Expressionists subjectively saw themselves as free from bourgeois influences, as the avant-garde which would bring about the "regeneration of man" (*die Erneuerung des Menschen*), objectively Lukacs sees them in a different light. Indeed, Lukacs views the avant-garde as indecisive in both its theory and its politics. Though the Expressionists were preoccupied with criticizing conservative social mores, militarism, and the bourgeoisie itself, nevertheless Lukacs sees these issues as being ripped from the specific socio-historical conditions which gave rise to them. In this way, the categories which they used and the critiques that they forwarded necessarily remained abstract and reifed.[11]

Once again, the mere immediacy of the artistic apprehension of reality comes to be seen as leading to a confusion wherein the artist reacts to a particular aspect of social intercourse without recognizing the objective forces which have formed it. The result is that, insofar as the particular is ripped from its "interconnection" with other aspects of the totality, this totality is itself dismissed and the possibility of even objectively comprehending the particular concern is lost.

In Lukacs' terms, "essence remained abstract, while the perceived object was left isolated and reifed in its independence." For Lukacs the full content and actual meaning of a particular issue can only be determined in light of the interactions which comprise its relation to the social totality. Thus, either consciously or unconsciously, for Lukacs, the Expressionists refused to come to grips with the reality which they sought to expose and judge. In fact, the very failings of their aesthetic led the avant-gardists to a position which was necessarily subjectivistic and moralistic since their criticisms could not be grounded in the objective contradictions which gave rise to the problems that they mirrored.[12]

Arising in the imperialist phases of capitalism, Expressionism consequently became nothing other than the idealist reflex of a capitalism in crisis — a reflex which could neither conceptualize nor solve the problems which it chaotically expressed. Thus, Lukacs dogmatically draws his consequences. For him, the result of leaving the essence of social reality

in the abstract — while subsequently reifying the particular — leads to a vision in which life is seen as a simple conglomeration of experiential fragments which are devoid of meaning. Insofar as these fragments are preserved from any interconnection with the social totality, insofar as they are closed to dialectical reason, reality necessarily becomes a "chaos"; a riddle to which an answer becomes impossible *a priori*. Within this chaos, the subject is left suspended in a world devoid of both values and meaning. For Lukacs, on the other hand, it is possible for the subject to situate himself and analyze his problems through a rational examination of his socio-historical conditions. But, because the avant-gardist chose to turn away from the objective conditions of social reality, for Lukacs it is no accident that avant-gardists like Kandinsky, Barlach, Nolde and others turned to a vague spiritualism in their quest for meaning.[13] From this perspective, it is also no wonder that abstract visions of catastrophe and utopia emerged in the Expressionists' works. In Lukacs' view, the consequence of this was that the *concrete potential* for qualitative change came to be ignored, since such a potential could exist only in the socio-economic complex from which expressionist art abstracted itself. As the Expressionists' aesthetic prevented their art from providing a proper "mirroring" of society, the misunderstanding of social reality assured the possibility of an irrational response towards it.

No matter how "radical" the Expressionists may have thought themselves, for Lukacs the expressionist opposition to the bourgeoisie was in fact nothing better than "romantic" and "petty bourgeois." In this revolt, social reality was turned into either a realm controlled by mystical forces or a "chaos" which was inherently indecipherable. Thus, a confusion necessarily occurred wherein it was no longer capitalist society which had to be covercome, but rather the "chaos" as such.

Ultimately, the need for revolution found itself transformed into a desire for the apocalypse, and it is precisely in this expressionist syndrome — often unrecognized by its victim — that Lukacs' basic point becomes clear. For, in the mysticism, in the abstract and arbitrary use of categories, the attack on the *status quo* could easily take on a reactionary form. In fact, as Lukacs views the matter, the expressionist critique can easily veer to its opposite extreme:

> to a critique of bourgeois values from the right, to that same demagogic critique of capitalism to which fascism subsequently became indebted for its mass base.[14]

Lukacs concluded that it was this denial of objective socio-economic reality and subsequently history itself, in favor of an abstract individualist — or no less abstract "humanitarian" — framework, which objectively served to keep Expressionism within the ideology of the bourgeoisie in the "imperialist phase" of capitalism.[15] Aesthetically, it was furthermore precisely this obliteration of the objective world and the emphasis upon the irrational and the emotive which led Lukacs to perceive that within

Modernism: "The principle tendency is an ever-increasing departure from realism, an ever-increasing liquidation of realism."[16] Consequently, for Lukacs, Expressionism and Realism are unalterably opposed. In the novels of Balzac, Tolstoy or Thomas Mann, nothing is left in the abstract. Instead, the particular aspects of reality are shown as they interact with the over-riding social forces in such a way that there is a clear understanding of the social context in which political events and individual actions take place. The social totality is closed within the work of art as an organic whole, which is then presented to a passive reader who is acted upon and drawn into the world which the author has created.

Of course, this is not to say that the Realists did not employ abstraction. The abstraction which they employed, however, stands opposed to the modernist abstraction away from reality (*Wegabstrahierung*). In the case of the realist authors, there occurs both a two-fold creative as well as ideological (*weltanschauliche*) effort:

> namely, first the intellectual discovery and creative formation of the inter-relations (of reality — trans.) and second, yet inseparable from the first, there is the artistic concealment of these abstractly worked-through inter-relations — the sublation (*Aufhebung*) of the abstraction.[17]

Essentially, Lukacs is suggesting that when a realist creates a character, he "abstracts" from the everyday individuals of a given milieu. Once this occurs, the character — by virtue of the special emphasis placed upon him — becomes "atypical." But, as this character is artistically brought back into the world of interactions which formed him, he reassumes a fundamental typicality while still remaining atypical; a realistic character — like Hans Castorp in *The Magic Mountain* — is then, at one and the same time, "atypically-typical" since the initial abstraction has been sublated (*aufgehoben*).[18] In contrast, a character in a play by an Expressionist like Yvan Goll or Walter Hasenclever never assumes either a concretely individual or a social content. The context in which his immediate experiences occur is never clarified, and so he remains at the mercy of indecipherable forces. Because the modernist character loses his specifically social content, Luckacs believes that he will always remain at the level of experiencing only the *appearance* of reality. The realistic character, however, always has his particular problem or experience explained in terms of the objective social conditions; in fact, it is this which validates the truth of the initial abstraction and the use of fiction to expose truth.

Thus, where the Modernist — whether Expressionist, Surrealist, or Futurist — remains stuck at the level of abstraction and illusion, the Realist abolishes the abstraction as he gives it a concrete content while employing illusion to reveal the objective reality which lies hidden beneath the given ideology. Precisely here is where Lukacs sees the strength of realism insofar as it always destroys its character's own illu-

sions and, of necessity, always seeks the actual interaction between the artist's experiences and the social processes which form them.

Moreover, the realist form, in which singular problems are explicated in a clear, objective manner, is what opens such a work to a broad public since the interaction which is exposed ultimately emerges in terms of the social life of an entire people. In this respect, Lukacs believes that Realism retains and manifests a relation to the masses, a *Volkstümlichkeit,* which Modernism does not with its subjectivist emphasis, often unnecessary difficulty, and purposeful obscurantism.

No doubt, Lukacs stresses this term in order to salvage the concept from the Nazis who employed it merely as an ideological tool to justify their "heroic" pseudo-classical *kitsch.* Surely, however, Lukacs also felt the constraint of Stalin's cultural emphasis upon "socialism in one country" and the effects of the Communist Party's position that art must be directly related to the struggles of the oppressed masses. Yet, it is equally obvious that Lukacs sincerely wished to preserve the notion of critical realism for a Marxist aesthetic and from the degradation of Zhdanovite "analysis."

In fact, the notion of *Volkstümlichkeit* becomes important for Lukacs in that art assumes a pedagogic function which coincides with his idea that true realism is "critical" insofar as it objectively explicates the true conditions of individuals under capitalism.

Any artistic trend which seeks to perform this pedagogic function in such a manner, must base itself upon the historical and artistic past of the particular nation which leads into its present. Still Lukacs is careful to point out that this does not lead to an "evolutionary" conception of either history or aesthetic development. Rather, for Lukacs, it is only in the consistent retention of the innovations of the past that the progressive, or even the revolutionary, possibilities of the present can be understood. In fact, from Lukacs' perspective, it is not Realism which comes to be aligned with revisionist notions of "evolution," but rather Modernism which subjectively feels itself opposed to all traditions. Because Modernism attempts to negate the entire past,[19] since it sees in history only ruptures and catastrophes, it becomes merely the anarchistic opposition — and not a true negation — to the evolutionary teachings of reformism. For, both Modernism and Reformism refuse to recognize the dialectical nature of history insofar as: "one sees only continuity, the other sees only ruptures, abysses and catastrophes. Yet, history is the living dialectical unity of continuity and discontinuity, of evolution and revolution."[20]

As the avant-garde refused to grasp the social totality, it also proved itself incapable of grasping the "unity" of history in its art. The product of a bohemian sub-culture, Modernism could only manifest a pseudo-radicalism insofar as it ran counter to the rationalist tradition of Marxism and insofar as it took the world as it immediately appeared. As a consequence, the avant-gardists mystified the reality which they despised while distorting the actual foundations of the crisis of bourgeois society. Thus,

for Lukacs, there remains little which the oppressed can learn from an ir-
rationalist, self-indulgent avant-garde that often quite consciously
separated itself from them.

From this perspective, the "Expressionism" debate took shape, and
Lukacs' views were challenged by other prominent Marxists. Both Ernst
Bloch and Bertolt Brecht took exception to Lukacs' unqualified defense
of Realism, the reductivism of his approach, and the often mechanistic
nature of his analysis. In this context, their response becomes as much
the attempt to preserve the need for a novel, experimental, and eman-
cipatory art as to justify Expressionism itself.

Ernst Bloch: Expressionism and Liberation

Although Ernst Bloch was also critical of irrationalist mystification —
calling mysticism the "ignorant caricature of profundity" — he believed
that there was still much to be gained from an "anticipatory movement"
like Expressionism.[21] In Bloch's view, such a movement contains traces
of a liberation which has not yet been achieved and harbors a socio-
political potential which projects alternatives beyond the given mode of
social intercourse. Thus, though Bloch also views dialectical reason as
the instrument by which reality must be examined, in contrast to Lukacs,
he believes that the heuristic concept of the totality cannot be left at the
level of its objectively discernible interactions; if the totality is in fact to
be total, then it must also include within itself its subjective and im-
aginative components.[22] Consequently, when Lukacs wishes to analyze
Expressionism from a socio-political perspective alone, Bloch argues that
this is actually an "academic" standpoint which ignores what is most im-
portant to an appreciation of Expressionism; that is to say, its manifesta-
tion of utopian desires for emancipation, its attempts to experiment with
new forms, as well as its emphasis upon the creation of "artistic joy"
(*Kunstfreude*).

The latter is especially crucial to Bloch's argument since, in this "ar-
tistic joy" the presentiments of a utopian condition and the opposition to
existing repression are achieved. Moreover, where it is easy to neglect
this dimension in literary criticism, it is impossible to forget this element
when considering more subjective forms of expression like poetry, music
and painting. Thus, Bloch can castigate Lukacs for dismissing these
forms from his analysis in favor of concentrating upon literature. As
Bloch correctly points out:

> this is all the more surprising since, not only were the relations be-
> tween painting and literature of the closest kind at the time, but the
> expressionist paintings are far more indicative of the movement
> than the literature.[23]

The chord which Bloch had already struck with the publication of his
Geist der Utopie, a work which he later termed "a testament to the original

expressionist impulse," is carried over into the debates.[24] In that early work, he writes: "We are starting from scratch. One is poor and has forgotten how to play."[25] In the disillusion which was plaguing the period centering around the First World War, Bloch saw the basis of the expressionist beginnings which set the movement off from both Naturalism and Realism.

Against the simple objectivistic *description of the factual,* Bloch contends that reality needs to be seen in its *dynamic movement* and can only be opposed through the creation of the "exact fantasy." What is actually true, what is non-alienated, non-reified and necessary for liberation, can not be found within the conventional logic of capitalist reality. For this particular system renders everything into objectively calculable terms and thus defines it within the constraints of the given. Consequently the truth, as well as the negation, of capitalist society is seen as lying hidden beneath that which social reality objectively brings to the fore. This truth, tied to the need for utopian emancipation, for Bloch does not lie in: "the simple portrayal of facts, but of processes; it is finally the revelation of that which has not yet come into existence and which needs him who will actualize it."[26] Expressionism, therefore, cannot be considered solely in terms of the way that it "mirrors" the state of capitalism in its imperialist phase, since its importance lies elsewhere — though, to be sure, this mirroring occurs as well. For Bloch, rather than attempt to reflect what was, Expressionism sought to define what was not. But this could only have been attempted through a reliance upon fantasy, a fantasy which manifests and seeks the fulfillment of those wishes which reality does not recognize or satisfy.

Thus, Bloch maintains that Expressionism remains — and was — a radical indictment of the *status quo* insofar as it manifests a "dream content" (*Traumsinhalt*) which becomes an essential part of the revolutionary "inheritance." For Bloch, the revolution to be achieved goes beyond the socio-economic base and enters the cultural and psychological realms as well. Truly, Bloch's position anticipates the slogan of "power to the imagination" which arose in May of 1968. In his view, this very emphasis upon the liberating power of imaginative inquiry catapulted Expressionism beyond the confines of the given reality and allowed this reality to be called into question. Distortion of objects, the juxtaposition of unrelated pieces of reality, the explosion of syntax, and the transvaluation of time, force the individual to see reality in a new way. Thus the possibility of a qualitatively different reality emerges as the on-looker is forced to draw his own conclusions and conceptualize this possibility himself.

In Expressionism, experiments abounded in order to attempt the freeing of the unconscious and the fantastic. At once, the exploration of the unknown and previously unimagined became a dominant concern, while fantasy itself interwove with the romantic character of the expressionist revolt. This appears in the attempts to "transfer" oneself into what has been preserved from the harshness of reality and the industrialization

process,[27] which was the very impulse which led to the concern with African art, to Klee's children's paintings and Marc's use of animals. Of course, such an attempt was enormously naive, and yet through this experiment the content of the aesthetic tradition and the definition of art were broadened.

A naive concern can thus have consequences for the future which transcends that concern. In the same way, the often confused theories which artists used to justify montage, collage and other experiments, can retain a liberating potential in spite of themselves. Through the "dream content" of the works, the use of experimental forms, and the emphasis upon the subject, the expressionist work can remain undefined and closed to total categorization insofar as it begins and then re-commences its interaction with a changing audience. Perhaps Bloch is right in claiming that the works of Expressionism attest to the fact that a "picture is never painted to completion, a book is never written to the end."[28] Thus, the non-objective character of the works themselves may provide an avenue for consistent re-interpretation in light of the constructions of the given — a self-renewing emancipatory fantasy in the face of represssion.

It becomes apparent from Bloch's argument that the use of abstraction and the freeing of fantasy are not the same by any means, and Lukacs does not draw the distinction. To be sure, the two inter-relate in the work as a whole. Yet, where abstraction is essential to the creative process in terms of the work's construction from the real, fantasy becomes the component of the work which initiates it and splits it off from the given; for Bloch, this is what gives the work its transcendent quality.

The liberation from the constraints of the given, through fantasy, is precisely what makes for that "artistic joy" which Bloch deems so important and which the Expressionists sought to actualize in so much of their art. For Bloch, however, the recognition of the liberating power of fantasy necessarily implies a willingness to "experiment" in order to realize fantasy's content. Thus, the Expressionists could not have accomplished their investigation into new forms had they simply relied on the forms handed down to them by the masters of bourgeois realist art such as Goethe, Balzac, and Tolstoy.[29] Yet, the break with the old forms did not occur by chance at that particular point in time: the crisis of capitalism had its effects and so, for Bloch, the totality changed its face. If, in fact, the social crisis was itself a reality, then:

> perhaps Lukacs' reality, that of the infintely mediated totality (*Totalitatszusammenhang*) is not at all so . . . objective; perhaps Lukacs' conception of reality still contains classical systemic traits; perhaps true reality is also . . . discontinuity. Precisely because Lukacs retains an objectivistic, that is to say closed conception of reality, he necessarily — while using expressionism as a vehicle — turns against every artistic attempt to bring about the dissolution of a worldview (even should this worldview itself be capitalistic). Consequently, he sees nothing except subjectivistic ruptures in an

art which interprets the actual ruptures of the surface interrelations of the existent, and which attempts to discover the new that already exists in reality's crevices. Thus, he equates the experiment of dissolution with the state of decadence.[30]

Therefore, Bloch does not view Realism as the aesthetic norm by which decadence should be judged. The movement away from this norm, which is itself a bourgeois value, may well result in an experiment with the new which might call this norm and its constraints into question. Consequently, Bloch does not believe that art can be judged through externally imposed categories which derive their value from those values which have been handed down from the past. Moreover, Bloch refuses to acknowledge that art can be evaluated in terms of its immediate practical consequences or by the way in which it comprehends a prescribed totality. In fact, the very priority which Lukacs gives to the totality over the particular experience is seen as condemning a particular art to re-creating the content of that art which preceeded it. Finally, in Bloch's view, even were Lukacs' totality to be truly total, there would still be that blindness in regard to the way in which a singular experience might possibly illuminate or expose the universal in terms of the existing potential within the totality.

Thus, the perception of the totality may not be the real issue. Perhaps a given potential within the existing society may become clear from a particular subjective experience. It is interesting to note how Brecht once said that Kafka was a writer who saw what was coming without seeing what was there. The thought also applies to Marc or Nolde. These painters, in their respective works *Fate of the Animals* and *Soldiers at War,* surely perceived a militarist dynamic — an aspect of the totality of class contradictions — and anticipated the catastrophe which lay around the corner.

Though Bloch admits that Lukacs is correct in pointing out the failings of Expressionism — in terms of its abstract pacifism, its bohemian conception of *Bürgerlichkeit,* and its neglect of the real class contradictions[31] — he is careful to note that Lukacs' analysis judges the activities of the past by the results and perspectives of the present alone. This, Bloch believes, is what led Lukacs to a position wherein he could relegate any movement which is not communist *a priori* to the ranks of the bourgeoisie or petty-bourgeoisie.

Indeed, Bloch points out that, at a given time, the Expressionists' slogan of pacifism was a valid political response.[32] In spite of all the mistakes which were made, theoretical as well as practial,

> It does not invalidate the fact that this slogan was, during the war itself and before its potential transformation into a civil war, a thoroughly revolutionary one. Moreover, it was understood as such by the politicians of the *status quo.*[33]

Politically, where it is true enough that Lukacs did judge events *ex post facto* and did issue such condemnations, it would be wrong to infer that this was always the case with regard to particular artists and their works; Thomas Mann, for example, publicly supported the First World War. Similarly, a support of the communist cause was not the only criterion for Lukacs either in judging the merits of a work; though Lukacs did laud Gorky and Sholokov, he also earnestly criticized the socialist-realist epigones.[34] In fact, Lukacs always contended that a great work need not be "proletarian" in order to be either realist or progressive since, in the comprehension of the totality by a bourgeois realist such as Thomas Mann, the role of the proletariat — or better, its position — would emerge of necessity. This, in fact, is one of the basic points which separates his "critical realism" from "socialist realism."

On the other hand, in this regard, Bloch conceals as much as he shows. Whether the early fascist supporter Gottfried Benn was an "Expressionist" or not,[35] Bloch knows that Benn was not the only avant-gardist to align himself with the reaction. Among the Expressionists, were Johst, Nolde and others. Then too, among the European avant-garde in general, there were other quite powerful fascist and parlor-fascist trends. One need only think of Wyndham Lewis or D.H. Lawrence, the Pound-Eliot clique, or the Futurists, in order for this to become evident.

In itself, this political question — posed in such a form by Alfred Kurella — does not really touch the issue. The real question is not *who* was a Fascist, but rather which tendency promotes a critical stance. Yet, Bloch's view on this issue buttresses an aesthetic position which becomes an almost unequivocal support for the avant-garde. This was what made it so easy for him to praise the Futurists for their "passion for frenzy, dynamism, and all-pervading sense of immediacy,"[36] while neglecting to mention the other proto-fascistic ideological concerns with which these qualities were intertwined.

All this, however, serves a polemical function. The positive thrust of Bloch's analysis is his real concern with experimentation with those possibilities for the qualitatively new which projects towards a "concrete utopia." In the name of pragmatism or "materialism" the issue of utopia is often dismissed far too quickly. Not only is it essential to define the content of emancipation, but without a notion of an emancipatory ideal there is no longer anything against which the present can be measured. In Bloch's view, the "horizon" for this emancipatory future is what needs to be gleaned from art and where the "prospective horizon is left out, there reality appears only as what it has already become, as the dead, and here it will be the dead — namely the naturalists and empiricists — who will bury their dead."[37]

The analysis of art must then not only be constrained within a discussion of what has been, or what is, but must also be freed to include a concern with what can be. The prospective horizon is reality's emancipatory potential — its often unconscious demand for the creation of a fully

liberated realm of freedom. Thus, for Bloch, it is no accident that the Nazis should have decried expressionist art.[38] Beneath the slogans, a pragmatic purpose was being served. Goebbels realized Expressionism's threat, the threat which the power of the imagination and fantasy always spell for the status quo as they seek that freedom from control which is so dangerous for any repressive regime. Consequently, it was not by chance that the oppositional artists — like Klee and Kandinsky — were not alone in being villified, but that official Nazi condemnation also extended to early Nazi supporters like Benn and Nolde as well.[39] Thus, it is crucial for Bloch that the fantastic and utopian elements of art must be retained. Without them, the future becomes hollow; nothing more than a simple elaboration of the present. Such a future holds the possibility of contradicting the present, but the true negation of the present can only emerge through those possibilities which appear beyond the alienated interactions of which the present is composed; that is to say, in the fantastic, the dream, and the "not-yet-conscious" (*Noch-Nicht-Bewusst*) which must be made conscious.

What will become central to Brecht's argument is important to Bloch's as well; for both, art is essentially an experiment. In Bloch's view, through this experiment the presentiments of a liberated future may be defined within the present. This must occur through an ever-greater artistic effort, insight and vision until the "exact fantasy" can arise. Thus, changes in the times are reflected in the changing artistic forms and, consequently, no one form may take priority. Indeed, for Bloch, if art is to maintain itself it must continually strive to develop new forms by which the potential within the present may be expressed.

The reliance on fantasy and the denigration of realism may, however, be carried too far. Lukacs certainly has a point when he stresses that in Bloch's view the fantastic comes to be confused with the objectively real. Clearly, when Bloch makes the assertion that there is indeed an "object" in a non-objective painting — namely the color itself, or *Farbigkeit* — he falls into precisely this mistake. True enough, color may be subjectively experienced as an object; in fact, it may even liberate the imagination in terms of the potential transvaluation of objectivity and call forth the demand for the destruction of reified subject-object relations. Yet, despite all this — and though Lukacs himself argues in terms of Lenin's *Materialism and Empirio-Criticism* — the color does remain only an object for contemplation; it does not exist as a mediated object of social interaction.

As soon as Bloch emphasizes the objectivity of such abstraction, he comes close to abandoning what is most forceful in his argument. He, so to speak, entered Lukacs' ballpark to play the game by the latter's rules. The fundamental question of whether one can actually negate the real, the determinate historically real, without a perception of its objective socio-historical content is submerged within Bloch's concern for polemically justifying the experiment with fantasy. Yet, once fantasy is allowed to envelop the real and become the singular tool for its examina-

tion, the entire notion of realism is opened to a relativism which can render the category meaningless. Though fantasy can enhance reality through elaborating what reality can become, or even should become, fantasy cannot in itself explain reality. The very transcendence of the repression within the given society by fantasy opens up a gap between the real and the fantastic which cannot be bridged at will.

Yet, it is precisely the existence of this gap which makes it correct to maintain that Expressionism's aesthetic thrust points beyond any direct relation to Nazism. For it was just this concern with the fantastic which confronted the banality of the existent, the conformity and tastes of the *Spiessburger* and the *Bildungsphilister*. It was a mixture of provincialism and *kitsch* upon which the Nazis relied, and that has little to do with the crucial aesthetic innovations of the avant-garde. Nowhere is this more apparent than in the use of montage, which necessarily involves the spectator in a mode of comprehension which effects changes in his preception of reality; a qualitatively different idea of reality emerges as montage reveals a richness within existence which cannot be discovered in the usual ways in which it is perceived.

Appalled by the existing society, Expressionism thus set the stage for the perception of a non-repressive social order. Even their cries of despair and anguish showed a concern for the abolition of these phenomena and, in the greatest expressionist works, the desires for a different sensibility, a different world, a new and free mode of experience, become paramount. No less than in the great realist works,[40] the expressionist aesthetic often manifested a vigorous humanism which even relates it to the cultural products of the revolutionary bourgeoisie. As Bloch realizes, it was this humanistic striving — within the aesthetic itself — which separated Expressionism from fascism in that Expressionism was a movement "which the philistine spat upon, an art wherein human stars — however inadequate, however singular — burned or wished to burn."

Bertolt Brecht: Expressionism and the Marxist Laboratory

Particularly in America, where the bulk of Bloch's works remain unavailable and where he is still not sufficiently recognized, it is the dispute between Lukacs and Brecht which has received the most attention in radical circles.[41] To a certain extent, this is also understandable insofar as the differences between these two Marxists run deep. The most obvious difference is that Lukacs was a philosopher and aesthetician whereas Brecht's theoretical concerns were clearly subordinate to his activity as a playwright. Yet, there is also the divergence in their backgrounds, in the intellectual traditions to which they subscribed, and in their differing notions regarding the function of art.

In the present context, this latter difference is the most crucial. For where Lukacs' aesthetic retains the emphasis upon the rationalist-idealist

tradition as a bulwark against the rising irrationalism of the Nazis and a world in crisis, Brecht's roots lie in the materialism of the Enlightenment. In his work there is the sense that — given the crisis of bourgeois society and the reification of Marxism in the thirties — art must change its traditional assumptions so that a new aesthetic can be developed which would directly relate itself to the potential for changing the given order, to the mutability of every aspect of existence, and to the contemporary demands of artistic production. Finally, where Lukacs' thought seems often to buttress the official Party line on aesthetics, Brecht's thought clearly stands in opposition on fundamental issues.[42]

These are the reasons why it is generally agreed that Brecht is the direct opponent of Lukacs in the expressionism debate.[43] And yet, such a view neglects the theoretical differences between Brecht and Bloch. In fact, Brecht positively sides with neither Lukacs nor Bloch. Instead, his own position seems to mediate the arguments which they forward insofar as he shifts the grounds of the debate.

Whatever Brecht's opposition to Lukacs, he was certainly no great friend of either the modernist avant-garde in general or Expressionism in particular. In fact, his very first play, *Baal,* was quite openly directed against Hanns Johst's *Der Einsame (The Lonely One)*. Moreover, the unleashing of emotion (*Eindrucksauslösung*), the pathetic scream of *"O Mensch!,"* the plaintive appeal for a recognition of "poor little humanity," and the excessive emotional baggage of Expressionism were repulsive to Brecht; indeed, Expressionism's tactical and theoretical attempt to emotionally involve the audience stands diametrically opposed to what Brecht eventually formulates as his *Verfremdungseffekt* (estrangement-effect).

It is true that Brecht himself integrates surprise, shock, playfulness and even a type of distortion, within his own work. Still, he always believes that the effects of an art which principally relied on exciting and manipulating the emotions will be shortlived, in that:

> The most extreme effect of a work of art occurs but once. The same tricks won't, on any account, go over a second time. To a second invasion of new ideas which make use of familiar, more or less proven devices, the spectator is already immune.[44]

Initially, this notion emerges as a critique of futurist *soirees* and dadaist happenings, but it also has consequences with regard to Lukacs' emphasis upon the formal techniqes of Realism. For Brecht, any fetishism of aesthetic technique is anathema precisely because of the formal contraints which it can impose upon the development of art and its interaction with the audience.

In fact, the role of the audience is one of the major points of conflict between Brecht's aesthetic and that of Lukacs. Where, for Lukacs the "essence-appearance" synthesis lies within the work as a formally closed totality from which the audience is excluded, in Brecht's view the active participation of the audience has to be taken into consideration. Conse-

quently, for Brecht, it is the conscious judgmental decisions which the audience makes in terms of the work which creates the potential synthesis between essence and appearance.

As with Bloch, Brecht sees the work as lying "open," insofar as it begins and then re-commences its dialogue with a changing public. Yet, in contrast to Bloch and the Expressionists, the interaction between the audience and the work is not to result in empathy or an elaboration of some abstract utopian potential.[45] Rather, in this interaction, through the conscious choices which the audience makes in its interpretation of what is presented, the work of art intellectually forces the public to confront their lives and the roles which they play in society.

Thus it is the rational nature of *the choice to be made,* stemming from the elaboration of the contradiction between the way society appears and the way it actually functions, which differentiates Brecht's art from both Expressionism and ninetennth century Realism. For, with Brecht, the emphasis shifts from a simple objective presentation of the world, or an exclusive concern with the utopian *novum,* to an immanent critique of the ideology of the existing society and the elaboration of those alternatives which either foster or prevent the creation of socialism.

Brecht forces his audience to reflect upon the existing society in its contradictions and conceptualize the need for change. Thus, through the creation of an interaction between the particular subjects and the work of art, both the work and the audience enter the current of history in the interrelation which is achieved between decision and action, art and politics.

Consequently, the exposure of social reality does not end with Lukacs' formalistic conception of realism which relies on the constructions employed by nineteenth century novelists. The validity of a particular aesthetic form, for Brecht, comes to be determined by the possibilities which it extends to a particular public in a particular society. In Brecht's view, forms arise within the context of changing social and aesthetic needs. Thus, to take Brecht's analysis one step further, to speak of the "decadence" of Expressionism is already mechanically to reduce the development of art to the perceived decadent development of the bourgeoisie.[46] But, if in fact there is a development in the change to the imperialist phase of bourgeois society, then there can be no clear-cut line of demarcation between the "vigorous" art of the early era and the "decadent" art of the later era; this is particularly the case since, within this change, art must meet the new needs and possibilities for liberation which arise.

The periods which marked the expresssionist upsurges were, for Brecht, transitional periods which required new modes of experimentation precisely because the age held a revolutionary potential. Yet, Brecht is the first to admit that this potential was not fully expressed or realized. In fact, he is essentially in full agreement with Lukacs that the "essence" of reality — which the Expressionists saw in terms of abstractions —

needs to be shown through an examination of the social forces and class contradictions within the given society. In opposition to Lukacs, however, Brecht feels that there is not only one form by which these contradictions might be elaborated — as the finest examples of modernist art make clear.

To condemn artists such as Picasso for his *Guernica,* or Döblin for his *Berlin Alexanderplatz,* or Dos Passos for his *U.S.A.* trilogy, in the name of realism is to accept a formalistic mode of criticism which only serves in binding one to the past. The concrete result is to constrict the revolutionary possibilites of art, and the category of realism itself, by defining it simply in terms of what it was and not in terms of what it can be or should be. Just such a blindness, self-imposed by the standards of orthodoxy, is precisely what Brecht deplores; all the more so, since for Brecht a viable conception of realism is of prime importance. This is not only true for aesthetics, but for political theory as well, since it is the category of the real which defines the content of that social totality with which Marxism must concern itself. Thus to chain the concept of realism to a nineteenth century mode of depicting objective conditions turns the concept into a trans-historical formula which will contribute to the reification of Marxism.

For Brecht, a viable notion of realism can only arise when the concept is related to a specific socio-historical context and when it is seen in its effects upon specific class relationships.[47] Therefore, Brecht views the relation to tradition as determined by the needs of literary production and social change in the present. Implicitly, Brecht comprehended the subjective factor in the choice of the aesthetic form which crystallizes, or translates, the possibilities for the transformation of the existing order. Also, this is what makes tradition itself a phenomenon of ever-changing content — and not a rigidified set of prescriptions or rules — which must be consistently reinterpreted in a determinate manner to meet particular needs. Consequently it is no accident that, although he was never an Expressionist, Brecht was able to make use of certain technical and formalistic advances which the Expressionists had initiated.

Subjectively, Brecht considered himself a realist and yet he understood that realism is not simply an extension of that form which grew out of the socio-economic circumstances of the nineteenth century. That specific form of realism is, for Brecht, by no means sacrosanct nor does it necessarily even take in the "totality." The historical situation itself changes with new discoveries and new problems, so that a new totality constantly emerges which needs expression in a new way. Thus:

> We cannot allow ourselves to be held up too long by the problem of form or, at least, we must be exact as to what we mean and speak concretely. Otherwise, as critics, we will become formalists, no matter what vocabulary we use. It disconcerts our contemporary writers when they have to hear, all too often, that "that's not the way our grandmother used to tell it." Okay, say that the old woman

was a realist. Assuming that we are also realists, would we then have to recount something in exactly the same way our grand-mother did? There must be some misunderstanding here.[48]

In spite of the ironic tone — Brecht fully realizes the seriousness of the problem. He is well aware of the fact that "form" and "content" are not realities unto themselves. Instead they are descriptive categories which may be used to analyze a work which is, in itself, an organic unity. Where abstractly the two can be separated, in the work itself they are inseparable. Consequently, what actually occurs when Lukacs demands the retention of the nineteenth century form of realism, is a restriction of that content which the twentieth century has enlarged. But reality is ever-changing in its content and, therefore in order to keep pace with it, art must change as well. As Brecht put the matter:

> Times pass, and were they not to pass, it would be grave for those who do not sit at the golden tables. Methods become exhausted, impulses give out. New problems arise and demand new remedies. Reality changes too and, in order to describe it, the manner of representation must change as well. Nothing arises from nothing, the new emerges from the old, yet it is indeed for that very reason still new.

But that is not all. If the most important concern is to show reality as it actually is, then the nineteenth century novel's inner unification of essence and appearance may not be the first priority in the modern age. For Brecht, if reality is to be shown as it actually is, then the existing contradictions must be presented as they are. If the synthesis occurs within a specific situation then all the better, but if in fact a synthesis does not occur in objective reality then it might also be valid to show how and why the potential unity between "essence" and "appearance" falls apart.

Of course, here again, the "open" nature of the artwork is involved and this leads to the question of the work's comprehensibility. Brecht, himself, was always skeptical of highly abstract art and continually sought to keep his own language simple and concrete. Still, for Brecht, a viable art

> should bring forth the thing-in-itself, the incomprehensible. Yet, art should neither depict things as self-evident (seeking an emotional response) nor simply as incomprehensible. Rather it should depict them as comprehensible, but not yet comprehended.[49]

For Brecht, the audience should never feel too comfortable and the work of art should force the public to strain its intellectual faculties. Since the consciousness of the general public does not change with the same speed as the substructure in its objective developments, Brecht's formula necessarily throws art beyond the over-riding modes of expression in a given period. In turn, this naturally leads to a certain amount of difficulty in terms of the work's comprehensibility.

The Soviet position on aesthetics, however, emphasized the impor-
tance of the immediate comprehensibility of an artwork by the masses; in
other words, it was seen as essential that a work integrate itself into the
cultural life of the masses (*Volkstümlichkeit*).[50] Formalistically, this was to
be accomplished through the artist's reliance on an objective "realistic"
style, the inheritance of the revolutionary bourgeoisie. In this sense,
Soviet aesthetics prized its ties to the past. On the other hand, the content
of the work was to be "socialist;" this meant that art — particularly in the
period of consolidation surrounding the extraordinary sacrifices made by
the Russians to industrialize — was to support the masses in their strug-
gle for socialism. Unfortunately, however, these struggles were seen as in-
carnated in the Communist Party and the immediate practical policies
which it chose to pursue. Thus any criticism of Soviet life became
counter-revolutionary by definition, while any formal departures from
realism could be seen as inherently elitist, "individualist" or "decadent."
Consequently, as the original liberating social function of realism —
namely, to expose the actual represssion of the existent — was destroyed,
the formalistic emphasis on the realist style created an artistic conformity
which was managed from the top down. In contrast, Brecht argued that —
rather than accept what has already been made comprehensible as the
only form which is authentically "popular" (*Volkstümlich*) — the future
socialist culture must be created by the experimentation with new forms.
This is the sense in which Brecht views art as a "laboratory." For he
realizes that a truly socialist art must also develop new *forms* for hearing,
seeing and understanding the world along with a new content. In fact, one
of Brecht's primary aesthetic concerns in his plays involves the undermin-
ing of the old forms of art and experience which he views as hampering
the class consciousness of the masses.[51] Moreover, Brecht can suggest
that this concern need not lead to elitism in the avant-garde sense, since:

> those other works which were understood were not always written
> like the works which came before them. Something had been done
> for their comprehensibility. So too, must we do something for the
> comprehensibility of the new works. There exists not only a state of
> being related to the culture of the people (*Volkstumlichsein*), but
> also a process of becoming related to the culture of the people
> (*Volkstumlichwerden*).[52]

Of course, this is not to say that the artist should simply neglect the
public of the present and concentrate solely on the future. Brecht only
wishes to emphasize that categories such as realism — which in his view
should be retained — may not be statically defined. Rather, they must be
revolutionized in the way that they are practically employed. For finally,
aesthetics must lead to a *new art* which does not simply copy bourgeois
realism from a socialist perspective.

A new critical vantage point which sees society — in both its form
and content — as mutable must be brought into existence; or, if it cannot

be brought into existence at the given time, an openness to the possibility that it can eventually be brought into existence must at least be maintained. In order for this new art to emerge, however,

> proletarian literature strives to learn formally from the older works. This is only natural. It has been recognized that one cannot simply skip over previous phases. The new must overcome the old, but it must overcome the old by taking it in, by sublating (*aufheben*) it. One must realize that there is now a new kind of learning, a critical leaning, a transforming revolutionary learning. The new exists, but it arises out of the struggle with the old, not without it, not out of thin air. Many forget about learning or treat it disdainfully as a formality, and some even take the critical moment for granted, treating that as a formality as well.[53]

In Brecht's conception, therefore, the notion of realism becomes broadened. For his view demands the experiments with montage, dream and fantasy. The new is born of struggle with the old. Learning involves, not the asinine wholesale opposition to the past which was so important to many avant-gardists, but rather a critical inquiry and transvaluation of the past.

Unlike Bloch, Brecht is concerned with the possible emptying of the category of realism through its complete relativization and he attempts to counter this from a class standpoint. Thus, Brecht's position with regard to the avant-garde is to a large extent conditioned by his perception of this art's minimal potential to initiate revolutionary politics and change. Consequently, he differs from both Lukacs and Bloch. On the one hand, Brecht favors a realist art insofar as its revolutionary potential for exposing the actual conditions of the given order are clearcut. On the other hand, he recognizes the fact that modernist experiments can be used towards progressive ends — not only in utopian terms, but in practical ones as well.

Still, Brecht is aware that aesthetics cannot be left at the level where it simply discusses the perception of reality through art. Rather, it must also discuss who is doing the perceiving and what consequences can be drawn. Precisely because there is the possibility of the bourgeoisie distorting the term realism, which might result in the most abstract and senseless art being viewed as somehow "realistic," Brecht sees the need for elaborating the content of the category.

In Lukacs' view, in order to have a viable conception of realism it is necessary to have a "standard" and such a standard can only stem from the historical past.[54] On the other hand, Brecht maintains that the concept of realism must be historically defined in terms of the specific possibilities of exposing the socio-economic conditions of the given order. Only from the examination of these social conditions can a critical aesthetic realistically determine what can adequately project the tendencies for liberation within them. But, in order for this to occur, the ideology

which prevents such an analysis must be undermined and exposed. For Brecht, the purpose of realism is to break through the world of appearances and to examine how society actually functions. In this he follows Lukacs. But where Lukacs accepts the "contemplation" of the subject in viewing a closed "objective" totality, the new element in Brecht's conception is the *commitment* to ideology-critique on the part of the artist and the audience, a commitment to show consistently and then understand how the "reigning viewpoints are the viewpoints of those who reign."[55] The dialectical exposure of the actual contradictions within society is however precisely what simultaneously links Brecht's notion to the past and what allows it to serve as a basic corrective to the possibility of a total relativization of realism. At the same time the emphasis upon ideology critique — which can naturally take on changing forms — calls into question any rigid, formalistic, view of realism. The attempt to elaborate the actual social conditions of a given period, coupled with the commitment to ideology-critique in the name of a new liberated order, is what Brecht's aesthetic offers to the struggles of the oppressed. From this it only follows that, for Brecht, realism takes its place as a special mode through which art can relate itself to revolutionary *praxis.*

Towards an Aesthetic of Emancipation

From the controversy over Expressionism, it becomes apparent that a new aesthetic is necessary in order to develop the dialectical relation between the social conditions in which a work emerges, the context in which it is received, and the transcendent possibilities for liberation within the work itself. For, despite Brecht's best efforts to broaden the category of realism, it is clear that two tendencies confront one another: the realist and the modernist.

But, in fact, this is a false dichotomy. Once the conflict between them is subjected to a critical analysis, a reductivism becomes evident from the proponents of both perspectives. Where, for Lukacs, the aesthetic question is reduced to a socio-political formulation, for Bloch, the concrete comprehension of a given reality is underemphasized in favor of an "anticipatory consciousness." In both cases, the particular work is reductively subsumed within the tendency that is to be judged.

This mode of criticism, however, becomes particularly striking from Lukacs' realist standpoint. For Lukacs judges a work by its tendency, and the tendency by a particular class standpoint that equates the worldview presented by the movement with the content of the specific works themselves. The circle is closed, so that the critical and emancipatory potential of aesthetic creation is lost. Rather than allow categories to emerge from the concrete content of what is being analyzed, Lukacs simply imposes a set of prescribed categories upon what is being examin-

ed. Consequently, a mechanistic element creeps into his aesthetic and reappears in his social analysis.[56] The analysis becomes fixed by the political standpoint of Stalinist policies in the thirties, and then hypostatized through its extrapolation as a theory that stands beyond this point in time. Thus, Lukacs' analysis cannot concretely comprehend aesthetic transcendence: the manner in which an artistic objectification speaks to a changing audience whose needs and values are historically mutable.[57] Where, in fact, a work necessarily remains "open," Lukacs closes its potential arena of meaning by conceiving of it as a set object that is to be contemplatively digested by an audience with a fixed consciousness. Therefore, the *possibility* for arriving at new interpretations — that *may* make the work relevant to new socio-political situations — comes to be denied.

Even the works of consciously fascist or proto-fascist artists such as Boccioni or Nolde — let alone consistently progressive avant-gardists like Picassco or Klee — may reflect contradictions that remain unresolved and needs that remain unfulfilled. Any blanket condemnation of such works necessarily leads to an implicit dismissal of those contradictions and needs — even if they may further the goals of emancipation. Therefore, from Lukacs' position, perhaps *the* function of a radical criticism comes to be truncated: the attempt to *de-ideologize the ideology* within a work and thereby extract an insight that may lie buried beneath the mystifying worldview of a particular artist.

Kandinsky may be taken as a case in point. In his non-objective works, the objective world of appearances is shattered in order to determine what lies beneath it. True enough, the essence which *he* finds beneath appearances is nothing more than the movements of a mystical "spirit." For him, this spiritual force is inherently inexplicable since it exists beyond objectivity. To perceive this elemental force requires a new mode of representation. For, in his view, it is impossible to deny bourgeois society's calculated regimentation of the audience's experience of an object without denying the object itself.

In short, if the spirit is to be free then it must be totally free and consequently deny the world of oppression in its entirety. Subjectively, Kandinsky's formulation tends to be idealist, mystical, and even irrational. Objectively, however, the attempt is made to validate the spontaneous moment of individuality — the uniqueness of the particular experience — which is undermined by the standardized bureaucratic routine of advanced capitalism. Furthermore, in his destruction of the object, Kandinsky attacks reification in a direct manner since the labor *power* and the imagination that were lost in the object — but which were necessary to create it in the first place — become visible once again. Aesthetically, this occurs through the force of the colors and the fantastic motion that results from the explosion of the object. Consequently, Kandinsky's experiment with the destruction of the aesthetic object *can,* through critical reflection, produce a call to remember what goes into the creation of

social objects. Finally, the realization of the human factors in production — which are forgotten in a society where the commodity form rules — can lead to the idea of a community in which the human component of creation is recognized in the production process itself.

Of course, Kandinsky himself did not view the matter in these terms. Still, despite his own views, a critical and emancipatory moment is preserved that can be illuminated. But, to find such a moment *the critic must be willing to look for it in the first place* and this necessarily calls into question the drive toward an objectivist, formalist, value-free aesthetic by structuralists and semioticists.[58]

What becomes clear is the need for a new set of categories that will overcome the notion that there is one universal emancipatory form, and allow the radical critic to confront a wide variety of aesthetic phenomena in which the emancipatory potential is shaped differently. Unfortunately, aside from his intolerance towards realism, Bloch fails to adequately differentiate the emancipatory moments of the "anticipatory consciousness" from one another or from their specific ideological sources; nor does he develop the categories by which this can be done. Yet, a critical evaluation of disparate artworks requires the categories for their differentiation. Devising such a typology of categories in which the emancipatory potential of aesthetic phenomena might appear would also go some distance in answering the traditional charge that radical criticism — through its imposition of criteria that are external to the artwork — does violence to the immanence of a particular work; such a new typology would allow the specific artistic achievement to determine the form of critical practice.

Naturally, not every artwork will fit squarely into one or another category and the development of derivative modalities will be required, but a provisional sketch of categories might look like the following:[59]

Immediacy. Even in what is commonly referred to as "mass culture," desires may be expressed that transcend the current socio-historical structures of gratification. But, as in the case of television sit-coms or certain rock songs that harp on sex or love, such expressed desires are neither self-reflexive with regard to traditional forms and values nor with regard to the structure of social relations that prevents (or would permit) their fulfillment. Due to its lack of reflexivity and indeterminacy, this form of anticipatory emancipation is easily manipulated through commerical advertising and the "culture industry." The critic's role would first involve subjecting the need (or plurality of needs for which it is the condensed expression) to evaluation, and then show the gap between the need and the structural conditions that deny its satisfaction.

Indeterminate reflexivity. A second form of anticipatory consciousness occurs in works that are reflexive in terms of those forms through which their particular medium immanently developed. Thus, they may adequately reflect the artist's desire to formally transvalue the past, but they do not necessarily reflect any comprehension of the

sources of their own content. As in the cases of Barlach or Macke, a formal perception of repression or liberating potential may be elaborated even though the concrete determinations of repression or liberation remain unexplored. In such instances, a major task of the critic is to situate the work's immanent comprehension of traditional forms and values in socio-historical terms.

Unreflexive determinancy. There is also the possibility of "naturalist" or "realist" works that comprehend a given set of socio-historical relations, but which do not call into question the traditional forms of aesthetic creation or experience. Balzac, Zola, or any of a number of prominent artists could serve as examples. In such works, the socio-historical sources of oppression are articulated, but without reference to the development of new forms of perception and experience or the need to overcome what Walter Benjamin called "the poverty of the interior." Caught within the logic and structure of the existing society and traditional forms, even the traces of an emancipatory alternative can be denied. Here, the role of the critic becomes particularly difficult. For, he must call into question what the artist epistemologically takes for granted and subject the work to a criticism that will attempt to define what must remain unexpressed.

Reflexive determinacy. Finally, as for example in certain of Brecht's plays, a work of art may comprehend the immanent development of forms and values in its own medium and simultaneously expose the socio-historical basis of that development. Reflexive with regard to the need for transvaluing traditional forms and values, the material basis for such a transvaluation begins to be articulated and with it the sources of liberation and repression. In such cases, the function of the critic principally involves the elaboration of how this artistic vision of socio-historical and aesthetic self-comprehension may radicalize existing cultural, social and political actions.

Obviously, it is inadequate simply to *separate* the "good" from the "bad" when evaluating either a work of art or a trend. Categories may overlap, and so too the functions of the critic who may well attempt to systematically relate these categories in a broader unity. In any event, many elements — both progressive and reactionary — can be retained in the same work or movement.[60] Though it makes little sense to excuse the failings of an artist or a movement through the perception of an implicit emancipatory potential, it is also a mistake to totally dismiss a work because its artist or tendency is deemed "reactionary" or "petty-bourgeois." For, once a work is finished, it separates itself from the author as a self-subsisting entity; the intentions of the artist, the beliefs that he holds, simply become *moments* in the organic *totality* of the work. Hence, even works of political reactionaries *may* retain critical or emancipatory moments; conversely, whatever its utopian possibilities, a work never fully escapes the constraints of its particular social context. Consequently, whatever the work, the critic must *both* do justice to its eman-

cipatory possibilities as well as to the conditions of oppression to which that potential is tied.

In terms of the critic, therefore, the real *choice to be made* does not involve making a dogmatic decision on style in the name of a radical political consciousness; instead, it involves choosing a mode of analysis that will clarify the unacknowledged potential in art which will radicalize political consciousness. Precisely this anticipation of liberation justifies the study and creation of tradition.

Besides, critics have consistently forgotten that a work of art does not exert even its indirect effects in an autonomous manner. The effects of a particular work or style are always mediated by the effects of coexisting works and styles. Thus, the recognition of the need for a critically rationalized conjunction of forms by a Marxian aesthetic only reflects the actual position of any particular work of art within the existing sociocultural whole. When finished, neither the realist nor the modernist work exists in a vacuum; where there is Kafka there is also Thomas Mann, and where there is Klee there is already Daumier. Whatever the differences between Realism and Modernism, whatever the subjective preference, the fact is that their effects interact in the minds of the public; choosing to ignore such an interplay is nothing other than a flight from reality. But this interaction, which is often unconscious, necessitates the critical thinking that will bring it to light and transvalue it in revolutionary terms. Particularly when the social contradictions are themselves recognized — a perception which Lukacs correctly claims is often closed to much of modern art — the position of fantasy in the social complex and its function becomes clearer. A social space emerges for the imagination and, in the perception of that space, criticism can begin to help construct the "exact fantasy."

A truly revolutionary art is always an art of diversity. This is not only historically apparent in the heroic years of the Russian Revolution, but in the period following the First World War, the Spanish Civil War, and the sixties as well. It was Modernism in general, and Expressionism in particular, that self-consciously proclaimed the validity of such artistic diversity, and this becomes a fundamental legacy. The real issue at stake is not of one style contra another, but whether the immanent relation between the imagination and the transformation of reality, art and emancipatory politics, is to be recognized.

Indeed, it is in this sense that Bloch and Brecht are correct in maintaining that art should be viewed as a "laboratory"; for without this experimental, imaginative component art would truly be condemned to consistent repetition. Furthermore, at this point in time, it would be the mark of the purest philistinism to argue — as does Lukacs — that montage is nothing more than a simple "distortion" of reality. Aside from the manifestation of pure play, which is evident in so much of Expressionism,

new dimensions of experience and reality can appear as objects take on new relations to one another, so that the world itself may take on a form that is different from the one which is experienced in everyday life. Though the critical exploration of everyday life is realism's truth, the perception of the possibility for a different form of existence cannot be taken for granted. In its finest representations, montage need not involve an arbitrary throwing together of "pieces" of reality. Instead, it may call for the restructuring of reality through the juxtaposition of dissimilar objects.

A bond between the experiential fragments of reality is there, albeit often withheld by the artist; consequently, montage becomes a method through which reality is to be comprehended by the on-looker in practical terms, through his active involvement in the work. The responsibility of the subject is awakened in this way as he is forced to take part in the active construction of something new.

This mirrors the truth that freedom is only freedom for the subject, and foreshadows a situation in which this active responsible freedom will become a reality in everyday life. Moreover, in terms of consciousness, the imagination of the on-looker is unleashed; the imagination, degraded by capitalist forms of labor, enters the work and ties together what the artist has disjunctively constructed. Thus, the imagination is released from its slumber; that chaos, initially presenting itself in montage, may in fact be nothing more than the appearance of chaos insofar as montage might well prove to contain a rationality within its very construct. Consequently, the search for meaning may be fostered and the use of reason may be propagated. This is the sense in which Bloch can argue that within montage there may be a "ratio of the irratio."

Still, it is easy to draw conclusions from Bloch's position that might lead to a concern with the new for the sake of the new. As a thinker, Bloch himself was extremely careful in regard to this issue. But, in an age of advanced capitalism with its planned obsolescence and institutionalization of the fad, ideological neglect can become manifest in the arts with regard to those possibilities that derive from older forms. Hence, an emancipatory aesthetic cannot disregard the potential for liberation that older movements developed. Instead, these developments must be reappropriated and transvalued in order to meet current needs.

More directly, it is by no means "academic" for Lukacs to note how the obliteration of the historical perspective, and the modernist emphasis upon subjectivity and chaos, can itself form a "tendency" that can lead to pure formalism or aestheticism. What Lukacs foresaw and feared — that abstraction would lead to an ever-greater lessening of social content — is just what has occurred with the formalism of the "new novel" and so much of the avant-garde theater, poetry, and art which is so popular today.

New forms of aesthetic expression can be absorbed by advanced capitalism. In fact, this is particularly possible when the concrete influences that society might have on the given artistic expression come to be dismissed out of hand. For, with many of the contemporary avant-

garde styles, even the potential for fantasy and the dream can come to be perverted by modernist epigones who seek to compensate for their own lack of concrete analysis by explaining reality through their personal visions. The finest Expressionists never made the pretense of giving a definitive account of the real through their visions, and at least they often sought to develop an alternative through emphasizing human solidarity and the need for an emancipated community. But writers like Burroughs, Updike, Pynchon and others simply impose their constructs upon reality and end up with nothing more than a chaotic despair or a sophisticated pessimism that leaves the world as it is. There is no possibility of solidarity, no community to be achieved; there is only the isolated soul in an alienated world.

Instead of forcing the reader to hold the existent up to question, to expose the possibility that the world can be changed, they induce the reader to acclimatize himself to the world and accept its absurdity. Though such ideological products can also be critically transvalued, a deep problem emerges insofar as the need for political revolt is reduced to the desire for personal rebellion while social inquiry gives way to existential and psycholgical meanderings. The result is a rebel who can happily coexist with repression, so that even the possibility for a qualitatively different future is denied. In such cases, a personal situation is simply extrapolated on to the world as the tragedy of society as a whole; the individual can find no solution for his problems, and logically neither can society. Consequently, the notion disappears that the world is mutable and what emerges is either resignation or the need to escape; this is the set of alternatives that is prevalent in American literature and unites such otherwise divergent novelists as Kerouac, Mailer, Plath, Oates, and a host of others.

But the cure for contemporary subjectivism is not the simple condemnation of subjective expression and the denial of experimentation with new forms in favor of those which have already been established. What becomes essential is a mode of critical thinking that places the subjective expression within its context, a type of thinking that allows the emancipatory "horizon" to emerge and which structures it within current needs. In this way, at least two functions arise for modern cultural production: that of exposing the needs of a repressive social order and that of projecting beyond the repression of that order in terms of a utopian alternative. But these two functions may not necessarily be actualized in a single work, or even in the products of a single style. In fact, such a perception is precisely what opens the way for an appreciation of both the transcendent possibilities that emerge from modernist experimentation and a realism that clarifies those created structures which, as they give rise to the expression of subjective needs, prevent their fulfillment.

In order for this to occur, radical criticism calls forth what might be termed a revolutionary tolerance. Let there be no mistake: this has nothing to do with the fashionable and popular "anti-interpretation

thesis.[61] Revolutionary tolerance does not imply that one interpretation be considered as valid as any other, or that every artist who picks up a pen stands beyond criticism. Rather, a truly revolutionary tolerance demands that the functional utopian dimension within cultural production must be recognized and that the norm of liberation must be introduced as a standard of interpretation and judgment. Such a tolerance does not guarantee the existence of emancipatory potential, but simply makes the critic open to the possibility that it can appear, and that it can be extracted from artistic creations of differing forms and contents. In short, revolutionary tolerance necessarily opposes the dogmatism wherein a critic simply attacks an artist for refusing to write the book that he would like to read.

This is the tolerance, the openness to new discoveries, which is essential for a viable Marxian aesthetic. Nor is this antagonistic to "dialectics;" in the "open" totality that marked Lukacs earlier writings, he himself elaborated the need for what Sartre would later call "totalization," or the process by which the totality would integrate new discoveries and possibilities in terms of the future to be achieved. Yet, in Lukacs' later work, the totality is closed and the role of criticism is narrowed. Where once the imaginative function of criticism was itself seen as a mode of aesthetic creation, by the form given through interpretation,[62] this creative function assumes a narrowly socio-historical character in Lukacs' later writings. For, in these later works that include his contributions to the expressionism debate, the critic no longer even seeks to relate a malleable aesthetic content to the possibilities that arise for it from a changing society.

Precisely because the Communist Party no longer exerts hegemony over the cultural thinking of the left, new possibilities arise for art and for the elaboration of the functions of aesthetic creation. Still, in class society, though the effects of a given art are mobile and do cross class boundaries, art remains in fact — if not in bourgeois theory — restricted to those who have the time, education, and socially-motivated desire to appreciate it.

This situation becomes particularly constrictive for an art that seeks to overcome traditionally accepted aesthetic rules. Still, a work need not simply formalistically ingratiate itself with what is accpeted by a mass public in order to become politically progressive. Against the Stalinists, it can be argued that the very elements that make for a work's transcendence of the present can delineate a public for the future. The fact that the modernist movements were separated from the proletarian struggle does not alone invalidate their progressive qualities, nor does it negate the possibility that the proletariat — under given conditions — can become a public for their works. As Brecht realized, realism was also separated from the proletariat and even the bourgeoisie; one thinks of Stendhal forgotten, Courbet despised, Daumier denigrated as a cartoonist. In a different vein, Brecht's own plays provide an example.

Originally many of them held a far more limited appeal than is generally supposed and his audiences consisted basically of the bourgeoisie and the left-wing intelligentsia. True enough, these groups still constitute the basis of his audience; yet there can be little doubt that the range and breadth of his public has expanded over the years.

In this respect, a different problem emerges. As the Frankfurt School theorists have pointed out, one of the strongest underpinnings for the power of advanced capitalism is its ability to ideologically integrate those movements and ideas which threaten it. Thus, the integration into that society which it wishes to oppose is the continuing danger for every work and movement.[63] In fact, it is no accident that even some of the most sincere and immediate attempts to merge art directly with the proletarian struggle have proved futile in a practical sense. As Kracauer observed, even Piscator's workers' theater served as "a sort of Grand Guignol for the rich, who enjoyed letting themselves be frightened by communism as long as they had no real fear of it."[64]

Given the expanding monopoly structure of publishing, television, and cinema, it is certainly questionable whether an avant-garde in the old sense is even still viable today. But, precisely because of the ever-increasing concentration of the culture industry, there is the possibility that pockets of cultural resistance might emerge on the periphery. In fact, given the experience of 1968 in France, these pockets of cultural resistance might even link themselves to a revolutionary audience.

Such a possibility, at this time, is naturally purely speculative. In any case, however, the continuing emphasis upon the absorption of aesthetic potential by mass society can lead to pure snobbery and complacent passivity. It is one thing to argue that the reflexive capacities of the audience have been dulled and that the manner in which the public has been educated to view art is false. It is quite another thing, however, to believe that the validity of an artwork is diminished to the extent that it becomes popular, or part of an amorphous "mass culture." The first position necessarily leads to the development of new categories that will shift the evaluation of an artwork from the size of its audience to the emancipatory potential within the artwork itself and the manner in which it may be perceived. In contrast, the latter position — while at least implicitly defending the old arbitrary dichotomy between "high" art and "mass" culture — easily leads to a pseudo-aristocratic elitism and some of the worst features of "l'art pour l'art." Furthermore, such a view runs counter to one of the most radical ideals of socialism; it is a point on which even Lukacs, Bloch, and Brecht could have fundamentally agreed: that art is there for the masses, not simply for an elite which can savor its negative power. This notion does not claim that art must relate itself to the immediate tastes of the public, but only that the broad masses have the right to know and appreciate Shakespeare and Goethe, or Rembrandt and Cezanne.

Of course, the question remains with regard to how this may be fostered. Thus, it becomes initially obvious that the artist, but also the critic, must concretely recognize the public which, even in the immediate context, might hold an affinity for what he will produce. A discussion of this issue is lacking in Bloch's analysis. Yet, Marxian dogmatists provide little insight either. In fact, to believe seriously that the working class is the public which is reading Balzac, or even Gorky, is to give way to the worst type of delusion. Then, too, the almost automatic response on the part of certain Marxists that this is all a question of tendency does not clarify the issue either.

A tendency is just that, and not an immutable fact. Tendencies are malleable. Thus, to extrapolate what one considers to be the form and content of a given tendency on the future is already to constrict the development of that tendency. In this regard, even the question of the "difficulty" of a particular work in the present does not preclude a heightening of the sense of wonder and a future sense of fascination with what is currently considered difficult. There are, of course, real problems involved in directly reaching potentially revolutionary forces through an artwork. The starting point here, however, involves a broader attack on the capitalist control of the cultural means of production and the administered hegemony of bourgeois ideology with regard to popular taste.

Still, this should not prevent the attempt from being made to break through the ideological mist. Such an attempt, however, does not in itself justify the use of cardboard characters, inane language, a sense of the oppressed as the "noble savage" incarnate, a pure emphasis upon the working class, or a refusal to admit that the working class has ever made a mistake. All this evidences a condescension of the worst sort, and an inverted snobbery which only leads to further mystification.

Then too, it is also a real mistake to neglect the intelligentsia in the name of reaching the masses or "proletarian art."[65] As Marx recognized, before any revolution can take place, a part of the ruling class must become disillusioned with its own ideology. If this is the case, then there is no reason to condemn an artist — like Godard — who is clearly conscious of his intellectual bourgeois public and who is trying to bring about this break and disillusionment.

The very existence of multiple publics — even in terms of the bourgeoisie itself — within the hegemony of advanced capitalism is what concretely necessitates extending revolutionary tolerance to differing styles that can undermine this hegemony in different ways. In fact, complementary functions can be fulfilled by opposing modes of aesthetic creation even within the same public. Thus, emancipatory fantasy seeks to awaken what underlies action: namely the will to act. But, if the will to act is to comprehend the obstacles that prevent its realization then the objective comprehension of social reality cannot be disregarded. From this perspective, even in a programmatic sense, the elaboration of fantasy and the explication of the real both emerge as fundamental components of a revolutionary aesthetic.

The creation of a revolutionary art is therefore a manifold act. Still, there are some contemporary artists who seek this unity within the particular work and who attempt to overcome what was previously seen as the absolute dichotomy between Realism and Modernism. In this — and not in the general cultural emphasis upon eccentricity, despair, inwardness, and irrationalistic subjectivism — something fundamentally new emerges in the radical artistic project of the present.

Whatever their shortcomings, the works of Gabriel Garcia Marquez — such as *One Hundred Years of Solitude* and *Autumn of the Patriarch* — evidence an aesthetically courageous attempt to merge fantasy with a fundamentally historical vision. Then there is the new attention which has been given to Bulgakov's *Master and Marguerita* and, in a different vein the consistently fine work of Günther Grass and Peter Weiss. Especially Weiss realizes that it is impossible to consider the possibility of a qualitatively different future without coming to grips with the unreconciled issues and unactualized dreams of the past that continue to press upon the present: these concerns are threads which run through his finest plays such as *Marat-Sade, Trotsky in Exile,* and the extraordinary *Hölderlin*. And then there are the musicians and painters, as well as the filmmakers like Straub whose *Moses and Aron* begins to reassimilate the memory of Expressionism. The list of artists can go on, but even if only from those who have been mentioned, the possibility arises for a new art — an art that seeks to comprehend the real without dismissing fantasy, memory, or the emancipatory promise. This is the art that might potentially transform the heritage of Modernism in general, and Expressionism in particular, while raising it to new heights.

Notes

I am particularly thankful for the numerous insights and comments which were provided by Rosalyn Baxandall, Tom Ferguson, Dorothea Frankl, Larry Hartinian, Douglas Kellner and Joel Rogers in the preparation of this essay.

[1] An excellent source on socialist realism has been edited by Hans-Jürgen Schmitt and Gödehard Schramm, *Sozialistische Realismuskonzeption: Dokumente zum 1. Allunionskongress der Sowjetschriftsteller* (Frankfurt: Main, 1974)

[2] The bulk of what would become the "expressionism debate" was carried on in *Das Wort* (The Word), a journal which grew out of the "International Writers' Conference for the Defense of Culture" whose most visible member was Heinrich Mann. This meeting of anti-fascist — but not necessarily communist — writers followed the Comintern directive to build a

Volksfront, a directive which was issued at its VII World Congress under the leadership of Dimitroff. In 1936, *Das Wort* appeared for the first time with an editorial board composed of Brecht, Willi Bredel and Lion Feuchtwanger.

[3]The articles comprising the debate have been collected by Hans-Jürgen Schmitt, *Die Expressionismusdebatte: Materialen zu einer marxistischen Realismuskonzeption* (Frankfurt: Main, 1973). Sections of the debate also have been collected by Frederic Jameson, *Aesthetics and Politics* (London, 1978), while many of Brecht's contributions have appeared in "Brecht on Social Realism" in *New Left Review* #84 and in John Willet (ed.) *Brecht on Theatre* (New York, 1975).

[4]It is important to point out that Germany lagged behind France in the arts. Impressionism came to Germany only at the very end of the nineteenth century and, in contrast to France where it had originally marked a radical departure, in Germany it developed in a conservative manner and marked that non-realist tendency which opposed the more experimental attempts of Expressionism.

[5]In this way, the issue opens up for Marxism. Most modern Marxists would not disagree over the fact that art holds a social function, that it plays a social role and that, moreover, the cultural impetus will figure prominently in the emancipation of the proletariat. Hence, to be sure, those individuals who would become participants in the expressionism debate were following a tradition. Almost every major Marxist thinker — even the most "practically" minded such as Franz Mehring, Georgi Plekhanov, Lenin and Trotsky — concerned himself to a greater or lesser degree with the role of art. Any inquiry into ideology must concern itself with the beliefs and values which are held in a particular period as well as with those demands for liberation which do not cross the immediate thresholds of political consciousness. The point for Marxism is that those beliefs and values which appear in cultural creation are themselves produced in a given society which is itself a historical product. Thus culture and the ideals of liberation which it contains are results of a social production over time in which the audience consumes what has been produced as it generates — through, and within the network of mediations — the concerns which the artist experiences. Through this interaction, the ideological climate of a period comes to be affected and different tendencies emerge.

[6]Perhaps the real instigator of the entire debate, Alfred Kurella in "Nun ist dies Erbe zuende. . . ," argued that Expressionism directly led to fascism. This obviously crude position was refined by Lukacs who went on to argue that Expressionism only — perhaps even unintentionally — helped create the climate in which fascism could thrive.

[7]It is important to note that Lukacs views the avant-garde tradition as beginning with Naturalism; sees his "Narrate or

Describe?" in *Writer and Critic and Other Essays* (New York, 1971). In fact, Lukacs often criticized the socialist realists for their "naturalistic" tendencies. The naturalist emphasis upon the "slice of life" initiates the "liquidation of realism." By this, Lukacs is clearly referring to the eradication of those social and material interactions within society which serve as the totality's mediated content. But, though it is true that modern art essentially grew out of the naturalist movement, the break with that movement is clearcut as becomes evident with regard to Zola or Millet and the Impressionists. Despite the importance of Modernism, even at the end of the First World War the realist-naturalist tendency was still dominant amongst the broader public. This is evidenced by the popularity of Thomas Mann, Erich Maria Remarque, Galsworthy, Ricarda Huch and others. In fact, it would be a serious mistake to believe that Realism or Naturalism is dead as becomes clear from the success of, say, Solzhenitsyn.

[8]Georg Lukacs, "Es geht um den Realismus" in Fritz Raddatz, (ed.) *Marxismus und Literatur* 3 Bde. (Hamburg, 1969), p. 61. All translations are by Dorothea Frankl.

[9]*Ibid.*, pp. 64-5.

[10]Lukacs' distrust of irrationalism, the subjectivist revolt, and mysticism of any sort is basic to his later thought in its philosophical as well as in its aesthetic components. In the expressionism debates, Lukacs' aesthetic position crystallizes and one can literally view it as a foreshadowing of his later work, originally published in 1954, the controversial *Die Zerstörung der Vernunft* 3 Bde. (Darmstadt, 1974 ed.) In this philosophical critique, what occurs is that — no matter what the subjective intentions of the particular thinker — irrationalism is necessarily seen as taking on an "objectively reactionary" content. Subjectivist and pseudo-historical, for Lukacs, the irrationalist tradition becomes an expression of the worst in bourgeois ideology. It is a step back from the revolutionary rationalism of Kant and Hegel who create the tradition for Marxism. Thus irrationalism comes to be intrinsically opposed to Marxism and, as the tradition enters the proper socio-economic complex, it helps create the cultural climate which lays the ground for fascism.

[11]This abstract determination of "essence" becomes clear when it is remembered how the Expressionists often simply labelled their characters "The Son," "The Friend," etc. Indeed, this was a specifically expressionist device which was used to bestow a universality upon the characters. At the same time, *in the aesthetic context*, it is also relevant to note that this made for a rather abstract humanism which was embodied in the famous cry of "*O Mensch!*"

[12]It is precisely this subjectivistic and moralistic element in the avant-garde critique which allows Lukacs to view the Expressionists as historically mirroring the position of the Independent

Social Democratic Party (USPD) which had split off from the Social Democratic Party over the older movement's stance on the First World War. Thus Lukacs finds in the subjectivism of the Expressionists a parallel to the Kautskyite position that the First World War did not serve the actual interests of the bourgeoisie, but rather that the majority of this class was "misled" by a small minority. As with the Expressionists, from Kautsky's perspective the actual class contradictions which led to the war tended to be overlooked in favor of viewpoints in which the causes were ascribed to a lack of moral insight or the failings of individuals, cliques, or "all of us." Precisely this inability to comprehend the material causes of the First World War from a dialectical perspective was what Lukacs believed led Expressionism and the Marxian revisionism of the USPD into "objectively" counterrevolutionary politics. As the Austrian Marxists saw the need for a moral education of the proletariat prior to any revolutionary combat, so too did the Expressionists place their main emphasis upon certain fundamental "moral" issues — from sex, to codes of conduct, to pacifism — which became threads tending to bind together otherwise disparate sets of literati. Once again, in both cases, the concern with morality led to a theoretical shifting of ground, from the class war with its objective conditions and causes, to a level of abstraction from which the *status quo* could never be changed in a revolutionary manner. It is worth noting that Lukacs himself later repudiated this crass and obviously Stalinist approach.

[13]From Lukacs' perspective, it can also be argued that it is no accident that the more directly politically minded Expressionists — like Georg Grosz, Hannah Höch and others — ultimately moved away from Expressionism and into *Neue Sachlichkeit*.

[14]Georg Lukacs, "'Grosse und Verfall' des Expressionismus" in *Marxismus und Literatur*, Bde. 3, p. 17.

[15]Thus Lukacs can write: "But since they thought that they could practice their critique without verifying the general economic, social and underlying ideological principles of the era — which is indeed only the ideological reflection of the fact that they did not make a break with the imperialistic bourgeoisie — even this critique proceeds on the common ideological ground of German imperialism." *Ibid.*, p. 13.

[16]Georg Lukacs, "Es geht um den Realismus," p. 69.

[17]*Ibid.*, p. 70.

[18]For a more elaborate analysis of the relation between the typical and the atypical, see Georg Lukacs, *Realism in Our Time* trans. John and Necke Mander (New York, 1964).

[19]In this regard, one need only think of Gottfried Benn, Marinetti, Miro, or Antonin Artaud and his famous: *"A finir avec les chefs d'oeuvres!"*

[20]Georg Lukacs, "Es geht um den Realismus," p. 83.

[21]For a fuller elaboration of the role of "anticipation" in Bloch's thought, see my "Revolutionary Anticipation and Tradition: In Honor of Ernst Bloch's 90th Birthday" in *The Minnesota Review* NS6 (Spring, 1976). Also, see Douglas Kellner and Harry O'Hara "Marxism and Utopia in Ernst Bloch" in *New German Critique* (Winter, 1976).

[22]Ernst Bloch, *Erbschaft dieser Zeit* (Frankfurt: Main, 1973), p. 149.

[23]*Ibid.*, p. 266.

[24]In 1918, at the time of the publication of *Geist der Utopie,* there still existed an extremely close personal as well as working friendship between Bloch and Lukacs. This friendship ended around the time of Lukacs' self-criticism for his *History and Class Consciousness.* Bloch's position in the debates is clearly derived from his earlier work, which was enormously influenced by Lukacs, and achieves its full elaboration in *Das Prinzip Hoffnung.* For Lukacs, however, despite certain elements which are retained from the early work, there is no question that his position in the controversy involves a critique of his early thought and his intellectual association with Bloch.

[25]Ernst Bloch, *Geist der Utopie* (Frankfurt: Main, 1974 ed.), p. 20.

[26]Ernst Bloch, *Die Kunst, Schiller zu Sprechen* (Frankfurt: Main, 1974 ed.), p. 65.

[27]The return to the "natural" was a fundamental component of romanticism, the roots of which can be found in Rousseau. Social concern was intrinsically connected with the revulsion to the suffering and horror which the industrialization process inflicted.

[28]Ernst Bloch, *Erbschaft dieser Zeit,* p. 250.

[29]This should not, however, be misconstrued. In contrast to Lukacs' view, the Expressionists often based themselves quite consciously upon the past. With regard to painting, artists as distant in time as El Greco and Grünewald proved highly influential, while Büchner was clearly of major importance to expressionist drama. Though Lukacs saw the development of a "tradition" as an organic or objective phenomenon, the expressionists did not. A subjective factor entered the choice of past masters and, in fact, tradition always involves a conscious choice of alternatives which the past presents within the objective constraints of the present.

[30]Ernst Bloch, *Erbschaft dieser Zeit,* p. 270.

[31]*Ibid.*, p. 267.

[32]It is important to note that Bloch was himself a pacifist — in contrast to Lukacs — during the First World War.

[33]Ernst Bloch, *Erbschaft dieser Zeit.*

[34]Georg Lukacs, "Briefwechsel mit Anna Seghers," in *Marxismus und Literatur*, vol. 2, p. 118.

[35]See Rudolf Leonard, "Die Epoche" in *Die Expressionismusdebatte.*

[36]Ernst Bloch, *Geist der Utopie*, p. 43.

[37]Ernst Bloch, *Das Prinzip Hoffnung* 3 volumes (Frankfurt: Main, 3rd ed.), vol. 1, p. 257.

[38]Yet, when Bloch writes how "interesting" it is that Lukacs could appear to be in agreement with the Nazis in his evaluation of Expressionism, he is off the mark. Though it is true enough that both Goebbels and Lukacs regarded Expressionism negatively, and that the "degenerate art exhibition" of the Nazis was taking place at the time of the debate, this is where the similarity ends. Essentially, where Lukacs criticized Expressionism as a "moment" which had acted to create a climate conducive to a Nazi seizure of power, Hitler saw this movement as an incarnation of those values which the Nazis had to overcome. The further differences are fully elaborated by Hans-Jürgen Schmitt in his introduction to *Die Expressionismusdebatte.*

[39]It is important to note that, though artistic experiments occurred in the early reign of both Mussolini and Franco, these modernist experiments were curtailed as soon as the situation stabilized.

[40]It would be a mistake, by the way, to believe that all those who considered themselves "realists" were either humanists or anti-fascists. Knut Hamsun, Robert Brasillach, and Pierre Drieu la Rochelle were proud of their "realism" and were all avowed fascists.

[41]In particular, see the introductory notes in *New Left Review* #84 and Eugene Lunn's fine historical article entitled "The Brecht-Lukacs Debate" in *New German Critique* #3. For an extremely pretentious and confused analysis of the Brecht-Lukacs controversy from a neo-structuralist perspective, see Terry Eagleton's "German Aesthetic Duels" in *New Left Review.*

[42]It is interesting to note the following passage in Benjamin's diary. "The publication of Lukacs, Kurella *et al* are giving Brecht a good deal of trouble. He thinks, however, that one ought not to oppose them at the theoretical level." Walter Benjamin, *Understanding Brecht* translated by Anna Bostock (London, 1973), p. 116. This statement only testifies to the emphasis which Brecht placed upon pratical production as against aesthetic theory.

[43]Nevertheless, it is dangerous to push Brecht's heterodoxy too far. This becomes obvious not only from Brecht's refusal to publish his contribuitons to the debate at the time, but from other choices as well. One interesting example is to be found in his play *The Resistible Rise of Arturo Ui.* This play is patently designed to elaborate the conditions which allowed Hitler to

come to power. The machinations of Hindenburg, Rohm, Goebbels, Dollfuss and others are chronicled with great precision. Yet, Brecht does not mention either the conflict between social democrats and communists, or the "social fascist" thesis. Of course, one can grant him "poetic license" in this regard — but it is a very convenient argument to say the least. In public, Brecht was always quite circumpsect with regard to the Communist Party. Cf. Henry Pachter, "Brecht's Personal Politics," in *Telos*, No. 44 (Summer, 1980).

[44]Bertolt Brecht, "Über den Dadaismus" in *Gesammelte Werke* 20 volumes (Frankfurt: Main, 1967), vol. 18, p. 6.

[45]For an interesting discussion of Brecht's notion of utopia, see Jost Hermand, "Brecht on Utopia" in *The Minnesota Review* NS6 (Spring, 1976).

[46]Unfortunately, this mechanistic argument cuts both ways. If the bourgeoisie is continuing to develop its productive forces, then Modernism is clearly not yet "decadent." Ironically, a justification of this position may be found in Lenin where imperialism is the "highest stage" of capitalism.

[47]Bertolt Brecht, "Förderungen an eine neue Kritik" in *Gesammelte Werke*, vol. 18, p. 113.

[48]Bertolt Brecht, "Praktischen zur Expressionismusdebatte" in *Gesammelte Werke*, vol. 19, p. 327.

[49]Bertolt Brecht, "Über alte und neue Kunst" in *Gesammelte Werke*, vol. 19, p. 314.

[50]Brecht was always, quite rightly, suspicious of a term such as *Volkstumlichkeit*. As he put it: "A people (*das Volk*) can be anything at all — except *Volkstumlich*."

[51]Thus, for example, in *The Three Penny Opera*, Brecht can attack the classical device of the *deus ex machina* while, in *Saint Joan of the Stockyards*, he can blast Goethe, Schiller, and Holderlin in formalist terms.

[52]Bertolt Brecht, "Volkstümlichkeit und Realismus," p. 33.

[53]Bertolt Brecht, "Bemerkungen zum Formalismus" in *Gesammelte Werke*, vol. 18, p. 314.

[54]Georg Lukacs, "Briefwechsel mit Anna Seghers," p. 125.

[55]Bertolt Brecht, "Volkstümlichkeit und Realismus," p.326.

[56]Thus, in the debate, Lukacs is concerning himself with the Western European avant-garde as a whole through his analysis of Expressionism. But, though it is true that to a greater or lesser extent virtually all the avant-garde groups overlapped, to label them all — with their differing forms of action and differing ideologies — as "petty-bourgeois" is at best an overgeneralization and, at worst, an example of schematic thought. In fact, the very internationalism of many modernist groups runs counter to the ideology of the petty bourgeoisie. Furthermore bourgeois domination appeared differently in differing

countries, due to differing levels of industrialization, etc.; the bourgeoisie created qualitatively different contexts in which the avant-gardes functioned and to which they responded different-ly. Thus, to place the Italian Futurists, who were quite con-sciously proto-fascist and then fascist in both their thought and political practice, under the same rubric as the Expressionists — many of whom were pacifists and supporters of the Spartacus insurrection — only results in reifying the dialectical method. For the very purpose of this method is to expose the concrete, particular, workings of historical agents. If class concepts are not to be dogmatically imposed, then they must spring from the thought and the actions of movements in their specific relation to the events that occurred during the time of their existence.

[57]A further point involves the position that an analysis of Modernism cannot rest simply upon the values of the past, or the exigencies of the present. The basic potential within Expres-sionism may not exclusively reside in its *direct* political manifestation, especially since future audiences will bring new and differing values to the interpretation of a particular work. Unfortunately, from Lukacs' perspective, literature and art no longer raise questions and possibilities, but rather, like social theory, *must* presuppose the answers within their formal modes of exposition.

[58]There may well be a place for semiotics *within* a Marxian criticism — despite the serious theoretical problems of linking a purely formal, trans-historical theory to one which is quintessentially historical. Such a linkage, however, has yet to be made. Still, one thing is certain: the analytic destruction of the work's organic unity — as well as the denial of its intrinsic relation to social reality — leads art and criticism to a place ex-clusively reserved for mandarins. In fact, the increasing for-malistic isolation of elements only testifies to the penetration of the division of labor into the critical faculty itself, insofar as it is precisely the increase of specialization that has produced the fragmentariness of modern world views. From the mandarins' method, any liberating potential within art comes to be neutralized. Moreover, a mode of criticism emerges that divorces criticism from art and perpetuates criticism's sterile reflection upon itself.

[59]I would particularly like to thank Joel Rogers for his help and suggestions in formulating the elaboration of these categories.

[60]In arguing that Expressionism helped create the cultural climate for fascism, Lukacs overlooks this point. He argues in terms of consequences, and he takes for granted that these con-sequences have been validated in reality. But, the reactionary consequences of Expressionism are not the only ones that can be drawn insofar as the attack on the structures that repressed the individual also sought to bring about the demand for solidarity. There can, of course, be little question that Expres-

sionism exerted an influence on Weimar. Nevertheless, to assess the influence of this movement purely negatively — as conducive to fascism — without even mentioning the disasterous "social fascist" policy of the Comintern, which directly created the political conditions for Hitler's triumph is dogmatic and one-sided. In positive terms, in terms of the needs of the oppressed, Expressionism always opposed the worst effects of industrialization, bureaucratization, and operational rationality. If there were elements in Expressionism that gave rise to a fascist climate, there were also elements that opposed the Nazis.

[61]Such a position, which simply mirrors bourgeois pluralism, brings forth a relativism that consigns art to a plane of uselessness and sterility barely imagined by the advocates of "l'art pour l'art." Cf.: Susan Sontag, *Against Interpretation* (New York, 1966).

[62]Cf.: Georg Lukacs, *Die Seele und die Formen* (Neuwied, 1971 ed.).

[63]Naturally, there can be no doubt that any work which is produced in capitalist society will become a product of commodity exchange. The mistake, however, is to believe that a work's *Kunstfreude* or utopian potential is annihilated to the extent that it becomes a commerical success and "popular." Thus Chaplin's movies, with their wide appeal, remain as fresh and rich as they ever were, and it is easy to find other examples.

[64]Siegfried Kracauer, *From Caligari to Hitler* (Princeton, 1957), p. 59.

[65]For an excellent attack on the concept of "proletarian literature," see: Leon Trotsky, *Literature and Revolution* (Ann Arbor, 1971).

Annotated Bibliography

Douglas Kellner

We conclude with a selected bibliography, focusing on recent literature on Expressionism which might be of use to our readers. There are two introductory books in English which provide a broad overview of the movement and a discussion of artists, works, and socio-cultural context. They are John Willett, *Expressionism* (New York: McGraw-Hill, 1970) and R.S. Furness, *Expressionism* (New York: Harper and Row, 1973). Books of essays on Expressionism include Ulrich Weisstein, editor, *Expressionism as an International Literary Phenomenon* (Paris and Budapest: Didier and Akademiai Kiado, 1973); Victor Lange, editor, *German Expressionism, Review of National Literatures,* Vol. 9 (1978); and Gertrud Bauer Pickar and Karl Eugene Webb, editors, *Expressionism Reconsidered* (München: Wilhelm Fink, 1979). These anthologies contain many interesting essays but do not, for the most part, provide a systematic examination of Expressionism, nor do they provide many new interpretations, or evaluations, of the movement as a whole. Weisstein's volume contains a large bibliography of works on Expressionism through the early 1970's. A French anthology, *L'Expressionisme dans le Theatre europeen,* edited by Denis Bablet and Jean Jacquot (Paris: Editions du Centre Nationale de la Recherche Scientifique, 1971) contains many fine essays, as does a German anthology *Begriffsbestimmung des literarischen Expressionismus,* edited by Hans Gerd Rötzer (Darmstadt: Wissenschaftliche Buch-

gesellschaft, 1976). The best recent works on Expressionism which offer new interpretations and perspectives are in German: Silvio Vietta and Hans-Georg Kemper, *Expressionismus* (München: Fink, 1975) and Richard Hamann and Jost Hermand, *Expressionismus* (München: Nymphenburger, 1976). A comprehensive series of studies in French is found in Jean-Michel Palmier, *Expressionisme comme Revolt,* two volumes (Paris: Payot: 1978 and 1980).

On the expressionist subcultures, the study by Roy Allen is useful, *Literary Life in German Expressionism and the Berlin Circles* (Göppingen: Kummerle, 1974), as are the recollections of the expressionist era collected by Paul Raabe in *The Era of German Expressionism* (Woodstock, N.Y.: Overlook Press, 1974). On expressionist politics, see Eva Kolinsky, *Engagierter Expressionismus* (Stuttgart: Metzler, 1970). On the so-called "expressionism debate," see Hans-Jürgen Schmitt, editor, *Die Expressionismus = debatte* (Frankfurt: Suhrkamp, 1973). Selections from the debate, with commentary, are translated in Frederic Jameson, ed., *Aesthetics and Politics* (London: New Left Review, 1977). On the expressionist era as a whole, see Roy Pascal, *From Naturalism to Expressionism* (New York: Basic Books, 1973) and Henry Pacheter, *Modern Germany* (Boulder: Westview, 1979).

There exist many useful introductions to expressionist literature in English, including the now "classic" studies by Richard Samuel and R. Hinton Thomas, *Expressionism in German Life, Literature, and Theatre* (Cambridge: W. Heffer, 1939) and Walter Sokel, *The Writer in Extremis* (Stanford: Stanford University Press, 1959). Also of interest are Egbert Krispyn, *Style and Society in German Literary Expressionism* (Gainesville: University of Florida Press, 1964); Wilhelm Emrich, *Literary Revolution and Modern Society* (New York: Ungar, 1971); and Roy Allen, *German Expressionist Poetry* (Boston: Twayne, 1979). A comprehensive German anthology contains many broad overviews of aspects of expressionist literature and studies of individual authors, *Expressionismus als Literatur,* Wolfgang Rothe, editor (Bern: Francke, 1969).

Translations of expressionist literature proliferated in the 1970's. Older anthologies include *An Anthology of German Expressionist Drama,* Walter Sokel, editor (Garden City, N.Y.: Doubleday/Anchor, 1963); *Modern German Poetry,* edited and translated by Michael Hamburger and Christopher Middleton (London: Macgibbon and Kee, 1966); and *Seven Expressionist Plays,* translated by J.M. Ritchie and H.F. Garten (London: Calder and Boyars, 1968). Calders and Boyars have also published translations of expressionist war plays (*Vision and Aftermath,* 1969), Georg Kaiser, *Five Plays* (1969); and Carl Sternheim, *Scenes from the Heroic Life of the Middle Classes* (1969). See also Ernst Toller, *Seven Plays* (New York: Liveright, 1936). Translations exist of Benn's poetry (1971 and 1972), but as of now there are no adequate collections in English of early expressionist poetry. Rothe and Vietta-Kemper, *op. cit.,* contain rather detailed bibliographies of German expressionist literature.

Most books on expressionist painting are extremely superficial. The best overall surveys are Bernard Myers, *The German Expressionists* (New York: Praeger, 1957) and Peter Selz, *German Expressionist Painting* (Berkeley: University of California Press, 1957). On theories of German expressionist painting, see Geoffrey Perkins, *Contemporary Theories of Expressionism* (Bern and Frankfurt: Herbert Lang & Cie, 1974) and the anthology *Theories of Modern Art,* Herschel B. Chipp, editor, (Berkeley: University of California Press, 1969) which contains selections from writings of expressionist painters.

The two major works on expressionist film are Siegfried Kracauer, *From Caligari to Hitler* (Princeton: Princeton University Press, 1947) and Lotte Eisner, *The Haunted Screen* (Berkeley: University of California Press, 1955). Contributors to our anthology have criticized Kracauer's excessively sociological approach and Eisner's rather mystical-irrationalist focus which is itself caught up in the ideologies of Expressionism. A still useful older book is Rudolf Kurtz, *Expressionismus und Film* (Berlin, 1926; reprinted, Zurich: Hans Rohr, 1965).

Studies in our anthology contain further references to primary and secondary sources concerning the major expressionist writers, painters, musicians, etc. It is our wish that works such as the present text, and the other studies listed in this bibliography, will lead to further translations of expressionist writing, intensified interest in all the genres of expressionist art, and continued studies of individual expressionist authors, works, artistic fields, and the movement as a whole. Expressionism is far from dead, and we hope that our studies will produce renewed interest in a movement that continues to fascinate and evoke controversy.

About the Contributors

James Bednarz has taught at Columbia and New York University. His interest in Paul Klee is part of a primary study of paradox and contradiction in cultural history.

Stephen Eric Bronner is the author of *A Revolutionary for Our Times: Rosa Luxemburg.* He has also published the fictional *A Beggar's Tales* as well as many articles on aesthetics, critical theory, and socialist politics. Prof. Bronner currently teaches political theory at Rutgers University.

A Los Angeles-based artist and art critic, Emily Hicks has published articles in *Art Week, Women and Revolution,* and *Social Text.* She holds a Ph.D. in Comparative Literature from the University of California at San Diego.

Peter Jelavich, a graduate student in the History Department at Princeton and a Junior Fellow in the Society of Fellows at Harvard, is currently writing a dissertation entitled "Theater in Munich 1890-1924: A Study of the Social Origins of Modernist Culture."

E. Ann Kaplan has been teaching and writing about film since the early 1960's. She is the author of *Fritz Lang,* the editor of *Women in Film Noir,* and writes for *Jump Cut, Wideangle* and *Millenium Film Journal.*

Author of *Karl Korsch: Revolutionary Theory* and the forthcoming *Herbert Marcuse and the Crisis of Marxism,* Douglas Kellner teaches in the Philosophy Department at the University of Texas, Austin. He has published articles on Sartre, Marcuse, Bloch, Adorno, Brecht and many others. His current interests include critical appraisals and creative alternatives in American film and television.

Marian Kester studies modern European history and the interpretation of social and historical change through the arts. She has written for the *San Francisco Review of Books, City Arts,* and *Bay Arts Review,* and *Damage* and *Wet* magazines.

Tibor Kneif is a musicologist at the Free University in Berlin. He has published widely on classical and popular music.

Manfred Kuxdorf teaches at the University of Waterloo, Canada. He is the author of *Die Suche nach dem Menschen im Drama Georg Kaisers,* and his areas of interest include German folksong and dance and problems of literary translation. He is an editor of *Germano-Slavica.*

Born into a family of professional musicians, Henry Lea holds a Ph.D. in German Literature from the University of Pennsylvania. His special concerns are German-Jewish relations, the fin-de-siecle, and exile music and literature. He teaches German at the University of Massachusetts, Amherst.

Arthur Mitzman is currently Professor of Modern History at the University of Amsterdam. He is the author of a book on Max Weber (*The Iron Cage*) and numerous other books and articles on German and French culture.

Henry Pachter (1907-1980) was an important intellectual of the German exile who authored *The Fall and Rise of Europe, Modern Germany, Paracelsus,* as well as other books and numerous articles. Formerly Professor of Political Science and Dean at the New School for Social Research, he also taught at the City College of New York and Rutgers University. Henry Pachter's *Weimar Etudes* was published by Columbia University Press.

Jean-Michel Palmier is Professor of Philosophy at the University of Paris, Vincennes, and is author of books on Trakl, Heidegger and politics, Marcuse and the New Left, and a two-volume study of Expressionism.

Mark Ritter currently teaches German language and literature at the college of St. Benedict, St. Joseph, Minnesota. A student of urban poetry and the early influences on German Expressionism, he has also done numerous translations.

Lenny Rubenstein is an editor of Cineaste and author of *The Great Spy Films.* He has taught film at LaGuardia Community College.

Marc Silberman is Assistant Professor of German at the University of Texas, San Antonio, where he specializes in postwar German film and culture and East German literature. His books include *Literature of the Working World: A Study of the Industrial Novel in East Germany,* and *Heiner Muller: Forschungsbericht.*

Seth Wolitz is Professor of Judaic Studies, French and Italian at the University of Texas, Austin, and has written widely on German culture.

Silvio Vietta is co-author with Hans-Georg Kemp of *Expressionismus,* from which our selection is translated. Vietta has authored many books and articles on German literature.

Since 1973 Barbara Drygulski Wright has taught at the University of Connecticut, Storrs. Her dissertation, from the University of California, Berkeley, was on Expressionist political philosophy. She spent 1967-68 on a Fulbright in Mainz and Munich.

Ulf Zimmerman taught modern German literature at the University of Texas, Austin, and Carleton College. His particular interests include studies of the image of the city in German fiction and he has published essays on the impact of urbanism in the work of Fontane, Rilke, Benjamin, and Doblin. He is currently teaching at the University of Houston.

Index